BERNARD BERENSON · THE MAKING OF A CONNOISSEUR

BERNARD BERENSON
The Making of a Connoisseur

ERNEST SAMUELS

THE BELKNAP PRESS OF HARVARD UNIVERSITY PRESS

CAMBRIDGE, MASSACHUSETTS, AND LONDON, ENGLAND

1979

Copyright © 1979 by the President and Fellows of Harvard College
All rights reserved
Printed in the United States of America

Library of Congress Cataloging in Publication Data

Samuels, Ernest, 1903–
 Bernard Berenson: the making of a connoisseur.

 Bibliography: p.
 Includes index.
 1. Berenson, Bernhard, 1865–1959. 2. Art critics—
United States—Biography.
 N7483.B4S25 709'.2'4 [B] 78-26748
 ISBN 0-674-06775-4

To Catherine, Caroline, and Nicholas

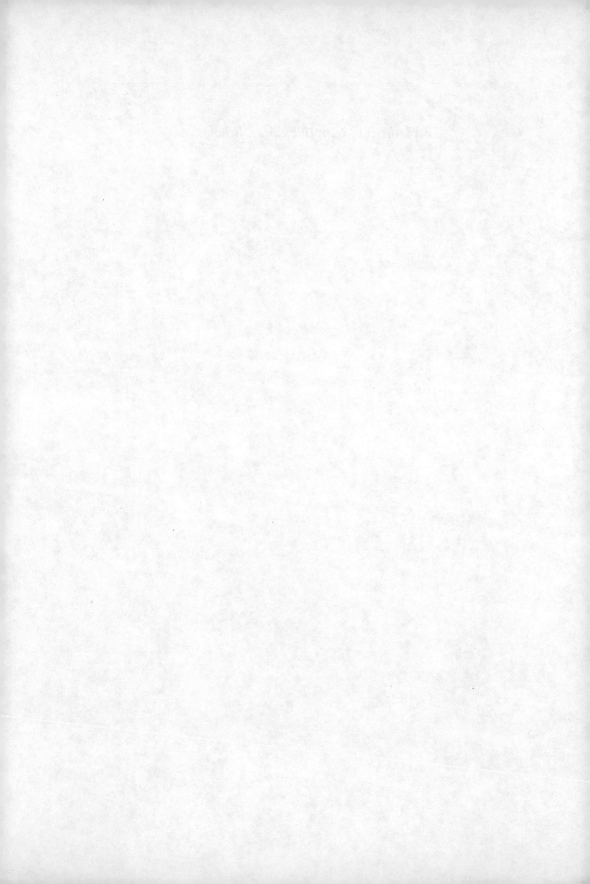

Contents

Illustrations

Credits

Special thanks are extended to the following for providing photographs and for granting permission to reproduce them: Dr. Cecil Anrep (for Villa I Tatti) 1, 2, 3, 5, 6, 14, 16, 17, 19, 22, 23, 26, 28, 29, 30. Ashmolean Museum, 18. Boston University, 4. Barbara Strachey Halpern, 12, 13, 15, 25. Harvard University Archives, 7, 8, 9. Houghton Library, Harvard University, 10. Isabella Stewart Gardner Museum, Boston, 11, 20, 21. Bernard Perry, 24.

Preface

WHATEVER legends and myths surrounded Bernard Berenson at the time of his death in 1959 at the age of ninety-four, one fact was undisputed, that for more than half a century he had reigned as the world's foremost connoisseur of Italian Renaissance art. Most of the Italian paintings which had come to America had borne his "visa on their passports." How he achieved that extraordinary eminence is a main theme of this book. It is a theme with complex and subtle variations, for much more than technical expertise and writings on art distinguished his long career. A revealing glimpse of the richly diverse world in which he moved and of the range of his intellectual interests was unexpectedly offered to me when in the course of my work on Henry Adams in the archives of the Massachusetts Historical Society I discovered a collection of his letters to that famous American historian.

It was that correspondence that brought me to Florence one bitterly cold day in February of 1956 during the coldest winter in more than eighty years. Gray sheets of ice floated in the Arno, and the Vespas roared and skittered on the Lungarno Acciaioli below my window at the venerable Berchielli Hotel. A short distance to the west the rebuilding of Ammanati's beautiful Santa Trinita bridge was still in progress. A memorial tablet would soon tell of Berenson's leading role in the restoration. The German legions had been gone for ten years, but electric power was still in short supply and the tiny bulb in one's bedside lamp seemed only to make the darkness visible.

A trolley from the Piazza San Marco deposited me at the Ponte a Mensola at the foot of the Settignano hill, and I made my way toward Berenson's Villa I Tatti past a roadside plaque which recorded the names of noted visitors who had tarried on the nearby hillsides—Boc-

caccio, John Addington Symonds, Mark Twain, Eleonora Duse, Gabriele D'Annunzio, and, at the end of the list, Bernard Berenson, who had tarried longest of all. A ten-minute walk along the curving Mensola streamlet led me to the lower gate of the villa, and I mounted the straight and narrow path, bordered on either side by giant cypresses, that led to the house. There, in my interviews with Berenson that week, this book had its distant beginnings.

Berenson, then ninety-one and confined to his alcove bed by a touch of flu, seemed an almost wraithlike figure, but that frailty was belied by the strong lines of his bearded face and the ready flow of his talk. It ranged allusively from the intimacies of Adams and his Paris circle to medieval church architecture and his hopes for the new state of Israel. Nor did I escape the quizzical cross-examination so familiar, as I afterward learned, to countless visitors. His memory was still prodigious, and his awareness of the raging controversies in the outside world was that of a young participant. Neither the horrors of war through which he had lived nor the disabling infirmities of old age had dampened his belief that sanity would ultimately prevail in our troubled world, and he talked of a revived humanism that would unite the intellectuals of the world.

During those visits to I Tatti I first met Nicky Mariano, the benevolent companion and secretary who had shared Berenson's life for nearly forty years. It was to her, as he acknowledged in the diaries of his postwar years, that he owed the happiness and achievements of the latter part of his life.

Nearly a decade passed before I again met Nicky. My work on Henry Adams was completed and the moment was ripe for new ventures. It was midsummer and the heat shimmered in the valley of the Arno, but it was cool and fragrant high on the mountainside at Casa al Dono, Nicky's summer home near Vallombrosa, and we sat in a little shelter overlooking the forested valley where Berenson used to jot down his reflections. Nicky carried her advancing years with infinite charm and good humor. Cultivated and intellectual, she made no show of her learning, and she was gaily down to earth in her uninhibited reminiscences of life at I Tatti and of the ceremonial stratagems by which its master had hoarded his declining energies. The strain of the war years and especially of the month-long bombardment they lived through during the siege of Florence was now but an exciting memory. Berenson had been forced into hiding during the Nazi occupation, and, as Nicky tells the story in her *Forty Years with Berenson,* she had played the role of a secret intermediary with considerable gusto.

Nicky spoke too of the astonishing series of writings that had been

fostered in the isolation of the war years—the confessional *Sketch for a Self-Portrait,* the vigorous theorizing of *Aesthetics and History in the Visual Arts,* and a half dozen scholarly essays in art criticism. She noted also the remarkable candor of the published diaries of his late years—*Rumor and Reflection* and *Sunset and Twilight,* works which had made him known to a wide public. We talked of the passionate aestheticism that made him a lover of life who at eighty-one could write, "My faith consists in the certainty that life is worth living, life on its own terms, [in] confidence in humanity despite all its devilish propensities, [in the] enjoyment of the individual human being as a work of art." There is, he added, "a formative energy in our makeup that drives us [to believe] that we can help to build, to improve, to adorn the ship which is to carry us from eternity to eternity, propelled by a Power we cannot know, but about purposes we need not despair. In short, even though life may be a vale of tears, it is one in which it is pleasant to weep."

The dramatic news that Berenson, long familiar to friends and journalists as "BB," had survived the Occupation, though doubly marked as an American citizen and as a Jew, brought him back to the public eye. Friends and well-wishers resumed their visits to the man whom writers were presently to characterize as "the last aesthete," "the last true humanist," and "the last Olympian." In the austerely elegant precincts of I Tatti, surrounded by his great library and treasures of Renaissance paintings, he held a kind of court for art historians and artists, poets and novelists, statesmen and tycoons, and dignitaries from every walk of life. Here too came in increasing numbers the merely curious, who were drawn by anecdotes of the ritual of the semimonastic household.

The outpouring of tributes to Berenson on the occasion of his ninetieth birthday in 1955 capped the many honors that had come to him. In the great hall of the Palazzo Strozzi in Florence before an international conference of art historians, the Italian minister of education bestowed upon him a medal of honor for his services to the study of Italian art. The University of Florence granted him an honorary degree, as did the University of Paris. Earlier both Yale and Princeton had proffered honorary degrees, but ill-health had prevented his accepting them. Years earlier the American Academy of Arts and Sciences had made him a member, and he had been similarly honored by learned societies of Belgium and Norway. The city of Florence, not to be outdone, made him an honorary citizen. Through this prolonged season of recognition news weeklies featured the sculptural lines of his face, the deep-set eyes enigmatic to the last.

Berenson's apotheosis was a twice-told tale to Nicky, for she had

long shared his triumphs. As his literary executor, she voiced her pleasure that I Tatti had become, in fulfillment of Berenson's dream of many years, the Harvard University Center for Italian Renaissance Studies, its library and facilities available to scholars and its archive crammed with the letters of more than fourteen hundred correspondents. The accumulation of perhaps forty thousand letters contained an unparalleled record of the life and thought, the hopes and aspirations of a not-yet-vanished world. Nicky spoke also of Bernard's wife, Mary, and of her long illness and her death in 1945 during the last days of the war.

What was freshest in Nicky's mind was the change in direction of Berenson's career as disclosed in his youthful papers and in the voluminous correspondence with Mary before his marriage. They were documents that traced the odyssey of the Harvard-bred idealist who, after long wandering, was to return to his earlier self. It was a period in which he bore the name Bernhard of his first years, the name that he retained until 1918, when he served in Paris with the United States Intelligence Department and adopted the French form, Bernard.

Nicky invited me to write of his life from the inside, so to speak, and as he truly was, a gifted human being, neither wholly saint nor sinner, a man who made what peace he could with himself and with a world not notable for understanding or compassion. This I have attempted to do.

Ernest Samuels

Northwestern University
November 1978

Acknowledgments

TO the late Nicky Mariano (Beata Elisabetta) go my first thanks for her friendly help and encouragement and for enlisting the interest of the late Professor Myron P. Gilmore, for ten years director of the Harvard University Center for Italian Renaissance Studies at the Villa I Tatti. It was Professor Gilmore and his gracious wife, Sheila, who made my repeated research visits to the villa with my wife periods of work to be recalled with the greatest pleasure. Professor Gilmore was an invaluable and sympathetic guide to the archival material, and he helped smooth my path in countless ways with his advice and counsel. Thanks to him we were able to join informally the community of scholars who each year received grants to work at I Tatti. The multilingual talk of art and life at the luncheon table would, I am sure, have delighted Berenson, who long ago presided at that table.

I owe a great debt of gratitude to the diligent staff at I Tatti, upon whom I called so often for expert help, and most especially to Nelda Ferace, the administrative secretary, Fiorella Superbi, the photo archivist, and Anna Terni, the librarian, who frequently supplied my linguistic deficiencies in dealing with Florentine officials.

For family information about Bernard Berenson I am indebted to his sister Elizabeth Berenson, his nephew Bernard Perry, former director of the Indiana University Press, and to his cousins the late Lawrence Berenson, who was his American lawyer, Janet B. (Mrs. Leonard) Kaplan, and Louis Urban Rubenstein.

It is particularly pleasant to acknowledge the help of Barbara Strachey Halpern of Oxford, England, a granddaughter of Mary Berenson, who very kindly gave me access to her extensive archives of the Smith family and granted permission to quote from them. I am simi-

larly indebted to Dr. Cecil Anrep, the nephew of Nicky Mariano, for permission to quote from the manuscript materials at I Tatti.

It is a pleasure also to thank Rollin van N. Hadley, director of the Isabella Stewart Gardner Museum, for a microfilm of the letters of Bernard Berenson to Mrs. Gardner and for Mr. Hadley's corrections and valuable suggestions. I am likewise grateful to Professor Sydney Freedberg and to the late Myron P. Gilmore for their helpful scrutiny of the manuscript.

For copies of letters and biographical information supplied in interviews or in correspondence, I wish to thank Harold Acton, the late Alda Anrep, Charles Henry Coster, Paul Cohen, Professor Edgar Ewing, Professor Michael Fixler, the late Edward Forbes, Alexander R. James, Professor Leon Katz, Hanna Kiel, Bronius Kviklys, Sir John Pope Hennessey, Count Umberto Morra, Luisa Vertova, Peter Viereck, Hugo Vickers, and John Walker.

To two fellow workers in the I Tatti library, R. W. B. Lewis, the author of *Edith Wharton,* and his wife, Nancy, with whom we passed so many congenial hours and with whom we exchanged discoveries, go our warmest thanks.

Among the many institutions to which I am under obligation for access to manuscript and other materials are the following: Ashmolean Museum, Boston University library and archives, The British Library, Colby College Library, Fogg Museum, Freer Gallery, Harvard University Archives, Horne Museum, Isabella Stewart Gardner Museum, Library of Congress manuscript division, National Gallery of Art, Massachusetts Historical Society, McMaster University Library Special Collections, the Department of Special Collections of the University of Chicago Library, and the Beinecke Library of Yale University.

As always, the members of the staff of the Northwestern University Library have been unstinting of their aid, particularly Marjorie Carpenter, Rolf Erickson, Russell Maylone, and Richard Olson.

I wish to express my appreciation also to Gordon N. Ray and the trustees of the Guggenheim Foundation for a fellowship grant which permitted a year of research in Italy.

I am under special obligation to my editor, Nancy Clemente, for her perceptive and sympathetic oversight.

To my devoted and resourceful collaborator in research and revision, my wife, Jayne Newcomer Samuels, who for nearly forty years has shared the pleasures and pains of literary work, no words can measure my deep gratitude.

E.S.

Berenson to Mary

"Put it all down. Nobody need
see while we are alive."

March 11, 1936

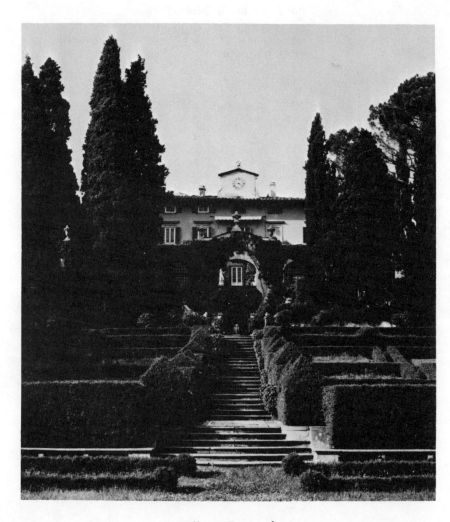

1. Villa I Tatti today

I

A Lithuanian Childhood

FROM the little road that curves steeply up the mountainside toward the turreted Castello di Vincigliato, a traveler can look down through the screen of close-spaced cypresses and umbrella pines upon a panorama of purest Tuscany. The view soars across the narrow valley of the *torrente* Mensola, where vineyards and olive orchards run upward to the sun and sweep past the clustered village of Corbignano coming to rest in the far distance on the heights of Settignano. Through the silvery haze the hills descend to embrace the plain of the Arno where it widens toward nearby Florence. Close by on a lower ridge, the tower of the parish church of San Martino affirms its age-old authority over the souls within the reach of its bells. Distant villas dot the hillsides, open to the sky and to the hilltop sightseer, but secluded by high stone walls and iron-sheathed gates from view of the passerby. It is a landscape rugged, even wild in its ravines and upland forest, yet here and there the land is gently humanized wherever foothold broadens into a field. The earth seems to wait, forever expectant of the painter's brush.

The most famous of the villas, the Villa I Tatti, escapes detection from above, for its rambling red-tiled roofs are almost completely hidden in a grove of towering cypresses. Here for nearly six decades Bernard Berenson made his home, like the chambered nautilus building out room after room to house his books, terracing the hillside for formal gardens within a shield of ilex woods, realizing at last his dream of a great good place.

And yet this most famous of modern Florentines could never quite forget that his roots were elsewhere, that his origin marked him apart from his fellows. It was a far leap backward in time and space from the Villa I Tatti to the village of Butrimonys in distant Lithuania, where

[1]

Bernard Berenson was born and spent the first ten years of his life. At the foot of his maternal grandfather's garden, the little streamlet of the Plausaupe meandered through the undulating landscape, dotted with clumps of birch and pine, toward the broad Nieman, a half dozen miles away. There the log rafts, seaward bound, hinted at other worlds and tantalized a boy's imagination.

The poignant memory of that far-off time never left Berenson. Now strong, now faint, the recollections of that buried childhood haunted his thoughts like strains of half-forgotten folk songs, insistent and disquieting. In Paris one day in 1887, when he was a youth of twenty-two, fresh from Boston and his adopted land, new made and quite transformed by its culture, he fell to brooding, as was his habit, over his proper role in life. The sense of his remote homeland swept over him with overpowering force. He wrote to his sister Senda that he had just read a Russian novel and the past rose to reproach him. "Often I think I should have stayed there," he reflected. A few years later when he happened to hear a theme of Dvořák, he exclaimed that it reminded him of a peasant song of his "so wonderful" childhood when "the world was big and fresh and dewy." So, too, when he heard Glinka's choruses they revived in memory the harvest songs of the Christian field hands which had once stirred him to ecstasy.

Beneath his romantic idealizing, however, lay deeper levels of consciousness, intimations of sadnesses, of divided loyalties, of long periods of "intolerable ennui" and "loneliness and despair." This awareness of the darker side of life no doubt reflected those realities in the Pale of Settlement of Imperial Russia that even the most romantically dreaming Jewish child could not escape. A scant generation had passed since a second wave of expulsions had herded additional tens of thousands of Jews into the towns and villages of the frontier provinces, which stretched from the Baltic to the Black Sea. Here they were deployed behind a *cordon sanitaire* thirty miles wide for having stubbornly resisted Christianization or the surrender of their ancient customs. Forbidden to take up farming, they crowded in upon their impoverished coreligionists whose ancestors had fled from the massacring Crusaders centuries before. Berenson all his life never forgot hearing about the "urgent and piteous" appeals of his elders to the government for the right to become farmers, appeals that expired in the czarist void.

Bernard's father was born in 1845 and brought up in the town of Daugai in the heart of the Lithuanian lake country, still famous as the favorite royal residence of the king of Lithuania centuries earlier. Almost nothing is known of his parentage or early life. He was born Albert Valvrojenski. The Slavic-sounding surname would be discarded

soon after he emigrated to America. At nineteen he was already be-
trothed and married, having journeyed some ten miles north to the
village of Butrimonys in Vilna province, where he caught the notice of
a prominent Jew, Solomon Mickleshanski, whose family claimed de-
scent from the Sephardic Abravenels of Spain. Solomon's wife's name,
as Bernard long afterward recalled, was Guedella.

Solomon, already a patriarch in the house of Israel, fathered nine
children, the eldest in 1823, the youngest, Judith, in 1847. It was this
youngest and prettiest of the children who in 1864 at the age of seven-
teen was given in marriage to the nineteen-year-old Albert. The mar-
riage was doubtless arranged according to custom by the *shadchen,* or
matchmaker, of the Jewish community. It would have been preceded
by the usual negotiations between the family counsellors, who debated
the merits and defects of the candidates with partisan zeal. On June 26,
1865, the first child was born and named Bernhard. He was to keep that
spelling of his name until the United States entered World War I. Three
years later Senda was born. Abraham, in 1873, was the last of the
children to be born in Europe. Rachel and Elizabeth would be Boston
born and bred. Since his native village was difficult to locate even on
the largest maps and in its Russian, Polish, and Lithuanian spellings
troublesome to particularize, Bernhard afterward settled the matter by
giving Vilna, the famous capital of the province, some forty miles to
the northeast, as his birthplace. This ancient cultural center of Lithuania
was also the greatest center of Jewish learning, and its seminaries were
the goal of the brightest students of the provincial yeshivas.

Albert's prospects had evidently been very slight, for he had been
bred to no trade or profession. He entered the household of his young
wife's prosperous family, remaining with them for ten years. But if he
had little money, he had unusual intellectual gifts. He was quickly
caught up in the Enlightenment, or Haskalah, movement which was
then spreading from the nearby German border and dividing the Jewish
communities into rancorous traditional and liberal factions. He avidly
imbibed the anticlerical skepticism of the German-Jewish writers. Ger-
man became the first language of his children, though Yiddish, Polish,
Russian, and scraps of Lithuanian met day-to-day needs in the polyglot
life of the village. Bernhard and his father were often to have violent
differences of opinion as he grew up, for they were both quick-tem-
pered individualists, but in later life the son gratefully recalled the early
example of his father's intellectual rebellion. Voltaire, in German trans-
lation, was the belated evangel of the Enlightenment and Albert became
a devoted apostle.

The town of Kovno (Kaunus), fewer than thirty miles away and

close to the German border, had already become a center of the tradi-
tion-breaking Haskalah movement. In the Jewish schools, study of the
Bible and the Commentaries comprised almost the whole of the educa-
tion of boys. The reform movement was introduced by Czar Alexander
II, who brought in the German-Jewish scholar Max Lilienthal to in-
troduce secular and scientific subjects alongside the traditional subjects.
The Society for the Promotion of Enlightenment gathered thousands of
recruits who dreamed of a Jewish renaissance in a world free from the
rule of benighted clerics. The venerable and pious rabbis of Vilna sus-
pected that the program of Russification through German language and
learning—adopted because of the nearness of Yiddish to German—was
a cloak for an astute plan to convert Jews to the Russian Orthodox
Church. Their suspicions were confirmed by the calamitous increase in
conversions.

There was a faction, however, that tried to mediate between the ex-
tremes, to preserve the most sacred of the old traditions and yet admit
the new learning. But nothing could arrest the movement of interior
alienation among the young. That alienation had its parallel in the
Christian world of Western Europe and the United States after the
publication in 1859 of Darwin's *Origin of Species*. If the effects of the
Western Enlightenment movement were more unsettling to the Jewish
communities of Eastern Europe, the reason was that those communities
had far more ground to traverse from the closed world of tradition to a
new secular society.

One of the most outspoken advocates of the new secular learning and
the hero of the young Jewish reformers was Abraham Mapu. Bernhard,
whose precocity in languages showed itself in early boyhood, read in
the original Hebrew Mapu's novel of Jewish antiquity, *The Love Tale of
Zion,* and never forgot its enchantment. The contrast between the an-
cient heroic glory and the beggarly existence of the village ghettoes,
shackled by ten thousand rabbinical taboos and prescriptions, implanted
a lasting detestation of Leviticus in sensitive and rebellious persons like
Bernhard and his father. But it was more than novels and essays that
turned father and son from the old ways to militant opposition. In
nearby Kovno Western dress had become the rule in the Jewish com-
munity; the cloaklike kaftan of medieval Poland and the ceremonial
earlocks were discarded, as were also the perpetual headcoverings of
males and the ritual wigs of married women. The modern Jewish busi-
nessman, his hair cut in the fashionable German style and often shorn of
his beard, had no time for thrice-daily prayers in the synagogue and
pious debates over obscure points in the Talmud.

A Jewish grandmother, in her reminiscences of the sixties, noted

with sadness that about the only religious custom observed in upper-class Jewish circles in Kovno, beyond the few great holy days, was keeping kosher. She rejoiced when her family had to move to Vilna, because there traditional orthodoxy reigned. The spectrum of apostasy continued to widen and included every stance from the smallest deviation from the Shulchan aruch, the prescriptive code of laws and customs, to Jewish anti-Semitism and atheistic nihilism. For the remainder of the nineteenth century, however, reform was no more than a minority movement; moreover, the divisions which marked the founding of Reformed temples in the Germany of the forties had already begun to widen and multiply. In this climate of warring opinion grew the roots of Bernhard's own youthful apostasy.

One surmises that Albert's father-in-law, like many other literate Jews in that timber-rich district, was engaged as a subcontractor to one of the great Polish landowners to organize peasant timber-cutting gangs and to superintend the building of the birch-log rafts on the tributary of the Nieman. If Albert helped his father-in-law, it could only have been as a kind of factotum, for he was a small man, rather delicate, even elegant in his ways, and as little muscular as his son. There were of course many tradesmen and artisans among the lesser Jewish folk in the village, which at that period numbered perhaps two thousand inhabitants, half of whom were Jews. With agriculture closed to them, the Jews eked out livelihoods as bakers, cobblers, blacksmiths, tailors, carpenters, Hebrew teachers, or members of the corps of religious functionaries who cared for the synagogues, looked after the ritual baths, performed circumcisions, and officiated in the kosher slaughterhouse.

On market days the horse-drawn carts would converge upon the village square, where the peasants chaffered on the hard-packed earth, displayed their buckwheat and potatoes, cabbages and cucumbers. There were bawling calves to be sold and poultry for the Sabbath evening meal. Artisans held up sturdy leather goods and pipes carved from swamp birch. Beshawled and barefoot housewives traded for saucepans, pots, and pieces of cloth. If custom prospered, the men grew convivial at the several inns in the afternoon, inns which the government shrewdly licensed only to Jews, relying on their traditional temperance and prudent business habits to ensure the flow of excise tax revenues to the state. The peasant liking for hard liquor made the expression "drunk as a Gentile" a household word among the Jews. For them the only true felicity was the drinking of the sweet kiddush wine at the Friday evening family service.

The child Bernhard spent the first nine years of his life chiefly in his mother's village, years varied by visits to his father's parents in their

village on the shores of Lake Daugai. They faded from memory, unlike his mother's parents. His maternal grandfather he remembered as "a very old and magnificent" patriarch. Though himself piously orthodox, Solomon was aware of the controversies in the Jewish communities. He was wont to say that the only thing that kept Jews together was persecution. To the young boy, however, this idea must have seemed the fruit of a dark legend. Butrimonys had long been free from the recurring pogroms, during which mounted Cossacks charged down the streets with lead-tipped whips and ransacked houses, but the memory of these outrages hung in the air for the boy's elders. What remained most vividly in the boy's memory was no such havoc, but instead the sight of a column of marching soldiers whom he ran after, intoxicated by the martial rhythm of their songs.

Bernhard was an extraordinarily precocious child with large eyes, beautiful features, and long delicate fingers, and he quickly became the darling of the household. At three, according to his parents, he could already read German, and before he was twelve he had steeped himself in the Romantic writers, particularly in his beloved Goethe. Catered to by the family, he assumed that he was destined to stand first in his village. He believed that thanks to his mother's ancestry he was of aristocratic lineage, and he felt superior to the illiterate peasants. In accord with noblesse oblige he sensed, even as a small child, a responsibility for their "welfare and improvement." Yet there came times, as he recalled, when he envied "the very poor because they were going to have a so much better time in Heaven."

He was attached more to his maternal grandmother Goldie than to his mother, for his mother, he later wrote, was only eighteen when he was born and was "herself too much the young girl—lovely and perhaps giddy to play the mother. She left the happy task to her own mother. My giant grandfather used, like Saint Christopher, to carry me seated on his right shoulder." One of the special pleasures of their home he was to savor in imagination for all of his life was the "succulent Sabbath food" and the great braided Sabbath loaf which glowed under the candles. When he was scarcely five years old, the death of Grandmother Goldie brought the first of the remediless anguishes of life. He felt the darkness of her absence day and night for many months. For the first time the big questions of life and death obsessed his childish mind, and it seemed afterward to him that he then fought through to the understanding that whatever the fraction of life given to one, it was sacred and to be treasured infinitely above nonexistence. The death of a playmate soon afterward deepened this conviction that life should be lived as a kind of holy ritual, indeed as a "sacrament."

[6]

Whatever his father's private feelings about a classical Hebrew education, they did not stand in the way of Bernhard's being enrolled in the traditional cheder. This primary Hebrew school usually met in the local rabbi's living room. Here the boys, scarcely more than toddlers, would bend over the aleph, beth of the alphabet, intoning them in chorus as the little forefingers moved along the line from right to left rather than from left to right as in the heathenish languages. Bernhard recalled with affection sitting beside his first rabbi and pulling his flowing beard unrebuked. The hours were long, and in the northern winters the class might begin before daylight and end after the oil lamps were lighted along the village street. By the time he was six, Bernhard had begun to read the difficult unvocalized Hebrew of Genesis, chanting out the rugged grandeur of the Creation and pausing from time to time while the rabbi delivered his commentary in Yiddish.

Certain notable glosses stuck in Bernhard's mind. The rabbi explained that Pharaoh's hatred of Moses arose because Pharaoh, who deemed himself a god, was once discovered by Moses to be moving his all-too-human bowels on the banks of the Nile. In another commentary he dramatized the story of the covenant between the Lord and Abraham with the curious sidelight on primitive folkways that the parties sealed the agreement by grasping "each other's virile members as they took the oath." The rabbi had his less earthy moments: it was blasphemous, he told the young boys, to name the Unknowable by any epithet because God was infinite and one dared put no verbal limitation on "His infinitude," hence the mystical tetragrammaton YHWH (Yahweh).

To the bookish little boy, the study of the Old Testament became the rock upon which his future erudition would rest. "I owe," he once wrote, "to the reading of the Hexateuch, the historical books, and the major Prophets of the Old Testament before I was ten and to learning much of them by heart, two dominant tendencies. One is an insatiable curiosity about origins. . . . The other . . . a readiness to indignation against injustice." But he recognized, too severely perhaps, that these traits had also fostered an indiscriminate pursuit of knowledge and a taste for the scholar's ivory tower, where moral indignation fritters itself away in mere verbal protest against the frictions of life. After the Hexateuch came the study of an anthology of the Babylonian Talmud, in which the exegesis of the Gemara heaped on the earlier Mishnah surrounded the islands of ancient text with seas of commentary. What shocked his childhood idealism was not the incessant slaughter in the historical books but the account of divine vengeance in Ezekiel, the destruction of Jerusalem. Nor did he ever lose his disgust for the "revolting" injunctions of Leviticus and the ritual minutiae of the Shulchan

aruch, which bound every aspect of life in an immense web of judicial commandments.

Three quarters of a century afterward, reflecting on a lifetime spent in the scholarly study of art and especially in the meticulous and exhaustive analysis of Italian Renaissance painting and drawing, he seemed to himself in retrospect to have been in effect a kind of "Talmud Jew," poring and brooding over books, receptive to the Talmud of all human learning. His mastery of the sacred Hebrew books may have raised hopes in the village that he would go on to a seminary in Vilna, for that was the usual course followed by the most talented students in the Talmud Torahs, but Bernhard seems never to have dreamed of the rabbinate, nor could he ever recall the presence of a rabbi in the family ancestry.

Of the daily life which shaped his early tastes and character little can be gleaned directly from his reminiscences. He rarely recurred to the details of his childhood, contenting himself, when speaking of it, to advise a correspondent to read a book like Henryk Sienkiewicz's *Bartok,* with its picture of the humble round of life in a Polish village. Or he would recommend Pauline Wengeroff's *Memoiren einer Grossmutter,* which affectionately describes life in a patriarchal Jewish family piously immersed in a life which centered in the village synagogue, its days moving to the rhythm of thrice-daily prayer and holiday festivals. Another memoir that made the past live for him was Schmarya Levin's *Childhood in Exile.* Levin had also had a studious boyhood with its ten hours a day in the classical Hebrew school, mastering a half dozen minor ancient Hebrew and Aramaic dialects and developing a taste for linguistics like Berenson himself. Levin, too, was a romantic. When he read of the glories of the ancient Jewish past, "The world of reality around me," he wrote, "became poor, anemic. . . . The pitiful present could not compare with the rich past." When Berenson encountered long afterward *Trial and Error,* the autobiography of the great Zionist statesman Chaim Weizmann, he remarked of the first chapter, "It was just like that."

Curiously enough it was a book, *L'Ombre de la croix,* published in the 1920's by Jean and Jérôme Tharaud, a pair of non-Jews who had collected many reminiscences of life in Galicia and Poland and woven them into a dramatic narrative, which seemed to him the most accurate re-creation of his boyhood, perhaps because the Tharauds in a moving passage touched a nerve whose sensitivity had never been dulled: "O sons of Israel . . . for many years and many generations you will remain unlike the rest of mankind. In you there will always be something alien, something apart which neither others nor yourselves will be able

[8]

to explain. That disquietude, that sense of want . . . that neurasthenia and sickness of mind are the trace you will bear of these long evenings passed amid snowstorms in this cage of prayer from which you so ardently wish to escape." They vividly pictured the poverty and oppression and the perpetual hope of divine deliverance which marked the life of the ghetto. Berenson recalled how deeply moved he himself had been when he heard the "blaring of the ram's horn at the end of the Day of Atonement and the wild cry of the congregation, 'Next year in Jerusalem.' "

Weizmann's account contains an amusing sidelight on the penetration of the Enlightenment movement into the smallest villages, the self-contained *shtetls* of Russian-Polish Jews. One young rabbi, a secret follower of the movement for secular learning, smuggled into the classroom a Hebrew textbook on natural science and chemistry, "the first book of its kind to reach those parts," and he and his favorite students would read it aloud in the usual Talmudic singsong so that no Jewish passerby might suspect the shocking heresy. Weizmann, who emigrated to England, became a noted chemist and as a leading Zionist was chosen first president of the state of Israel. His immersion in the Haskalah movement emancipated him from rabbinism, but unlike Berenson and many others, he preserved his Jewish identity as a political Zionist.

Weizmann wrote of a time nearly ten years after Berenson's childhood, but the winds of change must have already unsettled the synagogue in Butrimonys, if we may judge from a story which young Berenson published in the *Harvard Monthly* shortly after his graduation from Harvard. In that tragic tale, "The Death and Burial of Israel Koppel," a young apostate incurs the wrath of God for having forsaken his Jewish character. The setting recalls vividly what must have been the look of Berenson's grandparents' house. The front door, led up to by a short flight of steps from the village street, opened upon a neat and comfortable "common room," where the young apostate read his Gentile books. "The floor was clean and sanded. The large oaken table glowed with scrubbing. The spaces between the double windows were ornamented with suspended apples and oranges. Overhead the ceiling was white, resting upon heavy varnished beams." The light from the street gleamed upon the tiles of the great oven which filled one entire side of the room and which when winter gales howled at night provided a cozy refuge atop its warm bricks. The learned father who presided over the Talmud study club may well have depicted Bernhard's "magnificent" grandfather. Every minute detail of the unfortunate Israel's funeral is reported as only a keenly observant eyewitness could

have seen it, and the traditional observances are rendered with unsparing realism, as will be seen in a subsequent chapter.

Bernhard's love of art and nature was as intense as his love for books, and it appears to have been the chief nurse of his aesthetic development. Once, searching his memory, he thought he recalled that he experienced his earliest "sensation of rapture" in the presence of art while still in his mother's arms when he reached out "towards a picture of grapes on a wine bottle." He became an early worshipper of nature. As soon as he was able, he would wander alone for miles through the countryside in a quiet ecstasy of enjoyment. Clumps of white birches accented the undulating horizon. From atop one of the low hills his eye could sweep an immense vista, white with snow when winter winds swept in from the steppes but almost lushly green in the summer sun and laced by placid streams. There were little lakes to be circumnavigated and rural lanes to take one past the gingerbread façades of the manor houses of the Polish noblemen. In the fields the sturdy, barefoot peasant women in their kerchiefs and kilted skirts worked alongside their men, plying their hoes among the potatoes or helping with the rye harvest. In his mind's eye the impressionable boy took possession of the landscape, its people, and the ever-changing float of clouds, feeling that mystical expansion of spirit that would ever afterward astonish his companions in his daily walks among the Tuscan hills.

He identified himself with the Lithuanian poets and artists of the region, who were always adreaming by that landscape. What this seed-time of early childhood meant to his ruminating spirit found a poignant expression in one of the journal notebooks which he began to keep in his teens. "Sometimes now as I walk," he wrote at twenty, "the life of fifteen years almost rolls away. . . . I see again the world as it was to me when I was five years of age. There is the same mystery to everything, the same feeling of standing in the presence of things that I see, but have not yet thought of, the same feeling of saturating coolness that I used to throb with when I was a child of five years old, in the orchard of a spring morning, listening to the call of the cuckoo at the end of the garden by the brookside." He remembered how as a little fellow he wore out his "thin legs running as hard as I could to get beyond the horizon." Those hours under the open sky would always seem to him his "best" and "most formative."

In his love of the land Bernhard felt himself a thorough Lithuanian, proud of his country's ancient culture, which made that of the conquering Russians seem semibarbarous. Lithuania had once been a great dukedom stretching from the Baltic to the Ukraine. After the fourteenth century its grand dukes had ruled Poland as well. The brutal par-

tition in 1795, which reduced Lithuania and Poland to mere geographi-
cal expressions, drew all the inhabitants, including the Jews, together
against the common despot in St. Petersburg. Resistance to Russifica-
tion continued through the succeeding decades into Bernhard's own
time. He developed an "instinctive horror," he said, "for everything
touched with police power." He shared the sense of vanished greatness,
which merged in his mind with the departed grandeur of ancient Israel.

When he read the introduction to Sienkiewicz's *Bartok,* he was de-
lighted to note that it was written by a person born not far from his
"natal home," and he declared that the analysis of "the Lithuanian char-
acter" in it was like "a confession written by myself." He agreed with
the author that the Poles of Lithuania lived for the sake of art; they were
philosopher-artists, idealizing dreamers; they were instinctive linguists
in love with words; they were more spiritual than the Russians. He was
of their kin. Once on a boat trip through the German Spreewald, when
he saw the Wends in their native costume, he exclaimed, "It was almost
like getting back to my old home, for the language of the Wends is
Slavonic and their way of living is exactly like that of the peasants
whom I knew at home. I felt a nearness of relationship to the people
that was almost sentimentality." The women and girls, he felt, had a
Slavic beauty that showed "in Botticelli faces . . . even to the very
eyes." In his old age he wrote, "Longing and nostalgia have been my
condition through life. As a boy of ten in Boston, I slept every night
dreaming with radiant vividness that I still was living the day in Lith-
uania."

Strange and irrational ideas left their traces on the mind of the im-
pressionable child, traces of old taboos, folk fears, and superstitions
which would stubbornly defy his skepticism. He never could rid him-
self of the fear of the number thirteen, especially of Friday the thir-
teenth or a birthday on the thirteenth. Even more obsessive as years
went by was his fear of seeing the new moon on such days. He would
not risk beginning a project or going on a journey on such days if he
could help it. He was to concede the absurdity of these crotchets, but he
justified them, not without a touch of irony, as his tribute to the "nu-
minous" in human life. He escaped, however, the more serious absur-
dity with which peasants and gentlefolk in much of Europe still terror-
ize themselves—the belief in the evil eye, the power of some persons to
inflict grave hurt with a single glance. Once he took advantage of that
widespread superstition to clear a cathedral chapel in Italy of a crowd
which persistently blocked his view of the paintings by letting it be
quietly known through his companion that he possessed the dreaded *jet-
tatura,* the evil eye.

One day, probably early in 1874, Grandfather Solomon's comfortable home burned to the ground. Family tradition says that Bernhard's little sister, Senda, was heroically rescued from the flames by her mother. Albert and his wife were now nearly thirty, and the catastrophe obliged them to take stock of their situation, with three children to provide for. The house would be quickly rebuilt and the old widowed patriarch could manage, but for Albert, his son-in-law, the outlook had steadily grown darker. The status of Jews as second-class citizens of Russian Poland had worsened as one repressive measure followed another. The much-praised liberalism of Alexander II steadily eroded under the pressure of his advisers, who urged stronger measures of Russification for the Polish provinces. The Poles in their suffering turned against the alien people in their midst, in spite of the fact that many of them had fought in the Polish rebellion of 1863. A bitter proverb of the luckless ghettoes ran: "When in need turn to the Jew; when you prosper make him suffer."

In 1871, when Bernhard was six, there had occurred in Odessa with the connivance of the police authorities the first of a series of bloody pogroms. The news sent a tremor of alarm through the far-spread provinces of the Pale of Settlement. Two years later, the net of repression began to tighten with the closing of the two leading Jewish seminaries. Of course the Jews were not alone in their anxiety. The Lithuanian language and literature had already been proscribed, but the Lithuanian Christians were saved by their religion from the harsher measures taken against their stiff-necked fellows. New conscription laws for Jews made avoidance of military service more difficult because they required each village Kahal, or council of Jewish elders, to fill the inflexible quota of young recruits by whatever devious means they chose so long as the boys looked old enough to stand muster. The device would be remembered by the Nazis for an even grimmer levy. Once in the army, the boys were usually badgered into conversion during their seven years of service.

Anti-Semitism increased with the business depression which had followed the Crimean War and had been deepened by the cholera epidemic and famine of 1868–69. Those calamities were succeeded by the financial panic of 1873. The economic pressure from above and below fell heaviest upon the Jews, and life grew more somber and hopeless. Already the ghettoes abounded with what were called *luftmenschen*, persons who lived on air, so to speak, with no visible means of support. The only hope lay in emigration, and the word that came back from emigrants to America seemed to describe a new Jerusalem whose very

streets, in the fevered imaginations of the villagers, were paved with gold.

Berlin had provided sanctuary for some members of the Freedman family, Bernhard's mother's cousins, but the promising outlook in Germany had begun to be shadowed by the rise of virulent anti-Semitism. Two other members of the family had opted for America and had established themselves in the little Jewish colony in North Boston which formed the nucleus of the Butrimonys Society. The cousins prospered in the peddlers' supply business in Salem Street. One of Albert's own cousins appears also to have joined them.

With the storm warnings up in every direction in the Russian Pale, Albert had little choice: he must also emigrate. He chose America. Somehow money was found for his passage. He made his way across the German border in 1874, presumably to Bremen, and then in the noisome steerage of one of the many immigrant ships, he sailed to refuge in Boston. There he might hope to prosper, as so many other penniless immigrants had done before him, as a foot peddler carrying a basket or shouldering a pack filled with household notions and drygoods through the Boston countryside. What poor Jew in the Pale had not heard rumors of the fabulous rise of the earlier wave of German-Jewish settlers who had begun in the same fashion before the American Civil War? Who had not heard the legend of the humble beginnings of the Seligmans, whose firm now rivaled the great financial houses of the Gentiles? What was less well known was that social distinctions among the onetime outcasts had begun to be made, half seriously, depending upon whether their fathers had peddled on foot or with horse and wagon. Many immigrants, of course, had come from prosperous and cultured German families, refugees of 1848, and formed a kind of aristocracy in Boston and New York, where their affluence helped them to blend almost unobtrusively into the universal parvenu society of the Gilded Age.

Illusory as Albert's hopes would prove to be, they were sufficiently encouraging for him to send for his little family in the following year. Grandfather Solomon, now in his seventies, remained behind, to die in 1891 at the age of ninety-one. Judith and the three children arrived in Boston early in the summer of 1875. Few traces of the great fire of 1872, which had burned out a large part of the business district, were any longer visible. Instead, the immigrants saw blocks of handsome new buildings on streets which had been newly widened and straightened. Surely one could hope to prosper in a city so vital and affluent, where a quarter million inhabitants were pressing far beyond the metes

and bounds of the ancient parishes and where the marshlands of the Back Bay were being filled to make way for a new generation of countinghouse aristocrats and socially ambitious Silas Laphams. Things were in the saddle and mankind hardly felt the weight of the rider.

A Dreamer in Minot Street

THE North End of Boston, in which the family settled, had not yet become the clamorous ghetto of the 1890's, when the fourth and overwhelming wave of East European immigrants poured into it. As one of the very oldest sections of Boston, it had, however, undergone the slow process of displacement which always accompanies urban growth. The old families died out or moved to newer sections of the town and buildings gradually deteriorated. Much of the neighborhood was still pleasantly residential, but with the cutting up of many dwellings into profitable smaller flats, decay was now more rapid. Irish immigrants fleeing the disastrous potato famine of the forties had replaced most of the New England families. In the mid-seventies Polish and Lithuanian Jews began in turn to displace the Irish. At first, the nucleus of some fifty families, many of them from the village of Butrimonys, was rather widely scattered in the quarter-mile triangle between Charlestown Street and Hanover Street, an area now quite obliterated by expressways and urban redevelopment. A small synagogue, Beth Abraham Congregation, had been established in 1873, but so many of its peddler members were off on the road in the nearby towns each day that their children were hard put to summon a *minyan* of ten males for the morning and evening prayers.

From the beginning, Bernhard's father had avoided the synagogue and had forbidden his wife's attendance. Not until after his death, many years later, did she venture to attend Jewish religious services. Nor did he place Bernhard in a Talmud Torah to continue the Hebrew studies in which the boy had excelled, and he made no plans for the traditional Bar Mitzvah ceremony when Bernhard should reach thirteen. Albert now felt free to identify himself with the small group of violently antireligious Jews in the North End who assailed the pious with the skep-

ticisms of Voltaire and Renan. Some were so militant that on Yom Kippur, the holiest of days and one to be spent in prayer and fasting, they would scandalize the faithful by ostentatiously eating ham sandwiches in the street in the vicinity of the synagogue. Albert's orthodox relatives looked on his religious heresies with tolerance, if not understanding. One of his cousins, Louis Berenson, was on the way to becoming a director of the soon to be organized Congregation Beth Israel. Albert's relatives were afterward to remember his obsession with the writings of Voltaire as a harmless eccentricity. An impractical idealist, he increasingly took refuge in his books, acquiring the reputation among visiting cousins of being a confirmed bookworm. His militancy inevitably worked to separate Bernhard from the Jewish communal life, and the boy quickly gravitated to the more congenial world of the neighborhood grammar school.

The father's influence on the precocious youngster grew stronger during those first years in the freer environment of Boston. Writing to his father a half century later, when the violent disputes and the sudden rages which used to upset the struggling household had sunk into insignificance, Bernhard declared: "I found you the most stimulating and fascinating of companions. . . . I don't know what I don't owe to the talks I used to overhear between you and your friends." Thanks to his father, he had been imbued with a passion for German literature which had flooded across the border from Prussia, especially after the German victory in 1870 over the "decadent" French. He had been given the German name "Bernhard," meaning one as bold as a bear, as if to challenge him to live up to it. He felt at home, he recalled, with the "kindly Biedermeier cosiness" of such romantic poets as Chamisso and Uhland, whom he read in the Oxford Book of German Verse. He had reposed in their pages as in the soft embrace of an old-fashioned armchair.

Strongly predisposed to German culture, he inclined like his father toward the manners and customs of the older German-Jewish immigrants who were comfortably submerged in the wealthier South End. They prided themselves on their German origin and their Americanized ways and were disdainful of the Yiddish-speaking newcomers, the Litvaks from Lithuania, with their outlandish Slavic names, whose jargon seemed a base corruption of the noble purity of the German language. Their example acted powerfully upon an ambitious and romantic lad who had once dreamed of being first in his village. He soon learned to refer deprecatingly to the humble mother tongue of Yiddish as "German-Jewish." At the same time, he was never to forget his

boyhood resentment of the cruel condescension of the German Jews, who scorned him for his Lithuanian origin. In his old age he confided to an intimate that this treatment bred the desire in him to avenge himself by rising above them and compelling their admiration.

The example of the German settlers naturally influenced the newer immigrants in the choice of family names to replace those that were hard for Americans to pronounce or were unpleasant reminders of their place of origin. Albert's cousin who had preceded him probably adopted the German-sounding "Berenson" before his arrival. No record or tradition survives, any more than one does of countless similar adoptions, of how the choice was made. In 1880, Albert's certificate of naturalization as a United States citizen identified him as Albert Berenson, as did also the renewal of his peddler's license a few years later.

His cousin Louis Berenson was the proprietor of a peddlers' supply store at 95 Salem Street, and here Albert made his headquarters. As he trudged from town to town, graduating from basket to pack and from pack to pushcart, he became a favorite of the housewives. He was always neatly dressed and his trim pointed beard gave him a scholarly appearance. He was a little man with a quick and nervously alert bearing. Among the itinerant merchants he was a genuine exotic, for he talked easily of literature and French history, of Voltaire and Rousseau, as well as of cotton cloth and laces, and so was doubly welcomed by Concord ladies like Louisa Alcott and Emerson's daughters. His journeys sometimes kept him away from home from one Sabbath to the next, leaving Bernhard to pass his days and nights undisturbed among his books.

As a frustrated intellectual himself, Albert Berenson had no illusions about his occupation and certainly little pride in it. He discovered, as many of his fellow immigrants had, that peddling was no longer the open sesame to affluence. The crowded field had now to be shared with hundreds of impoverished Irish immigrants. Besides, a quickening economy saw the spread of retail stores in outlying neighborhoods and small towns. Albert was anxious that the social blight of his humble trade should not fall upon his children. Once in the early eighties, when Bernhard was in his teens and already known for his intellectual precocity, his father was met at the door of a Concord home with the greeting, "Guess who is in the drawing-room! A young man called Bernhard Berenson." Albert managed somehow to excuse himself and hastily retreated with his pushcart, unwilling to have his relationship exposed to the embarrassment of his son. He had a similar experience

with his beautiful daughter Senda when he caught sight of her among her schoolgirl friends in the aisle of a day coach. Again he escaped unseen.

Bernhard's mother was now a pretty and dignified matron in her early thirties. In order to eke out her husband's meager earnings, she set a table for some years for boarders, a common enterprise as new immigrants hurried in from Russia. She was noted for the dignity with which she presided at the table, and her guests remembered her cooking with fond relish. With the arrival of two more children, Elizabeth in 1878 and Rachel in 1880, she also took in sewing to add to their much-stretched budget.

Their first residence at 32 Nashua Street overlooked the siding and depot of the Eastern Railroad, where the chugging of the switch engine initiated the family to the nerve-rasping clamor of the lusty New World. When presently the family moved around the corner to a more respectable dwelling at 11 Minot Street, the change brought some improvement and a view of the new Lowell Railroad Station. They were still separated by a long half mile from the section where most of their fellow immigrants had congregated.

Berenson never forgot the grimness of these surroundings. Once near the end of his life when he was being interviewed by the playwright Sam Behrman in the cavernous limonaia, or lemon plant, shelter at the Villa I Tatti, the talk fell upon the observation of the Jewish harvest festival of Succoth. It was talk that came easy to them, as the aged Berenson recorded, because of "our common ghetto origin." From deep in his boyhood past he recalled that the profusion of opulent yellow globes about them were not really lemons but a citrus fruit used from time immemorial in the Succoth ceremony, the Ethrog of Israel, which both of them, being of Ashkenazic—Eastern European—origin, remembered as the Esrig. Berenson, ever the schoolmaster, explained, "Succoth, you know, or suka in Hebrew also means a hut. Did you ever have one?" "Of course," Behrman replied. "My father built it in our yard." "You had a yard!" exclaimed Berenson. "You must have been very rich." Behrman said it was roofed with fir branches and hung with pears, apples, and oranges and that the family had their meals in the suka for a week. "Didn't you have a suka?" he asked Berenson. Looking across the garden terraces of I Tatti to the distant Tuscan hills, Berenson replied, "The ambiance of the North Station in Boston where we were shunted when we arrived from Lithuania did not encourage pleasure domes."

There was indeed no yard at Minot Street, and even had there been one, Bernhard's irreligious father would not have countenanced a suka,

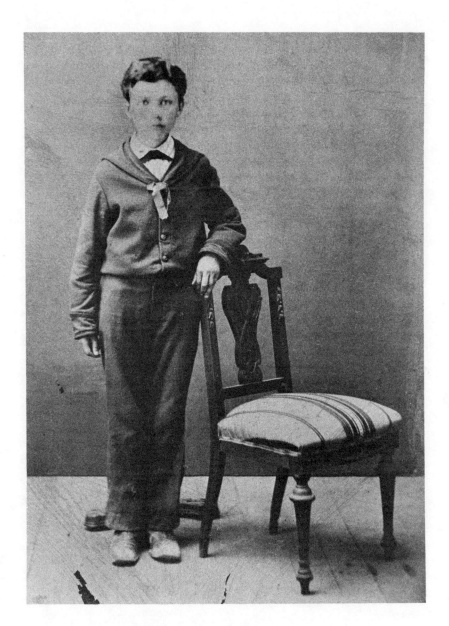

2. Berenson as a boy in Boston

3. Judith and Albert Berenson

though it might have relieved for his children the joyless surroundings. The noise and odorous clutter of the market carts that lined nearby Salem Street and the bawling cries of the street vendors must have lacerated the senses of the boy who remembered his grandfather's fragrant garden by the brookside. Sixty years after he had witnessed his first Fourth of July celebration in Boston, he wrote: "I had just come from quiet, neolithic Lithuania, a boy of ten. The heat, the sweat, the scorching sun, the noise, the clatter, the penny whistles, the firecrackers, the magenta toy balloons, the pink lemonade, the sticky balls of popcorn, the deadly fatigue, the sleepy weariness . . . I never again was exposed to this annoyance. On that day I was always at a safe distance from a celebration." It was the first time he was confronted by demos in all their untidy exuberance, and he never overcame his feeling of revulsion.

In the local grammar school the children came mostly from Gentile families, and in their company Bernhard welcomed the process of Americanization. With his unusual linguistic sense he quickly became proficient in his new language, attentive to correct idiom and grammar, for he aspired to be a writer. Habit remained strong, however, and in his schoolboy compositions the slightly Germanized script marches with careful precision across the page, the capitals always formed with a Teutonic arabesque. Within a year he began to haunt the Boston Public Library, located at the Tremont Street corner of Boylston Street, and he soon was borrowing books twice a week and devouring them at a rate that astonished the librarians. His tenacious memory became an encyclopedia of miscellaneous information. He hunted up the statistics of growth of his new country, read of the mysteries of interstellar space revealed by recent astronomy, steeped himself in history, literature, and books on art. He memorized German and English poetry as he had once memorized the Pentateuch. Within a few years he was reading Russian history and literature and ranging far afield into the lore of Islam, and while still in his teens was studying Arabic in order to read the Koran. He would often read far into the night, persuading himself that he required little sleep. For two years, from age sixteen to age eighteen, he worked so steadily at his studies "without resting *one* day," as he explained in 1883 to one of his older comrades, that toward the end of his first semester at Boston University he was "more of a walking ghost, a somnambulist, than a rational creature."

In his attic room in the house on Minot Street, the young romantic nourished his aesthetic yearnings among his books for hours on end, safely islanded against the worried councils of his parents below. Or on a summer's day he would retreat with a fresh treasure of books to an

abandoned canoe in a backwater of the Charles River. Bunker Hill Day always meant a holiday "pilgrimage to the monument" on Breed's Hill and "pleasant hours playing with the boa-constrictor cordage" just across the river in the Charlestown Navy Yard. In the bits and scraps struck from the float of memory, he recalled a Washington's birthday when he found himself on Washington Street with an "icy wind blowing dirt in one's face and shreds of dirty paper in the air." He felt the "taste of snow" that would soon give "place to something like the odor of violets." At that time the open country was within easy reach, and a sturdy solitary walker like his father, he tramped about Fresh Pond, Spy Pond, and the broad reaches of the Mystic River and enjoyed the smell of the salt marshes when the wind was from the east. Concord, especially, was a frequent goal, and he would gaze raptly at the home of Ralph Waldo Emerson. Sometimes he ventured a dozen miles along the North Shore to enjoy the mesmeric sound of the ocean at Clifton Beach, a sound that would suddenly come to mind again years later when he looked westward from a foreign strand.

He never seemed to get his fill of the outdoors and he savored it always with a literary relish. "I have just returned from a walk," he rhapsodized one evening in his journal, "very wild and adventuresome, through woods and across moors, over innumerable brooks and ponds. . . . Ah, it is indescribable the smell of the yellow brown earth, the edges of willows by the causeways with the single elms sprinkled among them. Then the tall, snow-white, exquisite birches, swaying from stem to top, rhythmically, with the sun on the horizon, glowing a living light through their midst. Then to fly over the ravine road, edged in white with the snow that fell this morning, between the tall heavy pines, and finally to strike over the hills with a change of view at every step, the sun already set, the moon two days old, light sulphur in color, peeping through a flushing purple cloud, and the river with a dull pink reflected from its frozen surface." In the years to come he would write a thousand such lyrical reprises in the face of nature wherever his wanderings in Europe took him.

Understandably, Berenson never cared to dwell on the painful struggles of the family to make ends meet during his boyhood in the North End. The uses of adversity seemed to him much overrated, and he developed a lifelong distaste for the spurious philosophy of the popular "rags to riches" stories of his youth. The only real life for him, as his notebook meditations of those days show, was the life of the mind, undefiled by the necessities of the material world. For a brief time when his father presided over a dry goods counter on the ground floor of their home the family hoped for better days, but the venture did not

flourish and Albert had to return to the pushcart. Flareups of his father's temper often pitted the visionary boy against the impractical father. The son, with a child's intolerance, thought his father lazy and unenterprising. As eldest son he tried to shield the younger children, especially his sister Senda, against his father's impotent rages. Little did he foresee that he too would have his seasons of indolence and like his father succumb to uncontrollable outbreaks of rage against the frustrations of daily existence.

Sixty years afterward, in one of the rare autobiographical references to his Boston boyhood, he remembered it best for his initiation into secular literature. Where as a small child he had identified himself with the heroes of the Old Testament, as a young boy he began to see himself as the hero of the Greek myths, which he encountered in Hawthorne's version, or as Robin Hood or Robinson Crusoe. He reveled in poems like Coleridge's "Hymn before Sunrise in the Vale of Chamonix" and Bryant's "Thanatopsis." Then George Eliot's essay on Young's *Night Thoughts* pricked "the vague cosmic visions" of these poets. It was also George Eliot who first presented him with "the idea that art values deserved as much consideration as those of life or of morals for shaping and directing actuality." His single-minded passion for self-culture, his "ferocious idealism," obsessed his school days. No day dared pass without a book in hand. He once recalled how on a hot summer's day he read Goethe's *Werther* while lying half-submerged in the Merrimack River near West Newbury.

From the grammar school he went on, in October 1881, to the famed Boston Latin School. At the end of the academic year he stood first in English, history, geography, and zoology and ranked seventh in his class. It was apparent that the brilliant lad was ready for more rigorous training. In the fall of 1882 he attended a private preparatory school, the now-vanished Myers-Richardson School, where he crammed for the university. He was able to pay part of his way by tutoring the duller candidates. Within a year he was ready for Boston University. He was eighteen years of age when he enrolled there in 1883 and impatient to become a master linguist. He began to dream of studying at Oxford, which for him, as for most scholarly young men of Boston, represented the highest idea of a university.

The year 1883–84 was one of determined intellectual and social improvement. "All that was rough, unpolished, and angular," he recorded in his schoolboy journal, "is fast disappearing, and already stands before me as a marble group, grand, sublime, far surpassing any work of Praxiteles." His classmates seem to have been a congenial group from all over New England, and the thirty or more members of

the class soon began a long series of class meetings. Many years later the class historian recalled "there never were any feuds or cliques in [the class of] '87. Rather was it a mutual admiration society!" and among the "top flight intellectuals" in the class none surpassed young Berenson. As the most learned member of the group, he supplied the class motto, neatly recorded in the class records in German script: "Der Marmor Wartend Steht" (The marble waits [for the sculptor]).

A school photograph shows a handsome face with wide cheekbones and full sensuous lips, the broad forehead surmounted by a well-trimmed shock of dark hair. His wide-set eyes look out intense and thoughtful. He stands at ease, neatly and fashionably dressed in the conventional four-button suit whose high lapels framed the inevitable dark bow tie. Not until he transferred to Harvard would he adopt the style of the Pre-Raphaelite poet, parting his hair in the middle and allowing it to fall nearly to his shoulders in the carefully trimmed curls of a Renaissance portrait. Though only a freshman in his Boston University group, he quickly became popular, especially with the young women. We catch a glimpse of him in a photograph of a class picnic in the woods, surrounded by a dozen students, most of them girls. The young women are attired, as the fashion then was, in long dresses reaching to the ground, and their faces are shaded by broad-brimmed hats. Among the girls was a certain Elizabeth, a girl of "wealth and culture," whom he worshipped, as he confided to his journal, all through his college days. Already a haunter of Boston's Museum of Fine Arts, he would take her there to spend an afternoon in rapt contemplation of a copy of Botticelli's *Birth of Venus*. With true Pre-Raphaelite ardor they longed to "unite their vision of beauty forever."

Outwardly the months at Boston University passed agreeably enough. He became a member of the Beta fraternity and joined the "Byras" society, a group of "splendid fellows, earnest, congenial," he wrote to his most intimate friend, Irving Pierson Fox, who had just recently graduated. He confessed, however, that there was no really kindred spirit to take Fox's place. It was true, he conceded, that a few students "venerated and even loved" him, but there was no young man really worthy of the highest friendship. And as mankind was too "wretchedly carnal" to understand Platonic love, such a love for a girl student inevitably led to malicious gossip. "Co-education must wait," he predicted, "until men and women can mingle freely."

He spent the Christmas holidays in rural West Newbury with some German friends, quietly recuperating among his books from his too ambitious program of study. It was Whittier country and Bernhard enjoyed, as he said, being snowbound. He felt free for the moment from

the "eternal hurry" of American life and its philistine pursuit of mere learning instead of the kind of culture extolled by Matthew Arnold. How unlike it was to Germany, "dear to me from my earliest infancy," where "hurry is absolutely unknown and scholarship flourishes."

The writings of Matthew Arnold already dominated his mental horizon, and his spirited responses marked the margins of *Culture and Anarchy* as his inchoate aspirations took more definite form. It was not enough to know "the best which has been thought and said in the world," as that might lead merely to pedantry. Culture must be "an inward operation, the pursuit of total perfection by means of applying to our *subjective* selves knowledge on all matters." In short, it was the "process of becoming perfect," of discarding stock notions and conformity.

He shared Arnold's contempt for the materialist education of the time, jotting down the observation, "There is no civilized country on the globe where culture and serious higher instruction are less encouraged, nay more despised than in the United States." Like Arnold, he deplored the neglect of Greek and Latin. But when Arnold urged the corollary aim of Culture as "the moral and social passion for doing good," Bernhard demurred: "On the whole I much prefer a *striving for perfection.*" He felt that "to a great extent culture consists in a precise discrimination of distinctions," a kind of connoisseurship of the spirit. Though touched by Arnold's dictum that the great Christian communions were "of more moment for a man's spiritual growth" than any other, he also admired Emerson's "Self-Reliance," which, he noted, "teaches the diametrically opposite." These opposing tugs upon his spirit were to have lasting consequences.

Bernhard's mild reservations did not last long, as he surrendered more and more to the influence of Arnold, though he was so devoted a disciple that he avoided going to hear Arnold when he lectured in Boston in 1883 for fear of losing his idealized image of the prophet. In a Harvard essay he declared that he read something of Arnold almost every day from his seventeenth to his nineteenth year. It was a revelation after "living alone with one's thoughts and anguish and despair" to make the "wonderful discovery . . . that another had lived the same inner life." In fact, he wrote, "I may say my social life began with Matthew Arnold." He rehearsed like a litany of worship the titles of the famous poems which had stirred his soul—"The Scholar Gypsy," "Thyrsis," "Rugby Chapel," and all the poems which like "Dover Beach" breathed a noble nostalgia for the past and a stoical sadness over the darkling future. His schoolboy copies of Arnold are among the few books of the many thousands which he came to own and study which

bear the underscorings and marginal comments of an intense communion. Seventy years later he wrote to Mark DeWolfe Howe: "I admired and sucked in [Arnold's] criticism, and his verses expressed me as no others of my youth. They still haunt my memory and speak as of old." From his earliest days Berenson felt the essential discord between Hebraism and Hellenism, of which Arnold had written in *Culture and Anarchy:* "Between these two points of influence moves our world." The tension was all the more tormenting because, as Berenson once ruefully acknowledged, he himself had "a double dose of Hebraism, an original Jewish one and piled tower-high above it, a New England puritan one."

His preoccupation with Arnold's doctrines overflowed in the copious pages of his letters to his admiring friend Irving Fox, who was beginning his apprenticeship as an editor and publisher. The two impassioned idealists unpacked their most serious broodings to each other in lengthy "epistles" until the end of the college year, at which time their intimacy ceased. Fox particularly besought Bernhard to explain more fully the difference between learning and culture. Bernhard replied with many variations on the theme of one "who saw life steadily and saw it whole." He lectured his friend: "The man of culture is a believer in the theory of development. He is in philosophy a relativist . . . in his religion . . . an Agnostic, or a Pantheist, whether Hegelian, or Buddhist. [He] consider[s] everything new in the light *only* of pure reason. He is nonetheless a poet, a painter, a sculptor (all in spirit) and above all an *idealist.*" In such rhapsodic fashion the young idealist stated his creed, to which he would thereafter be faithful in his fashion.

One of the subjects much on his mind, as on the minds of most of his contemporaries, was the effect of Darwin's theory of evolution upon religious belief, and in his discussions with Fox he revealed that he generally attended the Church of the Unity, whose pastor was the noted liberal Unitarian minister Minot J. Savage. Savage's sermons urged a frank acceptance of the new world view imposed by science and evolution, arguing that it enhanced the true values of Christian faith and ethics. "In spite of all orthodoxy," Bernhard wrote, "I think a great deal of Savage." Taking his cue from Savage's historicist view of religion, Bernhard responded to Fox's queries about Christianity with a twenty-page anthropological essay on the process by which Christianity arose out of earlier religions, assimilating their gods and rituals so that most people were still little more than idolators in their worship. Only a few can yet perceive the spiritual significance of this development. "You and I," Bernhard assured his friend, "have lived intellectually more than humanity as a whole . . . has in thousands of years."

Nevertheless, "average humanity," though it moved as slowly as a glacier, "will as surely reach the sea." The obstacles to a civilizing culture were great, but they could be overcome, and this too was part of the optimistic creed that would sustain Berenson through the terrible ordeals of two world wars.

Bernhard's awareness was all inward, literary, a sentimental and insatiable journeying among books. He was much given to introspection, brooding and dreaming on himself, as his fragmentary journalizing indicates. He seemed to feel from his earliest days that life for him must be a kind of intellectual footrace for which he must train himself to outrun his fellows. His diminutive stature and delicacy of frame ruled out any hope of distinction in the rough competitive sports in school and college, even had his bookish temperament not stood in the way. He grew somewhat vain of the immense breadth of his reading. Once in his mid-twenties, he dictated to the young woman who became his disciple and later his wife a list of the writers whom he said he had read before he was nineteen. It was an extraordinarily miscellaneous and overwhelming array, which she copied into her diary and to which she added his asides: "Marryat, Horatio Alger, Oliver Optic, Jules Verne, Cooper, Hawthorne, Howells, James, Thackeray, Dickens (always with great reluctance), George Eliot, Pater, Symonds, Vernon Lee, Newman, Schopenauer, Max Müller (a god of my boyhood), Whitney, Löldeke, Oldenburg, Sacred Books of the East (some in originals), Arabian Nights (in original and Burton and Payne), Persian (followed orientalism and philosophy), Grote, Gibbon, Mommsen, Friedländer, Sophocles, Catullus (read like modern), Heine, Goethe, Schiller, Tieck, Novalis, Uhland, and all the whole rubbish. Eddas, Nibelunglied, Gudrun, Minnesingers, Provençal poets, Dante and his precursors, Voltaire, Chateaubriand, Lafontaine, Racine, Corneille, Victor Hugo, Leconte de Lisle, Baudelaire, Gautier (doted on him), Maupassant, Daudet, Zola, Manon Lescaut, Pascal (hated), Bossuet, Molière (indifferent to), Tolstoi, Turgenieff, Pushkin, Gogol, Lermontov, Dostoevski, Madame Bovary, a lot of Goncourt, Jane Austen, very little Meredith (chiefly his poetry), Swift, Fielding (didn't like), Sterne, Smollett, Elizabethan dramatists, Lamb, Addison (always loved), Emerson, Carlyle Essays (nothing else), Walt Whitman (didn't like), (no Ruskin nor Montaigne), craving for oriental languages, histories, literature, for philology as a method, Shakespeare, Milton (preferred him), Matthew Arnold, never tried theology except church history. Gods: Pater, Arnold, Browning."

What an overwhelming evening of literary reminiscences this must have been and what a view of the compulsive character of his reading—and its astonishing rapidity. The book-intoxicated youth foreshadowed

the book-intoxicated man whose villa, which was enlarged from time to time to house his books, became, as he liked to say, a library surrounded by living quarters, a library that grew to more than forty thousand volumes by the time of his death. Little wonder that the earnest young man should have fascinated his college mates and their families when he began to discourse on almost any subject under the sun in a low rather husky voice that knew no stopping.

Bernhard's ambition to become a writer as well as a scholar took form even before he entered Boston University. In preparation for that career, he had already begun to fill little notebooks in his meticulous script with philosophic musings, interspersed with notes on his reading, all, as he hoped, to be mined for possible publication. One of the early entries shows him launched on his lifelong practice of coining words, however harsh to the tongue, to fit the impatient stride of his thoughts: "Optimism must imply contentment . . . which swiftly and imperceptively leads to Chineseism." Books were ever his true society; thus he remarks of Emerson's saying "I am never so little alone as when by myself," "I can express it no better. . . . What a host of friends I have then! from the Aryan ancestors to the men of today." For all his seeking, the path to culture seemed elusive. "Know thyself is the only guide to culture," he wrote in one place, but the maxim left him unsatisfied. Then one day in 1884, he wrote prophetically, "The church that admits one to the widest range of sympathies is nearest to the ideal. . . . The true and the beautiful are absolutely identical and are that which satisfies every demand of our consciousness."

The year at Boston University had been a considerable success. He had impressed his teachers and had made a great impression on his fellow students. Moreover, a few wealthy Bostonians, eager to encourage genius, had taken note of him. He had given every indication, as a writer in the Boston *Advertiser* recalled when Berenson revisited Boston in 1904, "of becoming a great philosopher." Nevertheless, he chafed at the limitations of the school and at last confided to Fox that he had completed arrangements to go to Harvard in the following autumn. He felt it would be almost suicidal for one of his decided tastes and inclinations to remain at a school that "savors much of a normal school." Only at Harvard with its two hundred courses to choose from could he hope to satisfy the needs of his "comparative-philo-ethno-theo-geological, as well as philosophical studies." He could foretaste the "absolute bliss" of studying under scholars like Lanman in Indo-Iranian, Lyon and Toy in Arabic and Assyrian, Goodwin and White in Greek, Lane and Allen in Latin, and Bowen in philosophy. It was only "a hundreth part" of what he would like to do.

When he decided to leave Boston University, he carefully wrote out the principles which ought to guide his studies as an "intensely practical" person, principles which "for so many years" he had had in mind: "I will not consider anything Kosher if it be not built up of the three following strata: 1. A commonsense knowledge of positive facts, or facts which serve as the best working hypothesis. 2. Deductions from these facts, that is the ideas in a Platonic sense underlying these facts and their unification. 3. Postulates from these deductions, and from their unification." The principles suggest the singular mixture of positivism and philosophic idealism which characterized his thinking then and afterward. The emphasis on the practical comes out in his use of the incongruously earthy word "Kosher."

As the summer waned, he became more and more preoccupied with "the eternal verities." Vacationing again at West Newbury, he enjoyed "an almost ideal life," reading incessantly and dreaming of "ideal reality." Only the poets, he felt, could minister to his dreams of perfection. Art too might become "a consoling divinity," if only he could "stop thinking philosophically, worse still, metaphysically" about it. "We must surrender ourselves body and soul," he reflected; "The Muses must be served."

III

A Harvard Aesthete

YOUNG Berenson entered Harvard as a freshman in the autumn of 1884, the admissions office not considering the year at Boston University the equivalent of one at Harvard. Precisely how the wherewithal was put together for these "neediest years," as he would afterward term them, is uncertain. The family fortunes remained as precarious as ever. Fortunately, the brilliant impression he had made upon his teachers and classmates had been well advertised. Young Edward Perry Warren, the son of a very wealthy paper manufacturer in New England, personally sponsored his admission to Harvard. Warren, during his last year at Harvard, had become friendly with Bernhard, who was then a freshman at Boston University. They shared a common taste in classical languages and archaeology, subjects which Warren was about to study at Oxford. Bernhard moved out of the family home in the humble North End, taking a room at 64 Mt. Auburn Street near the Harvard Yard. One of his first acts was to go shopping with his sister Senda for photographs to decorate his room. One of them, of Correggio's celebrated Diana of the Parma fresco, he specially delighted in because the face resembled that of one of his former classmates whom he idolized.

It was Bernhard's good fortune to enter the university at a particularly exciting time. The mid-eighties marked the beginning of what has been called one of Harvard's golden eras. It had its origin in the elective system introduced by President Charles W. Eliot in 1870, which had brought a wave of innovation in teaching and course content and had opened the way for the application of the scientific method to almost every discipline. Positivism, which had been barely tolerated a decade earlier, was now transforming the approach to all of the social

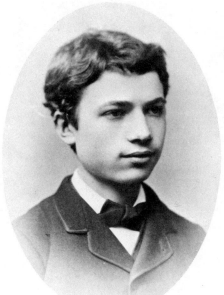

4. *Berenson at Boston University*

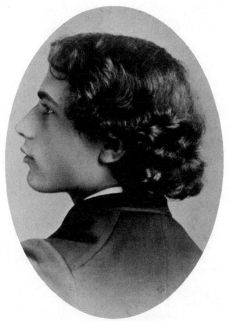

5. *Berenson as an undergraduate
at Harvard University*

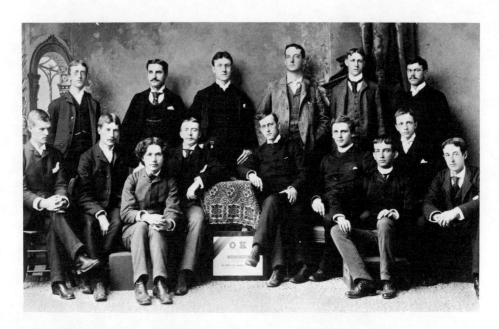

6. *O.K. Club at Harvard, Berenson seated front left on hassock*

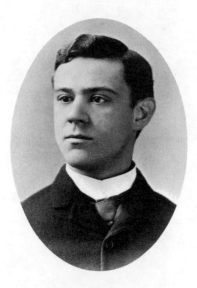

7. Charles Loeser
as a Harvard undergraduate

8. George Santayana
as a Harvard undergraduate

sciences, and Pragmatism was beginning to take shape in William James's popular course in psychology. Both the Harvard *Crimson* and the *Advocate* devoted columns to the question of the improvement of education. The spirit of innovation had its most vocal supporter in Barrett Wendell, a young English instructor, who pointed out in the *Advocate* to the new student unsettled by the freedom of choice among electives that this system enabled one to do two important things: elect courses which developed habits of mind needed "in the actual struggle" of daily life and choose courses, such as art and literature, which bore on the "off hours of life" and directly cultivated the "polite taste" characteristic of the gentleman. To Berenson the concession to the actual struggle of life must have seemed gratuitous. What filled his vision was precisely the off hours of life that marked the gentleman, and it quickly became apparent to him that Wendell really shared his bias.

Wendell, who was then thirty and already a campus character, had become immensely popular, though still only an assistant to the scholarly Professor Adams Sherman Hill, the Boylston Professor of Rhetoric and Oratory. Students loved his playful eccentricities, his semi-British accent, and his unconventional repartee, which he accompanied with his twirling watch chain. His office in Grays 18 became a popular rendezvous for campus intellectuals interested in creative writing. He introduced the daily theme in English 12 and was soon keeping as many as two hundred students scribbling away for dear life. With so much literary production going on, two students, William Baldwin and Thomas Sanborn, founded the *Harvard Monthly* in the spring of 1885. Wendell agreed to submit the best student essays for publication. The first editor-in-chief was Alanson B. Houghton. George Rice Carpenter succeeded him in the following semester, since the prescribed term of service was only for one semester. The new publication "kept all the best writers in the college on the qui vive," according to the *Crimson*, which also noted that never before had there been "so much interest in English composition and literature." What lent a note of urgency to this activity was the current charge that Boston was losing its literary prestige. Barrett Wendell saw himself as picking up the torch which the generation of Holmes, Lowell, and the aging members of the Saturday Club was on the point of relinquishing.

From its earliest years, the *Monthly* attracted a set of young men of remarkable promise, many of whom went on to distinguished careers in diplomacy, journalism, literature, philosophy, and university teaching: Houghton as ambassador to England; Carpenter as professor and author at Columbia; Santayana as a brilliant philosopher and author at Harvard; George Pierce Baker as a drama professor at Harvard whose

students helped transform the American theater; Herrick and Lovett as novelists and professors of English at the University of Chicago; the Hapgoods, Norman and Hutchins, as writers and influential publicists; William Vaughn Moody and Trumbull Stickney as dramatists and poets. The early numbers drew as well on the entire intellectual community of Cambridge and Boston. Among contributors were the novelist Owen Wister, the young poet Bliss Carman, the noted editor Thomas Wentworth Higginson, the Harvard philosopher Josiah Royce, the Boston litterateur Thomas Sergeant Perry, the New England historian F. B. Sanborn, and many others.

The intellectual stir at Harvard aroused Bernhard's ambitions to the highest pitch. The moment seemed one toward which he had been aiming since his earliest word-intoxicated childhood. Now the philosophic musings of his notebooks and the sonnets to a succession of feminine idols could at last be published. He quickly became a familiar of Wendell's circle of talented undergraduates and a contributor to the *Monthly*. The challenging excitement of Harvard was for him the perfect complement to the cultural resources of Boston; together they would always seem an Arcadia, and in his imagination they became his city of the soul, his only true home, "so hospitable, so human, so highly civilized," and, as he told an Italian friend in 1949, the *"forma mentis"* which had "influenced [his] character for life." In those influences Harvard played the greatest part and inspired in him a lifelong gratitude.

In the beginning at Harvard, Bernhard pursued his natural bent in languages, foreign and ancient, with rabbinical zeal, and he appears to have impressed his instructors with his remarkable aptitude. He excelled in Hebrew, approaching it now scientifically rather than by rote memory, as he had when a child in Butrimonys. Though Greek seemed taught, as he recalled, "not for its own sake but as a mental exercise," nevertheless, from the moment he began to spell out Xenophon he felt himself a Hellenist, and the landscape of ancient Greece at times appeared more real to him than that of his beloved New England. In his view, as he told his sister Senda, the world was divided between the elect who read Greek and those who did not.

In the prescribed courses in physics and chemistry he passed by the skin of his teeth, or as he impenitently put it afterward in his Parker Fellowship application, "I got no more glory than I intended to gain." Overall, he did well enough in his probationary year to be promoted directly to the status of a junior. He had earned a highly respectable 84 average, thanks in part to the literary promise of his English themes. He now came under the influence of Professor Charles Rockwell Lanman, author of a recently published Sanskrit reader. Lanman offered a

prize of five dollars for any error a student discovered. Bernhard promptly found one, "a short for a long i." Instead of the five dollars, however, he was rewarded, as he fondly recollected, with "many a supper of oysters and dry sherry after long evenings spent in perusal of the *Mahabharata*. . . . I recall interrupting to express admiration of a *sloka* just read. He looked up at me with bovine brown eyes and an expression of mingled surprise and distress at such a frivolous interlude."

Sanskrit was only one of the exotic languages Bernhard tackled in this second year of obsessive study. Professor Crawford H. Toy introduced him to Arabic and helped to make *The Thousand and One Nights* in the original one of his favorite books. Though he went on to advanced Hebrew with Professor David Gordon Lyon, he felt that only Arabic was really profitable, because it led him into belles lettres and art, whereas Sanskrit and Hebrew were like "biting on the trunks of trees" whose fruit he "had already enjoyed." Another course whose resonance would be heard to the end of his life in snatches of remembered poems was taught by the celebrated Kuno Francke. It immersed him in the romantic German epics and lyrics of medieval Germany and opened to him the world of Romanesque and Gothic art. At the same time he continued with Greek and Latin. In Greek he read *The Birds, Oedipus Rex,* the *Bacchae* of Euripides, and the tragic narrative of Thucydides. In Latin, under Professor James Bradstreet Greenough, he read Cicero, Livy, and Terence. What had the greatest influence upon what he termed his "intensely practical" side was a course in psychology and logic under William James. The impress of James's Pragmatism went deep, and so far as Berenson would afterward philosophize, it was chiefly as a follower of James. Like many other students, he found irresistible James's disarming invitation: "Come let us gossip about the universe." James proved to be another faculty member whose acquaintance ripened afterward into friendship. At the other philosophical pole stood the idealist philosopher Josiah Royce, whose course in the ethical and religious aspects of philosophy did little to modify Bernhard's distaste for purely metaphysical speculation.

As the year waned, there were more Greek and Latin texts to master and more Arabic, but what most excited his ambition was the course in "Themes" which had drawn him into the orbit of Barrett Wendell and the *Harvard Monthly* group. In the I Tatti archive are preserved some of these apprentice writings, bearing their meed of professional praise and blame. "Story à la Mode" was "good, but I do not find quite as much individual flavor in this as in your other story." A theme on love and marriage which stumbled a little in its phrasing wound up with the encomium "Excellent." At the moment Bernhard's drift was toward fic-

tion; if a name was to be made, it must be in the novel. He identified himself with the aspiring hero of Turgenev's *Roudine,* who believed that "ambition is the Archimedes lever" in a man's life. Roudine's tragic end on the Paris barricades, however, gave Bernhard a great scare when he came to it, for he sometimes feared that he would end like Roudine, tragically frustrated.

The courses which had the greatest influence upon his later career were those which he took in his final year under Charles Eliot Norton, the benevolent dictator of art in Boston. He enrolled not only in the one on Dante's *Vita Nuova* and the *Commedia Divina* but in the two on the fine arts—ancient art and the art of the Middle Ages and the Renaissance in Italy. In these Bernhard ranked well up toward the top of the class, and he struck up a respectful acquaintance with the eminent authority on art. Norton was puzzled about how to take the brashly self-confident young man, how to separate Bernhard's intellectual pretensions from his undeniably brilliant attainments. It seemed to him, as he confided to a colleague, that Berenson's ambition outran his abilities. Several years later, "the winning old pundit," in Van Wyck Brooks's phrase, was to show that he had unpleasantly sharp critical claws when faced with Berenson's first book.

Norton's Bostonian fastidiousness, his distaste for the cheap and nasty vulgarity of much of American life, inspired the witticism that Norton on entering heaven exclaimed, "Oh, oh! so overdone! So Renaissance!" Yet it was this very fastidiousness about life and art that endeared him to sensitive aesthetes like young Berenson. Norton's teaching and example were eventually to undermine young Berenson's literary ambitions and cause his inchoate strivings and yearnings to coalesce, as he had once foreseen, about the "consoling divinity of Art." Though he would outgrow Norton's preoccupation with the "historical and illustrative" in art, he would never forget "his charm, his good and great influence not only over the young, breezy and not always high-bred barbarians who already were snobbizing Harvard, but over the marginals like myself, on the ragged edge of the social body, with nothing to recommend them but their Pandora's box of personal gifts and characteristics."

Norton's fame and influence were even greater in Boston than at Harvard where, it was true, undergraduate "barbarians" sometimes escaped from the crowded lecture room as soon as the roll was taken. As a friend of John Ruskin, Norton had made the *Stones of Venice* and *Modern Painters* part of the American testament of beauty. He had known Browning and the Pre-Raphaelites and had been a devout student of art and archaeology in Italy. His articles in the *Atlantic* preached the re-

ligion of Culture, and in season and out he attacked the commercial spirit of the age, though as an editor and writer he had a keen eye for the main chance. Now, nearly sixty, and at the height of his fame, he held sway, again in the words of Van Wyck Brooks, as "a prophet, censor and sage." His amiable sister Grace Norton, a notable free-spoken intellectual and an author of essays on Montaigne, made her home a gathering place for talented Harvard students and young Berenson soon became one of her protégés. He in turn brought his beautiful sister Senda to the lively sessions of high-minded talk, determined that she too should rise in the world.

BEFORE the end of his first semester at Harvard Berenson had been elected to the exclusive literary society known cryptically as O.K., in which the initiates presented an essay on the mystic initials before proceeding to a champagne dinner in their honor. Founded in 1859 in reaction to the horseplay of the traditional social clubs, the society adopted the motto "Ars Celare Artem." Its membership included representatives of Old Family Bostonians and their peers. Theodore Roosevelt had been a member and the positivist philosopher John Fiske. Among its fifteen members in 1886 were three remarkable exotics whose alien origins drew them closely together—Bernhard Berenson, Charles Loeser, and George Santayana. A group photograph of the society shows an array of very serious young men, most in starched wing collars and waistcoats, pictures of sober elegance, all except young Berenson, who, being short, is perched on a hassock in the front row. More youthful looking than the rest, he faces the camera with an expression of candid, almost feminine innocence, his well-worn clothes a noticeable contrast to those of his fellows. Even more distinctive was the way he wore his hair. The luxuriant wavy curls, which were parted in the middle, swept backward over the tips of his ears almost to the nape of the neck. He was, as he recalled, one of the "long hair grands" in the Yard. Memory, as often happens, added a dimension to his boast, for the photographs of the nearly three hundred young men of his class of 1887 show only one other student who ventured the Florentine look of a Pre-Raphaelite poet. A classmate who used to see Berenson cross the Yard recalled that, small and frail in body, he gave the impression of an ascetic, an impression which was heightened by a certain delicacy and sedateness in his walk.

Berenson, Loeser, and Santayana formed a loose alliance, all three being marked by a certain foreignness, though Santayana's was the most complicated of the three. His mother, who was of Spanish birth, had married one of the sons of the great Boston family of the Sturgises,

who were engaged in the rich China trade, and she had borne him several children. Soon widowed, she married, while on a visit to Spain, Augustin Santayana and gave birth to George Santayana in Madrid. After several years his father finally concluded it would be best that his mother should return to live in Boston with all the children in what for her would be the more congenial society of her Sturgis kin, and he committed George to her care, preferring to remain himself in Spain, unpatronized by the wealthy Sturgises of Boston and London. Though largely brought up in Boston with his Sturgis half-brothers and half-sisters, George somehow felt closer to his Spanish father, perhaps because, unlike them, he looked a Latin, having olive skin and large lustrous eyes. Even after many years as a famous professor of philosophy at Harvard, he was to confess that he never felt really at home in America. He and Berenson had first met at the Boston Latin School. Charles Loeser, like Berenson, was of Jewish origin and hence also an outsider. The son of a wealthy Brooklyn dry goods merchant, he had already begun to collect books and paintings and would soon begin his lifelong benefactions to Santayana. All three young men had a common bond in their passion for art and literature. All three were linguists and aspired to be men of the great world. Loeser, who had been educated in a Swiss school, could speak French as well as German. Santayana added Spanish to their resources.

Membership in the O.K. club gave Bernhard entrée to the literary elite of Harvard, but he could not escape the complex social snobberies which abounded among the scions of Proper Boston as well as among the affluent outsiders. Acutely sensitive, he never forgot the slights which he experienced then and thereafter. Nothing, he would write, was "so cliquy and exclusive as the schoolboy or the schoolboy-minded Anglo-Saxon." In later life he sometimes called the breed "Angry Saxons." Perhaps for this reason he "kept much to himself," as Mark DeWolfe Howe recalled, and though they were fellow contributors to the *Monthly,* Howe saw little of him.

Bernhard found the faculty more accessible than his fellow students as well as more intellectually challenging, and he turned gratefully to Wendell, Toy, Norton, James, and Ferdinand Bôcher for stimulating conversation. Older persons he found responded more indulgently to his advances, for the older generation in Boston and Cambridge took culture very seriously and felt it a duty to foster it in talented young people.

One of the most notable literary persons who took Bernhard in hand was Thomas Sergeant Perry, one-time instructor at Harvard and at the

9. William James, about 1895

10. Charles Eliot Norton

*11. Isabella Stewart Gardner ("Mrs. Jack"),
portrait by John Singer Sargent, 1888*

moment lecturing at the recently founded Radcliffe Society for the Collegiate Instruction of Women. Tremendously literate and well-informed, he was chief reviewer of foreign literature for the *Nation*. He was an intimate of Henry James and William Dean Howells and dwelt at the center of Boston literary life. It was Perry who became the moving spirit in the little group of patrons who came to Bernhard's rescue upon his graduation from Harvard. Another member of the group who several years later would become far more important in Bernhard's life than any of the others was Isabella Stewart Gardner, the imperious "Mrs. Jack," who in the summer of 1885 had returned from a spectacular world tour in which she had hobnobbed with princes of the Orient and the Middle East. Given Bernhard's reputation as a genius, it was inevitable that he should be drawn into her net as yet another recruit in her train of protégés in art and music. Among Boston women of wealth none pursued the gleam of high culture more passionately than she and none with such a Medicean flair. What her inhibited Boston friends might dream of in the way of bejeweled gowns and unconventional behavior she put into flamboyant practice, to their mingled delight and outrage. A former New Yorker, wealthy, tough-minded, and self-indulgent, a collector of art and protégés, she made up for her plain features and small stature by a regal style of life. She flirted with her courtiers and ruled her salon like a despot, her motto, "C'est mon plaisir," as bold as that of the Sun King himself. She had become one of Norton's most dedicated followers in the cause of art and had already embarked on her remarkable career as a collector.

Neither she nor Berenson ever fixed the occasion of their first meeting, but the likeliest moment would have been after one of Norton's lectures some time in the fall of 1886, when Bernhard first enrolled in Norton's courses. He was soon sending her his contributions to the *Monthly,* and in her impulsive way she quickly decided he had a bright future as a novelist. Norton's influence was to affect Bernhard's future even more than it had Mrs. Gardner's, and by a fortunate chance would bring the two devotees of art into a lifelong intimacy. Norton helped his generation to burn with a possessive desire for Italian painting, and he taught the Proper and Protestant Bostonians to admire the Madonna and Child in a thousand painted versions. With his persuasive charm he helped set the stage for the enlightened, if wholesale, plunder of Italian art and for the migration of European masterpieces to the New World on an undreamed-of scale. The young man whose abilities Norton distrusted was destined to do more than any other person to accelerate that migration.

IF Norton seemed a colossus in Boston, the truth was that he stood on the shoulders of many fellow workers in the realm of art whose writings were shaping the taste of the Western world. What the art historian Oliver Larkin has called a "Renaissance complex" was already a full-blown cult in America, inspired by Burckhardt's magisterial volumes *The Civilization of the Renaissance in Italy,* published in English in 1878, and John Addington Symonds' romantic appreciations in his *Renaissance in Italy: The Fine Arts,* which came out four years later. Walter Pater's *Studies in the History of the Renaissance,* first issued in 1878, had gone from hand to hand among the avant-garde enthusiasts, its disturbingly sensuous "Conclusion" inspiring something of the fearful delight that accompanied the surreptitious circulation of Flaubert's *Salammbô.* Many Bostonians had succumbed to the lure of Italy even before the Civil War. The palatial studio in Rome of the New England expatriate sculptor William Wetmore Story had been the headquarters of many visitors like Nathaniel Hawthorne and the young Henry James. Hawthorne in his *Marble Faun* had provided a vicarious art tour of Rome, and James had followed him with vivid evocations of Italy in *Roderick Hudson* and in his recent *Portrait of a Lady.*

The first important American study of Italian art, *The Old Masters of Italy,* was published by James Jackson Jarves, a pioneer collector who had explored the art cities of Italy. He dedicated the book to Charles Eliot Norton when it came out in 1861. The book revealed what would become a too-often repeated experience in the later years of the century, the trials of a collector confronted by the "intrigue and mystification" of art dealers and their native "jackals," who levied tribute for every find they unearthed. Jarves cautioned the prospective critic that the recognition of genuine works of art required that "to a knowledge of conducting technical investigation it is essential to join the mysterious test of feeling; that which takes cognisance of the sentiment of an artist, his absolute individuality by which he is himself." Bernhard did not recall reading Jarves or taking up his "cult" until the mid-nineties, but it is likely that Norton passed on his friend's salutary warnings to his students and to his band of Boston collectors, for the authenticity of paintings bore mightily on their value. For example, in 1883 a great controversy broke out in New York over the genuineness of a reputed Raphael which was offered by its British owner at an enormous price. Most critics attributed all or part of it to Raphael's pupils. While the debate raged, the Boston *Transcript* wistfully editorialized that whether or not the *Madonna of the Candlesticks* was only in part Raphael's, it wished the Museum of Fine Arts could afford to buy it before the railroad and mining millionaires snapped it up. Buyers were scared off,

however, and the painting went back to England. A better version was acquired in 1901 for the Walters Collection in Baltimore, but the question of Raphael's part even in that painting remains controversial.

Bernhard may not yet have read Jarvis at this time, nor even Burckhardt or Symonds, all of whom were to exert a great influence upon him, but he made up for that lack by the way he saturated himself in Pater's *Studies in the History of the Renaissance*. What romantic aesthete with young blood in his veins could resist the call of its "Conclusion": "To burn always with this hard gem-like flame, to maintain this ecstasy, is success in life." For the future art critic and connoisseur there were passages in that "Conclusion" that epitomized every ideal aspiration: "To define beauty, not in the most abstract but in the most concrete terms possible . . . is the aim of the true student of aesthetics. . . . In aesthetic criticism the first step towards seeing one's object as it really is, is to know one's own impression as it really is, to discriminate it, to realize it distinctly. . . . What effect does it really produce on me? . . . And he who experiences these impressions strongly and drives directly at the discrimination and analysis of them, has no need to trouble himself with the abstract question what beauty is in itself or what its exact relation to truth or experience—metaphysical questions, as unprofitable as metaphysical questions elsewhere." Such a critic regards all art objects, and the "fairer forms of nature and human life, as powers or forces producing pleasurable sensations each of a more or less peculiar or unique kind." His end is reached "when he has disengaged that virtue and noted it as a chemist notes some natural element." Here in the most persuasive form, couched in a richly sculptured prose, was that emphasis on consciousness, on the psychological reality of experienced sensations which William James was expressing more colloquially in the classroom. That inspiring creed, Berenson would reminisce, "became part of my mind."

Yet when Bernhard lent the slim volume to William James, he returned it with the remark, "I don't like the book. It makes me feel as if I were sitting in a hot bath." James no doubt squirmed over Pater's too exquisitely sensuous prose, as he did against the convoluted style of his own novelist brother. If one had something to say, he once advised his brother Henry, he should "spit it out." Pater's *Renaissance* did not fare any better with Professor Norton, though, one suspects, for different reasons. Norton encountered Bernhard one day as he walked in the Yard engrossed in the book and asked him what he was reading. Bernhard told him. Norton borrowed the book and returned it in a few days. He laid his hand on Bernhard's shoulder and remarked with judicial finality, "My dear boy, it won't do." The setting of purely aes-

thetic and sensuous criteria above morality was an unforgivable heresy, and it would appear that Norton never forgave Berenson's lapse from virtue.

What Pater set forth as an aesthetic ideal he illustrated in February 1885, in the finely chiseled prose of *Marius the Epicurean*. In this book he depicted the spiritual odyssey of a philosophic Roman youth whose ideal it was "to meditate much on beautiful visible objects, more especially . . . on children at play in the morning, the trees in early spring, on young animals, on the fashions and amusements of young men; to keep ever by him if it were but a single choice flower, a graceful animal, or a seashell as a token of the whole kingdom of such things . . . and to disentangle" himself from repugnant objects at "whatever cost." These were the duties of the new Epicureans. Bernhard seized at once upon the new book. Its impression on him proved decisive. He shared its delights with Barrett Wendell, whose response echoed that of Berenson. To a friend, Wendell wrote, "It deepens and strengthens all that Italy means to me." There was, however, a deeper theme in the book, as Pater himself acknowledged to a friend. He had written it, he said, "to show the necessity of religion."

It was probably Bernhard's reading of *Marius* as much as any more prudential motive that led him in the fall of 1885 to take the first of his dramatic steps toward his ambition of perfect culture. With all the resonances of *Marius* in his mind, he came under the spell of the magnetic preaching of the Reverend Phillips Brooks, famous as the high-minded and intellectual rector of Trinity Church in Boston's Copley Square and the idol of one of the most aristocratic and conservative parishes in New England. Bernhard was of course already familiar with the Christian service. Chapel attendance had been compulsory at Boston University and was still so at Harvard, in spite of the agitation against it by campus radicals. Phillips Brooks officiated as one of the four regular preachers at Harvard. Perhaps no other congregation in America worshipped in more impressive surroundings than that of Trinity Church. The monumental Romanesque structure of red granite which soared upward one hundred and fifty feet to the massive central tower was acclaimed as the masterpiece of its architect, Henry Hobson Richardson. Its bold and rugged lines transported the onlooker to the ancient churches of southern France and powerfully suggested the birth of a new age of faith. The dim, vaulted interior glowed with the stained glass and murals of John La Farge. Here Bernhard could let his spirit soar to the wonderful cadences of Brooks's Episcopalian idealism. Here he could forget the irksome fetters of the orthodox religion against which his father and he had rebelled. Here it was easy to identify him-

self with the sensitive young pagan Marius, who had moved in almost dreamlike fashion toward Christianity. "As I remember," Berenson said, "Marius ended with a tropism toward Christianity not because of its *Heilkinde* [holiness] or metaphysics or dogma but that he was drawn to the kind of life the early Christians seemed to be living, and its ritual and discipline. . . . Salvation is not an act but a way of life."

On the twenty-fifth Sunday after Trinity, November 22, 1885, at the age of twenty, Bernhard was baptized a member of the church by Phillips Brooks himself. Brooks, who was noted for his personal charm and accessibility, had quickly taken to the brilliant and personable youth who came from such unlikely surroundings in the North End, and the acquaintanceship then formed ran on for a number of years of friendly correspondence until a more potent religious discipline replaced that of Brooks's enlightened latitudinarianism. Thanks to his conversion, Bernhard was cordially taken up by some of the ladies from the fashionable Back Bay. He discovered that churchgoing, like culture, generally was chiefly a woman's province. "The female element is strong here," he noted, "and I succumb to it. Only this distinguishes me from most of the other fools: I am well aware of my folly." Going to a large literary gathering one day, he discovered that there were fewer than half a dozen men present. Nevertheless, he enjoyed being lionized by the women as a Harvard genius and began his career of basking in the admiration of socially prominent and intellectual females. In appearance he must have looked to them like a strayed faun from Arcady, an unworldly poet in need of shelter from the harsh east wind of State Street and its bankers. For a short time a thin brown beard heightened the effect, leading an unsympathetic college mate, Robert Herrick, to suspect that Bernhard wished to resemble Christ in the popular painting.

Bernhard discovered that there were certain drawbacks in cultivating persons whose conversation was enriched by achievement rather than promise. Older persons expected more of one and quickly forgot the laggards. He advised his sister Senda to avoid his mistake, though she should hold fast to the social advances they had already made. He saw too that one could be too ingratiating. The well-established were all too alert to detect obsequiousness. And he found also that Anglo-Saxon husbands were not always as hospitable as their wives. Clearly, life must become a long calculation for a talented parvenu; somehow he would have to make the uncomfortably adhesive title of "Polish Jew" a title of interesting distinction.

The legend of his experience lingered on in Boston, becoming the subject of a revealing novel in 1908, *The Tether* by Ezra Brudno, in

[39]

which the dilemmas of Berenson's emancipation and that of his class-conscious fellow Jews were lightly disguised. In assimilating the high culture of his greatly admired Boston, Bernhard assimilated as well the current anti-Semitism and antiforeignism of the business and fashionable world. He learned to shudder at the crudity of immigrant manners and the strident vulgarity of many of the fugitives from the ghetto. He convinced himself that he had successfully escaped from his blighting heritage and had achieved a new identity. The truce—for it proved only that—which he made with his buried feelings would last for decades; suppress them utterly he could not; nor could he deny himself at times a lurking sense of pride in the Jewish roots of much of Christian culture or in the fact that his Hebraic puritanism had ancestral sources more ancient than the New England puritanism which he had adopted. He learned that life would be a prolonged accommodation to the prejudices of the great world and its upper crust. He would never quite lose the traces of Jewish self-hatred which at the turn of the century his sharp-eyed friend Henry Adams was quick to spot in his emancipated Jewish friends. He had much more to learn of the subtle ramifications of anti-Semitism, against which the garment of Christianity which he had put on would not protect him. The path to a personal identity would prove strewn with unexpected hazards and ambiguous guideposts.

lantic perspective the contrasts became all too plain. When the Enlightenment did come to Russia, it was not "an awakening to a wonderfully glorious and beautiful past, as in Italy; to a consciousness of boundless power, and joyousness, and delight in living, as in England; to a profound insight into the world of thought, and to a tender, inspiring sympathy with the mystic and enchanting that it discovered within itself, as in Germany"; it was rather an awakening "in the midst of the profound and unlovely sleep of Slavo-Tartarism . . . to Byronic despair." It took Pushkin and Gogol to turn to what was "heroic, if not always beautiful in their past." Turning then to the play itself, Bernhard declared, "An artistic literary work should be the point of convergence and divergence for everything that bears upon events and characters under consideration." The secret of Gogol's art could be aptly represented, he continued, by Elihu Vedder's illustrations to Omar Khayyám, which had been recently exhibited at the Art Club in Boston. They showed "a strong, decided swirl, converging into a heavy, whirling point of involution, and emerging from that in ever broadening evolution." The arresting visual analogy linking the aesthetic form of literature to that of painting suggested the direction that Bernhard's later theorizing would take. Though in this and other passages he skirted the edge of intelligibility, the magisterial note sounded in the remainder of his analysis and the profusion of recondite allusions commanded assent. The air of authority which he then assumed would become second nature. Carpenter promptly placed him on the Board of Editors.

The promised article on Du Bellay and Catullus did not appear, apparently forestalled by a fellow editor's essay on Catullus, but one on the autobiography of a friend of Goethe, Jung-Stilling, did come out in the very next issue. Sophisticated, mature, and highly allusive, the essay displayed an encyclopedic range of literary reference. The autobiography, he declared, surpassed Rousseau "because it has no rhapsodies of remorseful sermonizing over past weakness and meanness." Unlike the autobiographies of Maurice de Guérin, Amiel, and Senancour, which "are all analytic and introspective . . . Stilling's story is quite plastic," and it "is fortunately without that insufferably coarse tone of satisfaction with his practical self which is so natural to [Benjamin] Franklin." It was superior as well to the narrative of Lord Herbert of Cherbury in being free from the quaint if charmingly old-fashioned materials which were "incapable of perfect artistic treatment." In character Stilling recalled St. Francis of Assisi, "so far as Cardinal Newman will allow saintliness in a Protestant." To praise the style of the book, Bernhard disputed a little Matthew Arnold's animadversions in "On the Study of Celtic Literature" against the limitations of the German

I V

Literary Debut

BERNHARD'S debut as a writer for the *Harvard Monthly* in his second year at the university would seem to have come about through his friendship with Santayana, who was a fellow member of the O.K. society and a member of the *Monthly*'s board of editors. A meeting with the scholarly young editor-in-chief George Rice Carpenter led in early February of 1886 to a friendly invitation to contribute to the magazine. Carpenter's note acted like the breaking of a logjam. Bernhard responded with a rush of proposals. As a starter he could assure Carpenter of an article on a Gogol play, *The Revisor,* for the March issue. Though he was only ten when he left the Russian Pale, he confidently explained, "I know nothing that is so true of a picture of Russian 'Official' life as that play." He added that he had notes for three more essays, two on German writers and one on Catullus and a French poet, Du Bellay, as well as a sheaf of poems ready for publication. "Let me once begin to write," he said, "and I'll deluge you." And deluge him he did.

The article on Gogol duly appeared in the March issue. Written with a sure sense of American idiom, the article showed a writer remarkably familiar with the international literary scene. At the moment the Turgenev vogue was at its height and Dostoevsky and Tolstoy were rapidly gaining popularity. Gogol had all the promise of avant-garde novelty. Bernhard apparently had come upon the play in a recent German collection of Russian classics. It was only some years later that Isabel Hapgood translated its rollicking and mordant satire into English with the title *The Inspector General,* launching it on a long career of popularity on stage and screen.

In taking up Gogol's play Bernhard seized the chance to score the slow intellectual progress of his abandoned homeland. In the transat-

language. He agreed with Arnold that German prose, "obdurate and rebellious," did lack the " 'magical' timbre" of a Keats; but perhaps Arnold had not made "precise enough distinctions" to apply to Stilling's prose, which has "a lightness, a swiftness, above all a limpidness, a transparency that Goethe himself never surpasses and not always equals." It was a prose that reminded one of Dante's *Vita Nuova,* and Stilling's "magic" was the magic of the "Teutonic Dürer." Finally, the folksongs in the book were the equal of anything in "Brentano's Knabenwunderhorn—the Percy's *Reliques* of German literature." The essay was obviously a bravura performance for an undergraduate.

His article on Gogol's *Revisor* had at once marked Bernhard as the *Monthly*'s authority on Russian literature. He soon reviewed Isabel Hapgood's new translation of Gogol's stories, *St. John's Eve and Other Stories,* noting that it was part of the fashionable vogue of Russian translations. While he praised the translator's "sympathetic eye and skillful hand," he contended that because of her lack of intimacy with Russian manners and customs she had a "fatal facility . . . for just missing a joke, or a fine touch of sarcasm." He felt obliged to point out also that she had mistranslated some words, rendering *pannotche,* for example, as *Sir* instead of "My dear *little* Sir."

A spate of books on Tolstoy and Dostoevsky inspired an extended article entitled "The Writings of Count Leo Tolstoy." Bernhard suggested that Tolstoy was the writer "whom nature [had] chosen as the subject of . . . [an] experiment of bringing an almost perfect and free intellect to observe the world and report what he sees." Since Russia, unlike the West, had no long cultural past, "the Russian child is born free. His faculties have not been fenced in for centuries." Hence Tolstoy was uniquely able, as in "The Cossacks," to render life as it is actually lived. In spite of his rejection of "culture" and his deification of the peasant, Tolstoy succeeds as an artist because he avoids the overt moralizing of the English novelists by exhibiting a "tendency" in his characters, "their *karma* as the Hindoos call it."

The extraordinary breadth of learning which Bernhard displayed in his two terms as a contributing editor assured his election as editor-in-chief of the *Monthly* in his senior year, succeeding George Pierce Baker, who in his turn had succeeded Carpenter. The two issues which Bernhard edited during his term continued the high literary and scholarly standards of his predecessors. He continued the practice of opening each issue with an article by a distinguished "outside" writer. It was something of an editorial coup that he obtained such an article for his first issue from the leading literary figure of Boston, Thomas Sergeant Perry.

His own chief contribution to the issue was a tour de force of learn-
ing that must have kept him up many a midnight hour, a fifteen-page
essay entitled "Was Mohammed at All an Imposter?" It evidently grew
out of his study of the Koran in the original Arabic under Professor
Toy. The article is especially significant as an experiment in the psy-
chological reconstruction of a personality, an experiment that Bernhard
would resume a few years later in his studies of Italian painters. His
thesis was that in spite of the difficulty of reexperiencing the *"Wel-
tanschauung"* of a sixth-century Arab, one could reconstruct the psy-
chological development of Mohammed according to the familiar princi-
ples governing the workings of the conscious and unconscious mind,
principles which had been the staple of the course with William James
and which were soon to be elaborated in 1890 in James's great work
Principles of Psychology. "When the decisive time did come during
[Mohammed's] fortieth year, his mind was not only stocked with the
images that he inherited from his race, but with many a vague and half-
conscious thought. We can imagine how the struggle to find the mean-
ing of the vague, incoherent, meagre data in his possession . . . must
have commenced in him. . . . Then, while he lets the problem lie,
despairing of a solution, that wonderful something, that subtle, mental
chemistry which we vaguely call unconscious cerebration, takes hold of
it, settles it, and flashes the result upon the bare tablets of conscious-
ness."

The essay graphically analyzed the rhetorical strategy of mystical
prophets like Mohammed. To bring the truth to the people, "we must
place trees and shrubbery along the parapets, even as Xerxes did when
he bridged the Hellespont." If it was true that Mohammed could nei-
ther read nor write, the same could be said of the author of one of the
greatest German poems, Wolfram von Eschenbach, who based his Par-
sifal epic upon that of the illiterate Kiot of Provence. The prophet owed
his extraordinary influence to the difference of "the pure Semitic mind"
from the Aryan. "To the Semite the words church and state have no
meaning," as they had no meaning "under Gregory the Great, under
Savonarola, under Calvin, and in Old and New England under Puri-
tanism . . . so that between puritanic Christian and the puritanic Jew
—the real Jew—the difference is only superficial; and between the prod-
ucts of the two puritanisms, the typical Jew, a mythical creature, per-
haps, and the typical Yankee, fully as mythical a creature, we hope, the
difference is at the utmost nominal." Thus in passing and in the dry
light of scientific inquiry, young Berenson legitimized his own action
and silenced any lingering twinges of conscience. His conversion to

Christianity—so far as it involved the essence of things—was no real betrayal of his origin. It was hardly more than a change of names.

Though Mohammed may well have been neither perfectly sincere nor, on the other hand, an impostor, what was really important was that "things may be objects of great aesthetic pleasure to us and yet be nameless," or at any rate remain ambiguous. In common with such men as Savonarola and Luther, Mohammed possessed "a certain virtue . . . a certain grandeur, a certain transcendancy, a certain sincerity withal, that has a potent tonic effect upon us." His ultimate value, therefore, was emotional and aesthetic; he counted toward culture.

Bernhard's most personally revealing contribution to the *Monthly* was a story, "The Third Category," which had appeared in the preceding issue. The hero of the thinly veiled autobiographical fiction, Robert Christie, is an epicurean with a Faustian bent of mind, an exquisitely refined Harvard graduate and a gentleman of parts. Robert's aestheticism is that of a disciple of Pater prepared, as Pater enjoined him, to discriminate and analyze his impressions of beauty without resort to moral judgments or unprofitable metaphysics. He loves to psychologize himself and his fellows, being fonder of "accurately defining his relations to people" than of "the people themselves." As a connoisseur of his own consciousness, he asked himself "only what sensations did he find of which certain people were the subjects. What particular flavor did they possess that might serve his sensuous palate." Like his creator, Robert "slept little" and dreamed much. Intent on scientifically discriminating his pleasures, he has established a scale of personal relations with women: the first and lowest category comprises mere acquaintances; the second, persons who embody and share his aesthetic passions in the most intense form; the third category, from which he might choose a wife, those who achieved a golden mediocrity, not so lovely as to "disturb his plastic relations" with beauty, and yet worthy of his "thought and time" to improve with beautiful clothes. It was an ideal which curiously reflected the fashionable standards of Boston high society and one to which Berenson would remain faithful.

Robert seeks the perfect mate among four young women of whom he was fond but whom he did not love, for "it was no woman that he loved . . . but loving itself." There was Rosalys "with her exquisite ethereal form, her transparent complexion, her ocean-deep blue eyes, and rich golden hair," with whom he enjoyed looking at "some drooping, poppy-saturated pre-Raphaelite sketch or a drawing of the divine Sandro Botticelli." He also relished the "delightful touch of Bohemianism" of Miss Senda Vernon, who tossed her hair so dramatically and

improvised on her guitar while he read to her from the old French poets. Then there was "the wonderful Miss Claudine Soothby," a delicious creature of "Wordsworthian blitheness of heart and joyousness of soul" who ravished him with her dark and magnificent beauty. Most impressive was Miss Gertrude Hammer, "a Valkyrie doomed to abide in our tides and clime." As a devotee of Wagner's music, Christie felt exalted when she played something from Wagner or when they read together "the Niebelungen Lay or the Eddas or some of William Morris' stronger poems."

Christie realized, however, that the various beauties who were indispensable to the proper savoring of life exceeded the golden mean by their very intensity. Hence he sought and found a "goldenly mediocre" beauty in the person of Miss Cecily Grampian. An auburn gleam "played like a halo about her sweetly poised head, with its rich chestnut hair." Watts and Burne-Jones he thought would have delighted in "this perfect pre-Raphaelite picture" of a woman. It was she who met the tests for the perfect woman, the criteria of "the third category," beautiful but not too beautiful, educated but not too educated. She found his thoughts "shudderingly cold, fresh and grand," for generous and self-sacrificing as Robert was, "he found no room in the universe for another than himself"; but "that self included . . . everything of which he had consciousness."

Her one flaw was that she did not share his love for paintings of the life and passion of Christ and His saints and martyrs. He could not see how "in the long run he could bear to live with a woman who could not appreciate Fra Angelico's frescoes or Raphael's Sistine Child—as it should have been called—or Wagner's *Parsifal*." It was obvious that "the larger and more beautiful part of the fine arts," as exhibited in the Italian Renaissance, "was thus without deep meaning to her."

Robert Christie's attitude toward Christianity well describes Berenson's own motive in becoming a convert in 1885: "Mr. Christie . . . had no religious feelings or belief. But he had the profoundest admiration for Christianity, not only as a historic fact and still living force, but for its successful symbolization of human life. . . . His regard for Christianity was, on the whole, much more because it inspired artists than for any other reason. And he thought an appreciation of Christianity necessary now to enable us to appreciate the arts." In all his long life Berenson, though he soon left the church and rejected its theology, never surrendered this aesthetic attitude toward Christianity.

Christie's scheme to win the young woman miscarries because he so successfully proselytizes her that she becomes devout and deserts the purity of aesthetics for piety. He had tampered with her soul and had

roused her from "a deathlike slumber," but since he could not give up his intellectual independence, he abandoned her. Her reproachful tears so heightened her beauty, however, that unlike Hawthorne's "artist of the beautiful," whom the story recalls, he felt his experiment "was after all a success," since in the aesthetic realm morality was irrelevant. The sensuous beauty that he had helped create "repaid . . . all his trouble." To emphasize his hero's cynical detachment, Berenson has him walk away down Mt. Vernon Street at the end, humming in Goethe's German a line from "Vanitas, Vanitatus Vanitas": "My trust in nothing now is placed, Hurrah!"

The poetically extravagant descriptions with their Botticellian images of the young women may have reflected the sentimentalized eroticism of Rossetti and Burne-Jones, but the inspiration for them came from the depths of an ardently passionate nature. Yet his hero's intellectual detachment was also his. The story thus anticipates his lifelong struggle between the cerebral and the erotic. The visions of Titanism which his hero entertained, visions of lordly dominance, must have been a sort of compensation to Bernhard for the slights he endured in the "cliquy" Anglo-Saxon world. The story seems indeed a half-conscious manifesto of its author. He would aspire to be a modern Marius the Epicurean with the desires of a Faust and the powers of a Mephistopheles.

Two of the half-dozen book notices which he contributed to the *Monthly* have a particular interest, one, an appreciative review of *Baldwin: Being Dialogues on Views and Aspirations,* because it shows his early familiarity with the writings of Vernon Lee (Violet Paget), the formidable expatriate British writer and philosopher of aesthetics with whom he would begin a long and stormy acquaintance on his arrival in Florence; the other, a brief notice of Hermann Lotze's *Outline of Aesthetics,* a little volume of lecture notes. Berenson's passing remark that Vernon Lee's notion that "a work of art is the embodiment of a conception" and that her results "on the whole are the same as the canons given by Mr. Waldstein in his *Essay on the Art of Pheidias"* suggests one of the root sources of Berenson's own critical canons. Waldstein stressed the primacy of the *"plastic* character of mind" among the Greeks. The plastic mind, according to Waldstein, "comes to mean the mind which acts through the senses alone by pure and simple sensuous observation; while the pictorial or the poetic tendency is less intuitive, more reflective and associative." Waldstein deplored the loss of the power of simple observation in the modern world. "We make but scanty use of impressions of eye and touch, in fact use them merely as provisional means to be cast away so soon as we have translated them into some associative thought." His theory clearly reinforced "scien-

tifically" the ideal of refined sensuousness which lay at the core of Pa-
ter's *Renaissance* and *Marius*. Though Berenson was repelled by Lotze's
metaphysical speculations about beauty and aesthetics, he saw much
value in his efforts "to impress us with the importance of distinguishing
between our individual impressions [a matter of psychology] and ac-
cepted canons of criticism." The emphasis was again on scientific dis-
crimination.

A certain irony attaches to Berenson's review of Josiah Royce's now
long-forgotten novel, *The Feud of Oak Field Creek,* in the light of the
criticism of Berenson's own style that he later suffered at the hands of
his English intimates. He reproached Royce for his slips of idiom and
clumsiness of phrasing. "Why did not Mr. Royce get some friend to
tell him that 'now soon,' 'now already,' 'then already' is not English;
that the use of 'apt' in 'apt soon to be' is most uncouth . . . and that
the use of 'wealthier' in the expression 'life is so much wealthier' is in-
tolerable."

As editor-in-chief of the *Monthly,* Berenson commanded the respect
not only of his fellows but also of the great world beyond the Yard. He
succeeded so well in keeping up the literary quality of the magazine that
at the end of his term the Boston *Advertiser* editorialized that the *Monthly*
"is a notable and significant fact in American literature, and now as
the second year's work is done it deserves something more than passing
recognition. . . . More than once have their articles been spoken of in
terms more than simply favorable in England." And by England it was
safe to assume that the editor meant Oxford.

Such success was sweet, but there were also moments of disenchant-
ment. Then the passing hours, Bernhard confided to his journal, "fill
my heart with grief, but with joy no more or nevermore." And when,
on his way to dine with Grace Norton, a friend convinced him that
science had succeeded in disintegrating the atom, he "felt dizzy with
nothing to cling to for support, now that my ultimate . . . the atom
had been shattered." Oddly enough, the other side of his introspection
went unrecorded in his journal of these crucial months: his dream of es-
caping from the dollar-chasing of American life. He yearned to visit
Oxford, where he knew Edward Warren would welcome him. Warren,
on the way to becoming an erudite collector of art, had gone on to Ox-
ford to settle permanently in England. At Oxford Bernhard could hope
to pay his court in person to Walter Pater. Beyond Oxford the culture
capitals of Europe beckoned.

The Parker Travelling Fellowships offered the most promising means
of escape from the bleakness of life in the North End, where he had had
to return after a year in his Cambridge room. His application for one of

the four fellowships, dated March 30, 1887, reflected his confident expectations. As the acknowledged brightest undergraduate, the companion of faculty members and protégé of prominent Bostonians, he should need only to submit a full and candid account of himself. The resulting recital, brimming with self-assurance and naiveté, proved too full and too candid to be acceptable, certainly too wanting in decorous humility. As autobiography it tells much about the psychological defenses of the young man and a good deal about his patronizing intellectuality.

He wished to fit himself, he wrote, "as a critic or historian of literature," for which his preparation had begun at the age of eight, when he was able to read German, Russian, and Hebrew and make himself "understood in Polish and Lithuanian a little." In grammar school he "learned a lot from those teachers who personally appealed to me and nothing at all from pedagogues. . . . I used to read many hours each day, even during school hours, with the permission of wise teachers. . . . At fourteen I was trying to write for publication. I have resisted two temptations: to strike for academic honors; to abandon study and earn. I have seen the toil to which my father subjected himself and his five children of whom I am the eldest and I have never been anything but miserable at the thought of the burden I have been to him from the expenses of my unremunerative education. . . . It was quite natural that I should find Boston University insufficient for my needs." He also called the attention of the committee to the vagaries and injustices of the grading system, reporting that although he received 80 (the record shows 82) percent in Professor James's course, a senior in the same class whom he coached and "who knew nothing at all about the course . . . got 92 percent."

After briefly summarizing the rest of his main course work, he continued: "This is a fair summary of my college work which never, in reality, meant anything to me compared to the reading I was doing. . . . I have not been idle. I sleep very little. Few men sleep less and devote themselves to their true interests more than I do. . . . In time if my growth cease not, I may be able to address my generation in the most direct way, through the novel and the story. . . . This is the most decisive moment of my life. . . . I feel that if I stay here longer I shall stagnate and lose my savor. I plan if I get the Parker Travelling Fellowship, to go to Paris in mid-July and visit its buildings, galleries and cathedrals. In September I would go to Berlin University and spend the winter there studying practical art problems and Arabic. Then I would go to Italy and stay there until the end of the year in the study of Italian art and literature. Art prevails in this program because it is there I feel

myself weakest. My thought moreover is and for some time has been occupied with aesthetic problems. . . . In a sojourn abroad I would . . . continue with Arabic, Hebrew and Persian. In Paris I would be listening to Renan and going to the theatre and I would hope to have short stays in England and in Russia. I should be able to let things dye me through and through instead of having to swallow them." And finally, he concluded, "I should employ every minute of my time in fitting myself by reading, study, observation, and susceptibility to all cultivating influences, to enable me to do the work I feel I may do."

A number of his professors supported the application. Professor Hill wrote: "It is not often that Harvard has so good an opportunity to lend a helping hand to a young man whose tastes and talents so strongly urge and so well fit him to pursue a literary career." Professor Lyon spoke of him as "a man of unusual ability and brilliant promise." His favorite teacher, Professor Toy, declared, "His natural gifts and his attainments appear to me to be uncommonly excellent. . . . His reading is enormous without being superficial. He combines in a very unsuual way acquaintance with Eastern and Western literatures."

The absence of a commendation from Charles Eliot Norton must have sorely disappointed Bernhard, for he had tried hard to make a good impression. Only a few months earlier, while spending a Christmas holiday in the village of West Newbury, he had written to Norton to say that "the feelings I have had in hearing you speak are like those that come to one when a dear friend speaks to one of the things that are nearest and dearest to both of them." The present opportunity for quiet thought had made him realize "more strongly still how large a part of my consciousness you have become." The letter failed to conciliate his Rhadamanthine judge, who thought him too ambitious or perhaps too pushing. Berenson's application was denied.

The setback to his hopes aroused his influential friends. Thomas Sergeant Perry rallied a group of sponsors including himself, Mrs. "Jack" Gardner, Edward Warren, and Professor Ferdinand Bôcher to make up a purse which would be the equivalent of the $700 awarded to the Parker Fellows. As the wealthiest of the group, the fabled Isabella Gardner doubtless made the largest contribution. Berenson was already on very friendly terms with her and kept her posted on his literary progress. The year before he had sent her a copy of his story "The Third Category" and a few manuscript pieces which he deprecated as rapid class exercises, materials which had inspired her hopes for him as a potential novelist. On the eve of his departure for France he wrote to thank her for her "most encouraging words," but added, almost as if by way of warning, "I want more plastic, less subjective things."

Now that a year abroad was assured he was impatient to get away. He decided to forgo the Commencement Day ritual on the twenty-ninth of June and deputized a friend to pick up his diploma. The program listed him as receiving Honorable Mention in Semitic languages and English composition, the equivalent of *cum laude*.

One can imagine the excitement and the tearful farewells of the proud family at 11 Minot Street and the detachment of the young aesthete preoccupied with thoughts of the Grand Tour. On Friday, June 17, just before leaving Boston, he sent off a letter to express his thanks to Professor Bôcher, professor of French and father of one of his classmates. "I have not been a student under you, as it happened, but you have had few more enthusiastic listeners." He therefore begged the privilege of writing to him "to tell you what I am doing and to consult you about what to do," since in France he would be occupied with studies "of which you are a master." As the Perrys would also be abroad, he asked that letters be addressed to him in care of Thomas Sergeant Perry, Baring Brothers, London.

At the station in Boston there was the usual embarrassed waiting for the train while friends and family made conversation and Berenson fidgeted to be off. What upset him most at parting with his mother, as he analyzed his feelings aboard the train, was not her anguished grief but the fact that he felt no emotion whatever. He was accompanied to New York by two comrades and he noted that one of them kept watching him as if he were trying to "analyze my consciousness." Just before sailing time on Saturday afternoon June 18, he dashed off a note to his favorite sister Senda, seeking to console her and sending dutiful messages to his mother and father. As the afternoon waned the *Grand Bretagne* steamed past the newly dedicated Statue of Liberty on Bedloe's Island and stood out to sea. The pilgrim of culture could hardly have surmised that he would not see Bartholdi's statue again for seven years.

V

Cities of a Dream

ON shipboard young Berenson tried manfully to play the role of
a man of fashion, going in to dinner rather self-consciously
in a "boiled" shirt, as befitted a prominent Harvard student
starting out on the Grand Tour. One of his fellow passengers was the
"exquisite but scornful" son of the "divine Sarah" Bernhardt; he
wanted desperately to meet him but held back for want of the ability to
speak French. He was mortified to discover that the summer flannels
his father had generously provided were "six sizes too large." To Senda
he reported that all the nations of the world were congregated in the
microcosm of the ship, chiefly paired as uninteresting mothers and
daughters. Well schooled in the prejudices of a Proper Bostonian, he
also looked askance at the unpleasant prevalence of Jewish passengers.
He had by now achieved the "state of anti-Semitic rebellion" which
Henry Adams, who later accepted him as a friend, described as the
"mark of all intellectual Jews."

He arrived in Paris from Le Havre toward the end of June after trav-
eling through a countryside which to his intoxicated vision seemed an
"earthly paradise," the fields radiant with poppies and purple clover.
Paris looked as homelike as Boston, and from his little room in the
Latin Quarter near the Sorbonne at 16 rue Cujas, as he reported to
Senda, he could look out upon the nearby Pantheon and the church of
St. Geneviève. He soon felt himself a Parisian in the "most beautiful
city in the world." He haunted the Salon and lingered by the hour in
the endless galleries of the Louvre. "I am all stomach, mentally," he
told his sister.

Determined to become a writer, he kept sounding his feelings, inces-
santly noting his responses to the art and ambiance of Paris. In place of
the discipline of daily classroom themes he substituted letters and post-
cards to Senda and to Mrs. Gardner, pouring out in a never-ending

stream his impressions of life in Paris, indulging in pages of banal self-analysis in quest of the right note of identity. Thanks to William James, he and his fellows had become as aware of their consciousness as the students of a later age would become aware of their subconscious. As a result, to the young Americans of the fin de siècle imbibing the catechism of art for art's sake in the sidewalk cafés, the great world of politics and social strife was a world well lost. President Clevelands might come and go; beauty was eternal. In Berenson's letters home there were hardly any allusions to the world whose convulsions were the daily grist of *Le Figaro* or the *Journal des Debats.* Unmentioned was the dazzling procession of kings and princes at Queen Victoria's Golden Jubilee. Unnoted also was the recent partition of Africa by England and Germany, or the sentencing and hanging of the Chicago anarchists, or the frantic agitation in France to recover the lost provinces of Alsace and Lorraine. In the many-paged letters and the tightly compressed lines of the postcards, one encounters the single observation: "Things are by no means peaceful here."

In these first weeks in Paris, thrown so much on his own resources, he circled round and round in thought to discover the true essence of his being. Like Robert Christie in his story, he knew himself to be more cerebral than emotional, and he relished his intellectual detachment like a character in a Henry James novel. "I reflect this morning like a mirror," he mused in his diary. "Had I but a means of eternalizing the reflection, what a genius I should be! I am a magnificent sensorium, plus a kind of saving bank of sensation called an intellect. For instance, I heard this morning . . . of the death of Elizabeth [the Boston University classmate whom he had worshipped]. . . . For the first time in my life I felt a sense of loss. For an hour I was desolate. I seemed to be back with the great verities that I used to contemplate and hardly can recall today . . . and now I feel nothing more, heartless brute that I am." Only ten months before, Elizabeth had told him of the death of Cornelia, another classmate. "What a coincidence, I have lost the two friends who best knew me, who most loved me, who entered most into my life, and at a time when it was so serious, so ardent, so truth-seeking, so different from my present half-hearted existence, and with them all the glory of my youth is buried. . . . None are living now who knew me, the rare being I was four years ago, when I was so little self-conscious, when I so freely expressed my passions and yearnings. . . . When I was with [Elizabeth], when I wrote to her, I was the same sincere, ardent, live, godly youth that I ever was. . . . In Elizabeth's death I selfishly mourn the death of a great and better myself."

One day in Paris Berenson learned to his dismay that the question of his real identity was not only a psychological question but also a practical political one. He wrote posthaste to Senda that since "neither my name nor looks" are American it would be necessary to obtain an American passport to prove "what I am proud to be, an American." He commissioned her to send a copy of their father's naturalization in 1880 and a letter attesting to his identity, "to prove that I am I," as well as a letter from a prominent and well-to-do Bostonian vouching for their father's identity as a Boston resident. This was to be the first of Berenson's many irksome encounters with the red tape of American consular bureaus as the privilege of living abroad gradually came under closer scrutiny and restriction.

His friend George Carpenter was also in Paris in that summer of 1887, and the two tramped about the city together. Carpenter soon left to join Santayana, who had gone on to Berlin. Berenson plunged into buying cheap paperbound French books and fell back for a time into his old recluse mood, in which he desired nothing more than to read forever. Still, he worried about the fate of his writings. Before he left Boston he had sent off a story to the *Atlantic.* Hearing no word of it, he assumed, correctly, that it had been rejected. He therefore directed Senda to try *Scribner's,* then the *Century,* and as a last resort the *Overland Monthly,* but, as it turned out, all to no avail. He dispatched another story to *St. Nicholas,* hoping to earn a few "welcome" dollars. It too sank without a trace.

It soon became all too apparent that the $700 purse would not go very far if he indulged his passion for books, the theater, and the opera. After all, one dared not miss seeing Sarah Bernhardt or Coquelin. Paperback books were cheap but the score quickly mounted up and binding them cost seventy-five francs a month. Besides there were the occasional diplomatic gifts to be sent to friends back home and the indispensable French lessons, for which he had engaged to pay three francs for each of twenty-five sessions with his tutor. Thomas Perry, who had now arrived in Paris, was "kinder than you can imagine," he told Senda, but one really needed a thousand dollars to make both ends meet. Without further urging she somehow scraped together a hundred dollars for him. He deplored her sacrifice but felt obliged to keep the money.

He discovered that Charles A. Strong, another college mate, had also come to Paris, putting off for a season taking up his post in philosophy at Cornell. The two young men hit it off together. They talked for hours, philosophizing the night away. "You can hardly imagine what it

is," Bernhard exclaimed, "when two young men who are alive and absorbed in the study of what life is . . . when two such come together . . . without any reserve." At the Louvre he showed Strong his favorites, already feeling a sense of aesthetic proprietorship before the Botticellis and the Leonardos, the Fra Angelico fresco, the Venus de Milo, and the Victory of Samothrace. Already confident of his judgment, he scorned the "shameless mawkishness" of Guido Reni and the sentimentality of Murillo. To save his diminishing francs he crowded his commentaries in almost microscopic script on his weekly postcards to Senda and continually advised her on her studies. She must read the art books in his collection at home, especially the story of art and artists by Mary Erskine Clements. There was, he admonished her, "a good deal to learn that every cultivated woman should know." She must also study her French diligently and do fifty lines of Virgil or Ovid each week. As for his younger brother, Abe, it was important that he should go to the Museum of Fine Arts "once a week."

Within a month of his arrival in Paris Berenson moved to the quieter neighborhood of the rue de Vaugirard. Here he settled into a cozy sun-flooded room overlooking the Luxembourg Gardens and its museum. He fitted it up "beautifully" with his "books and things," carefully chosen draperies framing the windows, and charming, if inexpensive, bibelots spread about. Under the influence of the delightful and "subtle poison" of Paris, he felt himself becoming "a completely changed animal." As autumn deepened and the plane trees shed their leaves, he would look up from his ever-present book and lose his thoughts in the vista of open country suggested by the Gardens, or his gaze would travel to the open terrace nearby with its fairylike array of marble and bronze statuary. He continually marveled at the inflooding of pleasurable sensations, feeling himself a complete latter-day epicurean.

In this seedtime of art appreciation he saturated himself in the sight of the originals of the paintings whose photographic copies he had pored over so raptly in Boston. He haunted the galleries for days on end, developing the stamina, which would ever astonish companions, to stand before a single painting for part of an afternoon, absorbing every line and every brush stroke, training his eye to see and his memory to register with photographic precision. For the moment he scorned the taking of notes as interposing a veil between the object of art in its absolute reality and the receptive senses. The American acquaintances who came to the rue de Vaugirard admired his taste and sophistication and gladly accepted his guidance through the galleries of the Louvre. He urged his sister not to neglect cultivating these Boston and Cambridge luminaries

on their return. Senda, for her part, worried about his apparent dilet-
tantism and besought him to concentrate on his writing, for he had sent
her no manuscripts from Paris.

Those stories which he had left with her had not yet been placed.
However, an autobiographical essay on his early immersion in
Matthew Arnold's writings was published in the *Harvard Monthly* in
October by Mark DeWolfe Howe, who had succeeded him as editor-
in-chief. It kept his name alive back home, but since it brought no pay
he felt himself still an amateur. To make a profession of writing he
must write for pay. Frustrated by his lack of success, he began to
profess an aristocratic disdain for publication, as was then the fashion
among some of the Paris avant-garde. He lay awake at night, he said,
"concocting lots of things." Soon he would write again, but, of course,
"nothing for publication—during my lifetime, at any rate," he ex-
plained to Senda. "After that, perhaps, the English-speaking world will
be ready to listen." In this fashion he oscillated between his old dreams
of Titanism with the world admiringly at his feet and a state of rumi-
nating passivity when he loafed at his ease and interrogated the uni-
verse.

Perhaps his incessant letter writing then and later was a form of that
indolence, a paradoxical effort to keep his writer's hand in while avoid-
ing the necessity of writing for publication. His long-winded letters to
Mrs. Gardner delivered little lectures on the books he was reading and
urged her to read them also. In spite of their curiously patronizing tone,
she seemed willing to indulge his confessionals. Since he had come to
like her, as he told Senda, he could always write "a good deal to her."
His letters to her recorded the sinkings and soarings of his too easily ex-
cited feelings. There were weeks when he felt a "terrible solitude," and
then there followed weeks, especially during fine weather, when he was
as "happy as one can be away from Boston." In a self-critical mood he
wrote, "I feel I have no right to live but for what I shall write; and
whatever I may write it will always be about myself"; then in a fit of
revulsion he acknowledged that persons like himself "have been written
about to surfeit. Then why should I write, even if ever I can? Then why
should I live?" These moods and much more were the fruit of his recent
reading of Tolstoy's *Ma Confession.* When he read Sacher Masoch's
erotic *Venus in Furs,* he commented, "very romantic, very naturalistic,
very theoristic romances"; he is a writer who "vexes and delights me in
spite of his excessive morbidity and lubricity." One wonders what
Mrs. Gardner thought of that notorious shocker. Knowing her fluency
in French, he sent her a copy of *Bartok* by Sienkiewicz in its French ver-
sion to give her a sense of his Lithuanian childhood. On another oc-

casion, when he learned that a volume of Jules Lemaître which he sent interested her, he promptly followed it with Paul Bourget's *Mensonges*.

In another lengthy effusion he rhapsodized on the beauties of Paris, which he now professed to see with his soul in all its moods. Its theaters continually thrilled him, and Sarah Bernhardt's performance in Victorien Sardou's *La Tosca* inspired him to write a disquisition on the difference between ancient tragedy, which produces pleasure, and modern tragedy, "which was merely excruciating, being founded not on fatality but on accident so that the waste of life merely exasperates." Similarly, he asked, "Why, for example, did George Eliot need to drown Maggie Tulliver?" Then, widening the field, he put it, "Wasn't *Romeo and Juliet* unreadable for a similar reason?" The French were right in their version of *Hamlet* in sparing his life. So Bernhard went on giving free rein to his sensibility. He seemed to swim in a sea of impressions and passing enthusiasms. Recalling his study of the dreamy pictures of Puvis de Chavannes at the Salon, he declared that of all the living French artists "he is the only one to take hold of me." His paintings "are so simple, so sweet, so peaceful, so Greek without being 'Classic.' " In a second reading of Thoreau's *Walden,* he saw a likeness to Tolstoy's ethical outlook, though Thoreau is "too much the pedant." Thoreau's case was symptomatic: "American writers have all been amateurs—Emerson in philosophy, Longfellow in poetry, Hawthorne in romance, James in the novel." As for William Dean Howells, "He talks of people I care nothing about yet he is the nearest approach to a serious writer we have had."

Whether Mrs. Gardner ever troubled to challenge the heterodox opinions of her young instructor is unknown, for Berenson did not preserve her earliest letters to him, although she kept almost all of his. One thing is clear, she grew increasingly anxious to know what progress he was making as a writer, to know what he really was doing. In reply to one such inquiry, he confessed quite artlessly that he was "doing nothing apparently. Time escapes between my fingers. . . . I try to read a few hours every day. But my growth is not in that line. I have become so much more intelligent than I was six months ago. . . . I was ever so much more in earnest several years ago. I used to take life and art so much more passionately; but it was passionate play. . . . Indeed were I quite independent I hardly should look into books while in Europe. I could be so busy observing, looking at pictures, going to the theatre, and above all loafing miscellaneously." What weighed on his mind were the implicit conditions of the modest subsidy which had been raised for him, to which Mrs. Gardner was only one, if a chief one, of the contributors. He deplored the leash that limited his freedom

to follow his bent. "But as the good people who made it possible for me to come here expect me no doubt to return a paragon of all sorts of learning—sad will be their disappointment."

His sister's reproaches troubled him even more. He envied her her freedom, for she was loved, he pointed out, by persons who expected nothing of her. As for himself, he wrote, "I feel more and more the debt of expectation which I have allowed to accumulate to my account, and often the only way out seems bankruptcy, and to me not regretted were it not for my friends." What added most to his sense of inadequacy was that in the company of Thomas Sergeant Perry, his chief adviser abroad and the person who had rounded up the contributors to his "purse," he felt "unspeakably ignorant and narrow." His only consolation was the thought that Perry was twice his age.

The moments of depression, however, rarely lasted very long, for Paris quickly medicined his woes. He confided to Senda that it actually frightened him to be "so happy away from Boston," a fear that was destined ever to grow less. As if to signalize his liberated personality, he began to sign his postcards to her with the alliterative initials that later became his familiar appellation "B.B." and afterward was rendered "BiBi" by his Italian friends. In November he told her he was "enjoying every day now to the utmost." The autumn was not "gorgeous or passionate" as in New England, but "often sun-flooded" or "exquisite with mist." Now that the trees were almost bare, the view across the Luxembourg Gardens made a "wonderful picture unequalled in the city." The sunlight filled his room "from rising to setting." He was too busy loafing to write, "although my brain bubbles." His room was becoming "packed full of books." He squired visiting matrons and their daughters about the town, becoming "absorbingly fond" of one of them, a certain Maud Mosher, a friend of the young writer Clyde Fitch. A Miss Todd made a crayon sketch of him while he was reading. He enjoyed a grand Thanksgiving Day dinner at the Moshers, where they were "all in full dress." With the season in full swing, he attended the opera *Faust* one night and reported that "tomorrow" it would be Sarah Bernhardt, Monday the Odeon Theater, and Wednesday the Comédie Française. Young Edward Warren came over from Oxford for a breather, and the two art appreciators roamed the galleries.

One day in Notre Dame he bumped into Ralph Adams Cram, the brilliant young art critic for the Boston *Globe,* who was soon to begin a notable career as an architect and was now abroad to begin his quest of the Gothic spirit. His companion was the talented William Ordway Partridge, at twenty-six the oldest member of the trio and already well launched on his career as a sculptor. Recently married, he had stopped

off on his way to Rome to continue his training there. The two kept Berenson on the go for three days and nights, finally arousing in him the wish to run away to save himself from the deluge of friends and acquaintances. The meeting with Partridge was to prove providential, however, when a year later Berenson reached Rome. Soon Christmas Day was upon him, and though he missed the snow-covered vistas of New England, he passed the day pleasantly enough with the always hospitable Perrys.

As his sojourn in Paris neared the end of its sixth month, he realized that Parisian or not he must embark on the next projected stage of his study year abroad and go to London to present his letters of introduction. Also Warren, who had become very fond of him, was awaiting him at Oxford, having offered to share his table and his study with him. Leaving Paris was a more formidable chore than leaving Boston. The bag that had weighed down the youthful Irish porter at the dock in New York was now accompanied by a large trunk containing his treasured books, papers, and bibelots. Now that he was about to leave the Paris Bohemia of the Latin Quarter, he decided to have his curly hair cut short in the English fashion. At his pension a woman carefully studied the change and remarked that before he looked as if he were searching for something, "now, as if I had found it." He felt reassured.

AFTER a "miserable" Channel crossing to Newhaven from Dieppe, Berenson arrived in London on January 10, 1888. The pea-soup fog which hung thick in the air made his eyes smart "horribly." In the murky atmosphere, St. James's Palace and the Houses of Parliament loomed "like gigantic shadows." Once the fog cleared and he was settled in lodgings near Westminster Abbey, London seemed to him even more pleasantly quiet and provincial than his beloved Boston. The wonders of Paris paled before those of London. Westminster Abbey showed better proportions perpendicularly than Notre Dame. What really overwhelmed his impressionable eye were the paintings in the National Gallery, which, in the first flush of discovery, impressed him as finer even than those in the Louvre. It was a characteristic response. What filled the eye with delight at the present moment would often tend to thrust into second place equally intense delights of the past.

Perhaps the most important reason for stopping in London on his way to Oxford was the need to refurbish his wardrobe. Shopping made drastic inroads on his slender resources, and he felt "very blue" as the pound notes slipped away. A suitable dress suit, made to order as was the custom, came to eight pounds; a "day" suit, to five pounds; the indispensable well-furled umbrella to replace the one which "had been

repaired by so many girls" that it was beyond the pale of fashion came
to twenty-two shillings. The impressive new top hat cost a staggering
two pounds ten shillings. Senda had already offered to lend him
twenty-five pounds. He asked her to try for an additional twenty-five
pounds from one of their Boston friends, promising to repay the loan
somehow in a year. Within two weeks his devoted Boston allies had
filled the breach, but only temporarily, for he subsequently had to call
upon them again for small loans.

In the week in London he interrupted his exciting days in the galleries
long enough to lunch with the editor of the *Fortnightly Review* to pro-
pose an article on recent Jewish literature which he had sketched out but
had not yet put into presentable form. The editor did not offer him any
encouragement. As a result Bernhard resolved "to reform and begin to
write and not wait for inspiration." He would improve the article and
try elsewhere. He directed Senda to enlist one of their intellectual Jew-
ish friends "to write out for me, but in positive facts, all he knows
about Jewish novels and to copy out some fine passages from each of
those he speaks of. Perhaps you can help him."

He went up to Oxford on January 20, 1888, and made himself at
home in Warren's place at 31 Holywell Street, where a fire blazed cozily
in every room. Then he sallied forth in his "beautifully" fitting new
clothes to be introduced by Warren to the literary lights among the
students. He basked in their friendly interest, for his fame as editor-in-
chief of the *Harvard Monthly* had preceded him. To Senda he exclaimed,
"For beauty there can be nothing that equals Oxford and the friends I
make, and the men I merely look on. . . . How true my instinct was
five years ago, when I yearned to come here. . . . I may be getting less
and less fitted for living in the circumstances that Fortune made for me,
but I feel so strongly that every day I am more fitted to live. . . . Take
our best and imagine it more refined, more intellectual, saner, and you
have the English youth I meet." Warren, now twenty-eight to Bern-
hard's twenty-three, had, as Berenson wrote, taken him into the heart
of things at Oxford.

Warren had made a distinguished beginning at New College, but his
heart was in collecting rather than scholarship. He had interrupted his
studies some time earlier to go off to Greece in search of rare antiqui-
ties, returning with a notable terra cotta figurine. He too was a deter-
mined aesthete and was soon to give up Oxford to establish himself in a
spacious eighteenth-century house in the picturesque and historical
town of Lewes. The house was soon to become known as a "rarefied
and sumptuous retreat" for fellow bachelor scholars and noted for its
good food and fine wines. Here he was to live eccentrically by candle-

light, writing his letters with a goose-quill pen. His father's death later in 1888 made him wealthy so that he could busy himself in building up the great collections of Greek vases and engraved gems that he was to leave to the Museum of Fine Arts. Though he professed to hate Boston and its ways all his life, he felt duty-bound to improve them.

Berenson, eager to make every moment count, could soon boast to Senda that he went out with a new acquaintance every afternoon. One of the choicest spirits whom he acquired as a particular friend was Lionel Johnson, the talented poet who at twenty had already begun to walk through life, as was said by another of his friends, "aloof like some ascetic saint." He too felt himself to be a disciple of Walter Pater, and he viewed life, as he himself admitted, from the "heartless heights of epicureanism," much as Berenson had portrayed the type in "The Third Category." Johnson, a precocious young intellectual, had recently come up from Winchester. In his diminutive person, with his feet shod "in girlish shoes and blue silk stockings," as the two women poets known as Michael Field saw him, he epitomized the aestheticism that was then at its height at Oxford. Pater had welcomed him into his circle of devotees. At Winchester Johnson had known Lord Alfred Douglas and their acquaintanceship ripened into intimacy at Oxford. Eager to advance Douglas, Johnson had incautiously introduced him at this period to Oscar Wilde, an act that darkened Johnson's life when Wilde's homosexual liaison with Douglas erupted into public scandal.

Johnson had already passed through a Buddhist phase. At Oxford he came under the influence of an older student, Arthur Galton, a former Catholic priest who was now a modernist Anglican, passionately addicted to literature. Galton also took to Berenson. Bernhard told of taking Galton to lunch and Johnson to dinner, captivated by them as they were by him. When Berenson reluctantly departed from Oxford he carried with him a copy of Robert Bridges' *Prometheus the Firegiver* inscribed by Johnson "To Bernhard Berenson. March, 1888." Johnson was to go on to fame as a distinguished minor poet, only to die from a fall at thirty-five, a victim of the quest for more intense sensation, for "the madder music and stronger wine" of which his friend Ernest Dowson sang. Later that year Johnson recalled Bernhard's visit in a letter to Santayana, with whom he had earlier become acquainted. He wrote, "Berenson charmed Oxford for a term and vanished, leaving behind a memory of exotic epigrams and, so to speak, cynical music. . . . He is something too misanthropic but always adorable."

Much to Bernhard's regret, one bastion at Oxford refused to yield. His hero, Walter Pater of Brasenose College, whose writings he venerated as the scriptures of the life of culture, made himself unavailable.

In reply to Berenson's polite inquiry he wrote: "I would gladly admit you to my lectures were they of a public character, or, in the full sense, lectures at all. As a matter of fact they consist of informal instruction to the undergraduates of my college, and the course is now drawing to an end." In his old age Berenson recalled that when he did meet Pater somewhat later, the famed writer graciously remembered Berenson's inquiry.

As the idyllic weeks at Oxford sped by, the only thought that marred young Berenson's pleasure was the question of what he would make of himself when he returned to Boston at the end of his year abroad. He preferred to be "an intelligent tourist and nothing else," but Senda's persistent inquiries revived the nagging anxiety. "People who ask you what I am about, deserve no answer," he protested. "My ruin would be to narrow my horizon. . . . Two years more of such life as the last seven months will put me where I wish to be, and if I find I cannot have it the only honest, best thing will be to return and go to work for a while at home." He could report that he had just finished rewriting a story, one far removed in subject from the scenes of his present life. He suggested to her that in any event the two of them might join forces and perhaps live together for all of their lives. For that reason he urged her again to cultivate good society and strive like him for ideal culture.

He found it harder, however, to justify his existence to Mrs. Gardner. To her he wrote, "I feel at times I am going to pieces. . . . The sad thing is that I have not the least idea yet to take these pieces and reconstruct another self out of them. . . . I have cut with scholarship. I am as yet far from being a writer and further still am I from having the means or the spirit to be what on the whole I might best be, a man of the world, but you see that is not a profession and in America least of all." Various expedients suggested themselves. He was tempted to translate Baudelaire and asked her advice on whether an American publisher would be interested. He thought of visiting Russia but feared that that would mean prison for him, an allusion no doubt to his having escaped military conscription by emigrating to America. But, he added, he probably ought to spend the summer studying in Germany.

Much remained to be done in England, he told Mrs. Gardner. He must explore the cathedrals and castles in Warwick, Salisbury, Winchester, and Kenilworth. He needed also to revisit London. His letters of introduction gave him entrée to the London literary set, and he met, among others, William Morris and twenty-four-year-old Herbert Horne, "the great man of the next generation," as Berenson expressed it, "an architect, painter, poet, fine critic, and editor of the *Hobby Horse.*" Horne and he felt an immediate kinship of interest in Renais-

[62]

sance art that eventually led to Horne's joining Berenson's circle in Italy. One visit took him to the famous house on Tite Street that was the home of Oscar Wilde, who at the age of thirty-two was then at the height of his notoriety as an eccentric genius. The two aesthetes were immediately drawn to each other, Bernhard's beauty of person no doubt having its attraction, and there began a curiously unequal friendship which lasted until Wilde's sensational trial in 1895 and subsequent imprisonment in Reading Gaol. Young Berenson enjoyed, as he said, the "immortal Oscar's outrageous wit," but he prudently resisted Wilde's advances, an attitude which led Wilde to exclaim one day, as Bernhard recorded, that "I was completely without feeling, that I was made of stone."

It was probably more than a mere coincidence that led him to write in his notebook soon afterward with a certain naive wonderment that the world was right in "banning certain words. . . . It can stand nothing that will speak of Hermaphrodites, but what a subject! What can be more wonderful, more full of interest than a being who . . . can feel like a woman or like a man. What a revelation it would be to a man to feel even for an hour like a woman. The subject will not be tolerated. It is abnormal or worse." After the prudery and reticences of Boston, these first glimpses of the sexual ambiguities of the British literary Bohemia, these "slips of orthography," as Anatole France delicately put it, could not but rouse the censor in the moralistic young Berenson. Romantic idealist that he was, his admirations were vigorously heterosexual and for a long time quite monogamous. As the years went by, he achieved a sympathetic understanding of the passional anomalies of literary and social circles in England and their exquisite counterparts in Paris and Florence and at the same time became expert in detecting the epicene and fugal variations in his friends and acquaintances who belonged, as he used to say, to the "Brotherhood of Sodomites." In fact, long afterward the biographer of Count Robert de Montesquiou-Fezenac, the flamboyant "Prince of Aesthetes" whom Proust borrowed for his fiction, cited Berenson in defense of the Count's fundamental chastity: "In my long acquaintance with Montesquiou," Berenson told him, "I never noticed the side for which [Proust's] Charlus is famous, sodomy. And Lord knows that at the time, young as I was, I made homosexuals' mouths water."

Some dozen years after this first brush with the sexual deviations of Victorian society, he was asked by one of his high society friends in France to account for the puzzling, to her, phenomenon of homosexuality. His extraordinary reply shows how far the young Boston puritan had traveled in thought through the emotional landscape of the

Belle Epoque. It revealed as well the philosophy of ideal love which had come to govern his own life.

You ask me to write on a very delicate subject. Languages have their shynesses and reticences, and in English one almost blushes to mention certain subjects, and then can only stammer over them. So you must allow for much that I shall say.

All emotions whatever seem to be physical, that is to say a matter of sense. Insofar as we have a feeling towards a person as distinct from a mere scientific estimate, that feeling is necessarily a physical feeling. Training, habit, respect may keep that feeling—as they do towards parents and elders and sisters and brothers—from producing sexual stimulation. But where there are no such hindrances, the tendency of all feeling of warmth toward a person is to a sexual discharge. It is obvious that between the man and woman such a discharge is normal and desirable. If it does not take place, it is for social or hygienic-economic reasons—which reasons in the bulk we can call moral. But the same tendency holds between persons of the same sex. If it does not reach consummation, it is in the young because *ils ne savent pas comment s'y prendre,* and in older people either because of the artificial horror and disgust inspired by taboo, or because the sexual discharge is so complete elsewhere that the tendency dies in a mere ideation—as is the case with most men and a majority of women, thanks to their rich intersexual life.

It is pure superstition to talk of love between persons of the same sex as if it were unnatural from any physiological or physical standpoint. But not everything that is natural is reasonable and desirable. The reasonable and desirable are questions of social need and ideal. Now there are obvious reasons why society must encourage love between the sexes and condemn love in the same sex. And condemning it as society does, and we being social beings, if we act against the taboos of society, we feel, if not at fault, at least singularized, we tend to keep with those who have the same tastes, we grow mysterious, we lose our ease of frank intercourse with the run of mortals, and end by becoming a sort of unnatural abnormal being—in the sense that we are not striving to live in harmony with our social environment. We put ourselves out of the running from what seem to be the highest goods in the world, the successful striving for the completest social sympathy, and the strenuous effort to realize one's self mind and soul as well as body.

I therefore, with a delight in the beauty of the male that can seldom have been surpassed, and with an almost unfortunate attractiveness for other men, have not only never yielded to any temptations, but have deliberately not allowed temptations to come near me. And yet, how well I understand! I have spoken of the facts from the outside. Now let me speak from the inside. When one is young—and *only* when one is young—love possesses one completely. This early love is something so shy, so sacred, so awe-inspiring, that it lacks all conscious sexual concomitant. And when it gets to the pitch where union occurs, it is an infinite longing to become one with the beloved, to mingle with it

[64]

in every way, to leave no effort of interpenetration untried. Hence the extraordinary play of young lovers—a play which may be in actuality as monstrous as any *jeux de Venus* ever invented, and yet be not only free from lust, but as mystical and poetical as the ecstacies of a St. Theresa. Nor does it seem to me in the essence of things that this physical effort at mystical union, when inspired by as intense a love should not take place between people of the same sex. It is to be avoided, and severely avoided, for the social consequences. It is however not to be totally suppressed, but kept in tight rein. After all, it is a delightful thing to keep one's self in hand. I have enjoyed the effort not to possess, no less than the delight in possession. Think of the hundreds of women one has desired without love, and refrained from, even when one could have had them. Such suppressed desire immensely enriches life—and so it should, even when the desire is man for man or woman for woman. Only I protest that age, while it keeps all the possibilities of love for the other sex fresh and noble, acquires something stale and merely lustful when it is for the same sex. The *illusion* of a mystical union becomes too difficult for the middle-aged person when the object is of the same sex. And without such illusion love is mere lust—and for lust I have little but horror.

In that first visit to London in 1888 Bernhard stood on the threshold of the most fateful encounter of his life with a young woman. There lived at 44 Grosvenor Road a beautiful young matron, Mary Smith Costelloe, who had been born and reared in Germantown, Pennsylvania, of Quaker-bred parents. She had been a student at the Harvard "Annex" (the future Radcliffe College) when Bernhard was in his first year at Harvard and had in fact caught a glimpse of him at a Boston concert. He had been pointed out to her then as the most brilliant member of the sophomore class. She was now twenty-four, a year older than Bernhard, and since 1885 had been the wife of Benjamin Francis Conn Costelloe, an Irish Catholic barrister and politician in practice in London. Though already the mother of a baby girl, Mary had continued to be actively involved in her husband's reform politics and in the temperance and women's rights movements which were dear to her mother.

Bernhard and Mary had an intimate friend in common, Gertrude Burton, the young wife of Professor George Burton of Boston. In the preceding August Mrs. Burton, who had seen Bernhard in Paris, sent a letter to Mary which was well calculated to provoke intense interest in a young woman as impressionable as Mary Costelloe. The letter read as follows:

What does thee know of the aesthetic circle in London? Has thee met William Morris? And does thee know people who are earnestly devoting themselves to the cultivation of the beautiful? Does thee know anything of Walter Pater?

These thoughts bring me to my friend Bernhard Berenson of whom I am

sure I have spoken. He is now in Paris, having been presented with a five [*sic*] year private scholarship, as he graduated from Harvard this June. He has told me that he has seen Logan [Mary's brother]. They were in some class together and he even remembers observing thee the night of the Latin play. I am hoping that you may meet each other. He is to study art and literature in France, Spain and Italy. I believe that he is a genius—but I love him for his beautiful personality, and our friendship is as close as the friendship of two girls and seems to belong to another age it is so spontaneous, so lofty, and so tender.

Gertrude kept her posted on Bernhard's movements with the result that he received the following cordial invitation, dated February 28: "I have just heard from Mrs. Burton that you are in England now," Mary wrote, "and I cannot help hoping . . . that there will be some chance of my meeting you." She proposed a Thursday evening or, if he was not free then, dinner the following Sunday, March 4, or an evening dinner on a Thursday later in March. "Gertrude says you are apparently at Oxford. If you are, I am sure you must be enjoying it keenly. . . . I wonder if America will ever produce a place like it?" The note was signed Mary Whitall-Costelloe. Bernhard accepted the Sunday date. Well fortified by Mrs. Burton's recommendation, he appears to have duly presented himself to Mary and her husband, and if one may judge from her recollections, she was enormously impressed by the romantic-looking young man. One may only guess at the rush of reminiscences that may have enlivened that Sunday, since neither left an account of the occasion. For Mary, now removed by nearly three years from her student days, which had been filled with as much gaiety and romance as learning, Bernhard's visit must have sharpened her sense of the narrowing of life that accompanied wifely duty. Since he was committed to leave for Germany early in March, further visits lay hidden in the uncertain future. Mary, with her "lust for experiment" in her social relations, to adopt the characterization of her literary brother Logan Pearsall Smith, would therefore have to patiently bide her time. So began in this tentative way the intimacy that became, as Berenson once said in reviewing the distant past, "the determining factor in the rest of my life and career."

V I

Seedtime of Art

THE story which Berenson had so ambitiously dispatched to the *Atlantic* before sailing to France, one grown out of his vivid recollections of Jewish village life in Lithuania, was still unplaced when he got to Oxford, though it had made the rounds of a half-dozen editorial offices. He instructed his sister to make a final try to place the story commercially in *The American* and if that failed to give it to their friend H. G. Bruce, one of the contributing editors of the *Harvard Monthly*. It thus came to rest in the July 1888 issue of the *Monthly,* bearing the title "The Death and Burial of Israel Koppel." The story gave expression to the disquiet which must have haunted Berenson since he first began to shed his Jewish loyalties. Its somber theme embodied his deep and half-conscious anxiety about his own identity.

We are told that the young protagonist of the story had gone off to Vilna "to satisfy the yearning of his heart for that knowledge of the Gentile world which was beginning to sift into the Jewish communes of east-central Europe." In due time he returned to his native village shorn of the traditional earlocks and without the customary long black gabardine of the Hebrew scholar. He no longer moved with the shambling walk of the ghetto, but went proudly erect with the firm step of a Gentile and made friends with the Polish gentry. The Jews of the village were scandalized by his heathenish ways and came to believe that his transformation had caused the recent deaths of several infants by provoking God's anger. One day while reading a Gentile book, the youth fell apparently lifeless to the floor. Since the young man was an apostate, the burial brotherhood of the synagogue refused the customary free burial and insisted on a thousand-ruble fee. The burial took place. That night the father dreamt of being hideously pressed under a weight. The meaning of the dream soon dawned on him: his son had been

buried alive. The grave was opened and the father gazed upon the blood-stained and contorted body of his son. The Lord had avenged himself and the youth had expiated his sin. "An expiation for all of us," exclaimed the villagers.

The story of premature burial has its source not in the Gothic extravagances of Edgar Allan Poe but in the fearsome legends, familiar to pious Jews, of the mistakes that sometimes resulted from the Jewish requirement of burial within twenty-four hours. As a parable of the fate of an apostate Jew, the tale surely rose out of the night-time depths of Berenson's meditations on his own Faustian choice. In realistically portraying the superstitious and oppressively ritualized life of the Jewish microcosm, he seems to justify his own escape from it, but whatever the motivation of this strange tale, Berenson drew upon a rich vein of personal experience to render the authentic tone and color of *shtetl* life.

The mother's head is "cleanly shaven" as tradition requires and is covered by the traditional wig of the married woman. When she is unable to rouse her son, Israel, she rushes to the synagogue to find her husband, who is presiding over the Talmud study circle. Being a woman, she dares not invade their precinct and is obliged to shout above the noise of theological disputation. A doctor cannot be called because he would require the body to be kept the legal three days, in defiance of sacred law. A pious barber is persuaded to perform the necessary offices. The funeral procession forms, as the boy Berenson must often have seen it, the beadle walking ahead and crying out the traditional summons, "Come to escort the dead." The mourners pass the houses of the Polish gentry, who amuse themselves by "uttering blasphemies against the Jewish dead." The pious wailing stops as the mourners pass the Gentile churchyard with its menacing crosses. They spit as custom requires and mutter the ancient curse, the absit omen, "Despising shalt thou be despised and loathing shalt thou be loathed; for it is taboo, a dog are you." The corpse is removed from the coffin and laid on the earth at the bottom of the grave, a little sack of earth from the land of Israel beneath the head. Bits of pottery cover the eyes and a fork is placed in each fist to help the body rise when the Messiah comes, "with speed in our day," as the folk prayer beseeches. The father duly tears the lapel of his coat in sign of mourning and then throws four shovelfuls of earth into the grave and chants the "Aramaic hymn of exaltation of the Lord." His grief is overwhelming, for now he has no male child to pray for him when he dies: "Lord of the Universe, who will sing the hymn of exaltation at morning and evening to shorten my purgatory? Who will light the sacred candle [annually] for my soul?" And so the tale moves like a medieval morality to its

foregone conclusion, the village tragedy played out to its sad end with all the characters acting their roles as dictated by immemorial custom. Their dialogue follows custom also in its blend of the old Talmudic and folk sayings which tradition has provided for every ceremonial occasion.

The story also shows that Berenson had studied the Russian and French realists with careful attention; the details are rendered in a literal transcript from life, the style is objective, unornamented, impersonal, and the effect powerfully moving. It was a promising effort, but the unrelieved naturalism of the piece must have struck the successive editors in the commercial press as uncongenial to a readership that was largely feminine and more interested, as William Dean Howells was about to point out, in "the smiling aspects of life." As an admittedly avant-garde magazine—for its day—the *Harvard Monthly* could afford to please itself.

Senda, less easily discouraged than her brother, continued to prod him in the midst of his enjoyment of Oxford. "You almost break my heart," he retorted, "by urging me to write. I am going through a stage of almost ferocious hatred towards all things literary. . . . Yesterday I received a pile of Jewish books and merely to look them over made me sick to fainting. I made up my mind then and there to toy no more with things Jewish or Oriental. . . . If I had a boy to educate he should never learn Sanskrit, Hebrew, Assyrian, or any of those barbarous jargons. He should know the Classics and his English by heart." He pointed out that his new-found friend Lionel Johnson, a year younger than he, knew everything, including Latin and Greek, "by heart."

Having firmly made up his mind not to toy with things Jewish, Berenson characteristically recanted. The mood of revulsion passed and he impenitently took up again the abandoned article on Jewish fiction. Soon finished, it too went the rounds of the paying press and with no success. It came to rest at last in autumn 1888 in the pages of *The Andover Review,* the organ of the Andover Theological Seminary, under the title "Contemporary Jewish Fiction." His subject was, in effect, the remarkable outpouring of Yiddish literature in the Russian Pale of Settlement during the preceding few decades. As a Germanized Jew, he carefully referred to the folk language as a German-Jewish dialect. The assimilationist thesis which emerges and which perhaps was the original inspiration of the article is that this literature was designed to open the eyes of Jews to modern culture and that after having performed that function it would wither away: its writers would adopt the Russian language and their writings would become part of Russian literature.

Berenson could not bring himself, however, to press that thesis very

hard. Yiddish literature had yet much work to do. He took issue with
the notorious libels of Christian converts who tried to extenuate the
bloody pogroms of 1881 and who proposed compulsory assimilation
and the destruction of all Jewish communal organizations. Deep as his
own alienation was, Berenson could not share the animus of such anti-
Semitic commentators. His quarrel with them was that they did not un-
derstand Jewish psychology, the real character of this alien people, of
"them," as he disingenuously put it, as distinguished from "us." They
might indeed be incomprehensible, but what distinguished them as a
separate people was that their "interests and hopes were of the most
ideal nature," an idealism associated with their obsessive religiosity and
their "passionate longing for the Messiah." The revolt against rab-
binism which characterized Yiddish literature was in fact a renaissance,
a recovery of the dignity of a glorious past, rich with epic heroism. In
this it was unlike the Russian awakening, for the "Russian had nothing
behind him." In revolting against rabbinism, "the revolutionists had
only to cast off its absurd scholasticism to find themselves in the very
courts of Romanticism." The four million Jews of Central Europe
could thus be awakened to the grandeur of their common tradition, of
"their glorious and stirring past," and so learn to despise "their stupid
present."

In this struggle, he wrote, Abraham Mapu's Hebrew romance *Love
Tale of Zion* was a pioneer weapon for the revolutionary party. It was a
book, like *Paul and Virginia,* to be read before one was fifteen, for it
breathed "joy in living and blitheness of spirit." Had Mapu lived, he
might have achieved some of the "positive realism" of his successors,
among the greatest of whom was Perez Smolenskin, the spokesman for
his generation who sought the "preservation of Jewish nationality"
purified of the hateful corruptions of life in the Pale. It was not, how-
ever, until writers began to employ Yiddish, hitherto the language of
old wives' tales and pious commentaries, that modern realism could
take root. Berenson could not resist praising this German-Jewish dialect
that was spoken "in its most pleasing form in Lithuania, especially in
and about Vilna," his native province. Within the past ten years, he
declared, a flood of romances had appeared in this once disesteemed
dialect. This fiction was notable not for "psychological or physiological
realism" but for "realism that is truth to the details of life." Though he
had begun the article in a tone of deprecation, he concluded, almost in
spite of himself, on a note of high appreciation. The tasteless disguise of
"us" and "them" could have fooled none of his friends. He had, it is
true, crossed over to the other side and would remain an exile until the
rise of Hitler, but deep within him there would persist an inextin-

guishable sympathy for the world which he had renounced. The time would come in the distant future when he would turn against the corrupt values of contemporary Gentile life, reaffirming the humanistic idealism of the Haskalah enlightenment movement, whose moralism had mocked his every success in the great world to which he had forced entrance.

THOUGH his carefully laid plans called for a large dose of lectures and culture in Berlin, he did not now look forward to that phase of the Grand Tour with any relish, for he hated to leave England. It seemed like "sheer madness" to abandon so many delightful new friends, "including the immortal Oscar [Wilde]." Moreover, in the refined Oxford atmosphere he had become more of an Anglophile than ever, and his taste for things German had quite faded. There was, however, no turning back on his commitment. He reached Bruges in mid-March 1888, after a seasick crossing to Ostend. The Flemish "jargon" grated on his ears. The town seemed "the beastliest on earth" and the people hateful for being so German, but he did get to view some fine Memlings, and when he hurried on to Ghent he worshipped before the tremendous Van Eycks which he had known in reproductions since boyhood. If Germany was a specter on the horizon, he could at least comfort himself with the thought of what lay beyond. "One may bear even Germany when it takes one at last to Venice, Florence, and Rome."

Brussels seemed to him a little Paris. The French sounded like familiar music in his ears. He was disappointed, however, as he roamed from room to room in the museum to find only a few very good pictures among the innumerable poor ones. He went on to Antwerp for a day and then to Dordrecht to join a Dutch friend whom he had met at Oxford. The family entertained him "royally" in Amsterdam, took him sightseeing to the noisome and overcrowded Jewish ghetto, which struck him as the "most disgusting sight in my life," and wined and dined him in all "the great restaurants." He looked at Dutch paintings to agreeable surfeit. Always at the back of his thoughts, however, was the uncomfortable reflection that all this luxury and culture would have to be relinquished on his return to Boston. By the second of April, after a quick run to Hanover and to Hildesheim to see the churches, he was settled in Berlin, lodgings having been found for him by his friend George Carpenter, who was in Berlin on a Rogers Fellowship which he shared with Edmund Snyder. Like Berenson, Carpenter was homesick for Paris, which he had visited first; he deplored Berlin as "thoroughly provincial and countrified." The place he found for Berenson was on the Charlottenstrasse in the center of the city, close to the university,

the state opera house, and the chief art museum. Impressive as the situation was, Berenson found it "hard to bear after beautiful gay Holland," as he confided to Mrs. Gardner. "And to speak German, what can be worse!" Gone at last was his boyhood reverence for all things German.

In his letters to her in Seville, where she was then traveling, he gave detailed accounts of the paintings he had seen en route and reviewed for her the succession of books he had read: Stendhal's *Chartreuse de Parme* proved its author to be "the founder of the modern realistic novel"; Zola's *La Terre* belonged "among the very greatest of novels"; Ibsen's new play about Julian the Apostate deserved censure for depreciating an admirable person, though Berenson, eager to display his erudition, conceded that Julian was "a vain pedant." In one letter he included a translation of one of Baudelaire's sketches. He told her also that he had again reread *Aucassin et Nicolette* in Old French and "almost fainted out of sheer delight," and he transcribed one of the songs for her, glossing some of the words "which," he explained with a fine condescension, "may be strange to you." For the time being all this miscellaneous instruction seems to have pleased—or at least diverted—his correspondent.

His letters to Senda and to Mrs. Gardner began to show that his tourist's interest in pictures was giving way to a more scholarly and professional attitude and that he was working toward a critical vocabulary. For example, he explained that the Dutch and Spanish painters were inferior to the Venetians because the Venetians were "the freest from all affectation, the most sensuous, the most beautiful. They give one no ideas and almost direct sensation." It was true that "one may love Botticelli a thousand times more than the Venetians but the pleasure one gets from Botticelli is really an exquisite high-strung pain." He carried with him Jacob Burckhardt's *Cicerone,* the indispensable *vade mecum* of students of Italian painting, which had been recently translated and corrected by J. A. Crowe, the English collaborator of Giovanni Cavalcaselle. Burckhardt's dictum that Venetian painting "gives the greatest pleasure to the eye" confirmed Berenson's own rapturous discovery.

One feature of *Cicerone* must have made a deep impression on Berenson, challenging all his scholarly and scientific predilections. Again and again Burckhardt warned the reader of a mistaken ascription of one inferior painting after another to a great master. Even more unsettling must have been Giovanni Morelli's small book on Italian works of art in the Berlin, Dresden, and Munich galleries, which Berenson promptly acquired. Morelli's book, first published in German in 1880

and translated into English in 1883, had provoked a great outcry in German art circles, overturning as it had long-respected attributions by its application of Morelli's "experimental" method. The method was destined to revolutionize the profession of connoisseurship within a few years through disciples like Jean Paul Richter and Gustavo Frizzoni.

Museum directors had already accepted many of Morelli's attributions. In the Dresden gallery alone forty-six changes out of the fifty-six proposed by Morelli were adopted. He had performed a similar service in his survey of the Borghese collection in Rome. Although Morelli's work, published under the pseudonym of Ivan Lermolieff, was widely known in Europe at this period, it appears not to have been discussed in America. Two of his volumes were acquired by the Harvard Library in the early eighties, but there is nothing to indicate that they ever attracted the attention of Professor Norton, whose interests were of a more subjective nature. To the student patiently checking the labels on the paintings against the attributions in his guidebooks, accurate identification of the artist was crucial for studying the achievement of a particular painter and his relation to his teachers and to his followers.

EDUCATION went on apace in Berlin. Bernhard had obtained in advance a schedule of the lectures offered at the university and had anticipated hearing "a good deal on psychology, on Dante, on Provençal." Professor Toy's influence had clearly waned, for one reads nothing further about Arabic studies. He matriculated at the university in mid-April but discovered that the Prussian professors, as was their custom, were in no hurry to begin, unlike their counterparts at Harvard, and when they did they rattled off their lectures with such speed that in spite of his facility in German he could only stare in admiration at the incomprehensible feat. The old professors were interesting exhibits "but not very profitable." What was profitable now lay outside the lecture halls.

He saw a great deal of George Santayana and his faithful friend George Carpenter, both of whom were on official fellowships. Charles Loeser was also in town, making a welcome fourth for dinners and long evenings of philosophical talk. There were frequent expeditions to the theater and the opera. *Faust, Das Rheingold,* and *Der Freischütz* sent Berenson into ecstasies, Wagner's music spoke to him of the rebellious religion of "Prometheus rather than Zeus, perhaps with Satan rather than with Jevovah." The sweeping sonorities inspired in him "a sense of the tragedy of existence" and a feeling of "triumphant despair."

He struck up acquaintances with the undersecretaries at the British Embassy, charmed by their elegance. His Prussian acquaintances were also agreeable. He frequented the art museums almost every day, got

"on jolly terms with the porters and guards," and affably traded anec-
dotes with them. Instead of the boredom he had feared in Berlin, life
seemed a cornucopia of pleasures to eye and ear, and he somehow
thrived on the mounds of sausages consumed to the thunder of the
thumping steins in the student beerhalls. Insulated from politics, like his
fellow Americans he paid little attention to the death of Emperor Wil-
liam I and the accession of his fatally ill successor Frederick III. They
did, however, become aware of the universal admiration for the mili-
tary, the product of Bismarck's cynical playing on the theme that
France hoped to revenge 1870. Wagner's grandiose music dramas peo-
pled with heroic tenors precisely fitted the new mood of chauvinism, a
mood that Berenson recalled with rueful recognition in the closing days
of World War II.

As has been noted, not all of Berenson's kinfolk had emigrated to
America. In Berlin he visited with his prosperous cousins, the Freed-
mans, and enjoyed their open-handed hospitality, though as he told
Senda, he found it odd to come in contact "with people who still take
Judaism seriously." When he escorted one of his pretty cousins to the
art gallery, he was amused at her astonishment "that almost all the pic-
tures are about the Virgin." " 'That is why they are so beautiful,' I told
her." One Friday evening he visited the great synagogue, where the
singing of the cantor and the choir seemed "beautiful beyond descrip-
tion," but his hackles rose at the sight of the men swaying to and fro in
the traditional fashion while they raised their voices in clamorous and
discordant prayer. Irked by the noise and the lack of decorum, he
sneered that they were undoubtedly "selling old clothes" to each other,
a gibe that he could not resist including in a letter to Mrs. Gardner.

Still hopeful of becoming a writer, he sent off another story to Senda
aimed at *Lippincott's* magazine; he thoughtfully mailed a copy to Mrs.
Gardner, who professed to like it. When it was rejected, he expressed
the fear that he would "die without ever having anything published."
In moments of self-pity he complained that he had "hold of nothing
and that no one cares a whit for me in myself," except, he added
disarmingly, Mrs. Gardner herself. However, early in June he mailed a
revised last chapter to Senda from Dresden, instructing her to send the
tale to *Harper's* and then in succession to *The Cosmopolitan, The Over-
land Monthly, The American,* the *Epoch,* "in short to anything that will
pay me $25, for it's worth that."

The fact was that he desperately wanted money to collect photo-
graphs of his favorite pictures in the Dresden museum. "It would take
$100 and I hardly have 100 cents." He would need another loan, he told
Senda, if a friend of theirs could scrape together $50. Thanks to Car-

penter, with whom he was now traveling, he was able to keep up his theater- and opera-going. He heard the entire *Ring of the Nibelungen* again, which made him feel that he "had never realized before man's capacity for expression." He sent off to Senda for safekeeping his Dresden catalogue with his detailed annotations and fifty photographs, and he advised her to read Vasari's *Lives of the Painters* and other books on art so that she might share his enthusiasms. From this modest beginning he was to accumulate one of Europe's greatest collections of photographs of Renaissance art. "Photographs, photographs, photographs," became his watchword. "In our work we never can have enough of them."

The scholarly Dresden catalogue which he sent to Senda had just been published. It gave the provenance of each painting and the successive attributions, noting again and again that the painting was first correctly identified by Morelli, "one of the most acute and systematic of living experts." For Berenson these notes were a veritable education in the uncertainties and complexities of current connoisseurship. Morelli challenged the attributions of even such leading authorities as Crowe and Cavalcaselle, whose seven volumes Morelli acknowledged were the "foundation of all study of Italian painting in England, Germany and France."

Berenson received a significant reminder in Dresden of his meeting with Mrs. Costelloe, to which he referred in an oblique fashion in a letter to Mrs. Gardner. Writing from Vienna on July fourth, he mentioned that one of the friends he had met in England had sent him a copy of the new edition of Pater's *Renaissance,* the edition from which Pater had prudently excluded the hedonistic and incendiary "Conclusion" so as not to "mislead," as he said, "some of those young men into whose hands it might fall." Berenson assured Mrs. Gardner, "In the first edition I knew this book almost by heart." Now he felt sufficiently competent to be critical of the essay on Giorgione, having just steeped himself in the galleries in the works of the Venetian school. He also ventured to call Pater's style "bad," declaring that his true greatness lay in "his epithets, in their accuracy and rarity." Written on the flyleaf of the book in Mrs. Costelloe's distinctive handwriting was the inscription: "Mary Smith Costelloe, Dresden, June, '88."

From Dresden Carpenter and Berenson traveled to Vienna, "with Jews and other indecencies," as he apparently felt obliged to emphasize for Mrs. Gardner's benefit, and he found awaiting him a letter from his sister critical of his revised story. He disagreed with her strictures; perhaps "it was too light and fine for America." Off it went nevertheless to *Harper's,* where it fell into the editorial void and disappeared, leaving no trace of either title or subject. The repeated setbacks to his

literary ambitions brought their seasons of discouragement, but these always gave way to surges of self-confidence in other directions, as when shortly afterward he assured his sister: "I am beginning to feel like a man who glories in the use of strong limbs. My style leaves much to be desired yet. All my life I shall yearn for a better one than I shall ever get. But I feel so sure of my relation towards each book that I read, towards each picture that I see, each person that I contemplate critically, I grasp them all so firmly . . . that I have unbounded pleasure in using my powers. . . . I feel an exuberant confidence that when the moment comes to strike, I will."

For all his optimism, his prospects continued to be highly uncertain. Carpenter received notice from Harvard that his fellowship would not be renewed. That knocked in the head a plan they had entertained to settle down in Florence for the winter. They would have to hasten their harvest of art in the few months remaining to them. July found them in Vienna, where the daily gallery-going continued with unslackened zeal. Carpenter, who had distinctly American reservations about the supreme value of European culture, soon wearied of their slow pace before the countless Madonnas and Saint Sebastians, and their progress became a friendly tug of war.

It is noteworthy that one of the first essays that Carpenter had contributed to the *Harvard Monthly* had warned against the Oxford ideal that turned a boy's "face eastward" and made Harvard the university "least American in tone and influence." He had good reason to feel that Bernhard had succumbed to Oxford and its European hinterland. Bernhard persevered and the restless Carpenter heroically endured. Bernhard confided to Mrs. Gardner that in Dresden the paintings had moved him like "Wagner's orchestral storms," whereas those in Vienna, badly lighted and too often obscured by the presence of copyists, did not even add to his knowledge. To the long-suffering Carpenter the impression was to linger on that there was something pretentious, if not actually spurious, about his friend's obsessive absorption in art. In Vienna, Bernhard encountered some Boston acquaintances among the flood of tourists, and they told him he looked thinner and taller by a few inches. But they were most startled to see him shorn of his beautiful wavy locks, which had made his appearance so distinctive back home. Here he continued to send to Mrs. Gardner detailed critiques of many of the paintings he studied. He told her he would like very much to be her guide in person, though he admitted he might wear her out with his compulsion to "expatiate" in the presence of a notable painting. At the same time he tried to reassure her of his intention to become a novelist.

His recent reading of the *Journal* of the Goncourt brothers pointed out to him, he said, the strenuous apprenticeship he must undergo.

Berenson had cause for worry about the future because shortly afterward in Munich he had a sobering interview with his literary mentor, Thomas Sergeant Perry. He was obliged to agree with Perry that since no more money could be expected from his Boston sponsors it would be best for him to return home. His disappointment was great, for he had counted on a renewal of the subsidy. Nevertheless, he had no regrets, he insisted to Senda. "It is all for the best. Novel writing is a profession, and like others must be learned. . . . I had better begin at once." Meanwhile, he told her, he would make the most of Munich, "its pictures and its delicious beer." In addition, the Wagnerian operas were there to be enjoyed. For a third time he experienced the entire *Ring of the Nibelungen,* and he exulted that the songs of the Rhine maidens and the fire music drove him mad with pleasure.

With their joint funds running low, Carpenter and Berenson decided at Bayreuth, to which their wanderings had led them, that they could afford to attend only the performance of *Parsifal,* for the tickets were five dollars apiece. Besides they had not only heard the *Ring* twice in that city, but they had also attended performances of *Lohengrin* and *Der Meistersinger.* All Boston seemed to have converged that summer on the Wagnerian shrine, which was tended with rigorous piety by the Master's widow, Frau Cosima Wagner. Strikingly prominent as always among her sedate fellow Bostonians was the peripatetic Mrs. Gardner, who had come up from Spain impressive as "a locomotive with Pullman car attached," as Henry James once described her. Berenson lunched with her and the Shattucks, who were members of one of the oldest Boston dynasties. At the opera, he later wrote to Senda, the first rows were peppered with Bostonians, including, besides Mrs. Gardner, the Thomas Sergeant Perrys, young Barrett Wendell and his wife, Samuel Longfellow, brother of the poet, Professor George H. Palmer, and many others whose faces were familiar. There were so many acquaintances present that, as Berenson said, he could only "give a nibble to each." As for *Parsifal* it naturally was "great," though spoiled by the interminably long intermissions.

There remained nothing to do but to head back to Paris with Carpenter after a brief stopover in Cologne. Berenson was soon reestablished in his old room overlooking the Luxembourg Gardens. To his joy his Paris friends had not forgotten him, though in his English attire he no longer looked the poetic Bohemian. He roamed about Paris with Clyde Fitch, a vivid and intense young aesthete and devotee of Pater, who was

just beginning his career as a playwright. They shopped for books together on the quays. One day they sailed on a *bateau mouche* up to Bas Meudon to dine at a riverside cabaret. But their lean purses allowed only an omelet soufflé, decorative enough to impress fellow diners but not very filling. A strolling guitarist and a glorious sunset fed their souls, however, as did the return down the Seine by moonlight. Mrs. Mosher and her lovely daughters, Maud and Grace, were again in Paris, and at their apartment in the rue Washington Fitch read his one-act play *Frederick Lemaître* with such passionate intensity that a marquise on the floor below asked the American ladies and gentlemen to "make a little less noise." Berenson also heard him read his poems and stories on the balcony of his apartment in the company of the singer Sibyl Sanderson and the composer Massenet.

Early in August 1888 Berenson learned that his parents were at last planning to move from Minot Street. Since there was now a strong chance of his "being home very soon," he hoped that his mother would find a house "at least no less respectable than the one in which we have been living." A few days later he had exciting news for Senda. He had made one more effort on which he "had scarcely counted at all," an appeal for help to his friend Edward Warren at Oxford. A letter of credit had just come from Warren for $800. Warren's father had recently died and had left him a handsome legacy of $20,000 a year. Warren could now afford not only to be generous but to launch his own career as a notable patron of the arts. Assuming that he could count on $100 from another friend and that he would "be able to borrow or scrape together three hundred dollars more," Bernhard would have $1,200, enough, he explained, to carry out his plans to see Spain "and to get to know Italy thoroughly." This news was a blow to Senda, who had counted on him to be a companionable ally in the strained household, but she loyally fell in with his calculations. He apparently did not pass on to her the news that Warren even thought of continuing the subsidy for an additional three years.

Once more chance had come to Berenson's rescue and given still another turn to his life. It was not the first nor yet the last time that that fickle agent would favor his affairs. As an old man he would sometimes amuse himself by recalling these fortunate interventions which changed his life. His plans now took on an even grander sweep. He would travel through France and Switzerland as well as Italy and make a tour of Sicily and revisit England. He assured Senda, however, that he would be home by September of 1889. "To stay longer would not be wise, even if I had the means. While travelling I am too busy to write and writing is an art soon forgotten." He acknowledged that he had been

reconciled to, even happy at, the thought of returning home, but it would have been with the feeling that his aim in going abroad had been "quite missed," the aim of becoming a truly cultured man of the world. He could now resume that high quest.

VII

Beyond the Alps

IT was a happy pilgrim who packed his books and papers once more and set out full of anticipation for Geneva and the fabled art cities of Italy that lay beyond the Alps. Clyde Fitch accompanied him from Paris to Geneva and then left for England and America, his place as companion being providentially taken by a certain young Mr. Oppenheim. Bernhard's letters to Senda grew longer and more ecstatic as he elaborated on his plans for further study and travel in Europe. There were Holbeins to see in Basel; mountains to be climbed for a distant view of Mont Blanc and the breath-taking sweep of Alpine summits. A stop at Lake Zurich inspired more rhapsodies; but the most thrilling moment came when late in summer the diligence crossed the Simplon Pass and Berenson looked down upon the Italian landscape for the first time. Everything seemed better on the Italian side of the Alps, the stars clearer, the skies bluer. Lake Maggiore and Lake Como sparkled with a lovelier light than the lakes of Switzerland. The Italian cathedral at Como surpassed any Gothic edifice. The first few days were "dream" days. His delight in the Italian Arcadia gathered in its embrace the legacy of affection bequeathed by writers from every northern land: Hawthorne and James, Stendhal, Goethe, Byron, Browning, and scores of others. One heard the music of Byron's *Childe Harold* on the inner ear and the rugged lyrics of Browning. It was ground hallowed by Théophile Gautier and more recently by John Addington Symonds, whose monumental *Renaissance in Italy* and *Italian Byways* Berenson urged upon his sister.

Guidebook in hand, he trudged down the dusty lanes of the villages of Lombardy and Venetia from one out-of-the-way church to another and in the cities from one gallery to another, freshly armed to challenge every erroneous description, every careless attribution of a painting or

an altarpiece. In Milan he made the first of what would be countless visits to the Brera museum, rich in paintings of the Lombard and Venetian schools. At the Ambrosiana he pored over the treasures of prints, drawings, and paintings of the Borromeo collection and the works of Leonardo da Vinci. He lingered appreciatively before the famous *Portrait of a Lady,* delicate of profile and serene in her red cap. The *Cicerone* called it Leonardo's "single genuine finished picture." Only later, however, would Berenson learn from Morelli that it was in fact the work of Leonardo's follower Ambrogio de Predis. Already one catches the beginning of Morelli's influence in Berenson's noting the eloquence of such small details as the hands in Leonardo's *Last Supper,* hands which "said so much" and formed such "beautiful lines." But sensuous appreciation remained the dominant note. Some pictures, he reported, affected him like odorous flowers. A "St. Catherine" had "a strange perfume, not at all sweet but one that you cannot help inhaling." Wherever he looked he experienced a shock of recognition. What was theoretic before suddenly took on flesh and sprang to life, so much so that the Italian of Dante, which he had stumbled over in Norton's classes, seemed to come effortlessly to his lips.

He parted from his companion, whose duller sensibilities had begun to weigh on him, and made his way by a meandering route to Venice, stopping first at the famous Charterhouse of Pavia, a masterpiece of Renaissance architecture. At Parma he gorged himself on Correggios, spending hours, he declared, before the figure of the Magdalen in the painting of the Madonna and Child, "a dream of color, and so tender, so heartbroken." From Bologna he descanted on the imposing edifices that ringed the great piazza and the profusion of paintings of the Bolognese school. He pushed on to Mantua to view its gorgeously decorated palaces; then struck north to Brescia where the paintings in a dozen churches clamored for attention. At Vicenza, the birthplace of Palladio, the very streets seemed museums of Palladian architecture, lined as they were with exquisite palaces and churches, and beyond the walls he caught enchanting vistas of the countryside.

He reached Venice about a fortnight after quitting Milan. He had made a formidable reconnaissance of the north Italian art cities, locales which he would explore innumerable times thereafter in search of every discoverable work of their Renaissance masters. Venice was the first of his main objectives, and though he had saturated himself in books and guides to the treasures of the city that floated dreamlike among its lagoons, he was nevertheless overwhelmed by the splendor of the structures that rose miraculously out of the foul-smelling waters and shimmered like mother-of-pearl in the sunset. But it was the Venetian

painters who sent him into his most lyrical transports—Bellini, Giorgione, Titian, and Tintoretto. The color and drama of the great paintings so engrossed him that the two weeks he had set aside for Venice lengthened into four. He tore himself away at last, sure that Venice would haunt him "for ever and ever."

He resumed his role of passionate sightseer, interrupting his reportage only once to inquire plaintively of his sister what had become of the manuscript of still another story, "The Princess That Did Not Exist," which he thought was the cleverest he had ever written. That inquiry is the last one learns of it. He deluged her postcards covered with microscopic penmanship, often nearly forty lines of fervid descriptions of scenery, art, and architecture, and with little essays on painters, all reflecting his tireless enjoyment. He paused for a few days at Padua, where at the Museo Civico in the shadow of the many-domed basilica of St. Anthony he lingered over the lesser masters of the North. Across town he had his first sight of the overwhelming array of Giotto frescoes which covered the walls of the Arena Chapel. Bypassing Florence, he continued down the eastern flank of the Apennines to the walled city of Urbino, the birthplace of Raphael and the site of the colossal ducal palace of Federigo da Montefeltro, the polished walls of which rose like a precipice above the valley. Within the great Renaissance palace were rooms hung with paintings which solicited his zealous attention. From Urbino he now advanced by longer stages south through the Marches, Umbria, and the Campagna, his destination Brindisi on the east coast of the heel of Italy, where he could take ship to Corfu and Greece. En route southward, however, he swung down to Naples, where in the National Museum the world of Greek sculpture opened for him on a scale dwarfing what he had viewed at the British Museum and the Louvre. Here all that he had studied before of the art of Phidias and his followers in the plaster casts in the Museum of Fine Arts was embodied in the eloquent stillness of the original marble.

He reached Athens early in November 1888, eager to pick up the letters being held for him at the banking office from the many correspondents whom he had cultivated. For the most part his sightseeing in Greece was a far too hurried reconnaissance of the main archeological sites, whose ruins were being exhumed by battalions of foreign scholars. During one of his "many and comfortless wanderings" he crossed to the Peloponnesus at Corinth to see the immense temple ruins far to the westward at Olympia that the German expeditions had uncovered only a few years earlier. What made the greatest impression on him was "the severity and simplicity" of the deforested landscape, as barren of trees as the ruins were of the sculptures which had once

graced the palaces and temples. Everywhere he turned, remembered lines of the ancient poets jostled with the visual impressions. And one memorable day the veil between the past and the present vanished when in the ruins of an antique theater he attended a performance of *Antigone* and listened raptly to the sounding strophes of the Greek of Sophocles.

He was impatient to get to Sicily to study the transit of civilizations on that Mediterranean crossroads. Sicily was "the subject," he observed to Mrs. Gardner, "of all kinds of influences that interest me," especially of the Arabic and Norman influences of a later time. He picked up another companion in Greece, a young Oxonian who was soon to become a Welsh curate, Arthur West, and sailed with him from Piraeus to Messina, a city which still retained much of its medieval character as well as tantalizing vestiges of the successive civilizations which had been imposed upon it. The array of palaces on the Corso facing the harbor of Messina made a breath-taking show. Berenson hunted out the celebrated mosaics in the Norman cathedral and learned by heart the Antonellos and Caravaggios in the art museum.

He pressed on with West to Taormina, a picturesque jewel of a town perched on the steep ridges above the sea, its Norman-Gothic edifices long a magnet for artists. Most memorable of all was the Greco-Roman theater of rose-red stone, where in the uppermost tier, like Goethe before him, he looked out "through the ruins of the Roman proscenium at Etna and the blue Sicilian sea" below, with its "shapely promontories and crescent beaches." Goethe reminded him "that never any audience, in any theatre, have had before it such a spectacle." In the evening the sky above distant Etna shone with a lurid glow. "How foolish," he exclaimed, "to do anything if one could live there forever" amid such peace and beauty. But folly was perforce the wisdom of the two romantic voyagers, and they pressed on to Syracuse, whose great harbor had been the prize of ancient wars. They trudged from one ancient site to another ten hours a day, taking in the layered vestiges of a half-dozen cultures. At the fountain of Arethusa, the most famous of ancient springs, removed by only a few yards from the salt water of the harbor, Berenson and his companion "went wild over the graceful droop of the little forest of tufted papyrus stalks among which swam the sacred mullet."

They proceeded westward along the coast to Girgenti (Agrigento) for a few days' stay in the town whose terraced streets clung perilously to the high hilltop overlooking the vestiges of the ancient Greek city. The colonnaded temples loomed in the distance in dreamlike perfection against the eastern horizon. It was a setting in which the historic imagi-

nation took wing as Berenson looked out upon the vales and ridges where the battles of the successive Punic Wars had in the course of more than a hundred years reduced the great city to an unimportant settlement. Here among the massive ranks of columns open to the sky he read again the lesson of the fragile nature of civilization and the mutability of a culture, a lesson that made him cherish all the more the art and architecture that had survived the outrage of time and circumstance.

The coastal railway brought the two tourists at last to Palermo, whose artistic treasures demanded, as Berenson told Mrs. Gardner, that their praises be sung "in Arabic, for no other language has a vocabulary rich and varied enough." When they mounted to the cathedral of Monreale, they were overcome, as all tourists are, by the mosaics which fill the immense interior with color. In their delicacy and complexity they seemed to Berenson immensely superior to the mosaics of St. Mark's at Venice. It was the semitropical setting, however, that inspired his lushest prose as he tried again and again to render the color and atmosphere of a scene: "What evenings we had strolling along the Marina under the full moon which flooded the plain with its greenish light, made the mountains stand out as clean-cut as cameos and the sea yearn towards it. Then the air was full of delicious fragrance of which the orange and the lemon . . . formed only a part." In nearby Cefalu, east of Palermo on the coastal road, he and West visited the Norman cathedral, whose mosaics were reputedly the oldest and most perfect in Sicily. Pleasurable impressions had crowded upon him unceasingly since Messina, but no hint of fatigue or satiety ever crept into his letters. His was a sensorium that seemed ever to renew itself, and he sedulously cultivated it to respond to every aesthetic stimulus. When it came time to leave Sicily, he once more thought that his heart would break.

It was late November when he reached Naples again, a strenuous month since he had set sail from Brindisi. He settled down to two weeks of intensive study of the enormous collections at the National Museum, of which he had had an overview a month earlier. Perhaps most exciting of all on closer study were the scores of mural paintings recovered from Pompeii and Herculaneum. Again he felt that he was only reconnoitering territory that he must one day conquer. At Rome he parted from West and belatedly took stock of his situation. The outlook was not encouraging. Travel and photographs had turned out to be far more expensive than he had anticipated. Returning from a short visit to Naples to say "goodbye to the museums," he reported to Senda, "It is almost Christmas, my money is getting down to its dregs.

I may be home very soon." He found Rome "incredibly crowded" and though he climbed "thousands of stairs" he could find no satisfactory lodging. Once again chance came to his rescue. William Partridge, the sculptor he had met in Paris, offered to lodge him in his studio apartment for a trifling sum. His spirits again rebounded. Partridge fixed up a large south room for him, and he was made to feel at home. From the terrace of the apartment, on the Pincian hill above the Spanish Steps, he rejoiced in a superb view of Rome.

He dutifully visited St. Peter's Cathedral, but like Ruskin and Norton before him, he thought it pretentious and overornate. The paintings in the Vatican were quite another matter. "Now for the first time," he wrote to Senda, "do I understand why Raphael is the prince of painters and lord of the beautiful." He had felt faint in the presence of the *Parnassus* and the *Disputation,* a sure sign for him of supreme art. At the Capitoline museum he gave his unqualified approval only to the *Venus* and the *Dying Gladiator*. Everywhere he satisfied his appetite for seeing, and embraced the world of art in a great inflowing of color and form. In his letters he hurried off impetuous judgments which would inevitably be tempered and altered after the subsidence of his first raptures.

Even though living was cheap in Rome, he had to hoard his diminishing little fund, careful of each lira. He grew thinner and even more faunlike as his gray-green eyes roved obsessively from painting to painting. In the short daylight hours of winter, he would lunch economically on hot chestnuts at the ubiquitous charcoal stands, appreciating them not only "for the nourishment they brought but because they also warmed [his] hands," a comfort much needed in the icy galleries, where only scattered braziers took the edge off the chill. Fortunately, there were bright and gay companions enough in Rome to make the days pass delightfully at his favorite haunts, but the more he calculated the less chance there seemed of staving off return to Boston much longer. Yet protracted melancholy was not in his nature: somehow the Lord or Nature would provide; a deus ex machina would descend; another Maecenas might appear.

During these impecunious weeks he appeared to have drifted into the roles of an unofficial guide in the galleries, putting to use his fluent German and French and at the same time satisfying his passion for instructing the uninformed. With his instinct for seeking out the leaders in the fields in which he was interested, he managed to make the acquaintance of Cavalcaselle, the most noted of art historians and now at sixty-nine the National Inspector of Fine Arts in Rome. The meeting was a crucial one for Berenson, for which all of his haunting of art galleries since his arrival in Paris two years before had been an arduous preparation. Ca-

valcaselle had once been the secretary of Giovanni Morelli, the pioneer of scientific connoisseurship. Both men had come to art by a circuitous route after fighting in the struggle for Italian liberation against the Austrians in 1848. Captured by the Austrians, Cavalcaselle was condemned to be shot. He was rescued, took refuge in England, and joined the English art critic J. A. Crowe in a monumental revision of Italian art history which quickly became the chief authority in the field. In time Berenson acquired three editions of the work, including the six-volume German version, of which he made most use, despite his growing distaste for its plethora of "insipid adjectives."

Morelli, Cavalcaselle's comrade-in-arms, was now a venerable seventy-three. Though his early bent was toward art, he had been sent by his parents to Berlin to study medicine. His training in comparative anatomy under the famous Professor Döllinger gave him a fresh insight into the treatment of the human form in painting, bringing his approach into the same scientific current that had attracted novelists and historians to literary naturalism and scientific objectivity. After six years of medical study Morelli was diverted to the cause of Italian liberation, in which he led a corps of volunteers in the storming of Milan, serving thereafter as a peace negotiator. As a young man of family and wealth, he had long indulged his taste as a discriminating collector of Italian art. In the young republic he became a member of the fine arts commission that inventoried the Italian patrimony of art treasures in order to afford them some protection from being plundered by foreign collectors. When after the war Cavalcaselle returned to Italy to assist Morelli, the two men combed the countryside searching out neglected masterpieces. In this work Morelli brought to bear all his scientific training to identify long-forgotten works. He became particularly expert in deciphering the marks by which the various schools of painting could be recognized. In a series of down-to-earth articles published under his Russian pseudonym Lermolieff, he challenged the pretensions of German art historians and sought to recapture Italian art history for Italy and to establish what he hoped would be a "real science of art."

Berenson's meeting with Cavalcaselle in Rome marked a turning point in the young man's ambitions. The embryo novelist gave way to the apprentice connoisseur. Berenson's strong vein of pragmatism, nurtured at Harvard by William James, attracted him to this new and "scientific" approach to the question of attribution. In his letters there is no further allusion to stories languishing in the offices of unsympathetic editors. His quest would now lead him to seek out the chief followers

of Morelli, the noted art historians Jean Paul Richter and Gustavo Friz-
zoni, in Florence and their master himself in Milan.

WHILE Bernhard struggled to stay on in Rome, a long-awaited letter
from Senda brought painful news of her troubles with their headstrong
father in Boston. Senda, a restless young woman of twenty with in-
tellectual and social ambitions much like those of her elder brother, had
too much of her father's volatile temperament to get on well with him.
And the strain of making both ends meet in his precarious little business
did not improve his temper. There had been high words and Senda was
in despair. Bernhard tried to comfort her by saying that her plight had
decided him to come home in June. He would write to ask his friend
George Carpenter, who was now back in the States, to try to get him a
job. "It is my plan," he told her, "to realize the dream of my child-
hood, that is that we two should live together and if we are economical
and do not mind a little hardship to begin with, I'm sure I'll be able to
earn enough money for both of us. My one thought will be your happi-
ness. This will give me something to live for. . . . Oh, if I only were
home already to take you at once out of the hell in which you are. I
know father well enough. I know how utterly brutal he can be." He
urged her to keep at her piano lessons so that next year she might "do a
little teaching." In the same mail he sent off a letter to his father beg-
ging him to be kind to Senda. Afterward he repented the tone he had
taken, justifying it to Senda as having been written with a trembling
hand in hot anger. "I love him instinctively," he declared. "I might
hate him if I had to be with him but at this distance I cannot but think
of him with pitying love."

He too had his father's temperament, complicated by the habit of
lonely introspection. His letter to his sister was but another illustration
of the changeful moods which stemmed from his youthful misan-
thropy. He would flee the world if he could and find refuge from it.
The "cynical music" which his friends at Oxford had noted can often
be heard in these early letters. He no longer thought of marriage as part
of his future; nor strangely enough did he seem to foresee it in Senda's
life at the moment, though he would become concerned enough years
later. One surmises that the young puritan of twenty-three was still the
captive of his fastidious inhibitions. For all his "practicality" he did not
yet know or was not yet ready to confront the demands of his own sex-
uality. His aesthetic raptures were still singularly chaste, and though he
strove to burn with Pater's "gem-like flame," his gave off only an
etherealized heat.

The domestic crisis at home somehow abated, and in a stream of cards and letters Berenson recorded his sightseeing as he worked his way north from Rome to his journey's end in Florence. The valley of the Arno in the early spring of 1889 greeted him with vistas of greening vineyards and hillsides splashed with yellow broom, while below a brimming yellow flood hurried to the sea. His head was full of the literary associations that mantled the city. How many from Dante to Browning had paid tribute to it! His guidebook was adorned with quotations from Dante, Ariosto, Vasari, Milton, Shelley, Leigh Hunt, Coleridge, Landor, Hawthorne, the Brownings, Swinburne, and John Addington Symonds. Every stone in the narrow streets had felt the impress of a famous footstep. The fortresslike façades of the palaces spoke of Guelph and Ghibelline and the splendors of the Medicis within. Here at last he could look upon the originals of the Botticellis which he had worshipped as a boy in Boston.

To the lover of the picturesque there was, however, a touch of anticlimax. Berenson arrived at the very time when the modernizing faction in control of Florence, which a generation earlier had razed most of the city walls, had now laid its rough hands on the oldest section of the city, the old market and its environs in the center of the city between the Piazza della Signoria and the Duomo. What had once been a labyrinth of the twisting lanes of the fetid ghetto on the site of the ancient Roman forum was being cleared of the patched-up stone tenements, divided and subdivided through the ages, to make way for the future Piazza della Republica with its monumental edifices and imposing arcades. A great arch would commemorate the extinction of ancient squalor. Sentimental travelers in Europe and America had signed petitions to prevent the "disemboweling" of the Centro, but in vain. The Englishman Augustus Hare in his guidebook of the time could not forbear commenting: "This most interesting part of Florence was doomed to destruction by its ignorant and short-sighted Municipality in 1889." He also quoted the sarcastic remark of "Ouida (Louise de Ramée), a writer whom Berenson was about to visit: "It has been reserved for the thankless sons of Florence, of a venal and degenerate time, to efface all that the cannon of the Spaniards spared, all that the German and Frenchmen left unharmed."

The young man never forgot nor forgave the modernization of the old quarter. In his diary sixty years later he wrote: "I well remember after the demolition in Florence of the Mercato Vecchio, perhaps the most beautiful and characteristic product of popular Florentine art—a complex of bulk and shape in free-stone, in marble, in bronze, in glazed terra cotta the like of which Europe had never seen—when someone

had the courage to protest, Count Torrigiani, the syndic, indignantly replied that every bit of sculpture and painting of artistic value had been scrupulously saved and deposited in a museum." In retrospect the imposing piazza which replaced the picturesque, if squalid, quarter seemed to Berenson only "life diminishing."

Berenson took a room in a house on the quiet Piazza Santo Spirito across the river in the Oltrarno pleasantly removed from the noisy streets of the north bank, where lay the main part of the town. A fountain sparkled in the center of the tree-shaded lawns of the piazza. At the north end, rising from a broad stone terrace, stood the church of Santo Spirito, its blank face giving no hint of the colonnaded masterpiece within that Brunelleschi had designed. Here, on his way to and from the galleries a few times a day, Berenson would drop in to refresh his sight with the graceful proportions of the vaulted aisles and ceiled nave. Only a few streets away was the church of the Carmine, whose Brancacci Chapel contained the masterpiece frescoes of Masaccio. A short walk to the east took him to the galleries of the Pitti Palace, whose enormous bulk adjoined the parterres and fountains of the Boboli Gardens. Just across the Arno stood the monumental U-shaped Uffizi, the richest gallery of all, which he could reach through the lane of goldsmith shops on the Ponte Vecchio or by way of the covered gallery from the Pitti Palace. For a time in mid-April he did more reading than sightseeing "because," as he wrote Senda, "until Easter the churches are all covered up." Meanwhile the galleries engrossed him, and his lists of pictures studied grew longer and longer.

The only jarring note that disturbed the aesthetic harmony of his days came from Mrs. Gardner, who looked vainly for signs that her young protégé was living up to his promise. He responded to her renewed inquiry with the explanation that "the thousand nothings of the hour have driven every capacity for writing out of me." He was so busy, he said, that he did not dare ask himself whether he was amused since being amused was "after all not life, at least for Anglo-Saxons." Having thus set her to rights, he resumed his customary report. The people of the Anglo-American colony were "very nice, clever, polyglottic but somehow not entertaining." Ouida, the popular novelist, so irritated him on his second visit, he reported, that he left in disgust. He found that Vernon Lee, the author whose writings he had praised so highly in the *Harvard Monthly*, "not only looked at me thro' the wrong end of a telescope but what is even more disagreeable almost made me regard myself in the same way." At the villa of another novelist, the expatriate Constance Fenimore Woolson, however, he was received with "immense cordiality," but she "never gave me a chance to say a

word." On succeeding visits he found her "awful jolly. She is as broad, as deep, as entertaining as anybody I ever met. I am quite ashamed that I haven't read a word of hers."

One of his new acquaintances gave a reception in his honor to introduce him to Anglo-American society. As a result he succeeded in being taken under the wing of Jean Paul Richter, who was immediately impressed by this young man eighteen years his junior. Flattering as his reception had been in the society of middle-aged intellectuals, chiefly women, Berenson found it somewhat flawed by the "sudden change from the utterly matchless set of fellows I left in Rome."

He resumed for Mrs. Gardner his usual extended commentary on his reading to reassure her of his seriousness of purpose. Browning, he informed her, was "the Michelangelo of contemporary literature," whereas George Meredith was to be ignored as "a crude Paleolithic artist." Maupassant he admired for his lucidity and power and especially because "he has all the disgusts that I have" for contemporary society. He went on to assert the striking parallels between literature and painting. Shakespeare's *As You Like It* precisely reflected the Venetian school as displayed in Bonifazio with his "charming stiff beautiful music-making women and courtly men; in Titian as you see him in the Bacchus and Ariadne; and in Giorgione as you dream of him." But amidst all the talk of literature there was no mention of progress in novel writing, the one point that most concerned her. Berenson's light-hearted disquisition must have struck Mrs. Gardner as evasive and irresponsible. As she read on, she soon discovered the reason for his seeming indifference. Near the close of the letter he explained that a friend had recently promised a subsidy for a third year abroad. The "friend" appears to have been Edward Warren, who had begun to count on Berenson for advice on his art purchases.

Berenson concluded his recital in a manner that could hardly fail to annoy his one-time benefactress, who regarded Boston as a cultural capital worthy of her patronage: he said that when he finally returned to Boston he would be coming back "like a Roman who returns to the colonies. . . . What I shall do I do not know, almost anything for a living, writing or teaching as a *pis aller.*" He then added more prophetically than he knew: "I shall be quite picture-wise then, perhaps that will enable me to turn an honest penny. But all these nightmare thoughts can be delayed another year."

This lame and impotent conclusion of his letter of April 28, 1889, could not fail to offend his ambitious patron, who did not like her expectations to be so lightly disregarded. She had evidently made a mistake in taking up Berenson and lavishing her encouragement, if not her

funds, upon him. Without further ado she abruptly stopped their corre-
spondence. It was a painful rebuff, for it meant the loss of his most
promising social connection in Boston as well as of one of his most ap-
preciative confidants. He had confided in her, shared his inmost feelings
and doubts with a freedom not even shown to his family, albeit not
without a certain naive condescension, but his frank confessions, how-
ever compulsive or calculating, were not the kind of acquiescent affir-
mations that Mrs. Gardner habitually received. Nor was she alone in
her disappointment. At first he had enjoyed the role in which he was
cast, that of the promising genius, and he had basked happily in adula-
tion. Now his Boston well-wishers were growing more and more
skeptical, and the sense of their disenchantment brought home to him
in gossipy letters put him increasingly on the defensive and filled him
with a lurking resentment that they pressed him to publish as though he
were a mere academic. Five years would elapse before Mrs. Gardner
would again hold out her hand in friendship. ·

His sister responded to the news of the fresh prolongation of his stay
with deep misgivings. He protested in his defense—the most elaborate
he ever wrote—that "for your sake I would fly thither, but remember
that a year abroad is so much capital in America." He argued that in
America "the year might go by without my finding anything to do. I
could not possibly return to live in the family again. Abroad I should
continue the work I am at. What it's tending to 'God' knows. . . . I am
as conceited as ever, but my humility frightens me. I expect little from
life. I shall be satisfied if I get to be able to provide for you and me. If I
really do anything in London, it will be so much more capital. Settle
there I won't." He assured her, however, that "the facility to get at
books, my few friends, the love that one has for the spot in which ten
such important years of one's life have been spent will draw me back to
Boston. Otherwise my love for America is scant. The mere sight of an
American newspaper makes me sick, the sound of an American voice
nauseates me. Still I do realize that in Boston I shall be near the top of
the few and in London towards the bottom of the many. My vanity
will decide against London. I feel though that coming home I should be
doing what desperation almost drove me to before I finished grammar
school—to give up my aim of culture."

As for her plea that he free himself from dependence on the charity of
friends, the idea drew from him the sharpest scorn: "What you say of
independence seems to me false. Who that is wealthy is independent in
America nowadays, teachers absolute slaves to headmasters, clerks
bondsmen to employers, Harvard professors crouching before an Eliot.
But they work for their slavery. Is that a consolation? Nor am I idle. A

friend who is able and willing offers me means. Were I an American with an American's fine sense of honor—which I reverence—I should refuse it. But as I am not a scion of the coming race but a shoot from an 'effete' one, I feel slight compunction in accepting help from a friend delighted to give, whom I sincerely hope to be able to pay back in more than money some day. So fear not for my backbone. It will not weaken. It is you that draws me home. But if you can bridge over a year I believe I shall be of more service to you. In all sincerity I offer you four dollars a week which I wish you to accept, indeed command you to. I can quite well afford it. I know what our home is and what father is. He used to say of me too, 'Were it not for you, etc.,' but the dear man could not live without grumbling. Not that I cannot perceive that he has a good deal to grumble at. But you would not have married immediately. They would have kept you until then. He can *keep* you till I come for you. I ask him to *keep* you only. For everything else I undertake to provide."

He wished that she could get away for a few months in the summer to get good air, good food, and quiet. It could be done for five dollars a week. He would have liked to send money for little sister Elizabeth too. "How little I cared for you all two years ago. But my love for you and them is changing me completely. I think so little of ambition and fame and so much of you and your happiness. Some day I may be able to convince father that his suffering me to pursue my education was not so bad a thing even for him."

Thus he made his case for the disinterested pursuit of culture, presciently estimating his potentialities and the iron determination to fulfill them. Nor did his ambition stop at that point. He essayed to make his sister a convert to his ideal. Above all, she should not waste time. She should, like him, put system into her days, devote her best hours first to the piano and second to French. She should adopt his plan of memorizing something while dressing and undressing. "Just now you should learn by heart all you can of La Fontaine. Read all the novels you want, but not foolish ones, and remember there is a good deal of English verse an educated person should know intimately." She should read the Gospel of St. Luke to improve her writing—not that he wished to disturb her "happy religious indifference"—because the translators had written "the best English we have."

Freed by Warren's bounty from the need to earn his living in uncongenial ways, Berenson could continue without a break his unconventional scheme of self-improvement. Now, in Florence, began his lifelong love of the Tuscan landscape. Daily he absorbed the color and texture of the wooded slopes which lapped at the walls of picturesque

villas. Daily his walks carried him through narrow high-walled lanes which wound among vineyards and olive groves and their sentinel stands of cypress and umbrella pine. He became, like Thoreau, a surveyor of sunsets and cloudscapes. He filled his letters with his efforts to capture the chiaroscuro and *sfumato* with which Tuscan artists had suffused their paintings. No exertion was too great in the service of this vocation. One day he returned to his room in the Piazza Santo Spirito, filthy and hungry after "a walk of thirty miles, such an one as this dear land only can offer." This walk had followed one of twenty miles which he had taken only two days before to visit a country fair "much like a fair in Lithuania."

The summer of 1889 largely passed in reading the volumes of Vasari and a host of other works on Italian art. It was study that he acknowledged had little worldly value, no more than if he had gone to Vilna as a youth and buried himself in the study of the Hebrew commentaries. It was precisely its ideal intellectual and spiritual quality that inspired him. The paintings of the masters and the histories of art became for him a new Talmud, in which the beauty of the visible world was inscribed. For a time he found congenial companionship in Charles Loeser, who was also putting down his roots in Florence and seriously beginning his own career as an amateur critic and connoisseur of art. He shared Berenson's dream of culture and his distaste for the chromolithograph civilization of America.

During that summer Berenson made the most important acquaintance of his first stay in Florence, an acquaintance that brought his blurred resolves into sharp focus. His name was Enrico Costa. Berenson recalled him as a brilliant and tremendously energetic young man of twenty, "half Genoese and half Peruvian, with a slim long face, nose thin and slightly aquiline, delicate sensitive mouth and fine black eyes, black hair too, and of course a dark complexion. . . . He was one of the most gifted of men. There was no realm of literature into which he could not penetrate and, with instinctive accuracy, make a dash for the best." Costa's family were people of means whose wealth came from their native Peru. He had already begun to amass a rich collection of photographs and was even venturing to collect Renaissance paintings, a feat which still lay far beyond Berenson's means. They instantly hit it off together in their common passion for Italian painting and began to make the rounds of the galleries.

With Florence as their base of operations the two students of art journeyed to the hill towns and the cities of the plain where the artists had had their beginnings or done their greatest work. They studied the splendid frescoes of Piero della Francesca at San Sepolcro and delved

into the work of Raphael's father at Urbino. Bernhard sent off diary-letters to Senda rapturously recounting his "discoveries" of forgotten paintings at Lucca and Pisa. He told of revisiting Bologna, Parma, and their beloved Venice, to which he planned to return again at summer's end. On one ambitious *giro* their carriage had to be pulled over the Apennines by a pair of oxen to reach the pass that led to Urbino. Later they struck eastward to Ravenna to take in its Byzantine mosaics, then headed south along the Adriatic to Rimini to see the famous Renaissance temple embellished by the vanity of Sigismondo. After Pesaro, whose chief treasure was a Bellini *Coronation of the Virgin,* they swung west again to Urbino and thence across the mountains to Gubbio, Citta di Castello, San Sepolcro again, and thus back to Florence by way of Arezzo. It was a strenuous and highly methodical campaign and the prelude to many similar bone-wearying tours in quest of paintings and architecture, tours that would crisscross all of central and northern Italy year after year. Berenson was determined to assimilate it all, to possess it in memory as no one had ever done before.

After such devoted pilgrimages he could say with the poet Browning: "Open my heart and you will see / Graved inside of it, 'Italy.' " This feeling grew more intense as day followed day of study, and his desire to encompass the art of Italy became ever more imperious as he retraced his steps or sought out new caches of neglected and forgotten works of art in remote villages. Little wonder then that he early developed a sense of proprietorship in his discoveries. Santayana, who once accompanied him on one of these circuits, did not take kindly to Berenson's irrepressible commentary. He reflected that their friend Loeser, unlike Berenson, "loved the Italian Renaissance and was not, as it were, displaying it." If Loeser's love was in fact more disinterested, it was also to prove less fruitful.

In Florence, under Richter's personal guidance, Berenson began his real apprenticeship to the profession of art critic and connoisseur. Richter's earlier study of Leonardo da Vinci had recently been followed by his authoritative volume *Italian Art in the National Gallery.* Seeing in Berenson a prospective disciple, Richter reported his impression to Morelli in Milan in such glowing terms that Morelli promptly wrote back that he would give the young man the warmest reception. Morelli was equally delighted to learn of Costa's promise as a connoisseur, seeing in the two young men the beginning of a school of connoisseurship. The prospect of meeting the already legendary Morelli prompted Berenson to study his recent volume on the Italian paintings in the German galleries. Refining on the work of his predecessors,

Morelli aimed to distinguish the peculiar geography and ethnography of Italian painting and the distinctive techniques of the various schools. He taught how each master's work could be identified by such revealing details as the shape of an ear or a hand. Art historians like Burckhardt had long used the magnifying glass in the examination of brushwork; Morelli applied it to anatomical structures. Berenson quickly followed suit and in his copy of Morelli's book he attempted a few sketches of such details. But the path to certainty was still indistinct. From Venice that summer he remarked to Senda: "Curious how much like quicksand it all is. The more I study pictures, the less do I feel I know about them. Yet I am beginning to find it natural to say in seeing a work by a certain man, he must have done it thus and thus early in his career." Mastery might yet come if he could meet Morelli, "the greatest connoisseur in the old masters that ever lived." There was a chance, he said, of his meeting him in Milan soon.

Morelli had written that "only a close observation of the forms peculiar to a master in his representation of the human figure can lead to any adequate result." For this "the eye requires long, very long practice to learn to see correctly." The authentic "provincial dialect of art" needed to be studied not in "eclectic galleries" but off the beaten path in remote village churches, in frescoes in villas and farmhouses. Drawings were particularly important, for they revealed most sharply "the distinguishing characteristics of the several schools." He hoped that the art student would "make an independent and searching inspection of the actual *works* of the masters," for it was "easy enough to aestheticize and philosophize about art without taking the slightest notice of *works* of art." Such commonsensical advice served as a wholesome counterbalance to the aestheticism so winningly taught by Walter Pater. It brought art criticism down from the clouds of personal impression to the solid earth of the thing-in-itself.

Berenson was already moving away from the aestheticism of Walter Pater, or at any rate beginning to interpret his doctrine in a more discriminating way. The change can be read in an unpublished review which Berenson wrote about this time of Huysmans' controversial *A rebours,* a novel which was still creating a sensation in intellectual circles, though it was first issued in 1883. "When you have read through the biography of each one of the senses," Berenson declared, "you perceive that [the hero] Des Esseintes has taken Pater literally. He gets as much pulsations as possible out of a given moment. . . . Brought up by Jesuits, Des Esseintes has never been taught to think" and never learned "what an immense pleasure there is in sane cerebration. . . .

The upshot of *A rebours* is that no matter what art you take up, you soon exhaust it aesthetically. . . . Art cannot be separated from life, and still less from thought." What the precise relation of art was to life and thought was a question that would animate Berenson's meditations for the rest of his life.

VIII

Disciple of Morelli

IN the autumn of 1889 when the grapes hung in dark clusters on the Tuscan hillsides and the lethargies of August had passed, Berenson vacated his room in the Piazza Santo Spirito and departed on his long-planned visit to Spain. He took with him a new companion, James Burke, a wealthy young Englishman whom he had met on a visit to Cambridge University in the preceding year. Burke, who had taken an immediate liking to him, had impressed him as "a powerful thinker, eloquent about science and finance." He too was a devotee of art. They traveled the length of Spain from Valladolid to Gibraltar, studied the Italian paintings in the Prado at Madrid, and haunted the churches, tracing out the characteristic "signatures" of the artists and the marks of kinship among paintings, frescoes, and altarpieces. The world of art, like that of nature, was a great web of interrelationships. At Granada in the somber twilight of the cathedral the novelty of the Ionic capitals on the massive columns, for example, impressed Berenson with the remarkable diffusion of Greek architecture.

The congenial pair reached Gibraltar early in November. There, tempted by the agreeable sound of English voices, Berenson wavered in his resolution, recalling the pleasures of Oxford and London, but his unfinished studies in Italy tugged too strongly at his conscience. To his former comrade in Boston, Gertrude Burton, he explained that he felt obliged to return to Italy for a few months to see more paintings, after which he would go to London and remain there until he should have to return to Boston. Anticipating the inevitable reproaches that seemed to come from every quarter now, he assured her, "Of course, I have not wasted any time altho the gods only know what all this fine dilettantism is going to stand me." He went on in this vein to say that had he plenty of money, he would dream of nothing but continuing the study

of pictures the rest of his life or until he tired of them. It was a measure of his intense self-absorption that he passed over without a word the fact that, though an entire year had gone by since he had written to her from Athens, he resumed his introspective musings without a break, relying on their ardent friendship of years past.

It was wrong, he thought, of friends and acquaintances to worry over him as if he had become a bad investment in stocks and bonds. He added that though he had refinement and culture he had "no character at all," no real identity yet. So far he had thought himself "as plastic an object as the hero of a romance in the brain of a novelist." Nevertheless, by the following summer his three years of the study of art, however lacking in worldly value, will have made a "panopticon" of his brain. Had he stayed in Boston, he would now be a fifth-rate hack writer instead of a "first-rate connoisseur of art." He confessed that his sensibilities were so keen he could not bear to look at a picture while anyone else examined it or listen to music in the oppressive company of an audience. In short, the feeling had come to him in Madrid that he was "quite finer than anybody that had ever lived."

On his return to Florence in the latter part of November of 1889 he rented an apartment in the picturesque "castle-like palace" at 24 Lungarno Acciaiuoli, on the north bank of the Arno just west of the Ponte Vecchio. Sixty years later he still recalled the "hundred and thirty exhausting" steps that led up to it. There were compensations, however. From his desk in an embrasure of the wall he could look out on "the crowd streaming across the pea-colored river" and, above on the heights of the Oltrarno, "San Miniato lit up by the sunset glow." In this comfortable aerie he could immerse himself for hours without end in his growing collection of books and photographs, checking his findings against the volumes of Vasari, Burckhardt, and Crowe and Cavalcaselle, hurrying down from time to time to test his judgment in long contemplation of a relevant painting in the Uffizi or the Pitti Palace. Though he was frequently absent on his incessant forays hunting the works of a particular painter, the building remained his headquarters for the next three years.

He had returned with Burke from Spain by way of Genoa and Pisa. The alternating course of black and white stone and pointed arches in the cathedral and baptistry of Pisa recalled for him the mosque at Cordova and evidenced the debt to the "common enemy, the Saracen." Much to his relief Burke went his way, his company having grown so depressing that Berenson felt "almost cured of wanting companions for the future," as he confided to his former college mate Maxime Bôcher. Young Bôcher, the son of Professor Bôcher, one of Berenson's original

sponsors, was now studying for the doctorate in mathematics at Göttingen. Berenson excepted young Bôcher from his proscription, hoping that they might travel together the following summer. Berenson's twelve-page report to his friend, written on December 3, 1889, from Siena, revealed that once again, in spite of his failing purse, he might be able to delay his retreat to Boston. Edward Warren had written from England urging him to remain abroad until the end of the following October. "I should like nothing better," Berenson commented, "if I knew for certain that I'll find something to do directly after my return home. As it is, I fear I shall feel obliged to return in July unless Ned [Warren] offers to keep me abroad another whole year which offer he seems on the point of making. Have you had your hand in this again?"

He went on to tell Bôcher that his intimacy with Richter had progressed so far that Richter had lent him the advance sheets of Morelli's new book on the Borghese and Doria Pamphili collections in Rome. He noted that the introductory essay "Princip und Methode" repeated the substance of what Morelli had said in his *German Galleries.* Nevertheless, he was tremendously impressed—and a little envious. "No wonder Morelli is omniscient. He is six & seventy already, a conservative in politics and therefore out of tune with the humbug so prevalent here today." But neither the "humbug" of Italian politics, which were in a state of extraordinary flux, nor even the plague of beggars in Florence could dilute the joy of his return from Spain. "You can scarcely know what it is to wander at one's ease over Tuscan by-roads, overarched by autumn-tinted oaks and chestnuts, between tall hedges of ilex and laurel." The countryside about Siena reminded him of a softened Segovia.

How far he had traveled the route of the connoisseur appears from such comments to Bôcher as the following: "At Florence I spent eight days. I discovered a Lotto in the Pitti, Vitis and Palmezzanos in the Corsini, and Justus van Ghent's Mater Dolorosa of the Uffizi seemed wonderfully to show the influence of Giovanni Sanzio. I no sooner saw the portrait by Mantegna of the Tribune than it struck me as a Viti. Richter believes it is by Carotto, but would be on my side if it could be proved that it is a duchess of Urbino. I saw him several times. 'Have you seen my new acquisitions?' he asked the first time I called on him. . . . I could scarcely believe my eyes when I saw the Catena or as Morelli would have it the Rocco Marconi of Madrid, softened, toned down, finer, yet more glowing. This is not only the original, but a finer picture than I should have expected from Catena. . . . 'By the by,' said Richter, 'let me recommend you the best book on art written in this century, Justi's *Velasquez.*' 'Oh I have read it!' 'Don't you think

it is delightfully written?' 'Well, really I thought it was fearfully in-
volved and muddy.' 'But I don't want a man that has a great deal to say
to be clear,' retorted Richter." This paradoxical opinion only strength-
ened Berenson's scorn for German art criticism, a scorn that he was
glad to know was also felt by Morelli.

Berenson fell "thoroughly in love" with Siena, delighted that it had
preserved the fourteenth century as Bologna had the beginning of the
sixteenth. But he did not hesitate to be critical of the celebrated
Duomo. The splendid ornamentation of the façade struck his cultivated
taste as "scarcely worth its fame." And he dismissed the interior as "not
much," though he admitted that the banded white and black piers
pleased him. His impulse to patronize art as he often did persons was
not easily held in check, though his judgments, as in this instance, were
often subject to revision. The celebrated Duccios fared somewhat bet-
ter, though he failed to single out the remarkable *Maestà* which is now
the chief treasure of the Cathedral museum. He did concede that
though Duccio lacked Giotto's "graphic power and his grace in com-
position," he was superior in "perspective and modelling" and was thus
"much more modern." The long letter to Bôcher was peppered with
many more sweeping opinions. For example, nothing in Siena "rivals
the frescoes of the Farnesina" in Rome. Wherever he looked he saw
links and parallels with other artists and recalled with sharp perception
details of pictures seen elsewhere. He constantly drew together as in an
immense web what he was learning of the whole field of art and kept it
all simultaneously in view: Matteo one saw "much better in London
and Berlin." His women's faces were "very like Botticelli's." The *De-
position* in the Academy by Sodoma was "characteristically Lombard."
The composition reminded him "much of Solario's crucifixion in the
Louvre." One of the Marys is "very Leonardesque"; the mantle of
another recalls Gaudenzio Ferrari. Sodoma's "flesh tints" were "far
finer than Luini's."

What this and many other letters of the time show is that Berenson
had already laid the foundation of an encyclopedic knowledge of the
whole range of Italian Renaissance art. Much remained to be added and
refined; many peremptory judgments would have to be revised in the
light of deeper study; many paintings once disdained would come back
into favor. But all these revisions would be like editorial corrections of
a monumental text.

If with growing study he became more and more possessive of what
he looked at, he also became more concerned about the preservation of
Italian art, which seemed to suffer more from neglect than from expa-
triation. For instance, at Arezzo a few days before reaching Siena he had

sought out the frescoes of Piero della Francesca in the church of San Francesco and discovered that the church had been converted into a military barracks. He routed out the sacristan and made his way in. Church furniture was piled high, "jammed against the frescoes," and dust was inches thick. His indignation, he wrote, was "colossal, pyramidal and monumental. . . . But what riles me up so is that this wretched government pretends to protect the arts. What does it do? It spends a few francs in digging up things that are of great interest to their dear allies, the German dunderheads and their obedient slaves the Americans. As for the painting of the Renaissance wherever it cannot ruthlessly destroy it as it is doing at Arezzo, it sends the restorer always from Rome and the Sultan's silken cord was no surer death." His protest suggests one of the more admirable motives that led foreign collectors and museum curators of that period to acquire Italian art and self-righteously evade export restrictions.

Like the Wandering Jew of the fable, Berenson drove himself compulsively from town to town in his endless quest. The German boots he had bought in Spain resisted breaking in, and at day's end he could measure the success of his researches by how much his feet ached. Sometimes he pushed on so late in the day that in the gathering darkness of a remote village church he had to hold a candle that trembled in his tired fingers as he strained his eyes for the telltale characteristics of the artist. Above all, he hunted for the easel paintings of his favorite Venetian masters, preferring their unified composition to the distracting sweep of the historical paintings. He kept coming back again and again to the dazzling pictures of the Bellinis, of Bordone, Titian, Veronese, Carpaccio, Crivelli, Giorgione, Lotto, Palma Vecchio, and Tintoretto. He became engrossed as well in hunting out their followers. A principal guide was the encyclopedic Vasari, the Renaissance painter and art historian whose collection of biographies of his contemporaries and predecessors ranked as the greatest classic of Italian art history.

In early December 1889, accompanied by Enrico Costa, he went south again to Rome to see what had been "left unseen" on his previous visit and to rejoin the "matchless set of fellows" he had met there, for the preponderance of aesthetic women in Florence still jarred on him. There he promptly bought Morelli's *Kunsthistorische Studien über Italienische Malerei,* just off the press, and set to work on a review of it. The twenty-page essay was put aside and remained unpublished. It is valuable, however, as his earliest appraisal of Morelli's importance. He declared that although Morelli was unknown to the great mass of Americans his "services to the science of pictures are greater than Wincklemann's to antique sculpture or Darwin's to biology." He rel-

ished quoting Morelli's attack on the dogmatic Wilhelm Bode, director of the Berlin gallery and known facetiously as *der Kunstcaporal,* a man who was to become Berenson's principal rival in stalking Italian masterpieces.

Morelli, Berenson conjectured, would not make impressionistic comments, say, on Raphael's *Spozalizio,* as Bode might. "To begin with he would not be *above* telling [his audience] that the original was to be seen in the Brera at Milan. Then he would pin up on the board beside it a good large photograph of Perugino's 'Sposalizio' now at Caen. He would make them see that from this Raphael took his composition as a whole. . . . Signor Morelli would make it evident that no sooner did Raphael leave Perugino than he reverted to certain characteristics of his first master, Timoteo Viti of Urbino, such for instance as the bulging, fleshy palms; furthermore that the disappointed suitor breaking his rod is not a copy of the very mild youth in Perugino's picture but was suggested by the executioner in one of his father's Giovanni Santi's pictures representing the martyrdom of S. Sebastian, still to be seen in the oratory dedicated to that saint at Urbino. . . . In Raphael the dominant note is decision, in the attitudes, in the gestures, in the mouths shut so firmly. Indeed even where he tries to copy Perugino the firm mouth alone nearly always betrays him." Morelli's method was not therefore a mere reduction of a work to "accidental minutiae of dirty nails and queer ears and quirks and crotchets." It was not a mechanical system, as hostile critics supposed. It was a recognition of the organic character of an artist's manner and mannerisms. With this method "we may learn the style of the old masters, to distinguish accurately one from another and to assign the many lost sheep that still stray about the walls of the galleries to their right owners."

Nothing illustrates more forcefully, however, the precariousness of many attributions than the sequel to this unpublished essay, in which Berenson adopted the common notion, first expressed by Vasari, that the Caen *Spozalizio* (the marriage of the Virgin) was painted by Perugino, one of Raphael's teachers. Having accepted that attribution, young Berenson was limited to pointing out the differences between the two paintings. Six years later, when he was far more deeply immersed in his craft, Berenson returned to the problem and published a daring essay in French in the *Gazette des Beaux-Arts* (April 1896) which argued with exhaustive subtlety of analysis that the Caen *Spozalizio* was painted not by Perugino at all but by Lo Spagna and that Lo Spagna had imitated Raphael's original. The editor, recognizing Berenson's revolutionary departure, noted that the author had "inauguré" a method original with him of substituting a "positive" examination of

the painting for the common sentimental one and of submitting it to an intimate and scientific analysis. Critics did not tamely accept this dethronement of the *Spozalizio,* and most have since assigned it to Perugino, but the posthumous edition of Berenson's *Italian Pictures of the Renaissance* still gives the painting to Lo Spagna, cautiously adding "(with Perugino)."

More than ever Berenson realized that photographs would constitute perhaps the most important single aid in this new science. With these before him at his desk and with magnifying glass in hand, he could make his analysis undistracted by gaping tourists in the galleries. He already felt so strongly about the value of photographs that he sent off a short letter to the New York *Nation* from Milan in early January, after finishing his studies in Rome, praising the excellence of the photographs made by Marcozzi of the Poldi-Pezzoli collection. It was his first publication on art. The "perfect reproductions," he said, rivalled Braun's photographs "at one-tenth of the latter's prices." He hoped that increased patronage would induce Marcozzi to photograph other collections.

In mid-January of 1890 Berenson at last made the long-deferred call on Morelli in Milan accompanied by Costa, the two having returned from Rome, where they had done the "Lermolieff in the Rome galleries," as Richter put it in a letter to Morelli—playing on his famous pseudonym—"learning the galleries by heart." Berenson delighted Morelli by presenting him with a much-desired copy of the handsome catalogue of the Northbrook collection in London. Morelli thought his twenty-four-year-old visitor "an extraordinarily scholarly young man who had already advanced far in the study of art." "It was a great pleasure," he told Richter, "to see him stand before my pictures." "Today [January 18, 1890] friend Frizzoni will take him to the Poldi Museum and will see how far he has come in the analysis of paintings." Later Berenson went with Frizzoni to the great Brera gallery. Though twenty-five years separated the two, they immediately hit it off. Berenson felt more at home in his company because he thought that the learned Frizzoni was "truly devoted to painting," being completely disinterested and "far more serious" than Morelli and certainly than Richter, who, Berenson regretted, had too much of the art merchant in his makeup. He found it rather difficult to converse with Morelli because Morelli expected to be treated "en maître." Frizzoni had but one limitation, in Berenson's eyes: he was that anomaly among Italians, a Protestant, and thus cut off from his Catholic heritage. If art was in fact the organic expression of a culture, to understand it fully one must experience it from the inside; this was a conclusion to which Berenson was

being steadily driven. Frizzoni tended to see art in a literary context, one which Berenson now felt was inimical to a truly scientific analysis. The acquaintance with Frizzoni ripened into friendship and they continued to exchange opinions on disputed paintings for nearly a quarter of a century.

Costa too made a great impression on the veteran art connoisseurs and also received their blessing as a prospective disciple. Morelli had been too ill to accompany "the very promising Berenson" to the Brera, remarking to Richter that he would have enjoyed being with the "young Lermolieff from Boston" himself. Inspired by this laying on of hands, the two young men departed for Rome for another intensive session in the galleries. The discipline of seeing, of intensifying their visual acuity, became for them the highest goal. It was some such partnership as Emerson had envisaged when he wrote to Carlyle, "Suppose you and I promulgate a treatise, 'How to see'?" Berenson and Costa kept in frequent touch with Morelli concerning their discoveries. In mid-May 1890, Morelli wrote to Richter that the two "eager art scholars" had been energetically tracking the achievement of Lorenzo Lotto in Bergamo and the surrounding country. They had spent "a good hour" with him in Milan and their explorers' ardor had gladdened his heart.

It was on this journey to Bergamo that Berenson came to the full realization that he had found his métier, a realization that owed much to his meeting with Morelli, who had grown up in Bergamo. Here is how Berenson recalled that turning point in his life a half-century later in his *Sketch for a Self-Portrait:* "I was sitting one morning toward the end of May at a rickety table outside a cafe in the lower town of Bergamo. The matutinal freshness of that spring, almost summer, day was suited to encourage a young man to look upon the near future with appetizing expectation. Opposite me sat a chum I had picked up the year before in Florence. . . . His name was Enrico Costa. . . . Here was this gifted young man with his intellect, his love of the highest and deepest, and I, who, I must confess, had at twenty vague but radiant hopes of becoming a poet, a novelist, a thinker, a critic—a new Goethe in short. . . . Here we were . . . partaking of our morning meal and enjoying it although the coffee was poor and thin, the bread sour and badly baked and the butter sourer. I recall saying, 'You see, Enrico, nobody before us has dedicated his entire activity, his entire life to connoisseurship. Others have taken to it as a relief from politics, as in the case of Morelli and Minghetti, others still because they were museum officials, still others because they were teaching art history. We are the first to have no idea, no ambition, no expectation, no thought of reward. We shall

give ourselves up to learning, to distinguish between the authentic works of an Italian painter of the fifteenth and sixteenth century, and those commonly ascribed to him. . . . We must not stop until we are sure that every Lotto is a Lotto, every Cariani a Cariani, every Santacroce a Santacroce . . . etc., etc.' " Everything for nearly three years in his wanderings over Europe and especially over Italy had in fact pointed toward this moment of ripeness and self-discovery; the countless hours in the galleries and poring over photographs had produced in him a state of mind on which the meeting with Morelli and the lovely ambiance of Bergamo acted as potent catalysts. Having made this high resolve, the two young men at the café table laid their plans for visiting London.

IX

The Smiths of Friday's Hill

BERENSON and Costa reached London in July and found much to study in the galleries but, as they reported to Morelli, found nothing to buy at the art dealers' shops. Presumably, the purchases were to have been for Costa's collection. Frizzoni wrote from Florence to enlist their help in checking the attributions of several paintings in the Dudley and other collections. He especially wanted Berenson's opinion about a certain painting attributed to the seventeenth-century Spanish painter Murillo, as he and Richter were correcting a list of attributions under Morelli's direction.

If picture hunting had been Berenson's main purpose in coming to London, it was soon overshadowed by his second meeting with Mary Costelloe and his introduction to the exuberant Robert and Hannah Smith ménage. Gertrude Burton had continued to sing Bernhard's praises in her letters to Mary. An intellectual, like Mary, she too advocated women's rights and had published a youthful essay entitled "The Importance of Knowledge concerning the Sexual Nature." She had been one of the Boston University group of girls whom Bernhard had idolized in his sentimentally intellectual fashion. In her fitful correspondence with him the youthful Mrs. Burton kept an affectionate watch over his welfare. Ill with tuberculosis, she had taken refuge in Lausanne. When he informed her that he was not returning to Boston, she reproached him for his coldness to his family. He insisted he had chosen the wiser course and that he really was unchanged. He was sure that if she loved him before her marriage in Boston she would love him still and that he still merited her concern. Whether he stopped off at Lausanne on his way to London is unknown.

Mary had been intimidated by all that Gertude and others had told her of Berenson's intellectual prowess. To prepare herself for his visit

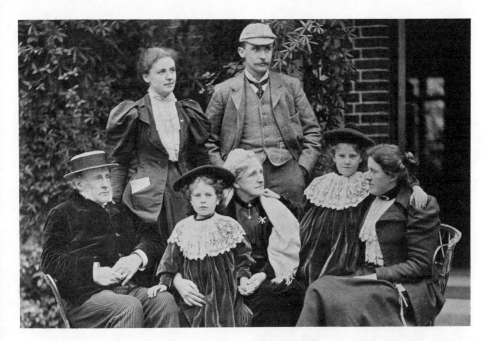

12. *Robert Pearsall Smith family at Friday's Hill, about 1894:* (front, left to right) *Robert Pearsall Smith, Karin Costelloe, Hannah Smith, Ray Costelloe, Mary Costelloe (later Mrs. Berenson);* (back) *Alys, Logan*

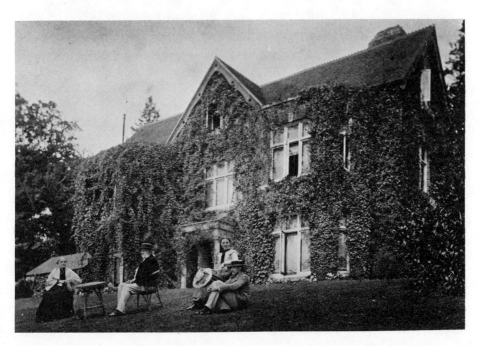

13. *Friday's Hill: Hannah Smith, Robert Smith, Alys, and Logan*

14. *Berenson, early 1890's*

15. *Mary Costelloe, 1889*

the weekend of August 2, 1890, she primed herself for the long hoped-
for meeting by reading the recent sensation, George Moore's *Confessions
of a Young Man*. The stratagem failed for Berenson witheringly com-
mented to his audience, "Oh, that rotten book." He also managed to
make her feel that her conversation was "rather silly and artificial."
However, she forgave his severity because he did admire her new pink
dress and he did dazzle the company with his heterodox opinions on
subjects as varied as Provençal poetry, the *Greek Anthology,* Russian
novels, and Wagner's operas. For a young woman of twenty-six who
had already made her mark in England as an accomplished lecturer on
women's rights and a popular campaigner for her husband, it seemed
an inauspicious encounter. But the vivacious charm which had brought
a succession of beaux to their knees in Philadelphia had its effect upon
Berenson, the idealizer of feminine beauty. Mary was undeniably hand-
some, fair-complexioned and clear-eyed; her bright chestnut hair was
gracefully swept back from her forehead. A Junoesque young woman,
an inch or two taller than he and at 145 pounds a bosomy and alluring
figure, she promptly drew him into her train, in spite of his intellectual
reservations.

The long anticipated encounter took place at her parents' recently
acquired country house at Friday's Hill in the picturesque hamlet of
Fernhurst, some forty miles southwest of London. Lying just two miles
south of Haslemere, the hamlet shared in the literary and artistic associ-
ations of that cultural center. Tennyson, now eighty, was a neighborly
friend. George Eliot had lived nearby, and there had grown up in the
vicinity a scattered colony of intellectuals and artists. Friday's Hill was
an ornate if undistinguished ivy-clad house at the top of a hill adjoining
150 acres of wood and meadow, of which the Smiths had leased 15
acres. The house overlooked the village of Fernhurst. It possessed a
billiard room and a room set aside for "secret" smoking, Hannah Smith
being opposed to such vices. There was also a tennis court and a con-
servatory. Two coach houses sheltered the carriages. The fourteen bed-
rooms never seemed to be adequate for the constant procession of rela-
tives and guests. Thanks to the open-handed hospitality of the Smiths,
their terrace at Friday's Hill during the summer months, with its
sweeping view of the Sussex downs, was a magnet for bright young
talents who came down from London to argue more or less amicably at
the top of their lungs about women's rights, poetry, progress, and
Culture.

Logan Pearsall Smith recalled that in those early days among the suc-
cession of guests "a black contingent of Steins would occasionally
darken our drive, led by the great Gertrude herself. All these would

settle like a flock of birds on our terrace, where tea was provided and the talk was free." George Santayana had already been introduced to the circle by Logan, as had the tempestuous young poet Robert Trevelyan, the artist William Rothenstein, the Fabian socialist Bernard Shaw, and the many literary lights among Logan's friends at Oxford. Bertrand Russell, then a lad of eighteen, was also a familiar figure. He had been brought from his grandmother's home to call on the Smiths by his Uncle Rollo a year before, for Lady Russell's home was only four miles distant. Mary's proud father pointed him out to Berenson: "Do you see that young man over there? He's Lord John Russell's grandson." Russell professed to enjoy his hosts' American "emancipation from good taste." Within a short time he became the suitor of Mary's sister, Alys.

The impression Berenson made upon his hosts during his four days' stay is best told in a letter that Mary's mother wrote shortly afterward:

We found at home as a visitor a young genius named Bernhard Berenson, an Americanized Russian, who is considered by those who know him to be one of the most rising young men of the world. He has devoted himself especially to pictures, and seems to know *everything* about *every* picture that has ever been painted. And the way he demolished the idols of the young people was something perfectly delicious. He proved by the most masterly system of criticism that most of the old pictures they admired were either bad originals or bad copies, and swept away into a place of utter contempt all the modern painters, including Turner, Burne-Jones, Rossetti, the new German school, and in fact all everywhere. He confined his admiration to the sixteenth and seventeenth centuries. It was as complete a rout to all of us as ever I saw. And the worst of it was that his criticisms were so pungent that one was almost compelled to be convinced utterly against one's will. He largely agreed with me about many of the Old Masters, and then I chuckled. But when he came to my beloved modern pictures I was annihilated! He does not paint himself, but is an art critic. You are sure to hear of him some day.

A quaint memento of his first visit is a shaky drawing of a decrepit-looking elephant in Hannah Smith's novel guestbook, in which each visitor was invited to portray his conception of an elephant. It is clear that drawing was not Berenson's forte. Not to be outdone by Hannah, her son, Logan, kept a supply of oil paint, canvas, and brushes on hand so that guests could leave a memento painting of their visit. It would appear that Berenson was excused.

As might be expected, the menfolk were less impressed by the handsome iconoclast. An older British visitor indignantly objected afterward that the "young whippersnapper" had dared to assert that the moon was more beautiful seen through the branches of a tree than seen sailing

across a clear sky. Mary's father did not take to the self-assured young man and was soon scorning him as a "penniless Bohemian." After a while, as Mary and her husband continued their association with him, her father became more outspoken in condemning Berenson as a dangerously seductive influence.

Long afterward, when Mary had been Berenson's wife for thirty years and had begun work on a biography of him—soon abandoned— culled from the thousands of letters they had exchanged, she wrote that Berenson's visit was "like a chemical reaction, precipitating the various elements held in solution in our family group." The elements were indeed highly charged, volatile, and socially explosive. They were an individualistic family of militant reforming Quakers who claimed descent from the secretary of William Penn, the founder of the colony. The "inner light" had blazed with uncommon intensity in both of Mary's parents. Her father, Robert, was the son of John Jay Smith, a successful Philadelphia glass manufacturer who had combined "piety and pence" (in Whittier's phrase) with remarkable success.

Mary's father had been taken into the glass manufactory in 1851 upon his marriage to Hannah Whitall, an equally devout Quaker with a talent for proselytizing. One day in 1867, when Mary was three years old, he felt an overwhelming influx of inner light and left the business to participate in the evangelical movement that was sweeping Europe and America. Having ample means, he and his wife went abroad and spread the Gospel to enthusiastic audiences on the Continent and in England. In Germany the empress sent for him and listened devoutly while he expounded the New Light through an interpreter. The pious nobility and other eminent Victorians welcomed them with Christian fervor. At that time Hannah's *The Christian's Secret of a Happy Life,* though only recently published, was already on the way to becoming a classic of Christian evangelism. Unfortunately, at the moment of their greatest success in England, Robert's caressing manner with some of his women converts set British tongues clacking and the Smiths hastily retreated to America.

Hannah became the prolific author of Bible Reading Leaflets, which she prepared as superintendent of the evangelistic department of the recently founded Women's Christian Temperance Union. She was a close friend of its president, Frances Willard, and was also a strong advocate of women's rights. She was ambitious for her three children, especially for Mary, for whom she envisaged a great career as a leader of women. As a militant feminist, she brought up her children as thorough individualists. Their moral idealism had a strong Emersonian coloring savoring much of "Self-Reliance." As a schoolgirl Mary

shocked her elders at a Baltimore parlor gathering with a lecture titled "The Duty of Self-Development." Moral self-examination occupied much of the family's thoughts and filled their letters to each other, letters in which the omnipresent "thee" and "thou" seem curiously archaic in the context of their own advanced social views.

The sense of moral duty placed a troubling burden on Mary's affectionate nature. Incurably romantic and like her father buoyantly enjoying her own emotions, she liked nothing better than reciting poetry in the music room of the family home in Germantown to the young men who called on her. She left Smith College after two years and subsequently enrolled in the Harvard Annex in 1884, two years after its founding as the Society for the Collegiate Instruction of Women and ten years before it became Radcliffe College. There the most persistent among her various admirers was the professor of Greek, George Herbert Palmer, "a queer little figure" with an immense mustache, in whose course she happened to be the sole girl. Her mother had particularly approved her transfer to the Annex so that she could keep an eye on her brilliant but dilettantish brother, Logan Pearsall, who had also enrolled at Harvard. She had kept a riding horse and maintained something of an establishment at Smith, where she managed to spend the sum of $5,000 in a single year, a fact that would suggest that Logan should have been charged to keep an eye on her extravagance. She had hardly begun to attend regular classes at the Annex when suddenly in September 1884, she met the darkly handsome Anglo-Irish barrister Frank Costelloe. Costelloe had come over to Montreal to attend a meeting of the British Association for the Advancement of Science in August, the first to be held on the American continent. He had become a member of the association in 1883. As the American Association for the Advancement of Science was to meet in Philadelphia shortly afterward, more than two hundred Britishers came down from Montreal to attend the proceedings, Costelloe being one among them. Many of them were housed by hospitable Philadelphians. Costelloe and several of the scientists stayed with the Smiths. Mary went, as she said, "to one lecture room after another" and "managed to look intelligent." She accompanied the new friends from England on a tour of the Annex at Harvard and promptly fell in love with the Irish barrister who was nine years her senior.

Costelloe had been born in Ireland and had early identified himself with the cause of Irish Home Rule. A devout Catholic, he had written a number of articles on theological matters, including one on the meaning of the Mass. He had long interested himself in the conditions of the London poor, and his reformist ideas appealed to Mary who had been

bred to philanthropy as a way of life. Besides, he was an intellectual and undeniably brilliant, having taken a double honors in philosophy and the Greek classics at Balliol, where he had been the favorite pupil of Benjamin Jowett. Mary had also immersed herself in philosophy and the Greek classics and she was now imbibing Professor Josiah Royce's version of Emerson's idealism.

Taken with her beauty and wit, Costelloe began a whirlwind courtship, and after a few months Mary was faced with the necessity of choosing between him and Professor Palmer. In November she still talked of completing a year at the Annex, and of then studying philosophy and sociology at Oxford. Thereafter she planned a year in Germany devoted to music, and on her return to America intended "to work for God and home and native land." But by the end of February 1885 she had accepted Costelloe's cabled proposal, and she wrote to an English friend that she hoped to marry and live in London for the rest of her life. Still for a time she wore Palmer's roses to placate her parents. As evangelical Protestants and only slightly lapsed Quakers, the Smiths were naturally horrified at the possibility of her marrying a Roman Catholic. Her distraught father took to his bed for a time. For a while her parents consoled themselves with the faint hope that Costelloe might leave the Church. Their earnest but tactful opposition only strengthened Mary's desire to make the dramatic experiment. What good was the freedom of thought and openness of mind which she had been taught at Smith College and at Harvard if she were afraid to try the challenge of a different religion. Besides, her parents had to concede that Costelloe had great personal charm and was infinitely thoughtful and considerate. The couple did agree to delay the marriage for several months while Mary and her sister, Alys, visited England to give Mary a last chance for sober reflection. That expedient proved as futile as all the others. Reluctantly, her parents consented at last to the marriage, though her mother was much disappointed at her dropping out of college and thus jeopardizing a brilliant career.

The family sailed for England and in spite of Mary's and Frank's desire for a quiet wedding, her father with his usual extravagance arranged for a lavish one, believing that the happy occasion should be shared by all their English friends. Mary had to become a Catholic, of course, quite as her mother had repeatedly forewarned her with full citations from Catholic authorities. The wedding was held at Oxford on September 3, 1885, immediately following Mary's baptism at the Jesuit house there. A special car was attached to the express train to bring guests up from London for the sumptuous wedding breakfast in the great hall of Balliol College, Costelloe's alma mater. Professor Ben-

jamin Jowett, the Master of Balliol and Regius Professor of Greek, gave a congratulatory address honoring his favorite pupil and the American bride.

The marriage seems to have gone well during the first few years. Mary may, of course, have been somewhat on the defensive when she spoke of her happiness. Marriage, she declared in one of her daily letters to her mother, brought "infinite peace and satisfaction." It gave one a chance to approach "perfection in every detail," and besides, she added, "It's such fun." She and Frank would sit by the firelight and have "a lovely time examining in a purely scientific way all our feelings," a hazardous amusement as it turned out. In the past her life had been given "to revolutions of all sorts, cutting loose from all standards." In Costelloe she had found "a great and strong and wide character that has grown up without revolutions and spiritual storms." Her mother, she insisted, had been quite wrong to be pessimistic. When someone asked Frank whether their marriage would last, he had replied, "Will our souls last?" He was so good he made her think of Wordsworth's "Happy Warrior." She enjoyed going to mass on Sundays and for a time there was even an agreeable novelty in submitting to her husband's authority.

She professed to find it easy to adopt her husband's conservative moral views and changed her mind "about many wild theories" she had held in college. She had admired Walt Whitman and was still his friend, but she could no longer accept his charge: "Henceforth I ordain myself loose of all limits and imaginary lines." Once she had approved divorce and even the right to suicide. She had praised the liberal-minded Goethe and even the adulterous George Eliot. But now she agreed with Frank that anyone who does anything "to upset the foundation of moral and decent society which is contained in marriage is doing *absolutely* wrong." It was "better that individuals should sometimes suffer than that society should run the risk of going to pieces."

Having studied philosophy, Mary loved to discuss questions of ethics with Frank, whose Jesuit training was more than a match for the facile idealism inculcated by Josiah Royce. On the question of marital authority Mary now found herself at odds with her militant mother, who had always insisted on the principle of marital equality. Mary now countered with Frank's distinction between moral equality, which carried the Platonic proviso that "it is the duty of the one with the highest moral nature to yield his or her claims," and legal equality, for which Mary's mother and Frances Willard were campaigning. Frank's view, said Mary, was that since man was generally the business head of the family and bore its responsibilities, the whole theory of "the solidarity

of society" required a law that fixed responsibility on the husband; some law was obviously better than no law. Tampering with the present system of marriage would only lead to worse evils. These ideas which Mary thus pressed upon her skeptical mother with wifely enthusiasm were the very ones that in a few years would become anathema to her.

When her mother expressed regret that Mary's marriage had cut short her college career and spoiled her chance of studying music and philosophy in Germany, she replied that she had no intention of neglecting these accomplishments. They would come later, "When I have learned other things as well." Then she impishly concluded, "Besides which think of the fun of having B.F.C.C. [Benjamin Francis Conn Costelloe] to rule over and to feel I am really living a useful life. Yahoo!"

Her usefulness had begun immediately after the wedding, for Frank had agreed to stand for Parliament for Edinburgh as a Gladstone Liberal, and Mary found herself in the midst of an exciting campaign. They both ardently supported Gladstone's Home Rule plan for Ireland. Soon she was swept into service as a campaigner. At one meeting the crowd, impressed by her good looks, insisted that she address them also. Her impromptu speech went well and other meetings were arranged for her. Before long Frank was employing her as a typist, dictating political speeches and legal documents for her transcription. But the battle for Home Rule and more democratic British elections brought no financial rewards, and Mary's father worried about their unpaid bills. Mary had her allowance of £300 a year but never lived within it, since there had always been ample money at hand in the Smith household.

Now Mary was requesting fresh advances. Her father demanded a full accounting, not having forgotten her extravagance in college. Frank dutifully pointed out that the political activity would in the long run benefit his law practice. He reminded his father-in-law that a barrister was peculiarly handicapped. It was unethical for him to dun his clients. He also explained that he earned some money as a writer for the *Pall Mall Gazette* and other papers "as an expert writer on social philosophical subjects." He felt confident, he said, of an income of £400 a year as a starter. Full of optimism, Mary exulted that if Frank won it would mean "Radicalism." And, unable to repress her high spirits, she added her schoolgirl exclamation, "Yahoo!" "When Frank is a Cabinet Minister we will together demonstrate to thee the falsity of thy opinions." She and her husband had, however, underestimated the British fear that a self-governing Ireland might one day ally itself with a hostile power. With the election lost, Mary and Frank consoled themselves with

the thought that at least he had made himself widely known as a powerful speaker and that Mary had also made her mark both as a political speaker and as an advocate of women's rights (with certain reservations) and, at her mother's behest, an advocate of temperance.

The pair took a holiday trip to St. Petersburg and tramped through the icy halls of the Hermitage to view its art treasures. For Mary too had felt the influence of Charles Eliot Norton and had caught the virus of art appreciation like the other members of her family. The study of art had early become one of the moral duties of life, to be enjoyed but to be taken very seriously. From her earliest childhood, debates over the relative merits of paintings were a staple of conversation in the household. On their return from Russia, they settled down in the house at 40 Grosvenor Road, generously furnished by her father. She returned to the study of Greek and resumed her piano lessons. She tried translating Plato to improve her English style. She helped Frank in the preparation of his cases for trial and assumed the role of a London hostess at first dutifully and then with lively relish. They continued to live beyond their means since Mary, as usual, could count on advances from her father to make up her deficits and did not hesitate to call on him. As time went on Frank seemed to her to become even more of a model husband. His good nature, she explained to her mother, "springs from such a reasonable and exalted moral ideal character and life that it is inspiring rather than indulgent." Still a romantic bride, she boasted that his habits were as easy to change as a child's. In her ceaseless confidences to her mother she told of their constant discussions of politics and morality, and though she invariably professed acceptance of Frank's superior wisdom, her mind was far too active and restless to surrender its depths, where lurked resistances that love concealed. Brought up in a household committed to frank self-examination, she parried her mother's anxious inquiries in one letter with the disarming admission that she was "in no sense a genius . . . yet I have a very keen mind for logical inconsistencies and for vagueness that cover inexact thinking. I am good at destruction though not at construction—all my philosophic teachers have told me that." These were qualities that would have an important effect on the career of her new friend Bernhard Berenson.

In Philadelphia Mary had been secretary of one of the sections of the Women's Christian Temperance Union. Now she became the British secretary of the Union and was soon in great demand as a speaker. In 1886 Frank tried again for Parliament and Mary threw all her energies into the campaign, speaking once more on Irish Home Rule, representation of women on the county councils, and the need for more local

control of government. Frank made a good showing but failed again to win a seat.

Their first child, a daughter named Rachel Conn, called Ray, was born in June 1887. It was an extremely difficult birth, a foretaste of the medical troubles that were to plague Mary for the rest of her long life. She was now twenty-three and for the moment she felt a sense of joyous fulfillment. Her letters to her brother, Logan, who was beginning his literary career, bubbled with playfulness and gaiety. Baby or no, there could be no let up in self-improvement and moral uplift. She added the study of German to music lessons and her Greek studies. Art also had to be mastered. Armed with a notebook and a fountain pen, she set to work to make her own original catalogue of the paintings in the National Gallery. She told her father, "I hope to get all through the Gallery in time and to know it as well as my own drawing room." Soon she was able to earn a little money by taking small groups of women on lecture tours of the gallery or on occasion by giving a lecture on the treasures of the Louvre, which she had visited with Frank.

Meanwhile, she and her husband found themselves "verging rapidly," as she said, "towards Socialism, a kind of socialism which may in time completely revolutionize my life." They had been caught up in the movement that had been inspired by Henry George's lecture tour advocating the "single tax." A further impetus came from Edward Bellamy's socialist Utopian novel *Looking Backward,* published in 1887. The Fabian Society had already come into being. In 1885 Bernard Shaw joined the London branch of the Society, where in quick succession he was joined by the young lawyer Sidney Webb and the schoolteacher turned political psychologist Graham Wallas. All of these young men were under thirty, and the Costelloes quickly found themselves at home among them. Sidney Webb, an "undersized little man," bearded and foreign-looking, became a frequent visitor at the Costelloes, as did Graham Wallas. Webb had not yet married the tall and beautiful Beatrice, who was to become his famous collaborator in the Society. Frank contributed his bit as a lecturer for the Society. Mary took up the cause with characteristic enthusiasm, avidly read the socialist pamphlets, and made her first "big political speech" at Dulwich near the end of 1887, Frank having stayed home with the baby.

The crowded and exciting years since her marriage in 1885 had passed swiftly, interrupted by occasional holidays, such as a long tricycle trip in England or a tour of the cathedral towns of France or the visit to Russia. Money worries continued intermittently because Mary's taste for luxuries remained a large obstacle to effective economizing. Since

her brother, Logan, was also established in England, devoting himself to a dilettante education and the writing of Jamesian pieces, their parents decided to leave Philadelphia and settle in London. The third child, Alys, remained safely cloistered at Bryn Mawr College.

Early in 1889, while expecting her second child, Mary was again drawn into Frank's political activities, now modestly reduced to standing for a seat on the Stepney County Council. At the same time she continued to drive herself with cottage meetings for women's rights. Her heart, however, was no longer in the game. "A woman who is going to have a child," she privately noted, "ought to be removed from all care and responsibility. . . . It was *wicked* beyonds words for us to dream of having a child if we were not prepared to give up something for it." Frank "is not prepared to give up any of his activities or pursuits to help me lead a quiet, restful, healthy life. We had no Xmas holiday, we never have an evening and he is always behindhand and worried with his work, and of course I am dragged along in his wake. I cannot live a separate life. But this has been misery for many months back." Frank won his election, "a good legal investment," Mary reflected, since few barristers were on the Council. He felt at last in his element and was to remain a member of his "beloved Council" for the rest of his life. His naive delight put Mary in mind of a character in Carlyle's *French Revolution* who felt "a predestination for the highest offices." She mused prophetically, "I do not feel the same predestination."

Her second daughter, Karin, was born in March of 1889, an easier birth than she had feared, since the doctor, knowing her "physical peculiarities," had used ether. Nevertheless, her strenuous life took its toll. She shortly afterward suffered some sort of nervous breakdown and her mother took her on a month-long tour of Europe to recuperate. A "cure" was actually effected, Mary believed, by a pair of spectacles which she obtained as a result of one of her mother's hunches, and she promptly wrote an article, "A Word to Overworked Women," based on her experience. Published in the *Pall Mall Gazette,* it brought her two pounds, ten shillings. A newspaper article in the *Home Reading Union* brought her another pound. At the same time she continued to be swamped with "Conference Work," resulting from her activities the previous year in organizing a "Women's Liberal Association" for Westminster to encourage women's participation in politics. She was elected president of the association. She also presided or spoke at other reform meetings. At one rally she shared billing with the famous radical member of Parliament Charles Bradlaugh "and other eminent speakers."

Her datebook, which she kept methodically, as was her habit, records a constant alternation between her London residence and her parents' country place at Friday's Hill, with forays to a dozen places to read her popular lecture "The Position of Women in America." It was a "bright and clever sketch," according to a reporter of the *Girton* (College) *Review,* which revealed the absence of convention and solidarity in the United States, where children held religious views at odds with those of their parents and where young women went about freely with young men, had easy access to the family purse, and when grown went into philanthropic work or a profession. An interviewer for the *Women's Penny Paper* gratefully reported being granted a quiet hour at breakfast with Mary and her husband. "Mrs. Costelloe," she wrote, is "one of the busy women of the world" who "had the good fortune to marry an extremely liberal man, who is deeply interested in all the questions that vitally concern our sex." Her mother, Mary is quoted as saying, "is exceedingly liberal-minded, and we were brought up to think and act for ourselves." Mary had camped two summers in Yellowstone and two at Yosemite. "Her political creed consisted of support for the Liberal Party, Irish Home Rule, votes for women, and electing women to the County Councils."

If anyone personified the new liberated young women, it was Mary Smith Costelloe. In one of her articles in the London *Star,* she boldly predicted that women's suffrage was inevitable. In the advanced and even radical circles of London she was accepted on equal terms with Sidney Webb, Graham Wallas, and Bernard Shaw and met familiarly with such literary figures as Oscar Wilde and William Morris and with the troop of young talents whom her brother, Logan, brought down from Oxford. She also became a friend of Katherine Bradley and her niece Edith Cooper, who published their poetical effusions under the pseudonym Michael Field.

Her most famous literary friendship had begun with Walt Whitman when she was still a college student. She had prevailed upon her reluctant father to take her and her brother to visit Whitman in Camden. Her father's disapproval quite vanished in the presence of the poet. At the end of the visit Mary's father had impulsively invited Whitman to return to Philadelphia with them and just as impulsively Whitman accepted. He stayed on for a month and thereafter was a frequent visitor. Mary became his favorite, his "bright particular star," he called her. She seemed to him "almost an anarchist" in her outspoken advocacy of social reform. In the summer of 1885, shortly before her marriage, she told him of the Toynbee Hall meetings in London at which she felt herself being drawn into the women's reform movement. He approved

"these libations, ecstatic life-pourings for humanity's good." But as the years went by and he sensed the almost feverish intensity of her involvement, he admonished her, "Don't invest thyself too heavily in those reforms or women's movements over there—*attend to thyself*—take it easy."

During his lonely illness Mary wrote her mother, "Whatever you may think of his poetry, he is a great genius and a genuinely good and beautiful old man. . . . I think I appreciate the greatness of his character now even more than when I was in the most ardent period of discipleship." When she sent him a clipping of a newspaper piece she had written for the *Pall Mall Gazette* about his Camden entourage and told him she was planning a "reminiscence" of him, he cautioned her, "Don't make me too good. I am no angel by a long shot." Once, in talking to Horace Traubel, Whitman remarked that Mary had thrown herself into public life in England with such energy she had "almost swallowed the whole camel. . . . It was just like Mary; just what might have been expected of her impetuosity, ardor, which is of a high order."

X

The Path to Monte Oliveto

BERENSON'S dramatic entrance into the Smith–Costelloe circle produced, as Mary said, a kind of chemical reaction, and on no one was the effect more agreeable than on Mary herself. The practice of continually subjecting her opinions on moral and philosophical questions to the judgment of her authoritarian husband had lost whatever charm it once had. Moreover, the endless theological discussions with Frank, who had never given up hope of completely eradicating all trace of the Quaker skeptic from her nature, had with frequent repetition lost much of their attractiveness. Mary had found it increasingly unpleasant to be a perpetual candidate's wife catering to the insatiable political ambition of her husband. The trait that his mentor, Jowett, had deplored had come to dominate his life. "It is most important in this world, Costelloe, to be pushing," Jowett had advised him, but, he cautioned, "it is fatal to seem so."

Six months before Berenson's arrival on the scene, Mary's discontents overflowed into page after page of despairing reflections in her journal on her husband's total lack of understanding of her needs. It seemed ironic that he could boast of the success of their marriage in the face of her manifest unhappiness over his incessant demands upon her for help in his law practice and his political campaigning. In the beginning these activities had been exciting and flattering to her self-esteem, but the dream of soul fulfilment which she and Frank had so rapturously shared faded in the glare of political meetings and duty entertainments. Their high-minded plan to seek "soul and philosophy" by writing a book to be their private guide had ended in her husband's reducing her to typing his dictation. "My bitterness came to me," she wrote in her journal, "when the book, too, began to be turned out with a view to the public." He would earnestly promise that they would

have their evenings free together and then dash off to his meetings and lectures. His militant Catholicism grew irksome as well, for she felt he did nothing to make her conversion stick. "I will not play the lie any longer of pretending to be a Catholic," she resolved. The many pages of her private recital of her grievances circled round and round the central point that there was no real equality in marriage. The husband "absorbs *the whole* of a woman's life." His interests and desires always take precedence. It had been a mistake, she concluded, to have put her life into his hands hoping for enlightened guidance.

Berenson's arrival at this moment of despairing self-sacrifice and stifled discord must have struck Mary and Frank as a providential diversion, freeing them from their interminable arguments over their way of life. Berenson was an ingratiating and elegantly handsome young man, an immensely sophisticated cosmopolitan, and, to Mary, a charming reminder of the freedom of her American girlhood. There was an attractive strangeness about him, an air of mystery and foreignness. It intrigued his hosts to learn that he was a Christianized "Polish Jew." In the first days of their acquaintanceship in the late summer of 1890, Berenson fascinated them with his bravura monologues on poetry and opera and, as Mary noted, "a hundred other enthusiasms and interests." As for Italian art, it was "already for him almost too professional for drawing-room conversation."

The entries in her datebook march neatly down the page that season, one precise entry succeeding another—suffrage society meetings, Christian conferences, speeches to be given, Fabian soirées, a visit to Oxford with the novelist Mrs. Humphry Ward, and then on August second, in large capital letters, the talismanic name twice underscored, BERNHARD BERENSON, an entry that soon became simply "B.B." He joined them for Sunday mass, which in his company took on a fresh, if ambiguous, meaning. The days went by and "talk" alternated in the record with "much talk." On a visit to Petworth House in West Sussex with her, her father, and Logan, Berenson astonished them by pointing out that the pictures were "mostly frauds." Up in London "B.B." and Mary began to haunt the National Gallery together, where he initiated her into a new way of seeing and gathered her into the Morelli fold.

Costelloe, busy in his law chambers, naturally could not join them, and the two art lovers soon became inseparable companions. Costelloe himself grew more and more taken with the young aesthete. He saw in him a soul to be saved for his beloved Church, and he plied him with his scholarly tracts on Catholic theology. Mary and Bernhard called one day on the aged Lady Eastlake, who had completed her late husband's influential book on religious paintings. Mary recalled how they "shared

their breathless excitement" as Lady Eastlake told how she and her husband had "turned pictures to the light from the lumber room of the Uffizi and whispered incredulously to each other 'Botticelli—Fra Filippo.' Bernhard and I looked at each other with shining eyes that confirmed each of our secret resolutions to follow in our humbler way the example of Lady Eastlake."

Bernhard returned with her to Friday's Hill to join the family for ten days, and the single entry "talk" went descending down the page of her diary. Frank listened indulgently as the two younger persons tirelessly explored each other's views on art. Sidney Webb was also a house guest, so that Berenson found himself exposed to the ardors of Fabian socialism, a subject which invariably roused him to defend the superior claims of high culture. "Culture has been my religion," Bernhard explained to Mary one day after she sent him one of Webb's Fabian pamphlets. "It is awful to think that I have no right to all the culture I can get." True culture simply could not coexist with socialism. He could not give up his ideal, which was not the superficial "Boston thing, but the real selfish passion" for training oneself to ascend to the very highest beauty. It was a work that required the "dignity of idleness," the opportunity for learning and meditation.

Early in September Berenson and the Costelloes crossed to Paris, where they were joined by Professor Bôcher. Again Berenson played cicerone, happily explicating in his softly modulated voice the beauties of his favorite paintings in the Louvre. The hypnotic talk continued in the Luxembourg Gardens and the Tuileries. After a conversation on the Pont d'Austerlitz Mary noted, "His words are golden." Their delight in each other's company was interrupted for a week while she cruised the Loire through the chateaux country with her husband. They returned to Paris, and once again she fell under Berenson's spell in an intimate talk in the Bois de Boulogne. Mary and Frank left for London on September 21, where she picked up her old activities with, on the surface, unimpaired enthusiasm. The speaking tours resumed and the political caucusing. Berenson went off to Germany with Costa, where they made a systematic reconnaissance of Frankfurt, Cassell, Berlin, Dresden, Vienna, and Budapest, preparatory to returning to Italy.

Berenson dispatched a veritable torrent of letters, often running to sixteen pages at a posting, in which he analyzed for Mary every important painting he studied. In a characteristic letter from Dresden he wrote:

There is nothing here to remind me of real life, of drudgery, of all that embitters existence elsewhere. I could live here for months and see nothing but the

[121]

Zwinger, the gallery, and the opera house. One can live here as Buddha did in the city from which every disagreeable sight had been removed. . . . In spite of my thorough acquaintance with the gallery I found a good deal that surprised me as if I were here for the first time. . . . The Sistine Madonna seemed so much greater than my recollection of it. . . . Costa, I think, used to fancy that I was more than fair to Raphael. I am sure that he sees now that Raphael was not merely the most perfectly balanced of painters, but also the greatest in conception. . . . We stopped just a minute or two before the masterpiece of all schools and then we went to work. I took up Dosso in whom my interest is greater than ever because of the portrait in Berlin. . . . Dosso was first a pupil Of Mazzolino, himself a pupil of Tura. . . . Correggio must have come early in his life under Dosso's influence. . . . In the upper part of the picture Dosso has tried to do something which anticipates the methods of later masters such as Rembrandt or Velasquez. These painters, Velasquez especially, are remarkable for having been among the first to notice that to get the real effect of an object in painting consideration must be taken not only of the object itself but what is between us and the object we are supposed to be looking at, that is to say, the atmosphere.

The two young connoisseurs did not always agree on their attributions and their spirited debates occasionally echoed in the letters, with Berenson usually the victor. Following Morelli's lead they challenged attributions wherever they went, acquiescing in an identification only after applying their tests. On one occasion Berenson encountered the original of a large framed photograph which he had given to Mary under the impression that it was a Botticelli. He now reported his mistake. Mary promptly took down the photograph from its place of honor.

Berenson's departure left Mary with a deepening sense of discontent; something vital had gone out of her life. Open-hearted as she was, she felt their separation more keenly than she liked to admit. Their feelings had obviously passed from those of friendship to something far more absorbing. "You did no wrong," he wrote from Cassell, "in letting me see how much you hated our parting. You are the one reality for me, and if I could not have hung on to that I don't know what I might have done." He reproached her for having thought that he had used her for his "education sentimentale." The truth was, he insisted, that he took her very seriously indeed. It made him happy to know that "to someone in the world my mere existence gives pleasure." Having given him her affection, Mary could not resist the impulse to try to improve him, a habit that would grow with the years and embrace in its benevolent net many of their friends. She joined the chorus urging him to make of himself something more than a brilliant dilettante of art. She urged him to begin to write about art. He responded that the feeling of a painting was so wonderful that to put it in words would be "almost indelicate."

She wrote anxiously to Gertrude Burton, "He needs ordinary ties and duties. It is quite extraordinary what a faculty he has of making people love him. They pardon him all his faults because he is so utterly delightful. I feel terribly worried about his future and yet he does not like to be reminded of it. I understand him so well because I care for him so much. He has quite filled my thoughts—our thoughts—this autumn." In another letter she added, "I do feel he ought to take thought for the future, that he is bound in honor to make some use for the world of the talents and opportunities so freely lavished on him." At the same time she sympathized with his ideal. "He feels, and I think with reason, that a few years more of the cultivation of the enjoyment and appreciation of beauty in Italy would give him that exquisite and rare culture which only one person in a thousand could attain. Because it is so beautiful he dimly feels that it must be of use to the world . . . whether he does anything useful or not." She conceded, however, that the great flaw in his ideal was his ignoring "the moral and social elements."

Mary confessed that she knew him "too well for my comfort." She believed that he would not go back to America. "If he would begin to work even here [in London] I would be overjoyed. Of course he does work on pictures, but I mean money-making, practical work. The mere suggestion fills him with disgust." His letters to her, she remarked, "when not about pictures have been diatribes against my ideas of duty and helpfulness. . . . It is *simply impossible* for me to express my concern about it all." The trouble was, she said, that he found so many clever ways of ridiculing her social ideals, saying that from the aesthetic point of view the attitudes of practical people and reformers were absurd. He insisted that they were not only absurd but personally destructive. "At times it pains me more than I can tell you," he wrote, "to think of the life you are leading. . . . Your activity seemed to me in many ways suicidal. . . . Sometimes I think that if a person ever arises who will absolutely enjoy all that the world has to offer his example will save the world." He cautioned, on the other hand, "I don't have much faith in the perfectibility of man. Nature will out. She is the supreme cynic."

The life he had been leading in the world of art, he argued, "has not been in any way a preparation for life in London. To have made it that I should instead of looking at pictures the greater part of the day have closed my shutters at midday, lighted the gas, and written about pictures. . . . It is so much easier writing about pictures after spending half an hour over a hundred." In the face of his resistance she hit upon an expedient that she thought might advance his career. She told Ger-

trude that she was keeping all his letters and numbering them so that a book could be made from them. Not until forty years later did she attempt that task. By then the sheer mass of correspondence proved unmanageable. Merely in the few months that elapsed between their parting in Paris and his return to Florence, he sent her eighty letters comprising some six hundred closely written pages, virtually one hundred and fifty thousand words of commentary, and these proved to be only the beginning.

For all his protestations Berenson nevertheless knew that he could not go on much longer in his present fashion. And so from Vienna he wrote that on his return to London he intended to "devote as much time almost to writing as I am giving to pictures here. Perhaps before I am left to my own resources I may have attained to sufficient skill in writing to earn my living by it. If not, there is America with its arms always open." Undiscouraged by his evasions, Mary sent him socialist pamphlets in the hope of arousing his social conscience. He remained unimpressed. He marched to a different drummer and was determined for his part to make *her* fall in step. Like Whitman, he urged her to give up her politics and Movements and attend to her own self-development. To her practical arguments he would respond with unworldly meditations: "Life should not outlive an exquisite moment. I can't forgive myself for waking up from the dream into which a very beautiful thing puts me. If only one could fade away at such a moment, become one as it were with the beautiful thing one was enjoying life would be a delightful affair." It was difficult for Mary to oppose his raptures when one side of her romantic nature and her very enthusiasm for the emancipation of women made her susceptible to his liberating doctrine.

Berenson continued his study tour with Costa late into the autumn of 1890. As he worked his way west through northern Italy, after spending a few days in his beloved Venice, he began a systematic hunt for the paintings of Lorenzo Lotto, then one of the neglected masters of the Venetian school, and he trudged from one village church to another in the vicinity of Bergamo in quest of his many altarpieces. At Vincenza early in November the two friends reluctantly separated. Costa went on to Milan to see Morelli for the last time and then set out for Madrid and the Prado museum. Bernhard pushed on toward Budapest.

The autumn tour with Costa opened a new period for Berenson of the most concentrated sort of analysis of Italian paintings. As the more historically minded student, he insisted on the importance of tracing influences and indebtedness; Costa, more evolutionary in his approach, argued the importance of the shaping power of environment, citing

Buckle, Taine, and even Morelli. Berenson retorted that Costa was reducing art to "a kind of flower of a lowly turnip." But as Berenson moved on alone, the puzzles of attributions grew no easier of solution. The gallery at Budapest posed a particular challenge, for there for the first time Berenson became involved in the long-standing riddle of Giorgione attributions. In the midst of one of his essay-letters to Mary, he asserted:

There was no Giorgione at Buda-Pest. This sounds like the heading of a leader does it not? But there are none! My first look yesterday at the picture Morelli attributes to Giorgione was very disappointing. Still I thought that ruin and repaint might account for my impression. . . . I know Giorgione's manner so well, I have felt him so thoroughly that from Morelli's description I conjured up a picture the like of which for beauty was never painted. . . . I thought of the exquisite effect of the sunrise, of the mystery in the air, of the newborn infant, and the shepherds starting back in "wild surmise" at the sight of him [the newborn Paris]. What do I find? . . . The legs are drawn as badly as possible. The feet are impossible. The hands are horrible. The faces are better, quite Giorgionesque in character and conception, although one shows his teeth, a rare trick in Italian painting. The landscape scarcely exists. . . . I concluded therefore that it is only a fragment of a copy of a Giorgione which certainly existed, as we know from the sources. In the beginning of the century while the Germans were talking about the what-ness of pictures, the Italians were already looking up the documents.

He went on to translate the description of an engraving of the picture to show that the Budapest painting was a copy of the lost painting. His identification of the painting as a copy was independently supported many years later by Giuseppe Fiocco, an art historian specializing in Venetian painting. Nevertheless, a doubt still lingers, as in countless other cases, because, as a still more recent historian, Luigi Coletti, remarks, "the many repaintings make it very difficult to express an opinion."

Again and again as he went along Berenson contested the traditional attributions, but for all his "science" he was unable to avoid occasional errors, errors that he would afterward be driven to acknowledge were inherent in even his remarkable method. A case in point concerned another famous painting at Budapest, the so-called *Portrait of Antonio Broccardo*. "At first sight," he wrote to Mary,

I thought I must bend to Morelli. It makes me more uncomfortable than I can tell you when I can't agree with him. . . . But he was here fifteen years ago and only for a day or two so that he may have been rather hasty . . . [and] let the writer run away with the connoisseur. He calls the face "very fine" and "noble." "The melancholy of this face weighs upon your heart . . . as if he

wished to confide to you the secret of his life." I don't find any of this. . . .
[The left hand] is not at all Giorgionesque. The portrait is very Giorgionesque,
but I should never have thought of calling it Giorgione. . . . This Broccardo
was born in 1502, so that the portrait could not have been painted before 1527.
Giorgione was already fourteen years in his grave. . . . Pulski [the director of
the gallery] believes that Titian painted it. . . . But I think I can come nearer
the truth and perhaps get the whole truth. The ear is very distinct and it is the
ear of Pordenone. The drawing and coloring, the lights and shadows are also in
Pordenone's manner.

Morelli had actually been somewhat cautious. Because of the condition
of the painting he had declared it was difficult to recognize the manner
of the master, nevertheless he "preferred" to regard it as a Giorgione.
Four years later, in the first edition of his *Venetian Painters* (1895),
Berenson decided to assign the portrait to Giorgione and maintained
that ascription to the end.

The meticulously written letters strayed occasionally into such per-
sonal observations as that he was learning to be optimistic about life
and taking it seriously thanks to Mary, that her long letters did not re-
ally bore him but were an inspiration, that at last he feels he is "cared
for in a way that I like." While the leaven of his instruction was plainly
working in her consciousness, he vehemently resisted her persistent ef-
forts to steer him in the direction of social service, to have him become
a moral light to the world as a teacher and lecturer. When she sent him
a volume of Fabian essays, he singled out one of Bernard Shaw's for at-
tack. "Mr. Shaw falls into the fallacy of believing that a diagnosis . . .
is a cure or at least that it shows the way to a cure. . . . In my opinion
nine-tenths of all the monstrous fallacies of this century . . . are due to
it. Mr. Shaw's attempts to rise to moral heights are perfectly ludi-
crous." Even while he tactfully protested that he did not think that
Mary was really trying to interfere with his life, he more than paid her
off in her own coin—and far more successfully—by urging her to think
"very much more than you do on self-culture and enjoyment," for she
risked killing a large part of her nature by thinking these things "crimi-
nal" or "sinful."

The enigma of his own personality continued to haunt him wherever
he went in his wanderings, and he seemed as much in quest of his own
identity as of the identity of the painters he was studying. The under-
note of his voluminous and disarmingly self-conscious letters during
these months seems always to have been: Who and what am I? He
poured out his doubts and inner conflicts to Mary. A letter from his sis-

ter Senda which forgave his decision not to return home made him feel "unloving" and "selfish." He mused:

At home I liked her because she was beautiful. Then when I came abroad I got to care for her so much more until I began to analyze my feelings . . . and to dread that it was a sham. After all, I knew her so little. I knew my own heartlessness. My scepticism was universal. I knew how much distance can do to make a sort of artificial affection to spring up. . . . I felt anxious and eager to know the truth. It was that more than anything else that made me wish to go home. As for my sister she never could have felt sceptical about me. . . . I knew that from the moment she found she really did not love the man she was going to marry, all her affections were concentrated on me. [The marriage did fall through.] . . . I wrote to someone not so very many months ago that I believed as little in love as I did in God. It was quite true. How I wish it were all false now! You don't know how I long to be real, how hard I am trying. But I so escape myself the moment I begin to analyze. You have done so much good because I have been able to take you without analysis and cynicism. You are teaching me really to care for people, steadily and constantly and not in flashes of idle emotion.

In this fashion on many a lonely evening in a country inn with his day's notes beside him, he would spin out the vagrant filament of his thought, compulsively savoring its complexities and contradictions.

With Costa off to Spain Berenson made his way back to Florence by the end of November 1890. Here he teamed up with the equally irrepressible Charles Loeser, who was also developing into a connoisseur, but one whose affluence permitted him to become a collector as well. Choice as Loeser's collection would become, his attributions reflected his somewhat eccentric temperament. On his death in 1928 he left thirty works of art—the main part of his Italian collection—to the city of Florence to be exhibited in the Palazzo Vecchio. A friendly critic noted that "a certain amount of discussion will no doubt arise about the attributions given by their late owner to some of the works," although the collection is of "great beauty . . . and value."

Berenson and Loeser took an apartment with a "palatial" sitting room in the same imposing edifice where Berenson had lodged the previous year and at nearly the same vertiginous altitude. Loeser's generosity toward Berenson took a somewhat singular form, if we may judge from his arrangement with his longest pensioner, George Santayana. After accepting a token contribution from his dependent, Loeser would make up out of his own pocket each day's deficit. He was also prone to exaggerate his hospitality, so that his dinners sometimes had more promise than substance, a failing that inspired Santayana one

day to privately circulate an oriental satire on "Loeser-ben-Loeser" among their friends. However, Loeser's modest addition to Ned Warren's subsidy did give Berenson a more comfortable financial margin and helped him enlarge his collection of books and photographs.

As soon as they were well settled, they went to Siena, which they were going to use as a base of operations for forays into the countryside. Berenson's particular quarry was the painter Giovanni Bazzi, commonly called Sodoma. He wanted, he told Mary, "to account for him completely and explain the painter as an organism" by identifying the successive stages of his development. The project had a certain urgency because he had solemnly promised Mary, who was impatient to have him publish, that he would prepare an article on Sodoma. As usual he found himself unable to put his tumultuous impressions into a disciplined statement. Loeser proved less than a calming influence. He too had become a Morellian, but unlike Costa he was not inclined to yield to Berenson's critical judgment, and they disputed attributions with mutual vehemence. Chagrined, Berenson complained to Mary that no other of his acquaintances "has so fought my point of view, just because it was mine."

The quest for Sodoma led them to Monte Oliveto Maggiore to study the tremendous series of frescoes on the walls of the cloister depicting the life of St. Benedict. They were paintings which the artist had executed before he was thirty. The massive line of buildings of the ancient monastery stood on the wind-swept heights of a chain of lofty hills. An austere and forbidding structure, protected by a dry moat and drawbridge and surmounted by a machicolated tower which recalled long-forgotten perils, it had the look of a medieval castle. Thickly clustering cypresses surrounded it and within, clinging to the steep slopes, were carefully tended gardens and olive orchards. With winter coming on, the hillsides looked ashen-gray in the pale sunlight and the chasmlike ravines dropped away bare and eroded from the hilltop. Yet there was undeniably a singular beauty about the solemn isolation of that high place. The two young men had trudged up the steep cart track from the distant railroad on foot, their luggage following on a bullock cart. The last five miles proved a "dreadful climb." In the fading sunset as they approached the monastery, the scene recalled for Berenson a Gustave Doré canvas or a painting by Savoldo: "A red light sifting through a thick layer of purplish clouds from which emanated a shimmer of almost imperceptible purple. How wild and grand it was, with the wind blowing and the air crisp and frosty."

They had journeyed to the monastery to study the frescoes in "cold blood," as Berenson said, but he at least had been overwhelmed by the

array of wall paintings, which ran the length of two sides of the cloister walls. The luminous rendering of the Tuscan countryside in the many panels and the unexpectedly graceful treatment of the female forms amazed and delighted him. They were cordially entertained for four days by the old abbot Gaetano di Negro, who with two or three monks was allowed to run the monastery as a national monument, it having been suppressed as a religious house many years before. (It was to be reconsecrated in 1935.) The abbot had been there for forty years and with a number of sharecroppers tended the fields which clung so precariously to the hillside. Kindly and unaffected, he took to Berenson at once, grateful to find so dedicated a student of religious paintings. To Berenson the fatherly abbot seemed the embodiment of unworldly serenity. He wore his religion with such easy grace that the dogmas of the Church scarcely troubled him. Benign, impractical, and unworldly, he quickly won the affection of the young wanderer.

The spare simple life of the tiny company of priests impressed Berenson as a kind of religious idyll. He pored over the old books in the library, the lives of St. Gregory and St. Benedict, and traced out the manner in which the frescoes translated the antique Latin pages into illustrative form and color. In that gentle contemplative ambiance he felt that only a single step separated him from really possessing Italy and being possessed by her. "In Italy," he confided to Mary, "it is so easy to feel Catholic just as in England it is so inevitable to be antagonistic to it all." The lure of the Church had in fact already made itself felt in Venice, when he stood before Bellini's great painting of the three saints Jerome, Augustine, and Christopher. He had then suddenly sensed a kind of parallel between himself and Augustine, who had renounced a decadent world. Abetting these feelings was his growing dependence upon Mary Costelloe, who to all outward appearance had seemed a good Catholic. Would he not be even closer in spirit to her if he could share her religion and that of her husband, whose philosophical Catholicism radiated conviction? By the end of his stay his mind was made up, and he decided to return in February and be received into the Church by Gaetano di Negro himself.

In the quiet of the monastery Berenson lingered over the volumes of Vasari's *Lives of the Painters,* impressed again by the vigor of his style though convinced that Vasari was wrong in his depreciation of Sodoma. With the actual frescoes before him, he agreed with Frizzoni that Sodoma was a hero among painters. In the evening in his austerely bare room, before a roaring fire, he browsed among the pages of Augustine's *Civitas Dei;* in fancy he too was a refugee from the barbarians. But mainly the paintings engrossed his working hours. Their exqui-

sitely "musical" charm transported him into "a world different from the real one."

Many other knowledgeable travelers had preceded him and he thumbed the pages of the visitors' book, delighted to see that Morelli was one of the earliest. One of the most recent, of a month before, was the French novelist Paul Bourget, whom he was to meet many years later in the company of Edith Wharton. Bourget recorded his sentimental journey to Monte Oliveto, as to many other of the out-of-the-way towns of Italy, in his *Sensations d'Italie*. The abbot confessed that he thought Bourget "more German than French, no spontaneity." While the impression of the place was still fresh in his mind, Bourget wrote a long sentimental story—"The Saint"—with Monte Oliveto as its setting. In it there figures a young man who repents stealing a precious religious object and is forgiven by the abbot. The story has its interest as a graceful tribute to the abbot. Many years later, however, it inspired a curious speculation by one of Berenson's biographer friends that the repentant young man may have been based upon Berenson himself. It was a piquant but groundless fancy since the tale was written shortly before Berenson's visit.

During part of each day Berenson and Loeser roved the rugged countryside in a primitive two-wheeled cart under a cloudless sky, "not minding the cold," exploring every parish church within reach—Montepulciano, Quirico, Buonconvento, Asciano, Montalcino—identifying each to his own satisfaction the multitude of altarpieces and frescoes. They finally took leave of their amiable host to digest and record their researches in their rooms above the Arno. The early winter rains had set in and the Arno, full almost to the brim, was "roaring like a cataract," sounding a kind of accompaniment to Berenson's sensations. The first day or two back in Florence always excited him. "It goes to my head in the absurdest fashion," he exclaimed. He resumed his rounds of the galleries, amazed now, he said, to discover how little he knew the great array of Florentine painters "from the inside." He knew the masters of course, but in his fresh awareness that seemed only a trifle. To command the field he must know them all, even to the "tenth rate." Scientific connoisseurship required nothing less.

The almost daily exchange of letters with Mary Costelloe drew them closer and closer together, but her moral exhortations only provoked his scorn, and he read of her lectures on women's rights and temperance with a skeptical irreverence. The world, he assured her, was notoriously subject to relapses. He did not want her sacrificed to the Moloch of improvement. "I want you to realize that beauty is scarcely less than duty. You do naturally I am sure," he remarked; "otherwise I

should scarcely have become your friend." Yet under the frequent prodding of Mary and her husband to be up and doing, he became aware that he was himself changing. Once when Loeser suggested a walk in the hills he begged off. "While the light lasts I hate to spend a minute of it except on pictures, and when I get to the room I bury my nose in a book and it exasperates me to be disturbed." He feared that he was "settling down into a grind." He could no longer loaf "about in ecstasy," losing himself in sensuous contemplation of the paintings in the galleries of Florence or of the golden vistas of the Tuscan hills. "Such is the influence of the Costelloes," he ruefully observed. Almost every night he would ransack the volumes of Vasari or the recent works of Frizzoni, Morelli, and their fellow specialists to prepare himself for the next day's study in the galleries. There was no escaping the almost daily pressure of Mary's letters. Even at Monte Oliveto he had felt her admonitions and had been sensible of a chill thrown over his appreciation of the Sodoma frescoes by the fact that he had come to study them with the ulterior motive of writing an article on Sodoma, an article that unfortunately refused to march. In self-defense he charged her with working "thirty-six hours" a day in London "sans wine, sans song, one might add, sans everything."

Nearly a half century after their first meeting, Mary, reviewing their tempestuous life together, thought back upon those far-off days when she had undertaken with the best intentions in the world to turn Bernhard's aesthetic passion into practical channels and wrote a mea culpa in the biography that was never to be finished.

Perhaps I was, after all, wrong, as sometimes even now I am charged with having been, to try to turn this creature, so rarely gifted for enjoyment of a not ignoble kind, into the "worker." To pretend that the renaming of a tenth-rate work of art was more "worthwhile" then an afternoon filled with the sight and events of one of the loveliest landscapes in the world meant such a reversal of values that I scarcely like to dwell on it. Not that knowledge did not always interest Bernhard profoundly, not that he undervalued any contribution that he could make to it, but all this time he had never ranked it above the real thing, the IT as he always called the inward realization of beauty, the absorption of his whole being in the beautiful object. This is still his religion if I may call it so. Yet my baleful—if it was baleful—influence profoundly modified his life, and gave him a secondary conscience about work, and especially about writing, that has never ceased to harass him.

As the year of 1890 drew to a close Berenson's thoughts turned rapturously to Mary's promised Christmas visit to Florence. In that delightful prospect all misgivings about the future vanished like a morning mist. The Uffizi, he told her, was his "workshop" and the Pitti

Palace his "parlor," and these he would exhibit to her as the domain over which his spirit ruled. Wherever he went, whether to the parish churches in the nearby hills or to favorite lookouts along vagrant roads, he enjoyed it all in anticipation through her eyes, so that one "happiest day of my life" trod closely on the heels of another. He assured her there would be no problem about accommodations. Rooms could be had at his apartment house on the Arno on the same floor, and she, her husband, and her sister, Alys, could use his sitting room. He promised that Loeser would not be in the way. The only drawback would be the ninety-two stone steps to their lodgings.

Meanwhile he drove himself dutifully through his assigned tasks, one day patiently duplicating another, and all recorded in his diarylike letters to Mary. He reported his growing enthusiasm for Masaccio, whose frescoes in the church of the Carmine proved to him Masaccio's superiority to his master Masolino and to such contemporaries as Castagno and Uccello in his power of grouping human figures in a coherent composition. He spoke also of his astonishment at the way the minor painters were growing on him. He had spent a whole morning at the Accademia examining the works of Neri di Bicci and noting with scholarly satisfaction that di Bicci was the first master of Cosimo Rosselli, "who in turn was the master of Piero di Cosimo and Ghirlandaio."

For a brief moment Mary's visit was in doubt. Her little daughter Ray had taken ill. His hopes suddenly toppled; he felt too numb and "sterile," as he said, to give Mary the sympathy he ought. For once he could think of nothing to say. Fortunately, the crisis passed as quickly as it had come. The anxiously awaited telegram arrived from the two persons who had "entered my life as no other people have." As he held it in his hand and gazed out toward the Forte Belvedere and the hill of Bellosguardo, the future glowed roseate again, alluring, tantalizing, and strangely promising.

X I

Master and Errant Pupil

DISTANCE had lent its enchantments to Bernhard's feelings toward Mary and hers toward him, feelings which had been continually fortified by the torrent of letters that had passed between them. However, once when the too ardent tone of his admiration made her uneasy with its intimation of forbidden pleasures, he hastened to reassure her: "If you know how I loathe animalism of any sort, if you believed that I was pure *au fond* you might think that I was not altogether unworthy of your friendship." Thus they had kept each other hovering on the edge of passion, veiling their eyes from the consummation toward which they yearned.

His visitors arrived on December twenty-third. On Christmas eve he went with them to the midnight mass in the great dim-lit nave of the Duomo and again in the morning to the high mass, where the swinging censers, the Latin chant of the hidden choir, and the nearness of his flesh and blood madonna, more radiantly beautiful than he had imagined, all conspired to inflame his spirit. He took her for long walks in the woods of the Cascine along the Arno, drove with her to the heights of Bellosguardo, whose villas and walled gardens had sheltered generations of poets and novelists. There on the crest stood the tower of Hawthorne's *Marble Faun*. Here Henry James had paid his visits, storing up the ambiance for his *Portrait of a Lady*. In the December light the groves of cypresses and umbrella pines stood in sharp outline against the tawny hillsides. Fiesole drew the strollers with its sweeping panoramas of the Val d'Arno and the haze-shrouded towers of Florence. At nearby Prato Berenson pointed out the varied works of art, the frescos, paintings, sculptures, and bronze work in St. Stephen's cathedral to show how versatile the artists of Florence had once been. Another excursion took the newcomers to the Medici villa at Poggia a

Caiano, famous for its frescoes depicting the parallels between Roman and Florentine history. Best of all the hours which Mary spent with Bernhard were those passed in the galleries of the Uffizi and the Pitti. Often they went alone, avidly marking their guidebooks together, sharing their enthusiasms like two conspirators. Frank Costelloe was evidently amused by the way Mary submitted to Bernhard's rigorous instruction, and he told his mother-in-law that the "Master" had had Mary "look at one arm and a little bit of drapery for two hours, without paying the least attention to the rest of the picture." From the sober heights of age, Frank no doubt complacently reflected that out of this charming and aesthetic friendship might come a brilliant convert to his beloved Church. Mary would surely succeed in saving so ethereal a soul.

In her datebook Mary briefly noted her excursions, sometimes embellishing an entry with a pair of wings to indicate her bliss after spending a day alone with their protégé, who wove a golden spell of words about his Italy and its treasures. In the first week in January the whole party entrained for Rome for more sightseeing. Berenson dragged them through unseasonable sleet and snow to see his favorite things, eagerly pouring out his erudition. His enthusiasm was so contagious that Mary and her husband "swore an oath to know every corner of Italy before we die." On a drive through the gardens near the Aventine Mary and Bernhard looked at each other in such an ecstasy of communion that a peasant was heard to say to one of his fellows, "Stanno per baciarsi." She asked Bernhard to explain. He blushed and said, "It means 'These people are happy.'" Only later did she discover that it meant "They seem about to kiss each other." Bernhard's attentions to the impressionable young matron kept her enthralled and the wings of bliss tripled in size on her pages. Their last drive together took them over the worn stones of the Appian Way, where amid the moldering tombs that lined the road Mary persuaded him that he should seek his fortune in London.

Mary and Frank departed for London on January 9, 1891, leaving Alys in Florence to await the arrival of her mother, who wished also to make her pilgrimage to the art cities of Italy. Mary plunged again into her socialist caucuses and temperance meetings, but she could no longer drum up enthusiasm for such causes or for the prosaic paperwork of a barrister's office. Mary's mother now had serious reservations about the value of such a career for her favorite daughter, and she chimed in with Berenson's criticism of Mary's political ambitions, though for a quite different reason. She was concerned about the proper rearing of Mary's children. With unexpected submissiveness Mary told her mother, "I am

[134]

going to take your advice and give up nearly everything to them while they are little. And politics can be taken up at any moment. I feel a great desire" (and here one feels the presence of Berenson) "to live a simpler and more natural life." Italy, she said, had made her "a changed person." She began to cut the cables that bound her to her husband's world of politics and social uplift. She confided to Gertrude Burton that she was finishing off her speeches "so as to have February free when Bernhard comes to stay with us."

Her chief pleasure now was in Berenson's daily letters. The mixture of exhaustive art commentary and personal confession in his letters "enchanted and half-frightened her," she recalled. He had gone down to Naples with Loeser to study the paintings and sculpture anew with the analytic tools which Morelli had placed in his hands. It seemed to him a virgin field for scientific connoisseurship and he detailed all its possibilities to Mary. There came a day when, in the gallery of bronzes, he found himself almost hypnotized by the figure of a young Mercury and there grew on him a perception that foreshadowed the theory of "tactile values" with which his name would always be associated. The resting figure affected him, he wrote, "like balm of the most soothing sort. . . . But it is feeling him draw his breath that gives me so much pleasure." This was indeed the germ, as Mary afterward noted, of his "later writing on the art of figure painting," in which "ideated sensation" would play a central role.

Reflecting on Mary's recent visit, he wrote to Gertrude Burton, who was still lingering in Europe: "I can't describe to you how I had been longing all these years for someone who could feel things as I do. . . . Mary satisfied every longing. Those days with Mary—and Frank—" he hastened to add, "were the happiest of my life." He thanked her for "having thought of sending me to her three years ago, when I was first in England. . . . You don't know what a wretched, worthless being I was, so you can never realize all that Mary is doing for me."

He took charge of Alys and Mary's mother in Perugia, shepherding them through the galleries while he expatiated on Perugino and his fellows. He reported that his charges had made "great progress" before they left for Rome without him. "What a pity," Mary wrote half-humorously to her mother, " 'Master' can't be there to start thee in the right track. Or perhaps thee has now made such progress that thee doesn't need him anymore. Didn't thee find his commentaries on things full of suggestion?" In spite of her conversion the Quaker form of address persisted, as it did in her entire family. Bernhard dutifully adopted it himself.

A further chance for his schoolmastering came in an encounter in

Perugia with the compiler of Murray's European guidebooks, who impressed by Berenson's speech and demeanor, had taken him for a born Englishman. Berenson was tempted, he told Mary, to tell him my "lineage was not so illustrious, that I am only a Polish Jew." The "dear old man" swore by Morelli but in Berenson's opinion had read him "all wrong." He had just been writing on northern Italy and was dealing with Bergamo. He begged Berenson to look over his manuscript. The two stayed up late one night, and Berenson made him "write it all over" and left a batch of notes with him, thus smoothing the path, Berenson hoped, for future tourists.

While still in Perugia he received an affectionatte letter from the old abbot of Monte Oliveto. The letter deepened his resolve to return to the monastery. Since Mary's departure he had formed the habit of attending mass. Kneeling at the altar rail, he seemed to feel, he said, "the bodily presence of God." He declared he was grateful to Frank for "having first opened my eyes to what the mass really meant" and to her "for having opened my heart," which was "the more vital thing." It seemed to him now that his baptism by Phillips Brooks into the fashionable Episcopal church had somehow "simply killed all my religious strivings for the time." He wished that Frank were a priest, for of all the people in the world "I should want him to receive me into the church." He felt such a rush of holy feeling at the thought that he would like to kneel and "kiss his hand." "Oh I have been so narrow," he continued, "and, what is more, absurd, bigoted. . . . Tell Frank I mean 'business' at last. . . . To myself scarcely anything is so significant as the ease with which I can now use the name of God. . . . Now it is so natural to pray, to kneel down, to cross myself, and to use many of the symbols as if I had done so all my life."

In this exalted frame of mind he arrived at Monte Oliveto early in February 1891, again in the company of Charles Loeser. There, in "faltering Italian," he made his confession to the abbot and was formally received into the Church. "With this new light," he exclaimed, "Italy seems so infinitely more beautiful." Intoxicated by these fresh feelings, he vowed never to despise "any person's strivings, no matter how mistaken." The old abbot, for all his unworldliness, could not forbear expressing his "horror of the Jews" and his joy in saving this one. Nor could he resist quoting the incriminating line from the book of Matthew, "May His blood be upon us and on our children." Bernhard thought it the one blemish on the occasion. Loeser greeted his friend's new enthusiasm with his usual skepticism, and when Berenson talked mystically about the presence of God, Loeser drily remarked he had "lost his sense of humor."

The several days Berenson spent with the abbot in his new state left an impression on him of such serene felicity that it was never erased, and in recollection long afterward, when his "vaccination," as Mary called it, had lost its brief efficacy, the visit lengthened to several halcyon weeks. Short as his stay was, he found time to resume his hunt for altarpieces and paintings in the scattered villages of the district, patiently hauled about by a peasant cabdriver whose worn clothes gave so little protection from the cold that when Berenson got back to Florence he sent some money to the abbot to put clothes on the fellow's back. Berenson's letters to the Costelloes continued to stream to London daily, sometimes more frequently to Frank than to Mary, since Frank's cerebral theology had given him a rationale for his conversion; the pages were crammed as usual with his visual adventures in churches and galleries and among the Tuscan hills. As these copious missives went from hand to hand in the Costelloe and Smith households, Mary's mother began to have misgivings about this intense friendship *à trois,* but Mary assured her that there was no cause for alarm: "the great advantage of marriage" was that it removed her from the "weary strife of frail humanity as to falling in and out of love, which agitates the unmarried." If not disingenuous, her remark showed how much she underestimated the unruly strength of her feelings.

Berenson returned to London toward the end of February, 1891, prepared for what all of them, including himself, thought was the start of a settled life. Soon thereafter he went down to Friday's Hill with the members of both households, all except Mary's father, whose dislike for Berenson had flourished in his absence. In spite of the distracting commotion of the household, Berenson's spirits expanded; his dark and moody vapors of the past, which had alternated so frequently with periods of almost mystical happiness, disappeared. Mary recorded for Gertrude that he was in "a nice sensible frame of mind, not at all exacting or interfering." He was "much improved by feeling that he is going to begin his real life here in a definite place and that he will be more like other people. Frank is very happy about him and so am I."

After a few weeks as a house guest, Berenson went up to London to take lodgings there. Mary returned to her meetings and caucuses, but she found managing Berenson's career a much more agreeable chore. She eagerly recruited friends and acquaintances for his lecture tours of the National Gallery, among them notably Katherine Bradley and Edith Cooper. She herself made a determined assault on the Italian collection at Hampton Court, whose official catalogue was full of erroneous attributions. In this project of preparing a revised catalogue she frequently took Berenson to Hampton Court with her, eager to be in-

structed in the finer points of the Morellian method. Her voluminous notebooks show her to have been an indefatigable pupil.

While still under the beatific spell of their shared passion for art— and each other—they went together one day in London to enjoy being confirmed by the most notable Catholic convert of the day, Cardinal Henry Edmund Manning. Berenson, now a family intimate in spite of Mary's father's active displeasure, returned again and again to Hasle-mere for long visits during the spring and early summer of 1891, meet-ing there with the lively mixture of notables and intellectual eccentrics whom the Smiths cultivated. There were also high-minded teas in the Costelloes' London home, at which the Fabian socialists came and went, consuming vast quantities of tea and biscuits. Here Bernhard again met Oscar Wilde, who had been so much taken with the person-able young American at their first meeting. The witty bird of paradise who still preened himself defiantly in London society dazzled the com-pany with his paradoxes, as Bernhard delightedly reported to Senda. He was also growing soft and fat, as another guest observed.

Wilde was sufficiently impressed by his young acquaintance to bring a copy of *The Picture of Dorian Gray* to Berenson's room in North Street, Westminster, shortly afterward, saying, as Berenson recalled years later, that it was "the first from the press." The next day at lunch Berenson told him "how loathsome, how horrible the book seemed" to him. So far as Berenson could remember, Wilde made no defense, but simply remarked that he had been hard up and the publisher had given him "a hundred pounds for the story."

The half-dozen earnest ladies in Berenson's lecture tour shortly grew to eight, and the series of seven lectures on the Florentine, Central Ital-ian, Venetian, and Milanese schools were given a second time before the end of the summer. These lectures, the first he ever gave, contained the germ of his earliest and most influencital writings. They also pro-vided his first regular earnings.

On one occasion his class was augmented by two notable Boston vis-itors, Grace Norton and Professor Bôcher. Barrett Wendell, who also happened to be in London, stumbled upon his fellow Bostonians in the National Gallery. They "were attached," he wrote, "to a party of well-dressed women who were following about a short, bearded youth who was lecturing on the pictures most intelligently." It was of course young Berenson. "He seems really at work in earnest," he continued, "having two or three such classes on hand, being engaged in a critical study of the pictures at Hampton Court." Wendell breakfasted with Berenson two days later in his rooms in "a little old house" just behind Westminster Abbey. It was modestly furnished, "all as simple as pos-

sible, and on a very small scale, but in perfect taste. . . . He has mastered his subject, he is thinking hard, and working, and writing; in short I think he has gone very far to justify the rather exorbitant demands he had made on his friends, in these years when to many of us he has seemed so idle."

Berenson's most impressionable and loyal protégés at this period among the Costelloe circle were the two women poets who wrote as Michael Field. To their eyes he seemed scarcely of the earth, so great was his frequently voiced scorn for the vulgar tastes of the mass of mankind. In their 1891 diary they noted that a great change had fallen on Bernhard. "Last summer there was no doubt, no fear. He was a piece of pure unflawed paganism. But now this pagan (though recent Catholic convert) wants to make people enjoy. He is thinking of taking up journalism." At the National Gallery one late February afternoon, the niece, Edith Cooper, rejoiced, "Ah, there, how great, how simple he is! He persuades me to enter into his experience. . . . His ideal is seeing, seeing, seeing. . . . He looked very handsome. All the gates of the senses lie open as in few faces, clear eyes, beating nostrils, the lips hung freely. . . . His glance is close, naive, without sympathy, like a faun's."

The elder of the pair, Katherine Bradley, then in her early forties, was the "Michael" of their pseudonym. She and her niece, the "Field" of their singular household, tall, wan, wistful, and strangely beautiful, led an almost symbiotic life. Arrayed in "imperial" hats of nodding plumes and feathers, they were the presentment of one of the more extreme aspects of the aesthetic ideal. Belated Ruskinians in their enthusiasm for early Italian painting, they hung adoringly on Berenson's pronouncements. In their frequent letters they began to salute him as "Dear Doctrine."

His lecture tours of the National Gallery helped spread his reputation as a rising genius, and it did not diminish his authority that he sometimes mystified his listeners with his erudite commentary. A few weeks after he took lodgings in London he had cards printed, presumably at Mary's suggestion, giving as his professional address as a lecturer on art the Costelloe residences in London and Haslemere, where in spite of her father's rages he continued to be a warmly welcomed guest. "It is such a pity [for Father] to hate him," Mary noted, "for if Papa took him right, Berenson could amuse and entertain him immensely."

Intimations began to appear at last that the contrast in Mary's eyes between the youthful art critic and her polemical husband did not favor the husband, who was now wrapped up in the affairs of the County Council. On one weekend at Friday's Hill his political eloquence gave

Mary and Bernhard no rest. Frank held forth quite unconscious of their suffering. As Mary said, "He was in his glory [and] he wished he had a whole clear week to 'talk things out.' " Her old rebelliousness against constraint was now a source of frequent quarrels with her husband. Berenson's presence did not help matters either, for the conversion he had so ecstatically experienced in Italy looked very different in the dry light of British common sense. He was experiencing the truth of his own remark to Mary only six months earlier that it was inevitable in England to be antagonistic to Catholicism. Required attendance at mass and confession in London had soon dissipated their mystical aura. The Catholic church, it turned out, offered no better refuge from his inner demons of self-doubt and insecurity than the Episcopal church of Phillips Brooks. He could lose himself neither in the Emersonian Oversoul nor the certainties of papal infallibility. For better or for worse, he had to accept the fact that the only religion possible for him was Art, all absorbing, tyrannous, impersonal, and lovely. The only release for him from the sordors of existence was to be found in the world of visual beauty.

For the two seekers of transcendent beauty the moment was deliciously perilous. Thrown together for days at a time in London and its vicinity, communing with delight in their response to art as Mary grew increasingly adept under Berenson's instruction, the two devotees could hardly escape the erotic suggestions of canvas after canvas which celebrated sacred and profane love. It was but a short step now from youthful patroness to lover, from protestations of idealistic worship to passionate love. Soon after they had shared the sacrament of confirmation, Mary recorded a dream, as was her regular habit, in which she saw herself sinking helplessly in a bog. "I realized," she wrote, "that I was dying but I knew that I could not die until I had seen Bernhard's face again and the thought of seeing him again made me so happy that I did not dread death." Then the dream shifted and she found herself running down a hill in the moonlight clad only in her long cloak. "He put his arms around me and we wandered off in the woods, I almost fainting with joy." One intimacy led to another, and on one occasion, it is said, when Bernhard was alone with her in her bedroom, her husband's unexpected arrival obliged Bernhard to take refuge in a closet like the familiar figure in a French farce.

Every interval of separation during the summer of 1891, however short, inspired an exchange of letters glowing with endearments. The twenty-seven-year-old matron felt herself a girl again, her marriage a strange and inexplicable dream in which she had squandered her existence. She would awake at night trembling with joy, she told him, liv-

ing over again their moments together. She worried that Frank might inadvertently open Bernhard's letters. She dreaded that some misadventure might drive them apart. Yet, she wrote to Bernhard, it seemed to her that Frank "is the only person who could understand in the least degree. . . . Oh my dearest, dearest, pray for me and *live* for me." Bernhard protested that he loved her "to distraction. I would gladly die for thee. In some ways it would be much easier than living a day away from thee. Darling love, how I long for thee; how desolate I feel without thee." And when her courage faltered a little in the face of his impetuous ardor, he reminded her, "Remember, I am a Jew and a Russian; therefore with blood in my veins which warms quicker than in most people thee can have known. . . . Love is capable of making me return to a very primitive state of feeling." So their passionate exchanges went on for weeks as they probed the nature of their shared miracle. They tried to reveal themselves completely to each other, with the result that their passionate confessions sometimes ended in recrimination. Then, fearful that they had hurt each other, they would hurry off two and three missives in a single day to patch the breach. Still, when Mary proffered too ready submission to his judgment, he would retort, "I don't want thee to parrot my words or think my thoughts."

When Berenson went over to Paris for further study, he wrote her of sleepless nights filled with thoughts of her. He urged that if he had ever offended her, "please never be taken in by my words." They were, he declared, the arrows of an inexpert archer. Every moment of his life, he said, "has been a prophecy of thee." She was a living poem to him. "What is the use of eyes," he exclaimed, "if I cannot see your lovely face and what is the use of ears if I cannot hear thy voice; what is the use of taste if I cannot kiss thee and use of nostrils if I cannot smell thee; what is the use of touch if every part of my skin cannot touch the corresponding part of thine?" After a night made wretched by longing he took a bath, and the warm fragrant vapor that rose from the water that laved him made him feel her presence "as if thee really was by me in all thy dear nakedness." At last he felt he had achieved the affinity of which he had dreamed through all his youth. "In all the world," he rejoiced, "thee understands me and I thee."

The volcanic fervors of love at length began to moderate, and their joint hunt for misidentified paintings moved again to the forefront. Mary came over to Paris to visit the galleries with Berenson and Professor Bôcher, for she was determined to finish her researches for the Hampton Court catalogue, which Bernhard had now relinquished to her authorship, having provided her with the needful data on the

painters. Fortunately, she could rely on her mother for the entire care of her two children, for though she adored them in her sentimental fashion, she could not bear to have them stand in the way of her career as an art critic and connoisseur. Being now so closely united with Bernhard, she tried more insistently than ever to direct his career and pressed him to put his brilliant talk on paper. After her return to London from Paris, he sent over an article on his favorite painter, Raphael, for her professional scrutiny. Her frank criticism discouraged him: "No I have not begun to write but I have read your critique twice and the article itself once. . . . Re-write it I never will." Nevertheless, he professed to want her criticisms; "Don't be stingy even if my weak flesh will not take them up with the alacrity which the spirit would dictate."

If Frank knew or suspected the full extent of Mary's interest in Berenson, he appears to have given no outward sign. But the rift that had begun over his assertive Catholicism and his insistence on the superior authority of the husband widened as her infatuation with Bernhard made her fret against the restrictions which her adopted religion put upon her freedom. The solemn vows which she had taken at Oxford six years earlier seemed hollow as she thought of their undreamed-of implications. No longer willing to submit to Frank's opinions without protest, she found him unyielding on the question of a Roman Catholic education for their children. The suppressed differences between them became a constant source of irritation; the days passed for her, as she said, in "a wild tumult of bitterness and uncertainty." She made up her mind to escape from his authority, if only temporarily. "I want to make it as easy as I can for Frank," she told her mother. "It isn't really his fault and he is paying dearly for his mistakes. I am quite sure that the only thing for me is to be absent for a time, till I fill my life with pursuits, but I don't want people blaming him. He can't help being a Catholic, any more than I can help not being one even less. It is not only his training but in his blood for centuries. . . . Nearly all the mistakes are mine." Mary's mother had the compassionate grace not to say, "I told you so." On the other hand, in spite of her militant feminism, she could not approve Mary's obvious attachment to Berenson. Both parents implored her in the most touching terms not to leave her husband and children. They later warned her that her going about Italy with "a young unknown stranger" would involve her daughters and herself in the most painful scandal. Their pleas proved all wasted ink and breath. It was plain that Mary was her errant father's daughter and must follow her will. Besides, she pointed out to her mother, "I am a rebel against orthodoxy in conduct as you are in religion." Her disturbed state became much too obvious to be ignored, and when the Ca-

nadian psychiatrist Dr. Richard M. Bucke, Walt Whitman's intimate friend, visited the Smiths at Friday's Hill, he obligingly diagnosed Mary's condition as "acute exhaustion" and recommended a year's change of scene on the Continent, a prescription that fitted in conveniently with Mary's desire to become Berenson's pupil.

The break with Frank began more or less amicably. Her plan to study art abroad with Berenson may have struck him as rather whimsical and unconventional, but he seems not to have scented real danger to his marriage. Berenson was too spiritual and high-minded a convert, Frank had reason to believe, too much of an idealist, to betray their friendship. As a man of principle he did not spy on their correspondence, though Mary constantly feared he might. Had he done so, he might have relied less on the power of religion. Meanwhile, Mary's fervid protestations of affection more than matched Bernhard's. After a brief separation in the early summer of 1891, she wrote: "My joy—Thy letter came, and in spite of this terrible, terrible absence, my heart is full of sunshine and gladness. . . . Sometimes I am tempted to think I love thee most, and again that thy love is more. . . . Yes—I worship thee, dear love. . . . I was thinking what I should say if I went to Italy with thee. It would not be apology. . . . I would as soon think of apologizing for the sunshine. . . . What bliss to know I shall see thee in 45 hours."

In midsummer Bernhard set out from Paris for Germany while Mary crossed over to Paris with Frank and a favorite client of his, young Count Eric Stenboch, a fellow Oxonian and the son of an Estonian nobleman. An extravagant and dissipated aesthete, the count had invited Costelloe to be his guardian and adviser, but his bizarre character remained unaltered, and he died demented four years later at the age of thirty-five, the victim of drugs and alcohol. Mary gave the oddly assorted pair a guided tour of the Louvre.

Having demonstrated her ability as a knowledgeable cicerone, she took leave of her husband and his strange companion and left for Antwerp to begin a systematic survey of Italian art in the Netherlands. Mary reveled in the newfound solitude of her life "more than I imagined possible." She felt for once completely her own mistress and as if she "had just waked up and as if nobody else in the world knew anything about life except myself." She filled her notebooks with detailed descriptions of paintings, drawing "Italian ears and hands" in the fashion of Morelli and often sketching in miniature the salient features of a picture, something that Bernhard for all his gifts could not do himself. Filled with high resolve, she announced that she would study German and read history since "the sweep of art is quite beyond my

theorizing." It was as if she were tasting freedom for the first time in her life since her girlhood in Germantown. Her decision to travel as Berenson's pupil worried his friend Professor Bôcher, who feared that the scandal would ruin Berenson's "scarcely begun career." He was especially concerned since it was he who had recently persuaded Edward Warren to promise another subsidy to Berenson. Warren also disapproved of the quixotic scheme, but fortunately he did not go back on his word.

Bernhard, meanwhile, had been working his way northward from Paris searching out paintings in out-of-the-way collections to add to the canon of paintings by Lorenzo Lotto, whose neglect had become an irresistible challenge to him ever since he first visited Venice, and he began to think of writing a monograph on his work. He joined Mary in mid-August in the town of Brunswick, Germany. The raptures of their reunion did not impede their rigorous program of work and study. Bernhard communicated to the more volatile Mary something of his own extraordinary power of concentration on the details of a painting, and she too learned the value of the magnifying glass. Although the museum at Brunswick was closed for the day Bernhard sufficiently charmed the guard to escort them through "room after room of Dutch and Flemish things splendidly hung." When they reached Berlin they were joined by Enrico Costa, whose interests seemed to Mary much narrower than those of Bernhard. The dedicated trio progressed to Dresden, where Morelli had made such important corrections of the Italian attributions. In the great gallery Mary concentrated on the Correggios and Dossos "so as to finish the Hampton Court thing," the catalogue, which had a way of spreading its tentacles far afield.

"Michael Field," aunt and niece, who had been making their own study tour of the German galleries as self-elected disciples of Berenson, were also in Dresden, though the niece, Edith Cooper, was inaccessible in a hospital with scarlet fever. The aunt, Katherine Bradley, recorded that Bernhard and Mary called on her, he "rather pale and quivering." Bernhard, disappointed at the niece's absence, remarked, "You will never know what plans I have been forming for your happiness, nor how I looked forward to being in the gallery with you. . . . I have been privately swearing at Jehovah. If he had knocked up a pair of Philistines it would not have mattered—but you who can enjoy so much! HE has no culture." Miss Bradley piously added: "Little blasphemer!"

The Wagner festival was in full swing, and devotees that they all were, they made their nightly pilgrimage to the opera house, surrendering themselves once again to the hypnotic sonorities of the *Ring* and its

Teutonic pageantry. Bernhard and Mary went on to Munich for still more Wagnerian opera, the sensuous music an exciting accompaniment to their passion for each other. The opera-going and railway travel took a heavier toll on their pooled resources, however, than they had expected, especially since for appearance' sake they always took separate lodgings. In spite of Mary's efforts at economy, travel still took six pounds a week, a considerable sum in 1891. Frank, struggling with his law practice, appeared able to spare only an occasional tiny remittance. In consequence, she asked her still indulgent father to send on what little remained of her annual allowance of £300 ($1,500). When she and Bernhard had crossed the Alps into Italy and had reached Verona, they took lodgings, as she recalled, in a "modest pension. . . . Our resources did not permit us more than five lire [$1] a day each." She was able to make do, however, with her sister Alys's old dresses and by writing only to people who sent stamps for a reply. Anxious to placate her mother, she promised to keep strict accounts: "It is the only thing to do, although Frank is perfect about making no complaints." She was sure she could ultimately pay for "all this expenditure" by the "writing I can do." She felt she could write "persuading and convincing books" on art "if only I knew enough."

That knowledge was now within her reach, she hastened to assure her mother. "Now this autumn I have a chance of study I may never have again. Berenson is not giving me information 'on the cheap' because in work like this you *have* to use your own eyes. In things connected with words it is not hard to borrow other people's ideas—no one has done it more than I! . . . However, his help is immensely valuable. . . . No one has yet been trained as I am being trained—to look at the really best things and to *start* where other people have ended." Hence she could not rejoin Frank to quiet gossip, as her mother urged, until later in the year. There were still too many north Italian cities to explore with Berenson, "whose suggestions and comments are of enormous help to any future writing I may do." As for his writing, she admitted she had not yet had much success in getting him to complete the abortive articles in his notebooks. "I question whether, under any circumstances, he will write much." Hence the field was left open for her.

She assured her mother that she was mindful of appearances and was asking her friend Gertrude Burton, who was in Florence at the moment with her children, to join her in Venice, "where you are likely to meet people, and I am as anxious as thee not to have any talking. In other places I assure thee there isn't the least objection to our being together. I am very careful about everything." She advised her mother to show this letter to Frank. "I do not want to spoil Frank's career. I should

want him to be as successful as if he had never known me." The separation might be hard for him, "but still not really worse than if he had not been married." As for herself, she was finding "complete independence too delightful, only purchased rather dearly I am afraid." She looked forward to a winter of "quiet work" in Florence.

Frank continued to write an occasional "nice" letter, still hopeful that she would return as he and her mother urged, and he tempted her with a "delightful snatch of bedtime conversation" with their two children. She was not to be so easily moved, though she was anxious about her favorite child, Ray, who was now four. The question of her schooling had arisen, and Mary desperately warned her mother that the child "must not be brought up a Catholic," little understanding the legal rights of her husband or the limits of his tolerance.

Both Mary and Bernhard had gone through a complete revulsion against the Catholic church. And their new attitude gained support from their joint reading of Leopold Ranke's *History of the Popes.* In his scholarly pages they traced the tainted sources of Frank's dogmatic theology to the arbitrary decisions of the Council of Trent and the intolerance which it fostered. Brought up as a Quaker, Mary could not help but shudder at the heartless command of the old Dominican Cardinal Caraffa: "No man must debase himself by showing tolerance of any kind towards heretics of any kind." In Bernhard the account of the rise of the Jesuits and their ruthless administration of the Inquisition instilled a lifelong detestation of the order. He jotted in his journal at the time, "The decaying Church is the puppet of the Jesuits as Rome was, in its decline, of the mercenary soldiers." Ranke depicted their beloved Italy of the Renaissance as the helpless victim of a greedy hierarchy. Mary finally admitted to her mother, "The more I read history the more *horror* I have of the Catholic Church." Bernhard's backsliding matched hers. He told of stopping by the church of La Badia in Florence with a friend to see its paintings, "but they were preparing to eat J[esus] C[hrist] raw to the accompaniment of an organ playing café chantant tunes which we could not stand," and so they did not enter. Still deep in Ranke's *History,* he commented, "He rouses in me a mad desire to consume the Jesuits alive." He concluded that "all the advances that . . . European humanity has made during the last four hundred years have gone hand in hand with the disintegration of Christianity."

Bernhard and Mary carried with them wherever they went Pater's *Renaissance,* "which we adored," although they "scribbled" it over with scornful notes apropos of his "lack of exact connoisseurship." They concluded, for example, that he was "unable to tell a real Botticelli from an imitation." They found that Pater had long preceded them even

"in the dusty little towns . . . of the roasting Lombard plain," and they felt a bond of sympathy on seeing his name "inscribed in the signature books of museums all over North Italy." More useful for their work was their well-worn copy of Baedeker, which was always at hand. Their notes from Crowe and Cavalcaselle provided them with more precise information than they had realized, for they had been blinded, as Mary said, "by our hot partisanship of our adored Morelli." Their greatest resource was Burckhardt's *Cicerone* because he directed them "to works of art rather than pictures" and thus gave them "endless delight." The two devotees often passed hours on the steps behind an altar deciphering the stylistic traits "of a Torbido, a Giolfino, a Brusasorci" to establish "their relation to the greater masters of the school," scarcely distinguishing, as Mary recalled, between the aesthetic pleasure of the moment and the enchantment of their "job." Sometimes they would "steal up on a painting in a church where the hot sunlight lay in a shining pool by the door" and in an ecstasy of discovery "whisper to each other a new name for an old thing. We used to wonder if Adam had half as much fun naming the animals as we were having renaming these ancient paintings." Later they were amused to learn that many of their "discoveries" had already been noted in the handbooks.

Though Bernhard and Mary had come to detest the theology and the politics of the Church and the bigotry of its zealots, they could not resist the aesthetic appeal of the art which the Church had inspired. Their reaction recalls that of the historian Gibbon: "The Catholic superstition which is always the enemy of reason is often the parent of taste." More than fifty years later, Berenson still puzzled himself over the contradictions of the Church. "I love Christianity," he remarked to the art museum director John Rothenstein, "and in a sense I count myself a Christian, but is is a marvel to me how anything so beautiful can have arisen upon the appalling iconoclasm which systematically destroyed the works of pagan art and literature." Mary reflected at the time: "I begin to forget all the dreadful things Christianity has made people do, and to feel immense gratitude for a sentiment that was strong enough to make people build such beautiful churches."

They passed a month in Venice as summer gave place to autumn, Mary more determined than ever to be free from Frank's influence. She wanted time, she temporized, to arrange the rest of her life sanely "and in a way that will make even Frank happier. I may be able to show Italy to him with pleasure someday." She was convinced that Frank was wrong in thinking orthodoxy had "much real influence on conduct. . . . A little impartial reading of history would show him it was practically no influence at all." She agreed to return to London for a short

visit if Frank thought it necessary since she did not want "to spoil his career," but she hated the thought of making such a long journey for such a hypocritical motive.

Bernhard, she, and Costa soon adopted a regular routine in Venice. In the mornings they would explore the churches, threading their way through the maze of narrow canyonlike streets swarming with foot passengers or voyaging in a gondola amidst the picturesque chaos of water-craft on the canals. At the church of Santa Maria del Carmelo the sacristan, impressed by their professional manner, invited them to clean one of the pictures, dark with "dirt, candle grease and cobwebs." The trio set to work; they washed the painting and, on the worst spots, Costa ventured to use turpentine. To their astonishment what emerged was a superb Lotto, *St. Nicholas of Bari,* now in the church of the Carmini. In the afternoons they worked in the galleries, Berenson and Costa carefully checking the originals with their photographs. Sometimes they sailed to outlying places, such as the island of Murano to examine a Bellini and a Veronese, or going farther afield, they would set off on the mainland in a light carriage, armed with notebook and stylographic pens for a systematic hunt for altarpieces of the Veronese school.

It was in Venice that Bernhard and Mary began their lifelong and often acrimonious dispute over the merits of Paolo Veronese. Mary insisted that though he was a "glorious painter" his pictures were spiritually empty and that his colossal figures seemed ready to topple over. Bernhard "badgered" or "hypnotized" her into believing that what was really important was the effect of "light and shadow and color and pattern" and not the "literary" values. Before the next Veronese the debate would resume, and sometimes it grew so furious they would storm off to separate restaurants for lunch and then, mollified with pasta and wine, return to the object of their dispute and make their peace before it.

Under Bernhard's tutelage Mary proved an extraordinarily apt student, and if in the main she adopted his artistic judgments and opinions, she often gave them more coherent expression, and she brought to their work the capacity for painstaking record-keeping which he lacked. The ledgers identifying the paintings and drawings which she began to keep that winter of 1891–92, in which she listed in alphabetical order hundreds of artists with concise descriptions of their works, became a chief resource for Berenson's first books.

On a brief foray to Padua they stopped at the famous Arena chapel, which Bernhard had first visited two years earlier. Built by Scrovegni in 1303 to expiate his father's usury, the chapel bore on its walls the

frescoes which Giotto had painted depicting in three great bands the story of the Christian redemption through the life and passion of Jesus. An obliging sacristan brought them tall ladders so they could examine the topmost band of frescoes. Here, with magnifying glass in hand, the nimble-footed Bernhard pored over the signature strokes of the master. There were repeated excursions to Florence, on one of which Mary began to compile a notebook on the Venetian pictures in the Uffizi. Afterward they set off for Vienna, where a new gallery had been opened with paintings from the royal collection. Here Mary became absorbed in writing a newspaper article on the collection, which she sent to her obliging husband for publication in the *Pall Mall Gazette,* to which he had entrée. She followed this with "a very heavy article on 'How to Study the Venetian Paintings at Vienna,'" as if to make up for Bernhard's inability to put his teeming thoughts into a sustained article. She offered the essay to Putnam's with the Hampton Court catalogue, but the publisher suggested that the essay might be publishable alone if combined "with something less cumbrous and of more general interest than the Hampton Court stuff."

How closely Bernhard and Mary collaborated at this period emerges in one of Bernhard's letters to "Michael": "As to my scribbling, that also is purely domestic. I am writing a little for practice, and much because it helps me think. . . . It was so sweet of you to send us real criticisms of our short articles, and I think that I mean to cavil at your criticism. Let me remind you that these short articles by us are by no means meant to be complete, but merely as brief and sufficient prefaces to the pictures at Hampton Court. . . . They all presuppose short introductions which we mean to give: one, on the uses and methods of scientific art study, the other, on the general character and evolution of the Venetian school." For Bernhard's part, as he wrote to Gertrude Burton, he still found the greatest difficulty in reconciling his two professions, that of the connoisseur and that of the writer; "an attempt to connect them is at first sight hopeless."

Mary parted from Bernhard and Costa in Vienna and reached London on December second of 1891. Appearances were served, but the hopes of Frank and her mother for a reconciliation proved illusory. In her two weeks in London she looked up many of her old political associates. She found them, she said, "quite as delightful as I ever thought them but their work interested me no longer or only vaguely." Moreover, it seemed to her that only a "very, very small proportion" of English women cared anything about women's suffrage. She was delighted with the signs of affection from her children and wrote at excessive length to Bernhard about them, unknowingly sowing the

seed of his jealousy of her preoccupation with them. Somehow she prevailed upon her husband to allow her to take the children with her to Florence. Possibly he felt that the gesture would soften her resolution to live apart from him. He sent presents for the children and a pocket-book for her. Her mother, still anxious for a reconciliation with Frank, joined her in Florence at the end of December, and soon thereafter en-trained for Paris, leaving Mary to stay on in Florence with the children and their nurse in an apartment near Berenson's as his pupil—and, what apparently was not yet obvious to her mother—as his mistress.

XII

Trial of the Scholar-Aesthete

THE short winter hours of daylight in the galleries left more time for Berenson to study at his bay window high above the Arno. Mary's example and prodding drove him to fill his notebooks with little essays and jottings on art, literature, and life, but they were still of a miscellaneous sort. The confidence he had once had in his college articles seems to have evaporated under the sense of pressure from well-meaning friends. Moreover, he found his English growing rusty with so much disuse, for it was now nearly five years since he had sailed from New York. Sound criticism, he reminded Senda, "is not a gift of the muse." It could only be "acquired by manifold experience. So don't be disappointed when I tell you that I have no publication to show you. Perhaps in a year or two it will be different. You must remember also that I am not at all ambitious. The utmost I feel is that I want to show the people who have kept me abroad that I have not wasted their money." He went on to say, "Of course five years seems a long time in which a man has ample chance to show himself a genius. It has been in truth long enough to prove that I am not a genius. But that people did not expect me to be. What they expected was that I should make a crack critic. That I *am* going to be and much finer than anybody expected, although too fine to satisfy expectation." What worried him was that the practice writing he had been doing at such length in his notebooks was causing him to lose his sense of intimacy with the paintings he was studying. In only a few months he found Titian and Paolo Veronese had grown hazy and he felt they would have to be relearned.

Senda, who was now a physical culture instructor at Smith College, wrote of her continued efforts toward self-culture. He cautioned her against wasting time on philosophy. "America," he assured her, "is almost the only place where people still take an interest in that odd af-

[151]

fair." Psychology was another matter. It and history did exist and it was "fascinating to know in the scale of diminishing stupidity what humanity has thought of its own psychology and of its relations to the universe." His own interest in applied psychology was soon to be greatly stimulated by his reading of William James's monumental *Principles of Psychology*. James's rejection of metaphysics in favor of naturalistic science paralleled for Berenson Morelli's rejection of subjective impressionism in the study of painting. James stressed the psychological and physiological problems of perception. He talked of "ideation," the derivation of ideas from physical percepts, and of the "tactile" sensations that might accompany those ideas. These passages Berenson carefully marked with his pencil as he mulled over their implications for the study of art, implications that he would finally express in a memorable section of *The Florentine Painters of the Renaissance,* the second book of the series on the Italian painters.

The question of the nature of the beautiful in art and the psychological mechanism by which it was enjoyed was then very much in the air and provided a favorite staple of debate in the Anglo-American salons of Florence. There was no forum more challenging to Berenson than the drawing room of Vernon Lee's villa, Il Palmerino, on the slope below San Domenico. Vernon Lee had already made an international reputation as a writer on psychological aesthetics, having popularized in the term "empathy" Robert Vischer's earlier conception of *Einfühling,* the projection of human feelings into inanimate objects. Both Gustav Fechner and Theodor Lipps had attempted verification of this theory of empathy and both had been cited by James. At that period, so far as Berenson could remember, he "went so far as to buy one or more of the earliest writings" of Lipps, but put him aside after a few pages because he found his vocabulary pedantic and his explanation of *Einfühling* as distasteful as "telling time by algebra as if putting oneself in the place of a work of art needed elaborate demonstration." As for another theorist, Johannes Volkelt, who was advancing a similar idea at the time, "I might have avoided [him] out of fear that he would rob me of my job, making me feel there was nothing left to say."

It is noteworthy that in their reading, as early as 1892, Bernhard and Mary had begun to approach the question from a more purely physiological point of view in an effort to avoid the more abstract theories then afloat. They jotted down in a jointly kept notebook Fechner's definition of pleasure as the "equilibrium of the nervous system." This impressed Berenson as an apt statement of the case and he observed that art was "the least expensive way of attaining equilibrium." They copied out from Edmund Gurney's *Power of Sound* a number of passages bear-

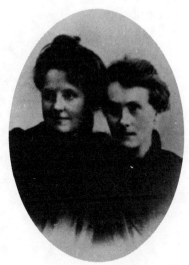

16. *"Michael Field" (Katherine Bradley and Edith Cooper)*

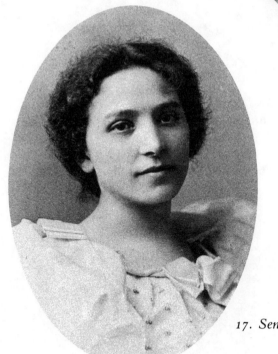

17. *Senda Berenson, about 1895*

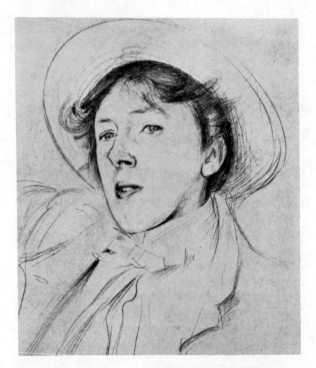

*18. Vernon Lee, drawing by John Singer Sargent,
1889, Ashmolean Museum, Oxford*

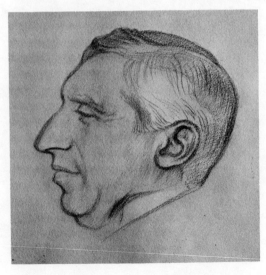

*19. Carlo Placci,
drawing by
William Rothenstein*

ing on their quest, one of which presages Berenson's own theory of "tactile values": "The object of sight we can not only touch but trace out part by part in space by a series of muscular and tactual sensations which run exactly parallel at every step with the accompanying visual sensation." Gurney also cited Ruskin's observation that "sculpture is essentially the production of pleasant bossiness or awareness of surface."

In Florence Vernon Lee was Berenson's favorite adversary. She had patronized him in the beginning while he struggled without much success to get his demurrers into her brilliantly allusive monologues on art. On one occasion when they were discussing the question of influence in art, she declared that she, being creative, could understand the nature of the creative process whereas he, not being creative, could not. He reported to Senda that he "boldly dissented" from the *argumentum ad hominem* but he had to admit that he enjoyed the talk of people like her who "cerebrate." In an encounter at the Uffizi, she talked "like a steam engine" until it dawned on him that she was pumping him for information on art to spare herself the "dirty work," as he said. From time to time Vernon Lee would break off their debate to commune with her alter ego, the "bovine" Kit Anstruther-Thomson, and the two women would exclude their young antagonist from their conversation with infuriating blandness. Coherence was flung to the winds. Manet had no brains, Vernon Lee declared; Rossetti was the intellectual painter. Berenson vehemently argued the reverse. Then the women cited their friend John Singer Sargent's praise of Watts as the greatest portrait painter of the age; Berenson, for the sake of argument, riposted that he was academic and vulgar. Berenson had to concede that Vernon Lee "knows a lot but it's all topsy turvy." In a curious fashion each granted the other a reluctant and grudging respect. He read her gossamer-spun *Euphorion* and thought "It is awful stuff," yet he eagerly solicited her critical opinion on his writings.

Equally ambivalent was his dependence on the criticism of "Michael," the elder of the "two-headed nightingale," to whom he sent long extracts from his notebook-journals, impromptu essays on life, literature, and art. A satiric allegory on the papacy in his journal might be juxtaposed to a description of how he might himself paint an ideal Annunciation. Here and there he would jot down gnomic sentences like "Watteau's people do not believe in pleasure," or aphorisms, "No matter what puritanism was in its origin it should now be called *pruritanism,*" or "Public opinion is the everlasting enemy of every advancement," or in an essay on painting, "Reality is only to be attained through light and shadow, tones, values and atmosphere." In motherly

fashion "Michael" advised him, "Don't write for an audience,—purge the lecturer from your style. . . . Let the thought grow and spread and wave softly at last like a seaweed in a tidepool." Undeterred by what were often random commonplaces, Michael sensed in these fragments a "fragrance and felicity not to be found in what you propose to write." A draft of an article on painting elicited the comment: "It is delightful; the reading of it greatly enlarged our pleasure before the Correggios. . . . Here and there I have taken the liberty of putting down a suggestion in pencil, where it seems to me the English requires to be [corrected]." He gratefully replied that he had adopted her corrections "almost without exception" and in the same breath invited the two women to "go over my Venetian article in the same way." Given his penchant for exuberant neologisms and a lingering habit of Teutonic inversion, Berenson found himself a vulnerable target for the purists among his British and anglicized American friends, and as a result his style grew less spontaneous, especially as he struggled to suppress what for them was the indelicate first person singular.

The presence of Mary's children proved no obstacle to research since they were left in the care of their nurse and the ailing Gertrude. Master and pupil managed two grueling *giros* of central and northern Italian art cities, tearing themselves away from their beloved Florence with Bernhard lamenting that he had not half mastered its paintings. Determined to ferret out the scattered works of every artist and to fix their details in his mind, he and Mary wandered from Pisa to Bologna and from Modena to Cremona, places he had not visited for two years. They made a side trip south for a first visit to the ancient fortress town of Volterra to examine the Tuscan masters in the Palazzo dei Priori. They also returned to Bergamo, to whose museum Morelli, who had died in 1891, had bequeathed his notable collection of paintings, for Berenson was still hoping to write a definitive article on the master. More study awaited the pair at Milan, where they would have the chance of comparing their findings with their fellow Morellian, Frizzoni.

Laden with notes, they all got back to London the latter part of May. The Michael Fields made a note at that time of seeing Mary at the home of Robert Benson talking to Oscar Wilde. Benson, a noted financier and art collector, was one of the many persons whose collections were opened to Bernhard and Mary through her friend Herbert Cook. Bernhard appears to have busied himself as usual in the galleries and in renewing contacts with Horne and Cook and the histrionic Oscar Wilde. After a visit to Wilde in Tite Street, he reported to Mary, who had gone down to Friday's Hill, "It was delightful for two hours and bored me the rest of the time. But he is wonderful. I wish I could

repeat to thee a hundredth part of all the clever things he said. . . . We talked about Verlaine and Mallarmé. . . . Oscar is delightful when you make allowance for nine-tenths of what he says as *manner*. . . . He is marvellously well read for one thing and when it comes to real thought he can go far. But he is British, mad and unbalanced. He was so funny at the beginning. 'Tell me at once are you living with the twenty commandments?' " Later in the conversation when Berenson told Wilde that he was engaged for every evening of the week, Wilde ejaculated, " 'Oh, I know, you are dining with the twenty commandments.' It was in vain that I tried to tell him that I chose to stand between the insanity that was Costelloe and the insanity that was Oscar Wilde." Wilde had evidently been amused by the thought of his Irish compatriot's numerous moral and theological principles. Bernhard's report of the visit continued: "One of the charming things that may fail to get into print is 'Absinthe has no message for me.' He has fearful, vulgar streaks, e.g. he has clippings about himself sent him by the newspaper agency. Poor fellow he is not so very unlike what I was without thee. He asked me to come to the Cafe Royal tomorrow. I told him I could not promise. 'Oh, then I shall be alone!' and such a terrible look came into his face, the look of a man who does everything as a *pis aller*. How well *I* know what that is my darling, my darling. Better Hell than that."

It was Herbert Cook who in the first years of his acquaintance with Berenson considerately arranged for them what Mary recalled as a "grand triumphal tour" of country houses in England and Scotland where Italian pictures were to be found. Young Cook, though trained as a barrister, had chosen to become a collector and patron of the arts, evidently inheriting his vocation from his grandfather, who had made an important collection of Italian masters. Cook was, in Mary's words, "something of a connoisseur," and he and Berenson had already "made a great many discoveries" in England. On the tour Mary and Bernhard were usually met with great kindness, but that kindness sometimes turned to bitterness and anger when, as Mary recalled, " 'that impudent young Berenson' " disputed "the grand names that had been affixed to the pictures." Their most unpleasant encounter took place at Gosford House in Scotland. Old Lord Wemyss proudly displayed one painting after another, giving each the name of a master. Outdoors a thunderstorm gathered and the tour continued by candlelight. The gloom deepened as Lord Wemyss perceived that they doubted the attributions. Finally when directly questioned, Berenson said he could not accept the Leonardo. Lord Wemyss "in a towering rage ordered them out of the house into the storm."

Berenson had a more disturbing experience in these apprentice years

[155]

when he mistakenly attributed a Bellini in Robert Benson's collection to the far less important Basaiti. He discovered his error too late to correct it; his word had already got out. Some time later, when he was put up for membership in the Burlington Club, Benson reportedly cast the black ball. Only much later were the two men reconciled, when Berenson was fortunately able to identify a painting in Benson's collection "as an important Antonelli." A curiously different experience met him at Lord Brownlow's house, where he identified a painting for which Lord Brownlow had no esteem as a Fra Filippo Lippi. Intensely annoyed at the challenge to his judgment, Lord Brownlow denounced Berenson as a "little American whippersnapper." At another house their hosts, according to Mary, "anxiously awaited his opinion" of their rubbishy collection. With his hosts hanging on his verdict, Berenson paused on his way out merely to remark, "I have never in my life come across such a convenient collection of rubber-bands as I found on the writing table in my bed-room." For a long time it did not occur to the dedicated young connoisseur that he had begun to leave a trail of enmities that would plague him for the rest of his life. These were to grow more and more virulent as his expert judgment often destroyed dealers' hopes of profitable sales.

London had its undoubted amenities for Berenson, but his relations with Costelloe and the Smiths had obviously become so embarrassing that he felt out of place in the houses in Grosvenor Road. Costelloe's attitude toward Mary was slowly hardening into animosity, especially over the question of her access to the children, and both Mary and Bernhard were becoming the subject of unfriendly gossip. Berenson returned to Paris in June with much relief and was soon joined by Mary, who for a time occupied Logan's apartment with the Michael Fields. "England certainly does not agree with me," Bernhard wrote to Senda. "My spirits go up at once on touching the Continent." Free once again with Mary in the anonymity of travel, he told his sister of a delightful visit to Rouen, where "it was granted to me by the gods to make several small discoveries—three predelle by Gerino da Pistoia and one by Matteo Balducci, the Gerino frisking under the name of Pinturicchio and the Balducci staggering under the awful weight of Botticelli's name." Almost for the first time he went on to include mention of Mary, aware that Senda did not approve his liaison. "Gerino is quite an interesting person. I believe Mrs. Costelloe and I are the only persons who have studied him up. You see even the most cold-blooded science would faint and fail and vanish on the breeze if it could not manifest itself to somebody. In my case Mrs. Costelloe—whom I shall henceforth indicate as M.—is that somebody. She is delightful because we look at

things in nearly the same way, are interested in nearly the same things and above all because we can understand each other *a demi mot* as the dear French say, who know how wearisome is discussion."

Mary continued to set an example of journalistic energy in Paris amidst her tabulations of pictures studied. She got off an unsigned article for the British *Woman's Herald* on the Paris Exposition des Arts de la Femme, an exposition that fell far short of her expectations as an ardent feminist. It showed little achievement in art, in her opinion, but much devotion to sitting for portraits and wearing costumes. So far, she concluded, "art has existed for women but has not been influenced by them." The hectic pace of life in Paris told on her, and her letters to her mother began to tell of bouts of ill health and weakness. Her Paris doctor diagnosed the condition as "inflammation of the ovaries." Her report from Paris to her mother also contained a revealing sidelight on the rights of English women: she was sending a pessary for one of her mother's friends. She felt "tortured" over her children, whom she beguiled with daily letters and installments of a moralistic fable of giants. The negotiations for a separation agreement hung over her intolerably while her husband procrastinated over its conditions. She was troubled also by her dwindling finances, but just as she began to despair, the outlook brightened. A check came for her article in the *Woman's Herald*. Small as it was, it led her to confide to Gertrude Burton that "it was the beginning of the wealth I dream of when I can buy as many photographs as I need." She was much cheered also when her mother informed her that her allowance would be increased by fifty pounds a year so as to free her from the petty economies which she found so difficult to make.

Old friends and acquaintances from Harvard were already converging on Paris, which had become the magnet for culture-hungry Americans. Robert Morse Lovett and his poet friend William Vaughn Moody, both just graduated from Harvard and veterans of the *Monthly,* promptly sought out Berenson in that summer of 1892, for his singular career had become the talk of the *Monthly* editors and contributors. Norman Hapgood and Robert Herrick of the Class of 1890, also former editors of the *Monthly,* joined the others in tours of the Louvre under Berenson's guidance and became converts to his way of looking at pictures. Norman Hapgood recalled in his autobiography how he kept a rendezvous with Berenson in front of the *Mona Lisa.* Hapgood arrived with his Baedeker in hand. Berenson asked him what the guidebook said. He read out something about the bright color of the lips. "Can you see the bright red yourself?" Berenson asked. Hapgood confessed he could not. Berenson explained that Baedeker was quoting Vasari,

who had seen the picture more than three centuries earlier, long before the color had faded. One needed, Berenson admonished him, to experience a painting with one's own eyes. Hapgood visited much with Berenson that summer and "for a while," he wrote in his autobiography, "I came to think more of art than of anything else." Berenson enjoyed Hapgood's easygoing and frank American manner. He was "not a bit touchy." He wished Hapgood could stay a year, "then he would make a cerebrator out of him." In long retrospect, Hapgood reflected that Berenson's old friends probably thought of him most often not as a famous expert on old paintings but "for his vivid and original conversation." They were agreeably impressed by the fact that he had preserved the Harvard habit of serious discussion.

Senda arrived in England in mid-July with a Smith College colleague, Mary Jordan, a professor of English language and literature, and Bernhard hurried over from Paris to see her and launch her properly on her two-month European tour. After their five-year separation, brother and sister met in London and picked up the thread of their existence with renewed pleasure. Senda had grown into a beautiful young woman, and Bernhard took delight in showing her off to his friends. Her meeting with Mary shortly afterward was sufficiently circumspect, for Bernhard's involvement grated on Senda's puritanical nerves. Such goings-on only confirmed an ordinary American's belief in the immorality of European life. The thought seems to have occurred to Senda that if he could be persuaded to return to America to lecture he might be extricated from his compromising position. In any event, on her return to America she decided to look into the possibility of his giving a course of lectures at Smith and elsewhere.

Bernhard's affluent friend James Burke returned to Paris in August from a visit to northern Spain. Eager to pick up choice works of art, he enlisted Bernhard's help in his picture buying. Accepted as a friendly challenge to his expertise, this collaboration had more practical consequences for Bernhard than his work with Costa. He helped Burke buy a Degas, a Besnard, a Pissarro, and a Boudin. Burke's pleasure in acquiring these paintings was very great, but not nearly so great as his delight in getting a Piero di Cosimo at a bargain £600. Berenson had carried on the negotiation for the painting with the dealer Gagliardi after his return to Florence toward the end of 1892. When Burke got the news he exclaimed, "You are the most marvellous man of business in existence!!" He had been prepared to pay £800 for the painting when he saw it at Gagliardi's, having heard that Benson and others were offering 800 guineas for it. He was so pleased with Berenson's "stroke of genius" in getting the painting for him at such a "ridiculous" price that he insisted

not on paying a commission—for that he knew would offend his friend—but on holding the £200 ($1,000) saved as a fund to be drawn on by Berenson at any time, and not as a loan but as an outright gift. It was a temptation that Berenson, living as he was on the precarious bounty of friends, could hardly resist, much as he had heretofore despised the art trade and its "jackals," as the intermediaries were called. Respected authorities like Richter and even the more disinterested Frizzoni might take commissions and deal in art on the side, but the practice had disturbed Berenson. To the more exigent Mary the news of Burke's benevolence must have opened delightful visions of returning affluence. If Bernhard would not write for publication, he could at least turn his great expertise to the far more profitable task of aiding collectors. And as if to justify such speculation, Bernhard had let it be known that he simply could not complete the article which he had begun to write in Bergamo on the collection which Morelli had given to the city because he could not establish an intelligible sequence among the pictures. He explained, in his defense, that he had made progress on his monograph on Lorenzo Lotto.

Undaunted by Bernhard's excuses, Mary decided to turn over to him her "heavy" article on the Vienna Venetian painters for reworking, since Putnam had turned it down. She suggested that Bernhard flesh it out with "lists of all the genuine works of Venetian painters." The Michael Fields had evidently been apprised of this, and Miss Bradley cautioned them, "If you could for a while cease to compose together and be content with severely criticizing each other's work, it seems to me you would grow stronger."

Persuaded at last to put aside his finicking scruples, Berenson found a certain satisfaction in writing avowedly for publication. He prepared a long essay on the Venetian painters, presumably adapted from Mary's piece, and read it to his friend Burke, who was "duly appreciative." The essay seemed to Berenson "something remarkable," but at the end of 1892 he fretted that it was still unpublished. He could not help chafing against the new regime which Mary had imposed on him. He felt torn in many directions and plaintively remarked, "If only I could feel that my sole function in life was growth I should be the happiest of mortals." To be conscious of constant growth and yet to be obliged to produce "makes production seem when it is squeezed out half insincere, for I know that tomorrow I shall see so much clearer."

If the tomorrows brought clearer vision they also often brought a completely changed vision, a fact that disconcerted his early disciples. It took Mary some time to avoid remarking, "But Bernhard you used to think ———." And in the mid-nineties their friend Israel Zangwill, the

British novelist, ruefully noted, "When you meet Berenson a second time you are beaten over the head for admiring what he taught you to admire the first time." As Mary put it, Bernhard's version of the "Lord's Prayer" was as follows: "Give us this day our daily idea and forgive us our yesterday's idea, as we ourselves forget our mistakes." In these years of growth he seemed governed by Emerson's aphorism: "A foolish consistency is the hobgoblin of little minds." That was one folly which he was determined to avoid as he ventured deeper and deeper into the enigmas of connoisseurship.

With the waning of summer in Paris and the departure of the hordes of tourists, it was time for Bernhard and Mary to resume their painstaking searches in Italy. Their itinerary took them to more than a score of towns in Umbria, Emilia, and Lombardy, where Berenson turned up still more Lottos. Mary's notebooks swelled with descriptive entries. Her "Index of Places" in a large ledger had already reached forty, with many entries yet to be transcribed.

Venice, as always, held them longest and produced in Berenson a characteristic overflow of self-analysis in his epistolary monologues to his sister. Revisiting the Giottos in nearby Padua, he reflected: "It is curious that my love for the fourteenth century painters grows in exact proportion to the increase of my interest in the very latest painters of all time. . . . Naturally I have a sense of form and composition. This was fed by the passionate interest I took in ancient art and in the architecture of the Renaissance, not only while I was at home, but even during my first year abroad. Of course in painting also I look for form, composition, and as to feeling, I look for the sentiment that Virgil in his Bucolics filled me with. . . . All this is as much as to say that painting as painting meant nothing to me . . . but time has changed all that. Quality of line in drawing, force, decision, mean everything to me. . . . After I have had my fill of the art in the picture then I ask what it says and I do my level best to hear what it says and to take care to say nothing myself.

"So you see, as the sentiment of the picture has become indifferent to me, I am ready to appreciate any picture with quality to it, whether it be Giotto, Masaccio, or Degas. . . . The critic will always best understand the artist who is most like him in temperament. . . . If I were [an artist] I should be a great deal like Lotto. . . . Lotto speaks to me with a directness that scarcely any other artist in any other art ever has. . . . The country I am journeying toward now is rich in his works, some of which I saw in an enchanted week in May, 1890, some of which, the most interesting, I am to see soon for the first time." He told also how he had "excursed" to Faenza to see a Donatello, "the

head of a boy, lovely locks, beautifully shaped cranium and a face full of yearning and sweetness. . . . Bode, director of the Berlin gallery, was there the day before and pronounced this work as by Rossellino, yet a child who had studied the art of connoisseurship scientifically could tell it was a Donatello."

Mary and Bernhard also discovered that they were following close on the track of Walter Pater, who had preceded them two months earlier, in August. "I suppose," said Mary, "he does not mind fleas and heat but I can't think how he endured it." In their travels Mary regularly went armed with flea powder as a weapon in the recurring "flea hunts" in country inns. On they went to the Marches of Ancona, finding eight Lottos in Loreto and five at Iesi. At Macerata they enjoyed wonderful cooking, "Mother's plus a Paris chef," he told Senda—and such bargains as a horse and carriage for all day for $1.80 and a full course dinner with wine for 20 cents.

Mary returned to England from Florence at the end of November 1892, leaving Bernhard very much at loose ends. In her absence he complained that "the mere chasing after pictures seems a rather vain pursuit." Florence was a desert without her. "Come back quickly, please," he wrote. "I am not much without thee. . . . If you want to get anything out of me thee must come back." He tried to write a review of a novel but gave up: "Perhaps when you come back—hasten the day—we can do something together." He had Costa for company in the galleries and the highly opinionated Loeser. Having acquired a reputation as a connoisseur, Loeser grated increasingly on Berenson's nerves. When he showed up again in Florence, Berenson exclaimed, "I wished him to the devil. He has been hobnobbing with kings all over Europe and been very intimate with Henry James in London. . . . He seems also to have advanced from Loeser to more Loeser." Yet, as he confided to his sister, he would try hard to avoid "mortally offending him." As for Costa, he had grown "too vehement and at bottom too indifferent about things."

As the year drew to a close without Mary's presence, his depression deepened and the state of affairs in Italy did nothing to lighten it. On Christmas day 1892, alone in his rooms above the Arno, he gloomily wrote: "It has not been a merry Christmas. Better so. Why should it be merry on the day that the institution I most hate in the world has chosen for its birthday. Has thee heard of the Pope's last encyclical [issued on December 8]? It was against Masonry and anathematizing, but by Masonry he defines everything that is dear to the end of our century, all modern culture and all modern life. . . . The Papacy must be believing itself on its deathbed, otherwise it would scarcely show its

pain so clearly." The Church was much on his mind at the moment, for he had been reading Michelet on the Reformation and had again taken up Ranke on the papacy, who, as he said, "kept me spellbound." He declared he was reading sixteen hours a day, "working up" the Council of Trent.

Burke, who was in Florence for a week, would come in and talk fascinatingly for hours on political economy and chemistry, on both of which subjects he was a master. For Berenson, expertise was the indispensable talent. He similarly admired Thomas Sergeant Perry, he told Senda, because he was the one person in the world whose opinion on literature he valued. "In matters of aesthetics, however, I consider myself the only original Adam, Columbus, etc. You see my interests are confined to the evolution of society and of ideas. . . . Outside of this subject I have very few interests."

One important result of Mary's winter visit to England was that the terms of the separation agreement with her husband were finally established and approved in Chancery. Though legal custody of the children was awarded to Costelloe, Mary's mother was to "have the right to the children for a while." Costelloe pledged also that Mary should always have access to the children. What made "the future look rather dark," however, was the proviso that the children were to be brought up as Catholics "and thus will probably learn to look on me as a horrid beast." Though she acknowledged to Gertrude Burton that nearly everyone disapproved of her conduct, she believed that if she succeeded in making a career even her family would grant that she had "the right to take my own life into my own hands."

A notable visitor to Florence in October 1892 was Professor William James, who had greatly influenced Berenson's thinking. His recently published *Principles of Psychology* had provoked widespread comment for its novel treatment of the subject. He had been granted a year's leave of absence and had settled in Florence with his family for a six-month stay. No longer overawed by his former teacher, Berenson enjoyed the chance of trying out his developing theories with the older man. Teacher and former student took long strolls up the walled lanes toward Fiesole. James vigorously objected to the high walls which shut out the view of the countryside. Berenson, attuned to a more subtle aesthetic, declared that the view was all the more delightful "for not having it constantly before one." But as Berenson recalled, James "would not listen. It was churlish to deprive one of the view. It made him mad." The two men encountered each other again in Rome a little later when Berenson went down for another of his frequent visits. His

aim, as he once wrote, was to revisit every important museum at least once every two years. That practice made him a lifelong peripatetic on on the Continent and in England so that the array of postmarks on his and Mary's letters read like the columns in a postal directory of Western Europe.

Berenson meanwhile had finally reworked Mary's material on the Venetian painters into a small book and given the piece the title "Introduction to the Study of Venetian Painting." Eager to have it criticized, he sent it off to Miss Jordan, Senda's colleague at Smith. He also hoped she might interest an American publisher. Her patronizing comments annoyed him and he asked Senda to return the manuscript forthwith, as well as other manuscripts he had entrusted to her. Senda too had seemed to patronize him. With defensive humility he insisted to her, "I simply know I am no genius. . . . I may never at all be able to write well. I can hope to write clearly however and some day when I am fifty I may find a few readers." He planned to "tinker" with the Venetian thing while in Rome, he said, and ready it for publication that very summer. He was confident it was the best thing of its kind. He thought he could get an English publisher for his writings. Still aggrieved by the derogatory comments that reached him, he complained there was no one in Boston fit to judge his work, for "Boston people expect me to return to them with strange but pretty and very intelligible toys for their amusement. All I can bring them is subtle, sincere, earnest interpretations of artists with whose very names they are unfamiliar." With a published book or two behind him the situation would be different, he said, and he would be able to return to Boston as Senda urged him to, finally relieved of the stigma of "loafer." What obviously counted was "the brutal fact that you get printed." Therefore, he was not yet ready to undertake lectures in America. Besides, with the Chicago World's Fair preempting attention there would be little interest in his lectures.

His consciousness of the exalted expectations held for him had by now become an obsession, and with no book to show, he kept imagining that Bostonians would take a malicious delight in giving him a "cold shoulder." He lectured his sister that he could not write like the Germans, who pasted together materials in the library into a big book. The fact was that "no German has ever known an Italian painter as I know Lotto. . . . I have at last got it all down in a small book, which once published is bound to become the standard book on the subject, but unfortunately it lacks the indispensable ballast of humbug and pretense." Moreover, he could not return because he felt his health could

not stand the summer's heat, and besides the cost of passage was prohibitively expensive. Unspoken was his manifest reluctance to be out of reach of Mary, on whom he had come to depend so greatly.

Mary, who had been back in Florence for some weeks, wrote to Gertrude Burton in March that now she was legally on "my own hook" and would soon be going down to Rome with Berenson. There they hoped to finish the book on Venetian painting and perhaps the one on Lotto. "We have worked a good deal on them." Presently, Bernhard wrote to Senda that the Venetian book was "now all done, but it has been an an awful job." He had "bent over innumerable notebooks for hours at a time. . . . But it is done and I love work particularly such as this which reminded me of every decent picture in Europe by a Venetian painter."

In this interminable letter to Senda he drifted off into a curiously revealing essay on his mystical love of nature, perhaps the only truly religious feeling that remained unchanged throughout his long life. "In nature," he wrote, "a thing is beautiful directly, in art, only by being strained through the web of a sympathetic and fascinating personality. . . . Perhaps nothing makes us so quickly and completely feel at one with the rest of the universe as certain landscapes seen under certain effects of light. That is why the passion for landscape has such a moral force and why in essentially religious natures it can take the place of dogmatic religion. . . . On the whole, dogmatic religion is merely the uncultivated person's striving for the beautiful, for the harmonizing principle." Wordsworth made "a real religion of landscape worship . . . and Matthew Arnold in most of his poems bids you to contemplate and follow landscape as Christians implore you to follow Christianity."

The arrangement with Burke with its considerate euphemisms for the payment of a commission suddenly took on a new importance early the next year when Bernhard learned from home that his father had developed "consumption," thus throwing the whole support of the family on Senda and his luckless brother, Abie. He immediately asked Burke to send him a check for $500 from the fund Burke was holding for him and forwarded it to Senda. He explained to her that he had earned a thousand dollars that winter, presumably in consulting fees, and more recently $150 and that he had laid up a little for Burke to invest in the event that he could not place his book on Lotto with a publisher and had to publish it himself. "If you could only know how gladly I send this money you would feel how near to me father and mother still are. The only bitter thing is that I cannot undertake to promise to continue this as an annual allowance. Yet I hope to be able to do something and I will make every effort to do my best for the family."

Later, he wrote that he could not come home because he had the expectation in Europe of "considerable driblets of money without interrupting my studies, without killing myself with lecturing and talking." Moreover, the *Nation,* only a month before, in April, had published his first considerable article, "Vasari in the Light of Recent Publications," a deflating of a recent German compilation. If he was to continue to contribute to the *Nation* as he planned, he would have to do so from abroad. He admitted that it saddened him to learn that some people thought he was spending his life "picnicking while my people are on the brink of starvation." "But you at any rate know," he reminded his sister, "that the profession I have taken to requires the life I am leading." He urged her to try to get their father to take the cure in the Adirondacks. "We must make a strong effort, you and I," he continued, "to keep the home together."

A few months earlier he had published a brief squib in the pages of the *Nation* correcting an error in a *Century* article on Tintoretto written by the well-known art critic W. J. Stillman. Berenson, who was then in Venice, was able to give the correct location of a disputed picture. Stillman published a reply admitting the error but affirming the accuracy of the accompanying attributions, unwittingly laying himself open to a more extensive demolition of his identifications. He had studied the documents but he had unfortunately not taken "the trouble to look" up the paintings themselves. Berenson's riposte in the February 9 issue, scholarly but patronizingly sarcastic, must have been sufficiently unpalatable to the older writer. It struck the schoolmasterly and impatient note that would characterize all of Berenson's later controversies. The editor, eager to end recriminations, prudently added a note: "We can print no more letters on this subject."

His *Nation* article on Vasari showed Berenson in complete command of the extensive literature on the subject. He concluded that the new compilation of documents by the German professor furnished "no new supplementary material" to Vasari. He conceded that Vasari abounded in contradictions and made "long excursions on loop lines to kick an enemy or to puff a friend." And it was obvious that Vasari "never in his life consulted a document." His great superiority, however, to the anonymous contemporary exhumed by the professor was that he "always describes a picture or a statue with the vividness of a man who saw the thing while he wrote about it and saw it so vividly that he did not think of looking up his notes." Berenson obviously felt a close kinship with Vasari, for Vasari had personally viewed "nearly all the best work" in Italy. His interpretation was "still the best there is." Though "not as penetrating as Mr. Pater nor so fantastical and poetical

[165]

as Mr. Ruskin, he is broader than either and in closer sympathy with actual humanity."

In the midst of furious writing and study in the spring of 1893, he received an invitation from a "perfect stranger" to come to Rome to look at some interesting pictures. He found himself face to face "with a party of American billionaires," he told Senda. "I saved them from spending $60,000 on four daubs not worth a hundred dollars." The unnamed tycoons paid his expenses and a fee of $100. "I think they will trumpet my name far and wide," he exulted, "as the only original patent back-action, double-running art critic." He saw the members of the party again in June in London, but again neglected to identify them in his letter to Senda. They were "most interesting," he wrote, "and I made a lot of money out of them," presumably much more than the hundred dollars. "They are likely to prove a pretty constant source of income." It appeared that no longer would he be dependent upon Edward Warren's bounty or Loeser's eccentric patronage. He had at last arrived as a professional critic and art expert.

XIII

Talent in Harness

WITH the approach of summer 1893 it was time to escape the heat of the Val d'Arno again for the annual visit to Paris. There the Salon disappointed him except for the "very latest Pissaros," which, as he said, were so sensuous they "made me feel as if I could lick them." He hurried across the Channel a few days later for the parting visit with the "American billionaires" and to begin a second course of lectures on Italian art, which had been arranged for him by Mary. The neatly printed announcements advertised "A Course of Ten Lectures on the Italian Masters by Mr. Bernhard Berenson," to be given on Tuesdays and Fridays. Berenson wrote to "Michael" that "Mrs. Bywater, at whose house I am to lecture, tells me she will be happy to have all the people come to my lecture that I can get. . . . If you know any people therefore willing to exchange two guineas for some sundry ideas on Italian masters please let them know of my course and that it will begin June 20 at 11 a.m. with a lecture on Giotto." The series ended on July 22 with a lecture on Veronese, and Berenson was once more free to travel. The course apparently gave him little pleasure and perhaps less money. In a voluminous letter to his sister, he merely remarked that "my lectures are over and I shall be leaving London in a week." In spite of repeated urgings by Mrs. Bywater, the Michael Fields, and Mary, he declined to give further courses in London.

Mary had also crossed to London, successfully defying her husband, who had threatened to overturn the separation agreement and divorce her if she came to London. Her defiance only increased his hostility, and he did everything he could to turn her mother against her and Berenson. Mary retreated from the poisoned atmosphere of London to Friday's Hill to spend several happy weeks with the children, who were

brought down by her mother. Among the many visitors whose lively conversation made the garden terrace an agreeable haven was young Bertrand Russell. He was especially interesting because though still a student he was now engaged to Mary's sister, Alys. His grandmother had been disapproving, but he, having recently turned twenty-one and come into an inheritance of £600 a year, felt free to defy authority, though, as it appears, not prudish convention. In his autobiography Russell recalled that he was so shy that it was months before he kissed Alys, though in principle and by natural endowment, as he was quick to add, he was far from puritanical. Alys seems to have been as inhibited as he. She thought herself an enlightened bohemian, yet she felt deeply ashamed of Mary's liaison with Berenson, much as did her counterpart, Berenson's sister Senda.

Always eager to make new acquaintances, Berenson presented in London a letter of introduction to John Robertson, the editor of the *National Reformer* and former secretary to the English free-thinker and politician Charles Bradlaugh. The new acquaintance met Berenson's prime test: "He cerebrates ceaselessly." At their first encounter they talked for eight hours. How his father "would enjoy Robertson—a man as rabidly anti-Christian as himself." From London he ran up to Oxford for a few days to renew old acquaintances, "with whom you could discuss anything." In that hospitable ambiance he found himself "getting fond of England at last," forgetting how enthralled he had been on his first visit to Oxford five years before. From Oxford he went on to Wales to visit West, the companion with whom he had traveled in Sicily and Italy in 1888. West was now a curate in a mining town, "where he has to philanthropize seven thousand people on a salary of 20 pounds a quarter."

Berenson felt that the summer in England had been sufficiently profitable. He had made a number of new acquaintances who were likely to prove useful. He had seen an "enormous number of pictures and drawings." He was disappointed, however, in not finding a publisher for his *Lotto*. Among the friends who turned up in London that summer were Vernon Lee and her companion Kit Anstruther-Thomson. Vernon Lee wrote to her mother that Kit had taken her and Berenson, "that little art critic who appears destined to become famous," to see the Velasquezes at Apsley House.

Though Berenson now felt he was on the way to freeing himself from dependence on patrons and friends, the years of accumulated obligation left him permanently on the defensive, and the long-enforced humility lent a shrill note to that defense. To hold to the course he had set for himself in the face of hostile gossip and rumor, real and imagi-

nary, he grew more and more self-centered and assertive and in conse-
quence more vulnerable to criticism. His case was not helped by his
being physically a "little fellow" among tall and athletic Englishmen.
Wanting social position and wealth, he had only one resource, intellect,
cerebral power, and he learned to flaunt it as others did their wealth.
Hence it was that intellectual achievement and the importance of unre-
lenting self-education, as weapons to force entrance to the world of
privilege, were the main themes of his letters to his sister Senda. He
was kept up to the mark by the class secretary at Harvard, who regu-
larly requested reports of progress from the members of his class. In
1890 he wrote that he was "studying and travelling in Europe since
graduating . . . making a careful study of the schools of painting." In
the summer of 1893 he wrote: "I have nothing to add to the account
that appeared of me three years ago. I am trying to fit myself to write
about Italian painting, soberly and appreciatively. I spend the winter in
Florence, the spring and autumn elsewhere in Italy, the summer in Paris
and London or else in Germany." Six years had passed since he left
Harvard as a young man of infinite promise. The college mates with
whom he had worked closely had gone on to careers as teachers in
universities and were growing rather skeptical of what seemed to them
Berenson's inordinate pretensions. Hence the note of urgency about the
"brutal fact" of publication was repeatedly sounded during the winter
and spring in his letters, and he grew increasingly suspicious of the mo-
tives of those who made inquiries about his work, always quick to
imagine malice and hostility.

Success came at last in the summer of 1893. Mary took to Putnam in
London the small book on the Venetian painters which Bernhard had
rewritten and expanded from Mary's essay and to which he had added
the "lists of all genuine works of Venetian painters," as Mary had sug-
gested. Putnam recognized its unusual quality and promptly accepted
it. It would carry Bernhard's name as author. Later that year Mary
explained to her father, "My idea of course was to have both names,
because I thought and still think that the best way to answer scandal is
to tell the exact truth as openly as possible, namely that we have been
doing serious and scholarly work together . . . but mother opposed it
so decidedly that I yielded the point and asked Mr. Putnam to leave out
my name. This I thought was only fair, as the smaller part of the work
is mine, and then I am using his riches for the Hampton Court book
which is to appear in my name." She had not yet found a publisher for
the Hampton Court book and declared if worst came to worst she
would publish a thousand copies herself. She estimated that the cost
would run to twenty-five to thirty pounds and optimistically conjec-

tured that the catalogue could be sold for sixpence. She was eager to publish it, she said, because "it will at once give me an *independent* standing among professional people, who now of course know me, if they know me at all, as a pupil of Berenson." She reported also that the *Chronicle* had accepted a review of hers on an Italian book and was "asking for more."

That Mary undertook the negotiation with Putnam was to prove characteristic of her relationship with Bernhard. And if he developed dexterity in his business dealings, though never losing his distaste for them, he owed it largely to Mary's down-to-earth practicality and driving energy. By nature shy and insecure, he gladly welcomed the protective zeal that shielded him from mundane affairs, though his dependence on her sometimes irked him and led to bitter disputes.

With their joint careers now well launched, Mary and Bernhard set off in the late summer for the Wagner Festival in Munich, where they were joined by Hutchins Hapgood, Norman's unconventional younger brother. He had been graduated from Harvard the year before, and was to return for his master's degree years later on the way to becoming a writer on the disinherited of the world. Entranced by the romantic themes of the *Ring,* the three travelers took nicknames from it and clung to them for many years. The "small wiry nervous Bernhard was Mime," the dwarfish Nibelung; Mary, who had developed into a "big woman, a splendid blonde," as Hapgood recalled, was Brünhilde; and Hapgood, on account of his "deep voice," was Fafnir, the giant in the *Rheingold.* At the close of the festival Bernhard and Hapgood set off for a few weeks' walking tour in the Dolomites, Mary accompanying them usually by stages in a diligence. But sometimes she walked with them as much as fifteen miles in a day and paid for it with agonizing bouts of rheumatism.

Long afterward Hapgood, at Mary's request, put down his recollections of their six weeks together. "Do you remember how I appeared in the Glyptothek [in Munich]? An old weather-stained slouch hat, knee-breeches and a knapsack. . . . I don't think Bernhard even noticed my appearance. You did of course but it amused you. . . . I would never dare to dress that way again with him! Do you remember when we were in your Corbignano villa three years ago [1923], how I painfully put on my evening dress when I went over to I Tatti? That was for Bernhard, not for you. . . . What an exquisite he has become!" One surmises that Berenson, grateful for a male companion from his beloved Harvard, willingly overlooked Hapgood's raffish appearance. Berenson's role as an "exquisite" was of course of much longer standing, dating back at least to the time when he fitted up his artistically

furnished lodgings in the rue Vaugirard in 1887 and cropped his curls and arrayed himself in a brand new, painfully expensive outfit for his first visit to Oxford.

Hapgood recalled how vividly he had felt Bernhard's "burning, constant desire of his soul for some constructive relation with beauty . . . whether he was talking pictures, philosophy, literature, 'Life,' or sipping his vermouth and seltzer (mainly seltzer) in some cafe. He was haunted literally by what was ahead, until he wished so intensely to overtake it that his very life seemed to depend upon it. You, womanlike, meanwhile desired at times to stop and realize socially and aesthetically what was at hand, but he always put his spurs into you at that moment—Onward it was. You groaned at times but were much excited and interested and kept on. . . . You helped him enormously to become more civilized, while he acted on you as an incentive to greater creativeness. . . . And he would not let you rest on a concept or a conclusion either. He seemed to hate what had been determined on the day before, and when you sometimes clung to it (faithful soul) he was full of venomous denunciation.

"I remember him on the trail all over Northern Italy hunting up a picture, here in a private house, there in a church, again in a little museum or municipal building—some pictures he had heard about somewhere—or just prowling about and discovering one. Then he would look for ear-marks—Morelli was always on his tongue, then. . . . He was always appreciating everything, with something of the quality of a religious fanatic, and he was so full of his own reaction that he felt morally bound to destroy everybody else's that did not correspond. But that delighted me for I was appreciating *him*."

For Hapgood the strenuous weeks of travel with Bernhard and Mary were an absorbing initiation into undreamed-of aesthetic experiences. Berenson's "ravenous" appetite for beauty struck him as that of a man feverishly making up for the want of it in his boyhood environment. Hapgood considered that his passion to share his ecstatic feelings came from a deep-seated drive for self-assertion and intellectual domination. Berenson might volubly protest, as he did to Michael Field, that he sought no converts for his "doctrine," but he could no more resist propagandizing for it than he could resist the summons of an unidentified altarpiece. In Hapgood's eyes Mary "was the one person in the world" whom Berenson "desired most to educate."

Hapgood strayed up to Berlin for the opening of the university, leaving his companions to push on with their researches, always punctuated by the recurring excitement of discovery as they gypsied from town to town, but letters from London kept intruding fresh anxieties. Mary's

husband, ambitious for a political career, peremptorily forbade her to return again to England. She bristled defiance. "B.F.C.C. [as she now referred to him] has every interest in keeping things quiet," she warned her mother when she learned of his threat to expose her if she returned. She promised to retaliate by publishing parts of her journal and their letters which, though not containing legal accusations, "would pretty effectively ruin his career." As for the gossip already afloat that Berenson had spoken of her as his "latest conquest," it was patently absurd in the face of their two years' work together. Besides, she added, with a bitter backward glimpse at marital discord, it was no more her business what Berenson's "immoralities, if he had any, have been than it is his business to know that I had a child without wanting it."

She denied that Berenson had "hypnotized" her or that she was living under the same roof with him, as was rumored. Hadn't she solemnly promised her mother that she would respect appearances? Her apartment at number 12 Lungarno Acciaiuoli was a discreet distance from Berenson's at number 24. She was a free person and resolved to carve out an independent career. She had made such progress in art criticism under Berenson's instruction, she told her mother, that he was confident she could "make a name" for herself even if they were never to see each other again. She was already known as a writer, having recently published an article entitled "The Woman Question in Novels" and a piece on Ibsen's *Master Builder*. Hannah had no choice but to accept this recital as a declaration of independence—up to a point.

In October of 1893, Mary completed the preface to her *Guide to the Italian Pictures at Hampton Court, with Short Studies of the Artists,* and dutifully asked her mother's approval of a proper acknowledgment to Berenson. This her mother refused. Mary insisted, however, that she would at least have to state her debt to Berenson in her discussion of Giorgione, since it was "unblushing plagiarism that got Vernon Lee into such trouble." What the "trouble" was seems past finding out, but as we shall see, it apparently left a lingering impression on Berenson's suspicious nature. When the *Guide* came out in the following summer over the pen name of Mary Logan, Berenson's first book had already been published by Putnam and Mary was able to include a footnote to the list of pictures "which can safely be ascribed" to Giorgione, stating as her source *The Venetian Painters of the Renaissance, with an Index to Their Works,* by Bernhard Berenson, "the most recent authority of Venetian painting."

Their "October wanderings" brought them once again to Venice, which they reached in the midst of a torrential rainstorm. Here they witnessed an astonishing sight in the Piazza San Marco, a flood like the

ones that would cause international anxiety in the next century. Mary told her children, Ray and Karin, in one of her daily letters to them how the water had flooded into the vast square "and all the children were wading up to their knees. . . . There must have been a hundred children, and how I *did* wish my two little darlings were there wading with the other children!!"

Bernhard sent off from Venice a three-column "letter" to the *Nation,* "Isochromatic Photography and Venetian Pictures," in which he reported the remarkable work of the Alinari Brothers in Florence and of Domenico Anderson in Rome in making accessible to the connoisseur the Venetian paintings hanging in the dark recesses of churches, paintings like the "splendid series" of Tiepolos in San Polo, which were "absolutely invisible except by candlelight." He prophesied that photographs like theirs, which preserved the relative values of colors and which made possible the comparison of paintings down to the smallest detail, could have as great an effect on the study of the Old Masters as the invention of printing on the classics. "The basis of connoisseurship," he wrote, "is the assumption that an artist develops steadily and gradually and does not change his hand more capriciously or rapidly in painting than in writings." Now one could supplement one's memory of a succession of a master's paintings seen at long intervals by simultaneous comparisons of photographs, a method which achieved "almost the accuracy of the physical sciences."

He immediately followed that article with an engaging essay, "A Word for Renaissance Churches," in the November issue of the London *Free Review* explaining why the Italian Renaissance church was commonly undervalued when compared with the Gothic church. Unlike the Gothic builder, who sought to impose a feeling of awe, the Italian aimed at the "noble spaciousness" of the antique Romans, desiring "perfect space, proportion, and order." The "crowning point" of his design was the dome resting on the center of the equal arms of a Greek cross. His chief concern was always the interior, on which he lavished his decoration, hence the many unfinished façades. However, the introduction of the long nave from the North, "a sacrifice to the spirit that prevailed at the Council of Trent," involved the Italian architect in a variety of compromises which, as in Florence, obscured the sublime effect of the great central dome. So too the rejection of the original plan of Bramante for St. Peter's in Rome led "to the most colossal failure in art," for the immense nave became a mere princely "salon" hiding from view Bramante's great dome. The Italian idea of "space composition" never died out, however, as might be seen in the great Glass Gallery at Milan.

The sweeping historical perspectives of the essay show the care with which Berenson had studied his copy of Taine's *Lectures on Art:* the development of art could be understood only if one knew the conditions of life and thought from which it sprang. The study of aesthetics was analogous to the study of the natural and moral sciences. This application of evolutionary principles to the history and criticism of art would be the dominant note of all Berenson's subsequent writings on art.

The essay had had a curiously laborious birth. Mary's aggressive criticism of his style, especially of its un-English self-assertion and its occasional vestiges of German syntax, put him on the defensive. He then tried out the essay on "Michael," who reassured him with praise of the piece. Then, rather rashly, he invited Vernon Lee's criticism. She was, after all, the leading literary figure in the Anglo-American colony and she had frequently accompanied him on tours of the galleries of Florence. In justification of his seeking her out, he observed to his sister that there was no use "in refusing to recognize superiority; recognizing it is a first step to acquiring it." If he had expected to impress Vernon Lee, he was quickly disabused. In her long critique she told him that their conversations on art convinced her of his "very rare" powers beyond mere "picture expertise." What he lacked, however, was the fine art of "literary expression." She offered to go over the essay with him, adding, "I am so confident of your future that I should be delighted to take a hundred times more trouble than this would imply."

He appears not to have accepted her offer in this instance, and in the absence of the original manuscript one cannot know what "improvements" his advisers urged him to make. In any case he persisted in seeking Vernon Lee's counsel. Shortly afterward he asked her to criticize the draft of his monograph on Lorenzo Lotto, with which he had been tinkering for nearly two years. She returned the manuscript with a devastating critique, concentrating most of her fire on his introduction, which she characterized as "virtually a mere onslaught on archivists and documentary criticism" that "entirely fails to make the reader feel the immense gifts he is to receive from the new school of criticism. . . . That is why I want you to learn to write. You do not do justice to yourself. Your conversation, your demonstrations in the gallery are full of suggestiveness and grip; your writings are almost empty of them." She declared that since he had "no literary gift as such," his "most valuable work [was] sure to be of the scientific sort," and she concluded her long homily on his literary shortcomings with a few notes on the manuscript.

It was a bitter dose to swallow, but swallow it he did. He jettisoned most of the introduction, which was full of the personal fervor of dis-

covery, and went back to the manuscript to cut out the flourishes which belittled his misguided predecessors. He never forgot the lesson—nor, it appears, did he forgive it for having helped render his writing on art impersonal. Not until he published his almost painfully candid *Sketch for a Self-Portrait* more than half a century later did his suppressed ego escape the inner censor.

In conversation soon afterward Vernon Lee must have tried to bandage his wounds and evidently succeeded beyond reasonable expectation, for he wrote to his sister that Vernon Lee "thinks I have a far clearer and deeper understanding of the laws governing the methods of criticism than anybody has ever had before and she is anxious that I should write it all down and get credit for it." She warned him, he said, that "a much more facile and lively writer than myself, one like herself, for instance [an unfortunate observation as it afterward turned out] would take hold of the idea and method . . . and publish them as his own." She liked his *Lotto* "middling well," went his gloss of her critique, not as "literature" but for its "matter and idea." Having seen "the truth of all she said," he had set to work on a new book. Putting the best face he could on what must have been a traumatic experience, he remarked for home consumption, "It gives me the queerest feeling to be again told, as I used to be in my giddy senior year, that I am a genius, etc., etc. I have long ago given up looking at myself in that light. . . . Vernon Lee can say as much as she pleases that I am a genius, far greater than Wincklemann, Lessing, or Hegel. I do not trouble to think about it." Mary, more sanguine than he, wrote in her journal, "The great event is that Miss Paget [Vernon Lee] thinks Bernhard has made a great, great discovery in aesthetics and has spurred him on to commencing a book on Scientific Art Criticism—a book which she prophesies will make its mark."

The book so promisingly begun was soon abandoned as the magnitude of the project became apparent, and only the first section was completed. It was subsequently published in 1902 in his collection of essays *The Study and Criticism of Italian Art,* Second Series, as "The Rudiments of Connoisseurship. A Fragment." In the preface to the collection he suggested that he had set aside the "Fragment" for the "wiser course" of writing his *Lotto,* in which he could exemplify his "method in a concrete instance." Actually, he had begun the *Lotto* earlier but subsequently rewrote it on the lines laid down in the "Rudiments."

The "Rudiments" was in a very real sense a manifesto of the new connoisseurship, and its belated publication was a defense against his many adversaries among collectors, art critics, and dealers, who had

come to resent his uncompromising and unsettling authority. The essay presented the principles on which that authority was grounded. He declared that "the materials for the historical study of art are of three kinds: Contemporary Documents, Tradition, the Works of Art themselves." Valuable as the contemporary documents might be, they were not sufficient proof in themselves of authenticity; noted painters sometimes put their signatures on the works of their assistants. Descriptions in contracts were often so "extremely laconic" that they might fit pictures by various artists. "Tradition" needed to be used with even greater caution. It followed, therefore, that chief reliance must be placed on the "scientific deductions of the connoisseur." These, he went on to point out, took account of "types, general tone, composition, technique," and finally "morphology," the study of the artist's characteristic treatment of the anatomy—the cranium, the eyes, the nose, the ears, the mouth, and the hands. Landscape, architecture, drapery, color and shade, all required analysis, but their value as formal tests depended on how easily they could have been imitated or had been subject to fashionable depiction. The crucial principle, he underscored, was that *"the value of those tests which come nearest to being mechanical is inversely as the greatness of the artist. The greater the artist, the more weight falls on the question of quality in the consideration of a work attributed to him."* It was this principle that was needed to modify Morrelli's system. A very great debt was indeed owed to Morelli, but he was too much of "a mere empiric" to develop a philosophy or rather a theory of connoisseurship. "What he would not attempt," wrote Berenson, "I have tried to do." Morelli, in short, had oversimplified the problem. The great number of subtle variables, though objectively visible, could be measured and evaluated only by the most highly trained and discriminating intelligence sensitive to every nuance of shape and color. The "Rudiments" provided in effect an outline of the proper training of a connoisseur, a rigorous course of training to which Berenson obviously had himself submitted.

If the "Rudiments" could hardly avoid being doctrinaire and even dogmatic, the same cannot be said of an essay on the Dresden Correggios which he wrote about the same time, undistracted by Vernon Lee's advice. It too had to wait for publication, until 1901. In it we see not the propagandist but the appreciative critic-historian full of the lively enthusiasm which in his gallery tours converted so many of his companions to his way of total seeing. The time had passed, he wrote, when enthusiasts eagerly debated the "Correggiosity of Correggio" and under the influence of the unhealthy German romanticism of the early years of the nineteenth century admired the contorted and monstrous

figures of the pictures of his maturity. With the advance of knowledge of the Old Masters, critics had come to recognize "that the latest works of a painter are not necessarily his best." This was especially true in the case of Correggio, who was more lyric than epic in his genius. One could most readily appreciate the fineness of his earlier paintings by perceiving how his genius transmuted the successive influence of Bianchi, Francia, Costa, and Dosso Dossi, and how finally in the *Faun* at Munich he absorbed the Venetian color of Palma and the movement of Lotto. Such a genetic study of a painter showed that there was "a large intellectual element even in pleasure supposed to be purely aesthetic." Moreover, if we learn to like his characteristics for their beauty and for their historical associations, we continue to like them, no matter how disguised. One can enjoy his Dresden St. Sebastian for its "high-strung sensuous emotion which inevitably suggests the music of violins," though the movement and feeling are "utterly out of harmony with the subject of a religious picture." In such fashion Berenson epitomized his habitual way of looking at the paintings of the Renaissance, the way in which the insights of the connoisseur are refined by those of the critic and the historian.

BERENSON's friendship with Vernon Lee did nothing to subdue his combativeness and self-assertion. Her villa, Il Palmerino, had rapidly become a chief meeting ground for intellectuals and aesthetes of Anglo-American and Florentine society, but it was a ground on which no quarter was asked or given for one's opinions. Intensely articulate and competitive, expatriates and natives alike enjoyed the self-dramatization of the *conversazione,* the meetings in each other's salons to debate set topics in art, literature, and science. Il Palmerino was a rustic villa at Maiano on the slope of Fiesole, approached through narrow, high-walled lanes that traversed the sloping fields and vineyards. There was something rather forbidding yet fascinating about the appearance of the mistress of the villa, as one gathers from the Michael Fields' record of a visit. She looked "a sybil in a tailor-made black dress, vine-dresser's hat and apron, sowing seeds. . . . She looks fifty; she is thirty-nine. She is very ugly; the face very long . . . restless features." The "tiny house," more farmhouse than villa, seemed without "charm." Having been instructed by Bernhard, the Michael Fields thought her "very stupid in what she said about art." In the privacy of her journal Mary concluded that Vernon Lee had "curious insights and genius" but was careless of her facts and talked "eccentric nonsense about literature." However, neither vehemently expressed opinions nor private reservations stood in the way of cordial visits. Mary, whom Vernon Lee

praised as "a fount of knowledge," often spent a weekend at Il Pal-
merino, and Vernon Lee, when in England, was equally at home at
Friday's Hill with Mary and her family.

It was a pleasant walk of but a few miles for Bernhard along the road
which followed the streamlet l'Affrico through the then green coun-
tryside to Il Palmerino, where he was a frequent and contentious vis-
itor. There one day in 1894, he met an Italian writer, four years his
senior, who was to become his oldest Italian friend. A brilliant exotic,
son of an Italian banker and a Spanish-Mexican mother, Carlo Placci
took to him at once. Their long friendship would eventually have its
painful interruptions over Placci's vagaries in religion and politics, but
these would be years in the future. When Berenson came to look back
on their friendship a half century later in an article in Cyril Connolly's
Horizon, having recently learned of the death of his estranged friend, he
wrote nostalgically of that first meeting: "I discovered him at Vernon
Lee's. It was evening. The light was dim. I got no clear impression of
his features, but they seemed pleasant and friendly. The voice was mel-
low, beautifully pitched, with a seductive timbre. To my surprised
gratification he looked me up the very next afternoon in my eyrie some
hundred and thirty steps up in Lungarno Acciaiuoli, and we had a long
talk. . . . He pulled me into his circle, not only inviting me to his
house . . . but he made a point of introducing me to all his friends
whether Florentine, Italian or foreign, who enjoyed his hos-
pitality. . . . I owe most of my social and nearly all of my society
contacts to Carlo. He was generosity itself in passing me from friend to
friend." Time and memory, as is often the case, had altered his recollec-
tion of their first meeting and a lingering gratitude had lent a touch of
romance. It was indeed at Vernon Lee's that the encounter took place,
and at that time he described it to Mary with characteristic acerbity:
"When in came Carlo Placci, a sleek, greasy and fearfully unpleasant
person. Vernonia [Berenson's private nickname for Vernon Lee]
seemed queer, excited like a girl when her sweetheart is unexpectedly
announced. I retired quickly." Berenson recoiled at first from this pat-
ronizing apparition who reputedly knew everyone worth knowing in
Europe and who regarded flattery as the ordinary currency of friend-
ship. He felt a certain superiority in the presence of this gilded person-
age who came in "with a swagger and grossly vulgar-sounding English
as if he owned the universe."

Not greatly talented as a writer—his stories struck Mary as un-
forgivably vulgar—Placci was nevertheless a young man of infinite
charm and rich enough to be, as his mother indulgently remarked, *il
ministro degli affari inutili,* "minister of idle affairs." He had a dilettante's

interest in socialism at the time; one day in 1895 he brought a young man to visit Berenson, "a rabid socialist named Gaetano Salvemini," who, as Mary reported to her mother, "almost fainted with pleasure when I showed him Sidney Webb's photograph. He says they adore Sidney Webb here." Salvemini was then a student at the University of Florence, at the beginning of a remarkable career as a historian and polemicist. In spite of his socialist opinions he became one of Berenson's closest friends. On this first meeting he harangued them for three hours. Unlike Placci's, Salvemini's principles were bone-deep. Much later, when Placci, to Berenson's disgust, became a convert to fascism, Salvemini, by then a distinguised historian, found asylum at Harvard as a lecturer in the history of Italian civilization.

Through Placci Berenson also became friendly with the German sculptor Adolf Hildebrand, who owned the palatial Villa San Francesco on the Via Bellosguardo. His emancipated wife, who had had a disastrous first marriage as a girl, had lived with him for many years, producing daughter after daughter, before she was finally prevailed upon to marry him. The houseful of young women in low-cut dresses with their long locks crowned with wreaths looked to Berenson "like young Goths." The villa was fast becoming a favorite meeting place for German artists and writers.

Hildebrand, who was still in his early forties, was something of an aesthetician and Berenson promptly read his recently issued book, *Das Problem der Form in der bildenden Kunst.* It helped to crystallize one of Berenson's leading ideas. Hildebrand concentrated his attention on the psychological aspects of how a work of art is actually perceived in three dimensions and carefully analyzed the optical factors. This led Berenson to postulate that "all arts, except music, were primarily occupied with *space composition."* Mary, who now was not given to easy acquiescence in Bernhard's obiter dicta, noted that she "lay awake half the night trying to refute" the idea. Berenson drafted a review of the small book, which, he noted, "was rousing a great deal of attention just now both in Germany and Italy." The book touched a sensitive nerve, for it aroused Berenson's inveterate dislike of German theorists. Its vocabulary, he declared, was "almost purely Teutonic" and therefore made discussion of "an abstract problem . . . as good as impossible." He abandoned the review but not the fertilizing idea of space composition.

Mary was soon writing that Placci, having taken Bernhard under his benign wing, had carried him off to meet "charming people like Countess Rasponi, the Baroness French, Signor Nericioni, Prince Galitzine, etc." These were but the first of a long list of titled notables in whose elegant company Berenson came to feel more and more at home

and whose luxurious villas filled with paintings and objects of art were bound to arouse in him the desire to create one day his own "great good place," one at least as finely expressive of his taste as the Villa Gattaia, which Loeser was furnishing.

His relations with Charles Loeser had continued to deteriorate in proportion to Loeser's growing reputation within his own circle as a connoisseur of art. The two egos which had clashed so frequently over attributions a few years before during their journeying about Tuscany had not mellowed. More self-confident than ever, Loeser took an almost malicious delight in contradicting Berenson and depreciating his work among their acquaintances. He became one of the first of those whom Berenson was to call his "enemy-friends." Beneath the surface of their continuing intimacy burned a mutual distrust and rivalry. To Mary and Bernhard he seemed insufferably "pretentious" in setting himself up as an expert connoisseur, and Bernhard was soon urging Mary to "lose no chance of exposing Loeser as a quack practitioner; the law defends doctors and lawyers, in science people must defend themselves." Loeser, casting about at last for a weapon to humble his rival, recklessly charged that Bernhard had welshed on a debt to him, and he tried to turn Mary against Bernhard by confiding to her that he felt "toward Berenson the most vigorous contempt," evidently entertaining the strange idea, as Mary noted, that he would in this way ingratiate himself with her. When Mary threatened to break all relations with him for spreading "the cruel slander," he promptly apologized. The breach was healed over for the moment and Mary even came to think him "rather nice," though she privately deplored his lack of brains and sensitiveness. His latent animosity did not diminish, however, and in time it would help fuel the bitter partisanship among friends and acquaintances which Berenson's success aroused.

Mary had returned to England early in December of 1893 to spend the holidays with her children and her parents at their Grosvenor Road address, defying her husband's threats that he would not tolerate her presence as a near neighbor. Her pleasure in seeing the two girls, to whom she was more devoted than ever, was marred, however, by the prolonged recurrence of her chronic menstrual troubles and a painful ear infection. It was during this stay that she managed to arrange for the publication of her Hampton Court *Guide.* On her way back to Florence she visited with her brother, Logan, in his Paris bohemia and, as always, checked attributions in the Louvre. Bernhard had fretted at her absence, for her help had become indispensable to him. As Mary put it, "it is 'obvious' to the meanest intelligence that we can't get along without each other." And this was true, although the romantic raptures of

their union had long since subsided and their lovers' quarrels were succeeded by professional arguments which occasionally flared up when they worked or traveled together. Day after day through the spring of 1894, he would pass the manuscript sheets of the *Lotto* to her for correction and transcription on her typewriter, or they would huddle over sheaves of photographs to establish the authenticity of the paintings. It was she who would prepare charts showing the filiation of painters and help him bring order out of the chaos of his notes. Gradually, he came to rely more and more on her practical business sense and gladly left in her hands much of the management of their curiously divided household.

They settled into a domesticity so complete as to raise no eyebrows in their cosmopolitan circle. Bernhard commonly breakfasted with her and was as much at home in her apartment as she was in his. Mary rented a piano to resume her music lessons and for a brief time undertook the formidable task of teaching Bernhard the intricacies of the keyboard. He did not prove an apt pupil, though he continued to be an avid listener and later, with the advent of the player-piano, made his own music. They often passed their evenings reading aloud to each other or immersing themselves in the volumes which he kept crowding into his shelves. From Taine's *Philosophy of Art* he would hurry on to James's *Psychology* and from that to Pater's *Plato and Platonism* and then go on, as Mary recorded, to "swallowing hundreds of pages of German rubbish on art" until, surfeited, he cried out, "Jesus, how I loathe the Germans." Yet he could not wholly resist the soaring phrases of Hegel's *Aesthetics,* which led to a violent dispute with Mary over his use of "such loathsome phrases as 'will a universe.' " She had come to detest metaphysics and "the whole incomprehensible jargon in which perfectly comprehensible ideas are dressed up." She had had her fill of that with her husband. However, when Bernhard and a new acquaintance, the German sculptor Hermann Obrist, who was two years his senior, traded scintillating generalities about art, Mary was "awe-struck" with the sense of Bernhard's genius.

Their financial circumstances, though still rather precarious, were beginning to ease as Berenson's services as an expert began to be solicited by friends and acquaintances who had caught the virus of picture collecting. His first really important client was the retired American financier and copper magnate Theodore M. Davis of Newport, Rhode Island. Davis had now become an important Egyptologist and in 1893 directed excavations in the Valley of the Kings. He may well have been one of the rich Americans who had summoned Berenson to Rome in that year for advice on their purchases of Italian paintings. In March of the following year Mary joyfully wrote in her journal, "Bernhard has

sold *another* picture to Mr. Davis." In a long letter to Berenson Davis told of his pleasure in his recently acquired "Moroni" and in the evidence Berenson had given him of its authenticity. He awaited the new picture with "anxiety and pleasure. . . . The blind confidence I have in your judgment and taste gives me great hope." He ended with the request, "If you see any VERY *fine* picture which can be bought *very* cheap, please advise me." One of the paintings had come from the choice collection of Berenson's friend the art historian Jean Paul Richter, who like others of his profession in that day was not averse to turning a handsome profit on his finds. Richter was to make increasing use of his knowledgeable young friend as an intermediary with American collectors.

If the connection with Davis marked the turning point in Berenson's fortunes, the "great event" of the spring of 1894 was the publication by Putnam's of *The Venetian Painters of the Renaissance,* a copy of which he discreetly inscribed to " 'Mary Logan' with the author's compliments." The preface paid Berenson's respect "to the founder of the new criticism, the late Giovanni Morelli and to his able successor Dr. Gustavo Frizzoni," to both of whom he was obliged for many of his attributions. He also thanked his friend Enrico Costa, whose "unrivalled connoisseurship" had provided him with notes on his recent visit to the Prado at Madrid. Berenson explained that he had "seen and carefully considered all the pictures" mentioned in his "Index of Artists" "except one or two at St. Petersburg," for which he relied on photographs, not daring to risk a return to Russia.

Berenson's "first brief rapture over my first-born—such a little one"—the small book ran to only 150 pages—was marred, as he told Senda, by his "disgust at the unfitness and vulgarity of the binding." However, he went on, he read the little book with absorbing pleasure, though "every awkwardness of English" gave him "a stab" and the occasional misprints "nearly killed" him. It was a moment of pardonable pride—and relief. Seven years had gone by since he had left Boston burdened with the exorbitant expectations of his well-wishers. He had been too long on the defensive against the critical Boston gossip which reached his ears not to feel a desire to press his vindication. He wrote to his friend George Carpenter, now a professor at Columbia, to try to get the book adequately reviewed in the *Nation,* where his articles on Italian Renaissance art had been appearing. The most recent of these, "Dante's Visual Images," had, in fact, just been accepted. Despite his fear that the *Nation* might assign the review to a hostile critic, one like the *Nation* regular, William Stillman, with whom he had crossed swords over Tintoretto's *St. Mark,* the anonymous reviewer in the April 12 issue gave it

a sympathetic appraisal: "The writer's ideas are interesting and worth attention," and his thesis that " 'Venetian painting is the most complete expression in art of the Italian Renaissance' " is supported "with very good reasons." He added that for many what would "prove most useful" was the "Index to the Works of the Principal Venetian Painters," which made up nearly half of the small book. He pointed out that some of the attributions in the Index were at "variance" with museum catalogues, being based on Morelli's and Berenson's own findings. With each edition of the *Venetians* and of the companion volumes which soon followed, the "Index of Artists" was to be successively enlarged as Bernhard and Mary located additional paintings in museums and private collections.

The book elicited a good number of reviews, especially in England, and for the most part reviewers found much in it to praise. *The National Observer* reviewer, for example, thought that in compressing the "motives, methods and masterpieces" of the principal Venetian painters into a mere seventy-eight pages Berenson was too elliptic; nevertheless, for those who desired a short cut "the services of so deft a guide as Mr. Berenson are not to be received ungratefully." Though not approving Berenson's comparison of the Renaissance to the birth and childhood of a man, the reviewer, nevertheless, "heartily" commended the volume to readers interested in Venetian art. An appreciative critic in *The Artist*, on the other hand, considered the "simile" of the Renaissance to the life of an individual to be an "apt" one. If the book was too slight a work to be a "standard" one, it was "very readable" and the "Index" of painters would be valuable to the student. "H.H." (Hutchins Hapgood) in the *Harvard Monthly* must have pleased Berenson with his remark that the "peculiar charm" of the book lay in "the intimate character of its aesthetic criticism."

Vernon Lee produced the most elaborate critique, a critique which carried into the pages of *The Academy* the prickly animus of many a debate at Il Palmerino. "Mr. Berenson," she wrote, "has done rather badly what so many essayists from Pater downwards have done very well"; moreover, "he has refrained from giving a full account of Venetian art morphology." She conceded that the "Index" showed, however "fragmentarily and unconsciously," that the Morellians had discerned the "reality of artistic form." What remained was to enunciate the law of the evolution of that form, a task which "it will probably be Mr. Berenson's mission in life to determine and promulgate."

What impresses one about Berenson's long essay on the Venetians is that though he wrote without the literary grace of a Pater or a Symonds, he did display the gift of an inspired commentator whose con-

tagious enthusiasm shows at every step a disarming passion for his subject. In a period of awakened hunger for culture, his uncomplicated account of the grand tendencies in Italian Renaissance art, the turning from heavenly concerns to "the growing delight in life with the consequent love of health, beauty and joy," offered a picture of felicity unattainable in the turmoil of the fin de siècle. Too occupied with duties of state to pursue either glory or learning, the Venetians had sought comfort, splendor, "refinement of manner," and indulged the social passions. And these found expression in the paintings of Bellini, Vivarini, and Carpaccio. Giorgione's paintings were, therefore, "the perfect reflex of the Renaissance at its height." In quick and vivid strokes he told how Giorgione's followers brilliantly exploited the vein of portraiture which catered to a pleasure-loving society, Titian above all others.

His absorbing narrative traced the changes of style through Tintoretto and Veronese and the lesser artists of the declining years of the Venetian state, painters like Canaletto and Guardi, whose picturesque views of Venice anticipated "the Romantic and Impressionist painters of our own time." What they lacked in force and "feeling for splendor" was supplied by their great contemporary Tiepolo, whose works inspired the revival of painting in Spain under Goya and in turn influenced later French artists. In such summary fashion Berenson swept his readers through the alluring vistas of Venetian painting. If it was true that the essay broke no new ground, except perhaps in the case of Lorenzo Lotto, it marked a significant point in the awakening of popular taste in England and America to the attractions of Venetian painting.

The cautious publisher had sent over only a hundred copies to London, the book having been printed by the New York branch, and these were sold out in a few days. It was obvious that the little book had caught on. The fact was not lost on the enterprising George Haven Putnam, and by the following spring he proposed that Berenson prepare similar small volumes on Florence, Rome, Verona, and so on, a suggestion that over the years was to lead to three more equally popular classics of art interpretation. What must have pleased its anxious author as much as anything else was a favorable review in his "hometown" paper, the Boston *Herald*. At last he could look the Boston world in the face, and he promptly made arrangements for a visit home in the fall of 1894. Senda had suggested that he come over to lecture at Smith College and he now seized upon the suggestion with alacrity, for he feared he was likely to be "fearfully pinched for money" and was therefore "anxious to earn all I can in a quick way." To guide her arrangements he explained that, having "next to no chest," he could not address a

large audience nor could he read a prepared lecture since it was his habit to improvise his commentary.

The rather elaborate lecture plans that filled their letters during the early summer of 1894 encountered the usual academic inertia, and the "series" had to be abandoned, and with it hopes for a series at Hartford and Boston, from all of which he had dreamt of earning $500 or possibly $1,000, but he did not give up his plan to show himself again in Boston. Meanwhile, he continued to pick up a few dollars with a succession of brief scholarly paragraphs in the "Notes" section of the *Nation* on European art and letters. For example, in the March 15, 1894, issue he observed that Maeterlinck's hypnotic repetition of a word or phrase in his poetry had a striking parallel in that of the Italian Renaissance poet Rucellai, a circumstance which brought to mind a scene in Wagner's *Rheingold*.

Mary, equally determined to earn her living as a writer, kept a sharp eye out for art books to review and managed to place a few reviews. But she soon turned to a more important task, a full-dress defense of scientific connoisseurship. Her essay "The New and Old Art Criticism" appeared in the May 1894 issue of the influential *Nineteenth Century* magazine, defiantly signed Mary Whitall Costelloe. She acknowledged that it might seem at first arrogant and revolutionary to question the knowledge or the good faith of those in authority over the great picture galleries, but such questioning was the beginning of wisdom "for the student of Renaissance art." She pointed out, for example, that the list of paintings in the Louvre catalogue attributed to Raphael was calculated to confuse one's appreciation and understanding of his achievement since of the fourteen paintings attributed to him only four were genuine. An unfortunate result of this particular error was that a school of French artists had modeled their supposed Raphaelesque style on the inferior pseudo-Raphaels. The case was no different in England, as she illustrated by exposing the errors in the catalogue of the National Gallery. "In teaching us to look upon such horrors as the 'Venus and Cupid' and the two circular 'Madonnas' as genuine Botticellis, [it] has probably done more to corrupt taste in a certain set of 'cultured' English and American people than volumes of bad art criticism could possibly have done."

She then proceeded to explain the "new scientific method which attempts to set matters right." In doing so she skillfully elaborated the program that Bernhard had set down in skeletal fashion in his unpublished fragment the "Rudiments of Connoisseurship." The same scientific spirit which now animated the study of philology and history needed to be applied to art, and it no more debased the study of art than

philology debased the study of literature. The new method would help people to avoid wasting their time and strength on inferior material. It called attention to the significant characteristics of a work of art, to what is "germane to the art" in contrast, for example, to the approach of Ruskin and his disciples, who in seeking the Gothic element in Italian art wholly missed its intrinsic character. The new method also aimed to provide an intelligible vocabulary for expressing the meaning "of the art of a given time." Such work was no mere pedantry—the common reproach against Morelli—"but of great consequence in the formation of public taste." In this fashion Mary assigned to Bernhard by unmistakable implication the leadership of the new movement.

XIV

New Vistas at Home and Abroad

THE Boston patron whose good opinion Berenson had most
keenly wished to regain was Isabella Stewart Gardner, that
wealthy autocrat of Boston culture who five years before had
given him up as a lost cause. Her good will might well be of use to him
on his projected visit to America. He asked the publisher to send her a
copy of *The Venetian Painters* and on March 11, 1894, he sent off a suf-
ficiently humble letter to tell her about it. "Your kindness to me at a
critical moment," he wrote, "is something I have never forgotten, and
if I have let five years go by without writing to you, it has been because
I have had nothing to show that could change the opinion you must
have had of me at the moment you put a stop to our correspondence.
The little book I now send is one for which I can count on more credit
from you than from most people; and I know you will understand the
effort of one who has condensed into the smallest possible space a per-
sonally appreciative account of a fascinating school of painting." He
hoped, he said, to send her "two or three other books in the course of
the next two years; and if they succeed in reviving some of the interest
you once had in me, I shall have had my reward."

The pose of suppliant could hardly have been congenial to him in his
moment of triumph, but knowing "Mrs. Jack's" appetite for admira-
tion, he had little choice but to bow as a courtier for favor if he were to
be reestablished in her good graces. That Mrs. Gardner should turn out
to be his Maecenas and change the course of his life must, at the mo-
ment, have lain beyond his modest calculations. Her acknowledgment
of the book, dated March 15, crossed his letter in the mails and showed
that her interest had indeed been revived. "I have heard nothing from
you for a long time[,] which was bad of you," she blandly reproached
him, ignoring the fact that she had been the offender. She hoped to see

him in Europe to talk over the book and the painters and, she significantly added, "in fact many things."

There had been an important change in her interests since their break. For years, under the influence of Charles Eliot Norton, she had been collecting rare books and antiques, but recently on visits to Venice with her millionaire husband she had turned her driving energies to collecting Old Masters. This shift in her interests undoubtedly owed much to the fact that not long before she had inherited nearly two million dollars from her father. The chance of renewing her friendship with her former protégé could not have come at a more opportune time, for she had urgent need for guidance in the raging competition for the art treasures of the Old World, a competition in which curators like Wilhelm Bode of the Imperial Berlin Museum were formidable rivals.

Berenson had his hands full with his monograph on Lotto, which had kept growing as he and Mary examined fresh batches of photographs, and the passing weeks of the spring and summer found him "slaving away" at the book under the inspiration of additional favorable reviews of *The Venetian Painters* in *The Scotsman* and *The Scottish Leader* as well as in the Florence press. The Chicago *Dial* too gave it a "longish and very delightful article," devoted, however, mostly to the value of the "Index" of pictures. This highly favorable review was written by Jefferson Fletcher, a Harvard classmate. Fletcher had earlier visited Berenson in Florence and impressed his host as "a real trump and for an American, pure and simple, amazing."

Professor Bôcher wrote from Cambridge that he was at Miss Norton's when the book came and she enjoyed it so much that she immediately ordered a half-dozen copies. Bôcher was so relieved to see that Berenson had redeemed himself that he had a little difficulty in striking the right note. He was glad, he wrote, "to see you starting, to begin to feel you are going to be a success," and then corrected himself, "I *began* to feel that long ago but now I feel it differently, to *know* it as it were." A thank-you letter from Edward Warren began with the curiously facetious salutation, "Dear Balbrogenski," an indication that the Lithuanian surname had not been completely erased. Like other friends, Warren urged him to keep an eye out for artistic treasures "at a moderate price," such as "a fine vase" or "any Greek sculpture or bronze in good condition."

The book was selling well and the publisher was already contemplating a second edition. For Berenson the time seemed ripe to find more comfortable quarters away from the noisy bustle of the Lungarno. The arduous climb to his rooms above the Arno posed something of an ob-

stacle to his role as a host to the increasing number of friends and friends of friends who stopped off in Florence for the plunge into art. He had to put work aside from time to time in order to make the descent and shepherd the visitors through the galleries. Norman Hapgood's parents showed up early in the year. Sometimes the pilgrims made up a little "class," as Mary recorded on the occasion of William Mallet's visit, and Bernhard would take them to the Pitti Palace and expatiate on the inexhaustible questions of style. Italy and especially Florence had become a magnet to American tourists who, in flight from the great depression of 1893, rejoiced in the fact that living was cheap there. Mark Twain and his family had spent most of the preceding year in the Villa Viviani below Settignano, where he declared the view over Florence was "the fairest picture on our planet." Henry James, who was drawn back to Florence in 1894, complained Italy had become "a snare . . . all Back Bay [of Boston] was there last year," and Bellosguardo, the older aristocratic enclave of the Anglo-American colony, was now "a cemetery of ghosts."

Early in March 1894 Mary and Bernhard went househunting in the vicinity of Fiesole. Their friend Maud Cruttwell, a young English art historian, had agreed to act as Mary's housekeeper. They found just what they wanted in San Domenico, a short way below Fiesole where the road and tramline clung precariously to the steep slope high above Florence. There were two villas which had apartments available, villas situated on a little lane that angled down from the highway to a narrow plateau, the Villa Kraus and the Villa Rosa. They arranged to move in at the end of the year, Bernhard in the Villa Kraus and Mary in the Villa Rosa a short way below. Few situations could have provided a more surpassingly lovely panorama of the distant city whose towers hung spectral in the morning haze.

But not long afterward the dream of shared felicity of those two mercurial temperaments appears to have suffered the first of a long series of painful disillusionments. For the whole month of May Mary's journal fell suddenly silent. A letter to her mother hints darkly at the cause. "I've been having a square stand-up fight," she wrote, "and have come out at the end victorious, but a little battered." Nonetheless, she still felt that "life is very wonderful and delightful all the same." The letter was written shortly after a "fascinating expedition" to one of the hill towns to see a painting. Berenson had organized the party, which included Loeser and their new acquaintance, Hermann Obrist, the young dashing-looking sculptor with whom Berenson was much taken and whom Mary found a "fascinating person." He had recently settled in Munich and had come down to Florence on a visit. Bernhard enjoyed

him as a delightfully serious companion and was so impressed with a fountain that he had just completed that he hailed him as a new Michelangelo. At the moment Berenson doubtless felt him to be a fellow liberator in the world of art. He was already known in Germany for his emphasis on "chromatic harmony" and on the need to reduce everything in art to basic elements. Ironically, his radical teachings were to be influential in the development of abstract expressionism, a development that would become peculiarly abhorrent to Berenson.

Obrist's effect upon the romantically susceptible Mary was of a different sort, for she promptly became infatuated with him. The "square stand-up fight" with Bernhard evidently resulted despite their emancipated views. The quarrel was soon patched up, as their quarrels usually were; for if Bernhard was thin-skinned, Mary usually disarmed his rages by promptly showing remorse for her shortcomings. Life settled back to more work on Lotto and Mary resumed her typing. She reassured her mother, in an apparent reference to Obrist, that there was "no danger from either side of our meeting again." As always, dissimulation, which her way of life seemed so often to require, was a frequent counterpoise to her frankness in her letters to her mother. In her journal she recorded on June 1 that she was seeing "practically nobody but Obrist (Bernhard of course), but him every day, while Bernhard has been going out more than his wont under the wing of Carlo Placci and meeting charming people." What Bernhard's private feelings were can only be guessed, for he would hardly have shared them with his sister, who continued to be critical of his liaison. Besides, he was still committed to the principle that Mary and he were free agents unbound by ordinary conventions. It was Mary's nature to be flirtatious. Her mother could have told him that she used to caution Mary not to confound her girlhood "mashes" with real love. One encounters a curiously oblique sidelight on this episode in a comment Mary made a few weeks afterward when she and Bernhard visited the cathedral at Strasbourg in the company of Hutchins Hapgood: "We discussed *Manon Lescaut* a good deal, and found it peculiarly wonderful because it was the first psychological presentation of a woman who could love and yet be 'unfaithful,' regarding her body as a thing apart." Mary may not have regarded her body as a thing apart, but her heart was proving divisible.

One of the most diverting events in Florence that spring was the visit of Oscar Wilde. He had been preceded to Florence by his dear "Bosie," Lord Alfred Douglas, whose mother, Lady Queensberry, had dispatched him to Florence precisely to get him away from Wilde. The always improvident Wilde had written Bosie that "the roaring of credi-

tors toward dawn is frightful," but he managed to escape them and for a few weeks shared an apartment in Florence with the young scapegrace. Other homosexuals had long found the town a pleasant haven from censorious Victorians. Perhaps the best known at that period was the English poet Lord Henry Somerset, who had escaped prosecution during the Cleveland Street scandal by going into permanent exile. Wilde and Douglas saw something of him at this time, as H. Montgomery Hyde records in his revealing biography of Wilde, and they also encountered another member of their proscribed fraternity, the young French writer André Gide. Gide noted that Wilde "looked 'old and ugly' but still excelled as a raconteur." Oddly enough, Wilde, whose notoriety ran before him with seven-league boots, professed to be traveling incognito. Mary took Wilde to call on Vernon Lee's semi-invalid brother at Il Palmerino. "Oscar talked like an angel," Mary told her mother, "and they all fell in love with him, even Vernon who had hated him almost as bitterly as he hated her." He declared that he liked "people without souls or else with great peace in their souls." Encountering Berenson, he asked whether he "really felt anything" or "really dreaded anything." "I told him," said Berenson, "I felt and dreaded *ennui* and that I preferred death. He pretended that that would make him forgive all my cruelty and all my 'moral' qualities."

With the approach of summer the time came for the regular visit to Paris and London to take the pulse of the art world. Berenson was once again feeling euphoric. The rewriting of *Lotto* was almost finished. He had hopes of its appearing in time for the Christmas trade. Since it would be well illustrated, he thought it "might sell for the pictures." He was also filled with happy anticipation of his trip to America in the fall. Life was full of things to enjoy, he told Senda. "Now, for instance, I have such a sense of pleasure all through my body as I get into bed. I never used to have it."

The two voyagers departed from Florence on June 14. They conferred with Frizzoni in Milan, canvassed the new collections in the galleries, and then stopped off in nearby Bergamo to renew their impressions of the Venetian school and especially of Lotto. At Strasbourg they loafed with "Fafnir" and in the course of their gallery-going happily discovered still another misattributed painting. Hapgood, being a good listener, as Mary observed, drew "B.B. out in a delightful way."

In Paris Mary made elaborate notes of the pictures in the salons and generously sent copies to Obrist in Munich. Bernhard called on the art dealers, eager to learn what new Italian paintings were coming on the market from private collections, paintings whose authenticity he would have to review for his revised indexes. They saw a good deal of Salo-

mon Reinach, the learned archaeologist and art historian who was then the assistant keeper at the National Museum of Antiquities at St. German-en-Laye. A renowned writer on ancient and medieval art and expert as well on the art of the Renaissance, Reinach lived at the center of the Paris art world, and he and his wife were cultivated by artists, dealers, and collectors. He presided as well over a circle of intellectuals and philanthropists. A free-thinking French Jew, he recognized a kindred spirit in Berenson, who was seven years his junior. Berenson also spent a day with Thomas Sergeant Perry, whose pessimistic prophecies about his former protégé had been so agreeably disproved. Perry was full of the exploits of Mrs. Piper, the Boston seer, and, as Mary said, "half-convinced [Bernhard] to a belief in the 'next world.' "

They crossed to London, took in the Ferrarese exhibition there, and then went up to Woburn Castle, the seat of the Duke of Bedford, to make notes on his magnificent collection of paintings. Their entrée may have owed something to the fact that Bertrand Russell, Mary's prospective brother-in-law, was a cousin of the duke. Mary went down to Haslemere to mother her two children. Vernon Lee joined her for a week and found the whole Smith family there—Mary's parents, her literary brother, Logan Pearsall, her sister, Alys, and Bertrand Russell. She wrote that the family were "very well off but live in extremely modest style quite without show or luxuries." Mary's father seemed "old and exhausted but the mother was a delightful woman . . . full of zeal for every good work." While she was there the report was "rife that Wilde has got into terrible hot water and left England."

Berenson remained behind in London, enjoying old friends such as the art collectors Herbert Cook and Robert Benson, the Irish author George Moore, and the art historian Herbert Horne, who was soon to follow Berenson's example and settle in Florence. As for the unfortunate Oscar Wilde, his prudent absence from the house on Tite Street put an end to their unequal friendship. Among the Londoners at this period it was George Moore of whom Berenson retained the most vivid impression in after years. "I enjoyed his Irishy, his absurdity, his malice, his anecdotes about Yeats, Hugh Lane, A.E. and other countrymen of his. . . . He was so silly in judgment of people, so uncritical about books and pictures, so ignorant, so anti-intellectual, so vulgarly vituperative against religions in general and Roman Catholicism in particular. . . . Yet when *Ave, Salve* and *Vale* came out I felt humiliated not to have perceived previously what a gift Moore had as a writer."

As the author of the much-praised *Venetian Painters* Berenson found his advice was much in demand. Mary recorded that in the few weeks in London he made new friends and earned £233 (nearly $1,200) "rec-

ommending pictures." He promptly wrote to Senda urging her to per-
suade "Father and Mother to have a vacation of three or four weeks,"
since he was sure he could spare at least $100, a substantial sum in those
far-off days of the gold standard. Life that summer seemed infinitely
delightful. He went up to Oxford as usual to renew acquaintances
among the young literary lights. On a river party he enjoyed meeting
the "youngish and rather sprightly" widow of the historian John Rich-
ard Green. Of other news there was little else striking to report to
Senda: "Pictures, people, money schemes, with a salting and peppering
of books and writing have made up my life here." Whether the long-
deferred meeting with his idol Walter Pater took place on this visit to
Oxford or during an earlier visit can only be conjectured, as his letters
make no allusion to it. On July 30 Pater died suddenly of a heart attack
at age 54. In any event, the meeting, as Berenson recalled it in extreme
old age, was unsought by him and "was very disappointing." His
reflection on it suggests the reason: "There can be no personally satisfy-
ing relation unless reciprocal."

Mrs. Gardner arrived on the Continent early in June for a year's stay,
but Berenson's journeying prevented their meeting that summer. He
kept in touch with her, however, by telling her of a splendid exhibit of
English paintings at the Sedelmeyer gallery which she ought to see.
Perhaps as a kind of test of Berenson's artistic judgment, she sent to
him in London photographs of two paintings which had been offered to
her and asked for his opinion on their worth. He responded with alac-
rity, no doubt sensing the important role he might play in shaping her
collection. Her revived interest undoubtedly flattered his self-esteem,
for she had become even more of an international personality than
when he first enjoyed her favor. A Boston newspaper had recently re-
ported: "All her movements are heralded in the press and she is treated
almost as England treats royalty."

He gave his opinion with a confidence that was never to desert him.
In the letter which he sent to her in Paris on August 1 he declared that
one painting was "by Bonsignori in spite of the Paris expert," scorn-
fully adding, "I should like, by the way, to know who the experts are
who are so ignorant of paleography as to think for an instant that the
signature can be genuine." The wrong attribution, however, did "not
detract in the least from the real value of the picture." The lines of the
other painting, a reputed Francia, were "too unsteady" and "too soft
for Francesco [Francia]" and suggested the work of his son Giacomo. It
was worth no more than £150.

Then, without a break, he proposed a spectacular coup. "How much
do you want a Botticelli? Lord Ashburnham has a great one—one of the

greatest, a death of Lucretia, a cassone picture to rival the 'Calumny' of the Uffizi. I understand that although the noble lord is not keen about selling it a handsome offer would not insult him. I should think it would have to be about three thousand pounds. If you cared about it I could I daresay help you in getting the best terms. It would be a pleasure to me to be able in some sort to repay you for your kindness on an occasion when I needed help." He could hardly have made a more tempting proposal to Mrs. Gardner and her sympathetic husband. For a Bostonian the sacred name of Botticelli was like the sweep of a hand across an Aeolian harp, sounding the keynote of culture. What aspirant to culture had not mused lovingly over a photograph of the *Primavera* or *The Birth of Venus?* The *Lucretia* depicted three dramatic moments in her tragedy, all gracefully framed against the magnificent columns and arches of imperial Rome. It was a large and impressive painting, some six feet wide and nearly half as high, a trophy worthy of Mrs. Gardner's reputation as a collector of rarities. The purchase was a large one, the largest that she had so far dared to contemplate, and she approached it with, for her, a degree of caution. The actual negotiation was left in the hands of young Otto Gutekunst, already the director of the famous London art dealers Colnaghi and Company, and there the matter rested for the time being.

The collaboration with Mrs. Gardner that began with Berenson's recommendation of the *Lucretia* was to endure without serious interruption until Mrs. Gardner's death thirty years later. More than a half century afterward Berenson thought he remembered that mere chance had brought them together again in the National Gallery in London, as chance had favored him on a few other crucial occasions, and that their long collaboration grew out of that chance meeting. But chance, as one sees, was powerfully assisted by Mrs. Gardner's resolute design. The meeting with her did not take place in London but on December 12, 1894, in Paris, after Berenson had returned from his visit to America.

The time for Berenson's departure for America hurried closer. Mary and Bernhard crossed to the Continent again to spend their last days together revisiting the cathedral towns of Normandy, on the hunt as always for Italian paintings and altarpieces and, as usual, arguing over their finds. Back in Paris on the eve of his departure, they took a companionable drive in the Bois de Boulogne. With some foreboding Mary wrote in her journal, "Alas, for our parting tomorrow." Yet it was she, the practical one, who had urged him to make the trip in the hope somehow of his cashing in on the success of his first book. It had been her suggestion as well that after so long an absence he ought to see his family. After Senda's visit she could hardly have avoided the feeling

that his mother blamed her for keeping him in Europe. Then, too, her relations with her own mother were so close that Bernhard's neglect of his mother must have seemed unnatural.

He arrived in New York during the first week of September and was met at the dock by Carpenter, who was quite unprepared for the changes in his friend's bearing. The easy camaraderie of their European journeyings could not be recaptured. Berenson felt himself a success and acted the part, somewhat too immodestly in the eyes of a proper New Englander like Carpenter, who was accustomed to the well-bred restraint of his academic colleagues. Berenson's obsessive preoccupation with Italian art, made more intense by the fact that his book on Lotto had just gone to the printer, oppressed Carpenter, for whom one quick look at a painting had always been sufficient when he and Berenson had toured the galleries in Europe. Berenson baffled him and he tried, in spite of the difficulty of putting it "in cold words," to explain his bafflement to their collegemate, a fellow New Englander, Robert Herrick, who was teaching at the new University of Chicago. "All that I can say bluntly," he wrote, "is that I find myself enormously disappointed in him. He is much less a gentleman and much more a charlatan than when I saw him last and as much as I admired stray scraps of knowledge in regard to the history of painting which he had acquired, I distrust entirely his habit of mind, and the extremely dogmatic principles on which he seems to base his work. I am glad, however, to see that he is steadily coming into prominence in this country and abroad. He should have his full chance as a critic of art. What the final verdict will be in regard to his work as a whole, I feel sure of, but he may be of great service to the world in accumulating facts and stimulating other workers." Though there was much of the social Philistine in the estimate, it rather shrewdly anticipated both the undercurrent of hostility that Berenson's success would inspire and the general acknowledgment of his importance as a pioneer worker in his field. It would soon become apparent—on the publication of the *Lotto*—that Carpenter was not alone in his distaste for Berenson's critical heresies.

Berenson went on to Boston filled with he knew not what doubts and misgivings about his family and the alterations seven years might have made. His fears vanished when he saw his parents' comfortable home in suburban Roxbury, situated on a high hill close to Franklin Park, where, as he told Mary, there were "exquisite views" over the mixed wild and cultivated lands. What with Senda's salary, Abie's earnings, and Bernhard's remittances, the family had entered upon easier days. The changes in Boston seemed so great that at first Bernhard felt positively disoriented; the Boston he had known so intimately from his

humble vantage point in the ghetto of the North End appeared altered and remote. But not so the countryside through which he used to roam. On a drive to Blue Hill ten years seemed to roll back, he told Mary, "and I throbbed and palpitated over the landscape and the cosmos as I did then. . . . O, I was a poet then."

From the windows of the house one was scarcely aware of "the dreaded America" except for the screeching of the trains in the valley below. America, so far, was "not as apocalyptic as I dreaded to find it," and he was glad he had come. His family were "a good ten times better situated than I ever dreamt of." The home was tastefully furnished and "as people" his kinfolk delighted him. "Age and life seem to have dwelt like artists with my mother, making her face refined and humane to the utmost." His father, too, was "much improved" and "sweetened." His handsome brother, Abie, looked a "Renaissance youth in profile and carriage, with the Donatello toss to the head." His greatest pleasure was in his little sisters. Bessie, with a faraway look in her pale blue eyes, was a picture out of Rossetti. Rachel, less beautiful, charmed him with her "laughing eyes." He was proudest of Senda, who, he assured Mary, bore no resemblance to "the girl you saw." Mary reminded him that she had prophesied it all. "I only hope now the rest of my prophecy will be fulfilled and that thy trip will lead to financial success as well." It all fitted in, she wrote, with "my scheme . . . that thee should be nice to thy mother and sisters and that thee should extend thy 'relations' with millionaires like Davis."

For a few days before she left for her post at Smith, Senda and he wandered about the Blue Hill Reservoir and over Corey's Hill, where he used to dream sunny hours away. In Brookline, where in his "day" there were fields and woods, he saw streets "lined with wonderful palaces." It was all strangely different from the old North End. Within the family home his mother could hardly take her fill of gazing at him, he wrote, and enveloped him almost embarrassingly in her pent-up affection. Yet he found it a joy to listen to her chat in "her queer, hopelessly bad English." She was filled with happiness and could hardly do enough for him. When she took him to visit one of his married cousins, he was seated next to a sister-in-law, a girl of seventeen as lovely, it seemed to him, as the Lotto in the Brera. "Happily I am twenty-nine," he wrote. "If I were twenty I know not what would have happened." Mary twitted him, "So twenty-nine is too old to have inflammation of the heart? O sage, beyond thy years, I salute thee!" But not content with irony, she added, "What would thee do with a girl of seventeen" who could not tell one Italian master from another?

MARY returned to Germany a few days after Bernhard's departure to resume her travel-study with Obrist in the galleries. Her involvement with him, which on the surface was entirely professional, had already taken on disquieting overtones. Mary and, apparently, Obrist seem to have persuaded themselves that their intense admiration for each other was genuinely Platonic, that theirs was an ideal kind of emancipated intellectual intimacy. In the letters she wrote him when she went back to England later in the fall, she relayed some of Bernhard's comments, as she passed on to Bernhard those of Obrist. One that she knew Obrist would relish was Bernhard's remark: "I must tell you that the people go mad at the sight of a photograph of Obrist's fountain—no, not quite at the sight, but directly I begin to demonstrate its merits." She added that Bernhard went into ecstasies about the beauties of the houses at Newport, writing that in their arrangements and furniture they anticipated many of Obrist's ideas and that the knowledge of this "would perhaps tie a cold bandage to his perfervid Teutomaniac forehead.'" She added that Bernhard had also had "several heart scratches as I predicted," and she quoted his artless admission about the beautiful sister-in-law of seventeen.

The exorbitant interest in psychology of Mary and Obrist formed a strong bond, which on Mary's side led to pages of self-scrutiny in her letters to Obrist. In one thirteen-page closely written screed, she declared he had given her "new insights—and helped me on towards being a really *psychological* art-critic." Away from his mental stimulation and that of B.B., she declared she merely vegetated. When she and B.B. should meet with him in Munich, she would "really be alive again." She felt that with Obrist she was at "the real beginning of a frank human relation," one in which they would report to each other what they found in their "expeditions into those 'Dark Continents' we call ourselves." After a day spent in the company of her children at Haslemere, she wrote, "I have often thought my *real* vocation was being a mother, and that I ought to have at least half a dozen children *of my own!* They interest me profoundly." In another long letter, reflecting on Alys's impending marriage to Bertrand Russell, she rejoiced that thanks to Bertie's unanswerable arguments, her puritanical sister had "been digged out of a pit of religiousness and 'morality'" and had persuaded the local doctor's wife to supply contraceptives to the poor women of the village, who were overburdened with children.

Mary's obvious pleasure in Obrist's friendship gradually aroused the jealousy of her absent lover, and when she passed on to him Obrist's ideas on the purity of Platonic love, Bernhard saw danger ahead and

sent her an earnest lecture on the importance of monogamy for the progress of civilization and the health of the population. The Anglo-Saxon race, with "comparative monogamy," was more prolific than the French, with "comparative promiscuity." One could not have an "adventure with an unabandoned woman without injuring her." Moreover, such adventures led to "greater and greater animalism and farther and farther away from what is the highest attainable pleasure—the sexual act as an expression of one's utmost yearning for union with what is not oneself." "You see," he said, "I am getting fearfully orthodox. . . . The one man one woman ideal is the highest social ideal. Even in its merely physical aspect it is as superior as dining regularly is to foraging for a meal in the woods, gorging upon it for days and then starving until more game has been bagged. . . . I consider 'adventure' as little else than a relic of savagery." Upon reading his curious homily, the romantic and free-thinking Mary noted in the margin, "A true Doctrinal comparison!!"

But she soon regretted her wandering impulses and free speaking—at least for a time—when Bernhard's letters fell off. The one solid reality in her life was their love, she hastened to assure him. When a letter came to last, she promised, "I shall wipe off old scores and thee must too. Like an Ibsen character, please allow me to stand with my psychology on my sleeve ready to change from the roots up after half an hour's talk. . . . I shall indeed be careful now. I had a lot of pain from all this. . . . Join hands and let us go together into a peaceful, regular life, full of work and enjoyment of impersonal things. Oh Fiesole!" And some weeks later, while he was still in America, she wrote from her parents' place at Haslemere, "Do come, dear! I want nothing but thee to be happy again. Oh, I do love thee so, my child." In the same letter she was able to assure him that in a revised separation agreement proposed by her husband he expressed a willingness to avoid all mention of Berenson. At least it was one point gained. She also told him that Costelloe charged that her conduct had impaired his health. He had developed an incurable eczemalike affliction and had pathetically written that he was determined to face his work as usual but would " 'probably get gradually worse until my power to fight is gone.' "

Her mother, still hoping that Mary would return to Costelloe, had argued, in a letter written to her in September while she was still in Germany, that the growing scandal would isolate her completely. Mary had replied that scandal was a "matter of absolute indifference" to her. "With time and freedom I can become one of the most important people in my own profession, as well as one of the most interesting women to cultured people. This will attract Ray and Karin [her two children]."

As for her association with men, there were no important women in her field and she therefore had to work with men. In her world there was no need for a chaperone. It was different from the world where people busied themselves in spying on one another and spreading scandal. "For the moment, however, thy mind may be quite at ease," she explained, since Berenson was in America, Enrico Costa had gone to South America, Herr Obrist had returned to Munich, Hutchins Hapgood was in Venice, and she was in Berlin with a woman companion. Finally, she reminded her mother that "with Signor Frizzoni not even the most malicious would gossip"; besides, he was in Milan. Grateful as she was for her mother's daily letters, she put her on notice that once she had made up her mind she disliked further advice because it tempted her to be less than frank. She took the same line with Bernhard, a tactic that produced endless disputes. Her energetic protestations of innocence kept recurring in her frequent letters to her mother, no doubt with the effect of increasing her mother's anxieties, just as they aroused Berenson's skepticism. In defense of Obrist, Mary declared that "his idea is that a modern woman should be treated as if she were a man and he cannot bear the idea of the faintest mixing of flirting and intellectual companionship. He is a thoroughgoing German doctrinaire in that respect and that is one reason why I feel so secure."

Berenson tried hard to swallow his misgivings about their artist friend, and a little later that fall, learning that Obrist was ill, he warned her, "But by all that is dear to you make your interest in him that of a human and not that of a woman." In a subsequent reprise, he told her, "I envy [Obrist] not his conquests so much—that too—as his feeling of irresponsibility." As for himself, he continued self-righteously, "In the presence of a woman who seems to have inclinations toward me, I bristle up with morality like the porcupine." Mary, however, did not let up in her proselytizing for a freer sexual morality, drawing from him a further protest: "I may be an old fogy but if there is no God, in God's name let us try to become gods ourselves instead of being satisfied to remain beasts. There is no danger of the monkey in us being neglected." It was fortunate for their peace of mind at the moment in this high-minded contest of principles that neither of them foresaw the succession of romantic infatuations to which each would fall victim and the train of heartaches they would bring.

Mary's own affections at thirty had a predictably unruly character which was soon to find curious expression in Paris in early November, thanks to Lady Russell's opposition to her grandson's contemplated marriage to Mary's sister, Alys. Lady Russell had used her influence with Lord Dufferin, the British ambassador in Paris, to take on Ber-

trand as an honorary secretary for three months and thus part him from his fiancée. Though he had occasion to return briefly to London, he kept to his agreement not to see Alys and in lieu of her presence he returned to Paris with Mary as her charming surrogate, since Mary had planned to run over to Paris to resume her never-ending work on her Louvre catalogue. Arriving at the Hotel Vouillement on November 4, Mary and Russell took rooms which shared a sitting room. To the warm-hearted Mary theirs was a most delightful propinquity. In the letters which Russell wrote to Alys twice a day with inflexible frankness, he told of their informal breakfasts together and of the exchange of brotherly and sisterly kisses which Mary had charmingly initiated. And Mary gave a certain entrancing fillip to their conversations, he confided, by being continually "interesting on all questions of sex." Their more or less harmless dalliance made Alys understandably uneasy. To her relief Mary departed for Munich on the fourteenth. Berenson was apparently spared an account of Mary's exhilarating ten days with Russell, since her letter would have been unlikely to reach him before he embarked on his return voyage.

WHILE at his parents' home Berenson finished the brief and much-revised preface and introduction for the *Lotto* and sent it to Mary for her scrutiny along with some of the proofs of the text, which were arriving from Putnam's with exasperating slowness. She took her job as editor seriously and did not hesitate to contradict his judgments. For example, she argued that the figure of "the Lotto 'architect' " in one of the paintings is *by no means* what you describe, a bluff, loud-voiced, honest Baumeister. He is sensitive like most of Lotto's portraits. . . . I am so sorry!! It spoils a good paragraph." She reckoned without the stubborn resistance of her adversary. The paragraph remained without substantial change. Though Berenson could not bring himself to yield on this point, he did acknowledge gratefully her help when, for example, he accepted her "happy suggestion" that certain paintings attributed to Lotto by Crowe and Cavalcaselle and Morelli were actually the work of Morto da Feltre.

Mary wrote him from Haslemere of a long visit from the Jewish novelist Israel Zangwill, a visit which was to draw him into Berenson's circle. Of the same age as Berenson, Zangwill had already made a powerful impression in England and America with his realistic depiction of Jewish life in *Children of the Ghetto* and *The King of Schnorrers*. He had invited her to criticize the manuscript of his new novel *The Master*. This she did, she told Bernhard, "as *thee thyself would have done,*" and when the grateful novelist vowed that she had a stunning career ahead in liter-

ary criticism, she "explained to him that so far my ink is all second hand. 'But you must have known astonishingly clever men,' he said; 'So I have,' I replied." She told Bernhard that though Zangwill had "considerable native brains" he had "no such education as thee." He was as pleased "as thee thyself" at getting new ideas "apropos of his book (which I found abominable) . . . but he is loathsomely ugly and repellent." Nevertheless, she did enjoy him, for she liked, she said, "to hear people talk" even, as in his case, when the talk ran to metaphysics. The important thing was that he was " 'our kind' [unsereiner was Berenson's favorite term for it] in matters of literature and dramatic criticism." She also reported a new health fad of which she had become a disciple on a recent visit—at least for the moment: walking about barefoot in the house to improve the circulation. "It is astonishing how warm it makes the feet. . . . We even went barefoot to supper tonight at our hostess's suggestion."

In his anxiety to get as much as possible into print, Berenson had made the mistake of sending a review of a recent monograph on Cima da Conegliano in substantially the same form to both the *Nation* and the London *Academy*. The two-column review appeared in the former, unsigned, on September 6, 1894, and in the latter, signed, on October 13. Berenson argued that the monograph had some value in calling attention to a neglected master but was otherwise useless because it had not been prepared by "carefully trained connoisseurs"; besides, it made "no attempt to recreate [Cima's] artistic personality." He also drew attention to a number of technical errors.

The duplication of the review was seen by their Paris friend Salomon Reinach, and he mentioned his surprise ("That wouldn't do here") in a letter to their friend Eugénie Sellers, who passed the latter on to Mary, who, of course, sent it on to Bernhard. Mary advised him, "I should not wait to be blown up but myself write a note of apology to the editor of the *Academy*, promising to be a good boy for the future." Whether he did so or not does not appear. At any rate, he published nothing further in that magazine. An allusion in Reinach's letter also casts a sidelight on Berenson's finicking scruples as a critic of art. Charles Ephrussi, who had recently taken over the direction of the *Gazette des Beaux-Arts*, had asked Berenson to do an article for him on an exhibition in London. According to Reinach, Berenson had refused, saying that the exhibition contained some Flemish pictures, about which he knew nothing. The refusal did not, however, stand in the way of Berenson's becoming a frequent contributor to the *Gazette*.

His letters to Mary from Boston reported zestfully his meetings with old acquaintances, some of whom seemed oddly diminished by the

lapse of time. He relished the pleasure of being lionized a little in the exclusive precincts of the Tavern Club, where he was given visitor's privileges. There he met familiarly at the round table with the "big-wigs" of Boston, men of family and property like Robert Grant, lawyer and novelist, who had recently been made judge of the probate court, and Dr. William Sturgis Bigelow, who, after giving up medical research, had returned from a long stay in Japan as an authority on Buddhism and had given his great collection of Japanese art to the Museum of Fine Arts. The wealthy artist and collector Denman Ross, another who had changed allegiances in mid-career, in his case from medieval historian, took Berenson to the museum to view this collection and to meet Ernest Fenollosa, the distinguished curator of the department of Oriental art.

He walked through the rooms with growing excitement, amazed, as he said, to find "what we never dream of in Oriental art, now surpassing Dürer and now Gentile Bellini." The perfection of line, color, and tone moved him to ecstasy. "I was prostrate," he wrote. "Fenollosa shivered as he looked. I thought I should die. Even Denman Ross was jumping up and down. We had to poke and pinch each other to let off some of the tension and almost we fell on each other's necks and wept. No, decidedly I never had such an art experience. I do not wonder that Fenollosa has gone into esoteric Buddhism." Forgetting his own initiation into Italian Renaissance painting, he exclaimed, "And where ever was religion so manifested as in these paintings!" They were unanimous in their judgment of the twelfth century as the supreme epoch of Japanese painting and agreed that the decline to the seventeenth century was steady and irreversible. Thus the rapt trio descended and ascended the centuries of painting. "The same cry rose from all our lips at the first sight of the great thing, and I never made an adverse criticism without its being seconded by Fenollosa. Here he had devoted twenty years to Japanese and I seven to Italian art and the result is a perfectly equal sense of quality in line, grouping, color, and tone."

He was cordially received at the home of William James, who had enjoyed *The Venetian Painters* and suggested that Berenson return "some winter and give a course of lectures to the college." They had much talk of "spiritism" and psychic phenomena, in which James was much interested at that time, and marveled at a recent report of the levitation of a peasant girl in France. Berenson also met with Santayana a number of times, dining with him or strolling around Fresh Pond. He thought him "more Latin, more refined and ascetic by temperament than I had supposed. He harbors something like a beautiful absolute in his mind." Santayana had returned to teach philosophy at Harvard but

was finding the utilitarian atmosphere distasteful. He told Berenson that he longed to get away and perhaps never come back and that talk with him was "like air and sunshine." He said he felt more at home with the undergraduates and that they helped him "keep up with the spirit of youth." Suiting his actions to his word, he took Berenson to one of their clubs for tea. On another occasion he carried him off to a football match, but that facet of the spirit of youth only bored his aesthetic visitor. It was also through Santayana that Berenson made the acquaintance of the poet William Vaughn Moody, who was an instructor in the English Department. Walking back with Moody from the Yard, Berenson found him "perfectly delightful" but full of naive metaphysical questions like those "asked by metaphysical children." Berenson's answers seemed so to satisfy him that he appeared "won over for ever."

The return to Harvard was balm to his spirit, and as a prominent "old grad" he relished being taken about to see the new buildings and to revisit the scenes of so many intellectual adventures. The warmth of his reception and the respect accorded him deepened his affection for his alma mater. His loyalty to her was to remain steadfast to the end. He felt at home at Harvard and never more so than one Sunday morning when two friendly seniors came to take him out walking. He was a welcome guest at Grace Norton's "salon," being one of her more successful protégés, but at her brother's hilltop manor house his reception was not wholly reassuring. Professor Norton exuded charm and the heady aroma of high culture as they talked about the absence of art in Germany and the value of life dedicated to beautiful things, but Norton's comment that he liked *The Venetian Painters* "even more for its promise than for what it did" struck Berenson as "the neatest cut I ever received." It was a chilling hint that the arbiter of Boston culture did not approve of the new connoisseurship nor the criticism based on it.

Great as his disappointment may have been at the collapse of his plan for a lecture series, he seems to have cheerfully accepted the setback and to have settled for two soirées at Northampton at the studio of a Miss Lathrop. There he discoursed on Raphael and his precursors to an audience of "fairly youngish women," among whom he spied two men. He talked, as he said, "a steady stream for an hour and a quarter" to such good effect that his listeners mistakenly thought he had memorized his discourse. He felt proud of his sister, who was a favorite of the students and young and pretty enough to be mistaken for an undergraduate. At a college dance he looked out on the crowd of fresh and graceful young women, he confided to Mary, as at a mere spectacle, where eight years before, when he was a million times the idealist he now was, he would have felt transports of exhilaration. Now, he felt sure no woman could

[203]

come between them. Yet he could not avoid adding a patronizing touch. At times, he mused, he might wish that she could change her sex and "be for a time a man with male methods of feeling and thinking." But, on the whole, he was satisfied with her as she was, a conclusion on which she discreetly withheld comment.

The most important business of his two-month visit, besides seeing the book on Lotto through the press, was with Theodore Davis, for whom he had already acquired a few important paintings. Toward the end of September Davis invited him down to fashionable Newport to stay with him in his palatial mansion "The Reef." Having known for so long the Spartan facilities of European houses, Berenson reveled in the luxury of a private bath. He reported to Mary that the Campi and the Licinio looked "gorgeous" on the walls of the drawing room and the Moroni "magnificent," these being paintings which he had helped Davis acquire. His host took him about to see the splendors of the resort, especially the picturesque Casino Club, of which he was a member. Listening to the booming of the surf, Berenson luxuriated in nostalgia. "It is as if twelve years had dropped away," he told Mary, "and I were seventeen on the rocks by the sea in a mood of infinite languor, cosmic spooniness, my every thought an intransitive love sigh, and my every word a poetical quotation." He sat a while at the end of the iron pier, lingering over a volume of Santayana's "noble" verses. Davis also showed him off at a meeting of the Town and Country Club at the palatial home of a Mr. Van Alen, "one of the richest Americans," Berenson reported, and the "perpetual butt of the comic papers." Van Alen had been so thoroughly pilloried in the press during the preceding autumn for having contributed $50,000 to President Cleveland's campaign prior to his appointment and confirmation as United States Minister to Italy that he had felt obliged to decline the appointment. The Town and Country Club appeared to run mostly to women and did not look as select as it was reputed to be.

Later when at Davis's invitation Berenson rejoined him in New York, Davis put him up at the Union League Club and warmly introduced him to his art-collecting friends. At the Metropolitan, where Davis proudly pointed out to him the Italian pictures which he had placed there on loan, Berenson met the curator, who to his annoyance talked only of Bode, Morelli's German antagonist. Davis also took him to meet "old Marquandt," whose New York mansion, "tremendously luxurious and beautiful," provided "a feast for the eyes" in its array of rare Persian hangings and priceless objets d'art. In such surroundings and under such auspices Berenson could well begin to dream that a life such as that enjoined by Pater, a life of pure aesthetic feeling among ob-

jects of beauty where one might burn with a pure gemlike flame, was indeed within his grasp.

Avid of impressions, he walked the streets of New York, stared up at the skyscrapers, battered his way among the crowds, and was "jangled to death by the bells of the cable cars and flared to death by the advertisements." People seemed to talk only in millions. He called on Wendell Phillips Garrison, the editor of the *Nation,* in which he had published so many notes and articles, and found him a shy, reticent, kindly man "who remembers, apparently, every word that has appeared in the *Nation* since he has been its editor." He made a last call on Davis, who was about to sail for Europe, and found that the "poor man has been having so many committee meetings of stockholders that he looked about a thousand years old." A last walk with George Carpenter took him over the Brooklyn Bridge, completed in 1883 and still a world marvel. He found it "wildly picturesque—the various levels, the cables, the lines of wires and the view of New York." "Imagine a Siena or San Gimignano," he suggested to Mary, "but on an apocalyptic scale." He admired the new skyscrapers along the length of Broadway for the way they each showed the "brains, the effort to treat the whole as a unit, with the stories coming in incidentally."

Full as the correspondence with Mary had been, it had its unsettling topics. She thought Senda's disapproval of her "priggish," though she admitted that she too had gone through such a phase when first married. Her travels in Germany with Herr Obrist of the emancipated sexual views made Bernhard uncomfortable while they challenged him to be equally enlightened. He agreed that on his return they ought to see "how our situation seems. For my own sake far more than for yours, I wish you to be in all your relations to me, perfectly free and autonomous." It was a brave resolve and perhaps assuaged his pride, but it could hold only for the cerebral side of his nature. His passions were yet to be tried in unexpected ways.

The parting from his family in Boston had its lacerating moments. It was dreadful, he said, to say goodbye to his mother, who stood "weeping her eyes out." Always the analyst for Mary's benefit, he could not resist adding: "She is the incarnation of motherly love, and seeing her brought me many a lesson I shall not soon forget. Well, well, it is wonderful to touch bottom in another person's heart." As for Mary, love did not silence the still small voice of his domestic editor. When Bernhard wrote that "it blowed a hurricane all night" before his departure on November 21 aboard the *New York,* she firmly noted on his page, "Blew, mon cher!"

X V

Secrets of the Artistic Personality

BERNHARD and Mary enjoyed a lovers' reunion at Rouen at the very end of November, he having proceeded directly there after disembarking at Southampton. Mary had come back from Munich to join him for a quick study of the church of St. Ouen, whose purity of architecture impressed Bernhard as surpassing in beauty the intricately decorated façade of the cathedral, which most regarded as one of the wonders of France. The next day in Paris they lunched with Bertrand Russell, and Mary noted with satisfaction, "Bertie and B.B. made friends." She wished to attend her sister's wedding, which was to take place on December 13, 1894, in a Quaker meeting house in London, but her mother firmly dissuaded her, being nervous about the possibility of an awkward confrontation between Mary and her injured husband. She had also enjoined upon Mary to write nothing about Berenson or his whereabouts so that if asked she could "honestly say she doesn't know." She still dreamed that Mary would cast him off and return to Costelloe to resume her proper place in London society, since she had remained on good terms with Mary's husband and shared his disapproval of Mary's misconduct. Though Mary did not grace the wedding, an even more notable abstention was that of Lady Russell and her kin, who deplored the misalliance.

In Paris Bernhard and Mary observed the letter of her promise to her mother, as was their settled practice, he taking lodgings at the Hotel Voltaire and she at a hotel in the rue de Beaune. In brief intervals of leisure Bernhard resumed his writing "for reputation," and before Mary's departure to spend the Christmas holidays with her children, she helped him work on a review of Adolf Furtwängler's *Meisterwerke der Griechischen Plastik* for the *Revue Critique,* making notes and tidying up the piece. "We quarreled as we usually do when we work together,"

ran her journal commentary, "but made it up." She left Bernhard to resume his role of cicerone and to welcome the American compatriots who gravitated as usual to Paris, friends like the Toys from Harvard and the Perrys who relished his growing success. Hutchins Hapgood bounded in eager for more instruction in art and impressed Berenson, in his term of highest praise, as "a keenly cerebrating person." He wrote Senda that he was also seeing "something of a very fascinating deformed creature, Jonathan Sturges, a writer, and a viveur too, but a rather tenacious thinker and a brilliant talker. My days here pass as the landscape through the window of an express train." Sturges had evidently taken to heart William Dean Howells' admonition to him: "Live all you can," advice which, thanks to Sturges, Henry James embodied in *The Ambassadors*.

Berenson again saw much of Salomon Reinach, whose frank admiration for Berenson's talent led the younger man to reflect that since Reinach had little real feeling for art, "in me he seems to have found a master." The friendship with Reinach gave him entrée to "all sorts of private collections" and his loosely scrawled notes piled up like forest leaves. Reinach also undertook to translate the review of Furtwängler for publication. The translation struck Berenson as too literal and lacking in creative insight, but he was glad to be relieved of the chore and subsequently accepted Reinach as a translator of other of his articles. Through Reinach Berenson became acquainted with a wide circle of intellectuals, including the director of the St. Germain museum, Professor Alexandre Bertrand, through whom he was to establish a lasting intimacy with Henri Hubert, the well-known archaeologist. It was gratifying also to meet another archaeologist, M. Jamot, who, he learned to his delight, was "demolishing" the German Furtwängler.

In all this satisfying bustle of society and study, of almost random and directionless activity, which he described with relish to his sister, there was yet no hint that a momentous change in his fortunes impended. In mid-December he made the acquaintance through Reinach of "another French Jew, a Monsieur Dreyfus, the only intelligent collector I have ever met" and quite a friend of Mrs. Jack Gardner. "This enigmatic lady is here," he remarked, "and Dreyfus, she, and I have been seeing some things together." Four days later he toured the Louvre with her, still puzzled by a certain reserve in her manner. The enigma was solved the next day. She announced to him that she would buy the Ashburnham Botticelli, *Lucretia,* which Berenson had recommended to her before he left for America. The price of £3,000 appears to have lost its terror for her, and on the nineteenth of December the deal was consummated through Otto Gutekunst. Mrs. Jack had achieved her first

great triumph, and one that would make her the envy of Boston. The exploit so endeared Berenson to her that when she saw him in Paris the day before Christmas she kept repeating, "You do not know what an extra pleasure it is to have you connected with the picture," and she added emphasis to her gratitude by giving him "a charming watercolor by Pissarro for Christmas."

After Christmas Bernhard crossed to London to confer with Gutekunst, who, flushed with the success of the Botticelli transaction, took him to see the rest of Lord Ashburnham's collection. At least one of the paintings appeared in need of "re-baptizing," a reputed Piero di Cosimo that Berenson declared "is obviously Flemish." In the meantime Obrist showed up and they gorged themselves with such talk on art that Mary subsided into astonishment at their brilliance. A chief reason for Berenson's return to London was to examine the exhibit of "Venetian Paintings, Chiefly before Titian" at the New Gallery for an article which Reinach had invited him to write for the *Revue Archaéologique*. He apparently had already had some suspicions about the exhibit before he left Paris, for he instructed Mary to check the Botticellis in the exhibit to see "if some of them are not Rafaelinos." What he found in his study of the exhibit posed an irrestible challenge to him to set things right, and his rectifications were to make him a marked man thereafter in England.

Mary had gone on ahead by a number of days to attend to other affairs. She stopped off in Milan to confer with Frizzoni and a few art dealers and to scour the Brera and the Poldi, notebook in hand, patiently inventorying paintings for Bernhard's and her own use. By January 20, 1895, she was back at the Villa Rosa in Fiesole and, thanks to Maud Cruttwell, she found the housekeeping in perfect order. Bernhard arrived a day or two later and they all descended on Florence in quest of house linen for him. His nondescript rooms in the Villa Karus naturally had to be redone, and Mary recorded that she had "caused desolation in Bernhard's rooms by trying experiments with his wallpaper which was of an overwhelming hideousness." Assisted by Mary's cousin Emily Dawson, they now selected sacking for the walls with a dado of green and buff matting. Refurbishing and furnishing his apartment to his high standards turned out to be much more time consuming and costly than they all had expected. "The upholsterer refuses to work between meals," Berenson remarked with wry amusement, "and the cabinet worker always waits for inspiration."

While his rooms were being put in order, he worked with Mary in her study, though not always amicably. Sometimes to avoid "squabbling" each took a separate path when they went out to walk, causing

Mary to reflect ironically, "How sensible! How next century, almost!" It was only at the end of February 1895 that Berenson was at last settled comfortably in his rooms at the Villa Kraus. He wrote Senda that finally "my books are on the shelves, my photographs in the cases and I at my desk. For the first time in my life I have drawers enough to put away various papers."

Evenings, over their coffee and cigarettes, he and Mary would often read poetry aloud together—Chaucer, Keats, Browning, Whitman, and Milton. Alone in his rooms Berenson ranged omnivorously through fare as varied as Nordau's *Degeneration,* Nietzsche's *Zarathustra* and whatever else of Nietzsche he "could lay his hands on," medieval French poetry, George Meredith's novels, and the *Knights* of Aristophanes. Long afterward he remarked that it was Nietzsche's writings that absorbed him most deeply and prepared him for writing his next book, *The Florentine Painters of the Renaissance.* Nietzsche's iconoclasm had touched a responsive chord, as he had indicated to Senda: "Nietzsche is a singularly paradoxical, conceited, involved German who has the good grace to loathe almost everything German and Teutonic. His real merit consists in the shaking he attempts to give to all new orthodoxies . . . and once in a while he even succeeds in planting you behind your own looking-glass and making you see what is there back of all that we mirror ourselves in." In long evenings by the fireside talk turned again and again to questions of aesthetics, and with nimble wit Berenson would dazzle his visitors with his impromptu lectures, whose salient points Mary would try to recapture in her journal. Nietzsche's value, he observed at this time, was that he "hates all that makes against life and loves all that makes for it," in short that he stood for all that was "life enhancing," a term that soon became a favorite catchword for Bernhard and Mary, along with its companion phrase "life diminishing." Berenson added that Nietzsche's *Birth of Tragedy* offered "the best thinking on aesthetics from a psychological point of view."

Almost from the first day of their return to Fiesole, Bernhard and Mary plunged into their writing, hammering out their ideas together and sharing their notes, Bernhard declaring that he wrote at least a thousand words a day. With his incendiary notes on the exhibit at the New Gallery before him, he commenced a devastating critique of the attributions in the official catalogue. Mary, for her part, undertook a defense of the *Lotto* for the London *Studio* (signing it "Mary Logan") and prepared a long analytic review of the book for Salomon Reinach's *Gazette des Beux-Arts.* However, it was in the pages of the *Studio* (May 15, 1895) that Mary, as spokesman for Bernhard, most forcefully as-

serted its importance as a pioneer contribution to art history. "The value of the monograph does not consist in its Morellianism. It is valuable because it is the first book, that starting with perfect assurance from the hard-won vantage ground of scientific connoisseurship, aims at something higher than mere connoisseurship or archaeology, which is yet not purely subjective criticism, not generally cultured talk a propos of the artist and his epoch. This book . . . aims at nothing less than the *psychological reconstruction of the artistic personality of the painter.*"

The *Lorenzo Lotto: An Essay in Constructive Art Criticism,* which Berenson had dedicated to Edward Warren, had come out in December 1894, bearing a London copyright, although it was printed in New York. It was a large octavo volume printed on fine rag paper with thirty halftone illustrations and wide margins, a format which owed much to Mary's ability to persuade Putnam to meet Bernhard's wishes. The 362 page book made no pretense of seeking a popular audience. It was avowedly a work of scholarship of the most rigorous sort, illustrating the application of the new theory of objective analysis.

Starting with a scrupulously detailed analysis of Lotto's earliest paintings, Berenson pointed out the stylistic affinities which showed that Lotto's true master was Alvise Vivarini and not Bellini, as commonly thought. The succeeding paintings demonstrated that "from youth to old age Lotto betrays the most subtle morphological connections with Alvise and his school." It was not of course that Lotto did not develop his own distinctive style but that it was a creative synthesis of influences of varying intensity. "One of the principal objects," wrote Berenson, "of the kind of criticism that we are pursuing is the discovery of the data that will enable us to form a fair estimate of the artist we are studying. . . . Our estimate of the artist is largely determined by . . . the proportion in his work of outside factors to personal factors, and by the kind of assimilation that has taken place between them." Such an analysis concerned itself with the psychology of artistic creation and was based primarily on the study of the works of art themselves.

Not until the final long chapter, "Resulting Impression," after tracing Lotto's development as a painter through his maturity and old age, did Berenson free himself from the monographic style to give eloquent expression to his appreciation of Lotto's genius. "Lotto was, in fact," he declared, "the first Italian painter who was sensitive to the varying states of the human soul." In this concluding biographical essay Berenson reviewed the springs of Lotto's personality, and we catch something of the emotional fervor with which he had pursued his long quest for Lotto's paintings in a comment on one of the paintings of his matu-

rity: "It contains all that refinement, all that unworldliness, and all that wistful unrest which were at the very foundation of his nature."

The book, as has been noted, had been years in the making, and a draft of it had evidently been completed as early as 1892, at which time Berenson prepared a preliminary introduction for it. In that introduction, written in the first person, he rehearsed at length his own rigorous initiation into the Morellian technique, in which the main emphasis shifted from the study of historical documents to the confrontation with the work of art itself, viewed in the light of a "profound acquaintance with the currents of thought and feeling in the epoch comprising his subject." Criticism, he admitted, did owe a debt to the writers who had published the contemporary documents, but the documents gave no "insight into the soul of the artist, or even into his passing mood or attitude toward the subject he had in hand." As finally published, the introduction subsided into a short impersonal preface describing the role of habit in the formation of a painter's style and the significance of "the less expressive, and therefore the less noticed" features of a painting: "the ears, the hands, the ringlets of hair, recurring bits of landscape," and the like that provided clues to the painter's origin and development.

Long afterward, in *Rumor and Reflection,* he recalled, "My beginnings as a writer encountered no little opposition. Not so much on account of my ideas. The crime was that I used the first person singular instead of the plural." The published preface of the *Lotto* revealed in its acknowledgments that he had consulted a formidable board of advisers. There was "constant aid and counsel" from Mary Costelloe and Dr. Frizzoni, and "many a hint" from Dr. J. P. Richter, and "finally . . . for suggestions while reading the manuscript" he was under obligation to Vernon Lee and Hermann Obrist.

The book was widely reviewed on both sides of the Atlantic and for the most part with appreciation of its originality. One of the earliest reviews, a long column in the January 13, 1895, New York *Times,* had little else but praise for this venture into what Berenson had called "An Essay in Constructive Art Criticism." The author comes to his work, the reviewer wrote, "with admirable qualifications—he is open-minded, highly informed, logical, with exceptional critical ability." The steps by which Lotto's personality as an artist was deduced from the stylistic development of his paintings seemed as interesting "as a well-executed detective story." Although Lotto was not given a place in the front rank of Italian artists, he was shown to be the first psychological and therefore "modern" painter, a position which the reviewer thought

Berenson had defined "with a delicate and happy touch." The reviewer pointed out with some amusement that though Berenson deplored poetical and rhapsodical art criticism he was not above lapsing into poetical passages of his own.

Berenson's satisfaction with this review was soon to be qualified by a six-column review in the *Nation* written by Kenyon Cox. Cox, a well-known American painter and critic, admitted that he had no quarrel with Berenson's conclusions, but he challenged the crucial importance which the Morellians gave to the unnoticed details of a painting, the "morphological" characteristics, as Berenson termed them. Nevertheless, 'Cox concluded that "the profound study, the great industry, the wide range and minute accuracy of knowledge which the book displays are worthy of all praise." Having given this tribute, he added the caveat: "The results of the application of 'modern connoisseurship' to the history of art can be accepted only with great caution."

Cox's objection was given a further turn in a review article in the April *Atlantic Monthly* which rather oddly pitted the "laboriously scientific analysis" of Berenson's *Lotto* against the imaginative transformation of "the whole mass of lifeless facts" in Professor Barrett Wendell's recently published *Shakespeare*. The reviewer conceded that the main impulse of the times was toward a fusion of historical and scientific research and away from the most "natural type of criticism which instinctively judges the art of the past from the point of view of the present." Berenson's "minute" study of Lotto was one of the most interesting examples of the tendency; but to "the ordinary lover of art," all these minutiae were "purely the dead learning of an expert, unattainable save by the few elect." They told no more about Lotto than the philologists have told us "about Shakespeare and Dante." The reviewer therefore urged the "new critics" to avoid giving prominence to insignificant facts. "Facts, crucial facts . . . may well be relegated . . . to convenient corners, to footnotes and appendices." The reviewer, who signed himself "R. Carpenter," was none other than Berenson's former classmate and one-time companion in Europe, Professor George Rice Carpenter of Columbia University, who had met him at the dock in New York with such ambivalent feelings. A review in the New York *Critic* was equally unsympathetic, willing to acknowledge only that the book had value as showing "the kind of work performed and the peculiar learning acquired by the expert."

The most curious review, patronizing and laboriously derisive, appeared unsigned in the London *Athenaeum;* its anonymous author, Charles Eliot Norton. Why Norton chose to publish his sneering attack in a British periodical rather than an American one is hard to fathom,

unless it was to deflate Berenson's growing reputation in England. Norton evidently had not been pleased that winter to see his prominent disciple Mrs. Jack Gardner adopt the young immigrant upstart from Lithuania as her adviser in the purchase of art. Moreover, Berenson's addiction to science undoubtedly grated on his sensibilities. What was new in the book, Norton thought, deserved no more than an article, "setting aside of course the psychical research, morphological investigations (the author is strong in ologies), the *da capo* passages and such like." Berenson, he scoffed, "is a disciple of the 'ear and toenail' school and that tends to prolixity." He suggested, however, that Berenson's readers might be "none the worse for coming under the influence of his innocent enthusiasm and they may derive instruction from the outpourings of his gentle culture." Norton was more prescient than he knew when he went on to express dismay at the possibility that Berenson's pioneer monograph might be the forerunner of a whole library of such technical studies of individual painters. In time Berenson learned of Norton's authorship of the piece and realized at last the depth of his hostility. While still ignorant of the identity of his assailant, Berenson plaintively reflected, "The worst charge the *Athenaeum* reviewer brought against me was that I came from Boston, where he strongly urged me to return. Fain would I have followed his excellent if scornfully given advice, for to come from Boston is to be the citizen of no mean city and to return to there must be the desire of everyone who has been privileged there to be nurtured. Unhappily I have chosen the study of Italian painting for a profession and that study can in Boston be pursued with even less profit than in London and how little that is almost any review in the *Athenaeum* on Italian art will show."

Berenson's reception in the British and Continental art world was much more favorable than in America. Heinrich Wölfflin, the famous Swiss art historian, welcomed the book as "eine sehr ernsthafte und wertvolle Arbeit," very earnest and worthwhile, and written with comprehensive knowledge of paintings. Richter, Berenson's friend and fellow-Morellian, gave the book two and a half laudatory columns in the March 21 *Kunstchronik*. In a six-page review article in the very influential *Revue Critique d'Histoire et de Littérature,* Salomon Reinach praised it as an important work, stressing that Berenson, though not the inventor of the method, was the first to present its principles with complete clarity. He pointed out that the objectors to the new analytic method which photography had made possible were repeating the folly of critics of twenty years earlier who resented the scientific editing of traditional texts. Correct attribution was not the supreme end, *le but suprême,* but the necessary first step to understanding the character and

development of the artist, a task which Berenson's book obviously had fulfilled. Reinach's translation of Mary's review appeared shortly afterward in the *Gazette des Beaux-Arts* over the pseudonym of Mary Logan. As an accomplished Morellian herself, Mary declared that the special significance of the book, besides its showing the true character of Lotto and his school, was that it furnished a model of what might be called psychological criticism. The long article ably supplemented Reinach's critique and refuted those who charged that scientific criticism dehumanized the study of an artist.

In England, Julia Cartwright (Mrs. Henry Ady), a prominent author of many works on contemporary and Renaissance artists, warmly recommended the *Lotto* in the London *Art Journal* as the work of "one of the ablest of Signor Morelli's followers." The "new science," she declared, "is still young, but it has already outlived the stages of ridicule and opposition. . . . Mr. Berenson's remarks . . . deserve to be read carefully by outsiders who smile at the constant references to ears and hands or locks of hair by which we are asked to decide upon the origin and training of a painter. . . . Again, Mr. Berenson deserves the praise of being the first writer who has done full justice to one of the most interesting and . . . least known members of that brilliant group of painters who flourished at Venice in the first half of the sixteenth century." An equally appreciative review came out in the London *Spectator,* the reviewer being careful to emphasize that Berenson was "a writer who is not a mere cataloguer of those [distinguishing] peculiarities, but who has a sympathetic interest as well in the spirit of the artist he investigates." In the same article he also praised Mary Logan's Hampton Court pamphlet for providing "a useful summary of recent conclusions as to the authorship of the pictures in that rich collection."

The "new science" may have outlived opposition and ridicule in Europe, but the reviews by Norton, Kenyon Cox, and Carpenter had indicated that the case was different in America. There was clearly need for a rebuttal while the controversy was warm. Having accepted Carpenter's review for the April *Atlantic,* the editor, Horace Scudder, almost immediately invited Mary to contribute an article in defense of the new school of art criticism. This she managed with her usual energy, again over the signature Mary Logan. In "The New Art Criticism," which ran in the August 1895 issue, she adopted Bernhard's line of argument: the critic should be able to "classify Italian paintings with the accuracy of a botanist in classifying plants." He can thus protect the unwary layman from exhausting his "aesthetic capacities" on "mere rubbish masquerading under famous names" in catalogues and Baedekers. But discriminating the genuine from the spurious was only the

beginning. "The psychological criticism begins, then, where Morelli left off with the much-ridiculed hands and ears and folds of drapery." The process by which old habits are transformed into new ones, into an artist's distinctive style, in which his vision of the life of his time is assimilated in his art, that process when uncovered by the critic brings us at last "face to face with the great masters of a past time, freed from the confusions and misinterpretations of the old criticism." She did not mention Berenson's name, but the knowledgeable reader of the *Atlantic* could hardly miss the implication.

Unquestionably, Mary's articles played an important part in buttressing Berenson's reputation. If she owed a great deal to him for instruction, it was clear that she richly repaid him for it with her eloquent and aggressive defense of his work. Still, while Bernhard wrote ebulliently to his sister of his successes, Mary, who knew how much they owed to her energetic efforts, felt strangely discontented. "Why have I lost heart," she wondered to herself, "just when everything is beginning to succeed? Is it because I care too much about H. [Obrist]?" It was true that in London she had found herself succumbing more and more to the physical charm of the free-thinking sculptor, and her equivocal relations with Obrist continued to cast a heavy shadow over her union with Bernhard. She and Bernhard had indeed become indispensable to each other as affectionate collaborators, but though Bernhard was still content with the monogamous state and loved Mary with an almost uxorious attention, the romantic rapture which Mary endlessly craved had long since faded.

About this time Berenson confided to Miss Bradley, the "Michael" of Michael Field, that Mary had given him "word of the greatest assurance of her love, but she still clings to Obrist." He admitted that he enjoyed Obrist's company very much, but he "could easily dispense with him." However, "she wants to continue his friendship . . . and I cannot get the heart to say her nay. . . . She promises, however, to be guided by my counsels, and never again deceive me. From all these promises I must deduct much for frailty." He was no longer in hell, he said, but "just beginning to climb the mountain of purgatory." As the years passed he was to learn that more mountains remained to be climbed and more promises discounted. Nor did he foresee that one day he too would be a frantically cross-gartered lover with ample purgatories of his own making and deceits too transparent to deceive.

XVI

Heretic at the New Gallery

COMFORTABLY established at last in their neighboring apartments, Bernhard and Mary found it easier to entertain friends and acquaintances who gravitated to Florence on recurring pilgrimages during the season, which, opening in February, reached its height in March and April. Hutchins Hapgood and his parents put in a welcome appearance, though Mary drew Bernhard's wrath for sharing dear "Fafnir's" low opinion of a Fra Angelico. "Fafnir" was admirable company on Bernhard's favorite walks, and they "Platonized in the moonlight," as Bernhard put it, "with the odors of violets and roses to soothe us, for hours and hours." The newlyweds, Bertie Russell and Mary's sister, Alys, came for a few weeks, and Bernhard initiated them into the fine points of the art and architecture of the Florentine churches. Professor Barrett Wendell and his wife stopped off for a few days, and it pleased Berenson to discover that Wendell's method of study was very much like his own. Another Harvard visitor was Professor Toy, who once had high hopes for Berenson as an Arabic scholar. Bernhard caught him alone once, away from his wife, and kept the "delightful old boy" talking for two hours. Bernhard too loved to hold forth, and after luncheon he would often launch into a brilliant impromptu lecture on the artist on whom he was working at the moment, be it Donatello, Botticelli, or Pollaiuolo.

One of the more distinguished visitors was Charles Dudley Warner, the popular essayist, travel writer, and novelist, who had collaborated with Mark Twain on *The Gilded Age*. He was at this time an associate editor of *Harper's*. Now he came full of talk about Mexican cliff dwellers. It was through him that Bernhard and Mary presently met the remarkable Janet Ross, who soon became one of their most intimate neighbors. Mrs. Ross had been talking to Warner about two paintings

she had acquired when she first came to Florence in the late sixties. In Warner's presence she wondered whether the attributions were correct. Warner, she recalled, "proposed to bring Mr. Berenson to see them, whose opinion would of course be conclusive." One result was that the pictures were soon sent off to London and brought several hundred pounds, a windfall which helped pay for the repairs of her imposing villa Poggio Gherardo, severely damaged in the earthquake of May 19, 1895. The other result, as she wrote years later, "was gaining a friend, whose pleasant and brilliant conversation is a great resource, and whose kindness is never failing."

Mrs. Ross was an athletic, handsome, and highly intellectual woman, regarded by many as strong-willed and formidable. She was the daughter of the famous Lady Duff-Gordon, and after her marriage to Henry Ross, the representative in Alexandria of a British banking firm, she spent several years in Egypt, where her ailing mother had become famous as a philanthropist. As a young woman in England, Janet Ross had formed a lasting friendship with the novelist George Meredith and with many other notables, including John Addington Symonds, who frequently visited her in Florence. She had already achieved notice as a writer and translator. In 1889, the year that Berenson arrived in Florence, she and her husband had acquired the villa known as the historic Castle Poggio Gherardo below Settignano and not more than half a mile from the Villa I Tatti, where Bernhard and Mary would finally settle. Legend had it that the castle had been the setting for Boccaccio's *Decameron.* "Like so many others," Mrs. Ross remarked, "Berenson fell under the spell of my husband's remarkable gift of relating his adventures in Asia Minor as a young man." Living with Mrs. Ross at this time was her charming young orphaned niece Caroline ("Lina") Duff-Gordon, who was promptly taken up by Mary and Bernhard as a sort of protégée, and in consequence Mrs. Ross became "Aunt Janet" to all of them.

Bernhard and Mary had resumed their amicable duels with Vernon Lee at Il Palmerino early in the year, though Bernhard seems to have avoided the more formal symposia, like the one on De Quincey, which Mary characterized as a "Sancta Conversazione" where all the saints were "female except Placci." Loeser was frequently in view at luncheon or dinner at Mary's rooms, always ready to stir up the company with his latest antipathies, whether to argue that Whistler was superior to Degas or, with ill-concealed venom, that Bernhard's *Lotto* was really all wrong. Mary, quick to resent his attack on the *Lotto,* speculated that he was suffering from "softening of the brain." Still, they liked him in his genial moments and continued to exchange visits.

[217]

If Florence was famous for its hospitality toward its foreign residents, it was also well known for its indulgence of their eccentricities, especially of what a later age would call their "sexual preferences." In spite of their latent puritanism, Bernhard and Mary soon learned to tolerate the remarkable variety of attachments among their acquaintances. One guest, however, "a noted Sodomite," as Mary described him, quickly wore out his welcome by falling in love with Berenson "at first sight." It was not the first nor the last time that the handsome and somewhat dandified Berenson inspired such overtures. Both she and Bernhard disapproved of the tastes of the "Brotherhood of Sodomites," as Mary called them, but they equally disapproved of the harsh laws that harassed them. When, shortly afterward, word came that Oscar Wilde had been sentenced to two years' imprisonment, Mary reflected, "It makes me miserable, although when he was here last spring I came to the conclusion he was somehow a loathsome beast," yet "how common the vice is. . . . It is sickening to think the punishment has fallen on the most brilliant of them all."

Berenson was always most in his element when he took their friends down to the Uffizi or the Pitti Palace to hold them spellbound by his eloquent allusiveness or, as on one occasion that spring, to astonish them with a new find at the Pitti, a Botticelli not yet ready for hanging. It was still in the private apartments of the Prince of Naples, and Berenson and his party, after crossing a palm or two, were shepherded past the ranks of brilliantly garbed retainers to the room in which the painting was hidden. Finally allowed access to the beautiful *Pallas,* he "gave the signal," as he put it, "and we all bowed down and worshipped." He sent off an appreciative account of the "find" for the June issue of the *Gazette des Beaux-Arts,* taking pains to demonstrate that contrary to received opinion this *Pallas* was not the one that Vasari had described.

Berenson put aside his writing in April 1895 in order to accompany Theodore Davis and his party on a tour of Siena, Perugia, Milan, and Bergamo. Berenson privately grumbled that his "half-cultured" charges expected to ravish art at a blow, not realizing that art had to be patiently courted. After parting with Davis, he went on to Venice to counsel—and humor—Mrs. Gardner, who seemed bent on making up for lost time in acquiring Italian Renaissance paintings. She had by now established her favorite summer headquarters in the gilded splendor of the Palazzo Barbaro on the Grand Canal. It had been bought many years before by the parents of Ralph W. Curtis, who were old Boston friends of Jack Gardner. Curtis senior had fled America in disgust after he was jailed for having violently resented an insult by a stranger. Unfortunately, the stranger proved to be a magistrate who contested the

point of honor. Ralph Curtis, who, like his parents, remained an expatriate, had achieved a small reputation as a painter; also he had advised Mrs. Gardner on some of her acquisitions. A companionable and witty young man, he fitted comfortably into the inner circles of Anglo-American society which migrated with the seasons to London, Paris, Venice, Rome, and Florence, and he numbered among his friends Henry James, Henry Adams, Berenson and all the tributary intellectuals of their group. Like Berenson, he too collaborated with local dealers.

Mrs. Gardner's purchases of paintings through Berenson began to accelerate with the opening of 1895. First came a reputed Mabuse portrait; then in late February she decided to take two panels then attributed to the Renaissance architect Baldassare Peruzzi, depicting a warrior of antiquity, the price £1,400. Since Berenson had volunteered to act as her agent for a fee of 5 percent rather than the usual 10 percent paid by collectors, she had reason to congratulate herself on her business acumen. The "Peruzzi" transaction had an agreeable effect upon Berenson's finances. Mary reflected, "We are low in funds and this means about seventy pounds."

Shortly after acquiring the "Peruzzi," Mrs. Gardner accepted in quick succession a Bonifazio Veronese *Sancta Conversazione* and a Catena *Keys to St. Peter* from the collection of Jean Paul Richter. A few weeks after the Richter transaction was completed, Berenson sent her word of a bargain painting by Clouet, a photograph of which he enclosed. "It has, it is true, been rubbed in the cleaning but it is a genuine Clouet—and genuine Clouets are rare—and the price I could get it for—eight thousand lire [about $1,600]—is absurdly cheap." Then, with the disarming change of tone which was habitual in his many letters to her, he became the earnest schoolmaster. "Have you read Huysmans' *En Route?* Il faut le lire." It was the story of a young convert who at last immures himself in a Trappist monastery. The tale was then making a sensation in France, where the Catholic question was dividing the country. In his next letter, a few days later, he told her that she could examine the Clouet and also a Franz Hals in the Bonormi-Cereda collection in Milan. She took the Clouet. It turned out that this was another of the disputed attributions which he made among her acquisitions, for the painting ultimately proved to be by Corneille de Lyon.

Berenson entered on his role as adviser to Mrs. Gardner with the greatest relish, for it was now obvious that she had made up her mind to form the finest private collection of art in Boston and, what was also apparent, she had the means to do it. The work would at last assure him the means to study and write without nagging anxieties about

money, while at the same time it would help make the city to which he was so deeply attached a world center of art. His letters to her now became a lecture in countless installments, guiding her searches wherever she traveled in Europe, introducing her to collectors, pointing out the works most worth seeing in museums, praising her discernment, or shrewdly disciplining her taste.

He wrote to her very much as he talked to friends whom he shepherded through the Uffizi. He had so immersed himself in the works of art that he took visual possession of them and proudly displayed his domain to his visitors, and just as each new beauty discovered seemed to outshine the beauties of yesterday, so in his letters, superlatives tended to succeed superlatives. It was as if he were an arduous explorer before the paintings he admired, the very first to stand upon a mountain peak and gaze upon a virgin and delectable landscape. If his language to Mrs. Gardner took on the heightened eloquence of an enthusiastic salesman, he seemed unconscious, at first at any rate, of any profanation of the temple of art. His earliest letters sounded the notes that would be habitual to him, the words of mingled guidance and temptation. Learning, for example, that she planned to visit Bergamo, he enjoined her to see the Lottos in St. Bartolomeo and St. Bernardino, and re-created for her the spell that Bergamo had cast upon his own spirit.

In St. Maria Maggiore, the intarsias after designs by Lotto, particularly the front ones (get the sacristan to open them) and those within the choir in the first corner on the left. Attached to Santa Maria is the Colleoni chapel wherein splendid Tiepolos in the vaulting. In the gallery the Lottos. In the Lochis section Raphael's St. Sebastian and a Madonna by Crivelli and an admirable one by Borgognone attributed to Zenale, a fascinating one by Tura, a fine little St. Sebastian by Antonello da Messina, a number of excellent Carianis, particularly the portrait of B. Carvaggio and a picture representing a woman playing and a man almost nude asleep.

He went on to single out paintings for her to study in the Morelli sections of the Accademia Carrara gallery in the lower town. He also told her that "the finest Moroni in the world" belonged to Count Moroni. Then there was Signore Giovanni Piccinelli, who had "two fine Lottos" in his collection and who would take her to Count Moroni's. He challenged her to examine the count's collection and tell him whether "there is a more distinguished and more refined as well as a more genial portrait in the world than the Count's 'Man in Black.' You will see it was not by any means Whistler who invented tone."

He concluded his recital with effusive thanks for the photograph of

Sargent's famous full-length portrait of her which he had implored her to send to him. Depicted with regal poise, she stands erect with hands loosely clasped to form a graceful curve beneath the double row of pearls about her narrow waist. The lines of her face are gently blurred against the dazzling whiteness of her skin, a whiteness heightened by her severely black décolleté gown. It was not one of Sargent's flattering society portraits. The artist had had difficulty with the face, whose plain features did not lend themselves to his usual idealized treatment. Mrs. Gardner, to his annoyance, had obliged him to attempt many revisions. When first exhibited in Boston, the painting had made a sensation and the décolletage became a matter for jest. Angered by the talk, Mr. Gardner put the picture away. It was not exhibited again until after his wife's death. "It is a great work of art," Berenson diplomatically assured her, "but could my hand follow my brain my portrait of you would be greater."

The note of fulsome flattery that would henceforth be rarely absent from his letters, the fervid tributes to her taste and good sense, were no more than what she was accustomed to from her large circle of friends. Yet she was not as easily influenced by flattery as many thought. More often than not, she turned a deaf ear to Berenson's recommendations and usually with the convenient plea of lack of adequate funds. Like the rest of the collecting tribe, she coveted the finest paintings at the cheapest price, but when she set her heart upon a really tempting acquisition, she could throw caution to the winds.

Berenson had cause now to view his situation with considerable complacency. His two books were selling well; two months' royalties on the *Lotto* alone amounted to nearly $200, and as he told his sister, reviewers were "spreading" his name in the land. "To be the personage of the moment is not a bad thing." He felt he was now "somebody" in Paris, and for proof sent her a copy of his recent review of Hermann Ulman's *Botticelli* in the *Revue Critique*. The product of long discussions with Mary, it was a scathing and meticulously documented piece that scorned some of the attributions of the great Wilhelm Bode on which Ulman had relied, thus further assuring Berenson of Bode's dislike. Berenson also reported that Putnam wrote "begging me to continue the series of Renaissance Painters with other volumes and probably I shall graciously condescend to do it." He made the commitment without delay.

In the midst of this success, however, he published a pamphlet which, while it made his name more widely known to collectors of Italian pictures, aroused, as Mary was to recall, "a great scandal and excited much hostility." It became a hostility that for the rest of his career

would lead his adversaries to miss no opportunity to impugn his motives. The pamphlet had its origin in the article that Reinach had invited him to write on the exhibit of Venetian painting at the New Gallery. He finished the long essay in Fiesole early in February and sent it to Paris, expecting it to be translated and readied for the press. Whether because of its excessive length or because of its outspokenness, Reinach rejected it. Momentarily cast down, Berenson burst out, "I can never write again," but the mood of desperation found no encouragement from Mary. She took the article in hand and revised it for publication as a pamphlet. Herbert Cook, who had come on from London for a "gorge of connoisseuring" with Bernhard, had agreed to subsidize it.

The forty-two-page pamphlet came out in London the first week in March 1895 and sent a shock wave of indignation and fear through the rich and titled owners of Italian paintings and especially, of course, through those who had lent their treasured paintings for the exhibition. In the official catalogue each work had been catalogued according to the attribution furnished by its owner. The hanging committee had, however, prudently prefixed to the catalogue a disclaimer of responsibility for the attributions. After several days of study Berenson had concluded that the public had been unwittingly imposed upon in a wholesale fashion. There was nothing for it but to rebaptize the pictures. He began disarmingly enough by praising the catalogue for its accuracy and tact in the actual description of the paintings, but that was as far as he would go. "It has one and only one fault," he declared, "that the attributions are, for the most part, unreliable."

With that he plunged into a devastating analysis, giving critical chapter and verse, so to speak, for the true identity. In the case of a copy, he gave the location of the original. Being a stickler for accurate scholarship, he incautiously—or by way of reproof—gave the name of the owner who had contributed the picture for the exhibition. Of the thirty-three paintings ascribed to Titian, he announced, "one only is actually by the master." He deplored the many instances of "superannuated connoisseurship" and implied that it was obvious that many of the owners had been misled by unscrupulous or ignorant dealers, though he avoided any direct accusations. Down the list he went, indicating the criteria of a painter's style, tracing the signs of his development from his sources, and succinctly showing his influence and relation to other painters. And he did not hesitate to differ from Morelli in an important instance concerning a so-called Bellini owned by Mrs. Benson, which Morelli had instead identified as "the triumph of Bissolo's art." Berenson proceeded to "prove that Bissolo had nothing to do with it, and that its real author was Basaiti." He called attention to

the details that showed that the painter was a follower of Alvise and not of Bellini, as Bissolo was. By the end of the essay Berenson had established that of some 120 paintings no more than 15 were correctly labeled.

In a brief preface Herbert Cook remarked that the pamphlet was intended to give "a clearer idea of the various masters than can be gathered from the official catalogue," that it was in fact "supplementary" to it. He concluded, "Should any of the owners . . . be induced by perusal of this essay to take a more critical interest in their family treasures, and to put Mr. Berenson's criticisms to the test, the following pages will not have been in vain." The plea was not one that was likely to be heeded with good grace, as Claude Phillips, who reviewed the exhibition in the London *Fortnightly,* made clear.

Phillips pointed out the shortcomings of the exhibition in not having genuine examples of some of the great Venetian masters, and he called attention to some of the misattributions in a more general way. He went on to say that "the critic of the modern systematic school—too harshly and narrowly styled the scientific, in contrast to the aesthetic and rhapsodical school of earlier days—gets nowadays more kicks than half-pence. He is hated alike by the dealer, who naturally resists the upsetting of established reputations and the reduction, for instance, of a forty thousand pound Raphael to a four thousand pound Sebastiano; by the owner, who revolts doubly from such a metamorphosis, as making him suffer both in pocket and by the partial eclipse of that reflected glory which has always been his; by the public, who resent the substitution for pleasant rose-coloured disquisitions . . . of inevitably more prosaic consideration relating to technique, the anatomy of a picture, and the real place of a painter in his school and his time. . . . The time has come when [the student of art and archaeology] must, because at last he can, substitute for the fantasies of amiable chroniclers, something much more nearly approximating the whole truth concerning the great artists and the great schools of the preceding centuries."

Berenson's confidence—and perhaps rashness—as an art critic was also reflected in a review article, published in early May 1895, in the *Revue Critique d'Histoire et de Littérature,* of the catalogue of the exhibit of works of the school of Ferrara-Bologna, which he had also visited at the Burlington Fine Arts Club in London. Though he acknowledged that the volume was beautifully done and would be very serviceable, he pointed out in careful detail, as he had in the pamphlet on the New Gallery, the errors in attribution. Since the name of the eminent art historian and archivist Leopold Venturi appeared, he noted, on almost every page of the catalogue, he suggested that the qualities suitable for

an archivist were not those that were needed by a connoisseur of art, and to prove his point, he explained how Venturi had been led astray in a few of his attributions, and thus, it appears, added Venturi to his foes.

Another important French periodical to which Berenson gained access was the *Revue Internationale des Archives des Bibliothèques et des Musées,* to which, early that year, he contributed two articles, a brief one reviewing a report on the Italian National Gallery and a ten-page review of a recent book on paintings in Florence in which George Lafenestre, the director of the Louvre, had a hand. The long review incorporated some of the copious notes on the book that Mary had prepared for him. Berenson, who had met Lafenestre, explained to his sister that he "is a charming man but ignorant. It pained me to have to show him up but I have done it."

Bernhard and Mary now had entrée to journals on both continents and could count on respectable payment for their contributions. Mary also had the advantage of her annual allowance of nearly £300, which at the end of 1895 was, at her father's cautious insistence, converted into an annuity. Since Bernhard's income was now the larger, they drew on it more heavily for their joint expenses, which grew by leaps and bounds. Every book read was a book purchased; every reference work on art required for their researches found its way to Bernhard's shelves or to Mary's. The indispensable isochromatic photographs of paintings from Alinari in Florence, from Domenico Anderson in Rome, and from expert photographers in Milan, Paris, and elsewhere made incessant inroads on his purse. Tasteful furnishings and occasional objects of art became necessities. Travel demanded the largest outlays; annual trips to France and England for lengthy stays and frequent *giros* around Italy regularly depleted their resources, so that their dependence on Bernhard's expertise as well as on Mary's rapidly increased. She proudly wrote home that she was the Italian correspondent of the *Chronique des Arts,* and "paid too!" At the end of 1895, Bernhard promised his sister Senda that, although his income was "as yet precarious and unstable," he would henceforth send home $500 a year, a sum equivalent to several thousand in our own day, out of which he suggested that she pay the $200 premium on the $5,000 life insurance policy she had taken out naming their mother as beneficiary.

The complex arithmetic of Bernhard and Mary's sharing of expenses is past finding out, particularly because each had claims which went beyond personal needs. For Bernhard there were the needs of his family back in Boston, the calls on his generosity by indigent artists, and the pressure to set aside money for investment against the uncertain future. Mary too tried to look ahead and like Berenson took advantage when

she dared of Theodore Davis's stock market tips on sugar and copper shares. Nor could she, in spite of every resolve, control her generous impulses toward friends and particularly, as they grew older, toward her two children, whose welfare became her most obsessive concern. It taxed her ingenuity and her scruples to put her hands on the sums she felt she needed, whether in dealing with Bernhard or in dealing with her parents. The inevitable result was that she occasionally employed a variety of subterfuges, which often resulted in painful recriminations.

For the moment they indulged each other with good grace, as one gathers from a letter she wrote to Bernhard from Paris in the following year:

About money: if thee remembers, we spent all our English gold paying for that ornament thee gave me in Munich, so I brought nothing but eight francs in French gold and Italian paper. Of the latter, one hundred lire I am keeping for my return, the former is gone. . . . I get my money on the first, however, and Mother [who was with her] has enough money to go on with. Besides, I shall get some money from the *Gazette* [*des Beaux-Arts*], so I really don't need any sent here, and in England I shall have my income [her annuity payable only in England], so I am all right. . . . Well for the future let us try to approach that ideal of unsordid existence that thee has always cherished.

Two years later, when their circumstances had grown much easier, Mary quickly fell back into her girlhood habits. She had shopped with her brother, Logan, and bought a superb Aubusson carpet and some china. "I enjoyed the spending of *money immensely!*" she confided to her journal. "But I feel that I shall never enjoy it again quite so much. . . . I think I can never again feel the same closeness to the dread of not having enough, the contrast which makes the first taste of the superfluous delicious."

Berenson could hardly say that he had not been warned of the perils that lay in wait for the connoisseur, of the endless vendettas and the rivalries that seethed beneath the surface of the art world, in which no quarter was asked or given. Nowhere else did the cash nexus and the pride of possession so infect its participants as in the traffic in art. With so much money at stake for others as well as for himself, the conscientious art critic had to make his way along the razor's edge of probity. In season and out, Bernhard protested to Mary that he was determined to live an unsordid existence and secure his position as an impartial scholar-critic through his writings. Though deviousness and mystification seemed inseparable from the trade in art, he was confident that his judgment would remain uncorrupted. But as he began to be drawn more and more into the world of the professional art expert, he was to

[225]

discover that there was another insidious temptation. That world promised to assure him the means of a comfortable, even luxurious existence, the means to satisfy his insatiable passion for books and photographs, to allow him and Mary to travel in comfort, and to have the indispensable leisure to write. It also threatened to tarnish the unsordid existence which he so dearly prized.

XVII

The Tactile Imagination

THE lengthening days grew warm and sultry and interruptions diminished as visitors decamped for cooler climes. Regulars like Placci could still be counted on to enliven an evening with vivid gossip of the larger world which he frequented or with brilliant improvisations on Mary's piano. Ever eager to improve herself, Mary had resumed her piano lessons, filling in what little remained of her busy days with lessons in Greek. The most favored of their British guests had been the Michael Fields, who had been installed in Bernhard's apartment when he left for a few weeks to act as cicerone, first to Theodore Davis and then to Mrs. Gardner in their picture hunting. The "Mikes," as Mary called the poetizing aunt and niece, whose "fussy and affected ways" grated much more on her nerves than on Bernard's, finally vacated Bernhard's apartment to return to England in May 1895, for which Mary uttered a fervent "Thank God!" She did not relish what she called the "strange delusion" of the pair that there was "a powerful affinity" between Bernhard and themselves. To Mary the idea was simply inadmissible. There was therefore more than a touch of spite in her reflection that the two women deluded themselves with the "hideously false" ideas that they were poets and belonged together and "no one dares tell them the truth." But if they were irritating at times, they also had their merits. For shortly afterward, when Bernhard and she visited Obrist in Munich early in July, she recalled with approval "Michael's" remark: "I know from experience what it was to listen to the great teachers like Socrates and Abelard whose words kindled men like flames, for I have heard the 'Doctrine' [her admiring nickname for Bernhard]." Mary seconded their opinion more simply: "Obrist is a dear, but being an artist he isn't a critic and Bernhard has simply proved himself a divine critic. . . . I have felt like a child between them

and have been simply overwhelmed with Bernhard's genius." As for Bernhard, he seems to have felt that the "Mikes" were far more genuine than did Mary, and their rhapsodical emotionalism apparently struck a responsive chord in him, as the hundreds of endearing letters that had begun to pass between them testify. Their friendship did have its ups and downs, for Bernhard's critiques of their poetry were sometimes less than diplomatic. Early that year, "Michael," the aunt, in a sudden huff, invited him to "sail out of her life." Mary, as usual, smoothed the ruffled feathers.

Free at last from distracting visitors and the remunerative chores of expertise, Bernhard turned to the writing of the new book commissioned by Putnam, *The Florentine Painters of the Renaissance*. The task at first daunted him, and he wailed to Mary that he could not write about the Florentines because he no longer enjoyed them as a school. Again Mary rescued him from his vaporous mood, and the two of them vigorously plunged into the new work. The writing went rapidly; as Bernhard finished a page in his sprawling script, Mary transcribed it on her typewriter. Meanwhile, she prepared the lists of painters and paintings which would form the appendix of the book. At the same time she wrote out what she called "Thinking Lessons" for her children, aiming also at the publication of them. In the midst of these congenial projects, poor Mary reeled from a "knockdown blow," as she called it, when word came that her husband, against all her comforting hopes, had arranged to rear their two children in the Roman Catholic faith, the religion which she had now come to feel had been the evil source of all of her marital troubles. However, under the terms of the separation agreement she could do nothing but wait and hope that somehow she could counteract the virus of the hated theology.

Fortunately for Bernhard, he could write to Senda, "I think of nothing but my book, read nothing but what concerns it and write many hours a day." Her news from home had been reassuring except for one fact. He was disappointed to learn that she had broken off her engagement. He hoped, he said, "that if the proper man ever comes along you will take him." Then he added significantly, "I am beginning to think I should enjoy nephews and nieces. They are securities for our interests in life. . . . In a week I shall be thirty. . . . As I am not very likely ever to have children, I cannot help hoping that the rest of you will."

Work on *The Florentine Painters* was, as Mary noted, "our meat and drink." When Bernhard read to her his chapter on Masaccio, it gave her a thrill of delight. "Each word brought out Masaccio's inner significance." One of the entries in her journal indicates an important change in Berenson's emphasis in this book that accounted for the notable dif-

ferences between *The Florentine Painters* and *The Venetian Painters* and made this book a landmark in the study of painting. "All this time [during June]," she wrote early in July 1895, they were "grappling with the book and enjoying it very much. Every day we saw deeper into the 'why' of real art enjoyment. Practically the whole will come out in Bernhard's books but I do wish I had kept a record of our discussions from day to day. . . . One of the happiest and most growing in our lives." What he had at last arrived at was his novel theory of "Tactile Values," a phrase that would become a catchword for more than a generation. The formulation of his theory evidently came in the middle of the writing, almost as an afterthought, and it was inserted as a long parenthesis ahead of the account of Masaccio. As he explained to Senda, "I nominally am writing on the Florentine painters, but really my absorbing interest is to know why, to find out the secret of our enjoyment of art." He felt he was closer to the secret than anyone had ever been before: that the solution of the aesthetic problem would be found in psychology and not in philosophy. Having established this premise, he turned to William James's *Psychology* for light on the nature of perception and of the role of "tangibility."

Bernhard and Mary had left Florence in early July 1895 to escape the summer heat, first stopping for a few days at Lake Garda, then going on to Munich for their visit with Obrist for several days. Mary crossed the Channel to be with the children again at Friday's Hill while Bernhard returned to Florence to put the finishing touches to the Florentine manuscript. He then sent it over to Mary for editing. She proudly showed it to her brother-in-law, Bertrand Russell, somewhat to Bernhard's annoyance, for he did not want his "discovery" given away. Bertie, however, did not share her enthusiasm, and she reported that she and Bertie were "at it hammer and tongs over thy theory of 'pleasure.' " The point was crucial, for Berenson made the theory central to his analysis of the chief Florentine painters from Giotto to Michelangelo. He asserted first that the painter, confronted with a two-dimensional surface, can give "an abiding sense of artistic reality" only "by giving tactile values to retinal impressions," that is to say, by evoking the sense of depth, of the third dimension, by visually arousing the sense of touch, the original source of depth perception. The painter needed to produce in the observer "the illusion of being able to touch a figure . . . the illusion of varying muscular sensations inside my palm and fingers corresponding to the various projections of this figure before I shall take it for granted as real, and let it affect me lastingly."

The power to stimulate the tactile imagination was particularly strong in the Florentine painters, Berenson declared, because they relied

much less on the art of coloring than the Venetian painters. It remained true, Berenson conceded, that painting gave a variety of pleasures. A painting might be admired for its character as *illustration,* for its dramatic or narrative content, or because it aroused agreeable associations like music, but the pleasure that peculiarly distinguished painting from other art forms arose from its ability to create the illusion of three-dimensional form. To the extent that it succeeds in doing this, it is "life-heightening" and "life-enhancing," or, in more technical terms, "it lends a higher coefficient of reality to the object represented, with the consequent enjoyment of accelerated psychical processes, and the exhilarating sense of increased capacity in the observer." The observer may indeed get much pleasure "from composition, more from color, and perhaps still more from movement . . . [but] *unless* it satisfies our tactile imagination, a picture will not exert the fascination of an ever-heightened reality."

The positivist language fitted in perfectly with the scientific temper of the times, offering an aesthetic freed at last from the metaphysical subtleties of the philosophers. Several years later, in 1903, in the preface to a collection of his essays, Berenson summarized his naturalistic philosophy in these words: "I for one, have been for many years cherishing the conviction that the world's art can be, nay, should be studied as independently of all documents as is the world's fauna or the world's flora. . . . Such a classification would yield material not only ample enough for the universal history of art, but precise enough, if qualitative analysis also be applied, for the perfect determination of purely artistic personalities." Undoubtedly, his theory owed much to Hildebrand's little book *The Problem of Form in the Figurative Arts,* which Berenson had carefully studied in the original German two years before, in 1893, when he met its author. But where Hildebrand had tried with Teutonic thoroughness to break down the problem into its optical and kinesthetic elements, Berenson, with characteristic boldness, cut through to the practical implications of the analysis, and in the words of E. H. Gombrich's *Art and Illusion,* "with his gift for the pregnant phrase . . . summed up almost the whole of [Hildebrand's] somewhat turgid book in a sentence: 'The painter can accomplish his task only by giving tactile values to retinal impressions'!" It is no doubt true, as Gombrich observes, that Berenson was more confident of the psychology of perception than now seems justified.

A striking result of Berenson's theory was that it gave him an effective instrument for assaying the strengths and weaknesses of the Florentine school of painters. Giotto's genius for seizing on significant detail enables "our palms and fingers [to] accompany our eyes much more

quickly than in the presence of real objects, the sensations varying constantly with the various projections represented, as of face, torso, knees; confirming in every way our feeling of capacity for coping with things,—for life, in short." Uccello, by way of contrast, "sacrificed what sense of artistic significance he may have started with, in his eagerness to display his skill and knowledge." His figures therefore have, so to speak, "a mathematical but certainly no psychological significance." His art does not give "the life-enhancing qualities of objects." In artists like Pollaiuolo and Verrocchio, the tactile imagination is stimulated not by touch but primarily by movement, by "muscular feelings of varying pressure and strain," as in Pollaiuolo's *Battle of the Nudes*. "We imagine ourselves imitating all the movements, and exerting the force required for them—and all without the least effort on our side. . . . And thus while under the spell of this illusion . . . we feel as if the elixir of life, not our own sluggish blood, were coursing through our veins." Botticelli's *Birth of Venus* was peculiarly effective in creating that illusion. "Throughout, the tactile imagination is roused to a keen activity, by itself almost as life heightening as music. But the power of music is even surpassed where, as in the goddess' mane-like tresses of hair fluttering to the wind, not in disorderly rout but in masses yielding only after resistance, the movement is directly life-communicating. The entire picture presents us with the quintessence of all that is pleasurable to our imagination of touch and movement. How we revel in the force and freshness of the wind, in the life of the wave!"

The essay also developed a theme that would be central to Berenson's lifelong conception of the fine arts and that would help explain his revulsion from Surrealist and Abstract art, namely, the central importance of the human figure. The nude, he declared, "is the most absorbing problem of classic art at all times. Not only is it the best vehicle for all that in art which is directly life-confirming and life-enhancing, but it is in itself the most significant object in the human world." Draperies masked tactile values and made the rendering of movement almost impossible. "The artist, even when compelled to paint draped figures, will force the drapery to render the nude, in other words the material significance of the human body." In the entire group Michelangelo was, of course, the greatest master of the nude because the most direct in realizing the tactile values of the human form.

Young Bertie Russell inundated Mary with his criticisms of the manuscript, and she tried as best she could to pass his objections on to Bernhard. Russell disputed the notion that pleasure resulted from the enhancement of "capacity for life," arguing that "capacity" involved capacity for something specific. In his view the "pleasure" of art arose

from the satisfaction of desire. And as for a sense of heightened awareness, *that* might come as well from pain, as in the case of a toothache. He protested against what he saw as the mixing of psychology and biology. Berenson acknowledged that he had dealt summarily with very difficult questions, and he reminded Mary that he planned to deal with their ramifications in the projected "big book" on aesthetics, the book that he finally abandoned. As for his alleged confusion of psychology and biology, he saw it as a distinction without a difference, "biology being after all nothing but psychology in a packed down form." Russell contended that the theory of tactile values dealt not with the psychology of the ordinary or normal man but with that of a person peculiarly adapted to the enjoyment of art, of one who like Berenson enjoys more because his senses are more responsive to art. This criticism drew Berenson's defense that unless one had the style of a Ruskin one had better be silent on the point, except in a "strictly scientific book." For the moment it sufficed, he felt, to encourage the spectator to aspire to increased sensitivity.

It was true that many earnest readers of *The Florentine Painters* were fated to suffer disappointment in the presence of Italian masterpieces when the muscles of the palms and fingers remained stubbornly unresponsive. Russell's criticisms sufficiently unsettled Mary to induce her to write immediately to Obrist for advice, for she believed the distinction that Russell urged went to the heart of Bernhard's theory. To succeed as aesthetics, it must be a psychological theory. She wondered whether the lectures of Theodor Lipps of which Obrist had spoken dealt with the point, that is, explained *"why* we enjoy that 'living into' " the work of art, that process of *Einfühling* (empathy) of which Lipps spoke. Of course, she added, "Not that we should have any right . . . to get his ideas before they are published."

Obrist was himself jealous of the originality of his own theories, and he feared that his friend might anticipate him without giving him credit, whereupon Mary lectured him that Bernhard's whole theory of knowledge was that "what each man does is a stepping-stone for further achievements—and when anyone opens the door for him—like Morelli—he rushes in to explore, but he never forgets to say *who opened the door."* She assured him that "B.B. has a much more impersonal, nobler side than thee suspects." Chastened by Mary's reproach, Obrist sent on his thoughts for Bernhard's eye, but since his interest was more in the literary and illustrative aspects of art than in "form," he could add little to the debate. Mary urged Bernhard that the three of them should get together in Munich—or Paris—for several weeks to work the ideas "into a clear and persuasive form."

By this time Berenson evidently felt that his own ideas were in danger of being smothered by friendly advice. He conceded that Russell might well be right in saying that his psychology was antiquated, but even after rereading William James, as Russell had suggested, he had "the feeling that the question is still in a muddle." "Even if our primary sensations of space be three-dimensional . . . the third dimension in precise form must largely be a result of tactile and locomotor sensations." Russell's criticisms, he told Mary, would be helpful for the big book on aesthetics which he hoped to write one day. "The present small volume must go as it is, however, and must not be overloaded with what is to the subject of purely outside interest." He therefore instructed her to make only the most necessary corrections in the manuscript before sending it on to Putnam; any "paring down of dogmatic statements [to which Russell had objected] we can make in proof." As for the "Lists" (identifying the paintings and giving their locations), which would constitute a major part of the book, these, he reported on August 3, would go forward as soon as he returned to Munich from Berlin, where he was again studying the paintings in the gallery.

Bernhard and Mary met in Paris in early September, and the two busied themselves as usual with Reinach, arranging for articles in the *Gazette,* which Reinach commissioned for the editor Ephrussi, and scouting for paintings to propose to their clients. At the Louvre Berenson's researches now began to take a new direction as a result of an invitation from the publisher John Murray to do a book on the drawings of the Florentine painters, a project that was to grow with the years until it became his overriding concern—and his most important achievement as an art historian. Meanwhile Mary plunged into work on a Louvre catalogue, rejoicing on "how sympathetically our tastes work together." When Bernhard told her that he had real hope for her career, she thrilled with "gratitude and love" for him that was "indescribable." But the moments of rapture would often be followed by rancorous quarrels in which her scornful wit sometimes roused him to blind fury. They read Henry R. Marshall's recent book *Pain, Pleasure and Aesthetics* and soon wrangled for hours over the definition of pleasure. They traveled through Provence and the south of France, rummaging in the provincial galleries for more candidates for the "Lists," at times disagreeing violently over the merits of a painting, as at Montpellier, or rejoicing in a joint discovery, as of an early Pesellino. Bernhard wrote Senda that the journey "opened out to me like a land of promise. I have annexed it to my universe, aesthetically speaking, as much as I might geographically by conquest." Such conquests would become the "life-enhancing" habit of a lifetime. The Romanesque cathedrals, such as

those at Albi and at St. Remy, awakened his interest in medieval art and architecture. It was still another domain on which he would become an authority, and it would be a lasting regret to him in his old age that he produced no major work on the subject.

During the late autumn of 1895 there erupted a final bitter quarrel with Charles Loeser, which kept these two highly temperamental art lovers at sword's point for many years and divided their acquaintances into two hostile camps. The quarrel had been brewing—at least on Loeser's side—for several years, ever since the dispute over the twenty pounds which Loeser declared he had "lent" to Berenson in Rome and which Berenson had regarded as a gift. They had apparently been reconciled when, according to Mary, Loeser had retracted his charge of dishonesty, and their intimacy had seemed to resume on the old footing. It now turned out that Loeser had secretly nourished his grievance and sense of injury unmollified and had masked his real feelings, as he said, entirely because of his pleasure in Mary's friendship. And he now contradicted Mary's recollection of his "apology." Earlier that year Loeser had shown Berenson a drawing he had bought which he attributed to Crivelli, citing Frizzoni and Richter in support of his opinion. He was understandably proud of his apparently valuable new possession. Berenson had unceremoniously dismissed the attribution as mistaken, and there for the moment the matter had rested as just another virulent difference of opinion between the two men.

What touched off the new imbroglio was Berenson's tactless remark to Jonathan Sturges that summer in Paris that all Loeser "knew about pictures was merely what he [Berenson] had chosen to tell him" and that all Loeser did was "to move in his tracks." Being an intimate friend of Loeser, Sturges promptly passed on the slur to him. Loeser's resentment was further fueled by a letter from Santayana. According to Santayana, as Loeser quoted him in an inordinately long letter to Mary, Berenson had many times boasted that he "was the first of living connoisseurs of Italian painting," and when Santayana asked him, "What about Loeser?" Berenson answered, "Loeser has come to learn something because he has seen a good deal, but he began the wrong way and it is impossible that he could ever attain to anything good." This had been more than Loeser could take of what he called Berenson's "crass arrogance" in going "out of his way to say excessively derogatory things of the qualifications I cherish in myself beyond all others."

Loeser retaliated by denouncing Berenson among their friends, charging that he had been guilty of lying and dishonesty, and when Mary indignantly demanded a bill of particulars, the most heinous offense he could recall was Berenson's denying to him that he had spoken

disparagingly of him to Santayana. As for his professional dereliction, there was his insulting rejection of the Crivelli drawing. Loeser went on also to criticize alleged errors in the *Lotto*. Mary, with some justice, replied that if he was dissatisfied with the *Lotto* he ought to publish a review of it. She undoubtedly touched a tender nerve, for he had announced to friends he was writing the scathing review that the book deserved. His indignation seems to have subsided before he could complete the review.

Of course, the quarrel degenerated into petty recriminations, from which Berenson managed to stay aloof, at least in writing, leaving to Mary's loyalty and energy a brisk defense. At an interview with Mary, which Loeser solicited, he poured out a passionate litany of slights which he believed he had suffered, all the more unendurable since he believed he was a finer connoisseur than Berenson, whose "conceit seemed measureless." When Mary suggested that perhaps there was more in life than connoisseurship, Loeser angrily retorted that since she was a woman she could not understand "how dear a man's profession became to him." "This to me," Mary fumed, "who have published books and countless articles, from an amateur who has never published a line!" her irritation inspiring her to magnify her own output. On he went with his heated recital of Berenson's imagined perfidy until she was driven to protest she could have nothing further to do with him. "Such stupendous, unfounded conceit," she concluded afterward, "approaches madness. . . . His jealousy of Bernhard has become absolutely pathological . . . and yet we kind of loved him. There is nothing for it but to part just as we shall have to part from the Michaels if they insist upon admiration for their dramas as a condition of friendly intercourse." The break came later in November 1895, and for more than a decade Loeser rejected all overtures for a reconciliation.

The whole dispute seems trival and even rather sordid, but it is significant in revealing the inevitable frictions in a small colony of intellectuals, all of whom were intense individualists afflicted with rootlessness and, like certain of Henry James's figures, given to emotional cannibalism. It has a special significance, moreover, for it cast a long shadow of ambiguity across Berenson's subsequent career. Out of it grew the two factions, the supporters and detractors of Berenson, who would draw substance from those staples of human intercourse, gossip and mutual disparagement. Loeser wrote to Robert Herrick at the University of Chicago a curiously backhanded acknowledgment of Berenson's success: "I more than share your indignation over Berenson's writings. . . . I am at this moment at work on a review of his 'Lotto.' This I want to put forth in the cause of righteousness. . . . The public wants

to be mystified and must have its augur. Berenson is a diabolic success in the role. He is possessed of the vanity that craves the worship of the masses."

Such caviling over pedantic details of connoisseurship came at the very time when Berenson and Mary found themselves gravitating toward a broader and more philosophic approach to art and to the question of the nature of pleasure in art, and it produced a feeling of revulsion in both of them. Berenson wrote to Michael Field that he was "sick unto nausea" of connoisseurship. "At bottom I no longer care a smart farthing who painted anything, and yea the archaeological, morphological, and even historical talk about pictures is like a wicked stench unto my almighty nostrils." The sentiment so matched Mary's own that she copied the entire letter into her journal. She was amused to note, however, that his disgust did have limits. One day in the midst of work on an essay, he exclaimed that "the whole business of the connoisseur" so nauseated him "that he was going out of the trade." When it was suggested, however, that their friend Maud Cruttwell could make use of his discoveries "in that line," he said he wasn't "going out quite so soon as all that."

The break with Loeser proved but one of a number of unsettling worries of the closing year. Word came from Boston that Bernhard's brother had developed tuberculosis and needed to be sent to Colorado. Their father had also fallen ill. Bernhard immediately dispatched funds to tide the family over. Mary recorded, on her side, that she was "under the screw of daily hearing how bad" her children's school was as well as suffering because she could do nothing to prevent their being educated as Roman Catholics. Most unsettling of all, however, was Bernhard's growing realization of Mary's inconstancy. Believing that as two rational persons they could get to the psychological root of her involvement with Obrist, they decided to read together the entire correspondence between her and Obrist, for she had asked him to return her letters. The reading of the letters turned out to be a painful experiment and one of dubious value as therapy. "Reading the last of these horrible letters," Mary wrote in her journal, "has broken me. Bernhard was very, very angry and hated me bitterly for many moments together. There seems to be nothing left to start afresh with—nothing." She was swept with feelings of remorse. "Up to now I hardly could feel that I had done it—I, myself, seemed so different. . . . To be a person who is fickle in soul, to have loved once as I really loved Bernhard and then to waver, . . . so selfish too, not to think of the pain to him and yet he should be my first thought as I know I am always his. When I left BFCC [Frank Costelloe] I thought my love for Bernhard was forever.

It was the only thing that justified my breaking up things and then I wouldn't hold firm, but yielded [with Obrist] to the delight of feelings that sprang up (for it *is* wonderful to be in love). I am glad at least that it has been stopped in time for me not to go all to pieces. And yet if it had been Bernhard, should I have blamed him? Sometimes I think not, for Love in whatever form it comes is a God, even if it destroys all one's so called 'moral nature.' It remakes the world 'nearer to one's heart's desire.' Why should we put faithfulness above it? But I must not think this way. It is my wickedness trying to make excuses for my unkind, miserable conduct."

What had begun to trouble her most, as she had confided earlier to Obrist, was not that she had fallen in love with him—love, after all, to a free spirit was its own glorious vindication, but that she had deceived Bernhard, whom she also loved. She repented the lack of courage that made her fall back into "that detestable woman's way of lying and managing and concealing." Besides, this strange avowal went on, "the bitterest sting of all" was that she had not been strong enough to have kept her love for Obrist. Several months earlier he had assured her that their love would "not die," and then all too soon he had wounded her and love "had died of the wound. . . . Once or twice I had moments of supreme love, even after the second week in Paris. Up to that time it was very, very wonderful. I was old enough to be conscious of each pleasure in it, and I was divinely happy. . . . I'm awfully sorry it was so short. And it left me stunned. . . . Then the bitterness of having deviated from my ideal for so ephemeral a creature as that short-lived love. If it had lasted it would have excused everything." If they should ever love again, she would know that it could not be what she had first hoped, "love which is stronger than death."

The effect upon the somewhat puritanical Berenson of these uninhibited confessions can readily be imagined. He found himself cast unpleasantly in the role of moral arbiter of his companion as well as her tutor in art. Could so emotional and impulsive a creature really be trusted? The doubt would linger and would lend a certain edge to his criticism of her shortcomings, shortcomings that she was almost pathetically eager to admit. If he found fault at times with her behavior, her open-heartedness and her romanticizing, he made up for it in her eyes by his dependence on her and his growing praise for her skill as a connoisseur. It had been balm to her spirit when he told her that she indeed had a future. And in spite of recurring tumult in their relations, she could note that year how "sympathetically our tastes work together," adding "when our minds get to working as well in harness it will be truly delightful all round." But the disturbing ground note could not be

quieted: "At present we tend to fight as in those old days of the writing of the Hampton Court Guide."

Mary's emotional vagaries added still another complexity to Berenson's struggle to free his life from all that was debasing. The quest for beauty and high thinking was growing strangely ambiguous in a world in which social and business morality had slipped their moorings. Nor could he be insensitive to the fact that his own ambition, his vanity, his very aestheticism was drawing him into that tainted current. The turbulent inner conflicts told upon his nerves—and digestion. He was now well on his way to a chronic dyspepsia, which would afflict him most severely on his visits to England, where the pressures upon him were most intense. He became finicking about his diet while his doctors hopefully plied him with their nostrums. The effect on Mary of the incessant tensions took a different course. As Bernhard grew thin and at times wraithlike, she put on flesh, finding surcease at the dinner table, until her opulent figure seemed to tower beside him, foreshadowing the Buddha-like form she ultimately developed, all to an accompaniment of "female troubles," real and imaginary. What his innermost reflections were on the prose to which the poetry of their ardor had subsided one can only guess, for his letters to Senda carefully avoided such depths.

XVIII

Only the Greatest in the World

W HAT helped temper for Berenson the increasing pressures and agitations of their life was the satisfying realization that the world had at last found a use for his singular talents and that he was in fact becoming the man of the world that he had so improbably dreamed of when he first visited Oxford. The projected series of four small volumes on the Italian painters of the Renaissance, with their immensely valuable indexes of artists was now half-completed, and beyond lay the magisterial work on the Italian drawings to which he had committed himself. The powerful new factor in his career was, of course, his renewed friendship with Mrs. Gardner. The number of her acquisitions rapidly increased as with characteristic élan she entered the contests among the growing ranks of collectors of Italian paintings in a competition as fierce as any that the Robber Barons of the time enjoyed in the world of high finance. Her passionate egoism and tyrannical individualism were a curious match to his. Their drives to distinction, hers as collector and his as connoisseur, did not so much complement each other as incite a rivalry of aspirations.

She had quickly realized that in young Berenson she probably had the most knowledgeable connoisseur of Italian Renaissance painting in Europe, one who was acquainted with the contents of nearly every significant public and private collection. The idea of building a gallery or museum to house her growing collection took possession of her imagination as her treasures threatened to overflow her Boston house. By degrees her dream took possession of Berenson and inspired in him the most grandiose visions. That he should be the chief agent in furnishing such a museum, of helping to create a great monument to culture in his beloved Boston, stirred his ambition as nothing else could have done. With her as patroness he would not be hampered by the cautious reser-

vations of the committees who usually tied the hands—and purse—of the director of a public museum. He caught the contagious ardor of Mrs. Gardner's wish to surpass her rivals. It was a breath-taking challenge for a young man of thirty who for years had skirted on the edges of a new Golconda. It was the challenge of what one of his distinguished disciples, John Walker of the National Gallery in Washington, would later called the intoxicating power of "other people's money" in the building of an art collection. With that vista before him, Berenson had written to Mrs. Gardner late in January 1895, "If you permit me to advise you in art matters as you have for a year past it will not be many years before you possess a collection almost unrivaled of masterpieces and masterpieces only. . . . I am already beginning to feel the pride in your collection which I shall be amply entitled to feel when it is in reality what as yet is only in my mind's eye."

In the complicated and often devious negotiations that swirled about important acquisitions, Bernhard and Mary continued to have the skillful assistance of Otto Gutekunst, the young dealer-connoisseur who, with his associate, E. F. Deprez, had joined William McKay as a partner in Colnaghi and Company. That art establishment dated back to 1760; it is mentioned in Thackeray's *Vanity Fair* as a fixture of the London scene. McKay had inherited the business from his father, who had acquired it from his famous cousin, Dominic Colnaghi. The firm name had been retained although the direct descendant, Martin Colnaghi, himself a distinguished connoisseur and collector, had recently joined the Marlborough Gallery. Bernhard could hardly have chosen a more important circle of associates. Gutekunst was no older than he but, according to the firm's historian, he was already "one of the finest judges of pictures ever to take part in the trade" and his "taste was impeccable." As a result he very quickly rose to the directorship of the firm. It was not long before he became an occasional visitor in Florence and cultivated the rising critic and connoisseur who seemed to have a golden touch.

Mrs. Gardner's letters frequently exhorted Berenson to keep a sharp eye out for first-rate things: "only the greatest in the world"—"nothing less need apply," as she put it, and preferably at a bargain price. As a sportswoman she coveted first place for her colors. Her acquisition of the famous *Lucretia* in 1894 placed her among contenders to be reckoned with. The news that Berenson had a new American client, not only rich, but bold and aggressive, a famous maverick in Boston society, quickly became common knowledge among art dealers and their enterprising contacts. Berenson found himself courted more than ever by prospective sellers. "Almost every other day," he told Mrs. Gardner

in December 1895, "I have things suggested or sent to me that are charming and nice," though "no real Filippino," on which she had set her heart, had yet come his way. Ever on the alert for rarities, rumors of which had caught her fancy, she would pass on tips and press Berenson to join the chase. At the moment she also craved that rarest of prizes, a Giorgione, as well as a "great" Velasquez, and Berenson promptly put out feelers on her behalf.

Mrs. Gardner was, of course, no newcomer in the field. With the help of friends like Ralph Curtis, or sometimes acting on an inspired hunch of her own, she had already acquired some twenty contemporary paintings, numerous objects of art, and a dozen representative paintings of the classical schools. But before renewing her friendship with Berenson she had bought only two Italian masters. Her husband, Jack Gardner, had from the start been an indulgent collaborator in her hobbies, but when in 1891 she received the large inheritance from her father, the New York merchant prince David Stewart, the collecting of art became her consuming avocation.

As the tempo of the art market quickened in the mid-nineties, decisions often had to be made quickly, and Mrs. Gardner's mailed acceptances, often scrawled in gold ink on heavy parchment notepaper, sometimes came too late, much to Berenson's embarrassment. He soon persuaded her to use the transatlantic cable. He had, for example, offered her a "delightful golden-tinted portrait" by Tintoretto in August 1895. A month later he was obliged to tell her that the painting had been sold by the time her letter arrived and he was therefore returning her check. Similarly lost to her that autumn was a Bellini which the owner, Berenson's friend J. P. Richter, had decided to put on the market. Another find, a Giottino, offered at the equivalent of only $750, took her fancy, but it too slipped away, for as Berenson cautioned her, "picture owners are absurdly capricious."

One point on which she insisted was that he was never to offer a picture to anyone else at the same time that he proposed it to her. Berenson agreed to her mandate, not foreseeing the problems it would pose. To console her for the loss of the Giottino, he substituted a notable Guardi for the equivalent of $7,800, and on her acceptance he wrote, "Brava! a hundred times brava! I cannot tell you how happy it made me to think of your possessing the most glorious of all Guardis." His almost artless enthusiasms touched a responsive chord in her romantic nature, and his hyperbolic superlatives in letter after letter delighted her as much as the dulcet notes of the chamber music in her Boston salon.

He was sometimes unable to obtain her favorite of the moment and,

unwilling to lose the occasion, would use his most lyrical blandish-
ments to persuade her to accept a substitute. Such a moment arose
when a temporary hitch developed in completing the purchase of the
Guardi. Berenson decided to fill the breach with a fresh proposal.

And now I want to propose to you one of the most precious works of art. It is a
madonna by Giovanni Bellini, painted in his youth after his wife, as I have
every reason to believe. What it is in expression, grouping, and composition,
the photograph I am sending will show you but its color is something un-
equalled even among Bellini's works. It is so clear, fresh, and pure. As for the
condition the panel is in—it is simply perfect. Well, when I proposed Richter's
Bellini last autumn I mentioned this one as the only likely to be on sale in our
days. . . . It belongs to a man of taste and means. . . . I have every reason to
believe that he will part with it for a sum no less than 1350 pounds [$6,750]. It
behooves you therefore to make up your mind. I know few pictures which at
the same time have the prestige and value of a great master's masterpiece at-
taching to them as to this while at the same time having such an intimate and
homely kind of charm. Besides I permit myself to dream of what your collec-
tion shall be and therein a Bellini must have his place. And for a great work by
him or a genuine one at all this is positively the last chance as Mr. Davis has
bought Richter's. I send a photograph of the latter so that you may compare the
two. In closing let me beg you to believe that my interest in all these matters is
just a little more than commercial.

How the Paterian idealist must have winced at the necessity of that
deprecatingly ironic last sentence. A few days later he wrote "in great-
est haste" that the owner had increased his price to £2,500 ($12,500), but
he pleaded that "in my Platonic idea of your gallery a Bellini there must
be and there never will be such another to be had." Mrs. Gardner
balked at the sudden doubling of the price and the deal fell through.
Not until twenty-five years later did she finally acquire a Giovanni
Bellini, the *Madonna and Child,* and that in less than perfect condition.
The price was $50,000. It was obtained for her by Berenson and Walter
E. Fearon at a private sale. Gutekunst managed to smooth over the dis-
satisfaction of the owner of the Guardi, who had counted on a hand-
somer price, and that painting also was safely in hand at the beginning
of 1896.

While waiting for the proofs of *The Florentine Painters,* Berenson set
to work on an article for the *Gazette des Beaux-Arts* describing the Ital-
ian paintings he had viewed in America the year before, the title, "Les
Peintures italiennes de New York et de Boston." It was published in
March of 1896, the French translation arranged for him as usual by
Reinach. The article is of special interest for its opening comment on
the state of the art market. For some years, Berenson declared, collec-

tors had had little interest in Italian painting. As a result public institutions in Europe had been able to acquire masterpieces at a low cost, preserving forever part of the artistic treasure of the world. With two or three celebrated exceptions, wealthy American collectors had also been remiss. Had they entered the market, the most beautiful works of Italian art might have become available to young artists, sparing them the necessity of going abroad to study. He predicted that within twenty years few Italian paintings of the first class would be on the market. Having thus warned American collectors to bestir themselves, he analyzed the Italian holdings of the New York Historical Society and those of the Metropolitan Museum, correcting attributions as he went along. In commenting on a supposed Leonardo in the Marquand collection, which he identified as a Boltraffio, he added a footnote raising a doubt about the recent reattribution of *La Belle Ferronnière* in the Louvre to Leonardo. That doubt haunted him for many years, and he did not finally dismiss it as groundless until 1914. The footnote, however, was not forgotten, and a generation later it arose to plague him in a famous lawsuit over a rival claimant to ownership of the original Leonardo.

Berenson took special pleasure in praising the Italian paintings which Theodore Davis had lent to the Metropolitan: his splendid Moronis, a Tintoretto, and a few others. In Boston, he managed to say that the poverty in Italian paintings of the Museum of Fine Arts was compensated for by its superb Japanese collection, but he could speak far more enthusiastically of the collection of Mrs. Gardner. He declared that it contained works of Italian masters which all European collections might envy, singling out of course the Botticelli as well as the three other paintings which he had procured for her: the Bonifazio Veronese, the Peruzzi panels, and the Catena. He remarked also the merits of the Italian paintings in the collections of Quincy Shaw, Charles Eliot Norton, and Denman Ross, identifying in scholarly detail the provenance, history, and stylistic characteristics of the significant canvases. The favorable comment on the collections of his American friends and patrons must have pleased them, giving as it did international recognition in the leading French art journal to their collections, and it was well calculated to encourage them to continue their acquisitions.

All was not business in the many letters that had begun to pass between Berenson and Mrs. Gardner. She was now avidly interested in his writings on art, for they bore intimately on her new and terrifyingly expensive hobby. Since his little book on the Venetian painters promised to become a vade mecum, he could now feel that her one-time faith in his genius had been restored, and he soon put himself on the old

footing of teacher and disciple. In his letters to her, he united practical matters with outbursts of purple prose inspired by fresh encounters with beauty in art and nature. For example, in one of his letters in the autumn of 1895, after disposing of the inevitable matters of business, he hastened to tell her that he "found his resonances to beauty increasing at a rate to make up for everything," and on another occasion he depicted the view from his aerie on the Fiesole hillside: "I now see flashing flecks of silver rising over the rim of opaline mists which cover the base of the Apennines but at the same time the medlar is in intoxicating bloom just outside my window." Later, in winter, when Mrs. Gardner faced the gloom and cold of Boston, he wrote, "I would, dear friend, that I could despatch this golden weather I am basking in. . . . It is more than sunny here, the mildness of changeless spring, the sweet odors of the happy island, the radiance of the summer land is here this winter. I spend all the afternoon wandering about 'an embodied joy.' "

The romantic mixture of art and nature stirred her susceptible nature. His letter had also tempted her with a Rembrandt and a Tintoretto. She responded with characteristic zest, "The photos and the delightful letter came last night. The latter by the way made me quite frantic to fly to Fiesole and drink in the air and perhaps saunter with you in the sunny afternoons. About the Bellini, the money bothers. Perhaps I can be able. I am bitten by the Rembrandt and today being Sunday I will cable 'Yes Rembrandt, Yes Tintoretto.' What do you think of that. . . . All of which means that I shall sell my clothes . . . and be very prodigal with my pictures with even my ears covered with debts and you must come over and see it all. Hastily and enthusiastically, Isabella." Shortly afterward, Berenson cabled that the Rembrandt *Self-Portrait* was hers at $22,000 and the Tintoretto *Venetian Senator* at $2,500. A generation later, Philip Hendy professed to see only the "influence" of Tintoretto in the bargain painting; however, Berenson in his 1957 revision of "The Venetian School" continued to maintain the attribution to Tintoretto.

The proposals began to come at a faster pace as Mrs. Gardner's relish for the new sport of American millionaires grew with each success, and Berenson quickly learned to cater to her inordinate desires and her vanity. Knowing that she liked to identify herself with the famous Isabellas of history, he proposed a portrait generally considered to be that of Isabella d'Este, the noted bluestocking of the Renaissance. It had been recently sold in Milan as a Titian, though obviously not by him; it was then thought to be by Polidoro Lanzani. Berenson cautiously noted that it was not in itself a great picture but suggested it would be suitable for "decorating a wall." Of course, Mrs. Gardner was delighted to have the noble lady with the skeptical glance for her collection. The price of

$2,500 was not formidable. In the review of her paintings after her death, Philip Hendy doubted the attribution and in 1974 gave the painting to Francesco Torbido with the simple title *A Lady in a Turban.*

Early in the spring of 1896 there came to Berenson's ears the rumor that Gainsborough's celebrated *Blue Boy* and Reynolds' *Lady Siddons as Tragic Muse* might come on the market, and he warned Mrs. Gardner that "a bait of less than $100,000 for each will be out of the question. All my subterranean efforts have thus far not succeeded in setting a definite price." He urged her to "borrow, to do anything" to get the *Blue Boy,* though it would still "require cunning angling to bring that beauty to land." The temptation to own the most famous of all Gainsboroughs proved irresistible and Mrs. Gardner instructed him to go as high as $150,000 if necessary. By post she added facetiously, "Now you see me steeped in debt—perhaps in crime—as a result. . . . I shall have to starve and go naked for the rest of my life and probably [die] in a debtor's prison." Both her husband and her financial advisers were now doing their best to restrain her extravagance with the most dire warnings.

In the meantime, eager to add a Titian to her collection, she had put Berenson on the track of a reputed Titian, hitherto unknown, which was being offered by its owner in the town of Forli, near Ravenna. It was said to be a painting of Maria Theresa of Austria. It had already been angled for by the Louvre and the Museum of Fine Arts. At first doubtful of the attribution of the unrecorded painting, Berenson after twice viewing it agreed that it was a very fine Titian indeed and thought £7,500 would fetch it, though £10,000 was now being asked for it. Then, apparently realizing he had been overoptimistic, he decided to put in a bid for £8,000. Thus began for Berenson one of the most exasperating negotiations he had yet tackled and one to be quickly matched by another as Mrs. Gardner repeatedly urged him on. The wily owner, the Marquis Fabrizio Paulucci de'Calboli of Forli, on one pretext and another increased his demands until in June of the following year (1897) Mrs. Gardner was forced to pay £16,000 ($78,000) for her prize. In the end it turned out that Berenson's initial skepticism was justified. The picture is now attributed to the Spaniard Sánchez Coello and the sitter identified as Juana of Austria.

Far more excitement, however, was now in store for both principal and agent. It began ironically enough in Berenson's too timid estimate of Mrs. Gardner's resources. He had learned through Gutekunst that the Earl of Darnley was ready to part with one of the most celebrated of all Titians, *The Rape of Europa,* a painting in an almost perfect state of preservation. The asking price was $100,000. Berenson decided to

offer it to Mrs. Samuel D. Warren, Edward Warren's sister-in-law and wife of a prominent member of the Museum of Fine Arts, only to learn shortly afterward that the *Blue Boy,* which he had urged on Mrs. Gardner, had been withdrawn by its owner, who had simply wanted to sound the market. Berenson now found himself in an awkward position, for it was inevitable that Mrs. Gardner would learn of the *Europa* and clamor for it. In his letter of May 10, 1896, in which he reported that the *Blue Boy* was lost to her, he told her he had a "frightful confession" to make on "bended knee." He had offered the *Europa* to Mrs. Warren because, having committed Mrs. Gardner to an outlay of £38,000 (nearly $200,000) for the Forlì "Titian" and the *Blue Boy,* he felt she would not be likely to spend another $100,000 for the *Europa,* and he had been anxious, he said, that it should not be lost to Boston.

He wanted very much to console her, he continued, for the loss of the *Blue Boy,* of which he had felt so sure. It was true, he acknowledged, that "no picture in the world has a more resplendent history" than Titian's *Europa.* Since Mrs. Warren had not yet acted on his offer, there was still time for Mrs. Gardner to triumph over her Boston rival. He felt that the changed circumstances should excuse him for disobeying her injunction always to give her first choice. If she cabled her acceptance and it came "in a bona fide way before Mrs. Warren's," the painting could be hers. He naturally begged her not to speak of the painting "until she reaches you so as to spare me with Mrs. Warren." He wrote that since she could not have the *Blue Boy,* "I am dying to have you get the 'Europa,' " since it is a "far greater picture than 'The Blue Boy.' " As the picture had at one time been owned by the Stuart king Charles I, he added the flattering comment that "it would be poetic justice that a picture once intended for a Stewart should last rest in the hand of a Stewart."

Mrs. Gardner hardly needed any urging. She promptly dispatched the cable of acceptance. Fortunately, Mrs. Warren had decided not to bid. Armed with the acceptance, Berenson proceeded to London and now pressed for a more realistic price. The final figure reached through the Colnaghi firm was $100,000, and as Gerald Reitlinger remarks in *The Economics of Taste,* it opened the way to a new scale of values for Italian Renaissance paintings. What gave a special fillip of pleasure to the transaction was that Dr. Bode had counted on acquiring the *Europa* for the Berlin Museum and he was reportedly furious at being outbid by American extravagance.

In spite of her success with the *Europa,* Mrs. Gardner still yearned for the Forlì "Titian." "My heart," she said, "has an unaccountably soft spot for it." Berenson was hard put to allay her impatience, and he tried

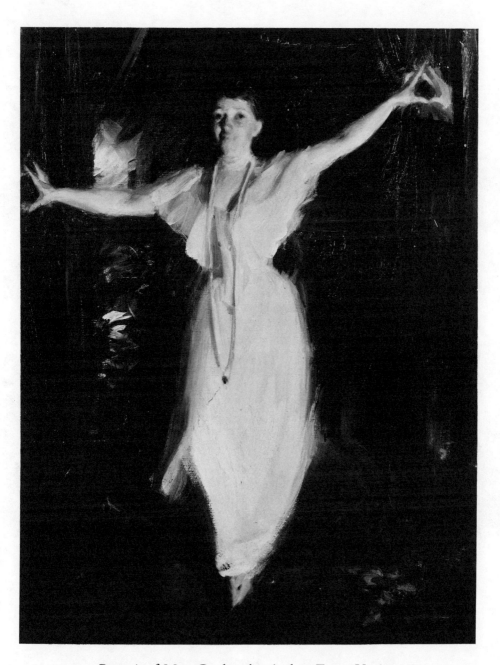

20. Portrait of Mrs. Gardner by Anders Zorn, Venice, 1894

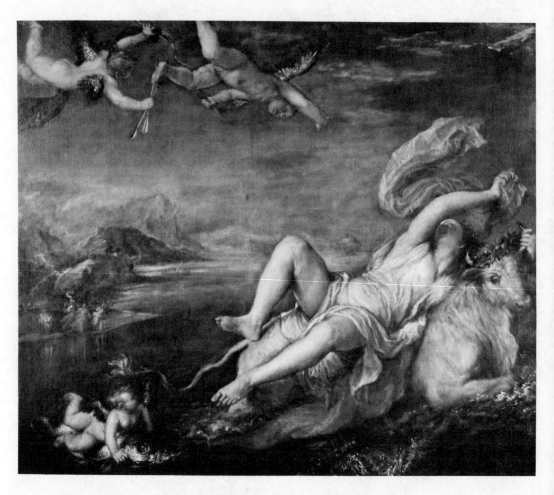

21. Titian's Rape of Europa

to beguile her with the offer of "one of the greatest and most renowned works of art," Rubens' *Earl of Arundel,* which had been acquired by Colnaghi. The price was a staggering £24,000. For the moment she resisted Berenson's advocacy, and it was not until two years later (1898) that she yielded to temptation and took the painting, the price having been reduced to £20,000.

Berenson found it difficult to take Mrs. Gardner's recurring pleas of imminent poverty seriously, for she was always eager to learn of new treasures, and if one caught her fancy the money for it was always somehow found. Within a few months of the *Europa* purchase, he invited her to bid on another Rembrandt from Lord Carlisle's collection, for which £10,000 was being asked. At first she replied that she hadn't a cent and that her husband, "who has a New England conscience[,] won't let me borrow anymore." But she added, after looking at the photograph of it, "I do want it so much," and concluded, "Try to steal that Rembrandt for me." The painting did not prove "stealable," and so Berenson threw out feelers for a great Velasquez. She had urged him, "Let us aim awfully high. If you don't aim you can't get there."

To meet her formidable challenges Berenson had to turn increasingly to Otto Gutekunst, who saw in Mrs. Gardner one of the most profitable of the firm's clients. Berenson became an invaluable ally in the firm's affairs because his incessant study of private as well as public collections all over Europe enabled him to keep the firm posted on possible acquisitions for their clients. In the course of seven years, until Mrs. Gardner forbade Berenson to make further purchases through the firm, it supplied her with some twenty major paintings, beginning with the impressive *Lucretia,* the array representing an investment of nearly three-quarters of a million dollars. During this period of rapid acquisitions Berenson also made use of other intermediaries for her and sometimes dealt directly with the owners of the works of art, as in the case of Richter. To a far lesser degree, she carried on her campaign, especially for modern art, through other advisers or tackled dealers herself, as when she picked up a Moroni in Rome in 1895 and a handsome portrait of Isabella of Austria by Frans Pourbus in Paris from the Durand-Ruel firm in 1897, successes which she proudly reported to Berenson.

In the summer of 1896, while he was wrestling with the final details for the transfer of the *Europa,* he learned of the possibility of another spectacular coup for Mrs. Gardner. Captain Holford was reported to be inviting bids for a superb portrait of Philip IV by Velasquez. Mrs. Gardner rose at once to the challenge. But much to Berenson's chagrin Holford refused to sell even when offered $100,000. Later that year, to appease her hunger for a Velasquez, Berenson informed her that he had

located an "unquestionably grander and profounder" Velasquez portrait of the much-portrayed King Philip. It was owned by Colnaghi, having been purchased from the Bankes collection at Kingston Lacy in Dorset. Berenson had in fact known of this portrait for some time. He had written to Mary in January while she was still on her annual holiday visit to England urging her to inspect it at Colnaghi's. "I am very anxious that you should see it," he wrote, "as I do not like to deal in such big game without autopsy . . . I should not ask you to do this if I did not believe you as competent as any living person to have an opinion." Mary's report evidently discouraged him, and it was not until he saw the painting himself that he concluded it would serve as a substitute. Mrs. Gardner now eagerly wrote to Bernhard, "Yes on the Velasquez . . . only do be a dear and get it cheaper if you can. I am so poor. I am selling little by little my stocks." In spite of the plea of poverty, she quickly raised the necessary $75,000.

What turned out to be his most vexatious assignment for Mrs. Gardner began a little gingerly late in September 1896. She had just heard that one of the greatest rarities of Italian painting, a Giorgione, was said to be for sale, the so-called Loschi Giorgione, a small panel which graphically depicted Christ bearing the cross. It was owned by the Zileri family of the Bourbon nobility and adorned a wall in their imposing Palazzo Loschi in Vicenza. It was a prize that Mrs. Gardner could not resist, especially since the Museum of Fine Arts also seemed to be angling for it. Rather too confidently, Berenson assured her, "So you want the Loschi Giorgione. Well you shall have it, if it is to be had—which I do not know—and if the Boston Museum does not take it." He cautioned her that General Charles G. Loring, director of the museum, had already invited him to negotiate for it and had asked him what he thought it was worth. He had set its value at £4,000.

Mrs. Gardner replied that she did not want to take it away from the Museum of Fine Arts, but she thought that "they might in the end lack the courage to get it and lose by delay." Rather than have that happen, she wanted Berenson to get it for her. "So please do." At the same time she challenged him to still another quest, "a dream I have to possess the Giovanelli Giorgione," which was reputedly owned by "very disagreeable people" and was shut up in a palace in Venice. It would need "oh such tact, such diplomacy, such cleverness. So you see I put it in your hands. What do you say?" He agreed that that was just the picture for her, but when the Giovanellis categorically refused to sell, he promised to resume the pursuit of the Loschi Giorgione.

Berenson thought the picture genuine, and though he conceded that he did "adore it," he did not believe it was quite "the kind of thing I

think of for you. It is sublime illustration rather than a great work of art." Mrs. Gardner was not to be deterred and his reservations only seemed to whet her appetite. The arrival of the *Europa* in Boston had created a gratifying sensation as she reported in a "life-enhancing" letter to Berenson; many had come to scoff, she said, "but all wallowed at her feet." The prospect of further *coups de théâtre* spurred her on to invite more great trophies for the walls of her future museum. She reported with delight that Edward Hooper, treasurer of Harvard and brother-in-law of Henry Adams, had once remarked to her that she was "the Boston end of the Arabian Nights," and that now he had added, "I told you so."

Soon she became alarmed when rumors circulated that the Loschi had been sold to the Louvre. Reinach, who was on the Louvre committee, assured Berenson that the rumor was unfounded. Still, Berenson could report no progress to his impatient client because it was not until February of the following year that the Museum of Fine Arts withdrew its offer and released him. Until then, he explained, he was "honor bound not to act." Returning to the attack, he now reported that he might get the picture for less than £4,000. However, because of its condition it would need to be cleaned by Cavenaghi in Milan, a step that would add to the difficulties of getting it out of Italy.

Early in May he sent welcome word that the sale had been concluded and that he would try to "ship as soon as may be," though he thought it would be better to pack it in her trunk when she came to Venice. She promptly sent him a check for £4,000. Two weeks later a much-chagrined Berenson wrote that "the absurdest difficulties" had arisen about the Giorgione, and "it still may escape." The Zileris were now insisting that a good copy would have to be made for £100 and that Berenson should assume "all penal consequences" if the government disapproved of the exportation. They of course would be in the clear since they would be selling the picture to him as an Italian resident. The situation might "be very nasty for him," but he stood ready to carry on. He would give the painting to a friend in Venice to have the copy made and then "pass it on to you. . . . It would be much easier for you in your vast trunks to get the picture out of Italy without risk of discovery than for me in a modest—a man's trunk is always modest—box. Furthermore that would get over the legal difficulties if such arose. For I could say that you were the real buyer, and that I delivered the picture to you in Italy. And for you they could whistle."

Then a new complication arose, and Berenson again dangled. The family decided to divide the estate, giving the option to sell the painting to the one who got it. As a result Berenson interrupted his travels to

call on the family in Vicenza and there heard a tale of "timidity, stupidity, and cupidity most laughable." It developed that the old count had originally willed the painting to the town and then revoked the legacy and left it to his family. Since this later information had not been passed on to the townspeople by the authorities, they still expected the painting and were angry that it had not been delivered. The young count, who had been chosen mayor of the town, had incurred more hostility, as Berenson dramatically narrated, by persuading the council to cancel the highly popular annual festival which commemorated "the heroic defense of the town against the Austrians" and to substitute a solemn commemorative mass, for the reason that the Zileris were in mourning for the old count. The outraged progessives and anticlericals took to the streets, and "the Palazzo Loschi had for a whole hour and a half a mob before it, smashing windows, hooting, and generally expressing noble sentiments of righteous indignation. Naturally this scared the poor Zileris."

The family finally agreed, after four hours' talk, to sell the picture in November, when the hue and cry would have died down, provided that "an exact and good copy" be made, presumably to allay the suspicions of the townspeople. November came and went and in December Berenson wrote that "the cat is out of the bag"; the will was being disputed in a lawsuit. Hence a new condition was proposed, that if the family were required to surrender the original painting to the town, it must be returned to them at the price paid by Mrs. Gardner.

Her patience was already on a short leash and Berenson hastened to explain that "the Zileris are honorable and gentlemen. They will not sell to anyone else. . . . The Giorgione now is yours if you are willing to accept the condition and willing to have me smuggle it out of the country, as pictures invariably are." On January 9, 1898, he was finally able to write, "I cabled to you yesterday that the *Giorgione* was safely exported. I entrusted it swaddled up like a baby in a blanket to some friends of mine. They took it to London."

The price as finally settled on soared to £6,000. How that figure was arrived at was still another chapter in the protracted negotiations, which Berenson carried on single-handedly. The painting had been assigned to the young Count Zileri dal Verme. Berenson learned that the debt-ridden count had tried to get a new loan with the painting as security. The bankers refused. Berenson offered to pay him the amount of the rejected loan, namely, £6,000, an offer which he promptly accepted. The copy was made and the lawsuit dropped into limbo.

There was, as one can readily appreciate, considerable justice in Berenson's remark to Mrs. Gardner during the course of the negotia-

tions that he had been "eating a thousand times more humble pie than is good for me." And for one as sensitive as he, the humble pie exacerbated the actual indigestion that had begun to afflict him. His doctor urged him to vacation in the mountains of the Engadine.

It was soon learned that the painting had been smuggled out of Italy, and a few carabinieri showed up, severe of looks and notebooks in hand, to query Berenson about the matter. As he was out Mary dealt with them. This is how she recalled the interview years later in a passage in her diary:

> "A Giorgione," I said. "What did it represent?"
> "I think it was a Christ," said the spokesman.
> "A Christ," I said, "Was it a piece of sculpture or what?
> After fumbling in their memories they said they thought it was a bronze.

Mary assured them that Bernhard had never heard of a bronze Giorgione being exported to England and gave them a sort of affidavit to that effect. Whereupon they left. But a moment later one of them put his head in the door and said, "Signora, I know of several bronze Christs for sale. Would you care to have me bring them up for you to see?" As Mary indulgently recalled the affair, Bernhard "had nothing to do with the actual sale or exportation" of the painting.

The flight of important works of art out of private hands in Italy into the insatiable world market seems not to have been greatly slowed by restrictive exportation laws. Neither seller nor buyer respected the law except in the breach thereof; the one resented the possible loss of a highly profitable sale, the other the officious interference with his collector's passion. Outright smuggling could sometimes be avoided by a ruse, as Richter had merrily recounted to Bernhard and Carlo Placci not long before. He had sold a reputed Giorgione and decided to get a *permesso* for legal exportation. The art historian Adolfo Venturi, evidently acting as an official adviser, came around and asked, "What is it?" Richter replied, " 'It is difficult to say.' So he passed it by and said, 'This portrait belongs in the Venetian School.' " When it came before the Florentine inspector, all that was said was: "It is a woman and a man." Richter then declared its value as 20,000 francs, "hardly daring to say so low a price" for what he knew to be so great a rarity. "The man laughed and said he needn't pay more than 200 francs for taking it out of Italy." Later the inspector told their friend Enrico Costa "as a joke that this 'puzzo Tedesco' [stinking German]" had valued an absurd picture at 20,000 francs. "Then Costa told him what it was and he was sick! Venturi, who was then preparing the catalogue of the national collections of Italy, heard of it and pitched into him for not keeping it

over for three months," the period allowed by law for investigation. He defended himself by saying it was addressed to a restorer in Berlin and hence was in bad condition. "The restorer was a blind for the Berlin museum."

The contest between the authorities and the owners of desirable paintings who were eager to profit from the inflated prices in the world market became a seriocomic game that taxed the wits of their intermediaries, but not their consciences. As Mary explained to her daughter Karin a few years later, "I don't consider this [illegal exportation] wrong because here in Italy the pictures are apt to go to ruin from carelessness." Passing off a damaged painting as of little worth was but one of the ways of getting it past a provincial inspector. A more common method, Mary told Karin, was to pack a "worthless daub of the same size" in a large box. "The Inspector looks at it and of course says they can do what they like with rubbish like that." The *permesso* is issued and the box is sealed and marked for export. "But all the time the box is cunningly made to open where he could never think of putting a seal. It is carried home, opened in secret and the good picture substituted." The inspector knows that it is "hopeless to enforce the law . . . so for the dealers with whom he is good friends, i.e., who bribe him, he doesn't look too carefully into how the boxes are made." In one notable instance in 1899 Bernhard and Mary devised a simpler expedient to ship a valuable painting to Colnaghi in London, a painting which soon afterward was sold to Mrs. Gardner. They had a large trunk made with a false bottom to contain the painting, and to account for the unusual size of the trunk they packed it with a lot of cheap dolls. A friendly Florence art dealer, Signor Gagliardi, posing as a commercial traveler, delivered the precious panel to Colnaghi.

The path to the acquisition of this painting had been a singularly complicated one that led to the haunt of one of the most famous forgers of the day, Federico Joni. Despite all their expertise Bernhard and Mary had been taken in by various unscrupulous dealers in at least half a dozen instances, as Mary calculated in October 1899, to the tune of nearly $3,500. One of the most embarrassing acquisitions was a beautiful copy of Pinturicchio's fresco of a kneeling knight purportedly executed by Benevenuto di Giovanni, a fifteenth-century Sienese painter. Berenson's loving description of it elicited Mrs. Gardner's agreement to buy it. But, in Mary's words, "awful doubts" assailed them because their agent was bringing "*too many* B. di Giovannis." They took it to Cavenaghi, their expert restorer in Milan, who recognized it as a forgery and put them on the track of the forgers, Joni and his associates.

It happened that Joni also dealt in original paintings. Mary got wind

of one of them and set out with Roger Fry and his wife to see it. They made their way to an out-of-the-way rural farmhouse and were greeted by "a rollicking band of young men, cousins and friends" who ran the workshop. Mary, perceiving that the alleged original which they were shown was a fake, said she would prefer "a genuine Joni to this picture. At this they laughed and nothing more was said." When Fry mentioned that the National Gallery had recently bought a forged Perugino, they laughed and dug him in the ribs, thinking that Fry had sold the forgery himself. They showed the chagrined connoisseurs photographs of nearly all of their admired masterpieces waiting to be re-created. There was a careful division of labor; one man drew, a second laid on the colors, a third put on the patina of dirt, and a fourth made the frames.

Mary did not give up, feeling sure the original did exist. She returned and was at last shown *"The* picture," which was hidden away in order to have the cracks mended. "It is a perfect beauty," she told her children, "one of the very best pictures painted in the fifteenth century and worth a very, very great deal." She got it, she said, *"just* in time to save it, for the panel on which it was painted had cracked right down the Madonna's face and figure, and the paint was all but falling off. The dear beautiful nose and one eye were nothing but a huge blister of paint and to bring it here strips of fine muslin had to be pasted over it in a dozen places. . . . Now it will probably go into one of the big city mueseums and be well taken care of and delight hundreds and thousands of people." It was "so beautiful and so unusual it ought to bring great profits to us all."

Because of its cost, Berenson had only a fifth interest in the painting; the remainder was presumably owned by Gutekunst and his associates. It was offered to Mrs. Gardner for £6,000 net, since, as Berenson explained, he had a part interest in it and was therefore not entitled to his usual commission. An *Annunciation* originally attributed to Fiorenzo di Lorenzo, it was subsequently assigned to Antoniazzo Romano by Philip Hendy in his Catalogue of the Gardner Museum (Berenson having conceded, "May turn out to be Antoniazzo in a Verocchiesque moment"), and then in Hendy's revision, to the Master of the Gardner Annunciation. Berenson had first seen the painting in a chapel in Assisi. Withdrawn soon afterward by the monastery that claimed it as part of its inheritance, it had disappeared from view for seven years. Whether Joni sold it on behalf of the monastery or was himself the owner does not appear. The panel, as Hendy described it, had "two long vertical cracks, that on the right defacing the Madonna's temple and nose."

[253]

XIX

The Critical Gantlet

IF the fervid and urgent tone of Berenson's correspondence with
Mrs. Gardner conveys the impression that her collection was the
chief concern of his life, it was really more a reflection of his skillful
advocacy than of the facts of the case. The temptation to magnify the
difficulties that beset him as her devoted agent could not easily be re-
sisted. That there were difficulties aplenty was true enough, but they ob-
viously grew in the dramatic retelling. Mrs. Gardner's affairs, it is true,
had begun to loom large on the mental horizon of Bernhard and Mary
and bore directly on their style of life, and there is a heartfelt sincerity
in Berenson's letter to Mrs. Gardner in June of 1896, when he was
languishing in London with one of his perennial attacks of dyspepsia, in
which he thanked her for her "most bountiful cheque" and wished he
were well enough "to rejoice over the riches you shower upon me."
But in actuality Mary's and Bernhard's involvement as professional ex-
perts, whether with Mrs. Gardner, Theodore Davis, or with several
others, formed only the background of their intense preoccupation with
their research and writing and their strenuous pursuit of culture, and
took up only a small part of their time.

No sooner were the proofs of *The Florentine Painters* out of the way
in November 1895 than Berenson began "slaving" over an iconoclastic
article for the *Gazette des Beaux-Arts* whose thesis was that the most
famous Perugino in the world, the Caen *Spozalizio,* which Raphael was
reputed to have copied, was not by Perugino at all but was the work of
Lo Spagna, and he felt "wickedly amused at the havoc this will make
among the learned." The article duly appeared in translation in the
Gazette des Beaux-Arts (April 1896) and was afterward published in the
original English in 1902 in his volume *The Study and Criticism of Italian
Art,* Second Series, substantially without change. It began as his "dis-

coveries" often did by telling how at first sight of the painting he was half-persuaded to accept what previous authority enjoined upon him. Then on closer examination there came to him the realization that the painting was strangely out of character for Perugino. What followed was a lawyerlike brief that justified his intuition by comparisons of color, drawing, and handling of telltale "Morellian" details of hands and ears that pointed to Lo Spagna as the painter. But like a courtroom advocate, Berenson moved somewhat too confidently from surmise to conjecture to final triumphant conviction, swept along by the sheer excitement of his argument. His dethroning of a widely accepted Perugino naturally provoked critical protests, and though Reinach urged him to reply he silently stood his ground. Long afterward, in his revised indexes of artists, he assigned the painting to Lo Spagna, but added parenthetically "(with Perugino)," the certainties of "science" having yielded a little, as was to be the case in many other instances, to the prudent reservations of the sense of quality.

In the intellectual hothouse atmosphere of Fiesole, writing was something of a communal affair, an uneasy mixture of mutual admiration and depreciation, a sharing of ideas and a jealous proprietorship in them. It was all very high-minded and disinterested, but egos remained touchy and the sense of rivalry seethed beneath the surface. When Berenson lent Vernon Lee the proofsheets of *The Florentine Painters,* she graciously condescended to offer a critique—and advice. Bernhard and Mary went down to Il Palmerino to dine and listen. "She posed," said Mary, "as a priestess of Isis, and would not lift the veil—*her* 'secret of aesthetics'—but we shrewdly suspected that there was nothing there. It turned out that she did not distinguish *movement* from *motion,* and by form meant nothing but shape. In fact, I grieve to say, she was really rather stupid though very charming and polite." Hence the evening "was 'stale and unprofitable' and we didn't get a single helpful idea from it."

Vernon Lee, as it turned out, was putting her own book *Renaissance Fancies and Studies* through the press. It was published in mid-February 1896, just a week before Berenson's *The Florentine Painters.* In the preface she insisted that the essays were "mainly the outcome of direct personal impressions," with little reliance on books "treating of the same subject." But she did acknowledge that she was "deeply indebted to the conversation and advice of certain among my friends," giving her "best thanks to the English archaeologist Eugénie Sellers and to Bernhard Berenson" and "particularly to my friend Mrs. Mary Logan, whose learned catalogue of the Italian paintings at Hampton Court is sufficient warrant for the correctness of my art-historical statements, which she

has had the kindness to revise." In her remarkably allusive and grace-fully written pages Vernon Lee adventured through her aesthetic im-pressions of the beauty and themes of Renaissance art. Her deprecatory attitude toward scientific connoisseurship must have exasperated Beren-son, as when in a footnote she observed, "I learn from the learned that the Florence and Louvre Madonnas, with the roses, are not Botticelli's; but Botticelli, I am sure, would not have been offended by those lovely bushes being attributed to him."

Having had such early access to Berenson's new book, Vernon Lee volunteered to review it for *Mind* because, as she informed her readers, though the book was intended for art lovers and students, "its great and original suggestiveness is fully appreciable only by professed psycholo-gists," even though it showed no "traces of psychological training." Nevertheless, "that lack enhances rather than diminishes the interest of his work in the eyes of psychologists" because its theories coincide with "recent psychological discoveries and hypotheses." It was an attempt by "an already distinguished connoisseur and art historian to make others share the aesthetic emotion of which he is himself aware." Ver-non Lee admitted that her conclusions did not tally with Berenson's "either as whole or parts" since his hypothesis was "complicated un-necessarily and even contradictorily with notions of self-conscious *Wille zur Macht* [Will to Power]." Besides, he was guilty of "deliberate ne-glect of so important an item in aesthetics as mere 'Beauty.' " She sof-tened the sting of her criticism, however, in her summing-up: "But . . . no person with the habit of aesthetic introspection can deny that Mr. Berenson has at last applied to artistic phenomena the only method which can lead us to differentiate and study them as an important branch of psychic life. . . . How significant the empirical study of aes-thetics can be Mr. Berenson has already shown with an acumen and a philosophical imagination which promise great achievements therein on his own part." The patronizing mixture of blame and praise was quite what Berenson might have expected from his severest critic, but that it rankled deeply and challenged an equally ambiguous retort would soon become apparent when their famous quarrel erupted in the following year.

Salomon Reinach in Paris seemed provokingly obtuse about "tactile values," obliging Berenson to lecture him earnestly that "my formula is that artistic form skims off the material significance of things, present-ing them to us in such a way that we must attend to them as form, and not as in actuality as so many objects appealing at haphazard to one of a million needs." In a painting "the retinal adjustments are reduced to the fewest possible, fewer than in actuality, of course. In a painted panora-

ma [which Reinach had suggested as not amenable to Berenson's theory] there are more than in actuality." The onlooker is given the "liberty to wander about aimlessly instead of being chained by the composition," and he is fatigued by the mixture of "real with fictitious dimensions." A panorama, therefore, lacked artistic form.

Thomas Sergeant Perry, who had so warmly welcomed Berenson's first book, acknowledged his presentation copy with a vigorous dissenting opinion. "I scoff at tactile values," he wrote. "What have they to do with Monet's best cathedrals?" He gave amiable notice that when he came to Fiesole to continue the discussion, "Look out for my snickersnee." He presently did show up with his wife at the Villa Kraus, but so far as Mary's diary indicates his snickersnee remained sheathed and he spent the time telling of his visits to Mrs. Piper, the famed Boston medium who was mystifying Proper Bostonians as well as psychologist William James. Still another heretic was their friend Israel Zangwill, who, as Mary diligently reported, "had gone back on his belief in thy theories, and was convinced that tactile values had nothing to do with art." Her latent distaste for the earnest Zionist broke out in the exclamation, "How thee can endure such obstinate slovenliness of thought I cannot conceive! At the table he ate tomatoes with the butter knife and the jam spoon."

The Nation's review of The Florentine Painters was assigned to the unsympathetic Kenyon Cox. In his omnibus review in mid–March 1896 of six books on art, which also included Vernon Lee's Renaissance Fancies, Cox remarked with a certain obtuseness that "Mr. Berenson is nothing if not modern . . . and his 'tactile values' are little else than our old friends significant drawing and sense of form." He did acknowledge that the extensive topographical index was "useful and welcome." As if to underscore his disapproval, he wrote of Berenson's rival Vernon Lee that though she was an "amiable dilettante" there was "Much charming writing in the volume and some keen-sighted analyses."

Mary, ever the loyal advocate, had rushed off a laudatory review to La Chronique des Arts et de la Curiosité as soon as the book appeared, her article being aimed at the European reader. She followed this with an anonymous review essay in the June 1896 Atlantic Monthly entitled "The Philosophy of Enjoyment of Art," in which for the literate American reader she argued that Mr. Berenson had with his theory of "tactile values" provided an answer to the question "How and what shall I enjoy in order to get the utmost pleasure from pictures?" A few months later in the English Studio, over the pen name of Mary Logan, she rehearsed in somewhat similar fashion Bernhard's analysis of "how great art is appreciated." Two other books covered by her review came off badly

by contrast "with the close-packed and original work of Mr. Berenson."

Berenson's friend Richter noticed the book in the *Kunstchronik*, describing it as most valuable and meritorious, but acknowledging that its chief merit lay in the topographical index. He avoided any discussion of "tactile values." The London *Spectator* admitted that the book was, as "one might expect from its author, full of knowledge and acute reasoning," but the reviewer drew the line at "the curious outburst of reasoning" called forth by "tactile values." Berenson was much more fortunate in the magisterial article in the October issue of the London *Quarterly,* in which the reviewer devoted twenty-five pages to a highly sympathetic discussion not only of *The Florentine Painters* but of Berenson's preceding two volumes and, in passing, bestowed a word of praise on Mary Logan's *Guide to the Italian Pictures at Hampton Court.* Though the reviewer, Mrs. Ady, gave an appreciative summary of each of the volumes, she made only a passing reference to Berenson's theory of "tactile values." She saw in him "the most daring of Morelli's followers." The "apparent affectation" of his style struck her as "often repellent," but she had nothing but the highest praise for "the acuteness of his insight, the zeal and enthusiasm with which he pursues his researches," qualities which had "already placed this young writer in the foremost ranks of living critics." It must also have pleased Berenson that his former teacher William James reviewed the book in *Science* as "the first attempt" to apply "elementary psychological categories to the interpretation of higher works of art." James thought the essay "charmingly written," but he cautiously added that whether Berenson's terms helped to uncover "the secrets of art-magic" better than the more familiar ones "may be left an open question."

Like *The Venetian Painters,* the book had, in fact, caught on. One of his sister's colleagues at Smith College adopted it as a text in her art class. That summer when Mary revisited some of the German galleries with Bernhard she noticed with pride that young people were carrying copies of Bernhard's books. Some critics might cavil at his brash theories, but he could not be ignored, and their reservations were not to deter increasing numbers of art lovers during the coming years from eagerly testing their responses to tactile values and their sense of life-enhancement. The book plainly marked an epoch. Toward the end of 1896, as he worked away at the third volume in the projected series on Italian Renaissance Painters, *The Central Italian Painters,* Berenson looked back at *The Florentine Painters* as in a sense the capstone of his studies. He felt the new book would scarcely equal his Florentines. "I never felt so secure of myself," he told Senda, "as when writing it and I

knew it would succeed and it has." He wondered whether he would ever surpass that book.

The Central Italian Painters was to be a small book like its predecessors, and once begun the writing went rapidly. However, the parallel project, the drawings of the Florentine painters, which Berenson had assumed with such ready optimism, was to prove a far more formidable undertaking. He had told Mrs. Gardner that it was to be a work of "grand luxe" with 160 illustrations and was to be ready by Christmas of the following year. He had no premonition that it would obsess him for nearly seven years and that the endless research for it would drive him nearly to distraction.

With the scheme of *The Central Italian Painters* taking shape in his mind, Berenson had set off early in May to renew his researches, traveling with Mary to Empoli, Siena, Orvieto, Rome, and Naples. They were accompanied by Costa, who for a time had been weaned away from them by Loeser's malice. The urge to enter the booming picture market, like other connoisseur-collectors, seems to have touched Costa, for he now asked Berenson to help him sell some of his pictures. Another member of the party was the temperamental and beautiful Eugénie Sellers. Her engagement to Sandford Arthur Strong, a leading member of the British art establishment, was for the moment in abeyance and she was not yet a sharer of his hostility toward Berenson. She did not want for feline candor, however, and told Mary that Bernhard had a reputation of being a man who could not bear other men, since he was furiously jealous of their reputations. Besides, both he and Mary were supposed to be very unstable and changeable in opinions and enthusiasms. Mary had to acknowledge to herself that summer that as she looked back at their disputes with Loeser, the Michael Fields, Burke, and even Obrist, she saw "the justice of her remarks."

In Rome the gallery and church studies went on indefatigably. At the Museo Cristiano the travelers had "a glorious time recognizing and baptizing all sorts of early Sienese and Florentine panels." Prince Colonna opened his private collection, Countess Pasolini was cordial, and Contessa di Santa Fiora and the Marchesa Passori showed them their treasured Turas. Bernhard, Mary, and Miss Sellers were taken to call on Harry Brewster, a wealthy New England expatriate. Brewster described their visit to Dame Ethel Smyth as follows: "Next day after lunch the aesthetic trio called: Miss Sellers whom I like very much, Mrs. Costelloe, a cultivated American young widow [*sic*] afflicted with the mania for knowing who has painted what, and rewriting the picture galleries (which could be done in three words *'requiscat in pace'*), and the young man, Berenson, whose words they drink in. They told me—in

his presence—that he had explained admirably the significance of the nude. A friend indeed! And he knows just the spot—two yards to the right or to the left would spoil it all—from which St. Peter's 'composes.' . . . The young man is far from stupid, but it is an unfortunate position to be in: the teacher and prophet of two admiring spinsters, one of whom is a widow." Neither Mary nor Bernhard evidently wished to correct him on that last point.

Once teased and pushed into writing on art, as he had been by Mary, he now seemed to live with his pen in hand, and he kept her busy typing an intermittent stream of pages in the intervals of their frequent absences from Fiesole and Florence. Each beginning, she noted, was an ordeal. He also left much of his business correspondence to her. He continued to be a frequent contributor of notes and reviews to the *Nation* as its European expert on Italian art. In the year that saw the publication of his *The Florentine Artists* he placed seven items in that weekly, one of them a long review article on an edition of Botticelli's *Illustrations to the Divina Commedia,* in which he argued that Botticelli had no ability to portray the "gloom and terror" of Dante's poem. His drawings were great as art but not as illustration. And, as if recalling his initiation into Oriental art at the Museum of Fine Arts with Fenollosa and Denman Ross, he added: Botticelli's "real place as a draughtsman" was among "the great Chinese and Japanese, with Ririomin, Harunobu, and Hokusai." Like these, he was "a supreme master of the single line."

Mary had to hurry off to England soon after their return from Rome, for her Italian doctor had diagnosed a chronic inflammation resulting from the difficulties attending the birth of her daughter Karin. Bernhard accompanied her as far as Paris and stayed on there for a time, seeing Herbert Cook, Placci, and Herbert Horne, before going on to London to begin a tour of Scotland. Mary went into a hospital in London to have her womb scraped out with a sort of spoon, as she recorded, but felt nothing since chloroform was administered. As if in sympathy, Bernhard complained of his liver, according to his doctor the seat of his recurring dyspepsia, and Mary vainly urged him to find surcease in Wales, as his doctor had recommended. One benefit of her stay in the hospital was that it somewhat trimmed her increasingly ample figure, a fact which caused Maud Cruttwell to beg her not to diet any more, for she really was too thin and "broadness" suited her. Mary knew better; she had a premonition of the losing struggles that lay ahead of her to control her girth. "The resemblance to Father that grows with widening cheeks," she reflected, "is enough to make me live on sawdust the rest of my life."

Bernhard's relations with Mary pursued their usual precarious course

this summer of 1896, now turbulent among the rapids of clashing egos, now tranquil in the smooth water of reconciliation. And the pattern hardly varied whether they were at work in the same room or separated by half a continent. As always, his style was a sore point with her. When, for example, she incautiously caviled a little at an article he was writing on the drawings of Andrea Mantegna, he breathed fire and, as she said, the "day ended in gloom." The next day they made up and together tinkered with the piece.

Bernhard had his innings when Mary sent him an article praising Obrist's designs for embroideries. Although Bernhard had himself written in the *Nation* that Obrist was "a young decorative artist of the highest genius," Mary's analysis somehow rubbed him the wrong way and he sent her a scathing critique. When she protested, he compounded the injury by accusing her of having dashed off the article in haste. She retorted, "I don't think, however, you are in the right to blame me for resenting your treatment of my article, considering that when I ventured to suggest the alteration of one word in your Mantegna article you were furious and quarreled with both Zangwill and me. . . . I did not write the article in 'a fury,' I took a good many mornings to it." What particularly distressed her was his saying that his good opinion of her "depended on my rewriting of the tiresome article."

The contretemps passed and with it the dismay and self-abasement which Bernhard's too-ready sarcasm so often evoked in Mary. Repenting his harsh criticism, Bernhard sent her a letter from Scotland, where he had arrived after visiting a series of country seats in England with their friend Herbert Cook, a letter "so cheery and nice," as Mary told him, "that I half repent me for resenting the off-hand snubbing way thee saw fit to treat my poor little attempt at an article." Again there was a lovers' armistice between the two tempestuous collaborators.

They joined forces in early September of 1896 for travel in Germany and met Obrist again in Frankfort. Berenson's fondness for the intense artist had survived Mary's abject confession, his respect for Obrist's talents having vanquished his jealousy. When Mary was in England early in January he had gone so far as to urge her to try to arrange an exhibit in London of Obrist's things. "Do not think I am irritated with O.," he had written. "I am very fond of him. . . I want us both to help O. to the utmost . . . if thee can pump all sentiment out of thy concern." Obrist, who had been visiting in Fiesole, could only be taken in small doses, however, and Berenson had been glad to see him leave with his store of fixed ideas that wore one out.

In Frankfort Bernhard persuaded Obrist and Mary to meet as if noth-

ing had happened between them. To her surprise, as she confided to her journal, she *"had* really forgotten" her infatuation. He now seemed an ordinary acquaintance and his ideas too utterly the same after an interval of fourteen months. The new embroideries with their semiabstract designs enchanted them and Bernhard promptly bought some for £145, leading Mary to reflect that Bernhard was an ideal patron. "A real artist could not wish for a better appreciator or a more generous buyer." Obrist left for London and Bernhard and Mary went on to Munich for a week of Wagner and Beethoven. In that agreeable ambiance Mary decided to rewrite her Obrist article, quite as Bernhard had urged. It was promptly published with handsome illustrations in the London *Studio* before the end of the year, over the name of Mary Logan. Bernhard's article on Mantegna's drawings, however, did not appear until 1901, when it was published in translation in the *Monatsberichte für Kunstwissenschaft und Kunsthandel.* The original English version was published in the following year in Berenson's *The Study and Criticism of Italian Art,* Second Series.

Through Placci Bernhard and Mary had become friendly with a number of prominent Italians, members of the local aristocracy and collectors of art, as well as with Italian art critics and dealers. But Mary, unlike Bernhard, never did master the language sufficiently to converse with complete ease, so that even much later in the troubled days of World War I she had much difficulty convincing Italian officials that she was a longtime resident. Their world tended, as a result, to be dominated even at this period by their English and American associations. The stream of visitors in the spring and autumn of 1896 had been made up mostly of foreigners responding to the lure of Florence. Berenson's name may not yet have become a household word, but in the world of European art he was becoming a magnet to the foreign visitors to Florence. Thanks in large part to Mrs. Gardner's "bountiful cheques," he could begin to live up to his reputation as a distinguished aesthete as well as a connoisseur of Italian art, and he basked comfortably in his fame.

One who especially relished his hospitality was Israel Zangwill. He returned to Florence full of talk about his work as "a creative genius" so that, to Mary at least, he was as wearing as the Michael Fields with their poetizing. Bernhard, however, found him a sympathetic controversialist, and his aggressive masculinity was undoubtedly welcome, given the prevalence of artistic women in Florence. Zangwill's novel *Children of the Ghetto,* published in 1892, when he was twenty-eight, had had a very considerable success, and it was the forerunner of an impressive series in the same genre. The son of a pious Jewish shop-

keeper in London, he was already a prominent figure in the London literary world and as a pioneer Zionist was becoming influential in the Jewish community. His vivid narrative of the cultural assimilation into British life of large numbers of Jews from the London ghetto undoubtedly touched a responsive chord in Bernhard's memories of his own life as a boy in the Boston ghetto. He too had in a sense raised himself by his own bootstraps. He urged Zangwill's novel upon his sister.

In his retreat from his quixotic conversion, Berenson seemed to take a special pleasure in Zangwill's conspicuous Jewishness, and he overlooked the traits that annoyed Mary. Zangwill provided a gratifying example of a Jew who had made his mark as a writer without sacrificing his identity. In this he was much like Salomon Reinach. Zangwill was fortunately on hand when Mary's father visited her at the Villa Rosa. The old man had not relented in his dislike of her bohemian companion, even though Berenson was no longer penniless. Berenson conveniently escaped with Zangwill and dined in town. Smith's various grievances, which had multiplied with age and eccentricity, so annoyed his daughter that, as she wrote, "I stole over to Bernhard's to let off my feelings." The poor man had begun to show signs of mental instability and Mary was torn between pity and disgust, feelings made more painful by the fact that she had always been his favorite.

X X

The "Wizard of Quick Wits"

BERENSON'S fame as an art critic and historian and his great success as a connoisseur and art expert made him a personage to be reckoned with. There had been French articles written about his *Florentine Painters,* as he was to tell Senda, "and the main article" in a recent number of the *Nuovo antologia,* the leading Italian review, translated "big bites out of it, almost literally in the course of a discussion of it." "The *Pall Mall Gazette,*" he continued, "published the other night a poem against me and this makes me feel as if I were really somebody." The poem, "Ballade of the New Art Criticism," was an amusing demurrer addressed "With compliments to Mr. Berenson and the 'Quarterly Review.' " The verses burlesqued the plight of the ordinary man bewildered by the changing fashions in art criticism. The "Envoy" ran as follows:

> Morelli's struck such reasonings dead
> And, measuring nose and ear and hand
> Plain man no more holds art in dread,
> The *modern* critic's in the land.

Old friends sought Berenson out and brought new ones in their wake. Placci presented him to a variety of aristocratic recruits. The Princess Ghika was one of them. She had just bought the loveliest of palatial villas in Settignano, the Villa Gamberaia. Placci who, as Mary noted, had the only *permesso* to enter the magnificent gardens, proudly took her and Bernhard there. On another occasion he brought over Prince Borghese, a scion of the great Roman family. That encounter led two years later to an exciting negotiation for the sale of a great Titian, *Sacred and Profane Love,* which had Mrs. Gardner been able to raise the tremendous sum required, would have been the most spectacular acqui-

sition of her career. Placci had also introduced him at luncheon at Doney's in the spring of 1896 to the flamboyant Gabriele D'Annunzio (his real name, Mary noted, was the comical "Arrafeta Cipollone!!"), whose sensual novels were titillating Europe, as was his liaison with the great actress Eleanora Duse. The luncheon was followed by exhilarating talk, during which, as Berenson re-created it for Mary, D'Annunzio "dropped his pose and became serious, impersonal, and modest, besides being astonishingly eloquent."

Among the English visitors who looked him up in Fiesole in 1896 to talk about art and to tour the galleries of Florence with him were Sidney Colvin, the biographer of Keats and Keeper of Prints and Drawings at the British Museum, and Laurence Binyon, the popular minor poet, whom Berenson had first met at Oxford. He was now an assistant in the British Museum Print Room. Herbert Horne was by this time well settled in Florence and had begun his new career as a collector and authority on Botticelli. He and Berenson became close allies and they would "gorge" themselves, as Mary put it, with connoisseuring. On one of their early searches they discovered in a little oratory near Settignano a damaged fresco by Botticelli of the Virgin and Child. They acquired it and equitably divided it between them, one half eventually finding its way to the collection at the Villa I Tatti, the other to the museum which Horne bequeathed to Florence.

Young Maurice Baring, then twenty-two, the fourth son of Lord Revelstoke, was also drawn into the hospitable net of Berenson's circle. He was just at the beginning of his brilliant career as a poet, playwright, diplomat, and war correspondent. The elderly poet laureate Alfred Austin, who had succeeded Tennyson, though his voluminous poetizing seldom exceeded mediocrity, was much impressed by Berenson when he came to Florence that spring of 1896. Soon afterward, when Berenson went to England to begin his tour of Scotland, he reported to Senda that he was staying with the poet laureate for a few days at Swinford Old Manor in Ashford, Kent, and enjoying the fragrant air of his garden and wrangling with him delightfully about poetry, a great relief after three weeks in London, where he had been ill and "rushed to death making up for lost time." Berenson's cousin Louis Freedman, whose family he had once visited in Berlin, spent a day with him in London. Bernhard introduced him to Zangwill and then "gave him some good advice and pushed him off to Germany." Zangwill, temporarily persuaded by Berenson's eloquence, published a laudatory review of The Florentine Painters in the Pall Mall Magazine. It pleased him to hear that Berenson's sister Senda had been reading his Children of the Ghetto with warm appreciation.

[265]

While at Austin's house Berenson wrote to Barrett Wendell at Harvard to thank him for his letter expressing a "more intelligent and more cordial appreciation" of his new book than any other critic. Having learned that Wendell's sabbatical year abroad had been rather disappointing, Berenson suggested that "you professors should have longer rests each year . . . to come abroad each year and enjoy as the Oxford or Cambridge don enjoys his vacation," and he added that one of his best friends, young Gilbert Murray, who had succeeded Jowett as the Regius Professor of Greek at Oxford, regularly allowed two months each spring "to rest his body and feast his mind."

If Barrett Wendell was unreservedly friendly the case was different with one of his students, Robert Herrick, who like Bernhard had been among the elect of the *Harvard Monthly*. He had recently left Harvard to join the English faculty at the newly founded University of Chicago. Bernhard did not know that Herrick had already been welcomed among his detractors by Charles Loeser, to whom he had written of his dislike for Berenson's recent writings. When Herrick and his wife came to Italy in the autumn of 1895 and stayed on until the following summer, Bernhard and Mary cordially offered hospitality. As a budding novelist, Herrick enjoyed feasting with—and, as it subsequently appeared, on—his unsuspecting hosts. He wrote to his friend and colleague Robert Morse Lovett, "We have seen something of the Berensons who are very fully installed and quite chic in every way. [Herrick no doubt relished the irony of the plural, knowing that Lovett was probably in possession of the scandalous facts.] We dined there. I think he is an awful liar but a tremendously clever man, a kind of wizard of quick wits. We have seen also Loeser and a grunt of aesthetes who would bring color to your cheeks and others. I don't care sixpence for the whole d—— thing and I don't believe you would now." Herrick's cheeks would undoubtedly have gone quite red had he attended one of the aesthetic luncheons in Florence that spring at which a young woman, according to Mary, posed nude "as various Greek statues." The guests, who included Bernhard and the English poet laureate Alfred Austin, "were in raptures over her beauty" and her "most delicious simplicity."

Bernhard's unexpected success after he had been practically written off as an egotistic pretender inevitably aroused envy in his less spectacularly successful contemporaries from Harvard. The signs of obvious affluence, more visible in Florence, where living was cheap, than in the depression-ridden United States of that period, must have seemed positively immoral. Herrick's correspondent replied, "Of course you didn't like Berenson, but you draw a fine portrait of him and his Olympus. It

is a spectacle isn't it?" It is not without a touch of shared malice that Norman Hapgood, another college mate, wrote Herrick that "Putnam's tell me that Berenson's *Lotto* has no sale." If the monographic *Lotto* had only a *succès d'estime,* as Berenson himself had anticipated, the same was not true of *The Venetian Painters,* of which the second edition was nearly exhausted and a third was being requested by the publisher.

Berenson not only guided Herrick through the galleries of Florence but also walked about the country lanes with him. When Israel Zangwill showed up, he introduced Herrick to him. Herrick, who was not lacking in Brahmin prejudices, took an instant dislike to the assertive Zangwill, as Blake Nevius has recorded in his revealing biography of the chill-blooded New Englander. Berenson soon struck Herrick as fair game for his first full-length novel, and he set to work on what was to be published two years later in 1898 as *The Gospel of Freedom.* By early spring 1896 he had the opening chapter under way. He would come up to the Villa Kraus for lunch or dinner on the electric tram that then wound its scenic way up to Fiesole from the Piazza San Marco and afterward hurry back to his rooms on the Arno to record his impressions. Bernhard afterward remarked that "whole slabs of talk (as if phonographed) recognized by all our common acquaintances as my own, were put into the mouth of a very odious character."

Herrick found much to feed his instinctive revulsion against the obsessive aestheticism of Berenson's milieu, with its amoral cult of "art for art's sake," especially as accompanied by the sexual freedom of the emancipated New Woman, and he made these aberrations the themes of his novel. "I have just been to the Pitti with Berenson who lunched with us," Herrick wrote to Lovett in April, "an enormously clever person—but perhaps I had best not go on. I should not care for his laurels at the price of his personality. Vernon Lee is an intolerable ass. But you don't know conceit until you meet her. But they are amusing and helpful and Florence is a dream of heaven, a place without one single blemish, eternally interesting and complete." He borrowed without scruple the traits of those who had entertained him—Vernon Lee, his friend Loeser, Mary Costelloe, but chiefly, and with special malice, Bernhard Berenson, who appears in the character of Simeon Erard, the repulsive little Jewish art critic and painter. Erard is depicted as the satanic spokesman of the self-indulgent, emancipated, rootless bohemians of the upper classes, a man who sponged on the wealthy and craved the adulation of a circle of disciples.

One senses the murky depths of Herrick's resentments in the heroine's final repudiation of her mentor: "You have pushed your way, you have taken what you want from the world, lived off it! You have

abandoned your own people, you have sneered at your own land." Her words were but one version of the malicious half-truths that would pursue Berenson to the end and titillate the ears of gossips. They were a distorted and cruel exaggeration, but they would stick in the public mind. Herrick denied in an unpublished autobiography that he had the "Florentine critic" in mind, insisting that his "little egoist" had several models from which he "divined the soul of Erard and projected him." However, as Nevius has amply shown, Herrick's literary conscience had its blind side, for, in spite of his denials, his novels regularly plagiarized his own experiences and exploited his acquaintances.

How opaque that side was is shown by the following extracts from a letter that Herrick sent to Berenson May 12, 1898:

Dear Berenson:

. . . . I have been very busy both at my metier and at making books—one of which I send you. But I have not forgotten the few delightful hours spent with you at Fiesole and Florence, some of the most stimulating and enriching hours I have ever had. And I have followed your books eagerly, with a sense of pain that I must perforce be so largely unintelligent.

I am sending you my first novel, which you may find interesting because it plays around the outskirts of your field of pictures. The book, in a way, I feel does not do justice to my very real interest in "the other side." I am afraid you will find it narrow and philistine. Perhaps that is in me, and at any rate, I find a novel self-determining. . . . I think you will see it tolerantly, and will be interested in it. At any rate I wish to recall to you our few hours and to express my gratitude for the intellectual and artistic pleasure you gave me. Although we found much that was debatable and had we continued to discuss should doubtless have found more, let me assure you that you have no more sincere admirer of your very genuine work.

<div style="text-align: center;">

With sincere regards,
Faithfully yours
Robert Herrick

</div>

It was a disarming letter that banked more on the tolerance of his hosts than Herrick appears to have realized. Their reaction found a place in Mary's diary shortly afterward: "I read a book by Mr. Herrick of the Chicago University of which Bernhard is the hero and I the heroine—a book in which we are both represented as loathsome reptiles. I was angry about it at first and then laughed but in a rather sad way. . . . Bernhard laughs over it too but the American point of view does make me sick." She noted also that the Lovetts were rather indignant over the novel. Touched perhaps by Herrick's seemingly ingenuous praise in his letter, Berenson willingly turned the other cheek and

forgave his detractor. And when, in 1898, the Herricks begged him to call on Harriet Monroe, the Chicago poet then visiting in Florence, he readily agreed.

A colleague of the Herricks, Adolph Miller, had occasion to call on Berenson's expertise that year. Vacationing in Italy with his wealthy wife, Miller picked up an alleged Titian in Venice and under its daily refulgence professed himself a "changed man." Doubts arose about its genuineness and Berenson was summoned from Florence. He adjudged the picture a fake. Herrick promptly wrote a story, "The Rejected Titian," on the tantalizing question: Was the painting less valuable, because it was not a Titian, considering that it had had "profound meaning" for its buyer and made her "feel happier than ever before" in her life? The painting is returned to the dealer, but the question is left unanswered.

Neither Bernhard nor Mary ever forgot Herrick's satire, but it did not seem to mar their amicable relation. Six years later, when, by that time legally married, they visited Chicago on their American tour, the Herricks entertained them very cordially at their home in Chicago. Bernhard and Mary reciprocated two years later at the Villa I Tatti, but Herrick still felt ambivalent about his hosts. "They do the thing in considerable form and very well," he admitted to Lovett, who as he knew had always taken a much more charitable view of Berenson. "B.B. is ultra-English. Their place is lovely and everything in the house perfect. The higher criticism does not go in rags." However, he still thought Berenson an "intellectual adventurer" and not to be trusted, though "he has made it *go*—he is somebody—he's imposed himself."

Robert Lovett, a far more genial temperament than his colleague, himself visited Florence in the autumn of 1896 with his young wife, their three-month-old baby, a nursemaid, and his sister-in-law. One object of his coming to Florence, Lovett wrote, was to renew his acquaintance with Berenson, whom he had last seen in Paris four years ago. Berenson promptly took them under his wing, and when winter came found them the Villino Illingworth above the Fiesole piazza. Berenson, Lovett reminisced in his autobiography *All Our Years,* was a "superb teacher." As a reader he "was omnivorous and omniscient. He liked company on a walk, and I profited from the fact that most of his guests were not pedestrians. He used at the outset to stand me up for the delivery of some idea or theme, recalling the Cambridge habit of serious conversation. He had a prodigious memory, of which I have a recent example. I wrote a review of Rosa Luxembourg's letters about the time of her death. Twenty years later Berenson wrote me recalling the review and asking me to obtain a copy of the book for him."

In the following spring Lovett took a bicycle *giro* with a Chicago colleague, the historian Ferdinand Schevill, who had turned up in Florence. In the course of this trip they visited Monte Oliveto, and brought back a very different impression of Berenson's hosts at the abbey. When they inspected the "magnificent paintings of Sodoma," Lovett recollected, "our guide was a lecherous old monk who identified *il suo moglie* [his "wife"] with a sly mixing of genders." The Lovetts failed to win Mary's entire approval, and she recorded her impression with her usual visceral energy: "Lovett himself, for a professor of English literature seems remarkably ignorant. He is stupid, too, for he had read four volumes of Creighton and never once thought whether he likes any of the popes or not. Mrs. Lovett is unspeakable," though she had "pretty hair, [and] a genial and heavy sensuous temperament." Mary deplored the fact that their infant was kept in the mother's room at night "modo Americano—to the ruin of her sleep."

One catches an amusing glimpse of the tenor of Berenson's life at the Villa Kraus and the Villa Rosa during the season from an impromptu sketch by Eugénie Sellers, who had traveled about Italy with Bernhard and Mary, a sketch, as Miss Sellers said, in the style of "Anatole France or any snobbish writer." "Mme Costelloe, étendue sur sa chaise longue avec des fourrures, etc. Des groupes des jeunes gens se détachaient, discutant la politique italienne. [This was the time of the Abyssinian troubles.] Une jeune homme de la haute noblesse [Bertrand Russell], qui avait laissé l'Embassade Anglais à Paris pour se marier a une politicienne Americaine et étudier la socialisme en Allemagne—[Russell's *German Social Democracy* had just come out] discutait violemment les théories de Karl Marx avec un autre qui venait de conclure un mariage romantique, etc., etc., tandis que, dans l'autre salle des archéologues s'échauffaient sur la question des dates des métopes, etc., par ici par là on voyait des gens qui s'amuseraient en feuilletant des albums de photographies choisis avec goût par le célèbre connoisseur M. Berenson—et une groupe de jeunes filles adorables se penchaient sur le balcon, admirant le Val d'Arno et Florence que s'étendait à leur pieds, etc., etc. De temps en temps tout parles cessait tandis qu'un musicien d'un talent rare évoquait les mélodies de Tristan sur le grand piano, etc. etc."*

*Madame Costelloe, swathed in furs, was stretched out on her chaise longue, etc. Groups of young people broke away to discuss Italian politics. A young nobleman who had left the English embassy in Paris to marry an American female politician and to study German socialism—violently discussed the theories of Karl Marx with another person who had just concluded a romantic marriage, etc., etc., while in another room archaeologists heatedly argued over the question of the dates of the metopes, etc.; here and there one saw people amusing themselves leafing through albums of photographs selected by the celebrated connoisseur Mr. Berenson—and a group of adorable young girls leaned

It was a charming parody and yet the scene was not greatly exaggerated. It was a scene often repeated with a constantly changing cast of characters, and as time went by and the stage became that of the Villa I Tatti, the figures became more numerous and the talents and titles more varied and more impressive.

Gossip about Mary and Bernhard naturally grew in the retelling as visitors to Florence brought back to England choice morsels they had picked up, especially that the liaison, as one traveler put it, was "a perfectly recognized fact." Mary wrote to Bernhard, when he was off on one of his frequent summer circuits of the art centers of Europe: "One must expect such things if one keeps open house for all and sundry as we did last spring. Even before this I have been feeling that it would be better to keep more to our kind of people. What do we want with a rabble of people whose interests are entirely different from ours." Then, as if to underscore their vulnerability, she added that her brother, Logan, had told her that even the Thomas Sergeant Perrys were saying "nasty things about thee."

Bernhard shared much of Mary's contempt for the "rabble," discriminating among acquaintances as he would among genuine and false Titians. The accolade of friendship became "unsereiner," our kind, one of the catchwords of their inner circle. When Senda challenged his unconventional opinions and his seeming snobbery, he responded, "Yes, it would be so much nicer if we didn't have to conceal our thoughts from each other. . . . Perhaps in time you will understand and sympathize. . . . I much prefer of course to be with people whose interests are historical like my own." "I can't tell you how happy it makes me to get back to [the Continent's] dear soil," he interjected. "There there is real freedom and people look humanized. . . . England is only a jumping-off place. . . . England certainly does not agree with me; my spirits go up at once on touching the Continent."

There was ample reason for his feeling about England, for his pamphlet on the New Gallery had left a trail of deep resentment among picture owners and their partisans among establishment art critics. No one seems to have been more vocal in his hostility than Sandford Arthur Strong, the art historian who had recently become librarian to the Duke of Devonshire at Chatsworth House and cataloguer of the duke's great collection of Old Masters' drawings. When Strong soon afterward married Eugénie Sellers, who had so charmed Bernhard and Mary, he enlisted her in his vendetta against Bernhard. Part of Strong's animosity

over the balcony admiring the valley of the Arno and Florence stretched out at their feet, etc., etc. From time to time all conversation stopped while a musician of rare talent evoked the melodies of Tristan on the grand piano, etc. etc.

was thought to stem from the fact that after a lover's quarrel in May 1896 his fiancée had run off with Bernhard and Mary for a prolonged art tour in Italy.

Admiring his sister as he did, it troubled Berenson that she did not approve of his continued self-exile. "It is better for you," he argued, "not to approve of my way of living and thinking. I must dogmatically state nevertheless that my ideal is civilization and that civilization I find I feel more keenly than ever is only to be found on the continent of Europe. . . . Don't feel responsible for me, dearest Senda, and I will continue to think of you with pleasure and to love you." Learning that she would be visiting Boston, he added, "How I long to see that place again. Boston may not be American, indeed I am not sure that it is not, but I feel very soft about it."

A particular sore spot with him was Senda's continued disapproval of his relation with Mrs. Costelloe. And so when he urged her to come and spend a month with him at Fiesole it was with the proviso that she come "in a friendly spirit to Mary who bears you no grudge and is ready to like you." He pointed out that Mary's brother and sister "had the sense to come round" and they were now all great friends. He adjured her to "come to sympathize and not to criticize." His letters continued to guide her reading and her plans for self-improvement. It was important that she read Maeterlinck in French, and that she study German in preparation for her visit abroad in 1897. He told her that he himself was reading an hour of Greek each day and intended to do so for the rest of his life. He was also concerned about their younger sister Rachel, who was now sixteen. He advised Senda that the child should immerse herself in English literature, but most important of all she should learn to express her very own self. "By hook or crook get her to write. Make her keep a journal, make her write to you about the books she reads, applaud her, even overmuch, even encourage her to speak wickedly of people, only make her express herself and urge her to acquire the art of manifesting her own personality. That is the art of art." He felt secure now about Senda's taste. When she spoke critically of Max Nordau's sensational *Degeneration,* Bernhard applauded, "Your instincts are exquisite."

One curious literary venture in which Berenson took a hand in the autumn and winter of 1896 was the launching of a short-lived little magazine called *The Golden Urn,* for which Mary's brother, Logan Pearsall Smith, was the prime mover. Logan had made himself at home in his sister's apartment at the Villa Rosa and settled down in easeful comfort as a litterateur. He had been a fellow student with Bernhard in William James's course at Harvard, but he did not become acquainted

with Berenson until they met in Paris soon after his sister, Alys, married Bertrand Russell. At first he had had misgivings about Mary's liaison with Bernhard, but they had now become fast friends. During the winter, as they debated the contents of the first number, they would sometimes "talk literature for ten hours a day," Bernhard told Senda. "Some day I hope to write about that as thoroughly as now on pictures. I look forward to it." The little publication was privately printed in Fiesole beginning in May of 1897 and ran to a third issue until it quietly expired in 1898. It was, as Logan recalled in his *Unforgotten Years,* "a pretentious little review" containing short extracts of what Logan, Mary, and Bernhard in highly animated consultations agreed were the "finest lines in Shakespeare, Milton, and Keats." It also included a list supplied by Bernhard and Mary of "the best, and only the best, Italian pictures in galleries and private collections." Its motto, on which the three collaborators at length agreed, was "Ars longa; vita brevis est," an unimpeachable if hackneyed sentiment. Logan had written to his sister, Alys, from Venice that the pamphlet would include "anonymous 'Soul Huntings.'" Mary's anonymous "soul hunting" was "Things children are afraid of." For a subsequent issue she prepared a list of "Sacred Pictures"; Bertrand Russell joined in with "Self-Appreciations: Orlando"; and Logan with "Tragic Walks" and "Altamura." "Altamura," in which Bernhard collaborated, was an elegant and mellifluously phrased fantasy which burlesqued the life of exquisite sensation and lofty thinking of Bernhard and Mary's Fiesole circle. The setting is the English monastery of St. Dion of Altamura in the remote mountains of Italy, and the narrative takes us through the seasons of the religion of culture, whose saints for one month are Keats and Mozart, Giorgione and Marlowe, and for another the great pessimists, and for still another the great Epicureans. The days pass in poetry, song, and philosophy and the festivals invoke the great writers of antiquity. "Freed from that narrow, feverish grind of passions and activities which is called 'Life,' the Dionites derive a richer more wonderful sense of self-conscious existence from the contemplation of Nature . . . the study of their sacred books, and the devout worship of those great forces and persons and works of art in which the spirit of Being has been most splendidly manifested. . . . What chiefly connects the followers of St. Dion with the life about them is the belief that, by real and devout enjoyment, the burden of the world's joylessness can be, in some mystic way, abated."

Bernhard and Mary doubtless relished this hyperbolic idyll, for it paid tribute in its way to their success in achieving the "unsordid" existence which was Bernhard's dearest ambition. The world outside might

be convulsed by calamities, but art and beauty stood serene above the battle. To their worldly and politically minded friend Carlo Placci, their detachment seemed unreal. Only a short while earlier, the Abyssinians had inflicted a crushing defeat on the Italian army at Adowa, on March 1, 1896, forcing Italy to sue for peace. The news seemed not to have caused a ripple in the Fiesole colony, and the patriotic Placci wrote in bewilderment to Berenson, "You strange people, inhabiting hills and abstract ideas, how do you manage to exist outside of actualities *à large base?*" The fact was, of course, that for the Anglo-American sojourners Italy, especially Tuscany, was then as now a land more of the imagination than of actuality, alive with literary and artistic associations, a theater where one acted out one's romantic aspirations.

The late summer's rovings of 1896 had taken Bernhard and Mary first to Munich, where fashionable culture required still another draught of Wagner, but this time Berenson balked at the ritual. The *Meistersinger* seemed inordinately dull, and after hearing more Wagner in Vienna he finally confessed that he found the music so noisy that he continually had the feeling he couldn't hear the music for the noise. The incessant picture hunting that followed across Holland, Germany, and Austria took their toll of Mary's strength, and she abandoned Bernhard to Placci and Herbert Cook, who had joined them in Vienna, and hastened down to Fiesole. The indefatigable Bernhard pushed on to the provinces of Croatia and Dalmatia with his companions in the ceaseless hunt for new additions to his Indexes. He rejoiced that what little he remembered of Russian proved unexpectedly useful in Dalmatia, where Slavic influences still lingered.

Scarcely stopping for breath in Florence, he set off again with Mary and Placci for the towns of Umbria and the Marches. The strain of notetaking and constant travel began to tell on their nerves, and Bernhard relieved his irritation by unmercifully criticizing Mary's looks and intelligence, leading her to think that he disliked her intensely. Fortunately, the light-hearted Placci managed to keep their spirits up, but the symptoms of deep tensions could hardly be ignored. For all her sense of independence Mary could not overcome the feeling of insecurity in her position, which depended so greatly on Bernhard's good opinion. She felt far more keenly than he the disappearance of romance in their relationship. For a short time Obrist had filled the vacancy, but she had paid dearly for reawakened ecstasy by the self-abasement that followed.

When they were once more back in Fiesole, life settled into its familiar pattern. Bernhard drove ahead steadily with the new book on the Central Italian painters, and Mary, when not busy with Bernhard's manuscript, turned to her own deferred Louvre catalogue. At the same

time, a third edition of *The Venetian Painters* having been called for, the all-important Index of Artists had to be revised in the light of their further searches. "So we cast off old attributions to take on new ones," Mary explained to Alys. "There are hundreds of changes to be made and all the new collections to be added. . . . The worst is that we nearly always quarrel while we are working over the lists." And when in one of Bernhard's recurring rages his voice would become harsh and his face distorted with passion at some real or fancied shortcoming of Mary's, she would again fear for their future together. At such moments her sarcastic tributes to the "Master" did little to calm him. As if these chores were not sufficient, the Index of Artists for a German edition of the *The Florentine Painters* had also to be revised before the close of the year. Still, time was found for moonlight walks, for long conversations with Logan, for rounds of visits to the Princess Ghika at the Villa Gamberaia and to the Placcis' for impromptu concerts, and for singing lessons for Mary. Theodore Davis came by on his way to Egypt for another winter of excavations and departed with the sage advice to put their money in sugar. He told them also that the New York art dealers, evidently alarmed by the wholesale upsetting of attributions, had warned him against Berenson's supposed wiles.

Then, early in December 1896, came the thrilling news that Mrs. Gardner was sending her check for $73,000 for the Velasquez *Philip IV,* which Colnaghi was holding for her. Mary jubilantly wrote Alys, "Berenson has made a lot of money and I have helped in it so I shall be able to see that [Mother] has everything to make her comfortable." Bernhard, for his part, reassured Senda, who had been worried by the magnitude of his remittances home, "Well, dear, do not fear about my sending too much money. I do not deprive myself of necessities and as for luxuries I truly know none so great as trying to make happier the creatures I love." In a following letter he elaborated: "In the year that is just ending, I have earned no less than $10,000. This will take your breath away, but it is true. Yet I wish you not to speak of this to the family. My reasons are that their heads may be turned. Mine is not. . . . I allow myself few luxuries except helping the family and one or two friends who have been in great distress." (He had just sent off $500 to friends in London, nominally for a copy of a painting, but, as Mary noted, "really for two delightful people to live on.") "The rest," Bernhard went on, "I invest, not only against the evil day which may come at any time, when I shall not be earning, but to leave the family with enough to live on in case I cease to be." So the two earnest collaborators signaled the private loyalties that would fuel their discords.

Bernhard briefly summed things up for Senda: "I am beginning to

feel less hurried about work, less vexed with other people's incompetence and charlatanism and contented with my lot. Homer is a great consolation and the beauty of nature still more." Mary saw him in a more searching light. Bernhard, she mused, "wants to go along the primrose path of connoisseurship [and yet] dally with philosophy and psychology" and with what is "specifically artistic" in literature. She shrewdly perceived that that exorbitant dream would obsess him for the rest of his life.

XXI

A Duel with Vernon Lee

WHATEVER misgivings Berenson may have retained about the primrose path of connoisseurship inevitably yielded to the lure of riches. And his feet once set on it, he strode down its often tortuous course for more than forty years with increasingly ambivalent feelings and a growing sense of entrapment. He now had within his grasp the means for realizing the dream of his young manhood of becoming a highly cultivated "man of the world." The world had, almost overnight, justified his own faith in his singular gifts. Had he not anticipated it all in his *Harvard Monthly* story of the latter-day Marius the Epicurean with a will to power? And had not Mary been the real-life counterpart of the girl of the ideal "Third Category"? Little wonder that the meteoric transformation of his circumstances made him rather giddy with self-esteem.

Only three and a half years ago, in the spring of 1893, he had earned his first fee as a consultant to the group of American collectors who called him down to Rome. How munificent that $100 had then seemed! In the short space of three years he had experienced a quantum jump in fees and commissions. He not only had been liberated from dependence on Ned Warren's bounty, but had outstripped in affluence Harvard contemporaries who had the advantages of birth and family connections. It even turned out that he had underestimated his income, for early in 1899 he reported to Senda that for the past several years he had earned "at the very least $15,000" a year. He added that he had written to their father "begging him to knock off work, assuring him that I should send him $1,000 a year for him and Mother." He would have assumed the obligation sooner, he explained, but for the fear that his fortunes might change. He wondered "what the dear man would do with his leisure. He will haunt his cronies, and that is well. He will read, but his inter-

ests are so limited, and so I dread lest having nothing to do he should worry Mother for sheer want of occupation." He promised to look out for books to interest him and begged Senda to seek out "amusements and occupations for him."

No income tax laid its blight upon Berenson's earnings and living was cheap in Italy. Thus he and Mary had at their disposal the equivalent of what would be late in the next century more than $100,000. It was indeed a breath-taking income to be achieved at the age of thirty-one, and it would have taken a far more humble temperament not to have patronized less fortunate acquaintances. The alchemy of wealth increasingly transformed the luxuries of life into necessities. Choice furniture imported from Germany was needed to make his study in the Villa Kraus habitable, as well as a few Italian paintings for its walls and books and photographs for shelves and cabinets. As for Mary, she could indulge her taste for a florid Aubusson carpet, graceful Empire chairs, and soft hangings for her rooms at the Villa Rosa, where Logan now made his second home.

At this juncture, with *The Central Italian Painters* ready for the press, Berenson felt a certain pause in his career, less need, as he confided to Senda, to press on impatiently with his writing. However, when Reinach lectured him early in 1897 for loafing and becoming an Epicurean, idling away days reading the Greek of Homer, he protested: "If I had told you I *worked* for two hours a day at Homer you'd have thought me very fine. Yes I have done this—only, because I have done it intelligently and therefore with great enjoyment, you think I am wicked! As for publishing, I cannot publish more than I am doing of the quality I care for. . . . In one season I have done a book on the Central Italian Painters, saying things never said before, systematizing in the lists attributions never made before. That finished, I am now hard at work on the Florentine drawings. . . . I am gathering them together from all the corners of the earth, attributing them properly—an almost gigantic task. . . . Come now, I am not a loafer. True I *am* an Epicurean, or, to be correct," recalling Pater's Marius, "a new Cyrenaic, but I work as hard as anyone. Only I have some of the calm of Epicurus which keeps me from publishing out of mere—forgive the paradox—*desoeuvrement* as most of you do." Berenson's gibe apparently did not rankle, for shortly afterward Reinach and his wife toured the galleries of Florence with him. A welcome counter to Reinach's reproaches came from England in the news that Russell was now on Bernhard's side. Logan reported to Mary from Haslemere that Bertie sent his regards to the "Bel Ermite," Bernhard, saying, "I am still arguing aesthetics, only as his views are attacked, I now defend them, meeting and answering all the arguments

I used against him last winter in something the same way he met and answered them—only better!"

The tide of affluence, though it brought a host of comforts, did not relieve Berenson's deep feeling of insecurity. Many persons remarked his habitual Olympian calm, unaware that it was maintained at the expense of much inner turmoil. He had lived from hand to mouth so long that the money nexus of existence continually haunted him. The thought of being cheated, even in such little things as a suspected overcharge on the delivery of a book, would make him furious and too often he took out his frustration on Mary. Too readily given to the belief that people sought to take advantage of him, he would sometimes brood for days over an imagined injury, as when he thought Putnam was delinquent in the payment of royalties on *The Florentine Painters*. The manifold pressures on him all made for dyspepsia. When Mary assured him during one of his spells of depression early in 1897 that his new book was as good as anything he had ever done, the "poor dear" declined to be cheered up.

He found also that his natural gregariousness had its drawbacks in a place as attractive to visitors as Florence, for he soon discovered that many acquaintances preferred the mildness of winter and the delights of early spring in Tuscany to the discomforts of those seasons in the north. Herbert Cook came to stay for a bit; Santayana put in his regular appearance; Arthur Strong, Eugénie Sellers' fiancé, came but hastened to Loeser's villa and the "enemy" camp; Lovett and his wife stayed on until summer; the Perrys looked in; and "heaps of others," as Bernhard put it to Senda, had flooded into town. Theodore Davis and his archaeological party were momentarily expected back from the Valley of the Kings and soon Mrs. Gardner and her husband would be demanding his company. It was all "too rich," he complained. It was "butter, butter, butter" that needed "spreading out." Worst of all "it murders time." In the midst of this surfeit of socializing there came a few diverting interludes when he sat for a portrait by James Kerr-Lawson, an impoverished artist whom he wished to befriend. Shortly afterward Kerr-Lawson executed a companion portrait of Mary.

The strenuous pace of life that season so told on Bernhard that in the spring his Italian physician diagnosed his condition as "general feebleness." Wherefore he was told he must aim for the airy heights of St. Moritz and the Engadine in August to recoup his strength, while Mary would spend the month in England with her children. Placci, a summer regular at St. Moritz, undoubtedly filled him in on the social ambiance of the place. Bernhard decided that St. Moritz would provide an opportunity to launch his sister into the European high society that so at-

tracted him. He invited her to come over at his expense to spend
August of 1897 with him, and he enjoined her to bring along some
"simple ball dresses" and urged her to get a "nice tasteful one and let
me make you a present of it." To Mary, concerned for his health, the
prospect of rest and salubrious Alpine air was reassuring; but for Bern-
hard vague visions of gaiety and romance seemed to share the stage
with therapy. Part of his malaise may well have arisen from his am-
bivalent feelings toward Mary. With the fading of the idyllic dream that
first brought them together, Bernhard, particularly, would often be-
come sullen with discontent, resentful of her absences in England and
of her devotion to her children and her family. In his disenchanted old
age he wrote that Mary "thought first of her offspring, then of her
lover, and then, if then, of me." He was repelled by her self-in-
dulgence at table, which broadened her figure, and he was unsparingly
critical of what seemed to him her naive mannerisms. Moreover, her
recurring female troubles with their train of clinical symptoms un-
doubtedly had a depressing effect upon his ardors. Certainly the inten-
sity of his frequent outbursts against her suggests more than frustra-
tions connected with their work.

As for Mary, these recurring frictions and acerbities inevitably
strained her attachment to Bernhard and left her emotionally at loose
ends, her romantic longings starved for an object. Waiting in the wings
was a young man who for a time would change the prose of her life to
poetry. The affair began innocently enough with the appearance of
Wilfrid Blaydes in Florence early in the winter of 1896. He sent over to
Bernhard and Mary a chapter, "Epicure and Death," of a manuscript of
his book on philosophy. They were enchanted with it, thought it had
real style and an attractive attitude toward life. His conversation im-
pressed Mary as that of a "deeply cultivated" person. Bernhard enjoyed
the presence of a new recruit with whom he could walk the lanes and
give voice to his ranging thoughts, especially since Blaydes was much
more of a listener than a talker. After a while Blaydes was more in the
company of Mary than of Bernhard, and they would spend hours read-
ing Renan and Shelley as they lay in the grass. It was not long before
the two fell ecstatically into each other's arms, and for several weeks
Mary's diary glowed with tumultuous passion. She afterward ripped
out most of what must have been the more torrid pages. Five months
later the affair had pretty well run its course, although Blaydes, who
was then in Siena, protested energetically that he still loved her and in-
sisted on an interview—an interview, as it turned out, which left her
weeping. "Dear Bernhard," she confided to her diary, "comforted me
very much," though he "could not help saying it was an original situa-

tion for *him*. But he was equal to it." Once more she confessed all to Bernhard and promised to "expiate" her sins.

Fearful of breaking up her collaboration with Bernhard, which now rested in large part on that strongest of foundations, mutual self-interest, she had not given up Blaydes without a wrench. He swore in his despair that he would never see her again; nevertheless, he hovered on the edge of their world for a few years. Mary remained concerned about him, worried at one time he might kill himself for love. Soon his plight stirred her maternal match-making feelings. If she dared not have him, at least she might pass him on to one of her friends. So began the first of her many match-making efforts, which more often than not left a trail of turmoil in their wake. She brought Blaydes and Janet Ross's niece Lina Duff-Gordon together, evidently seeing in the beautiful young woman a kind of surrogate for herself. Perhaps it was fortunate the match did not prosper. Mrs. Ross could hardly have been impressed by the impecunious young man, who for a short while was another one of Berenson's pensioners, having already borrowed £350. He finally drifted off into the practice of medicine, leaving Mary to sigh that it was lucky that she had not run off with him as he had once pleaded.

The aesthetic preoccupations of that liberated society on the Fiesole hillside inevitably fostered the worship of Eros in all degrees of intensity, especially since it contained more unfulfilled women than men and British censors were far away. There was, it is true, much high-minded study and work, but also much leisure beneath the Tuscan sun. The archetype for all lovers was the affair between the dashing Gabriele D'Annunzio and the Duse, which from 1897 on titillated all Florence with its poetic passion. As Berenson recalled, "one could not help being struck by the way he looked and behaved, always overdressed, very much aware of being taken for a remarkable man, and by the timbre of his voice." He was much courted by local society, especially by the women, who found him irresistible. He was then a "little blond chap" of thirty-four who impressed Vernon Lee with his "good manners."

Somehow Bernhard long resisted the temptations of amatory adventures, being still too puritanical in his principles and too fastidiously cerebral in his approach. True, he did flirt a little with the companion of the Princess Ghika at the Villa Gamberaia, the twenty-nine-year-old Miss Blood, but only as a slight accompaniment to teaching her Greek. She, by the way, was discovering that the liberated morality of the aesthetic colony was not honored by the doctors of Florence. Being unmarried, she learned that she was therefore debarred from consulting a local gynecologist.

Bernhard's month-long stay in St. Moritz with Senda among the

glamorous aristocrats of Italy aroused more adventurous emotions. At the Hotel Casper Badrutt he had, as he wrote Mrs. Gardner in Bayreuth, the "pick of Italy" constantly before him, the Colonnas, Pallavimis, Pasolinis, the Placcis, and the enchantress Grazioli, "whom I enjoy very much." His sister, he said, was proving a "great favorite among them all," despite her lack of Italian and French and their "small English." He reported to Thomas Sergeant Perry, whose misgivings about his protégé had quite subsided, that he was staying at one of the smaller inns, "forming a happy family with a small number of very rich people in Italy," where one "walked over glaciers, danced, and in short frivolled." He had come to St. Moritz in early August after his customary picture-hunting expedition in Italy and sessions with dealers and collectors in Paris and London in the company of Mary. In London he also had busied himself with expediting the shipment of Mrs. Gardner's treasures. There had been unusual pressure in this regard because the new U.S. tariff act that was about to go into effect imposed a 20 percent tax even on the importation of Old Masters.

In the bracing mountain air of the high valley in its setting of soaring peaks and transparent lakes, he felt wonderfully revived and strode up the mountain paths feeling the joy of "physical existence." He also found congenial diversion in reading proof on a third edition of his popular *Venetian Painters*. Of course he described it all in copious detail to Mary at Haslemere as well as to Mrs. Gardner. But amidst his comments on the inexhaustible beauty of the scenery, his glowing reports of new pictures for consideration and of progress on current negotiations, he somehow managed to keep in the foreground the name of Italian Duchess Nicoletta Grazioli. The Grazioli "with her later Stewart face [a bow to Mrs. Gardner], slender figure, graceful movements and fascinating ways" enthralled him, though he hastened to assure Mrs. Gardner that he saw through her pose. Mary conceded that she sounded fascinating but added a word of caution: "So the Grazioli walks thy pace, does she? That is a bad symptom. I hope thee won't suffer seriously." Reading of the fancy dress balls to which he took his sister, Mary reminded him that he had gone to the Engadine to rest and restore his ailing liver and not to dance the nights away. It was idle advice but as always she was unable to restrain her admonitory pen. Nor was she able to refrain from telling him with her usual mixture of frankness and guile that she passed a dreadful night with "torturing" dreams of the Duchess Grazioli.

The emancipated life had brought unexpected complexities. Love might be, as she had once told herself, a law unto itself, yet it humiliated its victims. With the thought of Blaydes still fresh in her mind,

and before him Obrist, she was obviously vulnerable and hardly en-
titled to be jealous. Still she held on to a remnant of pride. At their
parting in England Bernhard had promised to stick by her from "a
sense of duty." Her pride touched, she had responded, "Thee will soon
find it tasteless and boring, I fear."

Of all their friends Carlo Placci was proving the most durable and
companionable, and at St. Moritz he repaid their lavish hospitality by
introducing his distinguished friend to his fashionable acquaintances.
Placci had a contagious verve and his modest talents as a writer inspired
in Berenson no sense of rivalry. An aesthete of sorts, he nevertheless
clung to his conservative Italian roots among the emancipated cosmo-
polites of the Fiesole hillsides. Not long before they had patched up
their first serious argument over religion. Placci had fallen in love with
a seductive French Catholic countess, Madame Montebello. To Beren-
son's disgust Placci shed his cloak of socialist skeptic and became a
Catholic again, fasted on Fridays and talked religion. Berenson re-
marked to him that people who pray are only "half-educated." When
Placci resented the charge, Berenson took a conciliatory tack: "By 'half-
educated' I mean persons who seriously think that religious dogmas can
be defended on scientific principles. I think a man of (relatively) perfect
education may believe anything but such a man will not try to defend
his belief. With you I have no bone to pick. If it does not estrange from
me or make unpalatable one of the two dearest friends I have on earth, I
shall have nothing to say against your religion. I believe religion to be
an expression of temperament. Religion is a form of art; taken as objec-
tive reality it is the art of the unaesthetic; but taken consciously as sub-
jective it is perhaps the highest form of beauty." Mary could not help
noting in Placci's defense that she and Bernhard had themselves shared
the same folly when they fell in love.

Their differences smoothed over, Placci played a sportive alter ego to
Berenson at St. Moritz. Unwittingly, Mary provided them with an ex-
cuse for what must have seemed to them a chance to take Vernon Lee
down a peg. As a result it was to be twenty years before Berenson and
Vernon Lee would again be on speaking terms. Mary had been shown
the proof of a long article, "Beauty and Ugliness," jointly written by
Vernon Lee and her companion, C. Anstruther-Thomson, which was
to appear in the October issue of the *Contemporary Review*. In Mary's
precipitate judgment it appeared to plagiarize not only Bernhard's ideas
of tactile values and space composition but at times his very language.
She felt it her duty to put him on his guard, but at the same time she
urged him to avoid a quarrel: the thing to do was "just to drop such
people quietly." She suggested that the best pose would be "a dignified

approval of their work, sort of taking it for granted that those are the commonplaces of this sort of criticism . . . and to take a dignified, nonchalant air as if the world were large enough for thee and Vernon Paget both . . . but Bernhard, dearest, if thee tells even Placci, as I know thee will want to, it is all up. He will rage to the Pasolini, the Papafavas, everybody, and it will all get garbled round to Miss Paget. She will say . . . thee is jealous. . . . Thee doesn't want to put thyself in that position. Jealous of Vernon Lee!" Bernhard thanked her heartily for the letter about Vernon Lee's "thieving article" and her "excellent advice" and promised to act accordingly. "I will write to her very politely, but in a way that will make it perfectly clear to her that I am aware what she has done." Vernon Lee had just written to him enclosing a copy of the article, which he had not yet read, and he now construed her letter as "the expression of a very bad conscience." To Mary the article was a "caricature" of Bernhard's ideas in which the two authors had plundered phrases from his many discussions with them. She felt that though Vernon Lee's companion had little real understanding of art she had "a memory like a vise."

Granted that the general ideas were in the air, so to speak, as witness Hildebrand's earlier essay and William James's analysis of psychological perception, no one before Berenson had illustrated the part that muscular responses played in the visual perception of a work of art. The offending article developed the point in a far more systematic way than Berenson had done in *The Florentine Painters* and cited the recent scholarly treatises which had explored the subject. The thesis of the joint authors that "the perception of Form . . . implies an active participation of the most important organs of animal life" made the aesthetic experience a more complex process than that analyzed by Berenson. The argument was presented with an impressive array of technical psychological language and buttressed with much experimental data. It was almost as if Vernon Lee had decided to turn schoolmaster to Berenson, to show him how the matter really ought to have been treated. The parade of learning and science did not disarm his suspicion that his erstwhile friends were attempting to rob him of his claim of priority.

Egged on by the impish Placci, whom he had promptly confided in, he "concocted" the following letter:

St. Moritz, August 24, 1897

Dear Miss Paget,

I fully appreciate your kindness in sending me the proofs of your article. I am sure you intended to give me a taste of that pleasure which the blessed gods used to take in first fruits. I have just had my "first read off" [of] your paper,

and it certainly will not be the last. For where else shall I find such perfect dis-tillations, such delightful reminders of numerous conversations I have been privileged to have with you at the Palmerino, and of even more numerous visits with Miss Anstruther-Thomson to the galleries? And there I must make the *amende honorable*. Do you remember my sustaining that Miss Anstruther-Thomson was quite without a memory, while you opposed that she had a memory superhuman, incapable of forgetting? I see from your paper that you were right. Her memory is indeed startling. I confess it inspires me with a cer-tain awe; it is too much like conversing with a recording angel, one who stores up nothing against one, but takes the whole burden upon his shoulders.

With your main thesis I cannot agree—at all events I should not give it any-thing like the importance that you do. But with your instances, examples, and *obiter dicta* I am simply delighted. They are such familiar, cherished friends. Perhaps I was just beginning to like them too much as a matter of course, as something for the few initiated, already hackneyed, and you make me appreci-ate them afresh. How can I sufficiently thank you!

But it is your gift of putting things freshly, with all the illusion of lucidity that I envy. What is insight, experience, thought compared to it? All these and myriad other qualities are but purveyors to the divine gift of utterance. And yet I console myself, perceiving one fatal drawback to this gift. It is so frequently accomapnied by unconsciousness; and to people of my stamp, consciousness in every form, even under its ethical aspect of conscience, is after all the one humanizing thing—that which distinguishes man from brutes on the one hand, and the gods on the other.

I was very sorry to hear of Miss Anstruther-Thomson's breakdown, and anxious for her recovery. I am glad to know she is better. Pray convey to her my thanks and kindest remembrances. Four weeks of St. Moritz have ap-parently worked miracles with my health. Even if the after effects are indiffer-ent I shall have enjoyed days and days of the kind of well being that I had sup-posed vanished with one's teens. Then as luck would have it a number of our common acquaintances have been here. We have been discussing art a great deal, so that they will be well prepared to appreciate the originality of your method and result in aesthetics. I am sure they all would be sending you their regards if they knew that I was writing.

> Believe me,
> Very truly yours,
> Bernhard Berenson

If the form of the letter was a model of polite expression, its sub-stance aimed at the jugular, and one can imagine the delight of the two conspirators in honing the cutting edge of their reproof. After all, there were old scores to pay off. Vernon Lee had not spared Berenson's hypersensitive feelings in her destructive critique of his writings. He who had felt himself fitted for a literary career only to be bluntly told that he had "no literary gift as such" could hardly be blamed for leaping

to the conclusion that she had at last delivered herself into his hands. As for her old friend Placci, he too nursed unhealed wounds, for she had not spared the lash in criticizing his writings. The letter was undoubtedly a fine piece of satire and Berenson could take pleasure in its witty innuendos. But as Mary quickly discerned, the "semi-jocular" tone was needlessly insulting. The letter "appalled" her, and she rightly foresaw an "open unhealable quarrel, just what thee promised me to avoid." Then she added the more painful reproach, "I had idealized thee into a person who could not write such a letter at this." Moreover, he had compounded his "mistake" as she had predicted by confiding in Placci and the Pasolinis.

Berenson was satisfied that he had spiked "Vernonia's" guns, and he set off with Senda for Antwerp, where she was to embark for Boston on September 4. Mary met them there, and in the few hours they spent together sightseeing and shopping the two young women seem at last to have taken a liking to each other. Mary thought Senda "remarkably beautiful and refreshingly simple." Afterward, Bernhard wrote to his sister that Mary "is most enthusiastic about you." For the next two weeks Bernhard and Mary did the galleries at Wiesbaden, Darmstadt, and Mannheim and gorged themselves on Mozart, Wagner, and Berlioz at Karlsruhe. Mary returned to England to devote herself to her children, and Bernhard set out on September 20 for Venice to join Mrs. Gardner and her husband and then journey with them to Sicily.

For a number of days Berenson luxuriated as the guest of Mrs. Gardner in the ducal splendors of the Palazzo Barbaro. The visit to Venice of the Italian king, Humbert I, lent a carnival aspect to the city, and as Berenson and his hosts floated along the canals at night, fireworks lit up the sky, the water ran purple, and the balconies of the palazzi glowed like braziers to his eyes. He found himself growing fonder of Mrs. Gardner moment by moment. "She is the one and only real potentate I have ever known," he wrote Mary in September 1897. "She lives at a rate and intensity, and with a reality that makes other lives seem pale, thin and shadowy." He felt curiously reassured of his identity in her presence. "She seems really fond of me, of me, not of my petty repute, not the books I have published, and that is charming." The only grating note as they floated along was Mrs. Gardner's report of a luncheon talk the day before with Violet Paget, who in a mocking tone had allowed herself to wonder when Berenson would discover Whistler. Mrs. Gardner had assured her that Berenson had made the discovery long ago. Then Vernon Lee "uttered all the evil she could of you, how you were a dreadful poseur, always flitting about."

Mrs. Gardner and her husband had returned to Venice after an ardu-

ous trip buying antiques in Munich and Nuremberg, and for two weeks before Berenson's arrival had triumphantly raided the shops of Venice for "columns, capitals, reliefs, frescoes, mirrors, cassoni, chairs, fountains, balconies," and façades of palaces for the private museum they were planning to build in Boston. By the time Berenson arrived she had become a reigning celebrity, and when she appeared at a reception in honor of an English naval squadron which was paying a courtesy call, her magnificent jewels were the only ones described in the newspaper report.

During the final week of her stay, with Berenson beside her, she embarked on an "orgy of wholesale buying" of more furnishings for her palazzo-to-be. It undoubtedly added to her pleasure that she could count the famous young art critic and connoisseur among her prized acquisitions. For the moment Berenson enjoyed basking in the imperial sunshine. During the year he had already helped her to acquire four treasures, beginning with the superb *A Lady with a Rose* by Van Dyck, often called Van Dyck's Mona Lisa. This had been followed by a charming *Madonna and Child* attributed to Cima, then by the so-called Forlì Titian, for which Berenson had been kept dangling for so long. This was succeeded by Correggio's *A Girl Taking a Thorn from Her Foot.* Before the year closed she was to make two more purchases through Berenson, one, Carlo Crivelli's magnificent panel *St. George and the Dragon,* the other, two wonderfully expressive cassone panels by Pesellino. The year's purchases of those paintings alone exceeded $200,000. As fate would have it, the passage of time dealt unkindly with some of the attributions. The Cima is now said to be "after" the artist, and the Correggio "influenced by." And the Titian, as noted earlier, was ultimately rebaptized a Sanchez Coello.

A curious story attaches to the exportation of that painting in June. Berenson and his agent Apostali obtained a *permesso,* the venal or ignorant customs official in Milan accepting a declared value of 400 francs. Since Mrs. Gardner had paid something like $75,000 for it, it was important to insure it for its market value of 400,000 francs. The insurance representative granted the insurance, but because he feared that a corrosive acid had secretly been spread on the painting to destroy it before it reached London, he insisted on Berenson's staying in Milan until word was telegraphed that the painting had arrived safely and his company's liability ended. His reason, Mary noted, was to allow adequate time, if there was a plot, "to let the acid work!!"

The journey with the Gardners had been a leisurely one. As they moved south they had spent a couple of days "at my darling Siena," several more at Rome to collect more Renaissance bric-a-brac, and

many more in Naples before crossing to Sicily. Berenson lived over again the raptures of his first visit to Sicily and his purple prose in letters to Senda showed how much he relished his role of cicerone. Close acquaintance with Mrs. Gardner did not dim his admiration. She was "an enchantress if ever there was one," and he admonished Senda to cultivate her. Senda did as she was bidden and was in turn warmly embraced by Mrs. Gardner among her loyal retinue.

Mary had every reason to feel chagrin at the prospect of a quarrel with Vernon Lee, for the hospitality of Il Palmerino was a pleasant resource and she often found Vernon Lee an "enthralling talker." As one who cherished her own independence as a career woman, Mary obviously did respect in some degree Vernon Lee's achievement as a writer. She must also have realized that the loyal defense of Bernhard's position would inevitably fall on her and on her more facile pen. In uncomfortable situations Bernhard, having relieved his piqued feelings, retreated to the security of his study and left the hazards of the rearguard action to Mary. Vernon Lee's counterthrust was not long in forthcoming. She took Berenson to task for his "equivocating sarcasm" and his "jocular ambiguities" and, not one to mince matters, rendered his charges into the embarrassingly plain English of "plagiarism." In quite evident rage she denounced his criticism of her collaborator, declaring that three-quarters of the essay had been written by Miss Anstruther-Thomson, and then salted her riposte by reminding him that she had helped him in his "tongue-tied days." She demanded at great length in her letter that he provide the specific grounds for his accusations.

Berenson had only recently returned from his tour of Sicilian antiquities with Mr. and Mrs. Gardner, ready to resume work on the first chapter of his magnum opus on the Florentine drawings, when he was greeted by Vernon Lee's demand for a bill of particulars. Aware that he had been imprudent in challenging his Amazonian neighbor, he asked Mary to man his defenses. Perhaps it was her "passion for intrigue," which their friend Blaydes had once noted, as well as her loyalty to Bernhard that motivated her to take on the dubious task. Perhaps she had a guilty conscience for having been the first to alert Bernhard and to have done so with such vehement assurance that Vernon Lee had flagrantly plagiarized. It was not long, however, before she regretted being drawn into the affair, for the rejoinders and counterrejoinders that leaped back and forth between the Villa Rosa and Il Palmerino became interminable. In her first thirty-page missive Mary explained that Bernhard had "put the matter into my hands with the request that I shall act for him." Mary's letter was an eloquent defense of Bernhard's

theories of art as "life enhancement," of "tactile values" and "move-ment" and "space composition," but as Vernon Lee was quick to point out, it did not really establish plagiarism. Hence within a few days Mary responded in a twenty-five-page letter that "Mr. Berenson con-fessed that he made a mistake in profferring an actual charge of plagia-rism against you and Miss Thomson and that as he was not able to prove it, he would not repeat the accusation. . . . He asks me to send his regrets and apologies and to tell you that he will say the same to the two people with whom he talked it over."

Unfortunately, Mary was not permitted to stop there. She added Bernhard's qualification that "at the same time, his *impression* remains the same," a qualification which required lengthy exposition on her part. Moreover, Bernhard would have nothing to do with Vernon Lee's proposal that the matter be submitted to impartial arbitration. Mean-while, Miss Clementine Anstruther-Thomson joined the dispute, and Mary found herself involved in a voluminous exchange with her as well, in which she also offered a full version of Bernhard's explanation. She explained that he feels that in teaching you " 'to see' as you say," he gave "you his most precious possession, his attitude to art, his method. Though he did not invent it he thinks he has been the first to adopt consistently the introspective standard to painting, sculpture, and architecture, not being led astray by the subject, the technique, the art-ist, or the metaphysics of Beauty." As the rejoinders in the controversy piled up, Mary burst out to Vernon Lee, "I wish for all our sakes I had not come into it."

But she was hopelessly enmeshed, for on November 17 Vernon Lee informed her, "We are today writing Mr. Berenson an acceptance of the retraction and apologies which you kindly transmitted to us on his behalf, and here our intercourse with Mr. Berenson ends. But there remains a thing which our desire for a thorough hearing, and your own wish (manifested in both your last letters) for complete justice, makes us [believe] you will not refuse." As "an act of justice" she asked Mary to examine their notes, since Bernhard had apologized without having done so. Unable to resist the appeal to her sense of fairness, Mary agreed.

The meeting at Il Palmerino took place in the presence of witnesses. Vernon Lee and Clementine Anstruther-Thomson had Maud Crutt-well, Mary's former housekeeper, and a Miss Wimbush "as seconds," according to Mary's diary record, and Mary had her American cousin Edith Thomas, who was then visiting Florence. "We were ushered into the drawing room," Mary wrote, "and greeted as if we were execu-tioners, not a smile, not a remark. . . . Miss Thomson then led the

way into her study with the air of going into the room where a corpse lay, and proceeded to read us a paper containing the history of her art career. . . . A little discussion arose upon the question of what she meant when she said Bernhard had 'taught her to see,' I contending that he must have given her his method in the process and she contending practically that he never said anything to her except the dryest sort of connoisseur details. It was a frivolous wandering discussion, but she managed to lose her temper a number of times." She gave "the impression of real vindictiveness and vanity . . . the poor thing was quite grey and trembling. I thought of her remark 'If I stole my ideas from Mr. Berenson how is it I am now suffering from brain-exhaustion?' " Vernon Lee had presented her papers and notes very effectively and Mary was impressed. "I must say she convinced me that she had been *on the track* for many years." Mary came away from the futile airing of irreconcilable opinions liking Vernon Lee "better than before" but with her "bad opinion" of Miss Thomson "deepened." The pathos of the encounter lingered with her as she recorded that her American cousin "was curiously impressed by the sight of these maiden ladies, dressed in stiff shirtfronts with wrinkles where most women have a certain fulness, crossing their legs and putting their hands in their pockets, and taking this petty little squabble with the seriousness of a European war at least."

That the two extremely sensitive and thin-skinned rivals should have fallen out should hardly have been matter for wonderment. Both had entered the arena of art criticism as amateurs and outsiders, both were insecure challengers of the Establishment. If their one talent was death to hide, it was also death to share. To such ambitious and competitive temperaments eminence was not sufficient, one must be preeminent. Perhaps in their small way they simply reflected the prevailing temper of their age, an age of free enterprise and anarchic rivalries. Vernon Lee's high-minded criticism of Berenson's vanity was "slightly marred" for Mary by the fact that when she had invited Vernon Lee to contribute to the *Golden Urn* she said she could not afford to do so because it was so hard to "keep her name before the public as things were." If Berenson left the field without much honor, at least the overt hostilities were over, and to his relief, he told Senda, his "acquaintance [was] diminished by the whole Vernon Lee clan, her brother, her ass, her manservant, and all that is hers. Thanks be to God on high, and henceforth I pray for peace and goodwill to men on earth."

Peace of a more prosaic sort had been much on his and Mary's minds since early that spring, when Mary had fumed that their landlord Kraus "played his beastly Brass Band morning and afternoon," so that in des-

peration she had notified him that she would move by the end of the year. As Kraus and his fellows persisted in their hideous clamor, Bernhard and Mary began househunting once more. At first Berenson thought he would buy a villa and be finished once and for all with the chore of moving, but they finally chanced upon comfortable dwellings lower down on the hill at San Domenico in the little lane of the Via Camerata and engaged them on June 10. Mary and her brother, Logan, rented the more commodious villa at number 1, at the angle of their walled lane and that of the Via del Palmerino, the lane on which Vernon Lee lived. Bernhard took a place a few doors down at number 5. The leases were to run for three years. In the following year, when the villa at number 3 became available, Bernhard moved again, to become practically a next-door neighbor to Mary and Logan. Ironically, they would now be much closer to Vernon Lee, who had passed from their acquaintance. The move shortened the walk into Florence by a mile and a half, but it cost them their superb overlook of the valley. Once again the carpenters and the upholsterers were maddeningly under foot, and the contingent for Mary's Villa Frullino also included a troop of gardeners. The piles of books to be shelved had grown ever higher. They all lunched at Doney's on Christmas day, 1897, to escape the confusion. The next day they were able to spend their first night in their new villas.

Berenson's passionate interest in the decoration of his new dwelling reflected the current desire among upper-middle-class Americans to achieve the "house beautiful" of the fashionable world. Symptomatic of that vogue was Edith Wharton's sophisticated *Decoration of Houses,* which was about to be published. Knowing that Mrs. Gardner shared this taste, Berenson took her on an epistolary tour of his place, illustrated with a floor plan. He acknowledged that the view from his window was "tame" compared with that from his "Fiesole eyrie"; nevertheless, he could look out on "the dear toy castles on the heights," which made a "Gozzoli landscape." He told her he had turned the ground floor of the villa into an entrance hall and a guest room and had furnished the entrance hall with his "most gorgeous bureau." Then he described his own living quarters on the floor above, starting with a white-walled library with white bookshelves and walnut photograph cases. Next came the Green Room, dominated by the Venetian escritoire he had got at Della Torre's and a "resplendent armchair." Brown sacking hung on the walls from ceiling to floor, a "gorgeous cope" above a bookcase forming a striking contrast. An exquisite Aubusson carpet covered the floor. In the adjoining Red Room the walls sported a "wonderful damask yellow on a red ground." The climax of the tour,

he announced, was his bedroom. The dainty decor of Japanese matting on the floor and a Louis Seize baldachin covered with pale blue-green silk hangings over the divanlike bed had aroused the laughter of his friends, he said, because they thought it "not for a bearded man, but for a delicate creature, a Christabel." Mrs. Gardner thoroughly relished the account. "I shall come and take your rooms," she responded; it is much too good for anyone but me." "Your letters," she assured him, "are the joy of my days."

One visitor whom Berenson was spared that year was his old acquaintance Oscar Wilde, who had recently been released from Reading Gaol. Wilde had avoided Florence and gone down to Naples, according to Horne's report, and had joined up again with Alfred Douglas. Rumor also had it that a bookseller was paying him a pension of sorts to write indecent books to sell at thirty to fifty pounds a copy. Not long afterward Berenson received an urgent note from London signed simply "W.T.B." (William T. Blaydes) asking him to write to Oscar Wilde, who was living in Naples under the name of Sebastian Melmoth. The note declared that Wilde "is very susceptible to personal influence. . . . At present under the feeling that every man's hand is against him, he is utterly demoralized and going as straight as he can to the devil. He is provided with money for the present (which he uses chiefly to that end), and just now is making a foolish trip to Taormina for a few days. He says that when he comes back he does really mean to pull himself round—but he is mixed up with rascally people, and I fear he will find great difficulty." Berenson appears to have left the appeal unheeded. Wilde in fact was plainly beyond counsel. He had become a tourist attraction at his favorite café in Naples. It was true that Leonard Smithers was a publisher who dabbled in pornography on the side, but he was then busy with Wilde in putting the *Ballad of Reading Gaol* through the press. Soon abandoned by Douglas, Wilde returned to London and Paris to wear out what was left of his life.

XXII

A Tangled Web

BACK at his desk again early in November of 1897 Berenson tackled the dismaying array of notes which had been piling up on the drawings of the Florentine painters. Within two weeks he had finished a draft of the first chapter, having overcome his dissatisfaction with the project, which now threatened to heavily mortgage his future. It proved a deceptively rapid beginning. He found it hard to resign himself, he said, to falling away from his original vision of the great work on aesthetics, which now seemed to escape him. His deepening involvement with the exigent Mrs. Gardner and his other clients inevitably foreshadowed more distractions and anxieties over conflicts of interest. Her letters imperiously challenged him to be on the qui vive for more masterpieces, as if he were a favorite jockey on one of her mounts and expected always to finish first. And at his back, goading him helplessly forward, were the "racking business worries" of his new scale of life. Pounds and lire and francs drained away with uncommon speed when for large parts of the year one traveled first class, stopped at fashionable hotels, haunted the theaters and the opera, picked up expensive objets d'art, and maintained two establishments, one for himself and one for Mary. Mary particularly was not one to stint. Moreover, acting on friendly tips from Davis and others, they poured money into stock in Tennessee Coal and Iron and into tobacco and sugar stocks, with the result that debts piled up in a rather helter-skelter fashion and, left to Mary's management, seemed always to hang like a sword above them.

When they had parted in July, Bernhard going on to St. Moritz with his sister and Mary heading for Karlsruhe and Haslemere, Bernhard had cautioned Mary, "Only bear in mind we must decidedly begin to economize, and running backwards and forwards between Karlsruhe and

Haslemere takes money." But neither one could economize. For example, when a Roman dealer arrived with a "lovely Rembrandt" and some Japanese bronzes, Berenson impulsively bought the lot. And when soon after another dealer showed up with a Sienese portrait, he bought that also. Moreover, Berenson found himself taking ever-greater financial risks to obtain options on paintings to reserve them for possible purchase by Mrs. Gardner or by other clients. And in the process he and Mary succumbed to the get-rich-quick atmosphere in the booming art market. Once embarked on the path of lucrative connoisseurship, he was to find his moral landmarks subtly displaced in the demi-monde of art dealing, where intrigue and mystification were the order of the day.

Welcome word came, early in December of 1897, that his *Central Italian Painters,* the third small volume in the projected series, was now out. Mary with her usual enterprise set about writing a review article for the *Atlantic* to ensure its proper reception in America, as she had done for his previous books, but this time the article failed to get into print. However, the book did not need her puff. It met with especially gratifying reviews in England. The reviewer in the *Manchester Guardian* concluded by praising the "real sensitiveness to painting, the numberless acute remarks, and the constant stimulating quality of the thought that characterize the whole volume. Mr. Berenson seems to us to improve as a writer; he is not always faultless, but his exposition is forcible, his phrases and illustrations are often striking, and his descriptions of pictures sometimes touch a high level of eloquence. It is a book to be bought and thought over."

A more cautious critic in the London *Times* declared that many points were debatable and attributions too dogmatically asserted, but he admitted that the volume, like its predecessors, showed "a very great knowledge of the pictures themselves; for probably no one living or dead, not even Cavalcaselle or Morelli himself, has seen or noted so much." In addition, the volumes showed "a gift for philosophical generalization very rare among art critics everywhere." He concluded that the book "like his other works is an important contribution to the scientific criticism of Italian art." The review that must have given Berenson most satisfaction was that in the *Nation* by Kenyon Cox, the art critic whom Berenson had once considered his adversary. Cox praised the "ingenuity, the subtlety of reasoning and the wide range and thoroughness of knowledge which . . . make him a person to be reckoned with in all future criticism." Berenson's theory of "space composition," the sense of space as fostering the religious emotion, impressed Cox with its ingenuity and aptness; and he largely agreed with the

division of the elements of art into "Illustration," that is, everything, such as narrative, that is not purely artistic, and "Decoration," that is, everything purely artistic, such as form, movement, composition, and color.

The publication of the book gave a reviewer in the *Harvard Graduates Magazine* an opportunity to evaluate all of the four volumes which had so far been published by Berenson. He arrived at a somewhat guarded estimate, arguing that "tactile values" was an "obscure substitute for modelling or form." But if Berenson's "science" did not inspire confidence, he "delights by the vivacity, cleverness and profundity of his criticisms"; his judgments were so bold "that he exercises a fascination alike over those that trust and those that distrust him." Berenson could take satisfaction in the fact that he was honored in his own country, but the allusion to the partisanship which he had aroused was further evidence that he was becoming a symbol of the larger conflict between the romantic and the realistic schools of criticism.

William James was quick to see how well his former pupil had assimilated his own theories to the criticism of art. "I am enthusiasmé," he wrote. "The most utterly charming book about pictures, leaving out of course Fromentin's *Maîtres d'autrefois,* that I have ever read. You've done the job this time and no mistake. So full of love for the things you write of, so true pyschologically, and then such an English style! . . . Of course I like particularly what you say about habits of visualizing, etc., in this connection with taste. I think your life enhancement and your tactile values are ultimate analyses of the effects you have in mind. . . . I am sure that you are on 'sound lines.' I trust that the book will get you the wide reputation you now deserve." James's praise of the style must have given him particular pleasure since style was a sensitive point between him and Mary.

The critical problem which Berenson had set himself was to define the distinctive qualities which set apart the Central Italian schools of painting—those which flourished in Siena and Umbria—from the Venetian and Florentine schools, the one marked by the pursuit of "splendour and harmony of color," the other by the expression of "form and movement" and tactile values. He concluded that the great Central Italian artists—Duccio, Simone Martini, Lorenzetti, Signorelli, Perugino and his fellows, and even Raphael—were distinguished by their mastery of Illustration, or narrative and dramatic representation, at the expense of the more formal elements. Wherefore they attracted the attention of the most cultivated public, if not of the most artistic. They "were not only among the profoundest and grandest, but among the most pleasing and winning Illustrators that we Europeans ever have had." It was

true that some exhibited to a greater or less degree a grasp of the more purely artistic elements, whether of movement and tactile values as in Signorelli or of space composition as in Perugino, but in all, these elements were subordinated to the ideal of Illustration, to "the purpose of conveying ideas and feelings by means of . . . visual images." Wherever the painter stood in the hierarchy of excellence, he received an eloquent and sympathetic analysis of his special achievement: "Signorelli's Nude . . . does not attain to the soaring beauty of Michelangelo's; but it has virtues of its own—a certain gigantic robustness and suggestions of primeval energy." "Raphael was not only the greatest Space-Composer that we have ever had, but the greatest master of Composition in the more usual sense of grouping and arrangement," as in the famed *Disputa.*

In later editions Berenson did not revise in any significant way the verve and poetic fervor of his characterizations in this or the companion volumes, but having rendered judgment, he thereafter devoted his energies to correcting and expanding the appended Index of Artists, lists which ultimately became an all-consuming preoccupation. The progress of his and Mary's researches is illustrated in the second edition of the *Central Italian Painters,* which was brought out by Putnam's twelve years later; the lists of paintings and their locations which Berenson had ferreted out had grown from 75 to 180 pages. All the lists would be brought up to date in 1932 in two volumes and enlarged again in a series of volumes, the first, on the Venetians, in 1957 under Berenson's supervision, the remainder posthumously in 1963 and 1968, forming a guide without parallel for any other period or country.

His publisher had been prompt in exploiting Berenson's meteoric rise as a critic and connoisseur. *The Venetian Painters* was especially called for, so that the third edition, which appeared in the autumn of 1897, was offered in two forms, one with but a single illustration, the other a de luxe printing with twenty-four beautiful halftones. But pleasant as were these tokens of his success, they seemed only to mock him as he plunged deeper into his researches for the Florentine drawings. Digging in musty archives, struggling with bureaucratic curators for a glimpse of their holdings, poring endlessly over the enigmas of unsigned sketches, he sometimes felt he had lost his way, and he would lament the "dulness and unimportance of his work." He felt cheated of the aesthetic possibilities of existence and would take refuge in the hexameters of the *Iliad* and the *Odyssey* and the dramas of Sophocles or in reading aloud with Mary book after book of the Old Testament, as if to exorcise the trivial present. Then there would come an exciting interlude, as when he began to analyze the work of Leonardo da Vinci

and found himself carried away by the profound and subtle writing of the artist. The composition of the monumental work went by fits and starts, frequently interrupted by protracted negotiations for paintings and other works of art for his clients or occasionally for himself. The annual circuit of travel on the Continent and in England, with its perpetual inventorying of art and architecture, its pleasure jaunts and conferences with dealers and collectors, its opera- and theater-going, took its toll of precious time, until he confessed to Senda that at the rate the book was going "its completion becomes a matter of astronomic conjecture."

The only piece of new writing that he was able to publish in 1898 was an article in the *Gazette des Beaux-Arts* on a Madonna of the Florentine Alessio Baldovinetti that had recently been sold to the Louvre as a Piero della Francesca. He explained how some years before, while leafing through a photo album in the hospitable shop of Braun, Clement & Company, he had chanced to see a photo of this Madonna, which he immediately recognized as being not by Piero della Francesca, as represented, but by a far rarer master. He had finally examined it in the collection of the Duke de la Tremoille and had wondered whether he would ever see it again, for he knew that the peregrinations of a painting never ended until it came to rest in a public museum. He recognized that the museum practice of hanging pictures on a wall like postage stamps according to historical categories violated the sole legitimate principle, that of aesthetics; nevertheless, it did rescue art for the student. And this painting was the most important Italian work to be acquired by a public museum in many years. His purpose, therefore, was to establish the true identity of the painter; and this he proceeded to do by a detailed analysis of the contrasting styles of the two painters as seen in their already known works. He followed this by a careful dissection of the physiognomy, anatomy, scenic background, and color of the painting.

The impressively exhaustive demonstration showed once more that Berenson's authority as a connoisseur in his chosen field was unimpeachable. And once more it served notice on art dealers that the attributions of their Italian paintings were at the mercy of this brilliant and unsettling young upstart. One of the important London houses to which he had already given offense by spoiling "their game more than once," as he told Mrs. Gardner, was the firm of Agnew's with which he nonetheless maintained business relations. As a consequence there was no lack of adversaries eager to take him down a peg, and they were joined by hostile critics like Loeser and Vernon Lee in Florence and Arthur Strong in London and their circles of partisans. Hence a sharp

lookout was kept for word of any dereliction on his part, and the gossip mills seized on every whisper.

It was obvious that his Achilles heel was his now widely known connection with Mrs. Gardner. He had tried to dissuade her from referring to him as her agent or adviser, for he was jealous of his independence and fearful that advertising his association with her would hamper negotiations, but the fact could not be concealed, especially since Mrs. Gardner took such pride in his achievements on her behalf. Her husband, though indulgent of her whims, had begun to have misgivings about her extravagant purchases and her unquestioning reliance upon Berenson's judgment. Early in 1898 she wrote to Berenson that he thought that she should stop her buying. "He thinks every bad thing of you," she continued. "I too begin to look on you as the serpent and I as the too-willing Eve." Then, with charming inconsequence, she implored him "like a dear, like the true friend you are," to get a pair of Holbeins which she coveted, paintings which Berenson had told her were then tied up in a Chancery lawsuit to break an entail.

The year 1898 turned out to be one of spectacular acquisitions by Mrs. Jack, despite her protestations of poverty. The Loschi Giorgione owned by the Zileris was bagged at last, but it was now overshadowed by a great Rubens, the Count Inghirami Raphael, three Rembrandts, and a Cellini bust. To all of which was also added a Bronzino, a prized Ter Borch, and a small Masaccio, which for a brief while decorated one of the walls in Berenson's villa during the negotiation with the Florentine dealer Costantini. In fact, the year's purchases through Berenson came to nearly $300,000.

The tortuous closing of a sale and the successful exportation of a painting, often with an expensive detour to Cavenaghi in Milan for necessary restoration and repairs, did not end the chain of expenses. There followed the costly framing and packing in Paris for the voyage to Boston. But most onerous of all was the new American import duty, which seemed the unkindest cut of all. The Dingley Tariff Act, passed in July 1897, restored the 20 percent import duty on works of art that the McKinley Act of 1890 had removed. It exempted only those works of art intended for public museums. Though the new law was denounced in the press as "senseless" and "an almost unmitigated evil," it was not repealed until 1909, when paintings and sculptures more than twenty years old were restored to the "Free List." Four years later the twenty-year restriction was dropped.

The Forlì Titian, Mrs. Gardner reported in March 1898, had come too late to escape the duty and the exaction amounted to $15,000. However, the levy did not dim her sense of triumph, and she boasted

to Berenson that her Green Hill estate had become the "American Villa Medici" and she had established the "prix de Brookline" to replace the Prix de Rome. "Four painters are here, hard at work . . . [with] models if they like." She exulted that any time she wanted to she could see in her Boston salon her *Europa,* her Rembrandt, her Bonifazio, her Velasquez. "There's richness for you."

Nevertheless, the import duty rankled, and when in 1900 she purchased a little *Pietà* by Raphael at a cost of $25,000, she balked at the thought of a further outlay of $5,000 to the United States customs and at waiting for the painting while it languished in the bonded warehouse. In her annoyance she queried Berenson, "Can it be sent to me *smuggled* . . . so that I may get it as soon as possible without any duties?" Berenson dutifully passed on her request to Gutekunst, who replied that if Mrs. Gardner would assume all risks it could be sent express or by one of their employees, "but it must not be smuggled." What could be done, however, would be to declare the picture as of the "school of Perugino at six hundred pounds" and consign it to Colnaghi's agent in New York so that Mrs. Gardner's name would not appear. She could then send an agent to pick it up. The result would be a saving of $4,000 in duty. The picture arrived safely, but it did not end Mrs. Gardner's passionate longing for an ideal Raphael, a Madonna and Child, a treasure which Berenson was to search for in vain.

Berenson sometimes rushed an offer to Mrs. Gardner before he was certain of the price, and he would quote a figure high enough to assure him a free hand in the often frenzied scramble for a prized work. So when he learned that a reputed Dürer in the Czernin collection in Vienna was about to go on the market, he suggested to her it would "probably take 12,000 pounds or so to get it." Later, word somehow reached her that the painting could in fact be acquired for a lesser figure. In a rather roundabout explanation Berenson said that he had delayed urging the purchase upon her because she had complained of the difficulty of scraping together money for the Inghirami Raphael. In the meanwhile, he conjectured, the Czernins may have been getting more and more hard up and thus have become willing to take less. Hence the seeming discrepancy. Assuring her he had done nothing to spoil the market, he suggested that she have her informant get the painting for her if he could, and if not then to call on him again. Whether she felt the implied reproof does not appear. In any event that project fell through and she did not acquire a Dürer until three years later.

The letters that hurried back and forth between Berenson and Mrs. Gardner that year were livelier than ever, his filled with descriptions of paintings seductively offered, hers sometimes with excited acceptances,

but more often with reluctant refusals. Pleas of impending poverty would be followed by word that her financial advisers had relented and funds were being sent to Baring's, Berenson's London bankers. Her letters were sauced with such piquant sidelights as that Harvard had beaten Yale, 1 to 0, "and at football too. Ole! Ole!" (Meeting the captain of the team was "the proudest day of my life.") This animated exchange of business and banter was suddenly interrupted late in September 1898 by a cry of alarm from Mrs. Gardner: "There is a terrible row about you. . . . I have been sorry always when I have heard disparaging things about you; now the vile things have been said to Mr. Gardner. . . . They say (There seem to be many) that you have been dishonest in your money dealings with people. Hearing this Mr. Gardner instantly makes remarks about the Inghirami Raphael you got for me. He says things I dislike to hear and then brings up the Schönbaum Dürer and quotes the differences in prices. I cannot tell you how much I am distressed." She told him that her husband had nevertheless agreed to lend her money to buy the three Rembrandts from the Hope collection which Berenson had offered her, saying, at the same time, " 'Now we shall see if he is honest.' " She warned him, "You have enemies, clever and strong. What plots they lay for you I do not know but I am certain they are always watching for you, and misjudging you and making false representations. I pray that you may be successful in making excellent bargains for those three pictures and that you may go your own straight way in the teeth of these evil speakers. . . . I fancy . . . the Paget [Vernon Lee] crowd are not the only enemies you have. Be on your guard."

Mrs. Gardner's letter filled him with consternation, for he was aware that the price he had quoted for the Hope pictures was £1,000 more than the figure authorized by the Chancery Court and also that he had been less than candid with her about his sharing in the profits of several other of her purchases. Mary, always the pragmatic one, tried to console Bernhard with the thought that even if Mr. Gardner ("who was always jealous") did believe the accusations, "Still, *she* does not, and that is the important thing." Knowing his penchant for going to pieces in a crisis, she admonished him: "Above all, do not be frightened or ill at ease, or act as if any thing were on thy conscience. . . . Time to confess when something is suspected, and nothing even may be, so put a good face on, dear Bernhard, it may save the situation." It was frigid comfort, for he was overcome with remorse and fear. In his despair he saw his enemies triumphant and himself, as he wailed to Mary, poor and disgraced before the great world from which he had with so much dedicated study and labor commanded respectful, if sometimes grudg-

ing, homage. In anguished humility he wrote, "Could I count on you you would suffice me." The corrosive doubt lay close to the surface. Mary hastened to reassure him, though she could not resist emphasizing his moral lapses. She hoped that the trouble would be "a severe lesson for the future. Not that it is not what everyone does, but still thee has long felt that was not really an excuse." She felt a flood of "tender and devoted feelings," and in her private self-examination concluded that he was "the only really interesting person in the world to me. His mind is a continual delight."

Berenson's panic yielded to sober reflection. There was no sign that Mrs. Gardner was ready to abandon him. Relying on her bottomless vanity, he first turned the other cheek and then bent his knee in knightly submission. Her husband's suspicions, he assured her at the conclusion of a six-page letter, seemed to him "quite natural" under the circumstances and therefore he felt no animosity for Mr. Gardner. As for her uneasiness, "whatever comes, I shall always worship you as without exception the most life-enhancing, the most utterly enviable person I have had the good fortune to know. But I hope for the best and that our friendship is but at the beginning." Craving affection as she did, and never sure of it in Boston society, whose taboos she loved to flout, she found his flattering protestations irresistible. And when she graciously reassured him of her confidence, he pulled out all the stops of adulation: "You really are the most lovable person on earth, sunshine become flesh and blood. I know not how to describe you, but a miracle certainly, a goddess and I, your prophet." The high-flown and lavish tributes matched her queenly longings, and if less restrained than those tendered by such friends of hers as Henry James and Henry Adams, they were equally freighted with private irony.

What his financial arrangement was with Otto Gutekunst concerning the Hope pictures remains obscure, but in view of Berenson's panicky fears it plainly would not have borne disclosure. Mary shrewdly hit on a plan for accounting for the discrepancy between the price paid by the Colnaghi firm to Lord Francis Clinton-Hope under the Chancery Court proceedings and that quoted to Mrs. Gardner. She suggested that Gutekunst could be relied on to stand firm. If then it was learned that "the Hope pictures had been offered for less, thee must just make Otto divide up with [Charles] Wertheimer [a London art dealer] who will then keep silent . . . It wouldn't do to ask less now." Wertheimer was thus brought into the transaction [presumably for a consideration] as having a part interest, and the danger, so far as the Hope paintings were concerned, was passed. The scare brought the two strayed lovers together again. Mary wrote, "Thee can't think how I love thee and

long to console thee and cheer thee up . . . to help thee bear thy burdens as thee has long borne mine," an allusion to her anxieties over her children and her troubles with her husband. Bernhard replied that "this fight will have had its uses if it has succeeded in making you realize that you do love me—at least as one loves the dearest friend on earth." He was then visting Ravenna with Bertrand Russell and went on to say that when they sat down at the water's edge "under the graceful trees in the soundless air," though his "mouth was bitter and my heart in my throat, yet I doubt I ever enjoyed more. Strange paradox of sensation!"

Mr. Gardner, as good as his word, lent his wife the £40,000 for the new acquisitions—£19,000 for the Rembrandts (a self-portrait, the double portrait *A Lady and Gentleman in Black,* and the dramatic *Storm on the Sea of Galilee*), £11,000 for the Ter Borch, and £10,000 for the Cellini bronze bust of Bindo Altoviti. Payment was made, and Mrs. Gardner sent the 5 percent commission (£2,000) to Berenson's account at Baring's in London. Obtaining the three Rembrandts as well as the Ter Borch had indeed been a considerable coup, for there had been important rivals, including the Rothschilds. In a letter to Mrs. Gardner Berenson declared that he had been unable to beat down the price as she had hoped because he had in a way "rifled" the Hope collection to obtain its masterpieces for her and thus depreciated the value of the remaining pictures. Berenson was providentially relieved from the need of allaying Mr. Gardner's suspicions by his sudden death from apoplexy on December 9, 1898, at the age of sixty-one.

For a few months Mrs. Gardner's mourning figure was a striking sight, enveloped in a heavy black crepe veil that hid her face and nearly reached the ground. Inactivity was not her forte, however, and by the end of January, eager to get on with the plans for her museum, which her husband's trust fund now made practicable, she cabled Berenson to purchase the famous Holbein portraits of Sir William and Lady Butts and the exquisite Fra Angelico *The Death and the Assumption of the Virgin,* paintings which Berenson had proposed to her in the preceding year. They had recently been acquired by the Colnaghi firm and were then on loan to the National Gallery.

Mary had viewed the Holbeins with Gutekunst during a visit to England early in January and had been enthusiastic about them. While in her company Gutekunst had confided to Mary that he feared Bernhard had grown less fond of him. Bernhard, more given to suspicion than Mary, no doubt had held him responsible in some way for the painful embarrassment over the Hope negotiation. Mary, more acutely aware of their dependence on Gutekunst, urged Bernhard to reassure him. Bernhard obeyed, their affairs resumed a relatively smooth course, and

the Fra Angelico was soon on its way across the Atlantic. The Holbeins followed a few months later.

With Mr. Gardner's death the season of spectacular purchases began to draw to a close, and like many another widow Mrs. Gardner became aware of the shrinkage that afflicts an estate. Still rich, she nonetheless felt the far-distant chill of restraint, if not of actual penury. "I had two fortunes," she wrote in May 1899, explaining why she was turning down one of Berenson's proposals, "my own and Mr. Gardner's. Mine was for buying pictures, jewels, bric-a-brac, etc. Mr. Gardner's was for household expenses. The income of mine was all very well until I began to buy big things. The purchase of Europa and the Bull was the first time I had to dig into capital, and since then those times have steadily multiplied. All that reduces the principal, and then the income gets smaller and smaller, and leaves very little chance to replenish the principal. Woe is me! The income from Mr. Gardner's fortune is about half what it was before his death, owing to the trustees changing everything to perfectly sure investments that give very little return, so that household expenses are also much cut down, and I have a hard time of it." She said that people mistakenly thought that she had many millions and that she was, as a result, deluged with clever begging letters. "Probably much of the misunderstanding comes from the way I spend my money. I am the only living American who puts everything into works of art, I mean, instead of into show and meat and drink." Her estimate of her situation was to prove unduly pessimistic. She did continue to buy notable works of art from time to time until a few years before her death in 1924 and of course completed her remarkable museum in the Fenway, but her flair for the magnificent gesture began to be tempered by longer periods of prudence and curious bursts of drastic domestic economies.

Industrious as Berenson was in ferreting out choice things for Mrs. Gardner, he could on occasion be forestalled, much to his embarrassment, as in the famous case of the so-called Chigi Botticelli. It must have been particularly annoying to him that she first learned of Botticelli's exquisitely lovely *Madonna and Child of the Eucharist* through young Richard Norton, who shared his father's opinion of Berenson. He had been employed occasionally as her agent in buying objects of art. Norton was then in Rome, preparatory to becoming director of the American School of Classical Studies. The Chigi family were in financial difficulties and saw in their art collection a ready source of funds. Mrs. Gardner cabled Berenson to ask whether the painting was worth $30,000. Berenson replied that he felt sure that Prince Chigi was not ready to part with the painting, especially at such an absurdly low

figure, and that the Agnew firm had already failed to get it for $40,000. Undismayed, Mrs. Gardner would not give up. As the months went by he passed on to her rumors of various rivals who were said to be after the picture—the German emperor, a British consortium which had offered £12,000, and finally the Russian czar, who was believed to have bought it. The fact was that the Colnaghi firm had surreptitiously purchased it through one of the partners, Edmond Deprez, for whom it had been smuggled out of Italy in violation of the new Pacca law for protecting the Italian "patrimony of art." Gutekunst finally brought Berenson into the negotiation with the promise of a share of the profits if the picture was sold to Mrs. Gardner. Perhaps because of her dissatisfaction with the firm, Berenson professed reluctance to deal with Colnaghi and placed the burden on her to go ahead. Enamored of the painting when she saw it in London, she gave her orders and Berenson obeyed. The price was a princely £15,000 ($73,000). The news of the purchase, which was concluded in July 1899, finally got out, and Mrs. Gardner found herself the center of highly pleasing notoriety in the world press. One of the clippings which she collected described her as the fortunate owner of a painting for which "the Louvre or the National Gallery would have paid over twice the amount if international courtesy had permitted either of them to buy." The Italian government was not pleased, and Prince Chigi was haled into court and heavily fined; on appeal, however, the fine was reduced to a trifling ten lire.

In the midst of Berenson's renewed successes, an alarming hitch had developed with respect to the Holbein portraits that Mrs. Gardner had agreed to take. "Tell me exactly what you paid for the Holbeins?" she queried Berenson in a letter of May 31, 1899. "I have a most singular letter from the former owners. I am afraid something is wrong in the transaction." The news confirmed, she said, her dislike for the Colnaghi firm, a dislike which had been aroused some time earlier by its failure to send her Crivelli to Paris at the promised date. She angrily protested, "it might be a question of the Law Courts." She accused Colnaghi of charging her £17,000 for the Holbeins, whereas the owner had received only £16,000. Again Bernhard fell into an almost suicidal despair, not knowing how to appease her wrath. In spite of his anguish of the preceding autumn over the secret arrangement with Gutekunst in the sale of the Hope pictures, he had been unable to—or could not bring himself to—alter his arrangements with Gutekunst in connection with the Holbeins or the Chigi Botticelli. As Mary had pointed out in the case of the Hope pictures, "It wouldn't do to ask less now." Alone in his rooms in London Bernhard tossed all night in a cold sweat, as he wrote to Mary at Friday's Hill. He "saw everything at its blackest" and

felt he "never could face it. Yet I long to live. Can I?" Once again Mary tried to comfort him. Time, she assured him, would bring relief, as she had found in the case of her own troubles. If worst came to worst, they would still have each other in Italy. "Thy mind will still be there [and] our books. *We want nothing else, really,*" she emphasized, quite forgetful of her chronic inability to economize. "Even if thee give back to Mrs. G. all that thee took from the Rubens, the Velasquez and the Pesellinos, thee will still have enough to keep thy family considerably." As for themselves they could still manage to have things "elegant," and even learn to live on her money. She wanted nothing else out of life but him.

And then she turned, in a businesslike way, to advising him on the strategy of dissimulation he needed to adopt. He must find out what action Mrs. Gardner planned to take, and if necessary consult with Gutekunst and some "clever solicitor." He must "din into her ears" the great difficulty of getting rare works of art without the use of much bribery. Most important, he must "show no signs of thy inward agony." Self-reproach was futile. "Don't mourn over thy uncommercial ideals or wasted time. I know how sick thee is, sick of the mistake thee made and all but thee mustn't think of that. . . . Thee can do as good work as ever, and Time will pass over the worst things." If he must admit his wrongdoing, he should do so frankly and "explain what reparation it is in thy power to make." As for the thousand pounds, he must insist that it was a present to Colnaghi for the firm's "immense services." One important precaution he must take; he must direct Colnaghi to hold Berenson's share of the profits in the sale of the Chigi Botticelli or deposit the money in her own account at Child's, from which she could transfer the money to him. "Remember, there is nothing on *her* mind (whatever is in ours!) except the Holbein affair."

Thus armed, Berenson sat down to the defense of Colnaghi. He reminded Mrs. Gardner that he had written before that there was no way of "getting hold of the great things" except by "smoothing the way by a copious expenditure of money. . . . The dealers have to do it, and, when they sell, they of course include all these charges in the price they ask." In the case of the Holbeins, "the courts made the Colnaghis swear that they would not charge over sixteen thousand pounds and that is all they did charge," being allowed only £500 as their commission, but after "greasing the paws" of various friends of the owner, they ("one of the greatest art firms in Europe") were left with only £100 for four months' work. He could not therefore in all "conscience and expediency" see them left with such a "paltry reward." Without their asking for it, he made a present to them of £1,000 "to dispose them well for the future and out of a sense of fairness." Therefore, she could

not claim the thousand pounds from the Colnaghis but must look to him. If she did, he would pay it out of his own pocket, but "in that case, I cannot ever again undertake such big and complicated transactions as that Holbein business was." He declared that he could not give up the Colnaghi firm as she urged because Otto Gutekunst was one of the ablest connoisseurs he knew and when his judgment coincided with "my own [it] makes me sure against the world."

His labored explanation did not really placate Mrs. Gardner, and she fumed indignantly about the firm's pocketing an additional $5,000 on whatever pretext. She sent the money for the Chigi Botticelli, £15,000, but delayed sending the 5 percent commission, leading Bernhard to suspect—mistakenly as it turned out—that she was reimbursing herself for the thousand pounds. "And thus," he wrote Mary, "we great souls and illumined intellects live suspended on the whim of people to whom our secret attitude is to say the least a patronizing one."

Berenson began to feel that he was "out of the woods." Besides, he now had a tremendous card to play, the possibility of acquiring for Mrs. Gardner one of Titian's supreme masterpieces, the *Sacred and Profane Love* owned by the Borghese family. The family, after centuries of affluence and power, had like other princely houses suffered grave financial reversals at the opening of the decade. Their great library had been dispersed in 1891 and their ancestral palace and furnishings sold. The collapse of the building boom in Rome in the crisis of 1896 following the disastrous Ethiopian campaign forced further liquidations. Berenson had been introduced to Prince Paolo Borghese in Florence a few years earlier by Placci, and of course was very familiar with his collection. On one of his visits to the Borghese villa he had regaled Mary with "debauched comments" on the sensual pictures there, leading her to tease him that "Herrick didn't make thee out half the monster thee really is." Whether he learned from the prince himself that the Titian and other paintings might be sold or from the rumors which must have swept through the art world is unclear. Undoubtedly, feelers had been put out and the sensitive grapevine would have vibrated at Colnaghi's. Berenson appears to have got some sort of commitment from an intermediary because he offered the painting with considerable assurance.

When he first broached the matter to Mrs. Gardner, soon after her arrival in England in May 1899, the price he quoted, £160,000 (three-quarters of a million dollars), staggered her, for it seemed wholly out of the question, however much she coveted the painting. Berenson returned to the charge on July 13, 1899, with characteristic élan—and glowing rhetoric. He conceded that the price was "colossal" yet less

than what it "can and *will* fetch." No work of art was more renowned, and its possession, he assured her, "will be a title of glory in one's lifetime and of immortality thereafter." Hence it was no mere matter of business for him, for he felt that the painting "was the keystone to an arch of the building of which all along I have devoted my best energies." In fact, he so wanted it to crown her collection that if a 5 percent commission on so big a transaction seemed too much he would "be quite happy to take less from *you*."

Mrs. Gardner proved the "willing Eve," tempted beyond endurance by so great a prize. After dinner in her rooms at the London Savoy in late July, she said she wanted to talk business, and the business, it developed, was how she might raise the immense sum. Berenson found her "looking aged, in deep mourning," as he wrote to Mary, "but as fascinating as ever, an American girl, she seemed, not really grown up but mellowed by life." They talked of the museum she planned in the Fenway. Once more Berenson felt her extraordinary courage and vitality. The impression lingered. "She really was more fascinating than ever with a delicious caress in her voice," he wrote Mary shortly afterward from St. Moritz, where he had joined Placci and their glittering circle at the Hotel Caspar Badrutt. "God bless her! Blessed be the gods in their pure ether. I feel convalescent as if just out of mortalish illness." To his amazement she had said nothing against Colnaghi and had in fact accompanied him to the Colnaghi gallery to see the Botticelli she had bought. Thereafter, in a succession of urgent letters from St. Moritz, he pressed her to seize the chance to win the Titian, telling her he had a formal promise of control of the painting until September 10. It was to no avail. The money simply could not be pried out of her board of financial advisers since the price, now risen another £15,000, would have seriously diminished her trust funds. Berenson remarked to her that she might console herself with "the knowledge that a pearl of the greatest price has been offered to you, and was within your grasp. No other living person can say as much." She was in fact to have the satisfaction of knowing that no other private collector was ever to own the painting. With the collapse of the negotiations, Prince Borghese offered all his villa, palace, and the complete collection of art to the State, reserving the right to export this single picture. The offer was accepted and after long negotiation the purchase by the Italian government was completed in 1901–02, but the prince's option to export the picture was never exercised.

The exciting episode seems to have cleared the air, and Berenson's relation with his patroness was henceforward unmarred by any serious dispute. He grew more circumspect in his dealings with her and more

candid about his personal share in some of the paintings which he offered to her. By insensible degrees, largely through his association with Gutekunst, he had been drawn into the Byzantine maneuverings and mystifications of the art trade. For all his distaste for its sordid aspects, he craved its dramatic financial rewards, as Gutekunst reminded him. Hopelessly ambivalent in his feelings, he was swept along, secretly embittered by his predicament, which frequently led to long recurring bouts of nervous illness. How deep his regrets were for the mistakes and concealments of these years, for the betrayal of his ideals, would be revealed long afterward in the anguished self-reproaches of his *Sketch for a Self-Portrait* and in his unsparing contempt for business speculators in art. In his old age he would recall his meeting with Mrs. Gardner in the National Gallery as a "fatal moment" in his career. If she had been, as she said, his "too-willing Eve," he had been her too-willing Adam and had eaten of the apple of affluence which she offered him.

THE association with Gutekunst was not relinquished, but after the then pending negotiations for a few more paintings for Mrs. Gardner were concluded, Gutekunst figured in only one major acquisition by her out of the many others negotiated by Berenson, Dürer's *Lazarus Ravensburger* (later titled simply *Portrait of a Man in a Fur Coat*) acquired at the end of 1902 for approximately $50,000. With some reason, therefore, Gutekunst would plaintively wonder whether Berenson was as fond of him as he of Berenson. "Please send me a renewed vote of confidence in our friendliness and intelligence," he wrote as Mrs. Gardner's purchases from the firm dwindled. "I am duly depressed." As an accomplished player for high stakes in a trade noted for deviousness, he was plainly puzzled by Berenson's recurring anxieties and hesitations. Sometimes when he and Berenson took part in joint ventures involving other clients like Davis, Henry Cannon, and Edward Warren, Berenson would become uneasy over his share in a painting. To placate him Gutekunst would offer to buy him out. Or when, hard pressed for money, Berenson would nervously question the adequacy of his half share of the profits, Gutekunst would patiently review their joint contributions, and on one occasion he was driven to remonstrate, "You must own that *we* found and brought to you most of the things Mrs. G. bought recently, some in spite of yourself, like the little Raphael [*Pietà*] and we dissuaded you from the two expensive portraits of Bardini."

What irked Gutekunst most was Berenson's chafing against what Berenson regarded as the sordid expedients of the art trade. One day in 1901 Gutekunst bluntly lectured him: "Business is not always nice and I

am the last man to blame you, a literary man, for disliking it. But you want to make money like ourselves and so you must do likewise as we do and keep a watchful eye on all good pictures and collections you know or hear of and let me know in good time. If the pictures you put us up to do not suit Mrs. G. it does not matter we will buy them all the same with you or by giving you an interest in them—as you please. . . . You are much too intelligent to be annoyed at my telling you this." It was important to the firm as well as to Berenson, Gutekunst observed with a rare touch of wit, to "make hay while Mrs. G. shines."

Jean Paul Richter was another who hoped to bask in Mrs. Gardner's sunshine. Although his collection had been drawn upon by Berenson for two paintings for Mrs. Gardner in 1895, it was not until 1898 that he again offered paintings that Berenson thought desirable for her. In a characteristic letter Richter wrote: "I should like very much to sell one or two of my pictures. . . . I do not think I can part with the Giotto without telling first Mr. Mond and Poynter who both want the refusal. For this picture I want two thousand pounds. For the Solario I want five hundred pounds. For the Cariani, youth and girl three hundred fifty pounds. For Parentino's Battle piece three hundred pounds, the same for Bonsignori's Virgin and Child, and three hundred pounds for the St. Michael by Giambono on the staircase. I value my Paolo Veronese rather high, two thousand pounds. The Paris Bordone one thousand pounds. These prices are net. You will tell me your views, if you find anything to suit you." Berenson decided first on the Giotto for Mrs. Gardner, deducting from the price—whether from scruple or remorse—the commission of £500 which Richter had offered him. The rare and remarkably fine example of Giotto's coloring, *The Presentation of the Child Jesus in the Temple,* was acquired by Mrs. Gardner in 1900 and the Paris Bordone, *The Child Jesus Disputing in the Temple,* in 1901.

It is noteworthy that neither friendship with Richter nor their business dealings imposed obligations which Berenson as a critic felt bound to respect. When Richter sent him a copy of his National Gallery lectures hoping for a favorable review, Berenson refused to review it. He declared, "The various new suggestions you make there I can not at all subscribe to. In fact some of them are perfectly incomprehensible to me. Others are based on data of a very speculative if not altogether untenable kind. This is what I would have to say if I reviewed the book and I'd much rather say it in private than to publish it."

There were of course many other suns beneath which the golden harvest sprouted, though few so radiant as Mrs. Gardner, and Bernhard and Mary soon generously brought in the needy members of their circle to share some of the harvest. Whatever distaste existed for the moral

squalor of the marketplace gave way before the lure of exorbitant and easy profits. Among the first to be helped were the Kerr-Lawsons, whose moneyless plight in their Fiesole villa had long worried Berenson. He put them on to paintings that could be picked up for a pittance; one, acquired in Venice for £15, went to a rich Glasgow merchant for £350, placing the Kerr-Lawsons, as Mary put it, "three hundred and fifty pounds away from poverty." Another, Mary learned, yielded an even more spectacular profit. Bought for £1, it sold for £900. Thus launched, Kerr-Lawson established himself as a private dealer, no longer dependent upon the uncertain market for his own paintings.

Being a painter, Kerr-Lawson was subject to a special temptation, as his friend and fellow painter Roger Fry discovered one day. Fry, who often served as a professional expert, was asked by a Bond Street dealer for his opinion on a reputed Bellini that had been extensively repainted. Fry pointed out that "there was the outline of a genuine Bellini and precious little else." To his dismay Fry learned it had been sold by Kerr-Lawson, and "for a long price." "I always feared," he told Berenson, "that Kerr-Lawson was not overscrupulous about his ascriptions." The incident highlighted one of the most troublesome questions which perplexed the art trade: How much restoration of a damaged Old Master was legitimate? It has been said that Fry himself was not averse to a little judicious repair of time's ravages when occasionally dealing in paintings to meet the burdensome expenses of his wife's illness. Mary, who had been anxious about him, was relieved to learn on one occasion that he had bought a Lotto for £800 that he expected to sell for £2,000.

Even Mary's dilettante brother, Logan, turned aside for a time from his literary pursuits and his dreams of an aesthetic haven of "Altamura" to form a partnership with two Oxford friends, Philip Morrell, the son of a wealthy brewer, and Percy Fielding, in a London antique shop under the waggish name of "Miss Toplady." Mary liked to refer to it as an "iniquity shop"; she found it convenient for selling pictures in which she had invested. Venice was a particularly good source of bargains, and on one shopping trip there Mary and Logan bought "quantities of things for 'Miss Toplady.' " One item, a sculptured head, cost less than a pound. It was sold the same day to Theodore Davis, who was also hunting for bargains in Venice, for fifty pounds. When Davis visited Florence in the spring of 1899, Berenson left the way open for Logan, who had just bought a painting in Siena for twenty pounds, expecting to sell it to Davis for a hundred. Mary hoped that he would make a little money, for he was prone to run into debt to her. She thought the new shop should build up a satisfactory picture business. "There is plenty of money in it, as I have found," she assured her mother.

Herbert Horne also saw the advantage of capitalizing on his skill as a connoisseur and writer on Botticelli. In January 1899 he entered into a formal contract with Berenson to dispose of paintings in London for a half share of the profits. The arrangement continued for several years and was one for which Horne was very grateful, as it enabled him to enlarge his own collection and eventually house it in a palatial museum in the Via de'Benci in Florence. An indication of the success of his ventures is suggested in one of his letters to Robert Ross, Wilde's literary executor, who was the director of the Carfax Gallery in London. He told of having just sold a painting to an American for £200 which he had picked up for £20 and he added, "But you need not pass that on."

Still another recipient of Berenson's aid was F. Mason Perkins, a fellow American expatriate in his mid-twenties who had settled in Siena several years after Berenson came to Florence and had become one of his earliest disciples. He began to turn his expertise in Sienese painting to profitable account, though he met with a costly setback when he had to take back a too heavily repainted picture. Like Horne and Berenson himself, Perkins became an avid collector, and he left his pictures to the Sacro Convento of San Francisco in Assisi.

As one surveys the rapid growth of the trade in Old Masters at the turn of the century, nothing is more striking than the growth of the "cult of authenticity" among rich collectors and the rise of the profession of "consulting art historian." Collectors were often hopeful of successfully bypassing a dealer whose fashionable establishment required an extremely high markup. And dealers themselves needed to resort to the professionals to guarantee their attributions. So it was that Robert Dell, the art journalist, would one day join a Paris dealer, as the critic David Thomson had joined Agnew's in London. The art historian Langton Douglas was also to enter the trade for a time, and even the great Wilhelm Bode would be called on for his expert opinion. It would be many years before the role of art critic and historian would be sharply separated from that of private dealer and collector. In the flush times of the Belle Epoque such a scrupulous distinction was largely disregarded. Of all the critics and art experts concerned with the traffic in Old Masters, however, no one was to equal Berenson's success and no one was to be so greatly envied and slandered.

XXIII

A Man of Affairs

THE half-frantic worries about Bernhard's "mistakes" that plagued him and Mary for much of 1898–99 seem not to have affected the ordinary tenor of their lives. Bernhard's letters to Senda overflowed as usual with rhapsodic descriptions of his travels: "Every year I learn to enjoy more, everything more and most of all Italy. How I have drunk of her this blessed autumn! First Bacchus and Ceres in verdant still summer, flushed Umbria, then all the dazzling romantic spendour of the Lombard paradise, and now Tuscany. If I could convey to you how I feel when I see the cypresses dipping their whole heights into the depths of the immaculate ether, or the olives sparkling in the high, each little leaf like a fairy orb dashing sun spray into the unrippled air, I could make you feel the generous cheering heat which still is comforting us. Then you would understand how much it suffices, how complete it is just to bask and feel. It is not doing the world's work. . . . It is mad and sad, if you will, but it is sweet. . . . I ask myself, what is the purpose of life? . . . What if not the enjoyment of beauty? . . . I who do not care for nations and do not live on such catch-words as Liberty and Independence but cherish words of my own, such as Civilization and Enlightenment and Hellenism."

Nevertheless, the ugliness of the world broke in increasingly upon aesthetic meditations and he found himself moving again and again from refined cynicism to almost desperate concern. Thus in one letter he added the wry afterthought, "God is good. He daily provides us with some passionate interest. Scarcely was the Dreyfus case smothered when the Transvaal business began. . . . I am wildly, passionately for England and fight her battles over the dinner table relentlessly." The oppressive restrictions against British subjects by the Boers seemed a campaign against the culture that Matthew Arnold had taught him to

revere. There had been arguments aplenty with Placci when the Dreyfus case was reopened, for Placci had become devoutly clerical and an "idiotic" anti-Dreyfusard. Bernhard had been greatly agitated when in January 1898 the guilty Esterhazy was acquitted by a court-martial and Emile Zola's famous "J'accuse" blazed across the front page of *L'Aurore*. In spite of their "fierce wrangles" over the "affair," Bernhard and Placci established an amicable truce, and in the high society of St. Moritz that August Bernhard prudently kept his own counsel. Later in the year when the French minister of war showed that one of the documents incriminating Dreyfus was forged, the angry anti-Semites redoubled their campaign in order to offset the effect of the disclosure.

Again Bernhard was "awfully excited" by the scurrilities in the press and again he and Placci shrilled at each other, but when afterward Placci came to lunch he "was as lovely and dear as ever," according to Mary, "and won back our hearts" in spite of his "antiDreyfusism and his bigoted Catholicism." If Bernhard maintained a discreet silence in the face of Catholic bigotry among his aristocratic anti-Dreyfusard friends, he found some relief in his letters to his sister. Fresh from reading Frazer's *Golden Bough,* he wrote: "Superstition is a thing springing up ever new in the human mind." It needed, he said, to be provided with "proper cesspools. The largest and perhaps the most efficient cesspool is the Catholic church, which I should be inclined to approve of as I do water closets, provided this institution did not carry the joke too far, forgetting what gross and humble needs it serves." His antipathy toward the French nation and the Catholic clique that exploited the Dreyfus case flashed into fire again with the Fashoda incident in September 1898. A British army had annihilated an insurgent force at Omdurman in the Sudan, whereupon a French contingent rushed to Fashoda to share the spoils of war. It was attacked by a large Dervish force and only General Kitchener's timely arrival saved it from destruction. The incident, Berenson wrote, came "on top of all [France's] knavery, fraud, Jesuitism, and cowardliness, her even more odious crimes, her always trying to be the dog-in-the-manger in all the world's affairs. She needs a licking."

The outbreak of the Spanish-American War, occasioned by the sinking of the *Maine,* outraged him at first; it was "a gratuitous war in favor of speculators at home and desperadoes abroad." And when the Hearst press inflamed the mass of Americans against Spain on Cuba's behalf, he exclaimed to Thomas Sergeant Perry, "Instinctively I hate Demos." However, Dewey's dramatic victory at Manila Bay roused the patriot in him, even though, as he remarked to Mrs. Gardner, he was only "an adopted American." He hoped, he then wrote to Perry, that the annex-

ation of the Spanish colonies would make America less barbaric. Perry, then teaching in Japan, retorted: "Happy optimist! My hope is that in its new strutting it will sometime get the broken nose it deserves."

Strangely enough, the political turmoil that was racking Italy at the time hardly seemed to touch Berenson in his sanctuary of quattrocento art. The suppression by the army of the revolutionary disorders and bread riots of the spring of 1898 in Florence and other principal cities, with scores killed and wounded, went unnoticed in his letters and received only the barest mention in Mary's journal. Far in the future lay the trauma of totalitarianism and his outspoken opposition to it, but the first steps toward placing his heart on "the anvil of the grief-worn world" (as Havelock Ellis phrased it) had been taken.

FAMILY problems back in Boston continued to occupy his thoughts, and as always he was free with his counsel and financial help. His youngest sister, Rachel, was now ready for college, and he confessed in his letters to Senda that the matter gave him "almost as great a concern as Abie's future." After studying the syllabus of courses at Smith, he wrote, "I somehow feel as if Smith were not the place to give a person fine instincts in literature." He preferred Bryn Mawr, where the "teaching of Classics is better," but Senda's presence at Smith as director of physical education evidently decided the issue; Rachel enrolled there and Bernhard thereafter sent her a semiannual allowance of $250. She took her degree in 1902 and then moved on to Radcliffe College, taking an M.A. in classics in 1904. The middle sister, Bessie (Elizabeth), less academically minded than Rachel, soon joined Senda's staff as an assistant, having like Senda attended the Normal School of Gymanstics, and like Senda she did not go on for a college degree.

He continued the earnest pedagogue in his letters to Senda. For example, when she remarked that she thought Santayana's idea of beauty in his *The Sense of Beauty* was "an overflow from the sexual passion," Bernhard lectured her that the true source of beauty was the muscular association of the "tactile imagination" that he had set forth in his *Florentine Painters*. Then, pursuing the new train of thought, he added that the two living painters who were strongest in tactile values were the Englishman George Watts and the Frenchman Puvis de Chavannes. The eighty-year-old Watts, famous and popular for his grandiose allegorical murals, had already passed his zenith, and his vogue barely outlasted his death in 1904. Puvis de Chavannes, whose religious murals were suffused with a dreamlike quality, was to die in October 1898 at the age of seventy-four, his work already overshadowed by the Impressionist school. Berenson's partiality for these two almost out-

moded painters undoubtedly stemmed from the fact that both owed inspiration to Italian Renaissance painters, Watts to Titian and Puvis de Chavannes to the Italian Primitives. His tastes in art were clearly growing more conservative; in fact, he and Mary would soon wonder what they had been able to see in Monet. Even when Bernhard came to the defense of Matisse in 1908 in a letter to the *Nation,* he praised him not as an innovator in art but as being "singularly like" the "best great masters of the visual arts . . . in every essential respect." And later he was to link Cézanne in his mind with Fra Angelico and to regard both Matisse and Cézanne as marking the end of the "age of gold" in the history of modern French painting.

Through the multitudinous pages of his letters and Mary's diary there trooped as always the varied procession of friends and notable visitors: Kerr-Lawson, who had painted their portraits; the irrepressible Placci, who was a mainstay of their musicales; the affectionate Countess Serristori and her phlegmatic husband; young Robert Trevelyan, full of poetry and argument on their bicycle rides; the diminutive Alfred Austin inappropriately burdened with the laureateship; Bertie Russell, more concerned now with mathematics than with German socialism; Horace Scudder, editor of the *Atlantic,* who had welcomed Mary's defense of the new art criticism. Theodore Davis put in an appearance, boasting of his new "Leonardo," which if genuine, as Mary observed, would have been worth ten times what he paid for it. Langton Douglas, who was serving as Anglican chaplain in Siena and who prided himself on his expertise, came up to Florence one day in mid-1899 with a painting he believed to be by Duccio, counting on Berenson's buying it for a client. Berenson insisted it was not genuine and Douglas left "terribly disappointed." His disappointment was unfortunately compounded by an insult that helped add him to the growing list of Berenson's enemies. "My dear fellow," said Berenson, "until you can see that although this has the shape of a Duccio it lacks his quality, you'd better not write on art."

The magnet for visitors was always of course Florence, the strategic center of Italian Renaissance art study as well as a main entrepôt of art, and the villas of Bernhard and Mary were pleasant way stations for experts and amateurs alike. And they were by no means alone in ministering to the pilgrims of art. Hildebrand, Frizzoni, Horne, and Loeser, each had his following, and beside them labored a contingent of specialists such as Heinrich Brockhaus, Jacques Mesnil, and Aby Warburg. Warburg had written a doctoral dissertation on Botticelli in 1891 and settled in Florence in the autumn of 1897. As a Morellian Berenson had made no secret of his distaste for the pedantries of Teutonic scholarship,

and Warburg responded in kind when he later, with a fine impartiality, dismissed the work of "the whole nosey tribe" of "connoisseurs and attributionists" such as Berenson, Venturi, Morelli, Mayersdorfer, and even Bode, as "only inspired by the temperamen⁺ of a gourmand." There was already little question, however, of Berenson's supremacy. Even the circumspect Henry James back in London acknowledged the fact to a young intimate of his, the American sculptor Hendrik Andersen, telling him, as Mary relayed it from Andersen to Bernhard, "Thee was the *only* living authority on Italian pictures. 'There is absolutely no other, [James] repeated.' " The subject continued to interest James, and a dozen years later, after he had met Berenson, he wrote a novel, *The Outcry,* which, unlike Herrick's, treated connoisseurship with respect as an exercise in fine discrimination.

The one visitor who was to help give an unexpected turn to Berenson's career as a critic was the painter Roger Fry, the future editor of the *Burlington Magazine.* Fry and his wife arrived for a stay with Mary in April 1898 and soon he and Berenson became fast friends. Roger impressed Berenson as the scholar of the two, but Helen seemed to him "the superior person, exquisitely humorous . . . eloquent in her quiet looks." Fry's studies in biology at Cambridge had made him naturally receptive to Morelli's morphological system, and he enthusiastically applied it to the study of Florentine "primitives." He, like Berenson, had become a friend of Frizzoni when he first visited Italy in 1891. Since his own paintings remained unappreciated in England he devoted himself to connoisseurship and lecturing on Italian art. He and Berenson had probably first met in the spring of 1897 when Fry returned to Florence with his wife, whom he had married the previous year.

In his proprietary way Berenson came to regard Fry as one of his pupils, and he took pleasure in guiding him through the thickets of mistaken attributions. Fry, who was but a year younger than Berenson, proved an extraordinarily apt student who tended to strain a bit against Berenson's authority. His identification with Berenson as a fellow Morellian quickly exposed him to the hostility of Berenson's foes. In the following year, when Fry's book on Bellini came out, he sent a rueful note to his friend Robert Trevelyan: "My book is the subject of a mighty attack from Loeser & Co., who think they will be dealing a blow at B.B. So we are in the thick of a *kunstforscher* fight." The fight obscured his real position. It was not true, he assured Trevelyan, that he disapproved of Berenson, it was simply that he thought him too doctrinaire. "What is wanted now in the way of criticism is someone who will make appreciations as finely and imaginatively conceived [as

Pater's] and take them into greater detail as well. Perhaps Berenson will get to this if he ever gets over his theories." Long afterward Fry affirmed his lifelong creed in words that might also have been written by Berenson: "I am the victim of a perhaps quite absurd faith— the faith, namely that the aesthetic pursuit is as important in the long run for mankind as the pursuit of truth."

As the spring of 1898 turned to ardent summer and a perpetual haze veiled the distant hills, the succession of foreign visitors tapered off. Shutters were swung to against the sun and trunks were packed again for the summer's exodus. Bernhard ran down to Rome briefly to advise Edward Warren, who was on the lookout for pictures for his mother. By mid-June Bernhard and Mary had once more taken to the road with notebooks in hand, interrogating curators and custodes of galleries and churches in Lucca, Genoa, and Turin, and dutifully enduring the boredom of the provincial exhibitions. It was a relief to be reestablished in Paris, Mary as usual in the rue de Beaune, Bernhard at a hotel on the Quai Voltaire. Placci was already on hand, full of the Countess Montebello's Catholic politics and perversely announcing that as an anti-Dreyfusard he hoped to become a "supreme bigot." The Lovetts, who were still abroad, dined with them and voiced their indignation at Herrick's pillorying of Bernhard in *The Gospel of Freedom*. At the Reinachs' they relaxed in the Dreyfusard atmosphere and there caught up with the latest doings of the art world. But what they learned no longer pleased them. When taken to see a plaster sketch for Rodin's rough-hewn *Balzac,* they turned away with repugnance at that specimen of contemporary sculpture. They found also that the splashing colors of the Monet exhibit no longer excited them, for, as Mary noted, "We grow more and more wedded to our 'Primitives' all the time. *There* is art."

There were also private collections newly opened to them, Madame André's for one. She had denied Berenson's earlier requests but now relented and showed her things. There was much more to their purpose in the great Rudolphe Kann collection, some of whose treasures would one day pass through Bernhard's hands when the Duveens purchased it. Mary, not without a trace of envy, wrote, "All these Jew houses are terribly like Musées." During much of the time in their weeks in Paris Bernhard immured himself in the Louvre studying the Florentine drawings hidden away in the archives, to which he had been given private access. They began to avoid the ceremonial dining out which had been their habit, being now "so middle-aged," as Mary put it, "that we prefer our quiet home dinners," where they luxuriated over coffee and

their usual cigarettes. She was now all of thirty-four and Bernhard a venerable thirty-three. But youth and its distracting diversions were, as will be seen, not to be so easily put aside.

They found the theater brilliant with Coquelin as Cyrano in Edmond Rostand's new play and the incomparable Réjane in *Zaza*. But the great Eleanora Duse, D'Annunzio's current flame, disappointed them in Ibsen's *Hedda Gabler*. Bernhard thought that though she could not help being "charming," as he told Senda, "she was petulant, small, childishly malicious, ordinarily jealous—in short petite bourgeoise." He had expected her to portray Hedda as more of a temperament and less of the "sociological puzzle" of so many of Ibsen's characters and to "interpret her high spiritedness, her disdain, her love of smartness, bordering on real distinction, her momentary glimpse into a life of real passion, and withal the intolerableness of being what she is, having to put up with a world of petty interests and petty ideals. In this conflict there are the possibilities of great tragedy—more genuine tragedy than in a Clytemnestra, Lady Macbeth, or even Medea." The Duse projected none of this. The truth was, he confessed, that his taste for Ibsen was past. "Human problems interest me now in scarcely any form. Least of all do I care for the heart questions of the day." For the moment he fell again into the mood that so often recurred, that of the ironic and detached observer of the human comedy, immersed in the world and yet a rootless alien in it, alienated by the very intensity of his self-absorption. He was not alone in his spiritual isolation. Fin de siècle pessimism had spread in broadening circles from Paris, where the triumph of illiberal reaction in society and politics and the daily record in the press of wars, massacres, pogroms, and corruption drove sensitive observers to despair of the progress of civilization. The British *Annual Register* of events at the turn of the century reads like an encyclopedia of worldwide horrors.

Much to Mary's relief Bernhard decided to cross with her to England, and after the usual "hurly burly" of business in London he joined her for a few days at Friday's Hill. She had grown to dread their separations, for her annual summer reunions with her children put a recurring strain upon her relations with Bernhard. He deeply resented having to share her with her demanding family. She had to admit that she probably loved her mother above anyone else. The daily letters to her family which kept her secluded at her desk formed a world from which he was excluded. The visit to Friday's Hill was Bernhard's first in seven years. He no longer had to fear the disapproval of Mary's father. The old man, whose mental eccentricities had grown increasingly distressing, had died unlamented in April. And, as Mary observed, her

mother was blossoming forth in a surprising way, confident that her husband, in spite of his derelictions, had gone to his heavenly reward.

At Friday's Hill Bernhard was joined by Robert Trevelyan, with whom he was shortly to set out for a month's tour in the north of England. He and Trevy, as they all called him, found themselves in the company of Logan and their Oxford friend Galton, whom Berenson had first met in 1888, and of the silent Herbert Horne. Dispersed among the fourteen rooms of the big house or enjoying a "secret" smoke in one of the rooms set aside for the purpose were the usual "denizens of the colleges," Bernhard noted, "all pleasant, cultivated, quaint people," a thoroughly "merry company." It must at last have been clear to Hannah, Mary's mother, that Mary would never return to her husband, and she appears to have accepted Berenson's presence with cheerful resignation, if not approval. What he thought about her he discreetly kept to himself.

His intimacy with young Trevelyan had begun a few years earlier in Florence, and it led to a friendship that was to endure unbroken for more than fifty years. Trevelyan, a poet of rather modest talent, dedicated his privately printed *The New Parsifal: An Operatic Fable* to Berenson in 1914. Bernhard described him to his sister as follows: "He is tall and stooping with a long head, high forehead and beautiful clustering hair and eyes that have something fawn-like about them. You never saw a more unworldly person. He thinks nothing but poetry, knows his classics by heart and tries to walk in their footsteps. England produces his kind and for this I bless it." Trevy was clearly a fellow spirit.

It was full July of 1898 when they stopped off in Cambridge on the month-long tour before moving on to Sir George Otto Trevelyan's place in Northumberland. Trevy's father impressed Berenson as "a gentleman of the old school" who piously used the very inkstand and desk of his "revered uncle Macaulay," whose biography he had written. Soon afterward when Berenson read the celebrated life, which the old man sent him, he was amused to find that "it traces to its source so many of the virtues and faults of the Trevelyans." One of those faults was a violent and disputatious temperament. During Trevy's frequent visits to Italy he and Berenson would often wander among the Tuscan villages, on foot or sharing a bicycle, and at night in a country inn read poetry to each other or a portion of the Bible. One night Trevy read the story of David and Jonathan. Bernhard agreed that it stirred the imagination but insisted it was not well told. Outraged, Trevy swore "a fierce imprecation against critics who were 'like poisonous caterpillars on fruit trees' " and hurled the Bible at Berenson's head. Still they willingly indulged each other's tempers. Many years later Trevy re-

called a recent visit during which he helped or tried to help rewrite some of "B.B.'s purple passages." He ruefully recalled that "the rows were awful."

Berenson returned to the Continent alone to resume his search for more Florentine drawings, dropping down as far as Rome early in August 1898. Letters whisked back and forth almost daily between Friday's Hill and Bernhard's stopping-off places, so efficiently forwarded by the postal services that he and Mary were hardly ever out of touch with each other. Blaydes put in an appearance at Friday's Hill after Bernhard's departure, now meekly accepting his role as a purely Platonic friend. Mary was confident that she no longer loved him. She had already passed him on to Lina Doff-Gordon, Mrs. Ross's niece. Mary tried to reassure Bernhard that her passion for Blaydes was safely extinguished, but distance fostered his distrust so that her letters often complained of his cold tone.

She kept him up to date on the stream of visitors at Friday's Hill. Bertie Russell, Logan, and Alys had stayed on. Studying her sister and Bertie, she felt a premonition about them that time would justify. "I wonder if, à la longue, even love can bridge over such fundamental differences as there are between her and Bertie." She was seeing much also of Roger Fry, whose marriage had recently taken a tragic turn. His wife had begun to show signs of a severe mental disorder that was to entail long and costly treatment. Their friend G. Lowes Dickinson, the beloved "Goldie" of their Cambridge group, also put in an appearance. Santayana showed up, "the same indifferent spectator he always was." And she allowed Bernhard to imagine the witty gossip and aesthetic debates that went on endlessly.

In her odd hours Mary studied the piano again as an accompaniment to her "light soprano voice," and she wrote to Bernhard that she wished to buy a rebuilt antique piano for a bargain five pounds from the French scholar-musician Arnold Dolmetsch, who was establishing a workshop nearby. Bernhard, worried as always by any reminder of her spending, protested rather disingenuously that he could scarcely afford it since his affairs were "not only unsatisfactory" but giving him "a great deal of anxiety," but he told her nonetheless to get the piano and enclosed a French banknote for 100 francs to cover the shipping costs instead of the 50 francs she had asked for. He wondered "how in Florence we managed to spend so much money on the very modest life we live," forgetting his own unstinted outlays on books and paintings. The distinction between mine and thine in the course of their separate and joint accounting often became blurred, a fact that encouraged each

to err on the side of liberality. She offered money to her widowed mother, telling her that Davis was investing for them in stock paying 12 percent dividends, and added the thought "How interesting money is when you begin to invest, even if only a little." Only a short time earlier, when Bernhard reported an unexpected drop in income, she had assured him that there was no cause for worry; they could live on very much less and "thee can sell a little stock and pay off all thy outstanding debts and then we can start living within our income," especially since she would be "very careful of their household expenses." The resolve was but one of many variations on the same theme and quite beyond her power to carry out.

Yet it was not money matters that most troubled Bernhard. Rather it was the apparent ambivalence of Mary's feelings. To his suspicious nature her affections overflowed too readily upon friends and acquaintances. Her disarming frankness was often belied by her guileful concealments. She for her part sensed at times that he even hated her when she was away and declared therefore that she dreaded being absent from him. At the same time she argued they might "even yet, be truly happy." When he reproached her for her flaws, she confessed, "It is through my incapacity for sustained affection that so much is broken; really Bernhard if thee won't entirely lose heart and outgrab in despair, something even better, more suited to middle age, will come." Though the frequency of his letters did not slacken, the absence of endearing x's at the end of a letter made her so anxious that the reappearance of a few called forth the liveliest gratitude. All too aware of his dependence on her, he reassured her he would not leave her. It comforted her, she gratefully replied, that he would stick by her, "idiot spots and all." And she offered him her faith in his genius as a critic, even of poetry. Not Wordsworth, Coleridge, or Shelley had solved the question of empathy. "The world awaits thy pronouncement on Poetry!!!"

A comfortable truce reestablished, Bernhard and Mary made their rendezvous at Lille early in September 1898 and, accompanied by Herbert Horne, proceeded to Brussels, where to Bernhard's dismay the director of the art museum, a thorough bureaucrat, refused to let him study those Florentine drawings which were stored away, explaining that access was not even given to British Museum officials. They proceeded to Berlin with stops at Cologne and Hildesheim. The latter place, at the foot of the Harz mountains, seemed to him no longer picturesque despite its ramparts, its narrow streets and curious overhanging wooden façades. On his first rapturous visit, eleven years ago, it had looked the romantic epitome of late medieval Germany. Now its

quaint beauty paled beside the lovelier vistas of Tuscany with its walled towns perched on the hilltops.

In the Berlin national gallery he plunged into the archives of drawings, to which he happily obtained free access. In the gallery he renewed acquaintance with the art historian Georg Gronau, an authority on Leonardo da Vinci, whose drawings were now much on Bernhard's mind. He conferred also with the art historian Friedrich Lippman, the Botticelli expert and learned curator of the print collection, and with Max Friedländer, a rising authority on paintings. Berenson's friendly association with Friedländer, begun in these years, was to continue for more than half a century, during which Friedländer became curator of the print collection and ultimately director of the great Kaiser Friedrich Museum. Being a Jew, Friedländer was removed from the directorship by the Nazis in 1933, and he took refuge in Holland, where he survived the Occupation. In Berlin Bernhard and Mary also encountered a pair of London friends, the Holroyds. Charles Holroyd, a prominent English painter, had been appointed first keeper of the newly founded Tate Gallery in 1897. Knighted in 1903, he became director of the National Gallery three years later. He was noted for his knowledge of Italian painting, and Berenson corresponded with him from time to time until his death in 1917.

Bernhard and Mary and the ever-methodical Horne proceeded by easy stages to Dresden, where they were joined by Alys and Bertie. The days passed among the collections of drawings in the museum and in restudy of the paintings for the indexes of artists. In the evenings there were the inevitable Wagnerian operas, to whose "noise" Berenson had become reconciled: at Dresden, the *Götterdämmerung,* at Weimar, *The Flying Dutchman.* By the first of October the whole party had also visited the galleries of Leipzig and Altenburg, "guessing the pictures," and had taken careful note of the medieval church architecture in Naumburg and Eisenach. There were Holbeins and Dürers to see in still medieval Nuremberg, where they paused on the way to Munich, which beckoned with its far more important churches and art galleries, so surpassingly rich in paintings and drawings.

Surfeited with visual impressions and laden with notes, they alighted for a few days at Verona, Bernhard refreshing himself each evening with Homer and Mary diligently studying her Greek. The Greek myths had a fresh savor for him; he thought the religion of the Greeks was "the only kind . . . entertainable by refined and cultivated people. They had fixed no dogmas those wonderful Greeks and had no theology." To Mary's disgust the taciturn Horne refused to improve his mind with a

serious book. The oddly assorted pilgrims reached Florence on October 17, Mary settling in again in the Villa Frullino with Alys and Bertie and Bernhard taking up his abode a step or two away in the Via Camerata among his growing treasure of books and paintings. He and Bertie passed the days much in each other's company, pleasantly exploring each other's minds. They hiked up the steep lane above the Mensola one day to the little village of Corbignano to see the Kerr-Lawsons, who had established themselves in the old Casa di Boccacio to paint and deal in pictures. There was also a long bicycle jaunt along the Arno up to Pontasieve. Bernhard could not recall a more exquisitely lovely autumn, the air as fresh as early spring. In spite of his bad conscience about his languishing book on Florentine drawings, he could not bear to remain indoors, as he told Senda, when there was such beauty to be enjoyed. The skies burned with the "purity of intense flame" and the trees along the road glistened "golden green." "And all the time Russell turning some ordinary fact or idea over and showing you a side that had not occurred to you."

Thanks to their new bicycles, Bernhard and his companions found it easy, as he said, to revisit Verona, Mantua, Ravenna, and a number of formerly hard-to-get-at places. The roads were "perfect" and they "scoured" the countryside. They rambled about on the high dykes over the Lombard plains for a fortnight. Horne, unwilling to carry a watch, was always late and held up the party while he crammed his notebooks with "trivial" architectural inscriptions. On one of his forays with Bertie Bernhard put up for a few days at Imola near Ravenna in the villa of the Countess Pasolini, one of the friends whom he and Senda had met at St. Moritz the year before. He thought the place one of the "grandest" in Italy, soaring upward like a gigantic and elegant tower. He realized, however, that all this delightful "seeing" and loafing must soon end and wrote that he hoped for "eight months of quiet and continued work." Then he prudently added, "May the good Gods help my vows!" The magnitude of the task of scholarship to which he had set himself had grown with each fresh reconnaisance.

In November, with Alys, Bertie, and Mary's mother, who had been visiting her for a week, off to England, Bernhard and Mary buckled down to work, she to arranging their encyclopedic notes and he to a fresh chapter of the Florentine drawings. As always the year had been extraordinarily varied. New friends and acquaintances had come on the scene, old ones had departed. At the end of the year Mary prepared, as regularly before, a curiously revealing inventory of the people among whom they had moved as a kind of appendix to the year's journal. It

kept the canon of their social milieu up to date much as their lists of paintings registered corrected attributions. It stood substantially as follows:

"Common Friends":
Placci, W. Blaydes, Trevy, The Frys, H. Horne, J[anet] Dodge, S. Reinach, Miss Blood [companion of the Princess Ghika at the Villa Gamberaia], Mr. and Mrs. Ross, Lina Duff-Gordon [Mrs. Ross's niece], Emily Dawson, Robertsons, Jenkins, Morgans, Mr. Lovett, Miss Cruttwell, Miss Duff-Gordon, Fafnir [H. Hapgood], Michael Fields, Burkes, Gronau, Senda, Mr. and Mrs. [Herbert] Cook, Blair Fairchild, [Hendrik] Andersen, Sturge [Moore], Zangwill, Alys, Bertie, Logan, Dickinson [G. Lowes], Obrist, Kerr-Lawsons, Hildebrands, Dr. [Friedrich] Lippman, Placci

"B.B.'s":
Mrs. Gardner, Bywaters, Miss Placci, Contessa Rospau, Carpenter, Mr. Perry, Contessa Pasolini, Kitty Hall, Duchessa Grazioli

"Those who count in every day life here":
Placci, Kerr-Lawson, [Miss] Blood, Alys & Bertie, Blaydes, Duff Gordon, [Blair] Fairchild, Logan, Horne, Rosses, Cruttwell, [Janet] Dodge, Reinach, Senda

"My World":
Bernhard, Logan, Ray [daughter], Alys & Bertie, Mother [Hannah Smith], Reinach, Karin [daughter], Trevy, Blaydes, Mr. Colden-Sanderson.

"My real world":
Bernhard, Mother, Ray, Karin, Evelyn [Nordhoff] ("dead, alas, Nov. '98"), Lina [Duff-Gordon]

These annual registers continued for a number of years as a summing-up of their joint existence in Italy and England, the lists changing as new actors appeared on the scene or, having played their parts, dropped from sight. Then as the tempo of life increased, drawing into its whirling orbit more and more characters, and as work and business engrossed more and more time and energy, Mary abandoned the recapitulations. How greatly populated their world grew as Bernhard became so widely known as to become a legend in his own lifetime can be glimpsed from the posthumous *An Inventory of Correspondence* of the Berenson Archive, which lists more than twelve hundred correspondents from all over the world.

The winter of 1898–99 passed quietly, days given over with little remission to the early chapters of the new book and evenings usually spent in poring over photographs and innumerable volumes of art history and literature, old and new. One problem that greatly piqued Berenson's curiosity was the authorship of a number of drawings simi-

lar in style to Botticelli's that were ascribed to five different artists. The
more he examined them the more he felt they must be by one artist, a
friend and imitator of Sandro Botticelli, though the work was admit-
tedly "inferior in quality." The conjecture was too attractive and di-
verting to put aside, especially after his friend Herbert Horne sug-
gested, as Berenson afterward acknowledged, that "this artistic
personality might be connected with a real person." He interrupted his
main work and dashed off a two-part article on this "Amico di Sandro"
which, after Mary had scrutinized the proofs, appeared in the June and
July (1899) issue of the *Gazette des Beaux-Arts*. The beguiling tour de
force was so persuasively argued that the "reconstruction" of the imagi-
nary friend of Botticelli went unchallenged for several years. As Beren-
son was to write in 1937 in an appendix to the revised edition of *The
Drawings of the Florentine Painters,* "It took time before even so cautious
a student as the later Herbert Horne [who published an important book
on Botticelli] began to doubt its reality." "Many years later," Berenson
continued, "I returned to the subject with a better eye, a better method,
and greater knowledge, and it did not take me long to realize that
Amico di Sandro was a myth, that he had been, but was no longer, a
useful hypothesis and that he should be disintegrated and the remains
restored to the artists from whom they had been taken. And the ability
to do this properly and no longer by vague guessing was in large
measure due to Amico's temporary existence. I confess to a certain
regret in supressing this delightful, if mythical personality. An artist
who began with the best of the younger Botticelli, and ended early
with the best of the younger Filippino, was a more agreeable subject of
contemplation than the Filippino, who after doing most of the pictures
I gave to Amico, matured into the Filippino we have always known, so
over-draped, so uncertain in colour, and with such a tendency to antici-
pate those obvious exaggerations which for the vulgar constitute the
Baroque."

WORD came from Bernhard's brother, Abie, who had gone out to Cali-
fornia to seek his fortune, that he was giving up and returning to Bos-
ton. "Poor fellow, I wonder what will become of him," Bernhard
mused to Senda. "He troubles me more than a little." There was no
help for it but to subsidize the charming and feckless young man. Senda
also wrote that their mother was thinking of visiting her old home in
Russia. Bernhard exclaimed in alarm that he was "horrified at the no-
tion." The journey, he said, would be so full of discomfort "that I
should be on pins and needles all the time." Moreover, "the rigour of
the climate and the medieval barbarism of life" would disgust her, and

she would undoubtedly "find her brother and sister grown old, strange and sordid. Of course I would not for the world command Mother not to return to Russia but I am very anxious you should do all you can to make her change her mind. Father's scheme of going to Nova Scotia is only less extravagantly absurd." He urged that instead of undertaking such impractical ventures they go to South Carolina or Florida for the winter or to Colorado if they wanted more bracing air. He would send enough money to make their holiday comfortable.

XXIV

"Room for Berenson"

THE early months of 1899 went by uneventfully as Berenson had hoped, leaving him free to press on with the task of bringing order out of the overwhelming mass of notes on the Florentine drawings. Mary had been back in England with her family during January, leaving him to the care of their friend Janet Dodge, who managed his housekeeping and diverted his lonely evenings with piquet. Mary returned to her typewriter toward the end of January, and the transcription of Bernhard's sprawling handwriting resumed. The single-minded attention to detail with which he worked continued to be a matter of wonder to Mary, whose "pedantry," with which he sometimes charged her, seemed to her trifling beside his. Somehow they managed to pull together in harness, and by the end of May they had finished correcting the draft of the fifth chapter, dealing with the difficult Raffaelino del Garbo–Raffaello de Carli attributions. Bernhard had also painstakingly catalogued some 240 drawings of Leonardo for a major section of the work, and he noted with satisfaction that his chapter on Leonardo was drawing to a close. He subsequently unearthed an additional 80 drawings for the second edition.

Preoccupied as he was, he did not neglect his hortatory letters to his sister. He hoped that she would visit Europe every other year and rejoin with him his cultivated and fashionable friends. What particularly weighed on his mind was his father's situation, now that he had promised a liberal annual subsidy. "I cannot deny a strong merely psychological interest in how father will take things now," he reflected. "For the past thirty years his constant longing, I suppose, has been for a cessation of toil and leisure for culture and amusement . . . but all the while his work could scarcely help getting the strong grip of habit upon him and now we shall see how he gets on without it. . . . I fear that he may

find an excuse for groaning in that his leisure is bought by my labor. So you must make plain that I am not at all a martyr." Senda evidently succeeded in her mission; but what could not be allayed, as she reminded him, was their mother's longing to see her self-exiled son again.

The hoped-for eight months of quiet work proved a too optimistic expectation. The traffic in art could not be avoided, and society, which was its collaborator, had now beat a path to his door. Mrs. Gardner's affairs naturally had first claim, but there were others who also depended on him. For example, Edward Warren again summoned him to Rome in late February to assist in the hunt for more pictures for his mother, a delicate business because neither wanted Mrs. Warren to appear to be a rival of Mrs. Gardner. Eight months later Warren was able to report to Berenson that "the last of mama's pictures had left Italy"; the half dozen included a Titian and a Catena.

Warren had now become the chief agent of the Museum of Fine Arts for the collecting of classical antiquities. With the help of a fellow Oxonian, John Marshall, his housemate at Lewes House, he had built up a widespread collecting organization much like Berenson's and is said to have had the first refusal of most good finds. His arrangement with the museum was that he would receive 30 percent above the original cost. On the face it seemed a liberal one, but, as he told Berenson, it "neither covered ordinary expenses nor gave any reward for skillful buying." Berenson must have felt the irony of his own impulsive arrangement with Mrs. Gardner to charge her only a 5 percent commission, an arrangement which he had finally been tempted sometimes to circumvent.

Among the earliest visitors that spring was Lady Ottoline Bentinck, the half-sister of the Duke of Portland, who came to spend a month in Florence. Still in her twenties, Lady Ottoline was already affecting the flamboyant style that as a patroness of the Bloomsbury group would make her the talk of London. On her previous visit in 1898 Berenson had taken her to the Pitti Palace, but being full of gossip about the scandal-mongering Strongs, she had paid little heed to the pictures. He now took her to Bardini's famous gallery, accompanied by Logan. It was she who was soon to become a successful rival of Logan's for the affections of his dearest friend, Philip Morrell, his associate in the Toplady shop. Berenson showed her off at a grand tea party at Mrs. Ross's imposing villa, but that formidable lady conceived an "impetuous hatred" for her, as Mary recorded, "and behaved at her most outrageous so as to shock her, slapping her knee and saying 'By God' and 'Damn it!' [Lady Ottoline] looked gorgeous in a peacock hat and purple

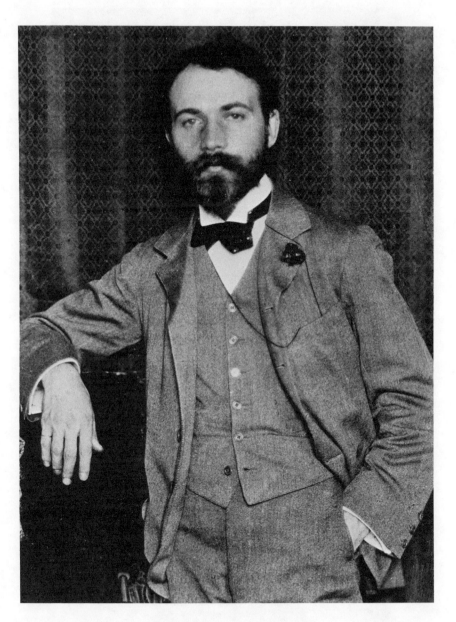

22. Berenson, about 1900

23. *Hortense Serristori*

cloak." Mary recalled that in spite of her attire "Henry James said of her she is the only woman he had ever seen who had absolutely nothing feminine about her." It was an opinion echoed by Zangwill, who said that in her case "the distinction of sex was a purely superficial one." Berenson's appreciation of her charming eccentricities declined greatly when her salon became the center of the detested "Gloomsbury" group, as he termed them.

The names of more and more titled and affluent personages now adorned his letters. Among his callers, for example, were "the two splendid types of the two races, English and Russian which now nearly divide the earth, Lord Balcarres and Prince Boris Galitzine." They were succeeded by Count Stroganoff, Prince Hohenloe, and Herr Adolf von Beckrath, the art historian. And, of course, near at hand there was always the beautiful Countess Hortense Serristori.

Bernhard's intellectual cousin Louis Freedman came down from Berlin for a few weeks, full of ideas on how to make aesthetics a mathematical science, but, as Mary put it, he nearly killed them with his theories. Otto Gutekunst dropped in, bringing news of the London market and no doubt assuring himself of Berenson's continuing confidence. One evening when Bernhard and Mary fell to discussing their friends, Bernhard in an access of frankness and jealousy confessed that he had never really liked Obrist, Blaydes, nor another one of her admirers, the young sculptor Andersen. This admission astonished Mary, for they were all people, she reflected, to whom paradoxically he had been "most awfully kind and sympathetic." He had even advanced a large sum to Blaydes for his speculations. The persons he really liked instinctively, he said, "in an intimate and *sans gêne* way were Trevy, Fafnir [Hutchins Hapgood], his classmate Carpenter, Reinach, Zangwill, and Placci."

The influx of visitors had the usual effect of preempting valuable time, and before long Berenson was miserable at not being able to get on with his manuscript. Then the oppressive heat of June drove him north again. On the train to Andermatt he encountered Loeser, and in their long and earnest conversation Loeser made no attempt to conceal his dislike, which he justified on the ground that he had an "entirely different view of art" and that he felt he "must keep his independence." Their talk nonetheless suggested to Berenson the possibility of ending their feud, and he wrote proposing that they reestablish their friendship. Loeser took several months to respond. "If I capitulated at our last interview," he wrote, "it was the quick and accurate firing of your guns that did it. But on taking counsel with myself I find that I cannot get over a sense of distrust . . . which will not let me wander out of

reach of my trenches. Moreover, I think with the German emperor that peace is best assured when one is armed for war." In this fashion Loeser confirmed himself as another one of what Berenson came to call his "enemy-friends."

Berenson's annual stay in London was darkened, as we have seen, by his fear of a break with Mrs. Gardner, but once he placated her he drew a relieved breath, checked the stocks of the art dealers in Old Bond Street, and ran up to Oxford to see his cronies at New College and Balliol, with whom he could share his renewed enthusiasm for Greek literature. On his first visit there in 1888 he had found a fellow spirit, the brilliant young classicist Gilbert Murray, a year his junior, whose dramatic readings of the Greek plays captivated all who heard him. Murray had gone on to teach at Glasgow, whence he was to return to New College in 1905 to become the best-loved and most influential interpreter of the Greek drama. Since their first meeting, he had been in intimate correspondence with Berenson and had sent him his first publications. Presumably, he was among the classicists who attended the July rendezvous at Oxford.

Refreshed in spirit, Berenson hurried off to his eagerly anticipated holiday at St. Moritz the first week in August, while Mary stayed as usual at Friday's Hill. "I am sure it is not without a thrill of longing," he tantalized Senda, "that you will read the postmark, St. Moritz." He told her he had come up by the same scenic route they had taken two years before. All the great spirits were again congregated there, with Placci skillfully dancing attendance on the princesses and duchesses and "Donna This and Donna That." There were "grand dinners, costume dances, and sounds of revelry by night." He found himself much in demand and was accorded one of the great privileges of high society there, that of directing a *tableau vivant* in which the beauties of the Hotel Caspar Badrutt displayed their sculpturesque charms. His beautiful sister was much asked after, even by the most extraordinary aesthete of them all, the ambiguous darling of the French high society, Count Robert de Montesquiou, of whom Berenson was seeing a good deal. In his letters Count Robert liked to salute him with the curious endearment "Cher Noosie."

He enjoyed the "life-giving air," he told Mrs. Gardner in the midst of his fervid descriptions of scenery and desirable paintings, and he reported a long evening "of fierce argument on aesthetics in Italian with Donna Laura Groppalo," a well-known writer and psychologist who was soon to become one of his devoted interpreters. To Mrs. Gardner he prudently stressed the health-restoring regimen prescribed by Dr. Murri, his "miracle working Italian physician," a regimen of "daily

baths, waters, and massage so that I shall be kept occupied in a most fashionable way."

The gaiety of life at St. Moritz admitted a shadow that Berenson determinedly ignored. Far off at Rennes the new court-martial of Alfred Dreyfus was under way, and in spite of the damning revelations of forged evidence it was clear that Dreyfus would not be exonerated. Among Berenson's titled acquaintances at the hotel there was open hostility to the long-suffering Jewish officer, and the talk in Berenson's presence ran to blatant anti-Semitism. What took place there came to the ears of Reinach in Paris and saddened him. Mary relayed to Bernhard what Reinach had learned, "that thee sat silent when the most outrageous things were said about Jews. This seems to Reinach dishonorable, and I don't suppose he *can* take any other point of view. He thought thy motive was to 'get in' with those swells, and of course lost his respect for thee." Then to soften the blow she added, "I am not sure that he has more sympathy with thy real motive, the desire to be amused by really amusing people, though I explained to him how much thee needed a change from work and the filthy set of connoisseurs among whom thy lot has been cast. He feels no need for such violent changes, and having no psychological insight, does not understand it. But this is the root of the matter, and other people calling thee ambitious, and conceited and self-seeking (!!) have done the rest. But it is not serious. He is personally very fond of thee."

Although the beauteous Duchess Grazioli graced the company, Berenson lost interest in her as a dazzling new charmer swam into view, completely bewitching him. She was Gladys Deacon, a girl just half his age, a mere seventeen, but already touched with tragic mystery. Her father, a member of a wealthy Boston family, had years before established himself with his young wife and children in the Hotel Splendide in Paris. His wife's former lover resumed his liaison and in 1892 the irate husband, finding him in her boudoir, shot and killed him. The scandal was immense. Deacon père was sentenced to a year in prison but was afterward pardoned by President Carnot. At the time of the pardon Gladys was being educated in a Paris convent. When her mother learned that her father planned to abduct her and take her to America, she persuaded a sympathetic court to keep the child secure in the convent. Now, in 1899, the father, who had succeeded in obtaining a divorce, was already beginning to show signs of the insanity that was shortly to lead to his confinement in Boston in the McLean hospital.

For the first time since his meeting with Mary in 1890 Berenson felt swept off his feet, and the "marvellous creature" seems to have been almost equally attracted by the slim, impeccably groomed, and hand-

some bachelor with soul-piercing eyes and neatly trimmed Van Dyke beard whose conversation glittered with ironic epigrams. Bernhard could not resist telling Mary of his infatuation. She had gone over to Aix-les-Bains to look after her mother, who was suffering from arthritis, and to take the cure to try to rid herself of the fat that was hurrying her into the middle age of which at thirty-five she was all too conscious. Earlier she had written of shopping in Paris, where she had spent sixty pounds for "very nice new dresses and a coat" and, since Bernhard held the purse strings, she feared he would have to send her fifty pounds to replenish her purse. Never having sampled the regimen at St. Moritz, she had remarked that the interlude of relaxation "is I am sure especially good for thee, who so seldom relaxes." Now, two weeks later she observed, "So thee is acquiring a taste for very young girls!! Seventeen and a half is young (But I am only laughing)." As a veteran of a number of infatuations she could be tolerantly indulgent. Thereafter, however, a certain testiness invaded their daily letters.

The contrast between his untrammeled existence at St. Moritz and the complications of his domestic situation seems to have goaded him to protest against Mary's protracted absences in England. "I wish to remark," he said, "that you are arranging so that we shall scarcely have a month to ourselves. I desire no more of your intimacy than you wish to give me but still,—either your indifference, or your conviction that I am the incarnation of stickfast, is great." She retorted that she was "neither indifferent, nor have I the fond belief in my so superior attractions to other women that I feel at all sure that thee will continue to prefer my society." But she insisted that the fact remained that she owed a duty to her mother and sister, who had done so much for her by looking after her children. Having made her point, she hastened to assure him that they were "nothing to me in comparison to even a suspicion of losing thee."

The reminder about her duties to her family and her children did not sit well upon him in his exalted state. He demurred that difficult as her situation was she did get pleasure and the promise of pleasure out of it, "in which I do not share, whereas it yields me but annoyance for the present and the promise of greater annoyance for the future." He cautioned her that she ran certain risks. "You leave on me an impression of indifference, and no great confidence that in a crisis you would prefer me to your grown-up children. The risk is that should I ever fall really in love with another free person, and be tempted to marry, I should not find enough of you in me to prevent me." But he too drew back from the precipice. "The danger, I may add, on a person so self-controlled as I seem to be is remote, yet—who knows himself?—so do not disturb

yourself." She admitted the truth of his analysis but observed disarmingly that it would be a pity "if thee were to go away just when I am finding out how nice thee is."

Perhaps Gladys saw in Berenson as much a father as a possible lover and husband. In any event she later attached herself to Bernhard and Mary and from time to time traveled about with them in their tours of the art towns of Italy. Something of the girl's fascination can be felt in Mary's description of her in a diary entry a few years later, when Gladys was twenty: "Siena. The event of this month has been the reappearance of the radiant Gladys Deacon so beautiful, so brilliant with her soft elixir ways, her hard clear youthful logic, her *gaminerie,* her lively imagination, her moods, her daring. It would take volumes to describe her and I don't feel up to it. . . . A wonderful creature but too young to talk to as an equal and too much of a born actress to take quite seriously but so beautiful, so graceful, so brilliant that it is enough to turn anybody's head. Part of her mysteriousness comes from her being, as it were, sexless. She has never changed physically from a child to a woman and her doctor said she probably never would. She calls herself a hermaphrodite but she is not, brought up by a mother who thinks of nothing but dress and sex. Her mind plays around with all the problems of sex in a most charming manner with an audacity and artfulness that make your hair stand on end. She is positively apish. . . . Her defects are bad form for she is distinctly in bad form and lying, but Bernhard says she is so wonderful that she can afford the first and she may outgrow the second. Gladys is of course interested in nothing but herself and what touches her and so brilliant a creature cannot be put down as so young a girl naturally would be, therefore all our endless talk centers around things that interest her." After Gladys left at the end of a week, Mary recorded: "Brilliant, cruel, selfish, untrained. What will become of her? She has now gone to Blenheim for a visit in which she told me that the Duchess of Marlborough was broken-hearted because the Duke would make such wild love to her. Was it true? All in all I never knew a person who told so many lies as that beautiful radiant creature."

Mary might well have believed the tale. Gladys was indeed a friend of the duchess, the former Consuelo Vanderbilt, whose marriage to the Duke in 1895 surpassed in splendid ostentation anything that New York had ever witnessed before. And by 1921, after a divorce had paved the way for Marlborough's marriage to Gladys, the duchess seems to have been relieved to turn over the duke to her friend, whose romantic involvements had been filling the press for many years.

With the chill hint of autumn in the air of the Upper Engadine

Berenson took his leave of the picturesque village on the edge of the lake overhung by soaring peaks, descended the dizzying curves of the Maloja Pass in his carriage, skirted Lake Como, and came to a halt in Milan. There he was greeted by Mary, who saw at once that something had made "Bernhard feel young again." That something was not hard to conjecture. His "amusing acquaintances" had dispersed for another year, dispatching him to Milan with a "nest of connoisseurs." Off he and Mary went to the Poldi-Pezzoli gallery to review the Lombard painters; then to the Brera, where they were escorted by the flowery director, Corrado, a member of the Italian art commission. They visited the workshop of Cavaliere Cavenaghi, already known as the ablest of all restorers, to inspect his progress on the paintings he was cleaning and restoring for them. He offered to teach Mary his craft whenever she was ready. In Milan they also encountered "the really remarkable youth" Trumbull Stickney, the Harvard poet who was a doctoral candidate at the Sorbonne and one of the so-called Harvard Exiles. Here too they joined forces with Sir Charles Holroyd, and when they dropped down with him in a few days to Florence, Berenson helped him with his book on Michelangelo's drawings.

There was much work to do, for the summer's notes were again voluminous, and Mary set to work to organize them. She tinkered again with her Louvre catalogue while Bernhard tackled the problem of identifying the growing mass of Michelangelo's drawings, which he had tracked all over Europe. In the midst of these projects the proofs came from Putnam for the second edition of *The Florentine Painters,* the corrections being Mary's province. There was also an appreciative review to be dashed off for the *Gazette des Beaux-Arts* of Sidney Colvin's *A Florentine Picture Chronicle.* But in the fine autumn weather there still remained time for bicycle excursions with Alys, Bertie, and Mary into the hills, sometimes the road so steep that the women were towed uphill behind a carriage. There was time as well for a hair-raising drive by carriage on the precipitous mountain road to Sansepolcro to view the two masterpieces of Piero della Francesca. Though Bernhard was passionately addicted to walking, Mary had to confess to herself that she really disliked going afoot, and hence when she tactfully could, she let Bernhard seek more athletic companions like Roger Fry for his daily rambles along the lanes through the olive orchards and pine groves.

Soon Berenson was summoned to Siena to join Mrs. Gardner and her young protégé, the pianist George Proctor, on whom she had reportedly spent $7,000 for music lessons abroad. He was now so constant a companion and house guest that gossip marked him out with its usual exaggeration as her future husband. Fully restored to her good graces,

Berenson took her to visit the abbey of Monte Oliveto Maggiore, where Padre Negro had baptized him. Here he had the pleasure of displaying to her the series of frescoes by Sodoma and Signorelli which had first lured him to the abbey. On the road there was also business to attend to, the closing of the purchase through Colnaghi of a reputed Martin Schongauer, *Madonna and Child,* for nearly £2,000 and the usual discussion of other possible acquisitions. After a few days Mrs. Gardner departed for Orvieto with her cavalier in attendance, and Berenson ran up to Milan to visit the great collection of Italian pictures of his influential friend Don Guido Cagnola at his palazzo in town and at his sumptuous Villa della Gazzada.

There was a momentary alarm when news came that Mary's husband wished to give up his cottage across the road from Friday's Hill because of the flareup of his long-standing ear ailment, which had been thought to be eczema. His London specialist continued to talk optimistically, but Alys and Bertie passed on the opinion of their doctor that it was a terminal cancer and that Frank could not live long. The fear that Mary's children would be deprived of the advantage of her mother's presence subsided when Bernhard offered to put up the money for Bertie and Alys to buy the cottage in their name. This expedient did not need to be resorted to, for Mary's mother bought the place herself. In spite of the hint of a portentous change in Mary's status, life for Bernhard and Mary went on much as usual. Bernhard's growing prosperity cast him more and more in the role of Good Samaritan to their improvident friends, who found in him a lenient creditor. Conspicuous among them was the impecunious Blaydes, who wired a plea for sixty pounds, although Bernhard had already advanced him three hundred and sixty. Mary, who had first persuaded Bernhard to help him, now warned that "he will be on thy hands again, and really thee mustn't be so kind to him. It has been ruinous for him." Then as if to even the score between them, a letter arrived from Gladys which suggested to Mary that Gladys might be a good deal in love with Bernhard. He prudently did not embroider the theme. The daily routine of work was briefly broken when excitement suddenly erupted over the Assisi painting which Mary had located at her forger friends'. Apparently their bank balked at financing the purchase. Whatever the difficulty, it soon evaporated.

Then on December 10, 1899, the event that Bernhard and Mary had never allowed themselves to dwell on suddenly loomed before them. A telegram arrived saying that Mary's husband was dying. She immediately left for London. In her daily reports Bernhard read the grim details of the progress of Frank's disease and the anxious debates, conducted out of Frank's presence, over the custody of the two children. It

was known that Frank's will attempted to prevent Mary from becoming one of the guardians and assigned their care to the young Catholic governess. Despite her resentment Mary could not help pitying the dying man as he tossed from side to side, "hopelessly plucking at the bandages and at his covers." It looked as if it would take at least three weeks to settle the will and as if she might have "to stay a long time in this land of unutterable gloom and sordidness, for he must die first." A few days later there was a temporary return to consciousness and "a reconciliation scene. He kissed my hand. I am now in hopes that he may be able to make a new will." The "unjust will" was much on his mind, and in lucid moments he said it would be made right and kept her constantly beside his bed. He did not rally, however, and the will remained unchanged. Her solicitor assured her that if necessary the children could be made wards in Chancery the moment Frank died.

A few days later another doctor was called to his bedside. While Mary watched, he confirmed surgically a diagnosis of cancer and showed that the case was hopeless. The long agony ended "without a struggle" on December 22. The German Catholic governess whom the will had attempted to make the children's chief guardian "came raving in about Purgatory and his soul calling out for prayers." Ray's first tearless question to her mother was, " 'Are we to come to you at once?' " Mary took the two children to her mother's house at 44 Grosvenor Road. At the funeral, she wrote, the little Catholic church was filled for the impressive service. "They sang the *Dies Irae* and prayed the beautiful Latin prayers for the dead, and though I know it's all 'made up' it comforted me to have him go in such decorous and seemly make believe." She learned that the estate amounted to only £6,000 (later discovered to be £7,000) and that the money would be tied up in a trust for the children and the income would have to be supplemented to ensure that Mary's mother could maintain the separate establishment for the children required by the Chancery Court. They, of course, would have to be educated as Catholics. With some ingenuity Hannah Smith was able to arrange a trust for the purpose, based on a Philadelphia property which her late husband had not encumbered, and the guardians were appeased.

On New Year's Day, Mary wrote from England, not without a trace of irony, "Of course it is a happy New Year, Bernhard, and I take the wishes that thee was too tactful to send. I am happy, perfectly joyful at the thought to do my utmost—it won't be half enough—to make thy life happy, and oh! unpreoccupied with worry, so that I can live in our interest. I feel like a god when I think my heart is inundated with joy."

For all her sense of relief, there lurked below the surface a hint of apprehension. Her divine joy had in fact been preceded by the pregnant reflection: "It will be interesting when all that is obscurely in your mind comes to expression." What was quite clear in her own mind was the fact that she was now free to marry Bernhard.

The complicated proceedings in Chancery dragged on from week to week until in February the judge mercifully refused to enforce the provision of the will which prohibited Mary's access to her children. Her daily letters to Bernhard spared him no frustrating or gratifying detail. Preoccupied with her children, she regaled him with gay accounts of their activities, doubtless hoping to inspire an interest in their welfare. She worried, however, that Bernhard would be alarmed at her expenses. The children's riding horses, for example, cost more than she had anticipated. "The burden of everything," she lamented, "is like that awful Kipling song, 'Pay, Pay, Pay.' I always feel desperately uneasy when I am in England—not that I am habitually extravagant, but I am always afraid thee will think I am spending too much on Ray and Karin." Though the disclaimer could not convince him, he dutifully sent funds.

Back in San Domenico Bernhard was thinking of other matters. "I have been working incessantly, joyfully," he commented to Senda. "I am seeing scarcely no one except Placci, who comes up every few days. I am having a gorge of reading. . . . My study is a sight. Marius [in Pater's novel] sitting in the midst of the ruins of Carthage may have resembled me for confusion at least. . . . Thousands of photographs and hundreds of books on all sorts of clashing subjects and in many tongues surround me. Notebooks frolic about sportively and run away with cigarette and cigar boxes; add letters answered and unanswered, bills paid and to be paid, orchids and carnations and elastic bands and as I turn around my eye falls on a 17th century globe shaped like a chuppah [a Jewish marriage canopy]." More circumspectly, he reported to Mrs. Gardner that he was working sixteen hours a day and never less than ten and at his solitary meals reading French plays. "If I keep on working," he asserted, "it will not be long before I shall take rank as indisputably the first authority on Italian paintings." This reputation, he added, "will give added lustre to a collection I have humbly helped to form." He did not neglect to keep her informed of a variety of possible acquisitions, most of which she managed to resist as her trustees tightened the purse strings. The only paintings she acquired through Berenson this year were Richter's Giotto, the long-lost painting by Fiorenzo di Lorenzo that Mary had unearthed; Rembrandt's *Obelisk,* for

which, at £4,500, she had outbid the unhappy Bode; and a Raphael *Pietà,* which commanded £5,000. He also obtained for her a range of late Gothic choir stalls for a modest £750.

The £23,000 advanced for these acquisitions was a substantial sum, but it was less than half of what she had spent the year before. The partial eclipse of her sun reminded Berenson of the uncertainties of his profession, and henceforward a note of urgency crept into his negotiations with Gutekunst. Fortunately, he was able to fall back on Theodore Davis, who was becoming an omnivorous collector. At Eastertime in Florence he was "buying everything he could lay his hands on" and keeping Berenson "very busy." Besides, there was his friend Edward Warren, who had been given a free hand by the Museum of Fine Arts. Warren assured Berenson that if Mrs. Gardner "failed" to bring more masterpieces to Boston "I would certainly do my utmost to fill the gap." He proposed that in that "contingency" they consult on strategy. As a starter he thought he might set up an independent fund by selling some of the things he had at Lewes House.

The partial breaking of Frank's will in February freed Mary for travel and, leaving the children in her mother's care, she busied herself mending professional fences for Bernhard and herself in London and Paris. She reported, for example, that Lady Henry wanted to sell her Ghirlandaio for £1,000 and asked, "Shall I suggest to Gutekunst? or Dowdeswell? Or could thee engineer thyself with Mrs. G.?" Berenson tried hard, but the painting was still another which Mrs. Gardner denied herself while the letters flowed back and forth. In one he told her that Walker Dowdeswell of the Old Bond Street art firm Dowdeswell & Dowdeswell, "one of the least bad firms in London," in Berenson's deprecatory phrase, was about to go to the United States and that he had given him a letter of introduction to her because he was "rather nice and so far as I know straight and gentlemanly."

With Mary's return in March, what was "obscurely" in Berenson's mind, as Mary had suggested at the opening of the year, had slowly and hesitantly come into the light. Apprised at that time that his affection for her was "dwindling," she had declared, "Though alas, I can't be to thee all I might once have been," still she felt sure that "thee will catch my gladness a little and oh I will be so nice to thee." The prospect of marriage after ten years of life together obviously unsettled him. He was all too conscious of the matriarchal character of the Smith family, in which life circled tightly about a strong-willed feminist mother who had no great respect for the male sex. Hadn't Mary's mother suggested to her militant women's rights associates at the time of Oscar Wilde's sordid trial that men ought to be castrated? Legend has it that Logan

persuaded Bernhard to propose to Mary, but Mary hardly needed her brother's advocacy. "I do believe," she remarked to Bernhard, "if we are married I can help thee in small business things, etc." The understatement could not have been lost on him, for she was already handling a great part of his business affairs. Returning to the charge a few days later, she wrote, "I am planning many happinesses for thee if thee marries me!!" For one thing, she told him, she had decided to take cooking lessons.

Whatever resistance Bernhard may have had soon evaporated, especially since he had been assured that Mary's children were to remain in England. As Mary said, "They needn't impinge on thy existence at all." He had found the awkward subterfuge of their twin establishments a strain upon his own sense of propriety as well as a heavy expense. Even the perceptive Henry James thought their relationship ambiguous, speaking of "Mrs. Costelloe who is supposed to be living with Berenson but really isn't." Berenson wrote to his family, "She understands me, my needs, as no other person and I am sure she will try to make me happy." They were to marry "when the decent year [of mourning] is over." When later that year he gave the news to Mrs. Gardner, she exclaimed, "If you two cannot be happy together no one can." Mary's mother responded philosophically that she had always seen herself as a patient ox pulling a cart that had to be full of some sort of load. "Frank has been lifted out, so there is room for Berenson and very likely he will be an easier load to pull." Logan had broken the news to her in early June, and he reported to Mary that she "took it very sensibly although she can't help despising a woman who, when she has had the luck to become a widow, deliberately chooses to marry again." Alys remarked that she couldn't think of a "mere brother-in-law she would prefer to B.B." As if to square herself with her somewhat skeptical mother, Mary declared that the marriage was "utterly without significance" for her but best for the welfare of the children, not of course that she was not fond of Bernhard. She had to admit, however, that she did "look forward with zest to stepping out from that equivocal position which I have been in for ten years."

To Bernhard's pious mother the announcement was more than welcome news, even though he was marrying a non-Jew. At thirty-five it was high time for him to settle down. Her letter to Mary trembled with joy and hope.

My dear Mary, if I may call you so: Your dear letter I received. It was a great surprise but a very happy one. It was my wish for a long time that Bernhard should marry. I know how necessary it is for him to have a friend who should

feel for him and make him happy and for that I trust you, my dear. He shows his greatness in that he does not take a very young girl who loves gaiety and forgets her duty to her dear husband. So I am very happy that he has selected a sensible lady who has already gone through a little in the battle of life and will know how to take care of him in an emergency. I hope he will make you a good dear husband. I need not tell you that he made the best son in the world. So I am quite sure he will make, also, a good dear husband. I could not tell you how happy it made me that you will come to see us in America. I can only say *Amen* to that. Nothing will please me more than to see you and Bernhard, my dear children. Bernhard's father sends his love to you. Yours lovingly, Judith Berenson.

In long, long retrospect, with Mary gone and all passion spent, Berenson in the twilight of his life got to thinking of the part that chance and inertia played in a life like his, buffeted by the winds of violent change. The past like a much varnished painting showed dim and lusterless, its truth equivocal to the last. "Did I marry for any reason more basic than that it was so much easier to drift along than to break and flounder about in search of another woman or to hang around till another woman came and took me?" But memory was not yet done with the past. At ninety-two, musing on the sources of his lifelong sense of being an "outsider," he reflected, "The furtive life Mary and I necessarily lived for ten years before we could marry encouraged a habit of isolation, except with the very few who accepted our situation, and with whom we felt free of concealment." In the jungle of the human psyche the trail of motives loses itself in ambiguity.

X X V

A Union of "Minds and Feelings"

THE talk of marriage on Mary's return from England in the early spring of 1900 naturally led to the decision to unite their two expensive establishments. Bernhard quite happily left the task of househunting to Mary and Logan while he hurried off to Genoa to welcome Senda, whom he had urged to come abroad at his expense, and take her to nearby Nervii to visit his "dearest and most interesting friend," the Marchesa Laura Gropallo. The marchesa, as he once wrote to Fry, was "a woman with real brains, much learning, and great culture." Her "enchanting villa stretched with its lawns and palms to the rockbound Mediterranean." There, he confided to Mrs. Gardner, he became convinced that the "life of dignified luxury in the open air agrees with me." The luxury included a gratifying call on Lady Brooke, the Ranee of Sarawak, wife of the famous Rajah Sir Charles Brooke. She charmed him with talk of Pater, Swinburne, and Henry James.

The househunting went on apace in his absence, and shortly after his return with Senda the search ended triumphantly with the leasing of the Villa I Tatti, a mile and a half to the southeast of San Domenico in the valley of the Mensola, below the village of Settignano and within its postal boundary. Mary reported to her family that it was much more beautiful than her Villa Frullino and though much in need of refurnishing would cost forty pounds less a year. To Bernhard she expressed the hope that he found it as pleasant to think of the Tatti as she did—"a haven of rest and quiet work," where, best of all, they could be "freely and openly together." With her usual optimism she was sure that even with a complete staff of servants they would spend "very much less than we have been doing." Bernhard shared her euphoria, but what pleased him most was that the villa stood "at the very entrance to the

most beautiful strip of rock and forest country that we have near Florence." What the name "Tatti" signified, though much guessed at then and afterward, proved lost to memory. Recent research, according to Professor Myron Gilmore, former director of the Harvard Center there, has suggested, however, that it may derive from a thirteenth-century land grant to a member of the Zatti family.

Situated in a sharp angle of the road that mounted steeply upward in a series of switchbacks to the castle of Vincigliata, the villa commanded a sweeping view across a fertile valley to the heights of Settignano, the natal village of the gifted Renaissance sculptor Desiderio. A mile or two of fields and woods still shielded it from the encroaching habitations outside the ancient city gates of Florence. I Tatti was a rural villa dating from the sixteenth century, built for permanence with the customary thick walls of Tuscan stone. The broad yellow-plastered façade rose three stories high to the sloping red-tiled roof. Green shutters on each row of the seven French windows gave protection from the afternoon sun. Midway in the façade, above the ground floor, a stone balcony sheltered by a canopy promised countless golden sunsets. At that date the villa was a simple massive oblong structure, the façade joined at either end by red-tiled stone walls which sloped downward to the broad and equally solid red-tiled shelter for garden plants, the limonaia as it would be called, the whole enclosing a spacious terrace and sunlit garden. Just within the entrance gate that opened on the road there stood a stone chapel, which had served earlier inhabitants of the villa. To the rear were the solid stone outbuildings and stable required for farming the adjacent fields. Lower down the hillside and beside the Mensola streamlet were the yellow-plastered houses of the contadini who worked the small tributary farms. As Florence, which then had scarcely two hundred thousand inhabitants, crept closer, beyond the Porta San Gallo, there would be need to add more fields and olive groves as protective buffers, until the estate should include some seventy acres.

The villa was owned by the remarkable nonagenarian John Temple Leader, who still actively supervised his widespread holdings in the region from his seat in the enormous Castle of Vincigliata, situated on the crest of the hill five hundred feet above I Tatti. Self-exiled from England some fifty years earlier, where he had been a liberal politician with a wide acquaintance in the highest literary and social circles, he settled in Florence and devoted his large fortune to Tuscan archaeology. He acquired the ruined medieval castle in 1850, restored it, and filled it with historic treasures. In a deep ravine a few hundred yards above I Tatti he impounded the Mensola behind a stone dam and bridge, creating a tiny lake, the "Laghetto" as it was called, in a picturesque grotto

beneath an overhanging ledge of rock. At the head of the lakelet he erected a replica of a medieval watchtower and near the edge of the water built a small classical temple, on the wall of which hung a marble placque commemorating Queen Victoria's visit in 1888. It was a romantic spot, and for several years Berenson and his guests were to be permitted to bathe in the deep pool. One of the most memorable sights, recorded by Mary, was that of their friend Gertrude Stein, "clothed in nothing but her fat," lowering her huge bulk into the cooling waters at their "Ladies Only" swim. Mary exclaimed to her mother that "she didn't know such enormities existed."

The previous tenant of the villa, who had recently died, had not been a stickler for modern conveniences. Hence among the many tasks Bernhard entrusted to Mary was that of arranging for the putting in of proper water closets and the laying in of water for the second story. So began a long tug of war with dilatory local craftsmen, who disdained impatient foreigners. Mary was sure that "being Italian, all these people were probably trying to cheat me," and she decided to take counsel with the redoubtable Mrs. Ross. Costs as always outran expectations and Bernhard, who was less sanguine about the future than Mary, showed alarm. Mary temporized, "but still, if thee thinks we can't afford it, we could give up the bathroom and leave the water closets as they are." On the other hand, the "possibility of a hot bath" for him and "a cold one" for her seemed too desirable to forgo.

Senda's arrival put an end to Bernhard's struggle with the Florentine drawings for some months, for he was determined, as he told Mrs. Gardner, to "show her Italy and enjoy her first impressions." And this he proceeded to do with brotherly zeal. He delighted to squire her about Florence, more than ever proud of her dark beauty and growing sophistication. He spread before her all the glories of Renaissance art, as he had done with many others, but with a keener relish, for she was his emissary to their family and could justify his long exile. There were always notables to be cultivated as they traveled about Italy, and sometimes a rare luminary, as when they visited Bologna and encountered the fabulous Cosima Wagner, the imperious director of the Bayreuth festival, whose single-minded devotion to the memory of her husband had become a world legend. There hung about her still the aura of romance and scandal as the illegitimate daughter of Franz Liszt and the faithless wife of the famous conductor Hans von Bülow. Highly cerebral and vigorous at sixty-three, she "bewitched" Berenson, who enjoyed her, as he said, as an "aesthetic impression" and under her spell even regarded her plain features as handsome.

In May Bernhard and Senda penetrated to the heart of the scenic

Abruzzi, which is dominated by the rugged Gran Sasso. Here one can be sure Bernhard expatiated to his sister on the painterly features of the soaring landscape, for to him the Italian landscape was as much a subject for devoted contemplation as the art which it had fostered. They made their way to Rome for a "gorge" of sightseeing and society and there rendezvoused with Mary. Toward the end of the month, after "doing" Cortona on its lofty hillside, where Fra Angelico had worked, and ascending to historic Perugia with its treasures of Umbrian art, they foregathered on the heights at Assisi with Lina Duff-Gordon, who was doing a book on Assisi, and gave themselves over to the dramatic frescoes of the Upper and Lower Churches of Saint Francis. In that genial ambiance Senda was persuaded to talk a little about her own work as a teacher of physical education, leading Mary to reflect, "What a sane, sensible, delightful creature she is. And her work, the using of bodily exercise as an aid to spiritual development, is wonderful. The real Greek ideal. I do admire her enormously."

There followed an idyllic month in Venice, Bernhard's favorite city of art, where the days passed in sightseeing and floating dreamily on the canals. On one occasion Prince Hohenloe took them all to his castle on the cliffs near Trieste, whose antique towers reminded them of Keats's "magic casements." There was also much shopping to do for exquisite furniture and furnishings for I Tatti, and the lire took flight with amazing ease. In leisurely fashion Bernhard and Senda journeyed across Lombardy, skirted Lake Como, and ascended the pass to St. Moritz, Mary having left them to rejoin her children at Haslemere. With Senda at his side Bernhard relished anew the gaiety and glitter of the Hotel Caspar Badrutt, where his titled North Italian companions paid court to him and his sister. "It is a smallish society, the Lombard, and slightly provincial perhaps," he explained to Mrs. Gardner, "but jolly, charming and handsome." The aristocratic French contingent had not yet arrived. At the fancy dress ball late in August he swept into the room in the romantic garb of an Arab prince and Senda took his arm in the dress of a lovely gypsy.

The long holiday came to an end on September 6 at Genoa, where he bade a regretful and long farewell to Senda, her companionship for six months having endeared her to him more than ever. After a few days at Nervii with the Marchesa Gropallo who had come to the pier to see Senda off, he hurried on to Paris to join Mary and see with her the marvels of the great Paris Exposition. "Mary was here at [the hotel] Sts. Pères waiting for me," he told Senda, "radiant with health and rejoicing in a magnificent figure which her new corsets are giving her. . . . I told Donna Laura of my [forthcoming] marriage; she was pleased and

altogether charming about it." Mary's own letter to Senda revealed that Donna Laura Gropallo had persuaded Bernhard to have a correct Catholic marriage, a suggestion she thought rather ironical coming from the marchesa "after the stories" Bernhard had told them of her "urgent invitations to him to go to Vallombrosa with her" alone.

The news of his engagement, Bernhard reported to Senda, "quite ruffled the placid surface at the lake of Como," when he returned there in October. "Everybody was expecting it yet, as I hear, Donna Carmelita felt furious." Mindful of his pledges to his family, he told Senda to expect a draft for $625 from Baring's. Of this $375 was his half-year's remittance to his brother and $250 was to go toward furnishing their parents' new house on Grampian Way in Roxbury. "I shall be greatly obliged if you spend it well." He kept her posted, as usual, on his omnivorous reading. He had gone "Carlyle mad," having finished all six volumes of the *Frederick,* and was now immersed simultaneously in the *Cromwell* and the *Essays.*

But life was more than gluttonous reading or romantic travel, more even than writing and connoisseurship. It was most intensely lived in talk, in the friendly duello of words across the tablecloth or in the circle about the fireplace, in the art of conversation, of which Berenson was a master. The flavor of those innumerable interchanges in his travels or at home is gone with the breath that uttered them and the animated gestures and looks that gave them emphasis. Something, however, of their character emerges in a few Boswellian notes which Mary preserved from this period. Once at Lake Como, she and Bernhard fell to discussing the nature of the picturesque. Bernhard remarked that once when returning from the Villa d'Este he had enjoyed seeing some half-ruined villas with great flights of stairs running down to terraces "more acutely than any form of painting—coming round at last, he said, to what every English old maid who paints in water colours undoubtedly feels. . . . Twenty years ago he used to go around with a thoroughly unintellectual set of art students who nonetheless appreciated this form of beauty which is now only being revealed to him. He questioned if it were not pure snobbishness and the weight of authority backing up the pleasures more difficult of attainment that makes us feel what we call art superior. I objected that surely a Greek statue suggests so much more and is so humanized, so full of stimulation to all one's best human ideals. 'Then it is an ethical and not an aesthetical question.' . . . B.B. wasn't quite sure that it was not culture-snobbery, but he said that he sometimes thought the point of things was that the *yearning* for an état d'âme was much more poignant and delightful than the full realization of that état d'âme. 'Picturesqueness throws you violently right in the

midst of the mood. . . . Art makes you long for the mood as some-
thing infinitely desirable. . . . For most people a mere suggestion is
good enough to bring on the mystical ecstasy which only fairly complete
artistic realization can produce in us. Pater, for example, undoubtedly
did have the art ecstasy through many inferior things—and think how
people are about music.' "

Mary took pains to record a subsequent conversation in which the
young English painter William Rothenstein took part when he visited
with them in the Via Camerata in the fall of 1900. The movers had not
yet dispossessed them. The conversation turned to Degas and Whistler.
"B.B. said they were both in his sense *archaic,* that is to say, they
reacted against the formulae they found and sought with passion to re-
cover some neglected or never seen detail—Degas movement, Whistler
atmosphere. R. objected that they were not fruitful in followers—hence
were cul-de-sacs instead of beginners. B.B. said the reason they had no
immediate followers was because the art formulas of the XIX century
had been so great and so greatly worked on that people were exhausted.
M. objected that new people were being born, not tired, but each one
fresh. B.B. explained that he meant the *formulas* were exhausted not the
people, and that an interval must occur before the new thing makes its
way. M. What formulas? B.B. The formulas of intellectualized
composition. Degas and Whistler came to smash that up. The tendency
of all art is from the single detailed human figure to generalized intellec-
tual composition. This gradually gets empty and the natural spirit of
Reaction leads to a passionate return to detail. . . . Reaction is our
means of preserving what was good in the past, which we are in danger
of losing. That is why when people come to me and deplore the 'Clas-
sical Reaction' I am not distressed. It would be terrible to drop out and
forget all that was good in religion and the religious attitude—which
we might do but for the blessed spirit of Ruskin. M. What a pity,
then, we can't carry it all along with us, instead of being so one-sided!
R. We can't. Any given attitude towards life, any sequence of views
is like a veil hung up between us and the rest of life—only now and
then there are rents through which we catch glimpses of a world we
aren't living in but which nevertheless exists. B.B. In Europe no
phase of art, no formula, has life for more than three generations. In the
East, on the contrary, instead of living ninety years it lives nine hun-
dred. . . . They preserve the past without the need for reaction."

Serious converse of this sort, in which Berenson had been initiated at
Harvard, as had Mary in her family and in the Harvard Annex, was the
chief nourishment of all their social relations. Of gossip there was
God's plenty, but it floated on the surface of the deeper stream of talk,

talk in which the participants could freely toss their ideas into the tumbling current to evoke a flashing ripple of wit or wisdom. They shared allusions as if they were all partners in an intellectual joint-stock company. If they were writers like Berenson, it was thus they tested their insights on a jury of their peers. Such talk became an established ritual at I Tatti, and Berenson would preside like a latter-day Dr. Johnson. Much of its rich texture and encyclopedic breadth would one day be displayed in the record which his great good friend Count Umberto Morra would publish as *Conversations with Berenson*.

Berenson found it hard to get back to his desk after the six-month interruption. He fretted that "there never was such an Augean stable to clean out as the mass of drawings ascribed to Michelangelo. Not one in a hundred proved really to be by him." The difficulties so oppressed him that in a moment of despair he cast upon Mary a "strange look almost of fright." He was weary of life, he told her, and confessed that the only thing that kept him going was her "good health and spirits." To Roger Fry he explained that he had "spent all last year cataloging Michelangelo's drawings, and now I am trying to make them give up their secrets. Frequently they refuse even under torture." He worked on with such desperate resolve that Mary was obliged to report to Senda, "B.B. with his characteristic lover-like ardor declares that nothing will induce him to get married until his Michelangelo is finished."

Mary was equally determined. She confided that she planned to get married the day before Christmas and added, "I have not communicated this to Bernhard yet as I do not wish to distract his mind." Meanwhile she and Logan were "grappling with the villa and the furniture." All the Venice things had arrived safely. One of their most admired acquisitions was a player piano with a goodly supply of rolls of Bach compositions. There was to be nothing but Bach, Mary said, and they would have the wonderful "privilege of hearing the same thing over and over again and as often as we like." She also bought a donkey for the planned visit of her children. It could hardly have been news to Senda, who had watched the pair at such close range, to learn from Mary that they had run out of money again. Mary was not daunted. She had consulted one of Placci's relatives at the bank and he had said he would lend her "as much as I wanted." She also observed that Bernhard's Tennessee Coal and Iron stock was down, plain proof to her that he ought to stick to what he knew, pictures, which were "a much better investment."

Her opinion was accidentally confirmed at this time by a remarkable find in what she described as "a little out-of-the-way hole-in-the-corner sort of place." Bernhard, Mary, and Logan happened on it in one of the

little lanes of Florence. A large painting hanging on the wall of the little shop consisted of three tall panels. Both Bernhard and Mary fortunately recognized it as an altarpiece for the Church of San Francesco at Borgo San Sepolcro painted by the little-known Sienese master Sassetta. Mary told her family that only Bernhard, she, and a professor at Siena (Langton Douglas) knew about Sassetta. The shopkeeper, unaware of its value, let it go for a modest 2,000 lire (about $400). Berenson in his old age thought he recalled that Loeser and Horne had also seen the panels and thought them of no value and that the ignorant shopkeeper was going to saw them up for faking Fra Angelico scenes. Jubilant over their prize, they talked of hanging it in the chapel at I Tatti and of selling it later, when the Sienese school became better known, unless they grew fond of it. In his imagination Bernhard saw it commanding as much as 10,000 lire. It was "a gorgeous triptych," he rhapsodized to Senda, "by that adorable Sienese Sassetta. Do you remember him at all?" The great painting did not go into the chapel but took a place of honor in the villa. For once Berenson's imagination fell short of the mark. The almost priceless painting was to become one of the chief glories of his collection.

Italian Renaissance paintings were the one special extravagance they allowed themselves, and Bernhard, Mary, and their inseparable companion, Logan, haunted the antique shops. On one expedition they haggled for a "severe" Madonna, pictured with the Child on her knee, and brought the price of 300 lire down to 200, but the shopkeeper's wife had such "a soft caressing voice B.B. not content with the one purchase fell completely under her spell," and as Mary told it, "would have spent his last penny there" had not she and Logan "dragged him away." When their hobby had run its long course, with paintings sometimes being sold off or added, their Italian Renaissance collection comprised some one hundred and twenty-five paintings that reflected the scholarly breadth as well as the curious byways of Berenson's eclectic taste.

Berenson's own possessions had already grown to impressive proportions. Leo Stein, the philosopher brother of Gertrude, wrote to her one day that autumn that he had lunched with Berenson. "He has sense, there's no doubt about that," he declared. "He's younger than I thought him—only thirty-five. . . . [Stein was then twenty-eight.] His house is filled with beautiful old Italian furniture and hangings and he has a really magnificent art library." Leo Stein visited with him again two days later, initiating a friendship that endured for nearly half a century, although he had been a little put off at first by Berenson's egotism. "There's simply that tremendous excess of the 'I'," he told Ger-

trude. "For example, when we were talking about Yiddish literature he spoke of the numerous myths that were current in his Lithuanian home, many of them of great interest and which he declared ought to be garnered up and saved. 'But there's no one can do it except myself and I'm forgetting them.' " He had also declared that "all recent writers on Italian art were not only fools but thieves as well, for they take everything that they have from him and almost never acknowledge indebtedness. The anti-Morellians hate him because he is a Morellian and the Morellians hate him because he isn't Morellian enough."

With the increase in stock dividends as the century drew to a close the financial situation eased. Sugar was "splendid, and tobacco too." Even Tennessee Coal and Iron was "booming." In addition, Mary rejoiced that "B.B. has made a sale that will cover all improvements." It was the sale of the Raphael *Pietà* to Mrs. Gardner in mid-November. The small panel from the predella of an altarpiece from the convent of San Antonio in Perugia had been acquired by Colnaghi from its British owner, and Berenson had described its somber beauty with more than usual eloquence. His offer in late October had been an irresistible siren song. The painting was a "jewel of the most exquisite delicacy. . . . In a word the little picture puts you in a mood as if far away and yet within hearing you suddenly heard angels playing on their stringed instruments. . . . So you see it is a Raphael of exquisite quality, of finest Umbrian feeling, of unquestionable authenticity, of perfect preservation and with an almost matchless pedigree." His lyrical prose had restored the color missing from the accompanying black and white photograph of the Virgin sorrowing over the dead Christ, and Mrs. Gardner dispatched her cable of acceptance without delay.

Though Mary's mother was reconciled to accepting Bernhard as a son-in-law, she worried, as a militant feminist, about the control of the purse strings. Mary, somewhat too confidently, as time would show, assured her that as they made money "B.B. would always invest part of it in her name," and she felt sure that they would "make a great deal of money." Besides, he planned to insure his life for £10,000, "which will be a practical settlement." She reminded her mother "that it is usual for the wife to contribute her share, just as Alys did. But I want to be able to leave all my money straight to Ray and Karin, so I don't want to settle anything now. . . . Besides the question doesn't really arise, for B.B. isn't a man to make ducks and drakes of his money, and he is as generous about it as he can be." Of quite a different order was the question of how Ray and Karin were to address their future stepfather, whom they regarded as "a sort of uncle." "B.B." would obviously not do and "Bernhard" would be equally presumptuous. "As he hoots at

any family name, I suppose," said Mary, "it must be Mr. Berenson." She was wrong. In due course it became "Uncle Bernhard," then "B.B."

Toward the end of November the movers carted Bernhard's belongings down to I Tatti while he took refuge under Aunt Janet Ross's hospitable roof at Poggio Gherardo. "I left my den," he recounted to Senda, "with considerable regret. At present I cannot believe I shall ever so completely reduce to my own pleasure and measures the new house." He prophetically added, "Even then I shall not be the one and only master thereof. This new place is still in a frightful chaos. Mary is too goodnatured and not overcompetent, the result being that the workmen have not got finished what should have been done long ago. Then she had the idea of having both her mother and her children out, just now, of all times. Either the mother or the children might have been tolerable, but the mother will not let Mary attend to anything but the amusement of the children, and I believe Mary wishes them at Jericho at certain times. These girls are nice children, not handsome, the older and favorite [Ray] looking just now huge and common with the distinct marks of Paddydom all over her face. The way she is brought up adds strongly to my determination never to have a child. Mary and I could never, never agree about the way it should be brought up. Mrs. Smith, Mary's mother, is, I think, determined to treat me nicely. I can appreciate her aesthetically for the largeness and almost heroic spirit that is in her, but we have no idea in common. . . . Since leaving my diggings I have been staying with the Rosses. . . . They are spoiling me and I fear when I return to Mary's housekeeping I shall be inclined to be more impatient with it than ever. The Rosses have given me a magnificent apartment to myself, and except for interruptions occasioned by the red tape in connection with the marriage, I pursue my work. Michelangelo himself I finished the last morning I spent in my old house. Since then I have done Sebastian Del Piombo." To Trevy he declared that though the long section on Michelangelo had been "the most dreaded part of my book" he was confident it "will be the best thing in it."

The marriage "red tape" proved more burdensome to Mary than to Bernhard. He had little difficulty establishing his identity through the American consul, as required by Italian law, whereas she as the widow of Costelloe had to make her peace with the British consul. As was to be expected, the bureau clerks did not abate a jot or tittle of their official prerogatives and wielded their rubber stamps with their customary relish. Mary complained to Fry, "Marriage seems to recede as the Italian law puts endless difficulties in the way. I am occupied in trying to prove my personality."

In the midst of the bustling preparations for the wedding and for moving into I Tatti, there appeared on the scene a remarkably personable visitor, Arthur Jermy Mounteney Jephson, one of the heroic officers who had accompanied Stanley on the dangerous expedition of 1888–89 to relieve Emin Pasha, the Egyptian governor of the Sudan. Jephson's book on his harrowing experiences had made him famous, and his succeeding volume, *Stories Told in an African Forest,* had become a classic. While on a lecture tour in the United States with Stanley, he met Mrs. Gardner and, according to report, became her "adoring lieutenant." She had evidently recommended him to Berenson. Both Bernhard and Mary found the forty-two-year-old veteran a fascinating companion, though as Bernhard wrote to Mrs. Gardner, he was "more of a lady's than a man's man" and he had "already made great friends with Mrs. Costelloe."

Preoccupied as Berenson was with his writing, he welcomed the diversion provided by Jephson's attentions to Mary. "I leave them a good deal together," he told Mrs. Gardner, "and he has put off leaving Florence again and again." It was almost as if he unconsciously hoped for a miraculous deliverance at the eleventh hour, as many another bachelor has done. In any case he seemed unaware of the risk he was taking, given Mary's romantically benevolent nature and his own capacity for jealousy. Jephson, somewhat at loose ends at this time and short of funds, promptly became another recipient of Berenson's philanthropy. Almost at the same time young Mason Perkins turned up in Florence again with empty pockets, which Berenson replenished with 700 francs. Plainly he could not forget his own earlier years in Italy, when he lived from hand to mouth on the bounty of others.

At last all the bureaucratic red tape was unwound and the new villa stood ready to be occupied. The horse and carriage which they had arranged for by the month stood conveniently by the door. Accompanied by Maud Cruttwell and their philosopher friend Alfred Benn, who were to act as witnesses, Bernhard and Mary journeyed down on the twenty-seventh of December to the Palazzo Vecchio for the civil ceremony. They were all kept waiting for half an hour while two clerks busily wrote with "their noses on the paper." Then an usher in evening dress wearing a colorful sash took them before the magistrate, where the "rigamarole," as Bernhard termed it to Senda, united them in a legal marriage. On Saturday the twenty-ninth, he told her, "there will be some more hocus pocus and a feast. Then we shall be man and wife." Saturday came and in the refurbished chapel of I Tatti the two long-lapsed Catholics knelt submissively before the prior of Settignano and with what theological reservations can be imagined exchanged their

vows. On this occasion Placci and his friend Buonamici stood by them as witnesses. Included among the well-wishers were Mary's mother, Logan, the two children Ray and Karin, Donna Laura Gropallo, Mrs. Ross, Herbert Horne, the Kerr-Lawsons, Maud Cruttwell, and Edmund Houghton. And in this festive atmosphere under the mild effulgence of the December sun the two restive collaborators took possession of the domain with which they would ever afterward be identified.

Appearances were at last satisfied, and much to her relief Mary could now face society duly certified as Mrs. Berenson. Her mother and the two children consigned to her care departed with Logan for England two days later, and Bernhard and Mary were left in the great house to face a future together of undreamed-of vicissitudes. If to Mary the marriage brought a measure of security, it also subtly altered their relationship. Bernhard may have assured Mrs. Gardner that "marriage can bring our minds and feelings no nearer than they already are," since for ten years they had shared "nearly every thought and feeling," but, as he had foreseen, life together under one roof for two such highly charged temperaments did not foreshadow unbroken serenity. He had long relied on Mary to extricate him from his mistakes and to shield him from the mundane concerns of daily living. To a degree she had mothered and managed him, not wholly without a patronizing irony even when deferring to him. Now her very apperance was that of a proprietary matron who physically overshadowed him, and what she had vouchsafed as a friend and compliant companion she would now exercise with the authority of a wife. For the confirmed bachelor that Berenson had thought himself, that authority could not help proving irksome.

XXVI

A Victorian Husband

MARRIAGE may have simplified their social relations but the new villa solicited complication. Every room was a challenge to their taste in decoration, though Bernhard left to Mary most of the work of getting things in order and paying the bills, which piled up with astonishing celerity. Stairs had to be carpeted, carpets relined, new curtains hung, furniture reupholstered, rooms readied for Logan and for the visits of the two children, and final touches given to Bernhard's and Mary's separate bedrooms. Three descending terraces linked by broad stone steps "immensely improved" the garden and gave an appearance of rooted solidity to the house. The new marble statues added a touch of classical elegance. A Dionysus stood among the cypresses, a Ceres on the wall near the front door, and a bust of Semiramis on a pedestal near the chapel. In the house his "masterpieces" were at last rehung to his satisfaction and his collection of photographs was filed, but his precious library would have to wait for the new shelving, whose construction was far behind schedule. A man of property, he proceeded to insure the paintings and furniture for close to £20,000.

The ambitious improvements on the Villa I Tatti had turned out to be much more costly than Mary's blithe estimate. Not only had the plumbing been attended to, but also a new tile roof had been put on the ample structure, the broken masonry had been repaired, the extensive terracing had been constructed, the whole exterior had been freshly plastered and painted, and the interior had been repaired and decorated. On the completion of the roof the forty workmen had been regaled with a festive dinner. As an aesthetic afterthought, all the interior painting was done over. Then in an unprecedented cold wave the new plumbing froze up. Worriedly, Mary confided to her mother that their

expenses "quite frighten me." The fee on the *Pietà* sale fell far short of their need. Fortunately, other picture negotiations bore fruit, and panic subsided when Bernhard received a handsome fee of £ 500 and Mary could once again pay their bills. In all the commotion of the early weeks in the new house, Berenson seemed surprisingly calm, for when Mary lost some photographs and expected his usual furious reaction he uttered "not a word of rage," she told her mother. "Logan will hardly believe this!"

Friends, eager to see what they had done to I Tatti, beat a flattering path to their door, and they enjoyed their roles of genial hosts. It was deceptively easy at first to entertain "with a good cook and good service," but when the cook turned out to be "a rogue" who took commissions from tradesmen and secretly dealt in antiques, he had to be dismissed. His successor, if more honest, proved deplorably limited in his cuisine. Mary, with her usual generous élan, promptly took a young pianist under her wing, a Miss Cracroft, and arranged a Saturday series of Bach musicales for her benefit at I Tatti. The audience evidently included a fair number of "Virgins of the Hills," as Mary called them. Leo Stein reported to his sister: "The other day at Berenson's I met Miss C[ruttwell]. . . . She's one of those frowsy-headed red-faced English women of uncertain age, whom you could put on the stage as a type of Britisher without any further makeup. There was a party up there, all freaks, to hear a girl play Bach, which by the way she played very well. . . . Among the people was a Miss Lowndes who appears intelligent and very decent. She translated Höffding's psychology and writes reviews for *Mind* and philosophical literary things."

Toward the end of February Gladys Deacon and her mother, who had assumed the name of Mrs. Baldwin, came down from Paris to stay for two weeks, and now Mary too succumbed to the fascination of the young girl. The Berensons were astonished to learn from their guests that rich people in Paris changed "all their clothes, nightgowns, and sheets every day" and spent five hundred or a thousand francs two or three nights a week for entertainers at their parties. They also heard a somewhat different version of Mrs. Baldwin's misfortune, namely, that her husband after telling her to take a lover inconsiderately shot him.

Soon they all traveled to Siena, where Bernhard lavished his erudition upon Gladys, though it was obvious that she found his person more interesting than his learning. Trevy and his new Dutch wife came on to I Tatti for a week and poetry flourished. Then Jephson turned up in Florence on a singular mission, to clear himself of the scandalous accusation of homosexuality growing out of his previous visit. Berenson explained to Mrs. Gardner, who was much concerned, that there was

supposed to be "quite a colony of these monsters" in Florence and that every society man who arrived and failed to kowtow to the self-appointed leaders of "foreign society" ran the risk of being defamed. Jephson had not paid his court, and when he was seen in a café handing his card to a young man who happened to want to study English gardening, a malicious story was soon circulated that he had been seen giving out his card to pretty boys near the theater. His traducers had sent their slanders on to England. Berenson reported to Mrs. Gardner that Jephson succeeded in obtaining apologies and written retractions, and he conveyed to her Jephson's love and kisses, homage that to Mrs. Gardner at sixty was now more than ever welcome.

From the beginning at I Tatti Berenson was beset by distractions on every side. Not the least of these was the stream of importunate antiquity dealers who came to the villa, in Mary's words, as if the house stood "under the Star of Bethlehem" and the "Kings of Antiquities" approached in procession bearing gifts. It happened, however, that from one of them Berenson acquired a painting they had never expected to get hold of, a much-battered Perugino. With an outlay of a few hundred pounds for restoration by Cavenaghi it promised to become extremely valuable.

Somehow in the midst of all the domestic bustle, Berenson managed to immure himself in his study and buckle down to his manuscript. "I am in the very hottest fever of work" he told Fry a month after the wedding. He nevertheless paused long enough to challenge Fry's criticism, in a recent article, of his chronology of Giotto's paintings. "You will perhaps do well to rest assured that I am not in the first place 'scholarly' or 'learned'," terms which Fry with considerable justice had applied to him. "I hate to read about art and love to use my eyes. So it happens that I have looked at Giotto's works as many hours probably as you minutes but have never read regarding them a page of Crowe and Cavalcaselle or anybody else of that kind. . . . Now my impressions are always of some authority with myself, but have not the categorical value of a voice from Sinai." He added that when he could spare a fortnight at Assisi he would reexamine the question. Fry was understandably perplexed by his friend's obvious resentment, but he must have sensed the fact that Berenson disliked being contradicted. Ironically enough, Fry's articles on Giotto gave even more offense to their common enemy Arthur Strong, for giving the honor of inventing scientific art criticism to Morelli rather than to Crowe and Cavalcaselle, for whom Strong was an ardent partisan.

Berenson undoubtedly felt beleaguered in his delightful refuge, and his prickly pride was his chief defense. He had chosen the path of con-

noissuership and was finding it strewn with nettles. He felt himself tugged at by a swarm of responsibilities, and in his new style of life the most urgent one was the need to make money. For a few years Mrs. Gardner's bounty had seemed bottomless and his dealings with other clients an agreeable superfluity. Now, however, her purchases were steadily dwindling. He wrote to her every few weeks, offering a succession of alluring pictures, but her five purchases that year amounted to scarcely more than £5,000, one-fifth as much as in the preceding year, which itself had been leaner than those before. And he was dogged by ill luck, as once before in the case of the *Blue Boy,* which Mrs. Gardner had so coveted years earlier and which he had failed to get for her. Now she greatly desired another Velasquez. It happened that early in the year he had learned that a great Velasquez, one of his many portraits of young Don Baltasar Carlos, heir to the Spanish throne, was coming on the market from Lord Bristol's collection. While Otto Gutekunst and his associates schemed and bargained for it, Berenson proposed it to Mrs. Gardner, at first for £20,000 and then for £25,000.

Her "sacred rage," as her friend Henry James would have called her acquisitiveness, was never more apparent than in her pursuit of this trophy. "As to the Velasquez," she had exclaimed, "I am with you. I *will* buy the Don and dog, but I ought not to. Only do get it for little. And buy me a heavenly Raphael Madonna and then let's sleep on our laurels. I think of putting on my pearls and begging from door to door—no other clothes but my Rosalina point lace." Everyone, she said, "adores" the Velasquez at the Museum of Fine Arts and she challenged him to get "one much more adorable." However, Lord Bristol dreamed of a much richer harvest, and as the negotiations dragged on he upped his price to £34,000, responding, as Berenson suggested, to "the wild stampede in London by people like Pierpont Morgan and Yerkes who buy anything at prices to make your hair stand on end." "No indeed, dear Berenson," Mrs. Gardner decided, "not for me the Velasquez at that price." Her disappointment at losing the painting on which she had set her heart was doubtless matched by Berenson's chagrin at the blow to his reputation as a skillful negotiator and at the loss of the much-needed fee.

Distasteful as the world of business and art dealing was to him, he found himself hopelessly mired in it, and the time of redemption receded farther and farther into the future. He who as a younger man had inveighed against insincerity and commercialism found himself growing adept in the age-old art of the huckster. Moving in circles where money seemed to spring to the touch of its members, he keenly felt the precariousness of his own position, which depended so largely on the

whims of a few clients. The uncertainty of his situation inevitably told upon his health. His complaints of bouts of dyspepsia and recurring weakness grew more frequent. In self-defense he attributed his malaise to the strain of finishing his manuscript and of preparing new editions of his books, but if in that spring of 1901 he hovered on the edge of a nervous breakdown, a contributing cause was his many financial worries, which marriage had done nothing to alleviate.

When Mary departed for England for her regular Easter stay with her children at Haslemere, Bernhard charged her to confer with Gutekunst about the possibility of joining his firm, for the pictures they owned in common were not selling. In a letter to Bernhard she rehearsed for him the points she believed he wanted her to emphasize. She was to point out that he had hitherto avoided joining any other firm out of loyalty to Gutekunst. If the Colnaghi firm would provide the capital and he the "brains," he could soon create "a corner" in important Italian pictures. The pressing fact was that Mrs. Gardner was "buying less and less" and he felt he "must be connected with someone who *has* a market." He was not without the suspicion, which he impressed on Mary, that Gutekunst was neglecting his interests. The "market" appears actually to have been stagnant at the time and the partnership did not materialize. In spite of the undercurrent of distrust, which seemed the normal climate of art dealing, the two men maintained friendly relations until Gutekunst's death in 1947.

Other outlets for his services did of course exist through the network of contacts which Berenson had cultivated. Florentine dealers often counted on him as a highly knowledgeable intermediary with such London firms as Dowdeswell & Dowdeswell and the prestigious Agnew's. It was through Dowdeswell, for example, that in 1901 he obtained for Mrs. Gardner a portrait of Queen Mary of England, which he attributed to the Dutch painter Moro. This picture, in which Agnew's appears also to have had an interest, went for £3,400. But Berenson's was a wayward and uncertain profession with more disappointments than successes, especially for a free-lance agent who found himself buffeted about in the turbulent world of international art dealing. His surviving papers of the period hint at many negotiations, and in the absence of any business records one can surmise that a sufficient number succeeded to keep him and Mary afloat amidst a sea of recurring financial worries and unkept resolutions to economize. Moreover, they had learned the aristocratic art of living on credit. Large bank loans evened out some of the troughs in their income, though the specter of eventual repayment hovered unpleasantly in the background. Fortunately, there were dividends from their American stock holdings, and

these were eked out by small additions from Bernhard's British and American book royalties and from the fees earned by Mary's two articles in 1901 in the *Gazette des Beaux-Arts*.

One of Berenson's strongest desires was to make Boston a world center of Italian art. In this aim Edward Warren was a dedicated collaborator. His family had long been identified with the Museum of Fine Arts, and since the recent death of his mother he had become involved in the disposition of her art treasures. As eagerly as Berenson he hoped for the emigration of art to America. "I don't like to see pictures wasted," he once told him. "And I do like to see them in the United States." As an agent for the museum Warren was given, as he said, "full liberty of selection," but since the object was to obtain only masterpieces—a costly enterprise—the task fell to him also of soliciting contributions from fellow Bostonians, and the tale of his trials in that respect was a leitmotif of his letters to Berenson. He counseled with Berenson about approaching Mrs. Gardner, apparently with regard to help in financing the purchase for the museum of the famous Crivelli *Pietà*, which his friend John Marshall had acquired in 1900 from the Panciatichi-Ximenes collection in Florence. If the museum could not afford it or, as Warren thought, did not have the spirit to back him, perhaps Mrs. Gardner could be induced to buy it. Their scheme fell through as Berenson cautioned it might; however, a member of the Warren family is thought to have closed the gap and the Crivelli did go to the museum.

Warren worried that his campaign for funds had been a "fiasco." "Boston does not provide enough money and I shall try other places." He thought he would "tackle a man in New York amply able to back us, and hitherto deterred from collecting by the misfortune of bad purchases at the beginning." What became of the plan to obtain funds in "other places" remains hidden in the cryptic allusions of Warren's letters. Their relations continued to be close, and some years later when the purchase of I Tatti impended and Berenson needed money, Warren offered to buy "one or two pictures of those that hang in your house. If you are like me, such use of pictures does not always imply a desire to keep them."

In one of his reports to Berenson Warren gave an amusing sidelight on the recent completion of Mrs. Gardner's "palace" in the Fenway. Having finished hanging the pictures and arranging her objects of art with a certain whimsical precision, she laid out a path through the rooms that visitors were rigorously obliged to follow without turning back or taking notes. Curiosity about her treasures had become so feverish that one souvenir hunter was discovered cutting a piece from a

hanging. "Eleven people have got into the 'palace,' " Warren wrote. "Eleven hundred are wanting to get in. . . . I hear from [Henry L.] Higginson that she is really out of money—at all events for the moment. It is said she has dismissed her carriage. These tips to show that I am not idle."

One visitor, however, would have been assured of a royal welcome, Berenson himself, whom she affectionately regarded as one of her most prized acquisitions. Learning of his low spirits and ill health in the spring of 1901, she commanded, "Well, Berenson dear, you shall come to America. There is no other way to get the brace necessary for your work, which should be done in grand style and not halting, lame of one foot." When he begged off she responded, "Come, bring your wife, and she must bring you. I have charming rooms ready at Brookline." More than two years would go by before he felt ready to submit to her hospitality. Months later, when he was still pleading dyspepsia and nerves, she burst out, "Fling the book into the sea and come." He defended that he was being well nursed. Balked in her plans for him, she responded, "Do get quite well although you don't deserve it for not coming here." Whatever his ailment (a later age might well have called it psychosomatic), it baffled his Italian doctor, who could only prescribe rest and the inevitable tonic.

That being Mrs. Gardner's guest could impose onerous conditions must also have figured in his decision. As an old man he once recalled a stay with her in her palazzo in Venice, when alarmed at having received none of the mail he had been expecting he finally spoke to her about it: "It just isn't possible I could be here all these days without receiving a single letter or telegram." His hostess pulled open a drawer and showered him with letters and telegrams. "Your mail, indeed! Here's your wretched mail! Do you think of nothing but yourself and your mail? Don't you ever think of me?"

During Mary's month-long absence at Eastertime, Bernhard consoled himself for two weeks at Nervii, ministered to by the Marquesa Gropallo, whose salon furnished some of the intellectual stimulation which seemed lacking in Florence. Even with the ever-present Placci to be counted on and his circle of familiars at Poggio Gherardo and the Gamberaia, the frequently renewed conversations tended to wear topics threadbare. Of acquaintances there was no lack, but Bernhard and Mary sometimes found themselves "starving for intelligent friends in Florence." Rejuvenated by the sea air, Berenson returned to I Tatti to his exacting literary chores. The infinitely complex details of the *Drawings* oppressed him. He complained that the book had become an "incubus," Sindbad's "Old Man of the Sea," and he put the work aside for

a time to meet the call of his publisher for an enlarged edition of his *Lotto* and to prepare a collection of his essays. The change of pace did not relieve his sense of strain. The *Lotto,* he told Senda, was "more of a task than one could imagine, for I had to live myself into the whole thing once more." He obviously felt that if his authority as a writer on art and as a connoisseur was to be maintained in the world of art criticism he must, like any academician, publish or perish. Under the lash of his own and Mary's ambition he was learning to live at I Tatti with a restless pen in his hand.

With Mary off in England for a month, he found that living alone in the house with an undisciplined staff of servants swiftly palled on him. Leo Stein kept him company for a while, but the young man seems to have immersed himself, as on later visits, in the bountiful array of books in Berenson's library and did not really succeed in diverting his host. Nor could Berenson have greatly welcomed the demanding consultations with Theodore Davis, who was again bargain-hunting in Florence, driven out of the Valley of the Kings by the fiery spring sun. To cap his troubles the cook whom Mary had optimistically hired proved an even greater failure than the first one, and the lax housekeeping outraged Bernhard's fastidious tastes. Naturally, he flung the blame on the absent Mary. She tried to disarm his wrath by admitting that she knew she was "a fearfully careless slovenly lazy person, but for thee I do mean to try to do better. . . . I have thought more of thee and tried more to take thy point of view. So don't despair, please!" Her cheerful letters during the Easter season telling of her joy in looking after her children and of entertaining Jephson as a house guest and recounting the interesting diversions of her visit to Paris, where she met Mrs. Baldwin and the incomparable Gladys, seemed only to make him miserable. His feeling of isolation must have grown even more acute when he learned from her that a fresh slander against him was circulating in London. It was charged that on the sale of Richter's Giotto he had taken a commission from Richter and also one from Mrs. Gardner, when in fact he had deducted Richter's proffered bounty from the sale price. The current of adverse opinion in London circles had become so strong that even Donna Laura Gropallo, who was visiting England, "would hardly listen" to Fry's explanation of the truth.

Exasperated by Mary's blithe recitals, Bernhard resorted to a familiar weapon—sarcasm. He would ask her to write the books and make money since she was "evidently incapable of doing the housekeeping." Dismayed by the accusation, Mary asked for a bill of particulars, promising to make full amends on her return. A sore point had of course been her preoccupation with her children, whose affairs had

dominated her daily letters to him. He had hoped, he said, for serious impersonal subjects. She admitted that she knew that "the very idea of children bores you," but countered that his own letters had been filled with complaints about his health, which though worrisome were hardly more elevating. She tried to mollify him by declaring that her imagination could not "stretch to any greater happiness than that of being thy wife" and that in all fairness he would have to admit that she was loyally attending to his business affairs in London, not only in dealing with Gutekunst and scouting for pictures but also in trying to place the Florentine drawings volumes with Heinemann who initially showed considerable interest. She wrote, however, that Heinemann wanted to see a couple of chapters as the basis of a possible monograph and would also like the opinion of Lippman, the Berlin art critic. Zangwill, who was regularly published by Heinemann, also tried to use his influence, but his report was even less encouraging, for he learned that Heinemann's capital was "already locked up in various forthcoming volumes" and until "the Boer war is over he is too timid" to make new commitments. In any case the negotiation fell through.

Bernhard was unfeignedly relieved at Mary's return. But one of her first tasks was to make up their accounts while he went on with the revision of the *Lotto,* and he was soon alarmed to learn that by her calculation they had spent nearly £3,000 in the five months since their marriage. His fits of despondency resumed and he announced that he was indifferent to life and bored at the thought of going on. In his despair he confessed he had no real warmth for anyone except Mary, and she reflected that "even Gladys [Deacon] had faded out of his grasp." In this summer of discontent, thanks to Mary's insistent urging, he found himself obliged to go to England to entertain his mother and his sister Bessie, who were due to arrive there toward the end of May. The prospect of being fussed over by his doting mother was not alluring to him in his dark mood. He believed their coming would be "an awful bore."

The atmosphere at I Tatti grew more cheerful when Don Guido Cagnola, the "most entertaining Italian" he knew, came to stay for a week. Another agreeable visitor was Elizabeth Cameron, the beautiful Washington hostess, wife of Senator James Donald Cameron and the favorite confidante of the noted historian Henry Adams. She was accompanied by her daughter Martha and by Trumbull Stickney. The scholarly Henri Hubert, Reinach's assistant in anthropological matters, was also a member of their party. Louis Freedman came down from Berlin, full, as usual, of his philosophical quiddities. Mary, always a captious critic in her appraisals, thought him a fool.

Berenson braced himself for the family visit by stopping off for ten days in Switzerland on the way to England while Mary went on ahead to find comfortable lodgings for his mother and sister in London. Bessie was now an athletic young woman of twenty-two, proficient as a basketball teacher at Smith. "They were very quiet, simple people," Mary recorded, "and not at all exacting. I felt it was B.B.'s duty to have them as his mother adores him, and he never goes, and never will go to see her." Berenson fulfilled his duty with what grace he could muster. He did not have the same rapport with Bessie as with Senda, and conversations with his mother, whose concerns were largely familial, were often marked by long silences which Mary had to bridge. The wayward and sentimental Jephson joined all of them for several days at Haslemere and in his endearing way shared his manifold troubles with them. Most unsettling was the fact that on account of an illness he had lost his post ss King's Messenger with its much-needed stipend. Berenson's mother must have been able to forget her own sorrows and earlier hardships listening to his more dramatic ones.

In London Berenson succeeded in arranging with Murray for the publication of *The Drawings of the Florentine Painters* and placed the enlarged second edition of the *Lotto* and his first collection of essays, *The Study and Criticism of Italian Art,* with George Bell & Sons. He found some diversion attending to business at Colnaghi's and at Agnew's, but his malaise became so obvious, he told Mrs. Gardner, that both his wife and his mother urged him to go to St. Moritz since he was "getting sicker and sicker." By mid-August he made good his escape to the Engadine, leaving his guests to Mary's care.

Mary took them on a visit to Oxford and Bessie wrote to him that they thoroughly enjoyed themselves. "I knew you would," he replied, "for there's no place more beautiful." He learned later from Mary that they had actually been quite unhappy at Oxford but that Bessie had not wanted to worry him, and that his mother had told Mary that Bessie had "nearly killed her by being so critical of everything she says and does." Mary declared it was a pleasure "to take them about, especially the little mother, who really enjoys things more, I think, than Bessie. Her O! O! O!'s are delicious to hear." Unfortunately, her enjoyment of things did not last, for she had "a dismal way of seizing the unhappy aspects of things" and lost herself in tears. She kept brooding pathetically on Bernhard's long exile. "What bliss I had those mornings when I could sit beside him and see him eat his breakfast." The report of his mother's grief elicited the somewhat guilty response, "Poor lady, I wish I was also there to comfort her." When the time came, early in September, for departure for Boston, Mary told of more tears. "Thy

*24. Berenson, his mother, Mary, and
Bessie Berenson at Friday's Hill, 1901*

25. Berenson with Ray and Karin Costelloe
at Friday's Hill, about 1900

poor mother cried and cried." In the cab to the station she wept on Mary's sympathetic shoulder. Mary could share her unhappiness, for Bernhard's letters from St. Moritz continued to harp on Mary's failings.

Berenson could not help contrasting the well-ordered routine of the Hotel Caspar Badrutt, ensured by squadrons of attentive servitors, with Mary's improvisations at I Tatti. Nor did his image of the absent Mary improve as he gazed on the svelte and elegant ladies in their bejeweled gowns on the terrace above the lake. He felt somehow cheated of his dream of exquisite existence as Mary urged upon him the practical and attainable satisfactions of their married life, insisting that happiness could still be salvaged. Made cruel by his despairing disappointment, he criticized her as "a fat middle-aged person of no importance." It was an unkind cut and the "fat" could not be disputed, but what increased the pain of his reproaches was her having heard from her cousin Grace that Bernhard had said at Friday's Hill that summer that he felt "lucky" to have Mary as a wife. That "lucky" touched a sensitive nerve. She protested that she needed the sense of "really being loved," of not being merely useful. "I struggle," she said, "under the sense of being a burden to thee, of being too coolly 'seen through.' Thee laughs at me for wanting admiration and praise, but I want it to make up for the criticism I feel thee is simply *holding in* about me." These daily forays into their emotions, breeding in their endless prolixity and self-examinations recurring discord and misunderstanding, were regularly set aside for discussion of household and business affairs, which had to be attended to regardless of the afflictions of the spirit.

One suspects that his recriminations sprang in part from his own conflicting emotions. Mary's artless confidences about the "loveable" Jephson awoke a feeling of self-pity and jealousy all the stronger because of his own hopeless infatuation with Gladys Deacon, who was dazzling the crowd at St. Moritz. "The pity of it is," Mary commiserated with him, that the affair "will come to very little from our point of view. . . . And it must be very hard to say farewell to her." Then to appease his jealousy she enclosed one of Jephson's letters. "I hope thee won't think it too affectionate in tone. I am glad he is so fond of me, for I know there is nothing in his fondness even a jealous husband could object to." Besides, "all thy goodness to him" would stand in the way of any disloyalty. "I do not believe," she concluded, "either of us would be happier free, or trying to give our hearts to other people." It was persuasive advice and Bernhard tried to accept it, but jealousy kept secret vigil. It was hard to forget Mary's referring again in one of her letters to the misery caused among some of their friends by the prevail-

ing sexual taboos. It must have been rather too reminiscent of what she had once told him of her discussions about sex with Obrist. Once again Bernhard protested against her depreciating the primacy of intelligence and will and once again he insisted on the importance of disciplining human nature.

From St. Moritz there came few complaints about his health. The long walks on the mountain paths in the bracing air and in pleasant company seem to have quieted his nerves. And the companionship of handsome and stylish women who hung on his conversation medicined his discontents. Donna Laura Gropallo paid him the compliment of becoming jealous of his attentions to Adelaide Placci, who in turn was jealous of Donna Laura. The woman whom he liked most, he said, was his Florentine friend the lovely Marchesa Serristori, "a gay, sunny, always amusing but perfectly self-conscious creature." That the exquisite Gladys Deacon was also fond of him must have been the ultimate compliment, even though she was for him the *princesse lointaine*.

The cerebral detachment that had impressed his Oxford friends long ago and invested him with a certain mystery still seemed to set him apart from his fellows. After a long chat with Adelaide Placci and Donna Laura at St. Moritz he exclaimed to Mary with a certain wonderment: "They really seem to regard me as a fearfully paradoxical and most unseizable person." Then with a self-deprecation that must have evoked her derision, he added, "How it amuses me, accustomed as I am to regard myself as so matter of fact, and commonplace." To the married women brought up in the indulgent conventions of European high society, Berenson's idealism and almost puritanical correctness appeared to be provocative coldness, and Mary jollied him on his return to I Tatti for having "an unnatural insensitiveness to feminine seductions." Mary recalled for him a recent episode that amusingly illustrated her point. He and a duchess had been "speaking of someone who was very *sweet*. "That's an adjective no one would apply to you,' said the gallant B.B. 'Au!' said the duchess in French, 'If you only knew—.' 'I will be very careful,' he replied." In the privacy of her journal Mary observed, "His answer is all right but he ought to have *felt* something, and he didn't." A letter from her brother recalling her romantic college days sounded a nostalgic counterpoint to the incident: "What aspirations, what boxes of candy, what generosity and ignorance and flirtation in that Arcadia in the cheerful American sunshine! Lord help us! Whither have we wandered since?" It was a question that would grow more perplexing with the passing years.

Reunited at Don Cagnola's immense dreamlike Villa Gazzada near Lake Maggiore, with its verdant park and distant view of Monte Rosa,

they effected a truce once more. Their hard words forgotten, they quickly resumed an affectionate intimacy. The week amidst the tasteful luxury of the place passed slowly however, for the autumn rains had set in and the two were impatient to get back to I Tatti and their unfinished chores. Still another new cook had to be trained to provide dishes for Bernhard's delicate digestion. And even as late as November Mary lamented to Roger Fry, "We aren't yet in order. It is too disgraceful to confess that I have six men working here all day, moving furniture and so forth, and the bookshelves are only just up and not painted."

Berenson meanwhile completed an essay for the February 1902 *Gazette des Beaux-Arts* on two very fine and hitherto unknown paintings of Masolino da Panicale that he had recently discovered at Empoli, one of them concealed behind a modern altar. He then put together his descriptive notes on the drawings of Andrea Mantegna, which he had come upon in his researches for the big book. The essay would help flesh out a projected second collection of his essays. The first collection, which was just out, was already being translated for a German edition. At the same time the enlarged *Lotto* was passing through the press. Only the finishing touches remained for the second volume of essays. He could now get back, he told Senda, to the exacting revision of the Michelangelo section of the *Drawings,* a task which at times seemed to overwhelm him with its difficulties. For relief he usually turned to his books, ranging widely in tomes on race and religion, subjects which he said had become of "inexhaustible interest" to him. The book that touched him most deeply, as it touched many of his contemporaries, was Maurice Maeterlinck's just-published *La Vie des abeilles,* an extraordinary blend of natural history and fancy based on the author's observation of his own beehives at Oostacker. "The real value of the book," Bernhard commented to Mary, "is in its beautiful statement of the latest man's attitude toward the mystery of the universe. This is so free from dogma, from tradition, from superstition; yet so full of reverence, of longing, even of hope, and above all of confidence in intelligence." Through two world wars and all the vicissitudes of his long life this half-mystical ideal would sustain Berenson. In old age he would call it the "numinous" dimension of existence, the sense of "awe before the universe."

The task of transcribing his sprawling handwriting on the typewriter fell to Mary's cousin Emily Dawson, since Mary was increasingly tied up with running the household and looking after the succession of house guests. Berenson's feeling of malaise and despondency returned with redoubled force as he lost himself compulsively in the labyrinth of the Florentine drawings. His unhappiness was now aggravated by Mary's

discovery that she was pregnant. The news alarmed him, for the last responsibility he wished for was a child in the house. Moreover, in his jealous state he could not be sure he was the father. A remorseful Mary surrendered her wedding ring to Bernhard as if symbolically to set him free. And so she left for London. Early in December of 1901 she telegraphed her safe arrival. In the letter that followed she wrote that though she hadn't yet seen the doctor she knew just what to do. When the ordeal was over in mid-December she added, "Poor old dear, I wish thee felt half as jolly as I am feeling now that the Anxiety is removed." However, she could not resist the forbidden thought: "And yet thee will be horrified; it opened a door on me that I thought was closed and sealed. Sometime—maybe?—what does thee think? It might be a good provision against dreariness in old age? Thee might like it Bernhard, it might give thee a stronger hold on life." Bernhard's reflections were evidently too somber to be preserved. As it turned out, his tenacious hold on life did not require her expedient.

In his depressed state his jealousy of Jephson grew, and his suspiciousness vented itself in harsh criticism as he imagined Mary and Jephson together in London. "Jephson isn't my love, never was, never will be," she protested, "but it is true that the thought of him has taken up too much of my attention and has been a silent barrier between thee and me." Once more she yielded to the impulse to make the worse appear the better reason, doubtless unaware herself how much was deceit and how much self-deception. Her circumstantial denials did not really pacify him nor did her profuse affirmations of her affection, which interlarded her reports on the paintings she was inspecting for him. She wrote that she had conferred with Gutekunst, who, worried about the state of the art market, urged that Bernhard visit America as soon as possible to extend the market for Italian pictures. The proposed trip might "save the situation" with Mrs. Gardner. "It means a lot of money to be on Mrs. Gardner's good side," she reminded Bernhard. But Bernhard was not to be distracted and hugged his grievances all the closer to his breast. To Mrs. Gardner he complained of neurasthenia and said he would be "sincerely glad to die at any moment." The unfinished *Drawings* so preyed on his mind that he vowed he would never undertake "so crushing a task again."

In her lengthy letters of self-scrutiny Mary admitted that her emancipated nature craved close friendships, whether with men or women. After all, she had made an identity for herself as a writer on art and deserved her own niche in the world. Nevertheless, knowing that a chief grievance of his was her month-long Easter absences with her children, she assured him that she had arranged things so that she need

not return to England in the coming spring, but then added that she hoped all the same he might be persuaded to come back with her for Easter, that "most heavenly of seasons in England."

Her beguilements did not appease him, and amid recriminations and despairing thoughts of the futility of his life he confessed to her his unrequited passion for Gladys Deacon. Mary, surprisingly, was all sympathy. "I had no idea, dear, thee was so much in love with Gladys as that. I think thee did wrong not to follow that strong feeling and try to marry her. There would have been some chance for thee to have at least a little real joy instead of the frugal fare of duty." A day later she qualified her balm with a hint of irony. "But even if thee had the bliss of marrying Gladys by *now,* I am sure, thee would be in hell. And could thee be sure of making a good third choice?"

It was abundantly clear that for all his free-thinking and his lip-service to women's rights he was at heart a Victorian, dependent on his wife and exorbitantly possessive. Mary concluded that it wasn't enough that she should care for him, "I must in a sense care *only* for thee." And the question would not go away, "Can I?" She told him she had "rebelled much against this conclusion" but saw that an "easy-going partnership" was not possible. She was therefore resolved, she said, to submit her "inmost nature to him" and do her best to live up to his standards, "since nothing else will make thee happy. . . . This is hard to say," she continued, "and perhaps impossible to realize." The crisis finally passed after a few weeks and scores of pages of anguished soul-searchings. Perhaps most effective was Mary's plaintive warning on the anniversary of their wedding day that she would not return unless Bernhard really wanted her to. Shocked out of his morbid self-pity, he relented and Mary departed straight for I Tatti and an affectionate welcome. Bernhard, once again in a forgiving mood, wrote to Jephson that he might resume his correspondence with Mary. A grateful Mary wrote in her journal, "Nothing could exceed Bernhard's delicacy and generosity about this whole affair. It would take a demon to go back on him after this!"

Bernhard had been only too ready to accept her ministrations, for he spent much of the day flat on his back. "My wife does all my writing," he explained to Mrs. Gardner, "not only my considerable correspondence, but even book reviews and she does all the proofreading of my elephantine book." He thought he had got over "the long depression that crushed me for years," a revelation that must have mystified Mrs. Gardner. What complex of anxieties he was alluding to, making ample allowance for his tendency to embroider his afflictions, can only be guessed at. Perhaps uppermost in his mind were his "mistakes" in

connection with Mrs. Gardner's purchases, mistakes that had made him despair of life, and that had added a darker color to his earlier discontents.

On February 14, 1902, Mary's thirty-eighth birthday, Bernhard gave her back her ring "in token of renewed trust" and she vowed to be worthy of it. To her mother she wrote, "Bernhard is less well, I am afraid, but his temper has softened and he is dear and considerate and loving. I really can't think what has made my fancy go wandering. It must be native inconstancy in me." Bernhard, reassured by her presence in the echoing halls of the villa, turned with desperate absorption to his Verocchio studies in the hope of at last finishing the revision of his analysis of the Florentine drawings. Placci looked in on him only to find him, as he told their friend Gaetano Salvemini, "irritable, sickly, and worn out with labor [*irritable, malaticcio, esaurito dal lavoro*]."

Mary had returned to find I Tatti "the perfection of comfort," with its walls so covered with paintings that little space remained for further acquisitions. While she was away Bernhard had added two more items to their collection. One was a three-quarter lifesize Istrian stone Madonna then attributed to Laurana, which had cost £160. In Mary's practical view it promised to yield £1,000. It remained permanently in their collection as of the school of Laurana. A more profitable acquisition, which Bernhard had spotted in the shop of the somewhat-less-than-reputable Constantini, was a Pinturicchio Madonna in "flat gold and vivid colors." For the moment it decorated his bedroom. She thought that the "fresh and lovely work" ought to bring at least £1,500. Her estimate fell far short of the mark, for it presently went to Mrs. Gardner for £4,000. Though Berenson frankly admitted to Mrs. Gardner that he had got it "cheap," when she saw the photograph she accepted the offer without demur.

The sale provided a lucky windfall for them since their debts had grown alarmingly. Once again solvent, Berenson dispatched $1,000 to his family—part of his promised annual subsidy—and Mary was assured of funds for her children and her mother and of the pleasant prospect of being regularly met at the Florence station by their own closed carriage. The alternation of financial feast and famine, accompanied by the fluctuations in the stock market, had continued to be a source of worry. Bernhard's great idea, Mary told her mother, was to "invest everything so that we soon may have enough to release him from the irksomeness of bargaining and arranging and offering pictures—so that when good chances come up he is apt to put all our money in and leave us stranded." The £4,000 swiftly dwindled. One thousand paid off a London bank loan. Fifteen hundred went into the new U.S. Steel Com-

pany and five hundred into the new Marconi wireless syndicate "with a certain and immediate return of 100%," an expectation that proved overoptimistic. Nevertheless, by the end of the year, not counting the possible Marconi dividends, they had a little more than £2,000 of clear income, of which £500 went to Bernhard's family and £300 or £400 to Mary's children. According to Mary, Bernhard hoped to acquire sufficient capital to yield them £3,000 annually and thus be free of the degrading stratagems of the art trade. The fulfillment of that hope lay many years distant, and the double life that his pursuit of it imposed upon him left a wound upon his spirit that was never really to be healed and a lingering resentment against Mary's driving ambition. More than thirty years later, looking back on their life together, she wrote: "Even to this day he is haunted by the same scruples and repugnance. At moments of conjugal tension I am accustomed to hear that I have ruined his life by turning him from the disinterested contemplation of beauty into its vulgariser."

XXVII

The Study and Criticism
of Italian Art

WHEN Berenson's volume of collected essays *The Study and Criticism of Italian Art* came out in the first week of November, 1901, the preface, written the preceding April, made clear that his attitude toward scientific connoisseurship had undergone a change in emphasis since that day in Bergamo when he and Enrico Costa had joined forces to dedicate their lives to its pursuit. Kenyon Cox, the perennial art critic of the *Nation,* promptly spotted that change when he reviewed the book later in November. Berenson, he said, showed a double character, on the one hand the "ingenious promulgator of certain broad views of art based on psychology," the inventor of "tactile values" and "space composition," on the other, the follower of Morelli. What Cox was relieved to point out was that Berenson wore his "Morellism" with a difference and that "in his interesting preface the critic of broader views peeps out and shows a refreshing skepticism as to the intrinsic value of attribution-mongering."

It was indeed true that on the very first page of his preface Berenson conceded that he now saw "how fruitless an interest is the history of art and how worthless an undertaking is that of determining who painted or carved, or built whatsoever it be. I see now how valueless all such matters are in the life of the spirit." That concession was, however, chiefly a philosophical one and, in a sense, a challenge to his critics to recognize the illogic of their resistance to scientific connoisseurship, for, having acknowledged the superior claims of the spirit, he went on to point out that the apprentice art historian did have need for the history of art and that "without connoisseurship a history of art is impossible." At the humbler level of the connoisseur "the world's art can be, nay, should be studied as independently of all documents as is the world's fauna or the world's flora." Moreover, such precise study would not

only suffice for "the universal history of art" but if aided by "qualitative analysis" would yield the "perfect determination of artistic personalities." Once that determination was made, one might turn to documents "chiefly for mere convenience of naming." A scientific "quantitative" analysis allows one to "define the motives and general ideas of an artist," though not "his ultimate power of giving independent existence to his imaginings." For the latter a "sense of quality" is essential, a sense which "must first exist as God's gift" and which, to "become effective . . . should be submitted to many years of arduous training."

Within this more modest frame of reference Berenson offered seven of his previously published essays, dating from 1893 to 1899, the earliest on Vasari, the most recent on "Amico di Sandro." The essays showed, he averred in the preface, the "signs of striving towards a critical method," and in commenting on his piece on Giorgione he added that "method interests me more than results, the functioning of the mind much more than the ephemeral object of functioning." The stress on method rather than on results may well have been aimed at those who were annoyed by his changes of attributions. Certainly his love of intellectual play, his cerebral ingenuity, his capacity for complex chains of deductions as well as his serendipity are brilliantly displayed in the conjectural creation of an artist friend and imitator of Sandro Botticelli, a creation which, nonetheless, left Cox unconvinced and which, we have seen, Berenson himself subsequently abandoned.

Something of the traditional attitudes which the new criticism and its handmaid, "scientific connoisseurship," had to contend with, especially in America, is reflected in Cox's passing comment that all these "confident attributions of third-rate works of art to third-rate artists are problematical and unimportant." Nevertheless, for proof of his charge that the "apparently settled conclusions of 1895 are all unsettled in 1901" Cox could cite only two items, reported in footnotes: in one Berenson surrendered an earlier doubt and in the other he admitted a single change of attribution.

Royal Cortissoz, the art critic of the New York *Herald-Tribune,* gave the essays a far more enthusiastic welcome. In an unsigned review in the New York *Independent* he praised "the intellectual exhilaration which everywhere transpires from this book," especially in the "critical purge" of paintings in the article on the exhibit of "Venetian Painting, Chiefly before Titian." Berenson's discriminating analysis showed that he knew not only the traits of Titian "but also the idiosyncrasies of a score of minor painters whom the master's fame has overlain." To Cortissoz this "Herculean cleansing" was "the most obviously interest-

ing," but he thought the "Amico di Sandro," which displayed Berenson's "rare perception," was "far the most valuable." He did register his dissent from the piece on Giorgione, in which Berenson had striven with utmost, if unconvincing, ingenuity to "reconstruct from a mediocre imitation the original which it travesties." The essays on Correggio and the review articles on Vasari and Dante appealed to him as varying agreeably "the assortment of good things which the book offers."

In England Roger Fry wrote a long and equally appreciative review in *The Athenaeum,* asserting among other praises that Berenson "has perhaps contributed more of permanent value to [art history] than any other living writer. . . . The right attribution of pictures, then, is not a mere parlour game"; the correct attributions have "their value in stimulating and setting free purely aesthetic perceptions." He too found the reconstructed "Amico di Sandro" persuasive. Berenson's discussion in the essays on Correggio of taste in art led Fry to hope "that in the future Mr. Berenson will turn aside occasionally from his more scientific studies and give us additional essays on this novel subject for which his tact and his quick intellectual sympathies fit him peculiarly." Mary wrote to Fry that Bernhard was "overcome by the nice things you say," especially "in the way you treat the value of attributions." His pleasure was tempered, she said, "by a raging envy of your style, which is always his admiration and despair." A flattering acknowledgment, it told only half the truth. Berenson may have admired Fry's literary style, but he was increasingly annoyed with what he regarded as his superficial method, the most recent example being his lectures on Velasquez, which were prepared without his looking at the important collections in Spain. Shocked by this omission, Berenson said that he simply would not discuss Velasquez with Fry, when he next encountered him, rather than play the hypocrite. Fry's method impressed him as presumptuous and in his nervous and irritable state that winter he grew mistrustful of his friend's motives and resolved not to lend him unpublished photographs.

The English art magazines, less scholarly in their interests than those on the Continent, paid no attention to the essays or the reissued *Lotto.* Berenson may well have suspected that his influential enemies in the Establishment, Strong and his close associate the art historian Langton Douglas, were somehow responsible for the neglect. The London *Athenaeum,* however, paid generous, if somewhat belated, attention to the *Lotto* in April of the following year. It called the book a "psychological romance, made out of the minutest" analysis of style, with the result

"that a man stands before us in vivid relief, a completely intelligible figure."

Carlo Placci tried to arouse Italian interest in the essays with an article in *Il marzoco,* but the Italian art world ignored the book, perhaps taking its cue from the leading Italian art historian, Adolfo Venturi, founder and editor of the prestigious *L'arte,* who was one of those who liked to pass on damaging gossip about Berenson's transactions. Significantly, none of Berenson's books were published in Italian until 1919, even though he was in friendly communication with Venturi as early as 1910. After 1904 Berenson did become a frequent contributor to the *Rassegna d'arte,* founded by his friend Don Guido Cagnola.

In Germany, Georg Gronau, one of the younger art historians with whom Berenson had struck up a friendship during his visits to Berlin, devoted more than a column in the weekly *Kunstchronik* to a respectful review of the varied contents of the book. To him the most noteworthy piece in the volume was the preface, in which Berenson set out the aims of each essay and showed how they illustrated a consistent artistic outlook. In the same issue of the *Kunstchronik* Gronau spoke appreciatively of the enlarged *Lotto* and its admirable array of hitherto unpublished reproductions of newly located paintings. Gronau also noticed the collection in the *Repertorium für Kunstwissenschaft.* This was not Gronau's first appreciation of Berenson's work: in a series of articles in 1895 in the *Gazette des Beaux-Arts* he had praised his felicitous characterizations in *The Venetian Painters of the Renaissance* and his valuable index-catalogue of Venetian paintings based, as he said, on *"longs voyages et d'érudits investigations."* With his entrée into German art journals assured, Berenson published two articles in them in 1901, one, "The Drawings of Andrea Mantegna," in the *Monatsberichte für Kunstwissenschaft unde Kunsthandel* and the other, a short article on the coronation frescoes of Oderisi, in the *Repertorium.*

A second collection of essays, *The Study and Criticism of Italian Art,* Second Series, came out in 1902, less than a year after the first one. Again they were largely essays dealing with questions of doubtful attributions. Of the nine essays which the volume included, five had originally appeared in a French translation and one in a German. Only two had been previously published in English: "A Word for Renaissance Churches," in the London *Free Review* in 1893, and "An Altarpiece by Girolamo da Cremona," in 1899 in the *American Journal of Architecture,* which marked Berenson's first entrance into an American art periodical. The one previously unpublished essay was "Rudiments of Connoisseurship." The preface declared that "there are but two papers

which require explanation," one, "A Word for Renaissance Churches," the other, "Rudiments of Connoisseurship," both of which, he explained, were written at the beginning of his professional career. Indeed, he asserted that the first had actually been written more than ten years earlier, presumably after his conversion to Catholicism had already withered on the vine, for he said that what led him as an "aesthetic spectator" to write it was that "I kept asking myself what it was that I, who took neither the builder's nor the churchman's interest in architecture, found to admire in Renaissance churches." As for the previously unpublished "Rudiments," it was to have been the first section of a book called *The Methods of Constructive Art Criticism*. He had published the *Lotto,* he said, expressly "to exemplify method in a concrete instance" and had been amazed that no reviewer of either the first or the second edition had drawn attention "to the general theory on which the book is based." He now offered the paper in the hope that "the candid reader will no longer find anything ludicrous or trivial in the new connoisseurship."

The *Nation*'s Cox considered the second collection more interesting than the first and, carried away by the ingenuity and learning of "The Caen 'Sposalizio,'" he called it "the greatest real achievement in modern connoisseurship." On the other hand, when he turned from the exciting contest between the rival claims of Perugino and Lo Spagna in that essay to the other examples in the volume of Berenson's learning and ingenuity, he rather inexplicably dismissed them as dealing with "the unimportant questions which occupy the modern connoisseur." Yet the article on a "Raphael" cartoon gave Brescianino as the true author; that on Alessio Baldovinetti confirmed the attribution to him of a new Madonna in the Louvre; that on Masolino credited him with two frescoes which Berenson had discovered at Empoli; and that on Girolamo da Cremona identified as his an altarpiece in the cathedral of Viterbo erroneously attributed to a local Lorenzo. Oddly enough, considering his prepossessions, Cox passed over without comment the ambiguous avowal in the Cremona piece that in the case of a work "not authenticated by documents . . . some of us are beginning to return to the opinion . . . that in the work of art at least, genius is, after all, everything."

The article on Filippino Lippi's *Holy Family* which Berenson included has a special interest as an illustration of a common practice among art experts of publicizing with illustrations notable acquisitions by collectors, thus rewarding their taste with a certain pleasurable notoriety. The article had originally appeared in a French version in the *Revue Archéologique* with the title "Un Chef-d'oeuvre inédit de Filippino Lippi."

The painting was evidently one of those acquired through Berenson for Edward Warren's mother from the Marquis St. Angelo of Naples. Berenson praised the picture as perhaps the greatest masterpiece of the artist "at the happiest moment of his career." Were it in a public gallery it "would certainly add great lustre to the master's name. . . . The fortunate owner of this masterpiece is Mrs. S. D. Warren of Boston." Subsequently transferred to her son's collection at Lewes House, the painting ultimately found a home in the Cleveland Museum of Art. Berenson had paid similar compliments to Mrs. Gardner and, as in those instances, he added this painting to his authoritative List of Florentine painters.

Royal Cortissoz, again writing in the *Independent,* shared Cox's high opinion of the "Caen 'Sposalizio.' " It left him, he said, with the "conviction of [the] universal, blind stupidity" of previous writers on the subject. Cortissoz regarded the essay "Rudiments" as the most valuable in the collection. "Gifted with perceptive faculties as keen as Morelli's, with a mind both logical and synthetical, Mr. Berenson has reduced constructive criticism to a science." It was thus much to be regretted that he had not gone on to complete the book on connoisseurship. "Valuable as is the smallest paper from Mr. Berenson's pen, it is a real loss to critical literature that he should cease to write books." In June 1903, however, Cortissoz expressed some cautionary second thoughts in "New Aspects of Art Study" in the *Atlantic Monthly,* an article reviewing the series of monographs titled Great Masters in Painting and Sculpture. He suggested that Berenson's disciples had done a great deal of work for the generally commendable series but that the work was too often marred by "bumptiousness and erratic judgments which proclaim the amateur cutting his fingers upon tools forged in the 'Morellian' workshop." He ventured that Berenson himself had too much confidence in the new method, yet he acknowledged that the "patient ingenuity" of the analysis of the Caen *Sposalizio* "leaves one not only appreciative of Mr. Berenson, but very favorably impressed by the critical method he has adopted." And like Cox he welcomed "the signs of a change of heart" expressed in Berenson's caveat at the end of the "Rudiments" that "the Sense of Quality is indubitably the most essential equipment of the would-be connoisseur" and "the touchstone of all his laboriously collected documentary and historical evidences, of all the possible morphological tests he may be able to bring to bear upon the work of art."

For all of his avowals of science, it had in fact become increasingly clear to Berenson from his own practice that the ultimate authority for an attribution must be the "properly trained eye" intently focused on

the work of art itself. It is this informed and educated "seeing" that almost from the beginning of his study had actually been a preoccupation; all mechanical tests were in truth subordinate to it. The idea runs through all these essays and beneath all the elaborate chains of deductions from parallels and similarities. One must be born to see and in the act of seeing recognize the distinctive physiognomy of the artist, whose unique lineaments are discerned from among those of a score of progenitors. It may be that Berenson had not realized the full implications of that principle, which he had years before enunciated when he originally wrote the "Rudiments," but his reviewers quickly seized upon the qualification. As the work of the artist escaped the constraints of convention and habit and responded more freely to the creative imagination, the discovery of its identity became less the product of scientific investigation than of critical intuition.

Mary, over the pen name of Mme Mary Logan, also drew attention to the change in Bernhard's outlook in an article reviewing five monographic art studies which she published in a French translation in the September 1902 *Gazette des Beaux-Arts*. One of the books she dealt with was Bernhard's revised *Lotto,* for whose illustrations "the tiniest villages had given up their secrets." She wrote that though the tenor of the book was substantially unchanged, Berenson's aims had undergone an important evolution. The study of a work of art so far as it illustrates a historical period or the history of an artistic personality no longer had charm for him, and had he studied Lotto in a purely artistic way, he would perhaps have assigned him a lower rank. Berenson had explained in the new preface that "when he first composed this book 'the point of view' was determined by interests that then seemed much more important than they do now." He was "little concerned at present with the work of art as a document in the history of civilization" but much more concerned with its aesthetic character; if he were to rewrite the book from his present point of view, it would be as if written by another author.

BERENSON's mystifying illness hung on through the rest of the winter of 1901–02 without quite disabling him from compulsive application to his writing, which he often carried on propped up in bed. By mid-March all but the last chapter of the Florentine drawings manuscript, that is to say, the chapter on Pontormo and Rosso, was ready for transcription. The work on the massively detailed descriptive catalogue of the drawings had presumably progressed alongside that on the text. With the end in sight he was ready for diversion, and it was provided by the arrival in Florence of Gladys Deacon for an extended holiday.

Gladys brought a welcome gaiety to I Tatti, entertaining Bernhard and Mary with her elfin gambols on the terrace and her irrepressible high spirits. They took her along on a *giro* to reconnoitre Pisa, Viterbo, and Siena. Near Viterbo they had an amusing encounter with Lady Ottoline and her new husband, Philip Morrell, Lady Ottoline resplendent in her strings of jewels and cascading laces. The carriages paused a bit for talk on high culture and then passed on.

After a few days Mary thought Gladys "too much the Circe to be satisfactory" company and B.B. too much "oppressed by the sense of [her] irrelevance to all the things we care about." But Mary underestimated the girl's magical power. When in one town Gladys played Pied Piper to a lot of schoolchildren, singing and dancing in the lead, Berenson joined them and to Mary's astonishment himself ran and shouted and leaped about and played with the children.

On one expedition alone with Mary that spring to a distant village Berenson hunted down a rare Sassetta. Since his fortunate acquisition of the St. Francis panels two years earlier, he had found himself drawn to the Sienese painter, whom he had hitherto ignored and was now making a special study of, a study, as it chanced, that in the following year would bring him into a bitter and fateful controversy with his English adversary, Robert Langton Douglas.

Berenson's rejuvenation did not last and by the time Gladys left in the middle of April he was again so unwell that he could not sit up after dinner, and he became strangely taciturn, as if hoarding his strength for the final remaining pages of his book. These were at last written, and a month later he was so much better that he "was furious at the idea of ever having been thought an invalid."

May 1902 was a month punctuated by the usual succession of visitors, among whom was the newspaper humorist Peter Finley Dunne, the famous "Mr. Dooley" of the Chicago *Daily News,* who pleasantly surprised Berenson by showing a familiarity with his books. He was staying at the palatial Villa La Doccia on the hillside above the Fiesole road. The new owner of the villa was Henry White Cannon, president of the Chase National Bank of New York and a brilliant financier who had risen from the ranks and at the age of thirty-four had been appointed United States Comptroller of the Currency. Now in his early fifties, he wore his reputation as a leading figure in corporate and railroad finance with a courteous charm. The Berensons became acquainted with him, and Bernhard wrote to Mrs. Gardner that Cannon was "a really delightful sort of man," quite different from the bargain-hunting Davis. "He regards you as a benefactor for having brought so many works of art to America." Cannon had not yet become a serious

collector of art himself but presently he was to acknowledge that under Mary's tutelage he felt "an entirely new vein of art" open to him with its "tactile values." Mary hoped to make a convert of him and succeeded. Four years later he bought J. P. Richter's entire remaining collection of Italian paintings and hung them in La Doccia.

Herbert Horne came up from Florence one day to entertain them with a jest going the rounds of London. People were being asked whether they were "Amico di Berenson" or a false attribution by "quite a different master." In a similar vein was the story, circulated in this period, by Robert Ross, Wilde's literary executor. "He had been to Florence and on his return he was not asked about the famous art treasures of the Uffizi and the Pitti but only, 'Have you seen Berenson?' This got on his nerves; so one day he announced a dreadful discovery had been made in Florence!! Berenson was not Berenson. The sensation was indescribable . . . No one knew what to do . . . Mrs. Berenson was packing up."

Relations with Theodore Davis, who was again shopping for art in Florence, were temporarily strained over a painting which he had just bought from the dealer Costantini. Both Horne and Berenson's friend Houghton were persuaded that the painting was genuine, but Bernhard and Mary were sure it was a forgery. The dispute soon became public knowledge, and as Mary observed, it made "B.B. literally sick to come into contact with all this knavery and folly." What especially dismayed them was that "we can't let Davis go back to America saying we don't know a genuine painting from a fake, and this is what he *will* do if we leave him the least loophole." Berenson explained to Mrs. Gardner, who was curious about Davis' acquisitions, that Costantini's son, who "toadied and catered to Davis in a way that has turned Davis's head," had himself executed the forgery and that it now brought to five the number of forgeries Davis had picked up on his own.

Unable to make any impression on Davis at this point, Berenson vented his feelings in a signed letter to the London *Times*. Moreover, he had a special reason for exposing Costantini, though he did not actually name him, because Costantini had reneged on the sale of a precious ivory for Mrs. Gardner for which she had already sent the money, with the specious excuse that he had, inadvertently, promised it to Davis. Mrs. Gardner, thwarted of her prize, had naturally reproached Berenson. The letter stated that "forging for forging's sake, was a pastime in Italy since the fourteenth Century." Then Berenson added that a painting by a well-known Florence forger had been offered at Christie's last spring at a "large price," a painting that "several of us had seen brand

new on the painter's easel before it underwent the process of staining and cracking and wormholing."

Davis was in fact escaping from Berenson's leading strings and, eager to save money, was hunting for bargains on his own. His experience with the spurious "Donna Laura Minghetti Leonardo" had not really convinced him of his fallibility, for a few years later when Davis exhibited his collection at the Museum of Fine Arts, he unabashedly included his "Leonardo," and it was so catalogued.

Knowing Mrs. Gardner's impatient interest in his "big book," Berenson could report early in May that it was at last done. "Few people will be able to appreciate its merits, or even to give me credit for the labor I have put into it. And why have I spent seven of the best years of my life on it?" he queried rhetorically. His answer might have been borrowed from Henry James: "One works not because he wants to, but because one must. An angel or demon impels me." To his brother, Berenson wrote more prosaically, "Now that I am alive to tell the tale I can confess that there have been moments in the last two or three years when it seemed as if the task would kill me. It has been a lesson, and I shall not begin another book or do work of any kind except to see the book through the press, until I have regained something of my old physique. It never was much, but still it was something. I half believe that if I had a body in fit proportion to my head, I should be one of the men of my time." His brother had taken a new job and sent a check repaying a loan of a hundred dollars. Bernhard, anxious about Abie's prospects, and his health, hoped that he had not stinted himself to do so. "No one will rejoice more at your success, as no one will blame you less for failure."

With the *Drawings* done, Berenson's thoughts hurried on, in spite of his prudent resolves, to the volume on the North Italian painters, which he had promised Putnam to complete his series on the Italian painters. It occurred to him that he might treat the Milanese as illustrating the way mediocre painters invariably follow a great artist. By this scheme, he told Mary, he could stick to the high art standards of the earlier volumes and avoid dwelling on the provinciality of the Milanese. The problem was to take more than three years for its solution.

With the precious manuscript in their baggage he and Mary fled the heat of the Val d'Arno for a refreshing few days at Interlaken before setting out for the "hurly burly" of London. Time nevertheless had to be taken to propose a change in strategy for Mrs. Gardner's acquisitions. A new law had been passed in Italy, he wrote her, that would make it practically impossible to export masterpieces. Houses were to

be searched for works of art and these were to be divided into two classes: those not to be sold under any circumstances and those to be subject to a 20 percent tax. And on these there would, of course, be the American import duty of another 20 percent. The new law, he said, was bound to raise "enormously the price of Italian pictures." It was hard on "people like myself who have put their savings into pictures and kept them in Italy," for although he had bought them to keep he had expected "in a pinch" to be able to raise money on them. He therefore proposed that since her collection of Italian paintings was "nearly complete" it was now time to supplement it with "a few great fifteenth century Flemings and Germans." Soon afterward he was able to offer her a notable Dürer portrait, the so-called *Lazarus Ravensburger,* which the Colnaghi firm had recently acquired from its English owner. This time she did not hesitate, though the price was £11,000, and promptly asked him to get it for her. At the same time she expressed her still-unrequited longing for a Raphael Madonna, posing a challenge to Berenson that try as he might he would never be able to meet.

Once settled in London to be available to the printers and lithographers and to struggle with Murray over the difficult make-up and costly illustrations of the *Drawings,* he took stock of his situation with Gutekunst. In the then depressed state of the art market it became clear to him that Gutekunst was right: he would have to visit the United States. It was high time to accept Mrs. Gardner's repeated invitation. "I know I can rely on you," he wrote, "to enlarge the circle of friends" to whom pictures could be sold. "I shall return," he sadly noted, "a very broken down youngish oldish little man." Once he was in America, he assured her, she would have as much of him as she could stand.

Her faith in him had remained unshaken in spite of the hostile gossip that was so eagerly brought to her ears, but it was evident that with advancing years and a growing circle of advisers at her Fenway Court museum, she was becoming more cautious in her purchases. A signal illustration occurred earlier that summer. Berenson had written that he had succeeded in getting out of Italy his "most precious possession," the Perugino Madonna, which Cavenaghi had restored. He described it to her in the most glowing terms and offered it at £4,500, pointing out that she did not have a Perugino in her collection. She hesitated. The mention of Cavenaghi's name worried her because she had learned of the dissatisfaction with his work on Mrs. Warren's "Crivelli," and she had vowed she would take nothing that Cavenaghi had worked on. Berenson explained away, as well as he could, her misconception of the nature of Cavenaghi's work. She also inquired about the provenance of the work, and Berenson had to acknowledge that it was rather sketchy

because the dealer from whom he had bought it could not be depended on. The attribution therefore rested wholly on internal evidence. Worried by the doubt, she this time resisted temptation despite the great beauty of the painting.

Subsequently, Edward Robinson, a curator of the Museum of Fine Arts, evinced considerable interest in the painting but did not press for its purchase. It finally found a home in the collection of John G. Johnson of Philadelphia in 1909, when it was sold as the property of Berenson's brother-in-law, Logan, for the much reduced price of £2,000. Although the attribution was later questioned by Valentin Raimond Van Marle, who nominated an anonymous pupil of Perugino, the posthumously revised list of the Florentine artists published in the 1963 edition of *Berenson's Italian Pictures of the Renaissance* continues to hold to Perugino. Given the notorious uncertainty which attaches to the identification of the painters of so many Italian Renaissance paintings as new generations of art experts bring more sophisticated technical resources to their aid, one can probably expect the process of rebaptizing to continue far into the future.

THE conferences over the printing of the *Drawings* kept Berenson busy in London for much of the summer. There were of course the reconnaissances in the galleries of the art dealers in Old Bond Street and Pall Mall where Agnew's, Goupil, Dowdeswell, and other dealers displayed their wares. Berenson was often in the Print Department at the British Museum, which was superintended by his friend the poet Laurence Binyon. There were rounds of visits with Fry, Lady Ottoline, and other friends, and he talked and listened for hours to Bertie Russell. Russell was in a curious state of mind, having discovered one afternoon while bicycling, as he alleged in his *Autobiography,* that he no longer loved his wife, Alys. While she sought solace in a rest cure, he felt much alone and complained to Berenson in the most winning fashion that no one understood his longing to find an art, a symbol, or a religion that would reconcile the intellect of man with the universe. His plaint seemed to echo his listener's yearnings. Berenson ran down from London for an occasional week at Friday's Hill with Mary, where he filled his quiet hours with the *Pickwick Papers,* William James's arresting *Varieties of Religious Experience,* and other works which caught his eye in that bookish household.

As the summer ebbed at Haslemere, Leo Stein and his sister, Gertrude, dropped in for a weekend with the Berensons. Leo found the country "absolutely lovely," the fields populated with "red cows, lamby sheep, white ducks, lordly roosters and clucking hens," and,

since the hunting season had not yet begun, pheasants, which oc-
casionally invaded the lawns from the thickets. J. M. Robertson, the
Shakespeare scholar, joined them all for dinner and provoked a violent
argument over the nature of genius by suggesting that geniuses lay
about "as thick as blackberries," only needing "decent social conditions
to make them sprout."

With the guests divided among Americans and Englishmen, talk
often became heated over the respective virtues of the two countries.
Gertrude Stein, whose girlhood had been passed in Oakland, Califor-
nia, and who was not yet an expatriate, fought hard in support of
American claims against the combined attack of Berenson, Bertrand
Russell, and a young journalist named Dill. The pot was also stirred
when Zangwill arrived ready to advocate Zionism at the slightest prov-
ocation, a subject that Mary did not relish. Bernhard, who still com-
plained of ill health, fell under the ministrations of Gertrude Stein. She
had spent four years at Johns Hopkins Medical School but had recently
left without a degree because she had failed a few courses in her last
year. Nevertheless, she was continuing research on the structure of the
brain, a doctor in spirit if not in fact. She insisted on his stuffing himself
with raw eggs in milk between meals and before going to bed. Accord-
ing to Leo the regimen was causing Berenson to "flourish like the
Green Bay tree." Leo wrote to his friend Mabel Weeks, "The more I
see of him the better I like him. There is something robust about his
delicate sensitive organization that gives his thought and conversation a
vitality that is rare. He has the great advantage over most people of
being able to dig his stuff out of himself without turning it up crude
. . . And then there is no pretentiousness even though he will tell you
for example that 'Roger Fry is the only man writing decent criticism in
England chiefly because he has managed to get my ideas straight instead
of mangling them as all the rest . . . do.' But then this is quite true."

Before leaving England the Berensons were drawn into a project that
promised to give Bernhard a solid footing at last in the intellectual
world to which he had been attracted from the time of his first de-
lighted visit to England fifteen years earlier. Under Fry's energetic lead-
ership plans had been laid to found a new art journal. Since a rival mag-
azine, *The Connoisseur,* which had been started in 1901, was subtitled
An Illustrated Magazine for Collectors, the new magazine distinguished it-
self as *The Burlington Magazine for Connoisseurs.* The justification for the
new magazine was, as the first editorial would declare, that Britain
"alone of all cultured European countries is without any periodical
which makes the serious and disinterested study of ancient art its chief
occupation." Robert Dell, a prominent journalist and recently subeditor

of *The Connoisseur,* had already begun work as the first editor to assemble contributors. Berenson put in fifty pounds and agreed to contribute the lead article, to be drawn from his forthcoming magnum opus, for the first issue, which was planned for the spring of 1903. The invitation to take such a prominent role was indeed a flattering tribute to his importance, and Berenson must have viewed with considerable satisfaction the opportunity to outface his British adversaries on their own ground. The sequel, unhappily, was to prove a complete disappointment, and it left him with a lasting hatred of the British art establishment.

On the way home the Berensons stopped off in Paris just in time to dine at the Reinachs' with Colonel Picquart, the "Dreyfus hero," as Mary put it, whose revelation that Esterhazy had probably forged the letter on which Dreyfus had been convicted had led to the reopening of the case and a pardon for Dreyfus. Reinach was a leading Dreyfusard and the talk doubtless turned on the continuing struggle to complete the exoneration of Dreyfus. After leaving Paris the travelers paused for a week in Milan to enjoy again Don Guido Cagnola's lavish hospitality, marred though it was by a house party of "shrieking Italians."

At the end of October Bernhard and Mary dropped down to I Tatti with undisguised relief after nearly six months' absence, the house "clean as a pin" and the servants all smiles. They relished afresh the "studious, art-loving atmosphere." Their journeyings, however, had left Bernhard fatigued and out of sorts again. His young doctor was summoned, took inventory of his patient, interdicted further exercise, and prescribed regular massage and hypodermic injections of phosphorus, his diagnosis being excess uric acid, the "new fashionable complaint," as Mary noted when he explained her frequent colds as stemming from the same cause. He also vetoed any journey to America in the spring, a journey that had begun to loom attractively on the horizon. It was becoming evident that Berenson had a substantial following in the United States and could count on a cordial reception. At Christmastime, for example, an American guest at I Tatti told him that she "gets fairly mobbed when people find out she knows him," and that he was especially idolized by New Englanders, who talk of "our Mr. Berenson," a remark that Mary was amused to see elicited "a sickly grin" from its object. Their visitor declared he would receive "a tremendous ovation there when he goes," leading Mary to reflect that she didn't care about the ovation but hoped that he would win the confidence of prospective picture buyers. "We might make thousands a year ourselves and spare them many more thousands without a bit of trouble."

Bernhard's recurring neurasthenia did not entirely let up during the

fall and winter, and in quest of sympathy he kept Mrs. Gardner well posted on the state of his health. His absence from her New Year's Day housewarming at Fenway Court somewhat dimmed her pleasure, and she lectured him, "If one had the right to take the responsibility I should have you put onto a ship at Naples and sent straight here! The utter change, the quiet would be just what you need." The clipping she enclosed of the occasion indicated that all had gone well but, she noted, "without you, more's the pity." Fortunately for Berenson, there were frequent remissions, whether due to his doctor's improvisations or despite them, and from time to time he could indulge his craving for visitors, though they often bored him with what he thought were half-baked ideas that he could predict even before they were uttered. Boredom did not attend the lovely Countess Serristori, who always brought in her train "a most delightful and sympathetic Pole," Count Rambelinski. Bernhard and the Polish count "confessed their sacred poetic cult for woman and said that if that were taken away from them, life would not be worth living." "Yet of woman," Mary observed, "neither of them think very highly. I cannot say I find in my heart a mystic cult of man. I wish I had." Bernhard and Mary relished the fact that they were part of "a civilization that brings together a Spaniard-Creole [Countess Serristori], a Russian Jew [Bernhard], a Pole [Count Rambelinski], and a Philadelphia Quaker [Mary] and enables them to pass three days together in perfect harmony, agreeing upon pretty nearly every subject." The dull Count Serristori had fortunately been removed by a telegram summoning him to Pisa.

The most stimulating of the house guests to spend the Christmas holidays of 1902 with Berenson was Bertrand Russell. He was accompanied by his disconsolate wife, whose "illness" puzzled the Berensons, for they did not yet know of the profound discord that had arisen between her and Bertie. Berenson felt such complete rapport with Russell's stoical view of the human condition that Mary was moved to remark to her mother, "Isn't it funny that Alys and I have married men whose view of the world is *almost the same?*" She added, however, that Bertie, unlike Bernhard, "believes in the possibility of doing good to large masses of people." Out of the earnest conversations of the two men came Russell's famous short essay "A Free Man's Worship," a Promethean cry of the heart, inspired by thoughts of his wife's distress and the troubles of his collaborator's wife, Evelyn Whitehead, who recently had a painful heart attack. Its theme chimed in with Berenson's own deeper feelings. "In action, in desire, we must submit perpetually to the tyranny of outside forces; but in thought, in aspiration, we are free, free from our fellow men, free from the petty planet on which our

26. Berenson and his mother,
Friday's Hill, 1901

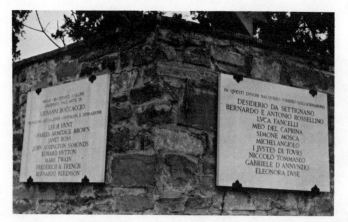

27. *Roadside plaque,*
 Via Vincigliata near
 Ponte a Mensola

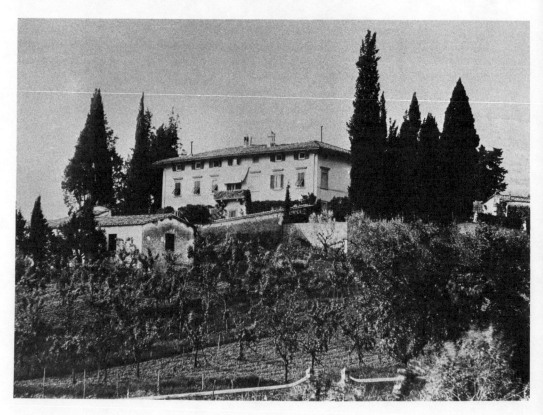

28. *Villa I Tatti, 1902*

bodies impotently crawl." Russell finished the essay on his return to England and dispatched a copy to Berenson with the regretful admission that he had abandoned for the present the hope of writing anything of a purely imaginative kind. "The intellectual habit is too imperious with me . . . I am convinced that the essay is the proper style for me." Berenson reassured him: "I have read your essay three times, and liked it better and better. Perhaps the most flattering appreciation to be given of it is that the whole is neither out of tune with nor unworthy of the two splendid passages you wrote here."

In the same letter he told of "the really great event of the last few weeks," the visit of Russell's Oxford friend Gilbert Murray, who was working in Florence. "I fear I should fall into school-girlishness if I ventured to tell you how much I liked him. . . . No woman in my earlier years made me talk more about myself than he has now. Conversation spread before us like an infinite thing, or rather like something opening out higher and greater with every talk. I found him so gentle, so sweetly reasonable—almost the ideal companion . . . He has absorbed my energies. What little was left went to my proofs. Happily they are nearly done." The proofs of the *Drawings* had been coming in for more than two months, first for the text and then for the catalogue, and Mary and Emily Dawson were hard at work on the extensive index.

Russell felt a lift of spirit at Berenson's praise, for it came at a time when, as he said in his response, he "was very dried up and full of the feeling that God had deserted men, but moods come and go and come again." He was much relieved that Murray, to whom he was "very much devoted," and Berenson had hit it off so agreeably. "I was afraid from your dislike of his work that you might dislike him too." Russell, who was then in the final throes of his magnum opus, *The Principles of Mathematics,* begun five years earlier, retained ambivalent feelings about his own visit to I Tatti. "In my heart," he confessed to Berenson, "the whole business about art is external to me. I believe it with my intellect, but in feeling I am a good British Philistine." His response to daily life at I Tatti he conveyed to Murray: "Just behind the house is a hillside covered with cypress and pine and little oaks that still have autumn leaves; and the air is full of deep-toned Italian bells. The house has been furnished by Berenson with exquisite taste; it has some very good pictures, and an absorbing library. But the business of existing beautifully except when it is hereditary slightly shocks my Puritan soul. . . . But I think one makes great demands on the mental furniture where the outside is so elaborate, and one is shocked by lapses that one would otherwise tolerate." The small lapses that were apparent to the

grandson of Earl Russell, those faint stigmata of Berenson's humble origin, were perhaps lapses of which Berenson himself was aware, and his lifelong preoccupation with elegant decorum, which later startled iconoclastic friends like Hutchins Hapgood, may have reflected that uneasy awareness.

Only in the presence of the unbuttoned demeanor of Israel Zangwill could Berenson let down his guard and in the lingua franca of their lowly Jewish origins discuss such alien matters as Zangwill's work with Theodor Herzl, the great Zionist, whose recent negotiations with the Sultan of Turkey, marked, as Zangwill expressed it to Berenson, "a new phase in the eternal history." When Berenson voiced confidence in the growth of tolerance in their world, Zangwill cautiously replied, "I wish I could share your optimism as to the trend of Anglo-Saxon civilization." Zangwill's plebeian manners and untidiness always outraged Mary, and after one of his visits she would fumigate his room; yet she had to admit to herself that "he is perfectly goodnatured, very kind, extremely witty, large-minded and sees the irony of things and he is one of the few people we can talk freely with and with no fear of being misunderstood."

Berenson's preoccupation with the *Florentine Drawings* seems to have had a calming effect upon his temper, so that for much of the winter the days had passed peaceably enough. But one fierce explosion over household affairs wore them out with its fury, and only Horne's arrival for dinner forced an armistice. "We were both in the wrong," Mary reflected; "the worst of quarreling is that we *can't* escape from each other after all these years and we know it." Bernhard, overcome with remorse, plaintively said to Mary, "But there is no one else I can be cross with, and I've such a lot of crossness in me."

The golden Tuscan spring of 1903 brought a succession of diverting guests to I Tatti. Norman Hapgood, who had fallen under Berenson's spell years ago in the Louvre, came up from Florence alone a few times, his wife having suffered a nervous breakdown. Hapgood had already published a few political biographies and was establishing himself as a political reformer in America. The number of nervous breakdowns among the women of the Berensons' acquaintance seemed to them to make that ailment almost fashionable. Even the irrepressibly energetic Gladys Deacon was said to be in a sanitarium for nervous disorders. Berenson, afflicted with his own recurring state of nerves, could readily sympathize with the many victims of social pressure.

If Hapgood brought idealistic politics to the Berenson salon, it was G. Lowes Dickinson who aired far more congenial topics. Dickinson, the author of *The Greek View of Life* and an intimate of Berenson's

circle of English university friends, was soon joined by Jane Harrison of Newnham College, Cambridge, the noted student of Greek religion and mythology. They provided a feast of high culture. Berenson confessed to Russell that Dickinson and Gilbert Murray were so engaging that they "spoil the rest of human intercourse."

The most picturesque visitor was undoubtedly the flamboyant egotist Gabriele D'Annunzio, who was living with the celebrated Eleonora Duse in a nearby villa. He struck his hosts as "dandified, hideous, vulgar," but he did love good talk and helped make it sparkle. His visits, in which he was often accompanied by the Duse, grew agreeably frequent, at least for Bernhard. Mary's account of one of those evenings when D'Annunzio and the Duse came over in the rain would suggest that he did not exercise his fabled charm upon her. "The Duse looks about 50 [she was 44 at the time], a sad but attractive face, large gestures, and something *populière* in voice and movements. D'Annunzio looks like a small, white, nasty worm and has common excited Italian gestures and talks a great deal about his poetry, plays, and novels—in short just the cad you would expect from his novels." He flirted with Countess Serristori, "turning the femme savante into la femme." "The Duse fastened on Norman Hapgood as 'useful' and they talked American theatre. D'Annunzio gave his view of life, how the four great guides to life were . . . Instinct, Pride, Will, and Volupté. He forgot Intellect, and quickly recovered himself when B.B. called attention to the omission and said the Intellect was the Ego which made use of those four ministers." The Duse fascinated even Logan, who had little romantic interest in women. She readily confessed that her interest in culture was only a pose, that her real interests were her career as an actress and her "affairs of the heart." D'Annunzio, who found in Berenson a man whose mind ranged distant seas of thought, sent him a copy of his newest book, *Il fuoco* (The Flame of Life), which celebrated his liaison with the Duse, inscribed "Bernardo Berenson, all'alto é libero spirito che naviga i mari lontani questo poem navale e fraternamente offerto." Since the Duse and her consort tended to stay late at the I Tatti musicales, Mary usually managed to disperse them by noisily winding up the clock.

Among American visitors a connection with Harvard always assured an especially friendly welcome at I Tatti, for Berenson's affection for Harvard was even greater than his affection for Boston. A fresh recruit that season to that charmed circle was the social critic and essayist John Jay Chapman, who had come to Florence with his talented second wife, Elizabeth Chanler, and their children to recuperate from a crippling illness. He too had been a literary aspirant and had gone on to the Har-

vard Law School the year Berenson entered Harvard. A certain tragic aura surrounded him as a consequence of a terrible act of self-punishment—he had held his left hand in a bed of burning coals. An impassioned idealist, he had spent the years since his graduation in political reform agitation and writing in New York. In August 1903 Chapman took his family to Romerbad in the Austrian Alps. From Romerbad on August 11 Chapman dispatched a warm approval of Berenson's projected trip to the United States, declaring: "The things you know about are needed by the age and . . . you are destined to supply them. . . . You have made a great name already. Everybody knows about you and you have the temperament that influences people even against their will. What you think important they begin to think important, and if you tell the truth about everything you will be of infinite service in America. I am encouraged about the Met. At least they accepted three French pictures Mrs. ·Chapman gave them." Three days later news came that one of Chapman's children had been accidentally drowned in a bathing pool at the mountain resort.

The most inharmonious encounter of the spring of 1903 took place at the splendid Villa La Doccia, an encounter that ironically led to one of Berenson's most treasured friendships. Henry Cannon invited Bernhard and Mary to meet a fellow New Yorker who had begun to receive recognition as a talented author. She was Edith Wharton, the finished product of New York society. Her two-decker first novel, *The Valley of Decision,* redolent with her recollections of the Italian landscape, had just come out, and the enthusiastic reception of it doubtless warranted in her a degree of self-assurance. Mary's private account of the meeting ran thus: "Logan and I drove to La Doccia to meet the great Edith Wharton. We found B.B. there, already, it was clear, loathing her. We also disliked her intensely. Mr. and Mrs. Johnson were there, he the editor of the *Century Magazine.* The little laureate [Alfred Austin] was also there, very elate at the prospect of having his play produced. The only nice people there were dear Mr. Cannon and his guest Captain Fairbairn." Afterwards she learned that Mrs. Johnson had received the same unfavorable impression of "intolerable sniffiness, rudeness [and] self-absorption." Edith Wharton, for her part, was apparently unaware, as her biographer R. W. B. Lewis records, that she had made an unpleasant impression. Thereafter, the Berensons avoided her, never letting pass a chance to speak scornfully of her, believing that she riposted in kind. The strange charade went on for six years and ended only with the intervention of their friend Henry Adams, who in September 1909 arranged a dinner party at Voisin's in Paris to bring the supposed adversaries together. Long afterward, in his *Sketch for a Self-Portrait,* Beren-

son's memory paid tribute to the significance of the encounter by recall-
ing it as a dramatic tête-à-tête in which a heavily veiled unknown
presently revealed herself under the electric light as Edith Wharton. In
actuality the party was judiciously leavened by the presence also of
Morton Fullerton, one of Berenson's former associates on the *Harvard
Monthly,* and of Adams' confidante Elizabeth Cameron and her daugh-
ter Martha, whom Berenson had entertained in Florence. Edith Whar-
ton surprised Berenson by "being affable to the last degree," and so, he
reported to Mary, "I buried the hatchet, and called on her yesterday."
In this fashion there began a cordial intimacy that ended only with
Edith Wharton's death in 1937.

XXVIII

The Wars of the
Burlington

ROBERT DELL, the first editor of the *Burlington Magazine,* recruited an imposing "Consultative Committee" of forty, which included such leading figures as Viscount Dillon, Lord Balcarres, Sir Edward Thompson, Sir Purdon Clarke, Sidney Colvin, Charles Eliot Norton, Charles Holroyd, Salomon Reinach, Laurence Binyon, and Dr. Wilhelm Bode. As active participants, Roger Fry and Bernhard Berenson were also listed in this pantheon, along with their co-workers Herbert Cook and Herbert Horne. Editor Dell, with an enterpreneur's oversanguine expectations, had led his associates to believe that he had "heaps of capital," as Fry told his mother afterward, "and it was on the strength of these assurances that Berenson, Horne, [Charles] Holmes, and I" lent our names. By the end of the first year those assurances turned out to be hollow, and the revelation precipitated a disillusioning struggle for control of the magazine.

Fry stood in the closest relation with the editor, and hence a good deal of the negotiations with contributors and with his own associates fell upon him. He soon found that he had to tread warily among the rival camps. Even in his own, among the three advisers on Italian art—Berenson, Horne, and Fry—there were private reservations about each others' characters and abilities that imposed a certain amount of diplomatic hypocrisy. For example, when Fry read Horne's translation of the life of Michelangelo, he confided to Berenson that it was "of the most soul-bespattering kind. It is a great relief to turn to your condensed extract." Berenson for his part privately deplored, as we have seen, Fry's superficiality. He also harbored a secret suspicion of Horne's loyalty, arising apparently out of their partnership dealings. What he had yet to learn was that Mary had inadvertently given aid and comfort to one of his most formidable enemies, Langton Douglas.

While he and Mary were still in England in the autumn of 1902, Dell had asked Mary's opinion about an article on Sassetta, "A Forgotten Painter," which Langton Douglas had submitted to him for the *Burlington*. Whether Dell had any qualms about consulting Bernhard himself does not appear. In any case Mary's reputation as an expert on Italian art and as a partner of her husband was now well established. Fry had told her, for example, that one London collector said "you know far more than B.B." Mary, not scenting danger, unthinkingly approved acceptance of the article, although she knew that Bernhard not only had a low opinion of Douglas' critical ability but also was himself planning an elaborate study of Sassetta. On learning of Dell's intention to publish the offending article, Berenson erupted to Fry with such fury that Fry feared he might quit the magazine. He begged Mary on January 30, 1903, to placate her husband since Dell, who was a friend of Douglas, did not want to go back on the acceptance and was in despair because he had acted on her advice. After all, Fry argued, Mary could reply to the article in a subsequent issue "completing and correcting his and showing where he's wrong. Then Dell won't accept any more from him. . . . It is very important that it shouldn't be said that the *Burlington* belongs to B.B.'s clique. I do really regret it when B.B. fights the Strong set on their own terms. I'm certain he oughtn't to. . . . Can't you persuade him?" Mary managed to win Bernhard over, but neither she nor Fry could foresee the unhappy complications which were to follow.

Just a week earlier Fry had found himself caught unexpectedly in the smoldering dispute between Douglas and Berenson when Douglas burst in upon Fry without warning and berated him for having stated in a review of Douglas' *Fra Angelico* in the *Pilot* that he had not given sufficient credit to Berenson. "He besieged me with proofs of his originality," Fry reported to Mary on January 21. "He has the persecution mania to some extent." Fry unintentionally threw fresh fuel on his visitor's ire by casually alluding in their conversation to a picture by Sassetta. Douglas exclaimed, "Oh, you mustn't say anything about Sassetta, *I've* been making most important discoveries about him." Fry, thinking then to please him, said, "Almost the only picture I know of him is a great favorite of mine—I mean the 'Marriage of Poverty' at Chantilly." In a frenzied rage Douglas asked him how and when he had learned it was a Sassetta. When Fry explained that "B.B. told me years before I ever saw it," Douglas demanded that Fry swear that Berenson had got the attribution from him. Of course Fry refused, since he "hadn't the remotest notion" how Berenson had learned the identity of the painter.

Almost simultaneously Fry ran afoul of another Berenson adversary, the art critic and poet T. Sturge Moore, who offered to review Sandford Arthur Strong's volume of reproductions of drawings in the Chatsworth collection, which Strong had lent him. Writing to Moore on January 21, Fry pointed out to him that the book had "one or two really obvious howlers in the matter of attributions," which would need to be noticed in view of the fact that "Berenson, Horne, and I are Italian advisers" and the *Burlington* "will, I suppose, go in for attributions so far as they count for aesthetic appreciation." When the review came in, Fry informed Mary on March 16 that it was full of "vehement diatribes against an imaginary idea of scientific criticism." Mary, who was then spending the Easter holidays with her children in England, wrote to Bernhard more specifically that it was replete with "snide criticisms of Berenson and company." Fry, she went on, was "pretty furious . . . at Moore, who, he says, is being used as a catspaw by Strong." Since Moore refused to "alter a word," Fry turned the article down, but he grew fearful that Berenson would be alienated by the Strong cabal; he therefore told Mary to assure Bernhard, as she relayed in a letter, that he would "fall in with *anything* thee wants, for if thee leaves the magazine, he is lost." In the same letter Mary sought to make amends for again deserting Bernhard at Eastertide when only a few months earlier she had promised not to do so by telling him how much she missed him and affectionately recalling "how awfully nice my morning visits to thee [were], finding thee in bed with thy windows open, and sitting and chatting for a while before the day's work began."

Whatever annoyance Berenson may have felt at this behind-the-scenes skirmishing that preceded and accompanied the appearance of the first issue of the *Burlington* in March 1903 must have been considerably tempered by the sight of his article on "Alunno di Domenico" handsomely printed in the lead position of the lavishly illustrated magazine. Its appearance was indeed a personal triumph over the members of the Strong cabal, and he could look forward to smiting them hip and thigh. The article displayed Berenson in his most ingenious vein, though he modestly deprecated it to his readers as having been written several years ago. Except for a few excisions it was to form part of Chapter IV of *The Drawings of the Florentine Painters*. Like his earlier "Amico di Sandro," it was a subtle and painstaking reconstruction of a hitherto unidentified "artistic personality" solely by means of technical connoisseurship. It displayed the acuteness of his ingathering eye and his prodigious memory of details of a widely scattered array of paintings. His hypothesis was that this admittedly minor artist was a dis-

ciple of Ghirlandaio and employed by him as an assistant and that his hand could be detected in a number of the master's paintings. By the purest chance Berenson's deduction had been confirmed by a recently published pamphlet demonstrating that the predelle of a famous altarpiece hitherto attributed to Ghirlandaio had in fact been painted by an assistant identified as Bartolomeo di Giovanni. Berenson had for convenience given the unknown artist the name of Alunno—pupil—of Domenico Ghirlandaio.

How jealous of their respective domains art specialists were was amusingly illustrated by a note in a subsequent issue of the *Burlington* contributed by Alfred Pollard, a member of the Consultative Committee and a specialist in book illustrations. In the course of the Alunno article Berenson had deduced that the artist had also prepared a number of woodcut illustrations previously attributed to others. Pollard hastened to reject Berenson's "light-hearted incursion into our little domain" as "speculative." He offered the note, he said, to prevent "exploitation by dealers and muddying the waters." As it happened, Berenson's new ascriptions survived the challenge.

Though the "Alunno di Domenico" effectively repelled by its example the scornful attacks by Douglas and company on the "scientific" method, Berenson still had a special score to settle with Douglas, for he particularly resented Douglas' shabby treatment of him in the *Fra Angelico.* As Mary had written to Fry, "Mr Douglas came here and got all sorts of things out of B.B. [concerning Fra Angelico] and professed overwhelming gratitude, etc., etc.; unfortunately he fell in with Strong with the result that taking all B.B.'s results he scarcely mentions him . . . Then worst of all uses that point of vantage to sling sneers at B.B. . . . It made B.B. wretched."

Berenson had already ventured to teach Douglas a lesson in aesthetic criticism, choosing for his text Douglas' recent *History of Siena.* He published an anonymous review of it in the March 19 issue of the *Nation,* in which he contrived to praise Douglas' narrative skill but only to heighten a damaging contrast: "It would be hard to find a better-told story of a people" in spite of pages which "bristle with pretentiousness." Unfortunately, Mr Douglas "shows himself merely a journalist—a diligent and interesting one, it must be admitted—but a journalist with the result that taking all B.B.'s results he scarcely mentions him. acter," his parade of scholarship without a sound basis and his use of authorities suspect; "although he made constant use of their attributions and historical observations, he quotes them only in a few minor points where he conceives them to have blundered. . . . Until he touches on art [he] is very readable." However, his defects as a writer become

most glaring "when he comes to speak on matters which call for a finer aesthetic culture than he seems to possess." In short, he "can do good work in subjects where fineness of taste and delicacy of eye are not needed." This last was perhaps the most painful thrust of all, but in the wars of the art critics it was normal to try to draw blood.

What had been particularly galling to Berenson was Douglas' patronizing footnote in his *History of Siena* discussing Sassetta, which said, "Mr. Berenson does not consider him worthy of a place in his list of Sienese painting and gives his best work [at Chantilly], his 'St. Francis and the Three Monastic Virtues' [also known as *The Marriage of Poverty* and *The Mystic Marriage of St. Francis*] to his pupil Sano di Pietro." It was embarrassingly true that Berenson had not included Sassetta in his *Central Italian Painters of the Renaissance* in 1897, having too readily accepted the then current attribution of the Chantilly painting. He corrected his mistake in the Index of Artists of the second edition of the *Central Italians* in 1909, but by a curious oversight he did not correct the text until some years later. He evidently felt it was a pardonable error, more than offset by Douglas' unacknowledged debt to him and perhaps excused by the campaign to discredit him.

Invited to review Douglas' *Siena* for the April *Burlington,* Berenson decided to turn the task over to his protégé, F. Mason Perkins, who was now well established as a scholarly critic. His authoritative study on Giotto had come out the year before, carrying his acknowledgement of "deep indebtedness to Mr. Bernhard Berenson for much invaluable assistance." Perkins seems to have taken his cue and his tone from Berenson's piece in the *Nation,* and he no doubt had the benefit of Berenson's lively counsel. Thus Perkins granted that Douglas "has in him the promise of a genuine historian" in spite of his "somewhat journalistic and irritating style." However, "Professor Douglas the art critic is, in fact, a very different person from Professor Douglas the historian . . . His opinions here are pronounced with remarkable assurance, but they lack consistency, they are often immature, and they betray a rather superficial acquaintance with his subject, and a taste as yet undeveloped [Perkins was 29 to Douglas' 39]. . . . His whole perspective of Sienese art is wrong." Citing chapter and verse, he then proceeded to eviscerate Douglas' survey of Sienese painting.

Douglas' short seven-page article on Sassetta (he was soon calling it a "monograph") appeared as scheduled in the May issue of the *Burlington*. In the very first paragraph he took obvious satisfaction in calling attention once more to Berenson's erroneous attribution of the Chantilly work to Sano di Pietro, an error which, he said, had been shared "even by scientific critics." To this piece of irony he appended a footnote:

"Since the publication of my *History of Siena* I have heard that Mr. Berenson has renounced his opinion." The allusion was, of course, to his indignant interview with Fry. Hagridden by his passion for priority of discovery, Douglas had leaped to his conclusion like many another scholar dazzled by an initial perception. The fact was, as has been seen, that both of the Berensons had recognized the great painting in the hole-in-the-corner shop in Florence as Sassetta's two years before the publication of Douglas' book. From Mary's remark at the time that the only other person familiar with Sassetta was a professor in Siena, one may surmise that, being then on friendly terms, the three of them had shared their new enthusiasm. Who, then, was really first appears past knowing. Bernhard and Mary must have felt a thrill of complacency to observe that Douglas wrote in ignorance of the fact that they possessed the three central panels of the great polyptych altarpiece that Sassetta had painted for the Borgo San Sepolcro, panels which were to figure importantly in Berenson's own long essay on Sassetta.

Still, Douglas flourished. Berenson had been disgusted to learn that his own publisher, John Murray, had invited Strong to revise Crowe and Cavalcaselle's classic history of Italian painting and that Strong had taken on Douglas as his collaborator. The first two volumes had now appeared, and Berenson, sure that the job was botched, urged his friend Jean Paul Richter to attack the edition. Richter, who plainly did not want to offend such influential opponents in the London Establishment, did what he could to soften Berenson's indignation. In a long letter to him in German he argued unconvincingly that the "Strong-Douglas-Benson-Loeser crowd" if left to themselves would destroy their own influence. He agreed that the choice of Strong and Douglas as editors had been a mistake and that their work was full of errors. He insisted, however, that though he never neglected a chance to defend Berenson no good purpose would be served by assailing Murray's mistake. Berenson was not mollified by Richter's evasive screed, and not prone to forgive disloyalty, he allowed their long friendship to languish.

Douglas' enmity was augmented in the April issue when Hobart Cust, a relative of one of the members of the Consultative Committee, published a letter criticizing Douglas' "serious errors" in the use of documentary evidence in the *History of Siena*. Douglas struck back in a long note in the following issue, linking his critic with his bête noire, Berenson: "Mr. Berenson, we know, has a contempt for so-called signatures and bases his conclusions on connoisseurship alone." In his brief reply in the June issue, Cust firmly reiterated his criticism. By the end of the summer Douglas' annoyance with Berenson and company had obviously grown. He must have learned or readily deduced from the fact

that Berenson was the known European art critic of the *Nation* that the insulting review of his *Siena* had been Berenson's. Richter had reported to Berenson that Douglas had complained to him that the *Nation* had attacked him unjustly. Nourishing his anger, Douglas bided his time, unaware that Berenson would soon be left open to his malice.

BERENSON's first contribution to the *Burlington* had, in a sense, looked back to his early achievements, that phase of his growing mastery of method which culminated in the *Drawings of the Florentine Painters*. His second contribution, "A Sienese Painter of the Franciscan Legend," reflected the shift of interest which he had announced in the preface to his second collection of essays to the "sense of quality" of paintings and to their "spiritual" meaning. The new article appeared in two parts, the first in the September–October issue of 1903, the second in the November issue. The painter was of course Sassetta and the painting, the polyptych altarpiece of which the Chantilly panel was a pendant. The article began to take form shortly after the Berensons returned from their brief tour in mid-May 1903 of the places where Sassetta had worked, especially San Sepolcro, northeast of Siena, where the great altarpiece had once lodged. By that time Douglas' article on Sassetta had already appeared and his ignorance of the fact that the Berensons owned the missing central panels of the altarpiece must have acted as a piquant spur to Bernhard's writing. The wholly novel drift of the essay took him back in thought to the excitement he had felt in the company of Denman Ross and Ernest Fenollosa in 1894 in the presence of the Oriental paintings in the Museum of Fine Arts. Contemplating Sassetta's St. Francis, he asked himself "why European painting is never religious while Chinese is." He confessed to Mary that he was fast moving "in the direction of feeling that things are Symbols, not facts, and that there is an infinite meaning in them—a kind of vague and hopeful religion which so possesses [a person] that no matter what his intellect says, he knows there is something the soul will recognize as beautiful behind it all." It was as if his prolonged meditation on the legend of St. Francis had revived the Emersonian idealism of his youth and fixed it with such force in his mind that ever afterward he held fast to a belief in the numinous in human existence.

The writing came with a rush. From Florence Mary wrote to her mother in mid-June that "Bernhard is getting on splendidly with Sassetta. It is a new departure for him to be looking for expression and 'soul' in pictures." In the flush of a congenial theme his spirits seemed to soar and his depression vanished. The Sassetta essay was quite unlike anything he had so far written. His daily contemplation of the central

panels of the Sassetta altarpiece at I Tatti had cast a kind of enchantment on his pen, for the artist's ethereal evocation of the saint had clearly touched a deep chord of lost innocence and simplicity in Berenson's nature. The more he studied the artist the higher his estimation rose, canceling out any reservations he may once have had about the Sienese school, for as Sassetta rose his confrères rose with him. All the reverent feelings that had uplifted him again and again in the church of St. Francis at Assisi were revived by the painting, which seemed to have a hitherto undreamed-of dimension. Thus in the opening pages of the first section of the article he described Sassetta as the type of artist who cut through the surface appearances of life, which the classic art of the West rendered with such profuse detail, to bring to light the very lineaments of the soul, as Oriental artists had done for centuries. Great as Giotto's frescoes on the walls of the Upper Church were, they gave only the "outward events" of the saint's life; they did not re-create "the Francis who composed the 'Canticle to the Sun' " nor the Francis who was "the knight-errant of Lady Poverty."

Giotto's frescoes over the tomb, Berenson suggested, depicted St. Francis as "a mere monk, and most monkish of all in the apotheosis." Such was not the living St. Francis. Rather he was, as Sassetta painted him, "the most uncloistered, the most loving, the most busily well-doing, the most social of free spirits! . . . He came nearer perhaps than any other European to that rarest and most unattainable of emancipations, the emancipation from one's self"—the freedom, Berenson may well have reflected, from the sordid demands of the world of getting and spending in which he himself was enmeshed. Giotto's failure to convey the "seraphic spirituality" of the saint was characteristic of Western art. In the art of "the extreme Orient . . . though their saints are frequently hideous [and] their converted hobgoblins and demons . . . fiendish all are spiritualized through and through. . . . Think of the curious fact that, after more than eighteen centuries, our art has not yet created a single image of its founder, while the Buddhist world soon incarnated the ideal Gautama in a form which left no room for change." To illustrate the point Berenson reproduced one of the Chinese Buddhist paintings which his Boston friend Denman Ross had acquired from among those they had together viewed in 1894. "Here we feel an ecstasy of devotion and vision, here we behold a transubstantiation of body into soul, whereof we rarely get as much as a vanishing glimpse in our own art."

Only the Sienese, "the most emotional and the most mystically inclined of peoples," could produce an artist with a similar capacity who might "bring to life again the spirit and teaching of Francis." Sassetta

"with the quasi-oriental qualities of a Sienese" understood the use of "space composition" to convey "mystic feeling." His "soaring spaces of silvery sky, lightens, uplifts, and dematerializes you, wafting you into an ideal world." Berenson brought the long allusive argument of the first section to a close with an equally evocative analysis of all nine panels of the famous altarpiece, which he had successfully tracked to their owners in France, an analysis culminating in the intimations of "ecstatic harmony" in the figure of St. Francis that occupied the central panel of the triptych on the wall at I Tatti.

In the continuation of the essay in the November *Burlington* he turned in a more subdued key to a re-creation of the artistic personality of Sassetta through a close study of his other works, tracing the complex filiations of Sassetta's art and the influences that played upon him to give him a central position among Sienese painters. In neither part of the long essay did he find it necessary to refer to Douglas' article, which his so obviously superseded, doubtless quite conscious that Douglas would be his most attentive reader.

Alerted by Part I, Douglas was permitted by Dell—presumably with the sufferance of Fry—to annotate Part II before its publication. A number of pages were therefore embellished with footnotes signed "Ed." calling attention to the priority of Douglas' article on Sassetta. One on the Chantilly panel, for example, read in part as follows: "In regard to this picture it is only just to mention that the first to publish its attribution was Mr. Langton Douglas, and the medium of its publication was this magazine. . . . Ed." These gratuitous and patronizing additions, made without Berenson's permission, clearly indicated that his role in the direction of the magazine had been undercut. The realization of that fact must have had a distinctly chilling effect on his regard for the London venture, in which he had once hoped to play a prominent part.

Douglas was not yet through with him, however, and in the December issue of the magazine in a "Note on Recent Criticism of the Art of Sassetta" he avenged himself for every slighting word that Berenson may have uttered about him and his work, even for those with which Berenson had rejected his "Duccio" years ago. He pointed out with due irony that Berenson now renounced the opinion of his *Central Italian Painters* of the essential inferiority of the Sienese school, and he once more called attention to Berenson's mistaken attribution of the Chantilly painting to Sassetta's pupil. Not without a touch of condescension, he remarked that as a fellow admirer of Sassetta he did thank Berenson for adding to knowledge of the artist "owing to the fact that he was fortunate enough to find those portions of Sassetta's Borgo San Sepol-

cro altarpiece which have long been concealed in private houses." He then turned his satire on Berenson's "friend and follower" F. Mason Perkins, determined to annihilate him for having attributed to Andrea Vanni the "chief ornament of the church of S. Pietro Ovile in Siena," an attribution endorsed by Berenson. Contesting with some complacence the details Perkins had relied on, he triumphantly concluded that the painter was really Sassetta, an erroneous conclusion that was to leave no trace in art history. Having thus disposed of the follower, he returned to the master. "In the present case it would be untrue even absurd to contend that the partial or complete atrophy of the sense of quality is a normal state. But there is, nevertheless, abundant evidence to show that Mr. Berenson, like many other distinguished conoisseurs, occasionally suffers from this malady. Had he not experienced some temporary numbness in this sense, he could never have deliberatedly accepted the attribution of 'The Mystic Marriage of St. Francis,' Sassetta's best picture, to his weaker follower, Sano di Pietro." Concerned to vindicate his authority, he ignored the fact that Berenson's essay had done far more than his to dignify the work of Sassetta, in whom he claimed a proprietary interest.

With such exchanges of personal amenities the first year of publication of the *Burlington* ended. But if friction among contributors could be tolerated, financial mismanagement could not. By early September, Mary became aware of "the apparently imminent smash of the *Burlington.*" Bernhard and Mary, who were then at Haslemere, went up to London to go over the balance sheet with Roger Fry and to interview Spottiswoode, the publisher. In her diary she wrote, "It was not very entertaining and one got tired of the muddle and the sordidness." They spent the evening debating with Fry the proper policy for the magazine and came away disheartened. The discussion convinced them that "if we succeed in reorganizing [there were] such differences of opinion that it seemed unworkable." What irked Berenson most about Fry was that in spite of the gaps in his research, he thought he had a "perfect right to be cocksure of his attributions." Still regarding himself as Fry's mentor, he had not looked with favor on Fry's speculative sallies, and when Fry in the course of a review in the May *Burlington* had argued the authenticity of a signature, Berenson had felt impelled to publish a communication, "The Authorship of a Madonna by Solario," in the June issue admonishing him for not having personally examined certain frescoes that contradicted his theory.

The contretemps over the future of the *Burlington* dragged on for several weeks while the Berensons departed for America on their long-postponed visit, leaving Fry to save the magazine as best he could. Fry

expected Berenson to raise funds in America, but it was now plain to
Berenson that the inner circle was reluctant to have him in it, and since
his was the only well-known name in the United States, as Mary ob-
served, he could hardly induce Americans to invest in an enterprise
over which he had no control. Soon Fry wrote to them that the maga-
zine had gone into voluntary liquidation and that he and his friend
Charles Holmes, a painter and author of books on Hokusai and Consta-
ble had set about reorganizing the venture. Another thousand or fifteen
hundred pounds was needed. "I've got twenty-five hundred pounds,"
Fry wrote Mary. "I do hope that B.B. will bring in some because I
want him to have a direct interest in the thing and we are having one
hundred ordinary shares, of which Holmes and I shall take a bare ma-
jority so as to keep control . . . so that if B.B. can bring in some he
might hold the ordinary shares and have a vote. . . . Hasn't B.B. sold
any pictures?"

With the affairs of the *Burlington* in this precarious state and his own
financial outlook uncertain and hinging on the results of his American
tour, Berenson decided not to invest in the reorganization. A whole
year had gone by with no really important negotiation since Mrs.
Gardner had bought the Dürer. Besides, the prospect of having a dis-
tinctly minor role in the magazine could hold no allure for him, espe-
cially after the humiliating drubbing Douglas had been allowed to give
him. Moreover, it soon developed that even had Berenson supplied a
thousand pounds he would still have been on the outside because Dell
came up unexpectedly with three thousand and Fry and Holmes had to
"compound" with him. Fry softened the news by explaining to the
Berensons that Holmes and not Dell would have "a deciding voice in ev-
erything." Fry hoped that they would not think him "weak; if we'd
had another thousand pounds we could have defied Dell. . . . I am of
course awfully sorry that Dell has taken the revenge of putting in Lang-
ton Douglas for the December number, but I suppose it was natural as
he thought it his last number. . . . If we hadn't got hold of the thing as
we practically have . . . he would have run on with Douglas, Strong &
Co., so that from that point of view it seemed worthwhile to make
terms." Nonetheless, Fry felt the awkwardness of his position, and in a
conciliatory letter to Mary he acknowledged that "London, by which I
mean the unholy alliance of officialism and dealerdom which begets
Bensons and embraces our Langton Douglases, is bitter with B.B. and
means to crush people like me out of existence. . . . I say all this that
B.B. may know that he's not the only person who is hounded by these
people. . . . He should come to this distant and semi-barbarous prov-

ince now and then and build a Roman wall to keep Balcarres and his fellow Picts to their side."

Berenson could hardly have avoided thinking that Fry had in fact been weak in not more vigorously opposing Dell's maneuvers, but amidst the excitements of his reception in America, he had little time to dwell on the untoward conclusion of his London adventure, and he wasted no energy in recrimination. Fry could still be counted on as a friend of sorts and an intimate of Mary if not of him. So when Fry, much pressed for funds at this time to meet the staggering expenses of his wife's mental illness, asked Berenson to try to sell some of his early Venetian paintings while he was in America, Berenson cheerfully went to work and disposed of them to a Mr. Rutherford of New York. Perhaps because of Mary's continuing intimacy with Fry, Berenson did not finally break with him until nearly ten years later.

With the reorganization of the *Burlington* Berenson's connection with it came to an abrupt end and with it his hope of establishing himself as a leading English art critic. He never again contributed to the magazine except for a brief article on a forgotten painter which he wrote nearly a half-century later. By that time Fry had been dead for sixteen years, but Berenson still brooded, perhaps unjustly, over what he came to think of as Fry's "perfidy."

XXIX

Mission to the New World

THROUGHOUT the winter and spring of 1903 the intermittent bouts of illness had recurred with maddening frequency in spite of the almost daily ministrations of Berenson's doctor, the daily attentions of a masseuse, and daily injections of phosphate. In the absence of a convincing diagnosis of the cause of his unruly digestion, he entertained the fancy that it was the result of his being fed sour bread and vodka as a child, a fancy that in time took on the coloring of fact. He had found some surcease from his distress while absorbed in the writing of the article on Sassetta, but the effort told on him, and friends like Leo Stein feared he faced a lifetime of invalidism. In his weakened condition, the thought of visiting America to repair his precarious fortunes so daunted him that he tried to call off the trip. However, Mary, more practical—and hopeful—than he, would not hear of further postponement, and they laid their plans to sail to New York on September 30 aboard the *Majestic*. In Mary's calculating eye, financial salvation lay in the projected tour; her guiding maxim was always that "something will turn up," and thus far it had. Her favorite dreams, she confessed to her mother, were about her children or about money. Her sanguine confidence seemed to keep pace with her weight, and as she grew more imposing in aspect, Bernhard, prone to worry about the uncertain future, grew more wraithlike, a mere 118 pounds to her blooming 190. For many months he turned over to her his voluminous correspondence, even deputizing her to write to his family. Though he would often rally in the presence of guests, he would sometimes, quite inexplicably, fall into a doze.

A fresh anxiety had surfaced in the spring of the year when word came that their aged landlord, John Temple-Leader, had died, leaving his properties to his grandnephew, Richard Bethell, third Lord West-

bury, a "gaming peer" according to rumor and a confirmed London clubman. The Berensons also learned to their dismay that some of the nearby woodland was to be cleared for a row of houses and that on the heights above them near Corbignano a hospital for consumptives was to be erected. Yet the thought of leaving I Tatti was not to be borne. For both of them it had become "the great good place," admired as much by their guests as by themselves. It is "a lovely old villa," Clyde Fitch wrote a year later, following one of his visits, "large, on a hillside, with two clusters of dark poplars [cypresses] at each end. In the garden is a little chapel where a monk comes and preaches on Sunday. The house is all white or grey walls, and green woodwork, with natural wooden beamed ceilings, some pieces of fine old red brocade and some splendid cinquecento paintings. Also some very nice old carved furniture. The whole effect was cool, subdued in tone, and real." The possibility of buying the place had to be rejected because all their capital was tied up in dividend-paying stocks or invested in paintings. The only alternative was to negotiate a new lease and this kept them in Settignano until mid-June.

A new financial burden fell upon Berenson when his brother, Abraham, now thirty and once more without employment, wrote of a business venture in which he had a chance to join. Mary had written to him, "My place is to keep practical worries from him [Bernhard], but to help him do the right thing when he can. . . . He feels miserable at the thought that good luck is delaying so long in coming your way, so if you have a likely scheme, do please write to me about it." Abraham did write of a chance of a partnership in a Springfield business that would require an investment of $10,000. Bernhard borrowed the sum from Baring Brothers in London and had Mary cable his brother that the money could be picked up at the Kidder, Peabody offices. He cautioned him to be sure of his partner's character, saying as Mary quoted him to Abraham, that "the Berensons are not distinguished for their knowledge of character." She added, "His being a German Jew, Bernhard regards as not especially in his favor." The loan, she explained, would be at 5 percent, the rate Bernhard would have to pay Baring's. It would be regarded only as a moral obligation, and in the case of Bernhard's death the obligation would be canceled. With this turn of events, Berenson's responsibilities toward all the members of his family fell into an established pattern of subsidies that would continue unbroken to the end of his long life, financing education, travel, and family trusts.

Upon the signing of the new lease, Bernhard and Mary departed for Bagni di Lucca, where for a few days they enjoyed the thermal baths in the picturesque mountain town, and then descended to Lucca to entrain

for the roundabout journey to Milan on the way to St. Moritz, where during this earlier than usual stay Berenson hoped to recuperate. It was to be Mary's first visit to the famous Swiss resort, and one can imagine her excited interest as their horse-drawn carriage ascended the spectacular hairpin turns with their views of terrifying chasms and forested ridges stretching to the horizon. At the crest of Maloja Pass, more than a mile high, the road debouched into the meadow and lake land of the Upper Engadine, where the river Inn has its source. On either side of the high valley snow-capped mountain peaks soared.

By July fifth they were settled in the Badrutt Palace Hotel, one of twenty hotels that now clung to the west shore of the lake. They were comfortable except for the fact that a new storey was being added over their heads. The svelte young Countess Serristori and her phlegmatic husband were already there, Mary thoughtfully noting that the countess had just turned thirty. Bernhard and Mary luxuriated in long walks together, including one of ten miles to Pontresina. The crisp thin air seemed to put new life into Bernhard, and he grew "more tranquil and philosophic." They entertained Clyde Fitch at lunch one day and drove about the lake with him. He had come up from Florence for a holiday before returning to New York for rehearsals of his plays. He was still the same jovial and energetic man whom Berenson had known more than a dozen years ago in Paris, but now he had become a distinguished personage, his plays sought by every important actor in America and England. Since their Paris days together, he had written or adapted thirty-five plays, and he told them that he expected to have nineteen plays on the boards that winter.

After Mary's departure for England to look after their business affairs and to visit her children, Bernhard stayed on for a few more weeks into early August, renewing acquaintance with the Italian and French aristocrats who came for their annual display of fashion and exchange of gossip. Among them was as usual the irrepressible Placci, who managed to irritate Berenson, perhaps with his ecclesiastical prejudices. Informed of an incipient quarrel, Mary advised Bernhard to avoid hostilities, for it would be "awfully uncomfortable in Florence to add him to one's list of enemies." Bernhard obeyed. Because of his health Berenson had to eschew the "pandemonium," as he told Mrs. Gardner, and spend his daily hours with the Countess Serristori, "one of the four or five women I am devoted to." Disappointed that Mrs. Gardner was not to take a "Lotto" he had offered her, he proposed in its place, again without success, a Rogier van der Weyden which Mary had seen in London and highly praised. Again Mrs. Gardner pleaded imminent poverty. He tore himself away from the charms of Countess Serristori evidently just

in time, for when he joined Mary at Friday's Hill on August 7, he congratulated himself on having drawn the right line in regard to her and so saved himself from heartbreak. Mary with a touch of irony "wondered and admired," reflecting that in similar circumstances she was sure she would have had "an attack."

Senda, who had been touring Europe since mid-June, had already arrived at Friday's Hill for a month's stay. Within a few days after Bernhard's appearance, a little "colony" had assembled in the neighborhood—Bertrand Russell and his wife, Alys, in the main house, the Michael Fields in Mary's cottage across the road, the Roger Frys, G. Lowes Dickinson, and Janet Dodge in a house nearby. The time passed leisurely enough in those bucolic surroundings for Berenson to lay in some reserves of energy for the impending siege of America, on whose issue so much depended. For Mary, who had her own ambitions, there was time to furbish up her lectures on art as their joint spokesman since Bernhard was less fit than ever for the public platform, although in the drawing room at Friday's Hill his provocative remarks captivated his audience. Mary wrote down the following summary of his remarks at an early gathering of the company.

"The Sancta Conversazioni have begun. It is Michael who draws out B.B. by her questions and Field by her silent intent appreciation. Today he talked about the emancipation from art he had gained from art. Art has made him see herself in all nature, has imposed her laws on his eyes so that he no longer needs her aid to get at Beauty. But the impossibility is to communicate this. . . . He needs a new language for people to see the Art in works of art. His own experience is analogous to that of St. Francis to whom was revealed the Soul of each human being, who was delivered from the mere illustrative words and actions, who saw them and felt them differently, following the laws of his revelation. What B.B. sees in nature is a quality which appears only accidentally in the greatest artists. He tries to communicate it, but has no means and flounders about in pedantry and connoisseurship."

Shortly after Senda's departure for the fall term at Smith, Bernhard asked her to return a recent photograph of him because it was needed as an illustration for a long article on his work which Laura Gropallo was preparing for publication in the *Nuova antologia*. The article would be the first extensive account of him as an art critic and historian to appear in Italy. Senda complied and the photograph went on to the Marchesa at Nervi. It seemed to symbolize for Berenson a kind of date in his life, portraying him in mid-career at the height of his achievement as an authority on Renaissance art, his magnum opus at last in the hands of reviewers in England and America. There would be countless more

photographs with which he would try to capture his identity and save it from the erosion of time. This one, for the first time, seemed to match the image he had of himself.

Standing with his right arm casually resting on a cabinet and his left hand thrust into his trouser pocket, he looks steadily out upon the world with a serious gaze, as if carefully taking its measure. Dark hair frames a broad brow, and the handsome features and a soft mustache and Van Dyke beard are set off by a fashionable wing collar and bow tie. A boutonniere accents the lapel of his open jacket, and a cord descends across his waistcoat to a pocket where his glasses are hidden. His pose is one of studied nonchalance against what appear to be the woven hangings of his study. Neither young nor old, he seems to stand at mid-journey in life, dignified, thoughtful, and self-aware.

"Off at last," Mary wrote in her journal as the *Majestic* steamed out of Liverpool harbor on September 30, 1903, "after so many fears and indecisions, like so many people standing naked by a cold bath, afraid to plunge in. Now we have plunged in. We are off to the unknown." Eighteen years had gone by since she left Philadelphia to marry Frank Costelloe, ten since Bernhard's visit to Boston. Buoyant and expectant, she exclaimed, "What fun it is going back together!" What visions of felicity or dole filled Bernhard's mind as the liner rose and fell to the Westerlies went unrecorded. Unlike Mary with her bent toward journal keeping, he had not yet learned to subdue the daily bustle of his thoughts to a regular diary, and with her at his side there was no occasion for the usual torrent of letters.

For the six months of their American journey, which at times took on the character of a royal progress, one catches frequent glimpses of him and his activities through her watchful and affectionate eyes. In her depiction of their many hosts and their tastes in art she found much to disapprove, a disapproval in which, more often than not, Bernhard joined. No doubt it was inevitable, after their long saturation in the cultural riches of Europe, that Americans should have appeared naive and immature to them, fertile subjects for education in art in spite of Charles Eliot Norton's efforts. The two travelers surely felt themselves missionaries of a sort, and they played that role with immense success in the course of a long itinerary that took them to New York, Boston, Chicago, Detroit, Cleveland, Buffalo, Pittsburgh, Philadelphia, Baltimore, Washington, and cities in between.

The ship docked at New York on the evening of October seventh, and the pair quickly learned how to expedite their trunks through the indignities of the U.S. customs. The officer, mindful of the watchful

inspectors, suggested that if they wished to give him five dollars they should hand it over to the porter for him. "Which we did, and no nonsense about it." They went directly to Newport, being met by their host Theodore Davis, who took them to his magnificent house, "The Reef," with its commanding view of the stormy Atlantic, whose surf dashed beneath the windows. It was one of the structures of the ultrarich, which like feudal castles were themselves overshadowed by the royal splendor of the Vanderbilts' "Breakers."

Mary was impressed by the luxurious surroundings as much as Bernhard had been ten years ago. Now, however, there was much more of "a strange mixture of beautiful things (Egyptian and Italian) and silly forgeries or indifferent stuff." After dinner when Davis proudly showed them his objets d'art, Bernhard confined himself to a muttered "Murder" before an atrocity or an admiring "Jiminy whiskers" before an authentic beauty. As with the Laura Minghetti "Leonardo," Davis preferred to believe that all his things were genuine. They noted with a pang of regret that not only were the fake "Leonardo" and the equally fake Costantini "Filippino Lippi" prominently displayed in the drawing room but " a little forgery Logan (unwittingly) sold him also had a place of honor." In any case, Bernhard confided to Mary that he was "so sick of the art critics' vocabulary which he finds everyone can use as well as he can that he never wants to use a word of it again!"

The Newport visit had been indispensable because more than any other of their acquaintances Davis had important connections in the financial world. In spite of the vagaries of his taste, he still admired Berenson and loaded him with sheaves of commendatory letters to his fellow magnates in New York. The ostentatious display of wealth at Newport suggested to Berenson and his wife that this was a society floating on rivers of silver, and Mary, especially, hoped a bountiful stream could be diverted for their more discriminating navigation.

Having established a strategic bridgehead at Newport, the Berensons proceeded to Boston to pay their respects to Bernhard's family in their house on Grampian Way in the suburban Savin Hill section of Dorchester. He and Mary were taken in tow by his attractive youngest sister, Rachel, to whom Mary took a great liking. The house proved "nicer" than they had expected. The doting "little mother" was beside herself with joy at seeing her adored elder son again, and his father's cordiality disarmed Mary, who had heard so much of his bad temper. The reunion passed off pleasantly enough and without incident, though the middle-class tenor of his family's existence had obviously grown more alien than ever to Bernhard. To the censorious Mary there was a "life-diminishing" quality about the household, charged as it was with fam-

ily anxieties—Senda and Bessie worried about each other and both worried about Abie and "all of them about Mother and Father." Mary reflected that "Bernhard's career has given them all a vision of life they cannot themselves attain; and the contrast makes them discontented. As life goes they are really very well off."

Like many another confirmed exile, Berenson found the members of his family more lovable at a distance than when seen together in the glare of their idiosyncrasies. Remembering the ordeal of affection of his earlier visit, he confided to Mary, "If they only knew that the one thing I dreaded in this trip was a further intimacy with my Family." The tensions that had darkened their earlier poverty-stricken years had taken their toll of nerves and health, nerves especially, and the mirror image of his own ailments daunted him. This almost involuntary antipathy would be his lifelong secret, to be compensated for by his lifelong generosity.

Other family gatherings followed, at which Berenson behaved quite creditably in his wife's eyes. The cousinship had grown considerably since that far-off day when as a boy of ten he landed in Boston. There were now a few prosperous lawyers among them, and to one of them, Arthur, a handsome young man of thirty, Bernhard was immediately drawn; afterward he enlisted his help with his investments. One of the more comforting occasions saw his sister Rachel introduce to the family her fiancée, the twenty-nine-year-old Ralph Barton Perry, an instructor in philosophy at Harvard at the beginning of his notable career. Bernhard must have been pleased at the prospect of this intimate link with his beloved Harvard. The marriage would be delayed until after Rachel completed her archaeological studies abroad. Bernhard and his parents surely must have felt a degree of relief that at least one of the three girls was to marry, even though she was the youngest. The most beautiful of the girls, Senda, at thirty-six was still single; her marriage to Professor Herbert Abbott of Smith College was yet some years in the future. In the twenty-six-year-old Elizabeth Bernhard may well have foreseen the cultivated and fastidious spinster that she was to become. All would be his hostages to fortune.

The warmth of Berenson's reception in Boston and Cambridge wonderfully revived him. His hosts plied him with compliments and, what was most gratifying, deferred to his opinions with obvious respect. His few detractors, except for Richard Norton, had fallen silent, making all the more distasteful in retrospect the atmosphere of London, where his rivals delighted in embroidering slanders against him. The more he was feted by old and new friends and acquaintances, the stronger grew his

resolution to avoid any connection with the *Burlington* crowd and to maintain a healthy distance from their civil wars. "They take it for granted here," Mary observed, "that he is honorable and learned and sincere whereas in England from Roger [Fry] down they take the opposite for granted and of course in Germany and Italy and France he is much more loathed than liked. To be always on the defensive is extremely disagreeable, if you care at all and he seems to care." He has "a natural desire to count as an influence among his contemporaries."

In Boston the readers of the *Nation* had already been instructed by Kenyon Cox in a five-column review that a major figure had come among them, trailing clouds of erudition. If Berenson had been admired before as an incomparable guide to Italian Renaissance art, his magnum opus displayed him as a scholar of the first magnitude. The work carried the formidable title: *The Drawings of the Florentine Painters: classified, criticised, and studied as documents in the history and appreciation of Tuscan Art with a Copious Catalogue Raisonné*. Murray had outdone himself in the production of the two great folio volumes, lavishly embellished with 180 plates and bound in khaki and brown morocco. Of the limited edition of 355 copies, 105 were being sold in the United States by Dutton. The price itself of $100, in that far-off time of the gold standard, was bound to command a certain deference. The two sumptuous volumes constituted the most important publication on art of that season, a fact which the London *Annual Register* would presently record, adding that "the result is a work which surpasses in value for the student and the collector any previous attempts in the same line and in other schools."

It was evident that Berenson had won his stormy conferences with the publisher over the makeup of the volumes. "In all but one or two cases [the] plates are the exact size of the original," ran Cox's appreciative comment, "and in almost every case they are so exact in color and the rendering of touch and method that they are, for purposes of study and pleasure, almost equal to the originals." He added that the "paper and printing are of the handsomest, and the text, considering the amount of it and its difficulties, remarkably correct." The first volume ran to more than three hundred pages of critical text, and the second catalogued and described nearly three thousand drawings. Cox stood amazed at the "prodigious amount of labor" that the work had entailed, the hunt through scattered collections all over Europe, the minute study of each drawing unearthed, and the large number of reproductions of drawings not previously photographed. The mere statistics suggested the magnitude of Berenson's undertaking. Eighty museums and sev-

enty private collections had been canvased all over England and the Continent, and the results were now painstakingly distributed among eighty-six artists and their schools.

Then Berenson had studied all the drawings again, Cox pointed out, "first as a critic, for their own aesthetic value and the light they throw on the aims and qualities of Florentine art; second as a psychologist, for their revelations (more intimate than those of completed work) of temperament and personality; third, in the case of the greater men, as an historian for their record of the origin and evolution of this or that world-renowned masterpiece." Cox declared that since "a half-a-dozen review articles would not suffice for the mere statement of Mr. Berenson's conclusions," he therefore had to content himself with giving a few of Berenson's more impressive feats of attribution, showing the ways in which the study of minor figures reinforced the study of their masters. Especially gratifying was Berenson's acknowledgement that the "sense of quality may be cultivated but cannot be reasoned about— its exercise is a matter of artistic sensitiveness, not of scientific accuracy." Cox concluded that "Berenson is the only connoisseur who has general ideas, and the only critic who has the equipment of an expert," and that when he should "subordinate the connoisseur to the critic . . . and add a little more of the artist in letters he should become a distinct force in criticism." The modest reservation could hardly diminish the effect of the tribute that Cox paid to Berenson's achievement.

A review by Royal Cortissoz, the art critic of the New York *Herald-Tribune,* appeared in the March *Atlantic Monthly* of 1904 while Berenson was still in the United States and added its plaudits to those of the *Nation*. In the course of the review Cortissoz stressed one of the larger implications of the work: "I am grateful for the additions he has made to the tools of art criticism, but I am grateful also for the influence which these volumes must exert in developing artistic taste where it is too often weak," namely, in the ability to perceive the "imaginative fervor" which distinguishes classic Italian painting. It must have pleased Berenson to read that his work far outshone Langton Douglas' new edition of Crowe and Cavalcaselle, which, as Cortissoz put it, redressed the balances against the Morellians "with a little needless temper."

The cordiality of these reviews was matched by the hospitality of the prominent people who deluged the Berensons with invitations. When they went to New York they learned that they were counted among the three visiting "stars of the season," along with the Irish poet William Butler Yeats and the novelist F. Marion Crawford. They were most at home of course in Boston and Cambridge, where memories of their

student days colored every vista. For Mary the past came back with a poignant rush one day as she walked along Berkeley Street near the Cambridge Common. On such a walk nearly twenty years ago she had held in her hand Frank Costelloe's cable sealing their engagement—"Thankfully I take and will hold the infinite gift." With a complacent sigh she mused, "And the poor man couldn't hold it, nor was it such a wonderful gift as he imagined. A tragedy and he is dead and I feel almost as young as I did then and even jollier."

The Berensons went over to Smith College at Northampton, where Senda gave a grand reception for them at which they shared the limelight with the novelist George Washington Cable. A round of dinners and luncheons followed during the next few days, and Bernhard's mother came on from Boston with Abraham to take part in the festivities. While Bernhard held forth on art with fellow guests, Mary dispensed their saving gospel "How to Enjoy Old Masters" to several hundred students and faculty. This division of roles was to be the pattern for all their proselytizing, since Bernhard dreaded the very thought of facing a large audience, whereas Mary thrived on it and relished the applause. She would have equally relished accepting honoraria for the luxuries they might have supplied but forbore when her husband reminded her that they were "after bigger game." By the time they reached Philadelphia, her free lectures were drawing large audiences, on at least one occasion a thousand auditors, many of them men. Like her mother, she was proving herself a magnetic evangelist, though of art rather than of Christianity. She was soon deluged with invitations to lecture before art groups and at universities, and before they left the United States in the middle of the following March she had given nearly twenty lectures on such topics as "The New Art Criticism," "How to Tell a Forgery," "Portraits Old and New," "Art Collections in America and Their Influence on National Taste," and other variations on her husband's gospel of art and culture.

In their first weeks in the Boston area Berenson renewed his Harvard acquaintances. William James received him with great cordiality, as did Barrett Wendell and the Toys. Wendell, alarmed no doubt by James's recent *Varieties of Religious Experience,* privately assured the Berensons that James was "intellectually damned." The aged Grace Norton, who still went her independent way, welcomed Bernhard at her dinner table as one of her own elect. Dinners with William James were the most congenial of all, for intellectual Cambridge seemed to gravitate to his table to enjoy the play of his iconoclastic wit. There too Berenson encountered again Denman Ross, whose collection of Eastern art had

grown impressively since their ecstatic enjoyment of the Oriental paint-
ings at the Museum of Fine Arts ten years ago in the company of
Fenollosa.

Berenson renewed ties also with his otherworldly classmate George
Santayana, now after fifteen years an assistant professor of philosophy
at Harvard. Santayana was bringing to a close his own master work,
the multivolume *Life of Reason,* a wonderfully orchestrated system of
ideal values. The paths of the two friends had diverged too far, how-
ever, for the resumption of their former easy intimacy. About a year
later, when Santayana spent a week at I Tatti, his state of mind struck
Berenson as even more remote than that of the Church-bred Italians of
his acquaintance. Santayana, he remarked to Mary, had "no vague
yearnings, no unclear but ardent aspirations. His universe is ordered, it
admits no room for those dusky corners in which what spiritual life
most of us have is carried on." A call on Professor Norton passed civ-
illy enough, though Berenson afterward raged that the old man with
his obsessive interest in Dante and "culture in general" continued to lay
a paralyzing hand at Harvard on "all efforts toward art itself." It
seemed symptomatic of that paralysis that unlike all the other major
libraries in the vicinity the Harvard library had not yet acquired *The
Drawings of the Florentine Painters.*

The Berensons were frequently in the company of Mrs. Gardner al-
most from the first hour of their arrival in Boston, staying with her for
a time at her country house, Green Hill, in Brookline, visiting the the-
ater to see the dramatization of Owen Wister's *The Virginian,* and at-
tending the symphony concert at which her protégé George Proctor
was the piano soloist. She put off taking them to her Renaissance palace
in the Fenway, as if waiting to set the stage properly for their inspec-
tion, and they perforce deferred to her whim. At Green Hill they found
that she spoke truly when she said she lived an ascetic life in the coun-
try. Mary wrote that the "plain and spare diet and freezing cold"—
there were no fires in the grates—had taken an inch off her waistline.
With advancing age—she was now sixty-four—Mrs. Gardner's unrea-
soning fear of poverty led her to practice curiously petty economies.
The moment the Berensons left their rooms "a servant rushes in not to
turn down the gas, but to turn it *out,* and in the music room, where we
sit, there is only one lamp and little odds and ends of candles which she
lights to see certain things and then puts out instantly." In spite of such
eccentricities Mrs. Gardner exhibited an ageless charm, and there was
something endearing about her imperious ways and her sometimes
amiable foibles, as when she appeared in public with great "jumping
ropes of perfect pearls" coiled about her neck and shoulders and a great

ruby on her breast, for which she had reputedly paid half a million dollars. In an affectionate gesture she allowed Mary to fondle the superb gem.

Once established at the Somerset Hotel in Boston, the Berensons held their own court, where Mrs. Gardner would come almost daily to hear the gossip of the day's adventures in Boston and Cambridge society. Often the Berensons were pressed by dinner companions to say what they really thought of her and her antics, but they loyally refused to humor the scandalmongers. The latest tidbit was that the government was demanding $200,000 in import duties on the ground that her museum was not really a public museum entitled to exemption since entry was by ticket and the museum was open to the public only four days a month. Mrs. Gardner refused to surrender her privacy, and in January 1904 she was obliged to pay the duties. But some of the anecdotes that swirled about Mrs. Gardner were too good to ignore. Clayton Johns, the eminent Boston pianist-composer, told them that when Mrs. Gardner had entertained the Thursday Evening Club in the dead of winter with no fires to warm them, someone said "she had put the last touch to her decorations with a frieze of eminent Bostonians."

The Berensons' "campaign" was now well launched, and the millionaire collectors of Beacon Hill plied them for counsel. Bernhard enjoyed being lionized by people "bearing the names that all proper Bostonians are brought up to adore—Cabot, Coolidge, Kidder, Peabody, Parkman and so on." There were "triple millionaires" like Larz Anderson to visit and nights to be spent with collectors like the wealthy Sir William Van Horne of Montreal, chairman of the board of the Canadian Pacific railways. In his company Berenson met the American painter John La Farge, who had helped decorate Trinity Church in Copley Square with his stained glass windows and frescoes. He found La Farge "a most winning and insinuating old man" with whom it was a pleasure to converse. La Farge, equally impressed, decided to pass Berenson on to his Washington companion Henry Adams, the distinguished historian, whose house in Lafayette Square, long bereft of its mistress, was the most notable haven of culture in the nation's capital. La Farge's letter asked Adams to introduce Berenson into Washington society; aware of Adams' indurated anti-Semitism, he added, with a touch of mischievous irony, "knowing your love for the race."

A less attractive acquaintance was James Loeb, whom they met at Professor Norton's home. A retired member of the international banking firm of Kuhn, Loeb and Company, he had been a brilliant classmate of Berenson's. An accomplished classical scholar, he later founded the Loeb Classical Library. Mary described him in her journal as "a hand-

some, fat, prosperous philistine Jew." Why Professor Norton cultivated him was beyond her "unless it is to get money for Harvard." To her mother she explained that "he is in with all the rich Jews in New York, and as we want to be in with them too, his acquaintance is a good beginning." Loeb counted among his three brothers-in-law members of the prominent Schiff, Seligman, and Warburg families. Though Mary felt apologetic for having to cater to a person like Loeb, the ordeal was necessary, she went on, "for we have an ideal of life that alas requires us to have enough money for ourselves and the people we love, not to have to worry about it. If a few months here can give us that, they are worth it." And a little later she added a moral corollary, "I think we are forming relations here that will be the means of getting good pictures here instead of forgeries and, incidentally, giving us an automobile to explore Italy and perhaps ply between Fernhurst and Grosvenor Road."

While the Berensons spared Mrs. Gardner the clack of her detractors, she did not hesitate to pass on to them the gossip that accompanied their progress. One morsel from the people at the Museum of Fine Arts told that Berenson had helped Henry Higginson, the patron of the Boston Symphony Orchestra, to choose a painting of a "voluptuous nude lady by Bonifazio 'as a memorial' to that sober and righteous citizen, Mr. Francis Hooper. 'That finished Berenson for us as a man of taste,' they said." The fact was that Berenson had thought the painting was to hang in Mr. Higginson's house. More serious was the word which Mrs. Gardner privately conveyed to Mary that one of Mrs. Gardner's friends had heard "vile things" about Bernhard at a fashionable dinner table in London. They said that he had taken advantage of her. "I wrote to him," Mrs. Gardner explained, "that I know Berenson well, that the stories were lies and of no consequence. But to you I want to tell the story, for it may be of great bad consequence to Berenson. . . . Really the story ought to be stopped. You can probably guess who the enemies may be."

Mary rehearsed for Mrs. Gardner the whole sorry campaign against her husband that had accompanied almost every important painting that he had obtained for her, from the Loschi Giorgione to the Dürer. There were the owners and sellers of pictures "whose fictitious attributions he has called in question"; there were collectors like Bode "from whose grasp he has snatched pictures for you"; there were "dealers whose pictures he hasn't sold to you." Then there was the professional jealousy of writers envious "of the success of his new book." Moreover, here in the States Richard Norton had gone everywhere, with flagrant disregard for the truth, charging that Berenson had sold Davis the false

Minghetti Leonardo and had made "lots of money out of the 'deal.' "
"I have, by the way," Mary told Mrs. Gardner, "written to Mr. Davis
[asking him] to contradict *that* in the *Nation.*"

The suggestion that she should make the request of Davis had re-
cently come from Edward Warren, who had been disgusted by Nor-
ton's peddling of the venomous mixtures of truth and falsehood of the
Sandford Strong camp in London. The peripatetic Richard Norton had
recently returned from archaeological studies in Asia, and, Mary be-
lieved, he hoped to be appointed to the Fogg Museum at Harvard and
mistakenly feared the post might go to Berenson. Whatever his real
motive, his appeared to be a settled malignity. Davis willingly com-
plied with Mary's request, and the following letter appeared in the *Na-
tion,* May 17, 1904:

My dear Berenson: Referring to the rumors that you purchased for me the pic-
ture known as 'The Donna Laura Minghetti Leonardo da Vinci' and that you
received a large remuneration for doing so, etc!—I purchased the picture with-
out your knowledge. You had not the slightest connection with the purchase,
and you did not know of it till some weeks thereafter, when I told you. You
may make such use of this letter as you please. Always yours, Theo. M. Davis.
Luxor, Egypt, January 7, 1904.

Mrs. Gardner's regal summons for them to visit her museum came at
last by telephone. On Monday, November 14, 1904, she escorted Bern-
hard and Mary through the carved doorway beneath the coat of arms
blazoned with the legend "C'est Mon Plaisir," and they gazed with
delighted amazement at the "fairyland" sight before them. Beneath the
lofty skylight lay "a huge court carpeted with bright green moss, and
lovely statues hidden in bay-trees and myrtle, and water gurgling from
dolphins' mouths into a marble basin against the wall overgrown with
ferns." The inside was that of a perfect and "enormous Venetian Gothic
palace, with its windows and balconies and stone lions and little marble
reliefs let into the walls." "We were quite overcome," Mary wrote to
her mother, "and she was delighted. . . . At the end she gave me a
Chinese bamboo and chased gold bracelet in memory of the occasion.
The whole thing is a work of *genius.* You can't think how disgusted
people have been since hearing us say so. They long to hear evil of her
and her works. . . . And they ought to pardon her everything for the
beauty of it, and her generousness in making it to leave to Boston."

The first impression had been one of unalloyed delight, and their
beaming hostess gave them the flattering sense that she had done it all
for them. As they strolled from room to room, they were gratified to

see that in spite of some of her recent acquisitions through other ad-
visers the things that Bernhard had bought for her dominated the col-
lection. But then there came a series of shocks. On the wall of a room
where the Fiorenzo *Annunciation* hung they were asked to admire a
Mantegna *Sacra Conversazione,* which she had acquired through Rich-
ard Norton in 1899. When Berenson had first learned of the purchase,
Mrs. Gardner had coyly avoided telling him how she had acquired it.
The painter John Briggs Potter, while on a mission for her in London,
had told the Berensons that it was "the most beautiful picture in the
collection." Berenson's appetite whetted for the masterpiece, he eagerly
scanned it and suddenly grew "quite faint." The picture struck him as a
"palpable forgery, and extremely feeble in the bargain." His condemna-
tion was to prove overhasty, and though he declined to include it in his
list of Mantegna's paintings in 1907, sober second though finally pre-
vailed, and in 1919 he listed it as genuine.

He and Mary continued on their tour unaware that far worse was in
store for them. In the gallery where hung the great Botticelli *Madonna
and Child of the Eucharist,* which Berenson had secured for her, they
were invited to look at a "Botticelli" on the opposite wall, a painting
which had been acquired by Mrs. Gardner in 1900, presumably through
Norton. They were "absolutely petrified with horror and disgust" to
recognize it as a "school picture" influenced by Botticelli, a painting
Berenson had once turned down for her. Unmanned by the sight of the
imposture, Bernhard "nearly fainted away," overcome by the thought
that "the glorious things she has have educated her so little that she can
believe it a Botticelli" and that *"he* would be held responsible."

Taken aback by the sight of his agitation, Mrs. Gardner asked,
"What is it?" He blurted out, "This is a picture I know and refused for
you two and a half years ago." Furious, she countered with the face-
saving remark, "No, it can't be. I've had it for at least five years." The
moment passed and they moved along the corridor, but the incident
"took away a good deal of one's first glow of enthusiasm." Bernhard
was afterward consoled by Mary's reminder that Mrs. Gardner had
been pretty faithful to his standards considering "that every dealer in
the world, professional and amateur, has been after her all these years."
Also to be borne in mind was "her irresponsible wealth, her caprice,
her ignorance." After all, it was "his good luck that she trusted him at
all."

The visit to the palatial museum which Mrs. Gardner had summoned
up as if by royal fiat in the flat wasteland of the Fenway as her monu-
ment to Boston culture seems to have inspired similar immortal long-
ings in Berenson, for on his return to I Tatti the following spring, sur-

rounded by his choice library and his already large collection of photographs and paintings, he began to dream of leaving it all to his beloved Harvard. It was a resolve that would grow with the years and at last be effected a little more than a half century later.

XXX

A New Beginning

CORDIAL as the Boston atmosphere was and enlivened with better talk than he could command in Florence, Berenson soon had to put down the cup of adulation and make plans for further conquests. Early in November he made an exploratory run down to New York to establish a base there, lunching with Theodore Davis on terrapin and woodcock and cementing relations with Henry Cannon in the inner sanctum of the Chase National Bank. Especially important for the success of his mission was the need to establish a regular connection with a prestigious international art dealer. This he effected with Eugene Glaenzer & Company, dealers in "Paintings Ancient and Modern," who had an establishment on Fifth Avenue and their main headquarters in the rue Scribe in Paris. Hitherto Berenson's negotiations with his American clients had been improvised for the most part through Gutekunst of the Colnaghi firm. Glaenzer, flattered by Berenson's overtures, soon invited him to act as an adviser and as earnest of his financial reliability referred him to his Paris bankers.

His entrée to New York secured, Berenson returned to Boston and the proprietary attentions of Mrs. Gardner. Eager to show him and Mary the progress of art in Boston, she took them to see the much-admired series of murals in the public library. They were much impressed by Puvis de Chavannes' allegory of the rise of literature and art, but they kept to themselves their scorn for Sargent's frieze of prophets and his religious symbolism, knowing Mrs. Gardner's great partiality for the artist who had painted her portrait. In her company they hobnobbed with the rollicking Anders Zorn, who had also sought to capture her enigmatic features on canvas in the painting he made of her in Venice in 1894, and with the genial Owen Wister, whose novel *The Virginian* was enjoying a popular success. In an interval of the Beren-

29. Berenson at I Tatti, 1903

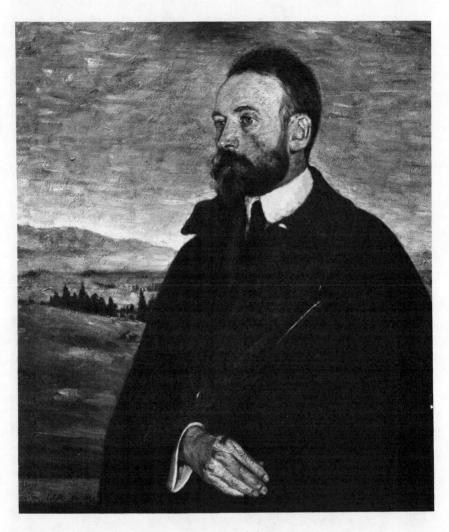

*30. Portrait of Berenson
by William Rothenstein, 1907*

sons' wining and dining in Boston, Mary went out to Wellesley College to give an inspirational lecture to the young women on the early Italian masters.

Having spread their influence far and wide about Boston, the two ardent missionaries departed for New York, where on December 7 they established their headquarters at the luxurious Plaza Hotel. Here "a great pile of invitations and letters" awaited them. One dinner followed another, apparently with no untoward effect upon Bernhard's fickle digestion. A lively night out with Van Horne tired him but did not dampen his revived spirits. Kenyon Cox came to call, and presently he and the editor of the *Nation* returned for a convivial dinner. Norman Hapgood, who was now a prominent dramatic critic, also paid his respects, but the renewed intimacy with Hutchins Hapgood and his wife, Neith, was more heartwarming. Hutchins' recent book *The Autobiography of a Thief* had brought him into prominence as a writer on social problems. In New York as in Boston, Berenson was made to feel a sense of generous appreciation. He was, said Mary, "quite simply given credit for his work and welcomed as 'a man America is proud of, sir.' It is much more agreeable than being suspected of underhanded dealings and charlatanism."

They found themselves again in the midst of friends and promising collectors. John Jay Chapman, back in his Broadway law office from his ill-starred vacation in the Austrian Tyrol, entertained them, and at his home they met a niece of United States Senator William A. Clark, a banker and owner of Western mines who ran his empire from 49 Wall Street. His mansion on Fifth Avenue, reputedly one of the world's greatest private residences, contained a famous art gallery, which was finally to find a home at the Corcoran Museum in Washington. The niece arranged an interview for him with Berenson because, she said, she wanted her uncle to get "good pictures instead of the horrors he is getting." Bernhard and Mary dutifully studied Clark's collection and also the collection of Charles T. Yerkes, the notorious street railway magnate. In both collections Berenson thought he detected examples of Costantini's modern versions of Italian masters. One suspects that on these occasions he discreetly stifled the impulse to disabuse the proud owners, who might become valuable clients. He and Mary had alienated too many already in England and on the Continent with their corrections. Once safely established, he would have ample opportunity to mend and unmend matters. Still another prospect was the head of the Equitable Trust, who had millions and was clearly in need of being weaned away from his preoccupation with French paintings.

The Berensons paused in their New York activities for a day in order

to go up to Albany to "conosh" a dubious Holbein and for Mary to give another one of her lectures to "the very best people in Albany." On their return they were welcomed by Clyde Fitch, whose new play *Her Own Way,* starring Maxine Elliot, had recently opened on Broadway. With him was the fashionable society actress Elsie de Wolfe, popularly known as producer Charles Frohman's "clothes horse" for her elegance on stage. She took an immediate fancy to the distinguished-looking Berenson, whose age comfortably matched her own, and marked him out as a promising candidate for the fashionable levées at the Villa Trianon on the Boulevard St. Jacques in Versailles, where she and Elizabeth Marbury, the veteran New York theatrical agent, entertained Anglo-American society. Berenson squired her to Fitch's new play, and she in her turn took him to a Christmas party at the Long Island home of the "beguiling, unprincipled Tammany politician" Bourke Cockran. It seemed as if all New York's élite wanted to meet them, and the pages of Mary's journal were soon sprinkled with the names of the great and the near-great with whom they lunched or dined.

Berenson decided to look up his erstwhile companion George Rice Carpenter, whom he had not seen since 1894. The reunion did not prosper. Both men were too aware of the distance they had traveled since they worked together on the *Harvard Monthly.* Carpenter was now the distinguished head of the English Department at Columbia University, a literary scholar and biographer, and quite conscious of a lineage that went back to the founding of the Massachusetts Bay Colony. Berenson, rather spoiled by the flattering attention he had been receiving, appears to have forgotten the modesty that it would have been wise for him to observe. As a result, a letter went from his censorious friend to Professor Herrick in Chicago. "I was greatly shocked," he wrote, "to find Berenson green in judgment and sense, in spite of his erudition in Italian art. Realizing that with him one must patronize or be patronized, I took pains to guy him which seemed to produce the desired effect. It's a dreadful thing to grow up in a circle of admiring women. I thought his wife an energetic but horrid woman."

While Berenson was in New York City an opportunity came to use the good offices of Eugene Glaenzer. Kerr-Lawson, who was supporting himself as an art dealer, wrote to Berenson that an El Greco, *Adoration of the Shepherds,* had become available. Glaenzer, apprised of the fact, promptly agreed to buy the painting for $7,500. "You are quite right," he later affirmed, "the Greco boom has come. I started it last year with the Louvre picture and now no self-respecting museum can afford to be without one. . . . The purchase of a Greco by the Boston

museum will help us tremendously as a great rivalry exists between museums." That purchase had already been arranged and gave the Boston museum the honor of being the first American museum to own an El Greco. Soon afterward Glaenzer informed Berenson, "It is my intention to play this rising card for all it is worth. . . . I believe that if I can succeed in getting Mr. Laffan to bring P[ierpont] M[organ] here, he [Mr. L] will ask P.M. to purchase it for the N.Y. Museum." Before the year was out Glaenzer had disposed of the painting to the Metropolitan for $35,000, thanks in large measure to Berenson's praise of its qualities to Frederick Rhinelander, president of the museum's board of trustees. From that sum, besides the cost of the painting, interest, and insurance, $2,000 had to be dispensed to a New York intermediary. There remained $25,000, of which Berenson's share was to be something over $8,000.

Another reassuring development was that feelers were being put out by members of the Metropolitan board of trustees to interest Berenson in forming a connection with the museum. Rutherford Stuyvesant, one of the trustees, invited Bernhard and Mary to his country place, Tranquillity Farm, in the hills of western New Jersey. While there Bernhard startled Mary by asking her whether he should let it be known that he would be willing to become the director of the Metropolitan Museum. Mary, who on her visit to the museum thought it a "vast collection of horrors," declared that taking the post "would be a waste of a man who could think." There was talk, she wrote in strictest confidence to her mother, of Bernhard's being offered the directorship at fifteen thousand a year to succeed General Di Cesnola, who had held the post for twenty-five years and at age seventy-one was nearing retirement. "B.B. is so in the flush of fast-coming impressions," she said, "that he doesn't know what he thinks! It even sounds attractive; but he admits he has no idea what sort of comments he will be making on the proposition a few months hence." Berenson later lunched at the museum with Frederick Rhinelander, who asked his advice about buying paintings and suggested the possibility of his becoming the European buyer for the museum.

Berenson was also looked over by William Laffan, the Irish-born owner and editor of the New York *Sun,* who was another influential member of the board of trustees. Laffan's wife, who was present at the meeting, did not take to Berenson. When some time later Roger Fry was being considered for the post of curator of paintings, Mrs. Laffan told him that Berenson "was the first person of whom she understood what people felt when they talked about the feeling of mistrust inspired by Jews." She inquired of Fry whether Mary Berenson was "a really

original critic." Fry replied, "No; she entered into BB's ideas, sympathized with them and kept him going." Her comment was, "Oh! we women sink very low—to keep Berenson going, what a métier."

There was something exhilarating in the hints of waiting directorships not only in New York but in other parts of the country, but quiet second thoughts counseled against seeking them. Florence might at times seem oppressively provincial, yet it was a gateway to the sophisticated capitals of Europe, where culture had mellowed like old wine. Life at I Tatti on the sun-drenched hillside amidst the olive groves had a seignorial quality that could hardly be duplicated in the clamorous democracy of New York City. As for Mary, the thought of braving the Atlantic every year to visit her family in England could hardly have been inviting. Nevertheless, it was with some regret that Berenson resolved to turn down an offer from the Metropolitan if one should come. The opportunity to do so did not arrive. Di Cesnola died before the end of the following year, but so also did Frederick Rhinelander, who had been Berenson's partisan. Rhinelander's successor as president of the board was the dictatorial J. Pierpont Morgan, and Laffan, who was Morgan's close adviser, became vice-president. Possessed of resources which no rival could match, Morgan, who had become one of the most formidable collectors in the competition for masterpieces, had been early set against Berenson by dealers like Fairfax Murray in London who resented Berenson's intrusion upon their preserves. Moreover, the Berensons had been outspoken in their criticism of Morgan's gullibility in buying forgeries, and one may surmise that gossip of their disapproval reached his ears. Still, whatever might happen in connection with the Metropolitan, Berenson and his wife had reason to feel encouraged by their New York campaign. As Mary told her mother, "With so many fish biting at our hooks, it will be odd if we don't haul some to shore."

THEY were now ready after three months in the East to cast their lines in remoter waters. On New Year's Day they sped westward to Chicago in a private compartment aboard the luxurious Twentieth Century Limited, which raced to its distination nearly a thousand miles distant in less than twenty-four hours. They marveled at the hot and cold water in their quarters, at the private water closet, at the newspaper left at their door, at the barber shop where Bernhard could have his beard trimmed, at the inviting library and observation car. There was even a stenographer to transcribe Mary's lecture notes. They arrived in Chicago in a snowstorm and found a city deep in mourning. All day long funeral cortèges moved along the snowy streets carrying the victims of

the terrible Iroquois Theater fire. Three evenings before, on December 30, a holiday crowd had filled the theater to watch *Mr. Bluebeard,* "the mightiest of Beauty Shows," replete with music and an aerial ballet and starring the "inimitable clown" Eddie Foy. A capsized stagelight had ignited the scenery. By the time the embers were extinguished 602 persons were dead.

The city was just beginning to recover from the shock, and the Berensons found many social functions canceled or suspended. Mrs. Gardner met them at the station. She was there with young Proctor for his solo performances with the Chicago Symphony Orchestra conducted by Theodore Thomas. The following evening the Herricks warmly welcomed them to their home near the University of Chicago for "a jolly informal Sunday supper," where some thirty guests sat about at several little tables. The incivilities of *The Gospel of Freedom* seemed decently buried. The food was "delicious" and the talk "pleasant." The Berensons thought the most interesting person there was the famous social worker, Jane Addams of Hull House. The next evening Mary gave a lecture to a faculty group, preceded by a dinner which the Lovetts gave for them at the Quadrangle Club.

The two weeks they spent in Chicago more than repeated the triumphs of Boston and New York. The cordiality of their hosts acted like a tonic on Berenson. Mary declared she had "never known him so cheerful." He enjoyed "things like a child." Mary's lectures at the Art Institute and at a fashionable club drew packed audiences; men came who were never known "to desert businesses at noon." Bernhard, at his ease in the library of the club, passed the time smoking and talking. Though he did not attend the lecture, he nonetheless received "equal homage."

At a grand dinner given by Mrs. MacVeagh, the wife of the leading wholesale grocer, Bernhard scintillated altogether to Mary's satisfaction. "Quiet little Uncle Bernhard was really so witty and so very, very amusing that I assure you I felt a sort of pang at the thought of confining him to the pokey, dingy society of Settignano. He really has unsuspected social gifts." Mary's dinner companion, Hermann Kohlsaat, a retired publisher and realty magnate, told her that the guests at the table represented $900 million of capital and that one of them, Abraham Lincoln's son, head of the Pullman Company, represented nearly $100 million. Bernhard's companion, a Mrs. Caton, the wife of a prominent lawyer, uttered the mock-complaint that no one would flirt with her in Chicago and that since Chicago was too virtuous for her she was going to Rome. "Oh," said Bernhard, "you're going to settle down in the Grand Hotel and eat your way into society?" "Yep," she shouted,

pleased. "You've just hit it." Mrs. Gardner, jealous of Berenson's attentions to Mrs. Caton, broke in to say that he used to read Theocritus to her under the olive trees in Sicily "in the days before he became a bald-headed pedantic married man." Mrs. Gardner's appearance had been sufficiently spectacular on this occasion to divert attention from her little wrinkled face. On her head she wore "two huge golden roses, and in between them, set on gold wire spikes, were two immense diamonds . . . sparkling and quivering with every movement. . . . Around her neck were rows and rows of huge pearls clasped with diamonds and rubies," and her long white gown was heavily embroidered with gold. On leaving, still nursing her grievance, she told the hostess, "Oh, I'm nothing now, it's all the Berensons." Whereupon Berenson exclaimed, "Oh Mrs. Jack, that's another of your usual whopping lies."

Everywhere the Berensons went in Chicago high society they encountered ostentatious signs of a shirtsleeves aristocracy. John Warnes Gates's vast house on the near South Side was crammed with "modern bronzes of the Via dei Fossi type and lamps worse than Tiffany's," modern paintings, and "Romneys, etc. of mediocre quality." Beginning life as a country hardware merchant, "Plunger" Gates had amassed a fortune, estimated at the time at $40 million, by spectacular coups in railroad and industrial stocks. In private life he was regarded as a lover of the beautiful, and he must have struck his visitors as an educable prospect. The Berensons also dined with J. Ogden Armour, a chief member of the meat-packing aristocracy, whose mansion, like those of his fellows, ornamented Michigan Avenue not far from the Union Stockyards. Armour hoped that Berenson would find a few good Italian pictures for him. At the country home of a timber merchant their hosts showed such charm and cultivation that the Berensons could not think what led their friend G. Lowes Dickinson, after his visit to America, to dismiss such people as "barbarous."

More collections remained to be tactfully scrutinized and more prospective purchasers to be listened to sympathetically before the end of their Chicago visit. Professor Frank Tarbell took them to view the collection of Martin Ryerson, president of the board of trustees of the University of Chicago and a member of the elite "capitalists" of the community. Except for "a few decent things," his collection needed to be weeded of its "forgeries." When Bernhard and Mary viewed the collection of old Cyrus McCormick, president of the International Harvester Company, they concluded that it too was "mostly awful rot." Nor were they much more pleased by the Logan collection, which was mainly "landscapes and cows of the Barbizon School." They conferred

also with Arthur Meeker, said to be the "brains" of the pork-packing industry. At the Union League Club Berenson shared the gospel of art with old William Deering, the retired president of the Deering Harvester Company, and with Daniel H. Burnham, the famous architect and city planner. The dinner party that seemed to hold the most promise for the future took place at the home of Harold Fowler McCormick, the thirty-two-year-old son of Cyrus. After the other dinner guests left, Fowler and his wife, Edith, the daughter of John D. Rockefeller, talked of the collection they would like to make and of their hope of escaping the wiles of ordinary art dealers.

The monumental chateau of Chicago's social leader, the recently widowed Mrs. Potter Palmer, quite failed to impress her guests. Her husband, who had built the famous Palmer House with its lobby inlaid with silver dollars, had amassed a great fortune in real estate speculation, and a good part of it had gone into furnishing the house that commanded Lake Shore Drive at the curve of Lake Michigan. Berenson thought the place looked like "an incredibly extravagant brothel" or "a scene for an orgy." "The whole house had a high wainscoting of brilliant expensive Venetian mosaic, the floors were like those of the New Jerusalem, jasper and chalcedony. Great nude bronzes in flying attitudes were grouped in corners,—Monets by the yard covered the walls." "It was the most revolting spectacle B.B. has seen," said Mary. Here was someone who could indeed use his instruction.

Before their Chicago visit ended, they gathered again with their friends at the University of Chicago. Mary gave a second lecture to the art history class of young Georg Breed Zug, whom they had known in Florence. While at the university, Mary received the compliment of an offer of a "chair" at a salary of $3,000. It was a fitting accolade for her missionary work. When they entrained for Detroit in mid-January they had reason for complacency. Bernhard was "as jolly as a cricket, cracking jokes with everybody," Mary soon wrote, "scarcely feeling nervous and tired at all." The moneyed aristocracy of Chicago had seemed bursting with wealth. More than anywhere else in their travels they had come face to face in Chicago with the stupendous energies of the New World, where wealth and power leaped symbolically from the ground in towering skyscrapers. The future seemed to stir in the American heartland more visibly than anywhere else, and that future promised to breed an insatiable hunger for great art.

Chicago was their farthest penetration into the teeming American hinterland, and they now faced about to head by easy stages toward Philadelphia and Mary's native soil. They stopped first at Detroit to call on Charles L. Freer, who showed them his extraordinary collection of

Whistler paintings, 120 in number. The collection was ultimately to go to the Freer Gallery in Washington. Freer reported to D. W. Tryon, the noted landscape painter, that Berenson "now ranks about first as a critic of Italian art. . . . He spoke in a very kind way about your work," saying that "no one in Europe is accomplishing anything in landscape work as fine as yours." To another correspondent Freer remarked that he liked the Berensons very much and that "Berenson sees very deeply into the finest periods of Chinese and Japanese painting."

From Detroit the Berensons progressed to Cleveland to be feted by Liberty E. Holden, the silver mining baron and publisher of the *Plain Dealer*. Here at his mansion they viewed with pleasure some of the early Italian paintings collected by James Jackson Jarves. Holden had acquired them from Jarves in 1884, they being the major part of the 54 Italian paintings of Jarves's second collection. His first collection of 120 paintings had gone to Yale University in 1867. When the Berensons expressed their admiration for his pictures, Holden "fairly worshiped" them, for he said the Berensons were "the first in many years to say a good word for his possessions." His collection too went to a public museum, that of Cleveland. From Cleveland the Berensons moved on to Buffalo, where they were warmly received by the Glennys, who for several years had had a villa near Florence, where Mrs. Glenny had painted. Mary lectured at the Art Institute, leaving Bernhard to his own devices. Afterward they made the obligatory pilgrimage to Niagara Falls. At smoke-shrouded Pittsburgh they were taken about by Mary's cousins to see the source of the steel sinews with which a new society was being strengthened. Mary declared she had "no stomach for machinery, but, strange to say, B.B. was able, is able, to take all this side of America, the vast industrial expansion, and the iron roads across the continent, the opening of lakes and mines, etc. as a sort of pre-Homeric stage in human history, the time of the founding of races and the conquest of the Forces of Nature."

With their arrival in Philadelphia at the end of January Mary was on home ground, surrounded by squads of relatives eager to entertain them. Here Bernhard met again Mary's celebrated cousin Carey Thomas, president of Bryn Mawr College. In the too cordial atmosphere the incessant lunches and dinners began to pall on him, and the continual inspection of paintings in public and private collections became an increasing strain. He showed signs of being homesick for Europe and the kind of life they led there and vowed that nothing now could induce him to stay in America. There were, however, important contacts still to be made, and one of the most significant was that with John Graves Johnson, a leading Philadelphia lawyer and a sophisticated

judge of art who was forming one of the great American collections. What they saw in his home was a "mixed and crowded" collection but one, they thought, with great possibilities. Berenson conferred with him a few times, and Johnson, who listened attentively to Berenson's appraisal of his pictures, took "a great fancy" to him and in his turn counseled him on his business affairs. As a result of these intimate talks Berenson would become one of his trusted art advisers. Several years afterward he prepared a catalogue of his Italian pictures.

During these last weeks in America Berenson examined two other distinguished collections which were also to figure prominently in his future. One was that of the Baltimore capitalist Henry Walters, which the Berensons went to see on February 8 at the time of the great fire that ravaged the business district. While skyscrapers flared "like giant torches against the sky," the citizens carried on much as usual outside the fire zone, and the Berensons emulated their calmness by proceeding to Walters' home. They gave his collection low marks, seeing "horrors everywhere," but they relented a little upon observing the good things among his objects of Oriental art. Impressed by Berenson's expertise, Walters enlisted him as an adviser and agent in obtaining Italian masterpieces.

The other, and greater, collection was that of old Peter Widener of Philadelphia, whose financial syndicate of street railways and public utilities had made him one of the world's richest men. Mary Berenson thought his paintings "about the rottenest we have yet seen." Agnew, she exclaimed, "has just simply dumped off all his unsaleable rubbish upon this ignorant millionaire." Widener even had a copy of the Chigi Botticelli that had been sold to him as the original, and in a place of honor she recognized a painting that her cook, Carlo, had once taken her to see in the Via St. Spirito, a painting she had refused to buy for 500 lire. "The Agnews got it and prettied it up and sold it as a priceless Filippino." The Berensons evidently were careful not to express their dismay to their host, for a dozen years later Berenson was called on to prepare a lavish catalogue of the paintings of the early Italian and Spanish schools of the Widener Collection. For a time he would also act as Widener's adviser and intermediary in the acquisition of a number of important masterpieces.

The last few days in Philadelphia ended in a flurry of activity. While Bernhard busied himself with Johnson, Mary flourished on the lecture platform. According to the Philadelphia *Press* of February 7, lovers of art thronged the lecture hall of the Pennsylvania Museum for her lecture "The New Art Criticism." Agnes Repplier, the literary essayist, introduced her as " 'Mary Logan,' whose criticisms on art are famous

throughout the world." Three weeks later her final address at the Contemporary Club drew a gratifyingly large audience. Its main lines, she acknowledged, had been sketched out for her by Bernhard. While she delivered their joint gospel, Bernhard lunched with the architect Stanford White and the painter Francis Lathrop and was taken by them to see an example of recent domestic architecture.

The Berensons reached Washington while the capital was still thrilling with satisfaction over President Theodore Roosevelt's success in peacefully "stealing" the Panama Canal Zone from Colombia with the assistance of his Secretary of State, John Hay. There was a special piquancy, therefore, in the Berensons' luncheon on February 14 with Senator Henry Cabot Lodge, one of Roosevelt's closest advisers. In the select company was Philippe Bunau-Varilla, the new envoy from Panama and, as they learned, "the deus ex machina of the whole Panama business." One can imagine the contentment that suffused the gathering and Berenson's patriotic glow at the evidence of America's beneficent expansion.

Their letters of introduction opened the door also to John Hay's imposing residence on Lafayette Square, where they found him relishing still another diplomatic triumph. The Russo-Japanese War had begun only a few days earlier with a crushing Japanese naval attack on Port Arthur. Eager to limit the hostilities, Hay had dispatched a "Circular Letter" to the great powers to respect the neutrality of China, and word had just come that the belligerents had accepted Hay's proposal. Hay knew little of Berenson's attainments and decided to make inquiries. When the Berensons returned on a second visit a few days later, he told them he had been surprised to learn from Fischer, a local art dealer, that Berenson was "the world's greatest authority on Italian art" and that Fischer had actually changed the label on a painting on Berenson's authority.

During their week-long stay in Washington the Berensons met a number of other prominent persons, including Justice Oliver Wendell Holmes, Samuel Ward, and Thomas T. Walsh, "an awful squillionaire" mine owner who lived in a $2 million mansion on Massachusetts Avenue, but no one impressed them so strangely as their host at two "twelve o'clock breakfasts," John Hay's next-door neighbor and confidant, the gregarious recluse Henry Adams. Adams' Richardsonian house looked across the Square at the White House, where two of his testy ancestors had each spent an embattled four years. Long solitary since the suicide of his wife, Adams had turned his back on his career as a distinguished American historian and was at the moment seeing through the press his evocation of the Middle Ages, *Mont-Saint-Michel*

and Chartres. The "stable companion of statesmen," as he regarded himself, he made his home a political and intellectual center of Washington.

Bernhard felt greatly drawn to this highly cerebral fellow-medievalist, whose encyclopedic knowledge and powers of conversation were more than a match for his own. And yet there was a hostile undercurrent in these encounters that Berenson could not help sensing. Though Mary thought that Adams was "pretty rude," she was told that his rudeness could be taken as "a compliment." Adams was repelled at these first meetings by Berenson's advances, and he surrendered to one of his most virulent prejudices. To his favorite "niece" and confidante Elizabeth Cameron he passionately unburdened himself: "At last Berenson and his wife! . . . I *can't* bear it. There is in the Jew deprecation something no weary sinner ought to stand. I rarely murder. . . . Yet I did murder Berenson. I cut his throat first and chopped him into small bits afterwards . . . I tried to do it gently, without apparent temper or violence of manner. Alas! murder will out." From this inauspicious beginning there arose not long afterward between the elderly Boston-born Brahmin and the Italianate adopted Bostonian an enduring friendship which was to link Berenson closely with the fashionable American colony in Paris which circled about Adams, Mrs. Cameron, and Edith Wharton. Though Adams could never quite free himself from his deep-seated anti-Semitism, he came to feel a curious dependence on Berenson. Years later he was to confide to Mrs. Cameron, "I have not an acquaintance now living—unless it is Berenson—who bites hard enough to smart," and to Henry James, "As usual, I got more active information from Berenson than from all the rest." Berenson came to savor Adams' prickly temperament, as he said, "like a fine dry sherry." During the ensuing years the two friends, in their frequent encounters in Paris and in their letters, held inquest upon their world, the elder as a confirmed pessimist, the younger as a life-enhanced optimist. Long afterward, meditating on their friendship, Berenson wrote, "We had much in common but he could not forget that he was an Adams and was always more embarrassed than I was that I happened to be a Jew."

Soon the time came to take leave of their hosts and head back toward New England. Mary dropped Bernhard off at New York and continued to New Haven for a lecture. At New Haven the preceding November she and Bernhard had viewed the array of Italian paintings in the original Jarves collection at Yale and listed fourteen choice ones they wished were at I Tatti, among them paintings by Simone Martini, Sassetta, and Sano di Pietro. Bernhard conferred again in New York with Stuyvesant, called on the beguiling Elsie de Wolfe, and laid plans with

Glaenzer for their collaboration. On his return to Boston, he had a long conclave with Rachel and Senda about plans for education and travel. "Bernhard is awfully generous," Mary reported to her mother. "He gives his family 250 pounds a year, besides their summer holiday, and occasional presents to his mother. He supports Rachel and pays for Bessie's and Senda's summers, and now he is going to practically keep Senda abroad for eighteen months. He has also given Abie 2000 pounds to begin business with. . . . It isn't as if we were rich, either, but this strain keeps him constantly worried and anxious and uncomfortably pinched." It was clear that Bernhard was now so deeply caught up in a coil of responsibilities that there could be no turning back to his old dream of unfettered freedom in the pursuit of Beauty.

The inevitable farewell party with the family was well watered with his mother's tears and blighted for Berenson with the usual painful banalities of parting. Far more agreeable was the reception that Mrs. Gardner gave in the Berensons' honor at Fenway Court, illuminated for the occasion with hundreds of candles. All fashionable Boston seemed in attendance. Proctor played eighteenth-century music on the harpsichord, accompanied by Loeffler on the viola d'amore. Everyone was "in ecstasies."

Overcome by the thought of their leaving her to her lonely state, which she complained was her lot in Boston, Mrs. Gardner proposed joining the Berensons in New York during their final days in the country. Her decision had an unexpectedly fortunate consequence for all of them. When she arrived, she took the Berensons to Glaenzer's gallery to see Degas' striking portrait of Madame Gaujelin, of which she had heard. The canvas showed a woman seated in a black gown, her hands clasped in her lap and an expression of resignation on her face. Perhaps Mrs. Gardner felt a kinship with the pensive sitter. In any event she was determined to have the painting, for which Glaenzer was asking $30,000. When she left for Boston, she jokingly declared to Mary, "If I don't get that Degas, I'll never write to you again." She did get it, and Glaenzer, pleased at this auspicious beginning of his connection with Berenson, sent him a commission of $3,000 even before the negotiation was completed.

In New York the wheel turned ever more rapidly. Bernhard and Mary attended a performance of *The Other Girl,* starring Elsie de Wolfe. "She is not much of an actress," Mary allowed, "but she dances well and looks ladylike." Bernhard again sought her out for lunch. They now met the forcefully masculine Elizabeth Marbury, the actress's inveterate companion. It was she who, Henry Adams used to say, was the only nephew among his many honorary nieces. One last

important collection which had to be viewed was that of Henry O. Havemeyer, the multimillionaire sugar refiner. The masterpieces in his library were already the envy of less fortunate collectors. Berenson again conferred with the men of the Metropolitan, President Rhinelander and the gray eminence of the museum, William M. Laffan. Their consultations, not yet shadowed by the disapproval of J. Pierpont Morgan, ended on a friendly note.

The raging snowstorm that ushered in the Berensons' last day in New York could not chill the warm glow of contentment at the success of their mission. It had been, Mary said, "a real lark from beginning to end." Their stateroom was cheery with the flowers, fruits, and books which friends had sent. In the predawn darkness of March 15, 1904, the *Kaiser Wilhelm* headed down the bay into the still wintry Atlantic with the two adventurers who had found the "bigger game" for which they had come. Gutekunst's advice to strike for the New World had proved sound and Mary's urgings had been vindicated. As a proselytizing team, Bernhard and Mary had in fact launched a new trend among collectors and a new interest among gallery-goers in Italian Renaissance paintings, bringing to a kind of focus the scattered enthusiasms in the field. And Berenson's authority as evidenced in the *The Florentine Drawings* was now seen to be based on the most discerning scholarship. In retrospect, the first impetus to the succeeding boom in Italian art can be traced to Berenson's negotiation for the purchase of Titian's *Europa* for Mrs. Gardner ten years earlier. The American tour made him the most widely known expert in Italian Renaissance art that the world had seen. That reputation would inevitably bring to his door the greatest and most daring of all art dealers, Joseph Duveen, and lead to an uneasy collaboration that would endure for thirty years.

On the occasion of the fiftieth anniversary of his Harvard class Berenson could report that most of the Italian paintings which had come to the United States had "my visa on their passport." That was indeed an astonishing achievement, and in the course of it he had achieved affluence, but when in his quiet hours he reflected on the high-minded aspirations of his youth, he felt he had somehow taken a wrong turning, and using a husband's prerogative, he tended to put the blame on his ambitious wife. Perhaps there had been chances to abandon the alluring path of the art expert, but they had successively eluded him as the price of exquisite living escalated. It was obvious at the conclusion of his American tour that there could be no turning back to a simpler existence and that all later regrets would be vain.

Hence the middle period of life that now lay before him with all the interests and pleasures that the Belle Epoque would offer him would be

a life very much in and of the Great World. It would be only after the terrifying and strange vicissitudes of two world wars that the philosophic idealist of his far-off youth would become at last the legendary sage of I Tatti, the confidant of protégés and princes, and the serene diarist of a world transformed.

SELECTED BIBLIOGRAPHY

NOTES

INDEX

Selected Bibliography

Manuscript Collections and Archives

Berenson Archive, Harvard Center for Italian
 Renaissance Studies, Villa I Tatti, Florence
Boston University Archives
 Irving Fox Papers
 1887 class records
 Walt Whitman Collection
The British Library
 Michael Field Papers
Colby College Library
 Vernon Lee Papers
 Thomas Sergeant Perry Papers
Prof. Michael Fixler, Tufts University
 Berenson letters to Mally Dienemann
Freer Gallery
Fogg Museum Archives
Isabella Stewart Gardner Museum Archives
Barbara Halpern, Oxford, England
 Robert and Hannah Smith family papers
Harvard Archives
Horne Museum Archives, Florence
Library of Congress
 Logan Pearsall Smith Papers
Massachusetts Historical Society
 Henry Adams Papers
Yale University, Beinecke Library
 John La Farge Papers
University of Chicago
 Robert Herrick Papers

The Writings of Bernard Berenson, 1886–1903

BOOKS

The Venetian Painters of the Renaissance. New York: G. P. Putnam's Sons, 1894.

Lorenzo Lotto: An Essay in Constructive Art Criticism. New York: G. P. Putnam's Sons, 1895.

Venetian Painting, Chiefly before Titian, at the Exhibition of Venetian Art, the New Gallery (1895). Preface by H. F. Cook. Privately printed, 1895.

The Florentine Painters of the Renaissance. New York: G. P. Putnam's Sons, 1896.

The Central Italian Painters of the Renaissance. New York: G. P. Putnam's Sons, 1897.

The Study and Criticism of Italian Art. London: George Bell & Sons, 1901.

The Study and Criticism of Italian Art. Second Series. London: George Bell & Sons, 1902.

The Drawings of the Florentine Painters. 2 vols. London: J. Murray, 1903.

CONTRIBUTIONS TO THE *HARVARD MONTHLY*

"Gogol's Revisor," 2 (1886), 26–30.

"The Story of Heinrich Jung-Stilling's Childhood, Boyhood, and Wanderings," 2 (1886), 116–124.

"*Baldwin: Being Dialogues on Views and Aspirations,* by Vernon Lee" (review article), 2 (1886), 207–209.

"The Mood of an Autumn Day" (poem), 3 (1886–1887), 14.

"*St. John's Eve and Other Stories,* Translated from the Russian of Gogol by Isabel F. Hapgood" (review article), 3 (1886–1887), 41.

"Between Autumn and Winter" (poem), 3 (1886–1887), 53.

"The Third Category" (story), 3 (1886–1887), 66–83.

"*Rambell's Remains:* Barrett Wendell" (review article), 3 (1886–1887), 124–125.

"The Writings of Count Leo Tolstoi," 3 (1886–1887), 138–149.

"Lotze's *Outlines of Aesthetics,* Translated by Mr. G. T. Ladd" (review article), 3 (1886–1887), 165–166.

"Ghazel: Thought and Temperament" (sonnet), 4 (1887), 33.

"*With Reed and Lyre,* by Clinton Scollard" (review article), 4 (1887), 42.

"Was Mohammed at All an Imposter?" 4 (1887), 48–63.

"*The Feud of Oakfield Creek,* by Josiah Royce" (review article), 4 (1887), 78–79.

"The Heart of the Weed" (review article), 4 (1887), 81–82.

"Scartazzini's *Dante Handbook,* Translated and Annotated by Thomas Davidson" (review article), 4 (1887), 123.

"*Spanish Idioms,* Collected by S. C. Becker and F. Mora" (review article), 4 (1887), 168.

"How Matthew Arnold Impressed Me," 5, no. 2 (Nov. 1887).

"The Death and Burial of Israel Koppel" (story), 6, no. 5 (July 1888).

ARTICLES

"Contemporary Jewish Fiction." *The Andover Review*, 10 (1888), 587–602.

"Marcozzi's Photograph." *The Nation*, 50 (Feb. 13, 1890), 130.

"Tintoretto's St. Mark." *The Nation*, 55 (Oct. 20, 1892), 301.

"Tintoretto's St. Mark." *The Nation*, 56 (Feb. 9, 1893), 103.

"Vasari in the Light of Recent Publications." *The Nation*, 56 (April 13, 1893), 271–273.

"A Word for Renaissance Churches." *The Free Review*, no. 2 (Nov. 1893), 178–189.

"Isochromatic Photography and Venetian Pictures." *The Nation*, 57 (Nov. 9, 1893), 346–347.

"Dante's Visual Images, and His Early Illustrators." *The Nation*, 58 (Feb. 1, 1894), 82–83.

"The Fourth Centenary of Correggio." *The Nation*, 59 (Aug. 30, 1894), 156–157.

"Les 'Gérard David' du Louvre." *La Chronique des Arts et de la Curiosité*, Dec. 29, 1894, 329–330.

"The Early Works of Raphael, by Julia Cartwright" (review article). *La Chronique des Arts et de la Curiosité*, Jan. 26, 1895, 35–36.

"Ulman's Botticelli" (review article). *Revue Critique d'Histoire et de Littérature*, Feb. 4, 1895, 88–95.

"Burlington Fine Arts Club, Exhibition of Pictures, Drawings and Photographs of Work of the School of Ferrara-Bologna, 1440–1540; also of Medals of Members of the Houses of Este and Bentivoglio." *Revue Critique d'Histoire et de Littérature*, 29, no. 18 (May 6, 1895), 348–352.

"La Pallas de Sandro Botticelli." *Gazette des Beaux-Arts*, 37 (June 1895), 469–475.

"Traduttore, traditore." *The Nation*, 61 (Dec. 19, 1895), 447.

"Le Gallerie Nazionali Italiane. Notizie e documenti, I. Per cura del Ministero della Pubblica Istruzione" (review article). *Revue Internationale des Archives des Bibliothèques et des Musées*, 1, no. 1 (1895), 56–57.

"La Peinture en Europe: Florence, par Georges Lafenestre et Eugène Richten-berger" (review article). *Revue Internationale des Archives des Bibliothèques et des Musées*, 1, no. 1 (1895).

"Les Peintures italiennes de New York et de Boston." *Gazette des Beaux-Arts*, 38 (March 1896), 195–214.

"Le 'Sposalizio' du Musée de Caen." *Gazette des Beaux-Arts*, 38 (April 1896), 273–290.

"Botticelli's Illustrations to the *Divina Commedia.*" *The Nation*, 63 (Nov. 12, 1896), 363–364.

"La Peinture au Château de Chantilly: écoles étrangères, par F. A. Gruyer" (review article). *Revue Internationale des Archives des Bibliothèques et des Musées*, 1, nos. 6–7 (1896), 134–138.

"Le Carton attribué à Raphael du British Museum." *Gazette des Beaux-Arts*, 39 (Jan. 1897), 59–66.

"Walks in Florence and Its Environs, by Susan and Joanna Horner" (review article). *The Nation,* 64 (Feb. 4, 1897), 94–95.

"The New Vasari" (review article). *The Nation,* 64 (March 25, 1897), 227–228.

"F. S. Robinson's *The Connoisseur"* (review article). *The Nation,* 64 (June 24, 1897), 472–473.

"De quelques copies d'après des originaux perdus de Giorgione." *Gazette des Beaux-Arts,* 39 (Oct. 1897), 265–282.

"Alessio Baldovinetti et la nouvelle madone du Louvre." *Gazette des Beaux-Arts,* 40 (July 1898), 39–54.

"Un Tableau de Jacopo de'Barbari au Musée de Vienne." *Gazette des Beaux-Arts,* 41 (March 1899), 237–238.

"Amico di Sandro." *Gazette des Beaux-Arts:* part I, 41 (June 1899), 459–471; part II, 41 (July 1899), 21–36.

"A Milanese Art Foundation." *The Nation,* 69 (July 20, 1899), 49–50.

"An Altarpiece by Girolamo da Cremona." *American Journal of Archaeology,* 2nd ser., 3, nos. 2–3 (1899), 161–176.

"A Florentine Picture Chronicle, Being a Series of Ninety-Nine Drawings Representing Scenes and Personages of Ancient History Sacred and Profane by Maso Finiguerra Reproduced from the Originals in the British Museum, critical and descriptive text by Sidney Colvin" (review article). *Gazette des Beaux-Arts,* 42 (Feb. 1900), 170.

"Correspondance d'Italie: une exposition de maîtres anciens à Florence." *Gazette des Beaux-Arts,* 42 (July 1900), 79–83.

"E. G. Gardner's *The Story of Florence"* (review article). *The Nation,* 71 (Nov. 22, 1900), 404.

"Un Chef-d'oeuvre inédit de Filippino Lippi." *Revue Archéologique,* 2 (1900), 238–243.

"The Drawings of Andrea Mantegna." *Monatsberichte für Kunstwissenschaft und Kunsthandel,* 1, no. 6 (1901), 253–265.

"Quelques peintures méconnues de Masolino da Panicale." *Gazette des Beaux-Arts,* 44 (Feb. 1902), 89–99.

"The Morelli Collection at Bergamo." *The Connoisseur,* 4 (Nov. 1902), 145–152.

"A Miniature Altarpiece by Pesellino at Empoli." *Revue Archéologique,* 1 (1902), 191–195.

"The Morelli Collection at Bergamo, II." *The Connoisseur,* 5 (Jan. 1903), 3–9.

"Alunno di Domenico." *The Burlington Magazine,* 1, no. 1 (March 1903), 6–20.

"The History of Siena, by Langton Douglas; *The Story of Siena and San Gimignano,* by Edmund G. Gardner" (review article). *The Nation,* 76 (March 19, 1903), 233–234.

"Art Forgeries" (open letter). *The Times* (London), April 4, 1903.

"The Authorship of a Madonna by Solario" (open letter). *The Burlington Magazine,* 2, no. 4 (June 1903), 114.

"Director Ricci." *The Nation,* 77 (Oct. 15, 1903), 301.

"A Sienese Painter of the Franciscan Legend." *The Burlington Magazine:* part I, 3, no. 7 (Sept.–Oct. 1903), 3–35; part II, 3, no. 8 (Nov. 1903), 171–184.

Other Works Consulted

Adams, Henry. *The Letters of Henry Adams.* Ed. Worthington C. Ford. 2 vols. Boston: Houghton Mifflin, 1930–1938.

Allen, Gay Wilson. *William James.* New York: Viking Press, 1967.

Antin, Mary. *The Promised Land.* Boston: Houghton Mifflin Company, 1912.

Baron, Salo W. *The Russian Jew under Tsars and Soviets.* New York: Macmillan, 1964.

Behrman, S. N. *Duveen.* New York: Random House, 1952.

—— *People in a Diary.* Boston: Little, Brown, 1972.

Birmingham, Stephen. *"Our Crowd": The Great Jewish Families of New York.* New York: Harper & Row, 1967.

Burckhardt, Jakob. *The Cicerone.* Trans. Mrs. A. H. Clough. Ed. J. A. Crowe. London: J. Murray, 1879.

Burdett, Osbert, and E. H. Goddard. *Edward Perry Warren.* London: Christophers, 1941.

Busbee, Frederick A. *Ethnic Factors in the Population of Boston.* Publications of the American Economics Association, 3rd ser., 4, no. 2 (May 1903).

Caro, Joseph. *The Kosher Code of the Orthodox Jew: "Shulhan 'Aruk."* Trans. S. I. Levin and Edward A. Boyden. Minneapolis: University of Minnesota Press, 1940.

Clark. Ronald W. *The Life of Bertrand Russell.* London: J. Cape, 1975.

Cohen, Israel. *Vilna.* Philadelphia: The Jewish Publication Society of America, 1943.

Coletti, Luigi. *All the Paintings of Giorgione.* New York: Hawthorn Books, 1961.

Crowe, J. A., and G. B. Cavalcaselle. *A History of Painting in Italy from the Second to the Fourteenth Century.* London: J. Murray, 1864–1866.

—— *A History of Painting in Italy, Umbria, Florence, and Siena, from the Second to the Sixteenth Century.* 2nd ed. Ed. Langton Douglas assisted by S. Arthur Strong. London: J. Murray, 1903–1914.

—— *A History of Painting in North Italy.* London: J. Murray, 1871.

—— *Titian: His Life and Times.* London: J. Murray, 1877.

Delamar, Alice. "Some Little Known Facts about Bernard Berenson and the Art World." *Forum,* 12, no. 3 (1975), 23.

Douglas, Robert Langton. *A History of Siena.* London: J. Murray, 1902.

Edel, Leon. *Henry James: The Conquest of London.* Philadelphia: J. B. Lippincott, 1962.

Ehrenfried, Albert. *A Chronicle of Boston Jewry, from the Colonial Settlement to 1900.* Boston: privately printed, 1963.

Field, Michael [pseud.]. *Works and Days.* Ed. T. and D. C. Sturge Moore. London: J. Murray, 1933.

Fitch, Clyde. *Clyde Fitch and His Letters.* Ed. Montrose J. Moses and Virginia Gerson. Boston: Little, Brown, 1924.

Fixler, Michael. "Bernard Berenson of Butremanz," *Commentary,* Aug. 1963, 135–143.

Fowles, Edward. *Memories of Duveen Brothers.* London: Times Books, 1976.

Fry, Roger. *Letters of Roger Fry.* Ed. with intro. by Denys Sutton. 2 vols. London: Chatto & Windus, 1972.

Gallup, Donald C., ed. *The Flowers of Friendship: Letters Written to Gertrude Stein.* New York: Alfred A. Knopf, 1953.

Ganzfried, Solomon. *Code of Jewish Law (Kitzur Shulchan Aruch).* Trans. Hyman E. Goldin. New York: The Star Hebrew Book Co., 1928.

Gilmore, Myron P. "The Berensons and Villa I Tatti." *Proceedings of the American Philosophical Society,* 120, no. 1 (Jan. 1976), 7–12.

Gombrich, E. H. *Aby Warburg.* London: The Warburg Institute, 1970.

Gropallo, Laura. "Bernhard Berenson." *Nuova antologia,* Oct. 16, 1904, 5–33.

Gunn, Peter. *Vernon Lee: Violet Paget.* London: Oxford University Press, 1964.

Handlin, Oscar. *Adventure in Freedom.* New York: McGraw-Hill, 1954.

Hapgood, Hutchins. *A Victorian in the Modern World.* New York: Harcourt, Brace, 1939.

Hapgood, Norman. *The Changing Years: Reminiscences of Norman Hapgood.* New York: Farrar & Rinehart, 1930.

Harlow, Virginia. *Thomas Sergeant Perry.* Durham, N.C.: Duke University Press, 1950.

Hendy, Philip. *Catalog of the Exhibited Paintings and Drawings of the Isabella Stewart Gardner Museum.* Boston: Gardner Museum, 1931.

―――― *European and American Paintings in the Isabella Stewart Gardner Museum.* Boston: Gardner Museum, 1974.

Herrick, Robert. *The Gospel of Freedom.* New York: Macmillan, 1898.

Hildebrand, Adolf. *Das Problem der Form in der Bildenden Kunst.* Strasbourg: J. H. E. Heitz, 1893.

Howe, Helen Huntington. *The Gentle Americans.* New York: Harper & Row, 1965.

Hyde, H. Montgomery. *Oscar Wilde.* New York: Farrar, Straus, and Giroux, 1975.

Johnson, Lionel Pigot. *Some Winchester Letters of Lionel Johnson.* London: G. Allen & Unwin, 1919.

Joni, Icilio Federico. *Affairs of a Painter.* London: Faber and Faber, 1936.

Jullian, Philippe. *Prince of Aesthetes: Count Robert de Montesquiou.* Trans. John Haylock and Francis King. New York: Viking Press, 1968.

Kiel, Hanna, ed. *The Bernard Berenson Treasury.* New York: Simon and Schuster, 1962.

Klein, Viola. *The Feminine Character.* London: K. Paul, Trench, Trubner, 1946.

Kviklys, Bronius. *Mūsū Lietuva.* 4 vols. Boston: Lietuvių Enciklopedijos Leidykla, 1964.

Lensi, Alfredo. *La donazione Loeser in Palazzo Vecchio.* Florence: Commune di Firenze, 1934.

Levin, Shmarya. *Childhood in Exile.* Trans. Maurice Samuel. New York: Harcourt, Brace, 1929.

Levin, S. I. and Edward A. Boyden. *The Kosher Code of the Orthodox Jew.* Minneapolis: University of Minnesota Press, 1940.

Lewis, R. W. B. *Edith Wharton.* New York: Harper & Row, 1975.

McComb, A. K., ed. *The Selected Letters of Bernard Berenson.* Boston: Houghton Mifflin, 1964.

Manning, Elfrida, and J. Byam Shaw. *Colnaghi's, 1760–1960.* London, 1960.

Mapu, Abraham. *Ahavat Ziyyon* [The Love of Zion]. Vilna, 1853.

Mariano, Nicky. *The Berenson Archive: An Inventory of Correspondence.* Florence, 1965.

———— *Forty Years with Berenson.* London: H. Hamilton, 1966.

Marle, Raimond van. *The Development of the Italian Schools of Painting.* The Hague: M. Nijhoff, 1923–1938.

Morelli, Giovanni. *Italian Masters in German Galleries.* Trans. Mrs. Louise M. Richter. London: G. Bell and Sons, 1883.

———— *Italian Painters: Borghese and Doria Pamfili Galleries in Rome.* London, 1892.

———— *Kunstkritische Studien über italienische Malerie.* 3 vols. Leipzig: F. A. Brockhaus, 1890–1893.

———— *Die Werke italienischer Meister in den Galerien von München, Dresden und Berlin.* Leipzig: Seemann, 1880.

———— and Jean Paul Richter. *Italienische Malerei der Renaissance im Briefwechsel.* Baden-Baden: Grimm, 1960.

Morra, Umberto. *Conversations with Berenson.* Boston: Houghton Mifflin, 1965.

Mostyn-Owen, William. *Bibliografia di Bernard Berenson.* Milan: Electa Editrice, 1955.

Mount, Charles M. *John Singer Sargent.* New York: W. W. Norton, 1955.

Nevius, Blake. *Robert Herrick.* Berkeley: University of California Press, 1962.

Norton, C. E., ed. *The Correspondence of Thomas Carlyle and Ralph Waldo Emerson.* Boston: Houghton Mifflin, 1884.

Paget, Violet [pseud. Vernon Lee]. *Vernon Lee's Letters.* Ed. Irene Cooper Willis. London, privately printed, 1937.

Paine, Albert Bigelow. *Mark Twain.* 3 vols. New York: Harper & Brothers, 1912.

Parker, Robert Allerton. *The Transatlantic Smiths.* New York: Random House, 1959.

Raisin, Jacob S. *The Haskalah Movement in Russia.* Philadelphia: The Jewish Publication Society of America, 1913.

Raisin, Max. *A History of the Jews in Modern Times.* New York: Hebrew Publishing Co., 1949.

Reitlinger, Gerald. *Economics of Taste.* 3 vols. London: Barrie & Rockliff, 1961–1970.

Ross, Janet. *The Fourth Generation.* London: Constable, 1912.

Ross, Margery. *Robert Ross: Friend of Friends.* London: Jonathan Cape, 1952.

Russell, Bertrand. *The Autobiography of Bertrand Russell.* Vol. I. Boston: Little, Brown, 1967.

Salvemini, Gaetano. *Carteggi.* Milan: Feltrinelli, 1968.

Samuels, Ernest. *Henry Adams: The Major Phase.* Cambridge, Mass.: The Belknap Press of Harvard University Press, 1964.

Santayana, George. *The Middle Span*. New York: Charles Scribner's Sons, 1945.

Sienkiewicz, Henryk. *The Fate of a Soldier* [Bartok]. Trans. J. Christian Bay. New York: J. S. Ogilvie Publishing Co., 1898.

Silver, Rollo G. "For the Bright Particular Star." *The Colophon*, n.s., 2, no. 2 (Winter 1937), 197–216.

Smith, Logan Pearsall. *Unforgotten Years*. Boston: Little, Brown, 1938.

Smyth, Dame Ethel Mary. *As Time Went On*. London: Longmans, Green, 1936.

Sprigge, Sylvia. *Berenson: A Biography*. Boston: Houghton Mifflin, 1960.

Steegmuller, Francis. *The Two Lives of James Jackson Jarves*. New Haven: Yale University Press, 1951.

Stein, Leo. *Journey into the Self*. Ed. Edmund Fuller. New York: Crown Publishers, 1950.

Taylor, Francis Henry. "The Summons of Art." *Atlantic Monthly*, Nov. 1957, 121–128.

Tharaud, Jérome and Jean. *L'Ombre de la croix*. Paris: Pion-Nourrit, 1920.

——— *The Shadow of the Cross*. Trans. Frances Delanoy Little. New York: Alfred A. Knopf, 1924.

Tharp, Louise. *Mrs. Jack*. Boston: Little, Brown, 1965.

Tompkins, Calvin. *Merchants and Masterpieces: The Story of the Metropolitan Museum of Art*. New York: E. P. Dutton, 1973.

Traubel, Horace. *With Walt Whitman in Camden*. Vol. III. New York: Kennerley, 1914.

Tutta la pittura del Perugino. Milan: Biblioteca d'arte Rizzoli, 1959.

Waldstein [Walston], Charles. *Essays on the Art of Pheidias*. Cambridge: At the University Press, 1885.

Weizmann, Chaim. *Trial and Error: The Autobiography of Chaim Weizmann*. New York: Harper, 1949.

Wendell, Barrett. *Barrett Wendell and His Letters*. Ed. Mark A. De Wolfe Howe. Boston: Atlantic Monthly Press, 1924.

Wengeroff, Pauline. *Memoiren einer Judischer Grossmutter*. Berlin: M. Poppelauer, 1908.

Whitehill, Walter Muir. *Museum of Fine Arts, Boston*. 2 vols. Cambridge, Mass.: The Belknap Press of Harvard University Press, 1970.

Whiting, Lilian. *Boston Days*. Boston: Little, Brown, 1902.

Whitman, Walt. *The Correspondence*. Ed. E. H. Miller. New York: New York University Press, 1977.

Wieder, Arnold A. *The Early Jewish Community of Boston's North End*. Waltham, Mass.: Brandeis University, 1962.

Woermann, Karl. *Katalog der Königlichene Gemäldegalerie zu Dresden*. 1887.

Bibliographical information for reviews of Berenson's writings is given in the Notes.

Notes

Notes are keyed by page and line number. The Selected Bibliography gives full citations for works cited in abbreviated form in the notes. The source of a quotation is indicated at its beginning, and in the case of an interrupted quotation the context will ordinarily show its extent.

Since the main source of unpublished letters and manuscripts is the Berenson Archive at the Harvard Center for Italian Renaissance Studies, the Villa I Tatti, Florence, Italy, reference to that repository is intended whenever no other location is given. All originals of the Berensons' letters to Mrs. Gardner are at the Gardner Museum. The "miscellaneous papers" (cited as misc. papers) at the Villa I Tatti include various groups of uncatalogued and unsorted papers, fragmentary early journals and diaries, early notebooks, unpublished essays and essay fragments, and biographical memorabilia. The letters exchanged among the following members of the Smith family—Hannah, Robert, Logan, Alys, Mary, and Mary's children—are part of the Smith family papers, the originals of which are owned by Barbara Halpern, Mary's granddaughter. Those items only in her collection are noted as Smith papers, Oxford.

The following abbreviations are used:

BB	Bernard Berenson
HS	Hannah Whitall Smith (Mrs. Robert)
Life of BB	Unpublished fragment at the Villa I Tatti
M	Mary (Smith, Costelloe) Berenson
Mrs. G	Isabella Stewart Gardner ("Mrs. Jack")
Rumor	BB, *Rumor and Reflection* (London: Constable, 1952)
SB	Senda Berenson
Sketch	BB, *Sketch for a Self-Portrait* (London: Constable, 1949)
Sunset	BB, *Sunset and Twilight* (New York: Harcourt, Brace and World, 1963)

I. A Lithuanian Childhood

1:28 Kviklys, *Mūsų Lietuva*, I, 396–397.

2:15 BB to SB, Nov. 4, 1887.

18 BB to Mrs. G, May 23, 1888.

19 BB to SB, Aug. 22, 1887.

24 BB, "How Matthew Arnold Impressed Me," *Harvard Monthly*, 5, no. 2 (Nov. 1887).

36 BB, *Rumor*, 194.

3:5 Louis Freedman, *Genealogy of Abravanel-Mickleshanski Family* (1903).

22 BB's passports, misc. papers.

4:28 BB, "Contemporary Jewish Fiction," *Andover Review*, 10 (1888), 587–602.

32 BB to Mally Dienemann, Sept. 6, 1950, Fixler collection.

42 Wengeroff, *Memoiren*, passim.

5:42 Kviklys, *Mūsų Lietuva*, I, 396.

6:2 BB to Dienemann, March 1, 1953, Fixler collection.

12 Mariano, *Forty Years*, 73.

20 BB, *Sketch*, 50.

6:32 Mariano, *Forty Years*, 102.

6:34 BB, *Sketch*, 130–131.

42 Ibid., 162.

7:14 Ibid., 56.

27 Ibid., 57.

38 BB to Dienemann, Sept. 6, 1950.

8:6 BB, *Sunset*, 302.

32 Sprigge, *Berenson*, 18.

9:26 *Harvard Monthly*, 6, no. 5 (July 1888).

10:6 M, Life of BB, X, 7.

10 BB, early journal, 21, misc. papers.

27 BB, *Rumor*, 414; Notebook, Jan. 11, 1886.

37 Ibid.

11:11 BB to Mrs. G, Aug. 24, 1887.

16 BB to Mrs. G, May 23, 1888.

22 BB, *Sunset*, 315.

27 BB, *Rumor*, 162; Mariano, *Forty Years*, 65.

38 BB, *Rumor*, 200.

13:8 Sprigge, *Berenson*, 29.

II. Dreamer in Minot Street

16:8 Morse Goldman to BB, Aug. 11, 1952.

19 BB to Albert Berenson, July 19, 1922.

27 BB, Diary, Dec. 2, 1945.

42 In BB, "Contemporary Jewish Fiction," *Andover Review*, 10 (1888), 587–602.

17:24 Sprigge, *Berenson*, 29.

38 Ibid.

18:25 BB, *Sunset*, 382.

31 Behrman, *People in a Diary*, 267.

19:6 BB, *Rumor*, 356.

32 BB, *Sketch*, 144.

35 BB to Irving P. Fox, Dec. 24, 1883, Boston University Archives.

20:2 BB, *Rumor*, 337.

6 BB, Diary, Jan. 17, 1944; *Sunset*, 425, 426.

16 BB to SB, June 22, 1887.

20:19 BB, early journal notebook, misc. papers.

21:17 BB, *Sketch*, 144.

21 *Sunset*, 408.

38 BB, among misc. papers.

22:2 *Boston University College of Liberal Arts Class of 1887, 1887–1937*, Boston University.

6 Minutes of the Class of 1887, Boston University Archives.

26 BB, early journal notebook, misc. papers.

34 BB to Fox, 1884, Boston University Archives.

23:8 Marginalia in Arnold's *Culture and Anarchy*, inscribed Bernhard Berenson Dec. 1883 and subsequently Feb. March 1945.

31 BB, Diary, March 20, 1945.

34 BB, "How Matthew Arnold Im-

Notes

Notes are keyed by page and line number. The Selected Bibliography gives full citations for works cited in abbreviated form in the notes. The source of a quotation is indicated at its beginning, and in the case of an interrupted quotation the context will ordinarily show its extent.

Since the main source of unpublished letters and manuscripts is the Berenson Archive at the Harvard Center for Italian Renaissance Studies, the Villa I Tatti, Florence, Italy, reference to that repository is intended whenever no other location is given. All originals of the Berensons' letters to Mrs. Gardner are at the Gardner Museum. The "miscellaneous papers" (cited as misc. papers) at the Villa I Tatti include various groups of uncatalogued and unsorted papers, fragmentary early journals and diaries, early notebooks, unpublished essays and essay fragments, and biographical memorabilia. The letters exchanged among the following members of the Smith family—Hannah, Robert, Logan, Alys, Mary, and Mary's children—are part of the Smith family papers, the originals of which are owned by Barbara Halpern, Mary's granddaughter. Those items only in her collection are noted as Smith papers, Oxford.

The following abbreviations are used:

BB	Bernard Berenson
HS	Hannah Whitall Smith (Mrs. Robert)
Life of BB	Unpublished fragment at the Villa I Tatti
M	Mary (Smith, Costelloe) Berenson
Mrs. G	Isabella Stewart Gardner ("Mrs. Jack")
Rumor	BB, *Rumor and Reflection* (London: Constable, 1952)
SB	Senda Berenson
Sketch	BB, *Sketch for a Self-Portrait* (London: Constable, 1949)
Sunset	BB, *Sunset and Twilight* (New York: Harcourt, Brace and World, 1963)

I. A Lithuanian Childhood

1:28 Kviklys, *MūsŲ Lietuva*, I, 396–397.

2:15 BB to SB, Nov. 4, 1887.

18 BB to Mrs. G, May 23, 1888.

19 BB to SB, Aug. 22, 1887.

24 BB, "How Matthew Arnold Impressed Me," *Harvard Monthly*, 5, no. 2 (Nov. 1887).

36 BB, *Rumor*, 194.

3:5 Louis Freedman, *Genealogy of Abravanel-Mickleshanski Family* (1903).

22 BB's passports, misc. papers.

4:28 BB, "Contemporary Jewish Fiction," *Andover Review*, 10 (1888), 587–602.

32 BB to Mally Dienemann, Sept. 6, 1950, Fixler collection.

42 Wengeroff, *Memoiren*, passim.

5:42 Kviklys, *MūsŲ Lietuva*, I, 396.

6:2 BB to Dienemann, March 1, 1953, Fixler collection.

12 Mariano, *Forty Years*, 73.

20 BB, *Sketch*, 50.

6:32 Mariano, *Forty Years*, 102.

6:34 BB, *Sketch*, 130–131.

42 Ibid., 162.

7:14 Ibid., 56.

27 Ibid., 57.

38 BB to Dienemann, Sept. 6, 1950.

8:6 BB, *Sunset*, 302.

32 Sprigge, *Berenson*, 18.

9:26 *Harvard Monthly*, 6, no. 5 (July 1888).

10:6 M, Life of BB, X, 7.

10 BB, early journal, 21, misc. papers.

27 BB, *Rumor*, 414; Notebook, Jan. 11, 1886.

37 Ibid.

11:11 BB to Mrs. G, Aug. 24, 1887.

16 BB to Mrs. G, May 23, 1888.

22 BB, *Sunset*, 315.

27 BB, *Rumor*, 162; Mariano, *Forty Years*, 65.

38 BB, *Rumor*, 200.

13:8 Sprigge, *Berenson*, 29.

II. Dreamer in Minot Street

16:8 Morse Goldman to BB, Aug. 11, 1952.

19 BB to Albert Berenson, July 19, 1922.

27 BB, Diary, Dec. 2, 1945.

42 In BB, "Contemporary Jewish Fiction," *Andover Review*, 10 (1888), 587–602.

17:24 Sprigge, *Berenson*, 29.

38 Ibid.

18:25 BB, *Sunset*, 382.

31 Behrman, *People in a Diary*, 267.

19:6 BB, *Rumor*, 356.

32 BB, *Sketch*, 144.

35 BB to Irving P. Fox, Dec. 24, 1883, Boston University Archives.

20:2 BB, *Rumor*, 337.

6 BB, Diary, Jan. 17, 1944; *Sunset*, 425, 426.

16 BB to SB, June 22, 1887.

20:19 BB, early journal notebook, misc. papers.

21:17 BB, *Sketch*, 144.

21 *Sunset*, 408.

38 BB, among misc. papers.

22:2 *Boston University College of Liberal Arts Class of 1887, 1887–1937*, Boston University.

6 Minutes of the Class of 1887, Boston University Archives.

26 BB, early journal notebook, misc. papers.

34 BB to Fox, 1884, Boston University Archives.

23:8 Marginalia in Arnold's *Culture and Anarchy*, inscribed Bernhard Berenson Dec. 1883 and subsequently Feb. March 1945.

31 BB, Diary, March 20, 1945.

34 BB, "How Matthew Arnold Im-

pressed Me," *Harvard Monthly*, 5, no. 2 (Nov. 1887).

24:2 BB to Howe, Jan. 17, 1954, quoted in Howe, *The Gentle Americans*, 428.

9 BB, *Sketch*, 27.

13 Irving Pierson Fox (AB, Boston University, 1883).

24:20 BB to Fox, April 12, 1884.

34 Ibid.

25:19 M, Diary, 1890.

26:15 BB, early notebook, misc. papers.

27:2 BB, early diary, June 21, 1884, misc. papers.

14 BB, early notebook (1884), 18, misc. papers.

III. A Harvard Aesthete

28:4 BB, *Sunset*, 168.

29:2 *Advocate*, May 8, 1885; *Crimson*, June 19, 1885, Jan. 25, 1886, Feb. 12, 1886.

28 *Crimson*, Jan. 22, Feb. 12, March 12, 1886.

32 *Brooklyn Magazine*, 3, no. 3 (Dec. 1885).

30:29 BB, *Sketch*, 102.

31:2 Ibid., 99.

32:4 M, Life of BB, VI, 24.

17 BB, *Sketch*, 51.

28 Early notebook, June 14, 1886, misc. papers.

32:30 BB, *Sunset*, 23, 52.

33:31 BB, Diary, Aug. 16, 1945.

36 Nevius, 64.

34:28 BB, *Rumor*, 28.

37:32 M, Life of BB, II, 1.

42 Ibid.

38:16 Wendell to Robert Thomason, Jan. 31, 1886, Wendell, *Letters*.

39:2 BB to Dienemann, May 17, 1951.

8 Baptismal Records, Trinity Church, Boston.

17 Early journal, Sept. 27, 1886, misc. papers.

40:16 Adams, *Letters*, II, 311.

IV. Literary Debut

41:11 BB to Carpenter, Feb. 9, 1886, Harvard Archives.

45:12 *Harvard Monthly*, 3 (1886–1887), 66–83.

48:21 Boston *Advertiser*, June 30, 1887.

27 Early journal, misc. papers.

50:10 Recommendations in Harvard Archives.

50:23 BB to Norton, Dec. 23, 1886, Harvard Archives.

30 Harlow, *Perry*, 109.

41 BB to Mrs. G, June 17, 1887.

51:11 BB to Bôcher, June 17, 1887, Harvard Archives.

24 BB, shipboard notebook, misc. papers.

26 BB to SB, June 18, 1887.

V. Cities of a Dream

52:5 BB to SB, June 22, 1887.

13 Adams, *Letters*, II, 311.

22 BB to SB, June 30, 1887.

53:22 Early diary, 1887, misc. papers.

54:7 BB to SB, July 11, 1887.

41 BB to SB, Aug. 22, 1887.

55:20 BB to SB, July 25, 1887.

56:26 BB to SB, Nov. 15, 1887.

56:30 BB to Mrs. G, Aug. 24, 1887.

37 BB to Mrs. G, Sept. 30, 1887.

57:2 BB to Mrs. G, Nov. 25, 1887.

8 BB to Mrs. G, Dec. 11, 1887.

32 BB to Mrs. G, Nov. 25, 1887.

58:6 BB to SB, Dec. 28, 1887.

20 BB to SB, Nov. 11, 1887.

28 BB to SB, Nov. 15, 1887.

58:37 BB to SB, Nov. 25, 1887.
59:15 Shipboard journal, misc. papers.
 31 BB to SB, Jan. 12, 1888.
60:13 BB to SB, Jan. 14, 1888.
 16 BB to SB, Jan. 20, 1888.
 25 BB to SB, Feb. 3, 1888.
61:10 Johnson, *Some Winchester Letters,*
 10.
 12 Ibid., 209.
 37 Johnson to Santayana, Aug. 2,
 1888, Santayana, *Middle Span,* 58.
62:1 Pater to BB, Feb. 16, 1888.
 5 BB, *Sunset,* 343.
 11 BB to SB, Feb. 19, 1888.
 23 BB to Mrs. G, Feb. 25, 1888.

62:40 BB to SB, March 1888.
63:11 M, Life of BB, II, 13.
 15 Unsorted papers, May 11, 1888.
 34 Quoted in Jullian, *Prince of Aes-
 thetes,* 109.
64:3 BB to "Deborah," Baroness Léon
 Lambert, née Rothschild, 1906.
65:25 M, Life of BB, I, 6.
 39 Gertrude Burton to M, Aug. 25,
 1887.
66:15 M to BB, Feb. 28, 1888.
 18 BB to SB, March 9, 1888.
 29 Cf. M's self-characterization "ex-
 periment lust" in Life of BB, I, 12.

VI. Seedtime of Art

67:11 Cf. Fixler, "Bernard Berenson."
69:17 BB to SB, Feb. 10, 1888.
 36 *Andover Review,* 10 (1888),
 587–602.
71:11 BB to SB, March 14, 1888.
 17 Ibid.
 29 BB to SB, March 27, 1888.
 40 Carpenter to Robert Herrick,
 April 1888, University of Chicago.
72:2 BB to Mrs. G., March 1888.
73:7 Woermann, "Vorwart," *Katalog.*
 22 BB to SB, March 27, 1888.
 37 BB, early notebook, misc. papers.
74:1 BB, Diary, Feb. 8, 1946.

74:19 BB to SB, April 20, 1888.
 26 BB to Mrs. G, May 23, 1888.
 31 BB to Mrs. G, June 14, 1888.
75:14 Woermann, "Vorwart," *Katalog.*
 19 Morelli, *Italian Masters,* 1883.
 28 BB to Mrs. G, May 23, 1888.
 36 BB to Mrs. G, July 4, 1888.
76:12 BB to SB, June 28, 1888.
 28 BB to Mrs. G, July 4, 1888.
77:21 Harlow, *Perry,* 109.
 25 Edel, *James: Conquest of London,*
 381.
78:10 Fitch, *Fitch and His Letters,* 42.
 19 BB to SB, Aug. 10, 1888.

VII. Beyond the Alps

81:12 BB to Mrs. G, Sept. 10, 1888.
82:5 BB to Mrs. G, Oct. 11, 1888.
 8 BB to SB, Sept. 6, 1888.
83:8 BB to Mrs. G, Nov. 3, 11, 1888.
 27 BB to Mrs. G, Nov. 28, 1888.
84:11 Ibid.
 22 Ibid.
 29 Ibid.
 42 BB to SB, Dec. 23, 1888.
85:5 BB to SB, Dec. 16, 1888.
 11 Ibid.
 25 BB, "Diario Romano," *Corriere
 della Sera,* 1953, in Sprigge, *Beren-
 son,* 96.

87:14 BB to SB, Dec. 23, 1888.
 25 BB to SB, Jan. 16, 1889.
88:4 BB, *Rumor,* 10.
 38 Ibid., 251.
89:23 BB to SB, April 11, 1889.
 29 BB to Mrs. G, April 28, 1889.
90:1 BB to SB, May 26, 1889.
 13 BB to Mrs. G, April 28, 1889.
91:19 BB to SB, May 19, 1889.
93:10 BB to SB, May 17, 1889.
 28 BB, *Sketch,* 59.
94:5 BB to SB, July 24, 1889.
 27 Santayana, *Middle Span,* 225.

94:34 Reported July 1889 in Morelli and Richter, *Italienische*.

35 Morelli to Richter, July 11, 1889, *Italienische*.

95:9 BB to SB, July 8, 1889.

16 Morelli, *Italian Masters*.

36 BB, unpublished review, misc. papers.

VIII. Disciple of Morelli

97:4 James [Jack] Burke; BB to Gertrude Burton, Nov. 5, 1889.

25 Ibid.

98:20 BB, *Rumor*, 397.

22 Ibid., 11.

26 Ibid., 397.

38 BB to Bôcher, Dec. 3, 1889.

101:4 Ibid.

37 Essay on Morelli, misc. papers.

103:12 *Nation*, Feb. 13, 1890.

103:23 Richter to Morelli, Jan. 12, 1890, *Italienische*.

104:10 Morelli to Richter, Jan. 24, 1890, *Italienische*.

15 Norton, ed., *Carlyle-Emerson Correspondence*, III, 29.

20 Morelli to Richter, May 17, 1890, *Italienische*.

26 BB, *Sketch*, 59.

IX. The Smiths of Friday's Hill

106:3 Morelli to Richter, Sept. 6, 1890, *Italienische*.

8 Frizzoni to Costa and BB, Aug. 17, 1890, Morelli and Richter, *Italienische*.

25 BB to Gertrude Burton, Nov. 5, 1889.

107:3 M, Life of BB, I, 11.

17 On M's "train" of admirers, see Smith, *Unforgotten Years*, 83.

40 Ibid., 223.

108:11 Russell, *Autobiography*, 76.

15 HS to (?), Aug. 4, 1890.

32 Smith papers, Oxford.

41 M, Life of BB, I, 12.

109:2 Ibid.

9 Ibid., I, 1.

110:17 HS to M, Oct. 14, 1884.

25 *Who's Who*, 1889; Parker, *Transatlantic Smiths*, 54.

111:7 M to (?), Nov. 1, 1884.

9 M to (?), Feb. 2, 1885.

21 M to Robert Smith, April 21, 1885.

112:10 M to HS, Sept. 9, 1885.

30 M to HS, Nov., 1886.

114:20 M to HS, April 16, 1886.

31 M to family, Nov. 29, 1886.

115:13 M to Robert Smith, Jan. 14, 1887.

35 M to family, Nov. 28, 1887.

117:5 *Girton* [College] *Review*, Dec. 1890.

12 *Women's Penny Paper*, Dec. 13, 1890.

38 Smith, *Unforgotten Years*, 103; Traubel, *With Walt Whitman*, III, 313.

118:1 Whitman to M, July 20, 1885, Whitman, *Correspondence*.

4 Ibid., Feb. 10, 1890.

X. The Path to Monte Oliveto

119:12 Smith, *Unforgotten Years*, 139.

26 M, Diary, Dec. 9, 1889 to April 4, 1890; Smith papers, Oxford.

40 M, Diary, Feb. 1890.

120:42 Datebook, August 15, 1890; M, Life of BB, VIII, 13.

121:26 Datebook, Sept. 7, 1890.

121:41 M, Life of BB, I, 14.

122:36 BB to M, Sept. 24, 1890.

123:1 M to Gertrude Burton, Nov. 11, 1890.

7 M to Gertrude Burton, Dec. 5, 1890.

36 BB to M, Nov. 6, 1890.

124:11 Ibid.
 21 BB to M, Dec. 11, 1890.
125:8 M, Life of BB, III, 3.
126:33 BB to M, Nov. 10, 1890.
127:7 Lensi, *La donazione Loeser.*

129:25 M, Life of BB, III, 38.
 37 BB to M, Nov. 25, 1890.
130:32 M, Life of BB, IV, 38.
 41 BB to M, Nov. 29, 1890.
131:26 M, Life of BB, IV, 28.

XI. Master and Errant Pupil

133:6 BB to M, Oct. (?), 1890.
134:14 Datebook, Jan. 1–8, 1891.
 21 M to HS, Feb. 4, 1891.
 24 M, Life of BB, VI, 1–2, Jan. 1891.
 42 M to HS, Jan. 8, 1891.
135:7 M to Gertrude Burton, Jan. 1891.
 19 BB to M, Jan. 15, 1891.
 25 BB to Gertrude Burton, Dec. 23, 1890, Jan. 31, 1891.
 34 BB to M, Feb. 11, 1891.
 35 M to HS, Feb. 7, 1891.
136:5 BB to M, Feb. 3, 1891.
 14 BB to M, Feb. 1, 1891.
 32 BB to M, Feb. 3, 1891.
 36 BB to M, Jan. 30, 1891.
 42 BB to M, Feb. 1, 1891.
137:4 BB, *Rumor,* 197.
 18 M to HS, Feb. 16, 1891.
 30 M to Gertrude Burton, Feb. 24, 1891.
138:21 BB, *Sunset,* 10.
 35 Barrett Wendell to (?), June 16, 1891, Wendell, *Letters.*
139:11 "Michael" [Edith Cooper], quoted in M, Life of BB, VII, 1.
 36 M, Diary, March 4, 1891.

140:2 M, Diary, March 10, 1891.
 28 M, Diary, April 21, 1891.
 35 Reported by Barbara Halpern.
141:4 This and the succeeding love letters, undated [1891].
142:8 BB to M, [Summer] 1891.
 23 M, Diary, Sept. 28, 1891.
 24 M to HS, Aug. 11, 1891.
143:34 Ibid.
144:20 M to HS, Aug. 19, 1891.
 32 Field, *Works and Days,* 57.
145:12 M, Life of BB, X, 1.
 18 M to HS, Sept. 26, 1891.
 22 M to HS, Sept. 12, 1891.
 38 Ibid.
146:12 M to HS, Oct. 13, 1891.
 28 M to HS, Sept. 17, [1891?].
 31 BB to M, Dec. 1892.
 39 M, Life of BB, X, 1 [Sept. 1891].
147:7 M, Life of BB, X, 4.
 11 Ibid., X, 5.
 27 BB to Rothenstein, 1948.
 31 M to HS, Sept. 1891.
148:10 M, Life of BB, X, 4, 5.
149:37 M to Gertrude Burton, Dec. 5, 1891.

XII. Trial of the Scholar-Aesthete

151:9 BB to SB, April 16, 1892.
152:27 BB, *Rumor,* 73–74.
 38 Misc. papers.
153:13 BB to SB, n.d., 1892.
 15 BB to SB, n.d., 1892.
 32 Quoted in M, Life of BB, VIII, 1.
 42 "Michael" to BB, Dec. 12, 1892.
154:9 BB to "Michael," June 16, 1893.
 41 BB to M, n.d., 1891.
155:29 M, Life of BB.
156:29 BB to SB, July 1892.
157:6 Oct. 29, 1892.
 13 M to HS, Aug. 27, 1892.

157:16 M to HS, Sept. 8, 1892.
 23 M to Gertrude Burton, 1892.
 40 Hapgood, *Changing Years,* 90.
158:7 BB to SB, Sept. 1892.
 38 Burke to BB, Dec. 30, 1892.
159:24 "Michael" to BB, 1892.
 41 M, Life of BB, II, 9.
160:19 BB to SB, Oct. 17, 1892.
161:8 M to HS, Oct. 20, 1892.
 18 BB to M, Jan. 1893.
 26 BB to M, 1892.
 36 BB to M, Dec. 25, 1892.
162:12 BB to SB, Dec. 29, 1892.

162:37 BB, *Rumor*, 126.
163:14 BB to SB, March 26, 1893.
164:8 M to Gertrude Burton, March 15, 1893.
9 BB to SB, April 23, 1893.

164:38 BB to SB, May 3, 1893.
165:16 *Nation*, Oct. 20, 1892, 130.
23 Ibid., 301.
29 *Nation*, April 13, 1893, 271–273.
166:4 BB to SB, April 23, 1893.

XIII. Talent in Harness

167:6 BB to SB, June 17, 1893.
11 BB to "Michael," June 1, 1893.
19 BB to SB, July 22, 1893.
168:18 Ibid.
21 BB to SB, Aug. 1, 1893.
35 Vernon Lee to her mother, July 21, 1893, Gunn, *Vernon Lee*, 149.
169:10 1887 Class Secretary Reports, 1890, 1893, Harvard Archives.
32 M to Robert Smith, Nov. 24, 1893.
170:21 Hapgood, *A Victorian*, 94.
31 Hapgood to M, Jan. 1926.
172:2 M to HS, Oct. 19, 1893.
30 M to HS, Oct. 29, 1893.
173:3 M to Ray and Karin, Oct. 1, 1893.

174:19 Vernon Lee to BB, Jan. 25, 1895.
31 Vernon Lee to BB, Jan. 1, [1894].
175:9 BB to SB, Feb. 19, 1894.
25 M, Diary, Feb. 14, 1894.
177:33 Field, *Works and Days*, 264.
178:15 BB, *Rumor*, 11; reprinted from *Horizon*, June 1946.
179:2 M to HS, June 18, 1895.
19 M, Diary, April 4, 1894.
39 M, Diary, June 1, 1894.
180:12 *Sketch*, 30; *Sunset*, 383.
41 M, Diary, Aug. 24, 1894.
181:20 M, Diary, Feb.–March, passim.
182:4 Davis to BB, April 18, 1894.
26 BB to SB, April 2, 1894.
184:40 BB to SB, April 2, 1894.

XIV. New Vistas at Home and Abroad

187:7 BB to Mrs. G, March 11, 1894.
26 Mrs. G to BB, March 15, 1894.
188:20 BB to SB, May 28, 1894.
30 Bôcher to BB, March 1, 1894.
36 Edward Warren to BB, March 28, 1894.
189:13 Paine, *Mark Twain*, II, 956.
15 James to Francis Boott, Dec. 15, 1894, Houghton Library, Harvard University.
34 M to HS, May 22, 1894.
190:32 M, Diary, June 23, 1894.
42 Hyde, *Wilde*, 168.
191:6 Ibid., 118, 168.
10 Ibid., 169.
38 M, Diary, June 23, 1894.
192:12 Ibid.
21 Paget, *Vernon Lee's Letters*, 1894.
33 BB, *Sketch*, 114.
42 M, Diary, Aug. 23, 1894.
193:2 BB to SB, July 28, 1894.
7 Ibid.
15 BB, *Sunset*, 526.

194:38 M, Diary, Aug. 1894.
195:17 Carpenter to Herrick, Oct. 22, 1894, University of Chicago.
38 BB to M, Sept. 28, 1894.
196:4 BB to M, Sept. 11, 1894.
10 BB to M, Sept. 14, 1894.
20 M to BB, Oct. 1894.
34 Quoted in M to Obrist, Oct. 1, 1894, Smith papers, Oxford.
197:23 M to Obrist, Oct. 1, 1894, Smith papers, Oxford.
31 M to Obrist, Oct. 4, 1894, Smith papers, Oxford.
198:3 BB to M, Sept. 22, 1894.
39 M to HS, Sept. 14, 1894.
199:31 BB to M, Dec. 24, 1894.
200:13 Clark, *Russell*, 55.
25 M to BB, Sept. 1894.
41 M to BB, Sept. 1894.
201:27 M to BB, Oct. 1894.
202:15 BB to M, Oct. 19, 1894.
35 BB to M, Nov. 21, 1894.
203:3 Ibid.

203:11 Ibid.
 26 BB to M, Nov. 21, 1894.
 34 BB to M, Oct. 17, 1894.
204:18 BB to M, Sept. 21, 1894.
 38 BB to M, Nov. 6, 1894.

205:4 BB to M, Nov. 9, 1894.
 10 Ibid.
 27 BB to M, Nov. 13, 1894.
 33 BB to M, Nov. 5, 1894.

XV. Secrets of the Artistic Personality

206:8 M, Diary, Nov. 30, 1894.
 14 HS to M, Nov. 17, 1894.
 28 M, Diary, Dec. 18, 1894.
207:6 BB to SB, Dec. 28, 1894.
 7 Ibid.
 32 BB to SB, Dec. 14, 1894.
208:3 Quoted in BB to SB, Dec. 28, 1894.
 31 M, Diary, Jan. 22, 1895.
 37 BB to SB, Jan. 2, 1895.
209:1 M, Diary, Jan. 29, 1895.
 4 BB to SB, Feb. 24, 1895.
 11 M, Diary, Feb. 13, 1895.

209:17 BB to SB, March 8, 1895.
212:6 Nation, Jan. 24, 1895, 76, 77.
 17 Atlantic Monthly, April 1895, 557.
 40 Athenaeum, April 13, 1895, 481.
213:30 Literarisches Central Blatt, Spalte 1452.
 35 Revue Critique, April 8, 1895, 271.
214:2 Gazette des Beaux-Arts 1895, 361 f.
 12 Art Journal, Aug. 1895, 30.
 22 Spectator, Sept. 23, 1895, 107.
215:15 M, Diary, April 2, 1895.
 27 BB to "Michael," [Jan. 10, 1895].

XVI. Heretic at the New Gallery

216:8 BB to SB, April 7, 1895.
217:3 Ross, Fourth Generation, 347.
 35 M, Diary, April 7, 1895.
 41 M, Diary, Feb. 22, 1895.
218:6 M, Diary, April 1, 1895.
 13 M, Diary, May 29, 1895.
 25 BB to SB, March 8, 1895.
219:8 Mount, Sargent, 137, 203, 241.

220:23 BB to Mrs. G, May 12, 1895, Gardner Museum.
221:28 BB to SB, Feb. 11, 1895.
 35 BB to SB, March 8, 1895.
 41 M, Life of BB.
222:7 M, Diary, Feb. 10, 1895.
223:13 Fortnightly March 1895, 423.
224:12 BB to SB, Feb. 24, 1895.
225:25 M, Diary, Dec. 15, 1896.

XVII. The Tactile Imagination

227:11 M, Diary, May 10, 1895.
 19 M, Diary, May 13, 1895.
 23 M, Diary, July 13–14, 1895.
228:29 BB to SB, June 19, 1895.
 38 M, Diary, June 12, 1895.
 40 M, Diary, June 13, 1895.
229:13 BB to SB, June 2, 1895.
 29 M to BB, Aug. 1, 1895.
232:8 BB to M, Aug. 3, 1895.
 26 M to Obrist, June 30, 1895.
233:5 BB to M, July 31, 1895.
 28 M, Diary, Sept. 14, 1895.
 30 M, Diary, Sept. 7, 1895.

233:37 BB to SB, Oct. 30, 1895.
234:25 Loeser to M, Dec. 3, 1895; "Wed. night" [Dec. 4, 1895].
235:40 Loeser to Herrick, Easter Sunday 1895, University of Chicago; M, Diary, Nov. 26, 1895.
236:9 BB to "Michael," Oct. 24, 1895, copy.
 16 M, Diary, Nov. 9, 1895.
 33 M, Diary, Oct. 31 ff., 1895.
237:15 Ibid.
 40 M, Diary, Sept. 14, 1895.

XVIII. Only the Greatest in the World

240:9 BB to Mrs. G, Dec. 18, 1895.
27 Manning and Shaw, *Colnaghi's*.
42 BB to Mrs. G, Dec. 14, 1895.
241:23 BB to Mrs. G, Aug. 1, 1895.
36 BB to Mrs. G, Dec. 18, 1895.
242:6 BB to Mrs. G, Jan. 4, 1896.
26 BB to Mrs. G, Feb. 16, 1896.
244:5 BB to Mrs. G, Sept. 20, 1895.
7 BB to Mrs. G, Nov. 17, 1895.
18 Mrs. G to BB, Feb. 2, 1896.
41 BB to Mrs. G, Feb. 16, 1896.
245:7 BB to Mrs. G, March 22, 1896.
13 Mrs. G to BB, May 7, 1896.
21 Mrs. G to BB, Feb. 4, 1896.
246:41 Mrs. G to BB, May 7, 1896.
247:1 BB to Mrs. G, June 18, 1896.
15 Mrs. G to BB, Aug. 18, 1896.
18 Mrs. G. to BB, Sept. 19, 1896.
248:12 Mrs. G to BB, Nov. 27, 1896.

248:14 BB to Mrs. G, Sept. 22, 1896.
31 Mrs. G to BB, Oct. 21, 1896.
34 BB to Mrs. G, Sept. 22, 1896.
42 Mrs. G to BB, Sept. 19, 1896.
249:17 BB to Mrs. G, Feb. 10, 1897.
23 BB to Mrs. G, May 9, 1897.
26 BB to Mrs. G, May 26, 1897.
250:1 BB to Mrs. G, June 16, 1897.
251:31 M, Diary, Sept. 27, 1896.
252:9 M to Karin Costelloe, Nov. 25, 1899.
21 M to her children, March 15, 1900.
33 M, Diary, Oct. 4, 1899.
38 M, Diary, May 26, 1899.
253:5 M, Diary, Oct. 4, 1899; M to children, Nov. 23, 1899.
14 Ibid.; M to Karin Costelloe, Nov. 25, 1899.

XIX. The Critical Gantlet

254:12 BB to Mrs. G, June 7, 1896.
255:24 M, Diary, Dec. 8, 1895.
256:10 *Mind,* April 1896, 270.
37 BB to Reinach, Dec. 17, 1895.
257:16 M to BB, Aug. 13, 1896.
258:23 James, *Science,* 4, no. 88, 318.
41 BB to SB, Dec. 4, 1896.
259:31 M, Diary, May 16, 1896.

259:37 Harry Brewster to Dame Ethel Smyth, May 1896, quoted in Gunn, *Vernon Lee,* 157.
260:39 M to BB, Aug. 23, 1896.
261:15 M to BB, Aug. 14, 1896.
27 M to BB, Aug. 13, 1896.
262:35 M, Diary, March 13, 1896.
263:18 M, Diary, March 8, 1896.

XX. The "Wizard of Quick Wits"

264:4 BB to SB, Dec. 4, 1896; *Nuova antologia,* Dec. 1, 1896.
24 M, Diary, April 21, 1896.
265:7 M, Diary, April 23, 1896.
35 BB to Senda, July 25, 1896.
266:22 Herrick to Lovett, Oct. 26, 1896, University of Chicago.
34 M, Diary, April 7, 1896.
41 Lovett to Herrick, April 11, 1896, University of Chicago.
267:19 Quoted in Nevius, *Herrick,* 67 ff.
26 Herrick to Lovett, April 17, 1896, University of Chicago.

268:5 Herrick, "Autobiography," University of Chicago.
14 Herrick to BB, May 12, 1898.
35 M, Diary, May 28, 1898.
269:20 Herrick to Lovett, n.d., 1905, University of Chicago.
270:19 M, Diary, April 16, 1896.
271:22 BB to SB, Jan.(?) 1896.
272:5 BB to SB, Aug. 28, 1896.
28 BB to SB, June 2, 1896.
34 BB to SB, Jan. 26, 1896.
273:5 BB to SB, Dec. 26, 1896.
274:31 M, Diary, Oct. 8, 1896.

275:3 M to Alys Russell, Dec. 12, 1896,
Smith papers, Oxford.
24 M to Alys Russell, Dec. 2, 1896,
Smith papers, Oxford.

275:27 BB to SB, Dec. 4, 1896.
30 BB to SB, Dec. 26, 1896.
42 BB to SB, Dec. 4, 1896.

XXI. A Duel with Vernon Lee

277:2 Primrose path, M, Diary, Oct. 25,
1896.
23 BB to SB, Feb. 19, 1899.
278:22 BB to Reinach, as quoted in M,
Diary, April 14, 1897.
41 Logan P. Smith to M., as quoted
in M, Diary, March 21, 1897.
279:16 M, Diary, Feb. 12, 1897.
29 BB to SB, April 16, 1897.
280:3 BB to SB, June 15, 1897.
11 BB, *Sunset,* 342.
42 M, Diary, Nov. 14, 1897.
281:27 BB, *Sunset,* 33.
31 Lee to her mother, quoted in
Gunn, *Vernon Lee,* 119.
282:3 BB to Mrs. G, Aug. 1, 1897.
9 BB to Perry, Aug. 29, 1897,
McComb, ed., *Letters,* 62.
31 M to BB, Aug. 25, 1897.
38 M to BB, Aug. 22, 1897.
283:4 M to BB, July 13, 1897.
18 Quoted in M, Diary, March 26,
1897.
41 M to BB, Aug. 20, 1897.

284:9 BB to M, Aug. 23, 1897.
286:5 M to BB, Aug. 29, 1897.
16 M, Diary, Sept. 2, 1897.
18 BB to SB, Sept. 8, 1897.
30 BB to M, Sept. 1897.
287:3 Ibid.
39 M, Diary, June 21, 1897.
41 BB to SB, Oct. 22, 1897.
288:5 Ibid.
18 Vernon Lee to BB, Sept. 2, 1897.
41 M to Vernon Lee, Oct. 31, 1897,
Colby College.
289:4 M to Vernon Lee, Nov. 7–8, 1897,
Colby College.
18 M to C. Anstruther-Thomson,
Nov. 12, 1897, Colby College.
40 M, Diary, Nov. 26, 1897.
290:34 Ibid.
36 BB to SB, Nov. 28, 1897.
291:30 BB to Mrs. G, Jan. 9, 1898.
292:6 Mrs. G to BB, Jan. 20, 1898.
18 W. T. Blaydes to BB, quoted in
M, Diary, Dec. 17, 1897.

XXII. A Tangled Web

293:14 BB to SB, April 19, 1897.
27 BB to M, July 18, 1897.
295:18 James to BB, June 15, 1898.
296:37 M, Diary, April 3, 1898.
297:9 BB to SB, Dec. 24, 1899.
12 *Gazette des Beaux-Arts,* July 1898,
39–54.
298:12 Mrs. G to BB, Jan. 12, 1898.
22 Bronzino, a "school picture" ac-
cording to Hendy (1974); attributed
to Bronzino, Berenson posthum-
ous list, 1963.
299:1 Mrs. G to BB, May 16, 1898.
11 Mrs. G to BB, Nov. 7, 1900.
15 Gutekunst to BB, Dec. 6, 1900.
28 BB to Mrs. G, May 4, 1898.

300:8 Mrs. G to BB, Sept. 25, 1898.
33 M to BB, Oct. 17, 1898.
301:1 BB to M, Oct. 10, 1898.
4 M to BB, Oct. 11, 1898.
14 BB to Mrs. G [frag.], [Oct. 1898].
23 BB to Mrs. G, Nov. 19, 1898.
35 M to BB, Oct. 9, 1898.
42 Ibid.
302:3 BB to M, Oct. 11, 1898.
20 BB to Mrs. G., Sept. 29, 1898.
303:6 Mrs. G to BB, May 31, 1899.
36 Tharp, *Mrs. Jack,* 199.
305:4 M to BB, June 9, 1899.
31 BB to Mrs. G, June 13, 1899.
306:13 BB to M, July [June] 9, 1899.
17 BB to M, July 11, 1899.

307:13 BB to M, July 12, 1899.
17 BB to M, Aug. 1899.
30 BB to Mrs. G, Sept. 9, 1899.
308:24 Gutekunst to BB, March 18, 1901.
35 Gutekunst to BB, March 27, 1901.
42 Gutekunst to BB, March 14, 1901.
309:14 Richter to BB, Sept. 4, 1898.
34 Quoted in M, Diary.

310:7 M, Diary, Nov. 3, 1899.
8 M, Diary, Dec. 8, 1899.
15 Fry, *Letters,* I, 218.
25 M, Diary, Jan. 30, 1903.
33 M, Diary, April 27, 1899.
311:11 Horne to Ross, Nov. 10, 1906, in Ross, *Robert Ross.*

XXIII. *A Man of Affairs*

312:5 BB to SB, Aug. 7, 1899.
23 BB to SB, Dec. 24, 1899.
313:3 M, Diary, Dec. 25, 1898.
5 *L'Aurore,* Jan. 13, 1898.
6 M, Diary, Dec. 13, 1898.
12 M, Diary, Jan. 14, 1898.
14 M, Diary, Nov. 30, 1898.
19 BB to SB, May 28, 1899.
31 BB to SB, Sept. 29, 1898.
36 BB to SB, April 21, 1898.
39 BB to Perry, Aug. 29, 1897, Colby College.
41 BB to Mrs. G, May 4, 1898.
314:2 Perry to BB, April 10, 1899.
9 M, Diary, May 10, 1898.
17 BB to SB, July 17, 1898.
31 BB to SB, April 21, 1898.
315:7 *Nation,* Nov. 12, 1908, 461.
10 Morra, *Conversations,* 199.
27 M, Diary, June 1, 1899.
316:2 Gombrich, *Warburg,* 143.
8 M to BB, Aug. 19, 1899.
19 BB to SB, Easter Sunday 1898.
35 Fry, *Letters,* 175.
41 Ibid., 171.
317:4 Ibid., 95.

317:19 M, Diary, June 25, 1898.
28 M, Diary, July 1, 1898.
35 M, Diary, June 28, 1898.
41 M, Diary, June 15, 1898.
318:8 BB to SB, May [June] 22, 1898.
319:10 BB to SB, July 17, 1898.
20 BB to SB, Feb. 13, 1898.
28 BB to SB, Aug. 5, 1898.
320:2 Trevelyan to ?, March 23, 1924.
18 M, Diary, Aug. 26, 1898.
25 M to BB, Aug. 11, 1898.
34 BB to M, Aug. 31, 1898.
321:3 M to HS, Oct. 1898.
7 M to BB, Sept. 1, 1898.
18 M to BB, June 4, 1898.
19 M to BB, Aug. 6, 1898.
27 M to BB, Aug. 17, 1898.
322:29 M, Diary, Sept. 23, 1898.
38 BB to SB, Sept. 1898.
323:14 BB to SB, Oct. 31, 1898.
27 BB to SB, Oct. 13, 1898.
325:6 Horne, BB in Preface, *The Study and Criticism of Italian Art.*
35 BB to SB, June 10, 1899.
39 BB to SB, May 8, 1899.

XXIV. *"Room for Berenson"*

327:23 BB to SB, Feb. 19, 1899.
328:11 M, Diary, Feb. 28, 1899.
13 Warren to BB, Oct. 22, [1899].
22 Burdett and Goddard, *Warren,* 71.
39 M, Diary, Feb. 23, 1899.
329:9 BB to SB, Jan. 10, 1899.
25 M, Diary, March 21, 1899.
27 M, Diary, May 18, 1899.
35 M, Diary, June 26, 1899.
39 Loeser to BB, Feb. 25, 1900.

330:21 BB to SB, Aug. 7, 1899.
36 BB to Mrs. G, Aug. 7, 1899.
331:11 M to BB, May 3, 1900.
332:5 M to BB, Aug. 23, 1899.
13 M to BB, Aug. 30, 1899.
19 BB to M, Aug. 26, 1899.
24 M to BB, Aug. 27, 1899.
34 BB to M, Aug. 29, 1899.
41 Ibid.
333:2 M to BB, Sept. 2, 1899.

332:9 M, Diary, March 1901; March 11, 1902.

334:5 M, Diary, Sept. 14, 1899.

18 M, Diary, Sept. 18, 1899.

335:29 M to BB, Dec. 12, 1899.

336:4 M to BB, Dec. 12, 1899.

8 M to BB, Dec. 14, 1899.

15 M to BB, Dec. 16, 1899.

17 M to BB, March 1, 1900.

337:3 M to BB, Dec. 26, 1899.

14 M to BB, [March] 14, 1900.

20 BB to SB, Jan. 7, 1900.

33 BB to Mrs. G, Jan. 7, 1900.

338:10 BB to Mrs. G, Easter Sunday 1900.

13 Warren to BB, June 15, 1900.

27 BB to Mrs. G, July 22, 1900.

34 M to BB, Jan. 25, 1900.

339:2 M to BB, April 16, 1900.

6 M to BB, April 18, 1900.

11 M to BB, July 23, 1900.

339:15 M to BB, April 22, 1900.

16 BB to SB, July 22, 1900.

20 Mrs. G. to BB, Aug. 3, 1900.

22 HS to M, June 15, 1900.

25 M, Diary, June 10, 1900.

28 M, Diary, June 16, 1900.

30 M to HS, June 17, 1900.

40 Judith Berenson to M, July 17, 1900. In an undated letter to Ralph Barton Perry, husband of his sister Rachel, BB noted his mother's name as Judith (letter courtesy of Bernard Berenson Perry). "Julia," however, appears to have been adopted as her legal name. Among her intimates her name remained "Judith," though given the Hebrew pronunciation.

340:12 BB, *Sunset*, 168.

16 Ibid., 170.

21 Ibid., 470.

XXV. A Union of "Minds and Feelings"

341:6 BB to Fry, Nov. 5, 1900.

11 BB to Mrs. G, March 14, 1900.

22 M to HS, April 7, 1900.

23 M to BB, April 14, 1900.

28 BB to Mrs. G, July 22, 1900.

342:4 Gilmore, "The Berensons," 7.

343:8 M to HS, June 13, 1908.

16 M to BB, July 13, 1900.

26 BB to Mrs. G, July 22, 1900.

39 BB to Mrs. G, April 1, 1900.

344:13 M, Diary, May 22, 1900.

31 M, Diary, Aug. 30, 1900.

39 BB to SB, Sept. 14, 1900.

345:4 M to SB, Oct. 1900.

6 BB to SB, Oct. 3, 1900.

28 M, misc. papers, Sept. 21, 1900.

346:11 Misc. papers, 1900.

347:11 BB to SB, Oct. 8, 1900.

14 M, Diary, Oct. 3, 1900.

347:17 BB to Fry, Nov. 5, 1900.

21 M to SB, Oct. 31, 1900.

26 Ibid.

41 M to HS, Oct. 26, 1900.

348:14 BB to SB, Nov. 1900.

35 Leo Stein to Gertrude Stein, Oct. 9, 1900, Gallup, ed., *Flowers*, 19.

42 Leo Stein to Gertrude Stein, Oct. 11, 1900, Stein, *Journey*, 4.

349:13 M to HS, Nov. 11, 1900.

31 M to HS, Sept. 11 and 21, 1900.

42 M to SB, Nov. 1900.

350:5 BB to SB, Nov. 21, 1900.

40 M to Roger Fry, Nov. 17, 1900, Fry, *Letters*.

351:12 BB to Mrs. G, Dec. 3, 1900.

16 BB to Mrs. G, Nov. 19, 1900.

35 BB to Mrs. G, Jan. 1, 1901.

XXVI. A Victorian Husband

353:13 M, Diary, Feb. 3, 1901.

354:3 M to HS, Feb. 1, 1901.

11 M to HS, Jan. 6, 1901.

354:19 Leo Stein to Gertrude Stein, [Feb. 1901], Stein, *Journey*, 7.

29 M, Diary, Feb. 24, 1901.

355:1 BB to Mrs. G, April 21, 1901.
8 Ibid.
15 M to HS, Jan. 13, 1901.
22 BB to Fry, Feb. 4, 1901.
37 Fry, *Monthly Review*, Dec. 1900,
Feb. 1901. Fry to BB, Jan. 23,
1902, Fry, *Letters*, 188.
356:20 Mrs. G to BB, March 11, 1901.
24 Mrs. G to BB, April 1, 1901.
29 BB to Mrs. G, May 5, 1901.
31 Mrs. G to BB, May 17, 1901.
357:15 M to BB, April 2, 1901.
358:9 Warren to BB, Feb. 28, 1907.
12 Warren to BB, Nov. 8, 1901.
26 Warren to BB, Sept. 12, 1902.
27 Warren to BB, Dec. 20, 1901.
33 Warren to BB, March 12, 1907.
359:1 Warren to BB, Jan. 21, 1902.
12 Mrs. G to BB, April 1, 1901.
16 Mrs. G to BB, Sept. 11, 1901.
26 Quoted in Delamar, "Some Little
Known Facts," 23.
32 BB to Mrs. G, April 1, 1901.
38 M, Diary, June 1, 1901.
360:3 BB to SB, May 8, 1901.
23 M to BB, April 1, 1901.
35 M to BB, April 4, 1901.
39 Quoted in M to BB, April 20,
1901.
361:6 M to BB, April 5, 1901.
16 Zangwill to BB, May 29, 1901.
26 M, Diary, May 24, 1901.
32 M, Diary, June 10, 1901.
34 M, Diary, May 6, 1901.
41 M, Diary, June 17, 1901.
362:5 M, Diary, June 12, 1901.

362:24 BB to Mrs. G, Aug. 25, 1901.
28 BB to Bessie, Aug. 23, 1901.
32 M to BB, Sept. 5, 1901.
33 M to BB, Aug. 20, 1901.
36 M to BB, Aug. 29, 1901.
38 M to BB, Sept. 6, 1901.
40 BB to M, Sept. 5, 1901.
363:13 M to BB, Sept. 9, 1901.
18 Ibid.
31 M to BB, Sept. 2, 1901.
364:1 M to BB, Sept. 7, 1901.
21 BB to M, Aug. 1901.
28 M, Diary, Oct. 26, 1901.
36 M, Diary, Oct. 1901.
365:7 M to Fry, Nov. 11, 1901.
28 BB to M, Oct. 7, 1901.
35 BB, *Rumor*, 3.
366:8 M to BB, Dec. 14, 15, 1901.
19 M to BB, Dec. 30, 1901.
30 M to BB, Dec. 10, 1901.
367:7 M to BB, Dec. 31, 1901.
11 M to BB, Jan. 1, 1902.
17 M to BB, Dec. 29, 1901.
21 M to BB, Jan. 3, 1902.
38 BB to Mrs. G, Feb. 2, 1902.
368:5 M, Diary, Feb. 14, 1902.
13 Placci to Salvemini, Jan. 12, 1902,
Salvemini, *Carteggi*.
20 M to HS, Jan. 11, 1902.
25 M to HS, Nov. 12, 1901.
28 BB to Mrs. G, Nov. 17, 1901.
32 M to HS, Jan. 9, 1902.
37 M to HS, March 30, 1902.
369:5 M to HS, Nov. 29, 1901.
7 M to HS, Dec. 8, 1902.
12 M, Life of BB, XX, 15, 16 [1934].

XXVII. The Study and Criticism of Italian Art

370:9 *Nation*, Nov. 11, 1901, 362.
371:36 *Independent*, Dec. 5, 1901, 2900.
372:10 *Athenaeum*, Nov. 16, 1901.
20 M to Fry, Nov. 18, 1901.
41 *Athenaeum*, April 18, 1903, 5034.
373:4 *Il marzoco*, Nov. 3, 1901.
14 *Kunstchronik*, no. 234 (1901), 424.
25 Gronau, *Gazette des Beaux-Arts*,
Feb. 1895, 161.
374:19 *Nation*, Nov. 6, 1902, 364.
375:13 *Independent*, Nov. 6, 1902, 2655.

375:27 *Atlantic Monthly*, June 1903, 834.
377:3 M, Diary, March 25, 1902.
8 M, Diary, March 22, 1902.
13 M, Diary, April 2, 1902.
16 M, Diary, March 31, 1902.
31 M, Diary, April 22, 1902.
40 BB to Mrs. G, May 11, 1902.
378:2 M, Diary, April 26, 1904.
8 M, Diary, April 21, 1902.
10 Ross in Field, *Works and Days*, 277.
22 M to HS, April 1902.

378:28 BB to Mrs. G, May 11, 1902.
 38 "Art Forgeries," *The Times,* April 4, 1903.
379:10 BB to Mrs. G, May 11, 1902.
 14 BB to Mrs. G, May 15, 1902.
 16 BB to Abie Berenson, May 15, 1902.
380:5 BB to Mrs. G, May 31, 1902.
 23 BB to Mrs. G, Aug. 9, 1902.
 25 Ibid.
 26 BB to Mrs. G, June 8, 1902.
 33 BB to Mrs. G, June 18, 1902.
381:5 M, Diary, Nov. 27, 1903.
 9 BB, *Catalogue of a Collection of Paintings and Some Art Objects,* vol. I: *Italian Paintings* (Philadelphia, 1913).
 10 Marle, *Development of Italian Schools,* XIV, 408; also *Tutta la pittura del Perugino.*
 31 M, Diary, June 18, 1902.
 39 Stein to Mabel Weeks, Sept. 19, 1902, Stein, *Journey,* 10.
382:22 Ibid.
383:12 M, Diary, Oct. 12, 1902.
 22 M to HS, Oct. 31, 1902.
 29 M, Diary, Dec. 1, 1902.
 33 M, Diary, Dec. 29, 1902.
 40 Ibid.

384:4 Mrs. G to BB, Jan. 17, 1903.
 14 M, Diary, Nov. 19, 1902.
 20 M, Diary, March 25, 1903.
 32 M to HS, Jan. 13, 1903.
385:4 Russell to BB, Feb. 27, 1903.
 6 BB to Russell, March 22, 1903, quoted in Clark, *Russell,* 95.
 21 M, Diary, Jan. 25, 30, 1903.
 24 Russell to BB, March 31, 1903.
 31 Russell to BB, Feb. 28, 1903.
 34 Russell to Gilbert Murray, Dec. 28, 1902, quoted in Clark, *Russell,* 93.
386:12 Zangwill to BB, May 29, 1901.
 16 M, Diary, Nov. 23, 1902.
 27 M, Diary, Feb. 25, 1903.
387:5 BB to Russell, April 1903.
 8 M, Diary, March 8, 1903.
 13 M, Diary, March 7, 1903.
 28 M, Diary, June 1, 1903.
 34 Logan Pearsall Smith to HS, March 22, 1903, Library of Congress.
388:8 Chapman to BB, Aug. 11, 1903.
 27 M, Diary, Feb. 19, 1903.
 41 Lewis, *Wharton,* 269, 270.
389:2 BB, *Sketch,* 24.
 8 BB to Mary, quoted in Lewis, *Wharton,* 270.

XXVIII. The Wars of the Burlington

390:10 Fry to Lady Fry, Sept. 20, 1903, Fry, *Letters,* 212.
 22 Fry to BB, Nov. 1901, Fry, *Letters,* 183.
 24 M, Diary, Jan. 16, 1901.
 25 M, Diary, June 1903.
391:7 Fry to M, March 6, 1903, Fry, *Letters,* 205.
 17 Fry to M, Jan. 30, 1903, Fry, *Letters,* 203.
 29 Fry to M, Jan. 21, 1903, Fry, *Letters,* 200.
392:5 Fry to Moore, Jan. 21, 1903, Fry, *Letters,* 201, 202.
 10 Fry to M, March 16, 1903, Fry, *Letters,* 206.
 13 M to BB, April 9, 1903.

392:19 Ibid.
 23 M to BB, Easter Sunday 1903.
393:23 M to Fry, Aug. 20, 1900.
 30 *History of Siena,* 1902.
 31 *Nation,* March 19, 1903, 234.
394:8 *History of Siena,* 386.
 25 Perkins' article signed "F.M.P.," April 1903, 259.
 38 May issue, 306.
395:25 Richter to BB, Sept. 12, 1903.
 35 April issue, 269.
 38 May issue, 396.
 40 June issue, 113.
399:26 M, Diary, Sept. 7, 1903.
400:4 M, Diary, Nov. 10, 1903.
 9 Fry to M, Nov. 17, 1903, Fry, *Letters,* 214.

400:27 Fry to M, Dec. 14, 1903, Fry, *Letters*, 215.

36 Fry to M, Jan. 9, 1904, Fry, *Letters*, 216.

401:10 Fry to M, Dec. 14, 1903, Jan. 9, 1904, Fry, *Letters*, 216, 217.

18 *Burlington*, 92 (1950), 345–349.

21 On Fry, see BB, *Sunset*, 489.

XXIX. Mission to the New World

402:16 M to BB, May 29, 1903.

403:7 Fitch, *Fitch and His Letters*, May 31, 1904, 267.

22 M to Abie Berenson, Oct. 24, 1902.

31 M to Abie Berenson, March 20, 1903.

404:34 M to BB, July 27, 1903.

37 BB to Mrs. G, July 5, 1903.

405:20 M, Diary, Aug. 20, 1903.

36 Issue of Oct. 16, 1904.

406:15 M, Diary, Sept. 30, 1903.

407:2 M, Diary, Oct. 8, 1903.

14 Ibid.

19 M, Diary, Oct. 11, 1903.

21 M, Diary, Oct. 8, 1903.

29 M, Diary, Oct. 12, 1903.

41 M, Diary, Oct. 31, 1903.

408:9 BB to M, in M, Diary, Nov. 3, 1903.

409:2 M, Diary, Dec. 31, 1903.

10 *Nation*, Aug. 6, 1903.

24 *Annual Register*, part II, 1904, 36.

410:39 M, Diary, Dec. 17, 1903.

411:5 M, Diary, Nov. 7, 1903.

21 BB to M, in M, Diary, Nov. 6, 1903.

36 M, Diary, Nov. 10, 1903.

412:12 BB to M, in M, Diary, Nov. 16, 1904.

17 M, Diary, Nov. 26, 1903.

31 M, Diary, Oct. 19, 1903.

35 M, Diary, Oct. 17, 1903.

41 M, Diary, Oct. 27, 1903.

413:18 M, Diary, Oct. 19, 1903.

23 M, Diary, Nov. 22, 1903. For a vivid recollection of the meeting with La Farge and Van Horne see BB, *Sunset,* 502.

37 La Farge to Adams, Jan. 1904.

42 M, Diary, Nov. 13, 1903.

414:19 M, Diary, Oct. 26, 1903.

25 Mrs. G to M, Jan. 19, 1904.

35 M to Mrs. G, Jan. 21, 1904.

415:25 M to HS, Nov. 17, 19, 1903.

39 M, Diary, Nov. 20, 1903.

417:2 M to Mrs. G, May 27, 1904.

XXX. A New Beginning

419:30 M, Diary, Dec. 17, 1903.

420:29 Carpenter to Herrick, Jan. 9, 1904, University of Chicago.

30 Glaenzer to BB, Dec. 24, 1903.

40 Glaenzer to BB, May 31, 1904.

421:9 Glaenzer to BB, Dec. 29, 1904.

27 M to HS, Dec. 20, 1903.

40 Fry to Helen Fry, Jan., 1905, Fry, *Letters*, 227.

422:29 M to HS, Dec. 31, 1903.

423:13 M, Diary, Jan. 4, 1904.

22 M, Diary, Jan. 7, 1904.

31 M, Diary, Jan. 10, 1904.

425:17 BB to M, in M, Diary, Jan. 7, 1904.

426:2 Charles L. Freer to Tryon, Jan. 18, 1904, Freer Gallery.

6 Freer to Frederick W. Gookin, Jan. 22, 1904, Freer Gallery.

16 M, Diary, Jan. 21, 1904.

26 M, Diary, Jan. 26, 1904.

427:5 M, Diary, Jan. 31, 1904.

13 M, Diary, Feb. 7, 1904.

24 M, Diary, Jan. 28, 1904.

428:14 M, Diary, Feb. 14, 1904.

28 M, Diary, Feb. 18, 1904.

33 M, Diary, Feb. 17, 1904.

429:7 M, Diary, Feb. 15, 1904.

11 Adams to Cameron, Feb. 16, 1904, Mass. Hist. Soc.

429:23 Adams to Cameron, Oct. 12, 1909, Mass. Hist. Soc.
25 Adams to James, Adams, *Letters,* II, 523.
27 BB on Adams, quoted in Taylor, "Summons," 126.
430:3 M to HS, Feb. 21, 1904.
15 M to HS, March 1, 1904.
31 M, Diary, March 12, 1904.

430:32 Glaenzer to BB, April 13, 1904.
38 M, Diary, March 3, 1904.
431:10 M, Diary, March 4, 1904.
20 Tompkins, *Merchants and Masterpieces,* 104.
31 *Harvard Class of 1887, Fiftieth Anniversary Report* (Harvard University, 1937).

Index